Theatre through the Ages
A Concise Anthology of Drama

Second Editon

James Winter
Southeastern Louisiana University

Kendall Hunt
publishing company

Cover image: Jaren Mitchell and Brandy Fulton in Southeastern Louisiana University's 2009 production of *A Midsummer Night's Dream*. Directed by Rusty Tennant. Photo by Steve Schepker.

Kendall Hunt
publishing company

www.kendallhunt.com
Send all inquiries to:
4050 Westmark Drive
Dubuque, IA 52004-1840

Copyright © 2007, 2010 by Kendall Hunt Publishing Company

ISBN 978-0-7575-7823-6

Printed in the United States of America
10 9 8 7 6 5 4 3 2 1

Contents

Introduction

Introduction to Theatre. Dramatic Literature. These courses usually require you, as the student, to purchase a very large, dry, academic tome filled with dozens of plays. Over the course of a single semester, you might be asked to read about six of these plays. Yet, because it is required, you pay over one hundred dollars for a book that makes *War and Peace* seem small by comparison, and you lug it around campus every time you have class.

This anthology is designed to be the student's answer to the above-mentioned difficulties. Your editors have worked hard to compile a small, more manageable text that still includes great plays by some of history's greatest playwrights. In addition to putting together a concise, twelve-play anthology, we've also attempted to write a textbook that is interesting and fun. Too often, people in academia and even professional theatre employees seem to forget why they got into theatre in the first place. They did it because it is an incredibly fun art form. Rather than introducing these plays with dry, academic analyses, we've given you what you need to know about the author and the play, while throwing in some things you'd like to know. Each play includes fun and interesting facts about the playwrights, the plays, and their production history. Our goal is to make you want to read these great plays and to give you a better understanding of the plays as vital elements of an exciting art, rather than dusty, historical relics.

For our second edition of this text, we've enhanced the variety of dramatic genres and provided a much more diverse range of playwrights. It was a challenge to keep this a small anthology while still showcasing a broad spectrum of authors. Doing so required increasing the total number of plays in the text. At a first glance, the selections seem heavily weighted toward modern and contemporary drama. This is primarily because theatrical diversity exploded in the twentieth century. In the thousands of years prior, theatrical movements sometimes spanned hundreds of years with only minimal changes in style. We've still included some of the major classical plays, but we've also chosen to showcase a greater range of the more modern genres. To help make up for this, we've included a disk for each instructor who uses this book. The disk contains several classical plays in the public realm that can be used to supplement (or substitute) those plays in the actual text. Because these works are in the public realm, the instructor can post them to Blackboard or any similar online instructional tool where the students can access them.

Almost every play in this volume is produced hundreds of times all around the world every single year. Some of your generation's finest actors, as well as history's greatest performers, have played the parts featured in this text. We're not talking about literary pieces isolated in the classroom. We're talking about plays that made or enhanced the careers of amazing actors such as Sarah Bernhardt, Don Cheadle, Elizabeth Taylor, Mary-Louise Parker, John Gielgud, James Earl Jones, Sir Lawrence Olivier, Kathryn Hepburn, Terrence Howard, and Paul Newman.

This edition of plays begins with one of the true essentials of theatre, Sophocles' *Oedipus the King*. The cornerstone piece of what the Western world calls tragedy, this place has been hailed by critics from ancient Greece through present day as a perfect example of the genre. Shakespeare, of course, is represented in the following pages. No drama anthology would be complete without *Hamlet*, the Holy Grail of dramatic literature; it is a script analyst's perfect dream or worst nightmare, depending on how you look at it. The title role has attracted history's finest actors who have all desperately struggled to bring flesh and blood to one of literature's most dynamic characters. *Tartuffe* gives us a look at the clever combination of wit and bawdiness only France's greatest Renaissance playwright, Molière, could bring to the stage. Any anthology venturing into the realm of modern drama requires at least one piece by Henrik Ibsen. Ibsen's *A Doll's House* is a classic example from the man who turned the theatre world on its ear with his cutting

exploration of everyday life and the troubles lurking behind your neighbor's front door. In *The Importance of Being Earnest*, Oscar Wilde uses his razor-sharp wit to take hilarious aim at the ridiculousness of society. One of the first major American works to explore homosexuality, Tennessee Williams's *Cat on a Hot Tin Roof* paved the way for major writers such as Richard Greenberg and Tony Kushner. Though short-lived, the Theatre of the Absurd had a profound impact on all theatrical work that followed it. Eugene Ionesco's *The Bald Soprano* is a humorous and disturbing look at the inanity of everyday suburbia. By the time Ionesco and his contemporaries were through, everything we thought about drama had radically changed. Following in the footsteps of the absurd, Amiri Baraka's *Dutchman* takes us on a terrifying journey aboard an inner-city subway where sex and race collide with haunting results. Called by many the greatest American playwright since Eugene O'Neill, August Wilson brings the experience of black America to the stage with a poetry and insight beyond comparison. Wilson's defining play, *Fences*, explores a man struggling between tradition and a changing world at a time when African Americans were beginning to push for a better life. We are proud to add several female dramatists to this anthology, including Paula Vogel. Her haunting play *How I Learned to Drive* takes us on a sometimes humorous and often disturbing journey into sexual abuse. Suzan-Lori Parks's *Topdog/Underdog* made her the first African American woman to win the Pulitzer Prize for Drama. It tells the story of two inner-city brothers battling their past and present in a desperate struggle for survival. Sarah Ruhl is one of the hottest contemporary writers in all of theatre. We've included her highly successful play *Eurydice*, a fresh and stylized take on the ancient Greek myth of Orpheus and his doomed bride. We've also further enhanced our section on new work for the theatre. Jim Winter's *Dead Flowers* remains in this new edition because it continues to move toward reaching a wider audience and it was popular among readers of the first edition. Along with Winter's tale of a mother torn between her addiction and her love for her son, we've included excerpts from two brand-new plays. Zachary Boudreaux's *Parking Lot Babies* is an unflinching snapshot of today's twenty-somethings, and Lisa Beth Allen's *Have a Heart* uses organ donors and reality television as the backdrop for a powerful tale of love and redemption.

This newer and stronger version of *Theatre through the Ages* is designed to serve as a springboard into the amazing world of dramatic literature. The fantastic works collected in this edition are as diverse as our ever-changing world. Enjoy them. And don't be afraid to read some of the plays your professors don't assign to you.

James Winter
April, 2010

Oedipus the King

Sophocles and the Theatre of Ancient Greece

Theatre in the Western world can be traced back to the city of Athens in ancient Greece. Much of the terminology, symbols, and conventions we associate with theatre today came from the theatre of ancient Greece. The first record of a theatrical event in the Western world was in Athens in the year 534 B.C For the ancient Greeks, drama was not merely a form of entertainment. Plays were performed only at festivals honoring Dionysus, the god of wine, revelry, and fertility. By the fifth century B.C., Athens held four festivals a year in honor of Dionysus. Plays were presented at three of these. Contests were held at each festival, and prizes were awarded to the various playwrights who competed.

Attending these plays was considered a civic duty, and as many as 17,000 Greeks would come to the amphitheatres built into hillsides to watch the competitions. Artwork and litera-ture from the time tell us that the performers in these plays wore masks. For centuries, scholars have speculated about the purpose of the mask in Greek theatre. There is even considerable speculation about the style of mask worn by the ancient thespians. We may never know for certain why these masks were worn and what specific purpose(s) they served, but we do know that none of the Grecian actors revealed their bare faces to the spectators. These stories were told and acted out from behind a mask.

Of the hundreds of plays produced in ancient Greece, very few have survived to modern times. We have only discovered the manuscripts of four ancient Greek playwrights: Aeschylus, Sophocles, Euripides, and Aristophanes. Only a portion of each playwright's work remains intact.

Greek theatre was a theatre of absolutes. A play was to be either a tragedy or a comedy; rarely were the two genres to be mixed. While the Greeks certainly enjoyed their comedies, tragedy was considered the high art of the day.

Sophocles was a tragic playwright who is widely considered to be the greatest of the ancient Greek dramatists and one of the greatest playwrights of all time. He was also a military general and a treasurer for a time, but his greatest contributions were as a writer. Over 120 plays have been attributed to Sophocles, but only seven survive: *Ajax, Trachiniae, Anti-gone, Oedipus the King, Electra, Philoctetes,* and *Oedipus at Colonus.* Fragments of an eighth play, *The Trackers,* survive. Records show that Sophocles won the tragedy competition twenty-four times in his career, beginning with his first victory in 468 B.C. He never finished lower than second place in the competition. Sophocles was the first playwright to add a third actor into dramatic performance. Prior to him, only two actors performed separately from the cho-rus. Sophocles also enlarged the size of the chorus from twelve to fifteen men.

The chorus is a defining feature of ancient Greek drama. The structure of most Greek plays features alternating scenes between the actors and the chorus. These choral scenes serve a variety of purposes. They help to explain the setting to the audience because little to no specific scenery was used. The chorus also explains much of the action that takes place off stage. One of the conventions of ancient Greek drama was that much of the violence and physical action of the play had to take place out of view of the audience. Perhaps the most important function of the chorus was that of representing the Greek audience watch-ing the play. The chorus raised the questions that the audience wanted to and reacted to the unfolding events in much the way citizens of the day would have. Every chorus trained for each specific play for an entire year leading up to the play's performance. You will also notice that much of the most lyrical and complex writing in an ancient Greek tragedy was

given to the chorus. Theories abound about how the chorus moved, spoke, sang, danced, and so on. We can only speculate, but watching a real Greek chorus in action must have been a sight to behold.

Oedipus the King

About one hundred years after Sophocles wrote *Oedipus the King*, a Greek philosopher by the name of Aristotle wrote the first piece of theatre criticism that we know of. It was called *Ars Poetica*, or *The Poetics*. In *The Poetics*, Aristotle defined the form and structure of tragedy. He repeatedly refers to Sophocles' *Oedipus the King* as the perfect, definitive example of a tragedy. Aristotle mapped the plot of Sophocles' play to showcase the various key components of a tragedy. Since that time, many of our great tragedies, even our modern ones, very closely mirror the sequence of events laid forth by Sophocles and Aristotle.

Oedipus the King takes place over a critical twenty-four-hour period in the life of the king of Thebes. His citizens are suffering from a terrible plague and have come to beg Oedipus, the king, for help. The Oracle at Delphi, a mysterious and powerful fortune-teller of sorts, claims the city suffers as a result of the mysterious murder of Laius, the former king who was murdered shortly before Oedipus arrived in the city. The Oracle claims that the king's killer must be found and punished in order for the plague to be lifted from the city. Proud and assertive; Oedipus vows to seek out the truth, find the killer, and bring him to justice at any cost. Oedipus' quest for truth and justice leads him into his own dark and mysterious past, and his final, shocking discovery ruins his life forever. It is an incredibly powerful dramatic style that takes us deeper into the past as the story progresses forward. This method of dramatic storytelling is still extremely popular today. One need only look at films like *Memento* and *Skeleton Key* as but two current examples of Sophocles' method put to modern use.

In *The Poetics*, Aristotle states that a tragic hero should be "a man who is neither a paragon of virtue and justice nor undergoes the change to misfortune through any real badness or wickedness but because of some mistake." In other words, a tragic hero is brought down by some kind of tragic flaw. There is something within the hero's personal makeup that leads to his demise. It isn't necessarily a negative quality either. In the case of Oedipus, many of the qualities that make him a great leader are also the qualities that lead him to ruin.

We have chosen to begin this anthology with *Oedipus the King*, not only because it is one of the first great works of Western drama but also because it is still widely considered to be one of the greatest plays of all time. Sophocles' master work is produced every year at theatres all over the world, and many of history's great actors have taken their turn at portraying the ill-fated Oedipus. Sigmund Freud even used the Oedipus myth as the foundation for one of his most popular psychological theories. Still controversial, still shocking, and always fascinating, Sophocles' *Oedipus the King* is an excellent portal into the powerful and thought-provoking world of theatre.

Food for Thought

As you read the play, consider the following questions:

1. Do you like the character of Oedipus? Was he sympathetic? Did you feel sorry for him?
2. What do you think Oedipus' tragic flaw is?
3. Is Oedipus a victim of fate?
4. What do you think the theme of this play is? In one sentence, can you come up with a theme for this complex play?

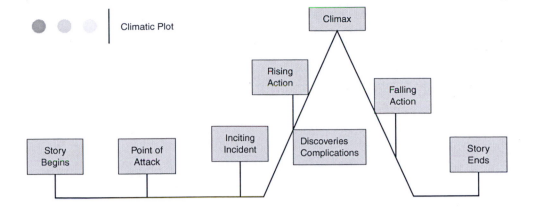

Climatic Plot

5. Why do you think this play remains so popular today?
6. On the chart below, see if you can map the events in the play as they would fall in Aristotle's plot structure for a tragedy.

Fun Facts

1. The ancient Greek audience was very familiar with the story of Oedipus, long before Sophocles wrote his play. Even though they knew exactly what would happen at the play's conclusion, audiences loved it. Much like the success of the film *Titanic*, *Oedipus the King* proved that it isn't the story that brings in an audience, it is how the story is told.
2. The ancient Greek theatre was completely devoid of females. Women were forbidden to perform and attend the productions. Even the roles of the queen and the daughters of Oedipus were played by men. Good thing they wore masks.
3. The famous symbol for drama featuring the two masks, one of comedy and one of tragedy, does not come from ancient Greece. That symbol comes from Roman influence. Many scholars believe the Greek masks were flexible and emotionless. This allowed the actor to convey a number of emotions in spite of the mask. Roman theatre was a theatre of absolutes, so their masks were good or bad, serious or comic.

Oedipus the King

Sophocles

Translator's Note

In the following text the numbers in square brackets refer to the Greek text; the numbers without brackets refer to the English text. The asterisks indicate links to explanatory notes inserted by the translator.

Characters

Oedipus, king of Thebes
Priest, the high priest of Thebes
Creon, Oedipus' brother-in-law
Chorus of Theban elders
Teiresias, an old blind prophet
Boy, attendant on Teiresias
Jocasta, wife of Oedipus, sister of Creon

Messenger, an old man
Servant, an old shepherd
Second Messenger, a servant of Oedipus
Antigone, daughter of Oedipus and Jocasta, a child
Ismene, daughter of Oedipus and Jocasta, a child
Servants and Attendants on Oedipus and Jocasta

The action takes place in Thebes in front of the royal palace. The main doors are directly facing the audience. There are altars beside the doors. A crowd of citizens carrying branches decorated with laurel garlands and wool and led by the PRIEST has gathered in front of the altars, with some people sitting on the altar steps. OEDIPUS enters through the palace doors.

OEDIPUS. My children, latest generation born from
 Cadmus,
 why are you sitting here with wreathed sticks in
 supplication to me, while the city
 fills with incense, chants, and cries of pain?[1]
 Children, it would not be appropriate for me
 to learn of this from any other source,
 so I have come in person—I, Oedipus,
 whose fame all men acknowledge. But you there,
 old man, tell me—you seem to be the one
 who ought to speak for those assembled here.
 What feeling brings you to me—fear or desire?
 You can be confident that I will help.
 I shall assist you willingly in every way.
 I would be a hard-hearted man indeed,
 if I did not pity suppliants like these.

PRIEST. Oedipus, ruler of my native land,
 you see how people here of every age
 are crouching down around your altars,
 some fledglings barely strong enough to fly
 and others bent by age, with priests as well—
 for I'm priest of Zeus—and these ones here,
the pick of all our youth. The other groups
 sit in the market place with suppliant sticks
 or else in front of Pallas' two shrines,
 or where Ismenus prophesies with fire.[2]
 For our city, as you yourself can see,
 is badly shaken—she cannot raise her head
 above the depths of so much surging death.
 Disease infects fruit blossoms in our land,
 disease infects our herds of grazing cattle,
 makes women in labour lose their children.
 And deadly pestilence, that fiery god,
 swoops down to blast the city, emptying
 the House of Cadmus, and fills black Hades
 with groans and howls. These children and myself
 now sit here by your home, not because we think
 you're equal to the gods. No. We judge you
 the first of men in what happens in this life
 and in our interactions with the gods.
 For you came here, to our Cadmeian city,
 and freed us from the tribute we were paying
 to that cruel singer—and yet you knew

[1] *Cadmus*: legendary founder of Thebes. Hence, the citizens of Thebes were often called children of Cadmus or Cadmeians.

[2] *Pallas*: Pallas Athena. There were two shrines to her in Thebes. *Ismenus*: A temple to Apollo Ismenios where burnt offerings were the basis for the priest's divination.

"Oedipus the King" translated by Ian Johnston. Reprinted by permission of Ian Johnston. Ian Johnston has a number of translations and lectures available on the web at the following address: http://records.viu.ca/johnstoi/index.htm

no more than we did and had not been taught.[3]
In their stories, the people testify
how, with gods' help, you gave us back our lives.
So now, Oedipus, our king, most powerful
in all men's eyes, we're here as suppliants,
all begging you to find some help for us,
either by listening to a heavenly voice,
or learning from some other human being.
For, in my view, men of experience
provide advice which gives the best results.
So now, you best of men, raise up our state.
Act to consolidate your fame, for now,
thanks to your eagerness in earlier days,
the city celebrates you as its saviour.
Don't let our memory of your ruling here
declare that we were first set right again,
and later fell. No. Restore our city,
so that it stands secure. In those times past
you brought us joy—and with good omens, too.
Be that same man today. If you're to rule
as you are doing now, it's better to be king
in a land of men than in a desert.
An empty ship or city wall is nothing
if no men share your life together there.

OEDIPUS. My poor children, I know why you have
 come—
I am not ignorant of what you yearn for.
For I well know that you are ill, and yet,
sick as you are, there is not one of you
whose illness equals mine. Your agony
comes to each one of you as his alone,
a special pain for him and no one else.
But the soul inside me sorrows for myself,
and for the city, and for you—all together.
You are not rousing me from a deep sleep.
You must know I've been shedding many tears
and, in my wandering thoughts, exploring
many pathways. After a careful search
I followed up the one thing I could find
and acted on it. So I have sent away
my brother-in-law, son of Menoeceus,
Creon, to Pythian Apollo's shrine,
to learn from him what I might do or say
to save our city. But when I count the days—
the time he's been away—I now worry
what he's doing. For he's been gone too long,

well past the time he should have taken.
But when he comes, I'll be a wicked man
if I do not act on all the god reveals.

PRIEST. What you have said is most appropriate,
for these men here have just informed me
that Creon is approaching.

OEDIPUS. Lord Apollo,
as he returns may fine shining fortune,
bright as his countenance, attend on him.

PRIEST. It seems the news he brings is good—if not,
he would not wear that wreath around his head,
a laurel thickly packed with berries.[4]

OEDIPUS. We'll know soon enough—he's within
earshot.

Enter CREON. OEDIPUS *calls to him as he
approaches.*

My royal kinsman, child of Menoeceus,
what message from the god do you bring us?

CREON. Good news. I tell you even troubles
difficult to bear will all end happily
if events lead to the right conclusion.

OEDIPUS. What is the oracle? So far your words inspire
in me no confidence or fear.

CREON. If you wish to hear the news in public,
I'm prepared to speak. Or we could step inside.

OEDIPUS. Speak out to everyone. The grief I feel
for these citizens is even greater
than any pain I feel for my own life.

CREON. Then let me report what I heard from the god.
Lord Phoebus clearly orders us to drive away
the polluting stain this land has harboured—
which will not be healed if we keep nursing it.

OEDIPUS. What sort of cleansing? And this disaster—
how did it happen?

CREON. By banishment—
or atone for murder by shedding blood again.
This blood brings on the storm which blasts our
state.

OEDIPUS. And the one whose fate the god revealed—
what sort of man is he?

[3] *cruel singer*: a reference to the Sphinx, a monster with the body of a lion, wings, and the head and torso of a woman. After the death of king Laius, the Sphinx tyrannized Thebes by not letting anyone into or out of the city, unless the person could answer the following riddle: "What walks on four legs in the morning, on two legs at noon, and three legs in the evening?" Those who could not answer were killed and eaten. Oedipus provided the answer (a human being), and thus saved the city. The Sphinx then committed suicide.

[4] *berries*: a suppliant to Apollo's shrine characteristically wore such a garland if he received favourable news.

CREON. Before you came, my lord,
 to steer our ship of state, Laius ruled this land.

OEDIPUS. I have heard that, but I never saw the man.

CREON. Laius was killed. And now the god is clear:
 those murderers, he tells us, must be punished,
 whoever they may be.

OEDIPUS. And where are they?
 In what country? Where am I to find a trace
 of this ancient crime? It will be hard to track.

CREON. Here in Thebes, so said the god. What is sought
 is found, but what is overlooked escapes.

OEDIPUS. When Laius fell in bloody death, where was he—
 at home, or in his fields, or in another land?

CREON. He was abroad, on his way to Delphi—
 that's what he told us. He began the trip,
 but did not return.

OEDIPUS. Was there no messenger—
 no companion who made the journey with him
 and witnessed what took place—a person
 who might provide some knowledge men could use?

CREON. They all died—except for one who was afraid
 and ran away. There was only one thing
 he could inform us of with confidence
 about the things he saw.

OEDIPUS. What was that?
 We might get somewhere if we had one fact—
 we could find many things, if we possessed
 some slender hope to get us going.

CREON. He told us it was robbers who attacked them—
 not just a single man, a gang of them—
 they came on with force and killed him.

OEDIPUS. How would a thief have dared to do this,
 unless he had financial help from Thebes?

CREON. That's what we guessed. But once Laius was
 dead
 we were in trouble, so no one sought revenge.

OEDIPUS. When the ruling king had fallen in this way,
 what bad trouble blocked your path, preventing you
 from looking into it?

CREON. It was the Sphinx—
 she sang her enigmatic song and thus forced us
 to put aside something we found obscure
 to look into the urgent problem we now faced.

OEDIPUS. Then I will start afresh, and once again
 shed light on darkness. It is most fitting
 that Apollo demonstrates his care

for the dead man, and worthy of you, too.
And so, as is right, you will see how I
work with you, seeking vengeance for this land,
as well as for the god. This polluting stain
I will remove, not for some distant friend,
but for myself. For whoever killed this man
may soon enough desire to turn his hand
in the same way against me, too, and kill me.
Thus, in avenging Laius, I serve myself.
But now, my children, as quickly as you can
stand up from these altar steps and take
your suppliant branches. Someone must call
the Theban people to assemble here.
I'll do everything I can. With the god's help
this will all come to light successfully,
or else it will prove our common ruin.

OEDIPUS and CREON go into the palace.

PRIEST. Let us get up, children. For this man
 has willingly declared just what we came for.
 And may Phoebus, who sent this oracle,
 come as our saviour and end our sickness.

*The PRIEST and the CITIZENS leave. Enter the CHORUS
OF THEBAN ELDERS.*

CHORUS. Oh sweet speaking voice of Zeus,
 you have come to glorious Thebes from golden
 Pytho—
 but what is your intent?
 My fearful heart twists on the rack and shakes with
 fear.
 O Delian healer, for whom we cry aloud
 in holy awe, what obligation
 will you demand from me, a thing unknown
 or now renewed with the revolving years?
 Immortal voice, O child of golden Hope,
 speak to me!
 First I call on you, Athena the immortal,
 daughter of Zeus, and on your sister, too,
 Artemis, who guards our land and sits
 on her glorious round throne in our market place,
 and on Phoebus, who shoots from far away.
 O you three guardians against death,
 appear to me!
 If before now you have ever driven off
 a fiery plague to keep away disaster
 from the city and have banished it,
 then come to us this time as well!
 Alas, the pains I bear are numberless—
 my people now all sick with plague,
 our minds can find no weapons
 to serve as our defence. Now the offspring

of our splendid earth no longer grow,
nor do our women crying out in labour
get their relief from a living new-born child.
As you can see—one by one they swoop away,
off to the shores of the evening god, like birds
faster than fire which no one can resist.
Our city dies—we've lost count of all the dead.
Her sons lie in the dirt unpitied, unlamented.
Corpses spread the pestilence, while youthful wives
and grey-haired mothers on the altar steps
wail everywhere and cry in supplication,
seeking to relieve their agonizing pain.
Their solemn chants ring out—
they mingle with the voices of lament.
O Zeus' golden daughter,
send your support and strength,
your lovely countenance!
And that ravenous Ares, god of killing,
who now consumes me as he charges on
with no bronze shield but howling battle cries,
let him turn his back and quickly leave this land,
with a fair following wind to carry him
to the great chambers of Amphitrite[5]
or inhospitable waves of Thrace.
For if destruction does not come at night,
then day arrives to see it does its work.
O you who wield that mighty flash of fire,
O father Zeus, with your lighting blast
let Ares be destroyed!
O Lyceian lord,[6] how I wish those arrows
from the golden string of your bent bow
with their all-conquering force would wing out
to champion us against our enemy,
and the blazing fires of Artemis, as well,
with which she races through the Lycian hills.
I call the god who binds his hair with gold,
the one whose name our country shares,
the one to whom the Maenads shout their cries,
Dionysus with his radiant face—[7]
may he come to us with his flaming torchlight,
our ally against Ares,
a god dishonoured among gods.

Enter OEDIPUS *from the palace.*

OEDIPUS. You pray. But if you listen now to me,
 you'll get your wish. Hear what I have to say

and treat your own disease—then you may hope
to find relief from your distress. I shall speak
as one who is a stranger to the story,
a stranger to the crime. If I alone
were tracking down this act, I'd not get far
without a single clue. That being the case,
for it was after the event that I became
a citizen of Thebes, I now proclaim
the following to all of you Cadmeians:
Whoever among you knows the man it was
who murdered Laius, son of Labdacus,
I order him to reveal it all to me.
And if the murderer's afraid, I tell him
to avoid the danger of the major charge
by speaking out against himself. If so,
he will be sent out from this land unhurt—
and undergo no further punishment.
If someone knows the killer is a stranger,
from some other state, let him not stay mute.
As well as a reward, he'll earn my thanks.
But if he remains quiet, if anyone,
through fear, hides himself or a friend of his
against my orders, here's what I shall do—
so listen to my words. For I decree
that no one in this land, in which I rule
as your own king, shall give that killer shelter
or talk to him, whoever he may be,
or act in concert with him during prayers,
or sacrifice, or sharing lustral water.[8]
Ban him from your homes, every one of you,
for he is our pollution, as the Pythian god
has just revealed to me. In doing this,
I'm acting as an ally of the god
and of dead Laius, too. And I pray
whoever the man is who did this crime,
one unknown person acting on his own
or with companions, the worst of agonies
will wear out his wretched life. I pray, too,
that, if he should become a honoured guest
in my own home and with my knowledge,
I may suffer all those things I've just called down
upon the killers. And I urge you now
to make sure all these orders take effect,
for my sake, for the sake of the god,
and for our barren, godless, ruined land.
For in this matter, even if a god

[5] *Ares*, god of war and killing, was often disapproved of by the major Olympian deities. *Amphitrite*: was a goddess of the sea, married to Poseidon.
[6] *lord of Lyceia*: a reference to Apollo, god of light.
[7] *. . . among gods*: Dionysus was also called Bacchus, and Thebes was sometimes called Baccheia (belonging to Bacchus). The *Maenads* are the followers of Dionysus.
[8] *lustral water*: water purified in a communal religious ritual.

were not prompting us, it would not be right
for you to simply leave things as they are,
and not to purify the murder of a man
who was so noble and who was your king.
You should have looked into it. But now I
possess the ruling power which Laius held
in earlier days. I have his bed and wife—
she would have borne his children, if his hopes
to have a son had not been disappointed.
Children from a common mother might have linked
Laius and myself. But as it turned out,
fate swooped down onto his head. So now I
will fight on his behalf, as if this matter
concerned my father, and I will strive
to do everything I can to find him,
the man who spilled his blood, and thus avenge
the son of Labdacus and Polydorus,
of Cadmus and Agenor from old times.[9]
As for those who do not follow what I urge,
I pray the gods send them no fertile land,
no, nor any children in their women's wombs—
may they all perish in our present fate
or one more hateful still. To you others,
you Cadmeians who support my efforts,
may Justice, our ally, and all the gods
attend on us with kindness always.

CHORUS LEADER. My lord, since you extend your oath
to me,
I will say this. I am not the murderer,
nor can I tell you who the killer is.
As for what you're seeking, it's for Apollo,
who launched this search, to state who did it.

OEDIPUS. That is well said. But no man has power to
force the gods to speak against their will.

CHORUS LEADER. May I then suggest what seems to
me
the next best course of action?

OEDIPUS. You may indeed,
and if there is a third course, too, don't hesitate
to let me know.

CHORUS LEADER. Our lord Teiresias,
I know, can see into things, like lord Apollo.
From him, my king, a man investigating this
might well find out the details of the crime.

OEDIPUS. I've taken care of that—it's not something
I could overlook. At Creon's urging,
I have dispatched two messengers to him

and have been wondering for some time now
why he has not come.

CHORUS LEADER. Apart from that,
there are rumours—but inconclusive ones
from a long time ago.

OEDIPUS. What kind of rumours?
I'm looking into every story.

CHORUS LEADER. It was said
that Laius was killed by certain travellers.

OEDIPUS. Yes, I heard as much. But no one has seen
the one who did it.

CHORUS LEADER. Well, if the killer
has any fears, once he hears your curses on him,
he will not hold back, for they are serious.

OEDIPUS. When a man has no fear of doing the act,
he's not afraid of words.

CHORUS LEADER. No, not in the case
where no one stands there to convict him.
But at last Teiresias is being guided here,
our god-like prophet, in whom the truth resides
more so than in all other men.

Enter TEIRESIAS *led by a small* BOY.

OEDIPUS. Teiresias,
you who understand all things—what can be taught
and what cannot be spoken of, what goes on
in heaven and here on the earth—you know,
although you cannot see, how sick our state is.
And so we find in you alone, great seer,
our shield and saviour. For Phoebus Apollo,
in case you have not heard the news, has sent us
an answer to our question: the only cure
for this infecting pestilence is to find
the men who murdered Laius and kill them
or else expel them from this land as exiles.
So do not withhold from us your prophecies
in voices of the birds or by some other means.
Save this city and yourself. Rescue me.
Deliver us from this pollution by the dead.
We are in your hands. For a mortal man
the finest labour he can do is help
with all his power other human beings.

TEIRESIAS. Alas, alas! How dreadful it can be
to have wisdom when it brings no benefit
to the man possessing it. This I knew,

[9] *Agenor*: founder of the Theban royal family; his son *Cadmus* moved from Sidon in Asia Minor to Greece and founded Thebes. *Polydorus*: son of Cadmus, father of Labdacus, and hence grandfather of Laius.

but it had slipped my mind. Otherwise,
I would not have journeyed here.

OEDIPUS. What's wrong? You've come, but seem so sad.

TEIRESIAS. Let me go home. You must bear your burden
to the very end, and I will carry mine,
if you'll agree with me.

OEDIPUS. What you are saying
is not customary and shows little love
toward the city state which nurtured you,
if you deny us your prophetic voice.

TEIRESIAS. I see your words are also out of place.
I do not speak for fear of doing the same.

OEDIPUS. If you know something, then, by heaven,
do not turn away. We are your suppliants—
all of us—we bend our knees to you.

TEIRESIAS. You are all ignorant. I will not reveal the
troubling things inside me, which I can call
your grief as well.

OEDIPUS. What are you saying?
Do you know and will not say? Do you intend
to betray me and destroy the city?

TEIRESIAS. I will cause neither me nor you distress.
Why do you vainly question me like this?
You will not learn a thing from me.

OEDIPUS. You most disgraceful of disgraceful men!
You'd move something made of stone to rage!
Will you not speak out? Will your stubbornness
never have an end?

TEIRESIAS. You blame my temper,
but do not see the one which lives within you.
Instead, you are finding fault with me.

OEDIPUS. What man who listened to these words of
yours would not be enraged—you insult the city!

TEIRESIAS. Yet events will still unfold, for all
my silence.

OEDIPUS. Since they will come, you must inform me.

TEIRESIAS. I will say nothing more. Fume on about it,
if you wish, as fiercely as you can.

OEDIPUS. I will. In my anger I will not conceal
just what I make of this. You should know
I get the feeling you conspired in the act,
and played your part, as much as you could do,
short of killing him with your own hands.
If you could use your eyes, I would have said
that you had done this work all by yourself.

TEIRESIAS. Is that so? Then I would ask you to stand by
the very words which you yourself proclaimed
and from now on not speak to me or these men.
For the accursed polluter of this land is you.

OEDIPUS. You dare to utter shameful words like this?
Do you think you can get away with it?

TEIRESIAS. I am getting away with it. The truth
within me makes me strong.

OEDIPUS. Who taught you this?
It could not have been your craft.

TEIRESIAS. You did.
I did not want to speak, but you incited me.

OEDIPUS. What do you mean? Speak it again,
so I can understand you more precisely.

TEIRESIAS. Did you not grasp my words before,
or are you trying to test me with your question?

OEDIPUS. I did not fully understand your words.
Tell me again.

TEIRESIAS. I say that you yourself
are the very man you're looking for.

OEDIPUS. That's twice you've stated that disgraceful lie—
something you'll regret.

TEIRESIAS. Shall I tell you more,
so you can grow even more enraged?

OEDIPUS. As much as you desire. It will be useless.

TEIRESIAS. I say that with your dearest family,
unknown to you, you are living in disgrace.
You have no idea how bad things are.

OEDIPUS. Do you really think you can just speak out,
say things like this, and still remain unpunished?

TEIRESIAS. Yes, I can, if the truth has any strength.

OEDIPUS. It does, but not for you. Truth is not in you—
for your ears, your mind, your eyes are blind!

TEIRESIAS. You are a wretched fool to use harsh words
which all men soon enough will use to curse you.

OEDIPUS. You live in endless darkness of the night,
so you can never injure me or any man
who can glimpse daylight.

TEIRESIAS. It is not your fate
to fall because of me. It's up to Apollo
to make that happen. He will be enough.

OEDIPUS. Is this something Creon has devised,
or is it your invention?

TEIRESIAS. Creon is no threat.
 You have made this trouble on your own.

OEDIPUS. O riches, ruling power, skill after skill
 surpassing all in this life's rivalries,
 how much envy you must carry with you,
 if, for this kingly office, which the city
 gave me, for I did not seek it out,
 Creon, my old trusted family friend,
 has secretly conspired to overthrow me
 and paid off a double-dealing quack like this,
 a crafty bogus priest, who can only see
 his own advantage, who in his special art
 is absolutely blind. Come on, tell me
 how you have ever given evidence
 of your wise prophecy. When the Sphinx,
 that singing bitch, was here, you said nothing
 to set the people free. Why not? Her riddle
 was not something the first man to stroll along
 could solve—a prophet was required. And there
 the people saw your knowledge was no use—
 nothing from birds or picked up from the gods.
 But then I came, Oedipus, who knew nothing.
 Yet I finished her off, using my wits
 rather than relying on birds. That's the man
 you want to overthrow, hoping, no doubt,
 to stand up there with Creon, once he's king.
 But I think you and your conspirator in this
 will regret trying to usurp the state.
 If you did not look so old, you'd find
 the punishment your arrogance deserves.

CHORUS LEADER. To us it sounds as if Teiresias
 has spoken in anger, and, Oedipus,
 you have done so, too. That's not what we need.
 Instead we should be looking into this:
 How can we best carry out the god's decree?

TEIRESIAS. You may be king, but I have the right
 to answer you—and I control that right,
 for I am not your slave. I serve Apollo,
 and thus will never stand with Creon,
 signed up as his man. So I say this to you,
 since you have chosen to insult my blindness—
 you have your eyesight, and you do not see
 how miserable you are, or where you live,
 or who it is who shares your household.
 Do you know the family you come from?
 Without your knowledge you've become
 the enemy of your own kindred,
 those in the world below and those up here,
 and the dreadful feet of that two-edged curse

from father and mother both will drive you
 from this land in exile. Those eyes of yours,
 which now can see so clearly, will be dark.
 What harbour will not echo with your cries?
 Where on Cithaeron[10] will they not soon be heard,
 once you have learned the truth about the wedding
 by which you sailed into this royal house—
 a lovely voyage, but the harbour's doomed?
 You've no idea of the quantity
 of other troubles which will render you
 and your own children equals. So go on—
 keep insulting Creon and my prophecies,
 for among all living mortals no one
 will be destroyed more wretchedly than you.

OEDIPUS. Must I tolerate this insolence from him?
 Get out, and may the plague get rid of you!
 Off with you! Now! Turn your back and go!
 And don't come back here to my home again.

TEIRESIAS. I would not have come, but you summoned
 me.

OEDIPUS. I did not know you would speak so stupidly.
 If I had, you would have waited a long time
 before I called you here.

TEIRESIAS. I was born like this.
 You think I am a fool, but to your parents,
 the ones who made you, I was wise enough.

OEDIPUS. Wait! My parents? Who was my father?

TEIRESIAS. This day will reveal that and destroy you.

OEDIPUS. Everything you speak is all so cryptic—
 like a riddle.

TEIRESIAS. Well, in solving riddles,
 are you not the best there is?

OEDIPUS. Mock my excellence,
 but you will find out I am truly great.

TEIRESIAS. That quality of yours now ruins you.

OEDIPUS. I do not care, if I have saved the city.

TEIRESIAS. I will go now. Boy, lead me away.

OEDIPUS. Yes, let him guide you back. You're in the way.
 If you stay, you'll just provoke me. Once you're
 gone,
 you won't annoy me further.

TEIRESIAS. I'm going.
 But first I shall tell you why I came.

[10] *Cithaeron*: the sacred mountain outside Thebes.

I do not fear the face of your displeasure—
there is no way you can destroy me. I tell you,
the man you have been seeking all this time,
while proclaiming threats and issuing orders
about the one who murdered Laius—
that man is here. According to reports,
he is a stranger who lives here in Thebes.
But he will prove to be a native Theban.
From that change he will derive no pleasure.
He will be blind, although he now can see.
He will be a poor, although he now is rich.
He will set off for a foreign country,
groping the ground before him with a stick.
And he will turn out to be the brother
of the children in his house—their father, too,
both at once, and the husband and the son
of the very woman who gave birth to them.
He sowed the same womb as his father
and murdered him. Go in and think on this.
If you discover I have spoken falsely,
you can say I lack all skill in prophecy.

Exit Teiresias *led off by the* Boy. Oedipus *turns
and goes back into the palace.*

Chorus. Speaking from the Delphic rock
 the oracular voice intoned a name.
 But who is the man, the one
 who with his blood-red hands
 has done unspeakable brutality?
 The time has come for him to flee—
 to move his powerful foot
 more swiftly than those hooves
 on horses riding on the storm.
 Against him Zeus' son now springs,
 armed with lightning fire and leading on
 the inexorable and terrifying Furies.[11]
 From the snowy peaks of Mount Parnassus[12]
 the message has just flashed, ordering all
 to seek the one whom no one knows.
 Like a wild bull he wanders now,
 hidden in the untamed wood,
 through rocks and caves, alone
 with his despair on joyless feet,
 keeping his distance from that doom
 uttered at earth's central naval stone.
 But that fatal oracle still lives,

 hovering above his head forever.
 That wise interpreter of prophecies
 stirs up my fears, unsettling dread.
 I cannot approve of what he said
 and I cannot deny it.
 I am confused. What shall I say?
 My hopes flutter here and there,
 with no clear glimpse of past or future.
 I have never heard of any quarrelling,
 past or present, between those two,
 the house of Labdacus and Polybus' son,[13]
 which could give me evidence enough
 to undermine the fame of Oedipus,
 as he seeks vengeance for the unsolved murder
 for the family of Labdacus.
 Apollo and Zeus are truly wise—
 they understand what humans do.
 But there is no sure way to ascertain
 if human prophets grasp things any more
 than I do, although in wisdom one man
 may leave another far behind.
 But until I see the words confirmed,
 I will not approve of any man
 who censures Oedipus, for it was clear
 when that winged Sphinx went after him
 he was a wise man then. We witnessed it.
 He passed the test and endeared himself
 to all the city. So in my thinking now
 he never will be guilty of a crime.

Enter Creon.

Creon. You citizens, I have just discovered
 that Oedipus, our king, has levelled charges
 against me, disturbing allegations.
 That I cannot bear, so I have come here.
 In these present troubles, if he believes
 that he has suffered any injury from me,
 in word or deed, then I have no desire
 to continue living into ripe old age
 still bearing his reproach. For me
 the injury produced by this report
 is no single isolated matter—
 no, it has the greatest scope of all,
 if I end up being called a wicked man
 here in the city, a bad citizen,
 by you and by my friends.

[11] *Zeus' son*: a reference to Apollo. The Furies are the goddesses of blood revenge.

[12] *Parnassus*: a famous mountain some distance from Thebes, but visible from the city.

[13] *Polybus*: ruler of Corinth, who raised Oedipus and is thus believed to be his father. The house of Labdacus is the Theban royal family (i.e., Laius, Jocasta, and Creon).

CHORUS LEADER. Perhaps he charged you
 spurred on by the rash power of his rage,
 rather than his mind's true judgment.

CREON. Was it publicized that my opinions
 convinced Teiresias to utter lies?

CHORUS LEADER. That's what was said. I have no idea
 just what that meant.

CREON. Did he accuse me
 and announce the charges with a steady gaze,
 in a normal state of mind?

CHORUS LEADER. I do not know.
 What those in power do I do not see.
 But he's approaching from the palace—
 here he comes in person.

Enter OEDIPUS *from the palace.*

OEDIPUS. You! How did you get here?
 Has your face grown so bold you now come
 to my own home—you who are obviously
 the murderer of the man whose house it was,
 a thief who clearly wants to steal my throne?
 Come, in the name of all the gods, tell me this—
 did you plan to do it because you thought
 I was a coward or a fool? Or did you think
 I would not learn about your actions
 as they crept up on me with such deceit—
 or that, if I knew, I could not deflect them?
 This attempt of yours, is it not madness—
 to chase after the king's place without friends,
 without a horde of men, to seek a goal
 which only gold or factions could attain?

CREON. Will you listen to me? It's your turn now
 to hear me make a suitable response.
 Once you know, then judge me for yourself.

OEDIPUS. You are a clever talker. But from you
 I will learn nothing. I know you now—
 a troublemaker, an enemy of mine.

CREON. At least first listen to what I have to say.

OEDIPUS. There's one thing you do not have to tell me—
 you have betrayed me.

CREON. If you think being stubborn
 and forgetting common sense is wise,
 then you're not thinking as you should.

OEDIPUS. And if you think you can act to injure
 a man who is a relative of yours
 and escape without a penalty
 then you're not thinking as you should.

CREON. I agree. What you've just said makes sense.
 So tell me the nature of the damage
 you claim you're suffering because of me.

OEDIPUS. Did you or did you not persuade me
 to send for Teiresias, that prophet?

CREON. Yes. And I'd still give you the same advice.

OEDIPUS. How long is it since Laius . . . *(pauses).*

CREON. Did what? What's Laius got to do with anything?

OEDIPUS. . . . since Laius was carried off and disappeared,
 since he was killed so brutally?

CREON. That was long ago—
 many years have passed since then.

OEDIPUS. At that time,
 was Teiresias as skilled in prophecy?

CREON. Then, as now, he was honoured for his wisdom.

OEDIPUS. And back then did he ever mention me?

CREON. No, never—not while I was with him.

OEDIPUS. Did you not investigate the killing?

CREON. Yes, of course we did. But we found nothing.

OEDIPUS. Why did this man, this wise man, not speak up?

CREON. I do not know. And when I don't know
 something,
 I like to keep my mouth shut.

OEDIPUS. You know enough—
 at least you understand enough to say . . .

CREON. What? If I really do know something
 I will not deny it.

OEDIPUS. If Teiresias
 were not working with you, he would not name me
 as the one who murdered Laius.

CREON. If he says this,
 well, you're the one who knows. But I think
 the time has come for me to question you
 the way that you've been questioning me.

OEDIPUS. Ask all you want. You'll not prove
 that I'm the murderer.

CREON. Then tell me this—
 are you not married to my sister?

OEDIPUS. Since you ask me, yes. I don't deny that.

CREON. And you two rule this land as equals?

OEDIPUS. Whatever she desires, she gets from me.

CREON. And am I not third, equal to you both?

OEDIPUS. That's what makes your friendship so deceitful.

CREON. No, not if you think this through, as I do.
First, consider this. In your view, would anyone
prefer to rule and have to cope with fear
rather than live in peace, carefree and safe,
if his powers were the same? I, for one,
have no natural desire to be king
in preference to performing royal acts.
The same is true of any other man
whose understanding grasps things properly.
For now I get everything I want from you,
but without the fear. If I were king myself,
I'd be doing many things against my will.
So how can being a king be sweeter to me
than royal power without anxiety?
I am not yet so mistaken in my mind
that I want things which bring no benefits.
Now I greet all men, and they all welcome me.
Those who wish to get something from you
now flatter me, since I'm the one who brings
success in what they want. So why would I
give up such benefits for something else?
A mind that's wise will not turn treacherous.
It's not my nature to love such policies.
And if another man pursued such things,
I'd not work with him. I couldn't bear to.
If you want proof of this, then go to Delphi.
Ask the prophet if I brought back to you
exactly what was said. At that point,
if you discover I have planned something,
that I've conspired with Teiresias,
then arrest me and have me put to death,
not just on your own authority,
but on mine as well, a double judgment.
Do not condemn me on an unproved charge.
It's not fair to judge these things by guesswork,
to assume bad men are good or good men bad.
In my view, to throw away a noble friend
is like a man who parts with his own life,
the thing most dear to him. Give it some time.
Then you'll see clearly, since only time
can fully validate a man who's true.
A bad man is exposed in just one day.

CHORUS LEADER. For a man concerned about being
killed,
my lord, he has spoken eloquently.
Those who are unreliable give rash advice.

OEDIPUS. If some conspirator moves against me,
in secret and with speed, I must be quick
to make my counter plans. If I just rest
and wait for him to act, then he'll succeed
in what he wants to do, and I'll be finished.

CREON. What do you want—to exile me from here?

OEDIPUS. No. I want you to die, not just run off—
so I can demonstrate what envy means.

CREON. You are determined not to change your mind
or listen to me?

OEDIPUS. You'll not convince me,
for there's no way that I can trust you.

CREON. I can see that you've become unbalanced.[14]

OEDIPUS. I'm sane enough to defend my interests.

CREON. You should be protecting mine as well.

OEDIPUS. But you're a treacherous man. It's your nature.

CREON. What if you are wrong?

OEDIPUS. I still have to govern.

CREON. Not if you do it badly.

OEDIPUS. Oh Thebes—my city!

CREON. I have some rights in Thebes as well—
it is not yours alone.

The palace doors open.

CHORUS LEADER. My lords, an end to this.
I see Jocasta coming from the palace,
and just in time. With her assistance
you should bring this quarrel to a close.

Enter JOCASTA from the palace.

JOCASTA. You foolish men, why are you arguing
in such a silly way? With our land so sick,
are you not ashamed to start a private fight?
You, Oedipus, go in the house, and you,
Creon, return to yours. Why blow up
a trivial matter into something huge?

CREON. Sister, your husband Oedipus intends
to punish me in one of two dreadful ways—
to banish me from my fathers' country
or arrest me and then have me killed.

OEDIPUS. That's right.
Lady, I caught him committing treason,
conspiring against my royal authority.

[14] There is some argument about who speaks which lines in 622-626 of the Greek text. I follow Jebb's suggestions, ascribing 625 to Creon, to whom it seems clearly to belong (in spite of the manuscripts) and adding a line to indicate Oedipus' response.

CREON. Let me not prosper but die a man accursed,
 if I have done what you accuse me of.

JOCASTA. Oedipus,
 for the sake of the gods, trust him in this.
 Respect that oath he made before all heaven—
 do it for my sake and for those around you.

CHORUS LEADER. I beg you, my lord, consent to this—
 agree with her.

OEDIPUS. What is it then you're asking me to do?

CHORUS LEADER. Pay Creon due respect.
 He has not been foolish in the past, and now
 that oath he's sworn has power.

OEDIPUS. Are you aware just what you're asking?

CHORUS LEADER. Yes. I understand.

OEDIPUS. Then tell me exactly what you're saying.

CHORUS LEADER. You should not accuse a friend
 of yours
 and thus dishonour him with a mere story
 which may not be true, when he's sworn an oath
 and therefore could be subject to a curse.

OEDIPUS. By this point you should clearly
 understand,
 when you request this, what you are doing—
 seeking to exile me from Thebes or kill me.

CHORUS LEADER. No, no, by sacred Helios, the god
 whose stands pre-eminent before the rest,
 may I die the most miserable of deaths,
 abandoned by the gods and by my friends,
 if I have ever harboured such a thought!
 But the destruction of our land wears down
 the troubled heart within me—and so does this,
 if you two add new problems to the ones
 which have for so long been afflicting us.

OEDIPUS. Let him go, then, even though it's clear
 I must be killed or sent from here in exile,
 forced out in disgrace. I have been moved
 to act compassionately by what you said,
 not by Creon's words. But if he stays here,
 he will be hateful to me.

CREON. You are obstinate—
 obviously unhappy to concede,
 and when you lose your temper, you go too far.
 But men like that find it most difficult
 to tolerate themselves. In that there's justice.

OEDIPUS. Why not go—just leave me alone?

CREON. I'll leave—
 since I see you do not understand me.
 But these men here know I'm a reasonable man.

*Exit CREON away from the palace, leaving
OEDIPUS and JOCASTA and the CHORUS on
stage.*

CHORUS LEADER. Lady, will you escort our king inside?

JOCASTA. Yes, once I have learned what happened here.

CHORUS LEADER. They talked—
 their words gave rise to uninformed suspicions,
 an all-consuming lack of proper justice.

JOCASTA. From both of them?

CHORUS LEADER. Yes.

JOCASTA. What caused it?

CHORUS LEADER. With our country already in distress,
 it is enough, it seems to me, enough
 to leave things as they are.

OEDIPUS. Now do you see
 the point you've reached thanks to your noble wish
 to dissolve and dull my firmer purpose?

CHORUS LEADER. My lord, I have declared it more than
 once,
 so you must know it would have been quite mad
 if I abandoned you, who, when this land,
 my cherished Thebes, was in great trouble,
 set it right again and who, in these harsh times
 which now consume us, should prove a trusty
 guide.

JOCASTA. By all the gods, my king, let me know
 why in this present crisis you now feel
 such unremitting rage.

OEDIPUS. To you I'll speak, lady,
 since I respect you more than I do these men.
 It's Creon's fault. He conspired against me.

JOCASTA. In this quarrel what was said? Tell me.

OEDIPUS. Creon claims that I'm the murderer—
 that I killed Laius.

JOCASTA. Does he know this first hand,
 or has he picked it up from someone else?

OEDIPUS. No. He set up that treasonous prophet.
 What he says himself sounds innocent.

JOCASTA. All right, forget about those things you've said.
 Listen to me, and ease your mind with this—
 no human being has skill in prophecy.

I'll show you why with this example.
King Laius once received a prophecy.
I won't say it came straight from Apollo,
but it was from those who do assist the god.
It said Laius was fated to be killed
by a child conceived by him and me.
Now, at least according to the story,
one day Laius was killed by foreigners,
by robbers, at a place where three roads meet.
Besides, before our child was three days old,
Laius fused his ankles tight together
and ordered other men to throw him out
on a mountain rock where no one ever goes.
And so Apollo's plan that he'd become
the one who killed his father didn't work,
and Laius never suffered what he feared,
that his own son would be his murderer,
although that's what the oracle had claimed.
So don't concern yourself with prophecies.
Whatever gods intend to bring about
they themselves make known quite easily.

OEDIPUS. Lady, as I listen to these words of yours,
my soul is shaken, my mind confused . . .

JOCASTA. Why do you say that? What's worrying you?

OEDIPUS. I thought I heard you say that Laius
was murdered at a place where three roads meet.

JOCASTA. That's what was said and people still believe.

OEDIPUS. Where is this place? Where did it happen?

JOCASTA. In a land called Phocis. Two roads lead there—
one from Delphi and one from Daulia.

OEDIPUS. How long is it since these events took place?

JOCASTA. The story was reported in the city
just before you took over royal power
here in Thebes.

OEDIPUS. Oh Zeus, what have you done?
What have you planned for me?

JOCASTA. What is it,
Oedipus? Why is your spirit so troubled?

OEDIPUS. Not yet,
no questions yet. Tell me this—Laius,
how tall was he? How old a man?

JOCASTA. He was big—his hair was turning white.
In shape he was not all that unlike you.

OEDIPUS. The worse for me! I may have just set myself
under a dreadful curse without my knowledge!

JOCASTA. What do you mean? As I look at you, my king,
I start to tremble.

OEDIPUS. I am afraid,
full of terrible fears the prophet sees.
But you can reveal this better if you now
will tell me one thing more.

JOCASTA. I'm shaking,
but if you ask me, I will answer you.

OEDIPUS. Did Laius have a small escort with him
or a troop of soldiers, like a royal king?

JOCASTA. Five men, including a herald, went with him.
A carriage carried Laius.

OEDIPUS. Alas! Alas!
It's all too clear! Lady, who told you this?

JOCASTA. A servant—the only one who got away.
He came back here.

OEDIPUS. Is there any chance
he's in our household now?

JOCASTA. No.
Once he returned and understood that you
had now assumed the power of slaughtered Laius,
he clasped my hands, begged me to send him off
to where our animals graze out in the fields,
so he could be as far away as possible
from the sight of town. And so I sent him.
He was a slave but he'd earned my gratitude.
He deserved an even greater favour.

OEDIPUS. I'd like him to return back here to us,
and quickly, too.

JOCASTA. That can be arranged—
but why's that something you would want to do?

OEDIPUS. Lady, I'm afraid I may have said too much.
That's why I want to see him here in front of me.

JOCASTA. Then he will be here. But now, my lord,
I deserve to learn why you are so distressed.

OEDIPUS. My forebodings now have grown so great
I will not keep them from you, for who is there
I should confide in rather than in you
about such a twisted turn of fortune.
My father was Polybus of Corinth,
my mother Merope, a Dorian.
There I was regarded as the finest man
in all the city, until, as chance would have it,
something really astonishing took place,
though it was not worth what it caused me to do.

At a dinner there a man who was quite drunk
from too much wine began to shout at me,
claiming I was not my father's real son.
That troubled me, but for a day at least
I said nothing, though it was difficult.
The next day I went to ask my parents,
my father and my mother. They were angry
at the man who had insulted them this way,
so I was reassured. But nonetheless,
the accusation always troubled me—
the story had become well known all over.
And so I went in secret off to Delphi.
I didn't tell my mother or my father.
Apollo sent me back without an answer,
so I didn't learn what I had come to find.
But when he spoke he uttered monstrous things,
strange terrors and horrific miseries—
it was my fate to defile my mother's bed,
to bring forth to men a human family
that people could not bear to look upon,
to murder the father who engendered me.
When I heard that, I ran away from Corinth.
From then on I thought of it just as a place
beneath the stars. I went to other lands,
so I would never see that prophecy fulfilled,
the abomination of my evil fate.
In my travelling I came across that place
in which you say your king was murdered.
And now, lady, I will tell you the truth.
As I was on the move, I passed close by
a spot where three roads meet, and in that place
I met a herald and a horse-drawn carriage.
Inside there was a man like you described.
The guide there tried to force me off the road—
and the old man, too, got personally involved.
In my rage, I lashed out at the driver,
who was shoving me aside. The old man,
seeing me walking past him in the carriage,
kept his eye on me, and with his double whip
struck me on my head, right here on top.
Well, I retaliated in good measure—
I hit him a quick blow with the staff I held
and knocked him from his carriage to the road.
He lay there on his back. Then I killed them all.
If that stranger was somehow linked to Laius,
who is now more unfortunate than me?
What man could be more hateful to the gods?
No stranger and no citizen can welcome him
into their lives or speak to him. Instead,
they must keep him from their doors, a curse
I laid upon myself. With these hands of mine,
these killer's hands, I now contaminate
the dead man's bed. Am I not depraved?
Am I not utterly abhorrent?
Now I must fly into exile and there,
a fugitive, never see my people,
never set foot in my native land again—
or else I must get married to my mother
and kill my father, Polybus, who raised me,
the man who gave me life. If anyone
claimed this came from some malevolent god,
would he not be right? O you gods,
you pure, blessed gods, may I not see that day!
Let me rather vanish from the sight of men,
before I see a fate like that roll over me.

CHORUS LEADER.. My lord, to us these things are ominous.
But you must sustain your hope until you hear
the servant who was present at the time.

OEDIPUS. I do have some hope left, at least enough
to wait for the man we've summoned from the
fields.

JOCASTA. Once he comes, what do you hope to hear?

OEDIPUS. I'll tell you. If we discover what he
says matches what you say, then I'll escape disaster.

JOCASTA. What was so remarkable in what I said?

OEDIPUS. You said that in his story the man claimed
Laius was murdered by a band of thieves.
If he still says that there were several men,
then I was not the killer, since one man
could never be mistaken for a crowd.
But if he says it was a single man,
then I'm the one responsible for this.

JOCASTA. Well, that's certainly what he reported then.
He cannot now withdraw what he once said.
The whole city heard him, not just me alone.
But even if he changes that old news,
he cannot ever demonstrate, my lord,
that Laius' murder fits the prophecy.
For Apollo clearly s\aid the man would die
at the hands of an infant born from me.
Now, how did that unhappy son of ours
kill Laius, when he'd perished long before?
So as far as these oracular sayings go,
I would not look for confirmation anywhere.

OEDIPUS. You're right in what you say. But nonetheless,
send for that peasant. Don't fail to do that.

JOCASTA. I'll call him here as quickly as I can.
Let's go inside. I'll not do anything
which does not meet with your approval.

OEDIPUS and JOCASTA go into the palace together.

CHORUS. I pray fate still finds me worthy,
　　demonstrating piety and reverence
　　in all I say and do—in everything
　　our loftiest traditions consecrate,
　　those laws engendered in the heavenly skies,
　　whose only father is Olympus.
　　They were not born from mortal men,
　　nor will they sleep and be forgotten.
　　In them lives an ageless mighty god.
　　Insolence gives birth to tyranny—
　　that insolence which vainly crams itself
　　and overflows with so much stuff
　　beyond what's right or beneficial,
　　that once it's climbed the highest rooftop,
　　it's hurled down by force—such a quick fall
　　there's no safe landing on one's feet.
　　But I pray the god never will abolish
　　the rivalry so beneficial to our state.
　　That god I will hold on to always,
　　the one who stands as our protector.[15]
　　But if a man conducts himself
　　disdainfully in what he says and does,
　　and manifests no fear of righteousness,
　　no reverence for the statues of the gods,
　　may miserable fate seize such a man
　　for his disastrous arrogance,
　　if he does not behave with justice
　　when he strives to benefit himself,
　　appropriates all things impiously,
　　and, like a fool, profanes the sacred.
　　What man is there who does such things
　　who can still claim he will ward off
　　the arrow of the gods aimed at his heart?
　　If such actions are considered worthy,
　　why should we dance to honour god?
　　No longer will I go in reverence
　　to the sacred stone, earth's very centre,
　　or to the temple at Abae or Olympia,
　　if these prophecies fail to be fulfilled
　　and manifest themselves to mortal men.
　　But you, all-conquering, all-ruling Zeus,
　　if by right those names belong to you,
　　let this not evade you and your ageless might.
　　For ancient oracles which dealt with Laius
　　are withering—men now set them aside.
　　Nowhere is Apollo honoured publicly,
　　and our religious faith is dying away.

JOCASTA enters from the palace and moves to an altar to Apollo which stands outside the palace doors. She is accompanied by one or two SERVANTS.

JOCASTA. You leading men of Thebes, I think
　　it is appropriate for me to visit
　　our god's sacred shrine, bearing in my hands
　　this garland and an offering of incense.
　　For Oedipus has let excessive pain
　　seize on his heart and does not understand
　　what's happening now by thinking of the past,
　　like a man with sense. Instead he listens to
　　whoever speaks to him of dreadful things.
　　I can do nothing more for him with my advice,
　　and so, Lycean Apollo, I come to you,
　　who stand here beside us, a suppliant,
　　with offerings and prayers for you to find
　　some way of cleansing what corrupts us.
　　For now we are afraid, just like those
　　who on a ship see their helmsman terrified.

JOCASTA sets her offerings on the altar.
A MESSENGER enters, an older man.

MESSENGER. Strangers, can you tell me where I find
　　the house of Oedipus, your king? Better yet,
　　if you know, can you tell me where he is?

CHORUS LEADER. His home is here, stranger, and he's inside.
　　This lady is the mother of his children.

MESSENGER. May her happy home always be blessed,
　　for she is his queen, true mistress of his house.

JOCASTA. I wish the same for you, stranger. Your fine words
　　make you deserve as much. But tell us now
　　why you have come. Do you seek information,
　　or do you wish to give us some report?

MESSENGER. Lady, I have good news for your whole house—
　　and for your husband, too.

JOCASTA. What news is that?
　　Where have you come from?

MESSENGER. I've come from Corinth.
　　I'll give you my report at once, and then
　　you will, no doubt, be glad, although perhaps
　　you will be sad, as well.

[15] This part of the choral song makes an important distinction between two forms of self-assertive action: the first breeds self-aggrandizement and greed; the second is necessary for the protection of the state.

JOCASTA. What is your news?
How can it have two such effects at once?

MESSENGER. The people who live there, in the lands
beside the Isthmus, will make him their king.[16]
They have announced it.

JOCASTA. What are you saying?
Is old man Polybus no longer king?

MESSENGER. No. He's dead and in his grave.

JOCASTA. What?
Has Oedipus' father died?

MESSENGER. Yes.
If what I'm telling you is not the truth,
then I deserve to die.

JOCASTA. [to a servant] You there—
go at once and tell this to your master.

SERVANT goes into the palace.

Oh, you oracles of the gods, so much for you.
Oedipus has for so long been afraid
that he would murder him. He ran away.
Now Polybus has died, killed by fate
and not by Oedipus.

Enter OEDIPUS from the palace.

OEDIPUS. Ah, Jocasta,
my dearest wife, why have you summoned me
to leave our home and come out here?

JOCASTA. You must hear this man, and as you listen,
decide for yourself what these prophecies,
these solemn proclamations from the gods,
amount to.

OEDIPUS. Who is this man? What report
does he have for me?

JOCASTA. He comes from Corinth,
bringing news that Polybus, your father,
no longer is alive. He's dead.

OEDIPUS. What?
Stranger, let me hear from you in person.

MESSENGER. If I must first report my news quite
plainly,
then I should let you know that Polybus
has passed away. He's gone.

OEDIPUS. By treachery,
or was it the result of some disease?

MESSENGER. With old bodies a slight weight on the
scales
brings final peace.

OEDIPUS. Apparently his death
was from an illness?

MESSENGER. Yes, and from old age.

OEDIPUS. Alas! Indeed, lady, why should any man
pay due reverence to Apollo's shrine,
where his prophet lives, or to those birds
which scream out overhead? For they foretold
that I was going to murder my own father.
But now he's dead and lies beneath the earth,
and I am here. I never touched my spear.
Perhaps he died from a desire to see me—
so in that sense I brought about his death.
But as for those prophetic oracles,
they're worthless. Polybus has taken them
to Hades, where he lies.

JOCASTA. Was I not the one
who predicted this some time ago?

OEDIPUS. You did, but then I was misguided by my fears.

JOCASTA. You must not keep on filling up your heart
with all these things.

OEDIPUS. But my mother's bed—
I am afraid of that. And surely I should be?

JOCASTA. Why should a man whose life seems ruled by
chance
live in fear—a man who never looks ahead,
who has no certain vision of his future?
It's best to live haphazardly, as best one can.
Do not worry you will wed your mother.
It's true that in their dreams a lot of men
have slept with their own mothers, but someone
who ignores all this bears life more easily.

OEDIPUS. Everything you say would be commendable,
if my mother were not still alive.
But since she is, I must remain afraid,
although what you are saying is right.

JOCASTA. But still,
your father's death is a great comfort to us.

OEDIPUS. Yes, it is good, I know.
But I do fear that lady—she is still alive.

MESSENGER. This one you fear,
what kind of woman is she?

[16] *Isthmus*: The city of Corinth stood on the narrow stretch of land (the Isthmus) connecting the Peloponnese with mainland Greece, a very strategic position.

OEDIPUS. Old man,
her name is Merope, wife to Polybus.

MESSENGER. And what in her makes you so fearful?
Oedipus. Stranger,
a dreadful prophecy sent from the god.

MESSENGER. Is it well known? Or something private,
which another person has no right to know?

OEDIPUS. No, no. It's public knowledge. Loxias[17]
once said it was my fate that I would marry
my own mother and shed my father's blood
with my own hands. That's why, many years ago,
I left my home in Corinth. Things turned out well,
but nonetheless it gives the sweetest joy
to look into the eyes of one's own parents.

MESSENGER. And because you were afraid of her
you stayed away from Corinth?

OEDIPUS. And because
I did not want to be my father's killer.

MESSENGER. My lord, since I came to make you happy,
why don't I relieve you of this fear?

OEDIPUS. You would receive from me a worthy thanks.

MESSENGER. That's really why I came—so your return
might prove a benefit to me back home.

OEDIPUS. But I will never go back to my parents.

MESSENGER. My son, it is so clear you have no idea
what you are doing . . .

OEDIPUS. (interrupting). What do you mean,
old man? In the name of all the gods, tell me.

MESSENGER. . . . if that's the reason you're a fugitive
and won't go home.

OEDIPUS. I feared Apollo's prophecy
might reveal itself in me.

MESSENGER. You were afraid
you might become corrupted through your parents?

OEDIPUS. That's right, old man. That was my constant
fear.

MESSENGER. Are you aware these fears of yours are
groundless?

OEDIPUS. And why is that? If I was born their child . . .

MESSENGER. Because you and Polybus were not related.

OEDIPUS. What do you mean?
Was not Polybus my father?

MESSENGER. He was as much your father as this man
here, no more, no less.

OEDIPUS. But how can any man who means nothing
to me be the same as my own father?

MESSENGER. But Polybus
was not your father, no more than I am.

OEDIPUS. Then why did he call me his son?

MESSENGER. If you must know, he received you many
years ago as a gift. I gave you to him.

OEDIPUS. He really loved me. How could he if
I came from someone else?

MESSENGER. Well, before you came, he had no
children—that made him love you.

OEDIPUS. When you gave me to him, had you bought
me or found me by accident?

MESSENGER. I found you in Cithaeron's forest valleys.

OEDIPUS. What were you doing wandering up there?

MESSENGER. I was looking after flocks of sheep.

OEDIPUS. You were a shepherd, just a hired servant
roaming here and there?

MESSENGER. Yes, my son, I was. But at that time
I was the one who saved you.

OEDIPUS. When you picked me up and took me off,
what sort of suffering was I going through?

MESSENGER. The ankles on your feet could tell you that.

OEDIPUS. Ah, my old misfortune. Why mention that?

MESSENGER. Your ankles had been pierced and tied
together. I set them free.

OEDIPUS. My dreadful mark of shame—
I've had that scar there since I was a child.

MESSENGER. That's why fortune gave you your very
name, the one which you still carry.[18]

OEDIPUS. Tell me,
in the name of heaven, why did my parents,
my father or my mother, do this to me?

MESSENGER. I don't know. The man who gave you to
me knows more of that than I do.

[17] *Loxias*: a common name for Apollo.

OEDIPUS. You mean to say you got me from someone
 else? It wasn't you who stumbled on me?

MESSENGER. No, it wasn't me.
 Another shepherd gave you to me.

OEDIPUS. Who?
 Who was he? Do you know? Can you tell me
 any details, ones you know for certain?

MESSENGER. Well, I think he was one of Laius'
 servants—that's what people said.

OEDIPUS. You mean king Laius, the one who ruled
 this country years ago?

MESSENGER. That's right. He was one of the king's
 shepherds.

OEDIPUS. Is he still alive? Can I still see him?

MESSENGER. You people live here. You'd best answer that.

OEDIPUS (*turning to the* CHORUS). Do any of you here
 now know the man,
 this shepherd he describes? Have you seen him,
 either in the fields or here in Thebes?
 Answer me. It's critical, time at last
 to find out what this means.

CHORUS LEADER. The man he mentioned is,
 I think, the very peasant from the fields
 you wanted to see earlier. But of this
 Jocasta could tell more than anyone.

OEDIPUS. Lady, do you know the man we sent for—
 just minutes ago—the one we summoned here?
 Is he the one this messenger refers to?

JOCASTA. Why ask me what he means? Forget all that.
 There's no point in trying to sort out what he said.

OEDIPUS. With all these indications of the truth
 here in my grasp, I cannot end this now.
 I must reveal the details of my birth.

JOCASTA. In the name of the gods, no! If you have
 some concern for your own life, then stop!
 Do not keep investigating this.
 I will suffer—that will be enough.

OEDIPUS. Be brave. Even if I should turn out to be
 born from a shameful mother, whose family
 for three generations have been slaves,
 you will still have your noble lineage.

JOCASTA. Listen to me, I beg you. Do not do this.

OEDIPUS. I will not be convinced I should not learn
 the whole truth of what these facts amount to.

JOCASTA. But I care about your own well being—
 what I tell you is for your benefit.

OEDIPUS. What you're telling me for my own good just
 brings me more distress.

JOCASTA. Oh, you unhappy man!
 May you never find out who you really are!

OEDIPUS (*to* CHORUS). Go, one of you, and bring that
 shepherd here. Leave the lady to enjoy her noble
 family.

JOCASTA. Alas, you poor miserable man!
 There's nothing more that I can say to you.
 And now I'll never speak again.

JOCASTA *runs into the palace.*

CHORUS LEADER. Why has the queen rushed off,
 Oedipus, so full of grief? I fear a disastrous storm
 will soon break through her silence.

OEDIPUS. Then let it break,
 whatever it is. As for myself,
 no matter how base born my family,
 I wish to know the seed from where I came.
 Perhaps my queen is now ashamed of me
 and of my insignificant origin—she likes to play
 the noble lady.
 But I will never feel myself dishonoured.
 I see myself as a child of fortune—
 and she is generous, that mother of mine
 from whom I spring, and the months, my siblings,
 have seen me by turns both small and great.
 That's how I was born. I cannot change
 to someone else, nor can I ever cease
 from seeking out the facts of my own birth.

CHORUS. If I have any power of prophecy
 or skill in knowing things,
 then, by the Olympian deities, you, Cithaeron, at
 tomorrow's moon
 will surely know that Oedipus
 pays tribute to you as his native land
 both as his mother and his nurse,
 and that our choral dance and song
 acknowledge you because you are

[18] . . . *still carry*: the name *Oedipus* can be construed to mean either "swollen feet" or "knowledge of one's feet." Both terms evoke a strongly ironic sense of how Oedipus, for all his fame as a man of knowledge, is ignorant about his origin.

so pleasing to our king.
O Phoebus, we cry out to you—
may our song fill you with delight!
Who gave birth to you, my child?
Which one of the immortal gods
bore you to your father Pan,
who roams the mountainsides?
Was it some daughter of Apollo,
the god who loves all country fields?
Perhaps Cyllene's royal king?
Or was it the Bacchanalian god
dwelling on the mountain tops
who took you as a new-born joy
from maiden nymphs of Helicon
with whom he often romps and plays?[19]

OEDIPUS. (*looking out away from the palace*).
 You elders, although I've never seen the man
 we've been looking for a long time now,
 if I had to guess, I think I see him.
 He's coming here. He looks very old—
 as is appropriate, if he's the one.
 And I know the people coming with him,
 servants of mine. But if you've seen him before,
 you'll recognize him better than I will.

CHORUS LEADER. Yes, I recognize the man. There's no
 doubt. He worked for Laius—a trusty shepherd.

Enter SERVANT, *an old shepherd.*

OEDIPUS. Stranger from Corinth, let me first ask you—
 is this the man you mentioned?

MESSENGER. Yes, he is—
 he's the man you see in front of you.

OEDIPUS. You, old man, over here. Look at me.
 Now answer what I ask. Some time ago
 did you work for Laius?

SERVANT. Yes, as a slave.
 But I was not bought. I grew up in his house.

OEDIPUS. How did you live? What was the work you did?

SERVANT. Most of my life I've spent looking after sheep.

OEDIPUS. Where? In what particular areas?

SERVANT. On Cithaeron or the neighbouring lands.

OEDIPUS. Do you know if you came across this man
 anywhere up there?

SERVANT. Doing what? What man do you mean?

OEDIPUS. The man over here—
 this one. Have you ever run into him?

SERVANT. Right now I can't say I remember him.

MESSENGER. My lord, that's surely not surprising.
 Let me refresh his failing memory.
 I think he will remember all too well
 the time we spent around Cithaeron.
 He had two flocks of sheep and I had one.
 I was with him there for six months at a stretch,
 from early spring until the autumn season.
 In winter I'd drive my sheep down to my folds,
 and he'd take his to pens that Laius owned.
 Isn't that what happened—what I've just said?

SERVANT. You spoke the truth. But it was long ago.

MESSENGER. All right, then. Now, tell me if you recall
 how you gave me a child, an infant boy,
 for me to raise as my own foster son.

SERVANT. What? Why ask about that?

MESSENGER. This man here, my friend,
 was that young child back then.

SERVANT. Damn you!
 Can't you keep quiet about it!

OEDIPUS. Hold on, old man.
 Don't criticize him. What you have said
 is more objectionable than his account.

SERVANT. My noble master, what have I done wrong?

OEDIPUS. You did not tell us of that infant boy, the one
 he asked about.

SERVANT. That's what he says, but he knows nothing—
 a useless busybody.

OEDIPUS. If you won't tell us of your own free will,
 once we start to hurt you, you will talk.

SERVANT. By all the gods, don't torture an old man!

OEDIPUS. One of you there, tie up this fellow's hands.

SERVANT. Why are you doing this? It's too much for
 me! What is it you want to know?

OEDIPUS. That child he mentioned—
 did you give it to him?

[19] Cyllene's king is the god Hermes, who was born on Mount Cyllene; the Bacchanalian god is Dionysus.

SERVANT. I did. How I wish I'd died that day!

OEDIPUS. Well, you're going to die
 if you don't speak the truth.

SERVANT. And if I do,
 there's an even greater chance that I'll be killed.

OEDIPUS. It seems to me the man is trying to stall.

SERVANT. No, no, I'm not. I've already told you—
 I did give him the child.

OEDIPUS. Where did you get it?
 Did it come from your home or somewhere else?

SERVANT. It was not mine—I got it from someone.

OEDIPUS. Which of our citizens? Whose home was it?

SERVANT. In the name of the gods, my lord, don't ask!
 Please, no more questions!

OEDIPUS. If I have to ask again, then you will die.

SERVANT. The child was born in Laius' house.

OEDIPUS. From a slave or from some relative of his?

SERVANT. Alas, what I'm about to say now . . .
 it's horrible.

OEDIPUS. And I'm about to hear it.
 But nonetheless I have to know this.

SERVANT. If you must know, they said the child was his.
 But your wife inside the palace is the one
 who could best tell you what was going on.

OEDIPUS. You mean she gave the child to you?

SERVANT. Yes, my lord.

OEDIPUS. Why did she do that?

SERVANT. So I would kill it.

OEDIPUS. That wretched woman was the mother?

SERVANT. Yes. She was afraid of dreadful prophecies.

OEDIPUS. What sort of prophecies?

SERVANT. The story went that he would kill his father.

OEDIPUS. If that was true,
 why did you give the child to this old man?

SERVANT. I pitied the boy, master, and I thought
 he'd take the child off to a foreign land
 where he was from. But he rescued him,
 only to save him for the greatest grief of all.
 For if you're the one this man says you are
 you know your birth carried an awful fate.

OEDIPUS. Ah, so it all came true. It's so clear now.
 O light, let me look at you one final time,
 a man who stands revealed as cursed by birth,
 cursed by my own family, and cursed
 by murder where I should not kill.

OEDIPUS moves into the palace.

CHORUS. O generations of mortal men,
 how I count your life as scarcely living.
 What man is there, what human being,
 who attains a greater happiness
 than mere appearances, a joy
 which seems to fade away to nothing?
 Poor wretched Oedipus, your fate
 stands here to demonstrate for me
 how no mortal man is ever blessed.
 Here was a man who fired his arrows well—
 his skill was matchless—and he won
 the highest happiness in everything.
 For, Zeus, he slaughtered the hook-taloned Sphinx
 and stilled her cryptic song. For our state,
 he stood there like a tower against death,
 and from that moment, Oedipus,
 we have called you our king
 and honoured you above all other men,
 the one who rules in mighty Thebes.
 But now who is there whose story is more terrible
 to hear? Whose life
 has been so changed by trouble,
 by such ferocious agonies?
 Alas, for celebrated Oedipus,
 the same spacious place of refuge
 served you both as child and father,
 the place you entered as a new bridegroom.
 How could the furrow where your father planted,
 poor wretched man, have tolerated you
 in such silence for so long?
 Time, which watches everything
 and uncovered you against your will,
 now sits in judgment of that fatal marriage,
 where child and parent have been joined so long.
 O child of Laius, how I wish
 I'd never seen you—now I wail
 like one whose mouth pours forth laments.
 To tell it right, it was through you
 I found my life and breathed again,
 and then through you my eyesight failed.

The SECOND MESSENGER enters from the palace.

SECOND MESSENGER. O you most honoured citizens of
 Thebes,
 what actions you will hear about and see,

what sorrows you will bear, if, as natives here,
you are still loyal to the house of Labdacus!
I do not think the Ister or the Phasis rivers
could cleanse this house. It conceals too much
and soon will bring to light the vilest things,
brought on by choice and not by accident.[20]
What we do to ourselves brings us most pain.

CHORUS LEADER. The calamities we knew about before
were hard enough to bear. What can you say
to make them worse?

SECOND MESSENGER. I'll waste no words—
know this—noble Jocasta, our queen, is dead.

CHORUS LEADER. That poor unhappy lady! How did
she die?

SECOND MESSENGER. She killed herself. You did not see
it, so you'll be spared the worst of what went on.
But from what I recall of what I saw
you'll learn how that poor woman suffered.
She left here frantic and rushed inside,
fingers on both hands clenched in her hair.
She ran through the hall straight to her marriage bed.
She went in, slamming both doors shut behind her
and crying out to Laius, who's been a corpse
a long time now. She was remembering
that child of theirs born many years ago—
the one who killed his father, who left her
to conceive cursed children with that son.
She lay moaning by the bed, where she,
poor woman, had given birth twice over—
a husband from a husband, children from a child.
How she died after that I don't fully know.
With a scream Oedipus came bursting in.
He would not let us see her suffering,
her final pain. We watched him charge around,
back and forth. As he moved, he kept asking us
to give him a sword, as he tried to find
that wife who was no wife—whose mother's womb
had given birth to him and to his children.
As he raved, some immortal power led him on—
no human in the room came close to him.
With a dreadful howl, as if someone
had pushed him, he leapt at the double doors,
bent the bolts by force out of their sockets,
and burst into the room. Then we saw her.
She was hanging there, swaying, with twisted cords
roped round her neck. When Oedipus saw her,
with a dreadful groan he took her body
out of the noose in which she hung, and then,

when the poor woman was lying on the ground—
what happened next was a horrific sight—
from her clothes he ripped the golden brooches
she wore as ornaments, raised them high,
and drove them deep into his eyeballs,
crying as he did so: "You will no longer see
all those atrocious things I suffered,
the dreadful things I did! No. You have seen
those you never should have looked upon,
and those I wished to know you did not see.
So now and for all future time be dark!"
With these words he raised his hand and struck,
not once, but many times, right in the sockets.
With every blow blood spurted from his eyes
down on his beard, and not in single drops,
but showers of dark blood spattered like hail.
So what these two have done has overwhelmed
not one alone—this disaster swallows up
a man and wife together. That old happiness
they had before in their rich ancestry
was truly joy, but now lament and ruin,
death and shame, and all calamities
which men can name are theirs to keep.

CHORUS LEADER. And has that suffering man found
some relief to ease his pain?

SECOND MESSENGER. He shouts at everyone
to open up the gates and thus reveal
to all Cadmeians his father's killer,
his mother's . . . but I must not say those words.
He wants them to cast him out of Thebes,
so the curse he laid will not come on this house
if he still lives inside. But he is weak
and needs someone to lead him on his way.
His agony is more than he can bear—
as he will show you—for on the palace doors
the bolts are being pulled back. Soon you will see
a sight which even a man filled with disgust
would have to pity.

OEDIPUS *enters through the palace doors.*

CHORUS LEADER. An awful fate for human eyes to witness,
an appalling sight—the worst I've ever seen.
O you poor man, what madness came on you?
What eternal force pounced on your life
and, springing further than the longest leap,
brought you this awful doom? Alas! Alas!
You unhappy man! I cannot look at you.
I want to ask you many things—there's much

[20] This line refers, not the entire story, but to what Jocasta and Oedipus have just done to themselves.

I wish to learn. You fill me with such horror,
yet there is so much I must see.

OEDIPUS. Aaaiiii, aaaiii . . . Alas! Alas!
How miserable I am . . . such wretchedness . . .
Where do I go? How can the wings of air
sweep up my voice? Oh my destiny,
how far you have sprung now!

CHORUS LEADER. To a fearful place from which men
turn away,
a place they hate to look upon.

OEDIPUS. O the dark horror wrapped around me,
this nameless visitor I can't resist
swept here by fair and fatal winds.
Alas for me! And yet again, alas for me! The agony
of stabbing brooches
pierces me! The memory of aching shame!

CHORUS LEADER. In your distress it's not astonishing
you bear a double load of suffering,
a double load of pain.

OEDIPUS. Ah, my friend,
so you still care for me, as always,
and with patience nurse me now I'm blind. Alas!
Alas! You are not hidden from me—
I recognize you all too clearly.
Though I am blind, I know that voice so well.

CHORUS LEADER. You have carried out such dreadful
things—
how could you dare to blind yourself this way?
What god drove you to it?

OEDIPUS. It was Apollo, friends,
it was Apollo. He brought on these troubles—
the awful things I suffer. But the hand
which stabbed out my eyes was mine alone.
In my wretched life, why should I have eyes when
nothing I could see would bring me joy?

CHORUS LEADER. What you have said is true enough.

OEDIPUS. What is there for me to see, my friends?
What can I love? Whose greeting can I hear
and feel delight? Hurry now, my friends,
lead me away from Thebes—take me somewhere,
a man completely lost, utterly accursed,
the mortal man the gods despise the most.

CHORUS LEADER. Unhappy in your fate and in your
mind
which now knows all. Would I had never known
you!

OEDIPUS. Whoever the man is who freed my feet,
who released me from that cruel shackle
and rescued me from death, may that man die!
It was a thankless act. Had I perished then,
I would not have brought such agony
to myself or to my friends.

CHORUS LEADER. I agree—
I would have preferred your death, as well.

OEDIPUS. I would not have come to kill my father, and
men would not see in me the husband
of the woman who gave birth to me.
Now I am abandoned by the gods,
the son of a corrupted mother, conceiving children
with the woman
who gave me my own miserable life.
If there is some suffering more serious
than all the rest, then it too belongs in the fate of
Oedipus.

CHORUS LEADER. I do not believe
what you did to yourself is for the best.
Better to be dead than alive and blind.

OEDIPUS. Don't tell me what I've done is not the best.
And from now on spare me your advice.
If I could see, I don't know how my eyes
could look at my own father when I come
to Hades or could see my wretched mother.
Against those two I have committed acts
so vile that even if I hanged myself
that would not be sufficient punishment. Perhaps
you think the sight of my own children might give
me joy? No! Look how they were born! They could
never bring delight to eyes of mine. Nor could the
city or its massive walls,
or the sacred images of its gods.
I am the most abhorred of men, I,
the finest one of all those bred in Thebes,
I have condemned myself, telling everyone
they had to banish for impiety the man
the gods have now exposed
as sacrilegious—a son of Laius, too.
With such polluting stains upon me, could I set
eyes on you and hold your gaze?
No. And if I could somehow block my ears and kill
my hearing, I would not hold back.
I'd make a dungeon of this wretched body,
so I would never see or hear again.
For there is joy in isolated thought, sealed off from
a world of sorrow.
O Cithaeron, why did you shelter me?
Why, when I was handed over to you,

did you not do away with me at once, so I would
never then reveal to men
the nature of my birth? Ah Polybus,
and Corinth, the place men called my home,
my father's ancient house, you raised me well—
so fine to look at, so corrupt inside!
Now I've been exposed as something bad,
contaminated in my origins.
Oh you three roads and hidden forest grove,
you thicket and defile where three paths meet, you
who swallowed down my father's blood
from my own hands, do you remember me,
what I did there in front of you and then
what else I did when I came here to Thebes?
Ah, you marriage rites—you gave birth to me,
and then when I was born, you gave birth again,
children from the child of that same womb,
creating an incestuous blood family
of fathers, brothers, children, brides,
wives and mothers—the most atrocious act
that human beings commit! But it is wrong
to talk about what it is wrong to do,
so in the name of all the gods, act quickly—
hide me somewhere outside the land of Thebes, or
slaughter me,
or hurl me in the sea,
where you will never gaze on me again.
Come, allow yourself to touch a wretched man.
Listen to me, and do not be afraid—
for this disease infects no one but me.

CHORUS LEADER. Creon is coming. He is just in time to
plan and carry out what you propose.
With you gone he's the only one who's left
to act as guardian of Thebes.

OEDIPUS. Alas, how will I talk to him?
How can I ask him
to put his trust in me? Not long ago
I treated him with such contempt.

Enter CREON.

CHORUS. Oedipus, I have not come here to mock
or blame you for disasters in the past.
But if you can no longer value human beings,
at least respect our lord the sun, whose light
makes all things grow, and do not put on show
pollution of this kind in such a public way,
for neither earth nor light nor sacred rain can
welcome such a sight.

CREON *speaks to the attending servants.*

Take him inside the house
as quickly as you can. The kindest thing
would be for members of his family to be the only
ones to see and hear him.

OEDIPUS. By all the gods, since you are acting now so
differently from what I would expect
and have come here to treat me graciously,
the very worst of men, do what I ask.
I will speak for your own benefit, not mine.

CHORUS. What are you so keen to get from me?

OEDIPUS. Cast me out as quickly as you can,
away from Thebes, to a place where no one,
no living human being, will cross my path.

CHORUS. That is something I could do, of course,
but first I wish to know what the god says
about what I should do.

OEDIPUS. But what he said
was all so clear—the man who killed his father
must be destroyed.
And that corrupted man is me.

CHORUS. Yes, that is what was said. But now,
with things the way they are,
the wisest thing is to ascertain quite clearly
what to do.

OEDIPUS. Will you then be making a request
on my behalf when I am so depraved?

CHORUS. I will. For even you must now trust in the gods.

OEDIPUS. Yes, I do. And I have a task for you
as I make this plea—that woman in the house,
please bury her as you see fit. You are the one
to give your own the proper funeral rites.
But never let my father's city be condemned
to have me living here while I still live.
Let me make my home up in the mountains
by Cithaeron, whose fame is now my own.
When my father and mother were alive,
they chose it as my special burying place—
and thus, when I die, I'll be following
the orders of
the ones who tried to kill me. And yet I know this
much—no disease
nor any other suffering can kill me— for I would
never have been saved from death unless I was to
suffer a strange destiny.
But wherever my fate leads, just let it go.
As for my two sons, Creon, there's no need

for you to care for them on my behalf—
they are men—thus, no matter where they are,
they'll always have enough to live on.[21] But
my two poor daughters have never known my din-
ing table placed away from them
or lacked their father's presence. They shared
everything
I touched—that's how it's always been.
So take care of them for me. But first let me
feel them with my hands and then I'll grieve.
Oh my lord, you noble heart, let me do that—
if my hands could touch them it would seem
as if I were with them when I still could see.

Some SERVANTS *lead* ANTIGONE *and* ISMENE *out of the palace.*

What's this? By all the gods I hear something—
is it my two dear children crying . . .?
Has Creon taken pity on me and
sent out the children, my dear treasures?
Is that what's happening?

CHORUS. Yes. I sent for them.
I know the joy they've always given you—
the joy which you feel now.

OEDIPUS. I wish you well.
And for this act, may the god watch over you
and treat you better than he treated me.
Ah, my children, where are you? Come here,
come into my arms—you are my sisters now—
feel these hands which turned your father's eyes,
once so bright, into what you see now,
these empty sockets. He was a man, who,
seeing nothing, knowing nothing, fathered you
with the woman who had given birth to him.
I weep for you. Although I cannot see,
I think about your life in days to come,
the bitter life which men will force on you.
What citizens will associate with you?
What feasts will you attend and not come home
in tears, with no share in the rejoicing?
When you're mature enough for marriage,
who will be there for you, my children,
what husband ready to assume the shame
tainting my children and their children, too?
What perversion is not manifest in us?
Your father killed his father, and then ploughed
his mother's womb—where he himself was born—
conceiving you where he, too, was conceived.
Those are the insults they will hurl at you.

Who, then, will marry you? No one, my children.
You must wither, barren and unmarried.
Son of Menoeceus, with both parents gone, you
alone remain these children's father.
Do not let them live as vagrant paupers,
wandering around unmarried. You are
a relative of theirs—don't let them sink
to lives of desperation like my own. Have pity. You
see them now at their young age deprived of every-
thing except a share
in what you are. Promise me, you noble soul,
you will extend your hand to them. And you,
my children, if your minds were now mature,
there's so much I could say. But I urge you—
pray that you may live as best you can
and lead your destined life more happily
than your own father.

CHORUS. You have grieved enough.
Now go into the house.

OEDIPUS. I must obey,
although that's not what I desire.

CHORUS. In due time
all things will work out for the best.

OEDIPUS. I will go.
But you know there are conditions.

CHORUS. Tell me.
Once I hear them, I'll know what they are.

OEDIPUS. Send me away to live outside of Thebes.

CHORUS. Only the god can give you what you ask.

OEDIPUS. But I've become abhorrent to the gods.

CHORUS. Then you should quickly get what you desire.

OEDIPUS. So you agree?

CHORUS. I don't like to speak
thoughtlessly and say what I don't mean.

OEDIPUS. Come then,
lead me off.

CHORUS. All right,
but let go of the children.

OEDIPUS. No, no!
Do not take them away from me. Creon. Don't try
to be in charge of everything. Your life has lost the
power you once had.

21 Oedipus' two sons, Eteocles and Polyneices, would probably be fifteen or sixteen years old at this time, not old enough to succeed Oedipus.

CREON, OEDIPUS, ANTIGONE, ISMENE, *and*
ATTENDANTS *all enter the palace.*[22]

CHORUS. You residents of Thebes, our native land,
 look on this man, this Oedipus, the one
 who understood that celebrated riddle.
 He was the most powerful of men.

All citizens who witnessed this man's wealth
were envious. Now what a surging tide
of terrible disaster sweeps around him.
So while we wait to see that final day,
we cannot call a mortal being happy
before he's passed beyond life free from pain.

[22] It is not entirely clear from these final lines whether Oedipus now leaves Thebes or not. According to Jebb's commentary (line 1519), in the traditional story on which Sophocles is relying, Oedipus was involuntarily held at Thebes for some time before the citizens and Creon expelled him from the city. Creon's lines suggest he is going to wait to hear from the oracle before deciding about Oedipus. However, there is a powerful dramatic logic in having Oedipus stumble off away from the palace. In Book 23 of the *Iliad*, Homer indicates that Oedipus died at Thebes, and there were funeral games held in his honour in that city.

Hamlet

Renaissance Drama and the Theatre of Elizabethan England

In Europe, the Middle Ages came to an end with an explosion of learning, exploration, discovery, and artistic output that was called the Renaissance. How religion was practiced and interpreted began to be questioned as science grew in scope. As a result, the religious plays that had become popular during medieval times began to decrease in popularity. There was so much fighting and competition among the different factions of the church that Queen Elizabeth I actually banned the production of religious drama in England. Without the support of the church or the government, theatre had to become a commercial enterprise in order to survive. In England, for the first time in history, theatre artists had to find a way to support themselves and their art without the aid of both the government and the church. It is here that we begin to see theatre become a business. In many parts of the Western world, theatre has remained a commercial enterprise through modern times.

In Elizabethan England, actors and theatre artists were considered vagrants who had no training to do other jobs. In an attempt to earn money and legitimacy, these artists joined together to form companies. These companies petitioned wealthy citizens who enjoyed theatre and asked them to become producers. Many of England's wealthiest citizens were more than happy to lend financial support to budding theatre companies. For a time, owning your own theatre company was actually considered quite a status symbol among the rich. The actors literally became servants of these wealthy individuals. Acting companies of the time reflected their patronage in their names. Many theatre companies in Elizabethan England had names like the Lord Admiral's Men, The KING's Men, and so on.

Because the public now had to pay for their admission to the theatre, new plays needed to be developed constantly so the audience would keep coming back. It really wasn't that much different than today's world of television. If a television series doesn't keep putting out new episodes, people will stop watching it. It was this need for a constant supply of new material that gave birth to the true importance of the playwright. At the time, however, playwrights didn't think of their writing as literary work. William Shakespeare didn't even publish most of his works for the stage. The majority of his plays weren't published until after his death.

William Shakespeare

One man has come to define the theatre of Elizabethan England during the Renaissance: William Shakespeare. He began his career as an actor but went on to become perhaps the greatest playwright of all time and surely the most famous. The question is, Why is he so famous? Many of you probably can't remember back to a time when you didn't know the name Shakespeare. We begin learning about the man and his plays when we are children. Most high school English classes require the reading of at least one Shakespearean play. Students all over the world may not recognize the names of any other British playwrights, but they know the name Shakespeare. Why? Perhaps it is because he has written so many great plays. You might recognize a few of these titles:

Hamlet	*Julius Caesar*	*Henry V*
Romeo and Juliet	*Much Ado about Nothing*	*KING Lear*
Macbeth	*Othello*	
A Midsummer Night's Dream	*Richard III*	

These are but a few examples of Shakespeare's famous works. But again we ask, Why are these plays so famous?

If you were to ask this question of someone whose knowledge you respected, you might get any number of answers. Perhaps the reason for Shakespeare's enduring fame and popularity has nothing to do with how timeless or beautiful his plays are. Many playwrights have written timeless and beautiful plays. Let us venture forth the following theory: Shakespeare's fame is a direct result of his amazing contribution to the English language.

Shakespeare had an incredible vocabulary. He is credited with adding over three thousand (that's right, three thousand) new words to the English language, many of which are still used today. Here is a small sampling of some of the words Shakespeare literally invented:

accused	addiction	advertising	amazement
arouse	assassination	bandit	bedroom
birthplace	blanket	bloodstained	blushing
bet	bump	buzzer	caked
cater	champion	compromise	critic
dawn	drugged	dwindle	epileptic
elbow	excitement	exposure	eyeball
fashionable	flawed	frugal	generous
gloomy	gossip	gust	hint
hurried	impede	jaded	label
leapfrog	lonely	lower	luggage
majestic	mimic	moonbeam	negotiate
obscene	ode	outbreak	puking
radiance	rant	ecure	skim milk
submerge	summit	swagger	torture
tranquil	undress	unreal	varied
worthless	zany		

Certainly you recognize at least a few of these. You can thank Shakespeare for inventing them and adding them to our language. Once again, this is a small sample. There are hundreds upon hundreds of words still found in our modern dictionaries that Shakespeare invented by changing nouns into verbs, changing verbs into adjectives, adding prefixes and suffixes, connecting words never before used together, and creating entirely original words. Scholars estimate that we still use about seventeen hundred of the words Shakespeare invented.

It is not just his individual words that have become part of our everyday lives. Many of our most popular sayings and idioms come directly from the plays of Shakespeare. Take, for example, these famous quotes:

1. "To be or not to be, that is the question."—*Hamlet*
2. "All the world's a stage"—*As You Like It*
3. "What's in a name? That which we call a rose . . ."—*Romeo and Juliet*
4. "The play's the thing"—*Hamlet*
5. "The course of true love never did run smooth."—*A Midsummer Night's Dream*
6. "All that glisters is not gold."—*The Merchant of Venice*
7. "Now is the winter of our discontent."—*Richard III*
8. "We are such stuff as dreams are made on . . ."—*The Tempest*
9. "I'll not budge an inch."—*The Taming of the Shrew*
10. "Out, damned spot! Out, I say"—*Macbeth*

11. "O Romeo, Romeo! wherefore art thou Romeo?"—*Romeo and Juliet*
12. "He hath eaten me out of house and home."—*Henry IV, Part II*
13. "Tomorrow, and tomorrow, and tomorrow . . ."—*Macbeth*
14. "A horse! a horse! My kingdom for a horse!"—*Richard III*
15. "Beware the ides of March"—*Julius Caesar*
16. "Why, then the world's mine oyster"—*The Merry Wives of Windsor*
17. "To sleep, perchance to dream"—*HAMLET*
18. "But love is blind, and lovers cannot see."—*The Merchant of Venice*
19. "Nothing can come of nothing: speak again."—*KING Lear*
20. "By the pricking of my thumbs, something wicked this way comes."—*Macbeth*

Once again, these are but a few quotes from Shakespeare's plays that have become part of our everyday language. There are many, many more. Just how big was Shakespeare's vocabulary? Let's put it this way, the average college graduate has a total vocabulary of forty thousand words. Shakespeare's works contain over eight hundred thousand words.

Certainly, Shakespeare's enduring popularity is due to a number of reasons. His writing is so unique and beautiful that many scholars have gone so far as to suggest he didn't even write many of his plays. These conspiracy theories range from the idea that several of Shakespeare's contemporaries, such as Ben Jonson and Christopher Marlowe, actually wrote these plays to the notion that Queen Elizabeth herself wrote them. Over time, many of these notions have been dispelled. The more we look, the more we find that one man, Shakespeare, is responsible for these amazing contributions to the world stage.

Reading Shakespeare

When you first pick up one of Shakespeare's plays, you will immediately notice that it is not really written in everyday prose. The language is heightened; almost poetic. There is a very definite rhythm to most of the lines the characters speak. It goes something like this:

De-DUM de-DUM de-DUM de-DUM de-DUM

We call this **iambic pentameter**. Most of us prefer to call this style of writing **free verse** because it sounds a lot friendlier. This means that each line uses ten syllables, with light and strong stresses alternating five light ones and five strong ones. Sounds complicated doesn't it? It probably makes you think you'll never be able to read the play without getting a headache. Not so fast. If you listen to English speech, you will notice that most of our everyday phrases and sentences match iambic pentameter. If that isn't enough to make you feel better, consider this: most of you have probably heard of Dr. Seuss, the famous author of children's books. Remember the book *Green Eggs and Ham*? It is written in iambic pentameter. Most five-year-old children have no trouble zooming through *Green Eggs and Ham*, so don't be afraid. The content may be a little more intense than a preschool story, but the language is only a heightened version of our everyday speech. As William Ball wrote in his brilliant book on script analysis, *Backwards & Forwards*, "There is little in *HAMLET* that a normal fifteen-year-old cannot fathom."

For more information about William Shakespeare, check out shakespeare.about.com.

Hamlet

HAMLET might just be the most talked about play in the history of theatre. No character in the history of drama has been more closely scrutinized, by everyone from scholars to historians, to psychologists, than the title character in this play. The character of *HAMLET* has been played by great actors (and actresses) such as Richard Burbage, David Garrick, Edwin Booth, John Barrymore, Sarah Bernhardt, Richard Burton, Laurence Olivier, Mel Gibson, John Gielgud, Patrick Stewart, Ethan Hawke, Kenneth Branagh, Alec Guinness, and Kevin Kline.

The idea behind this play was far from original when Shakespeare wrote it. HAMLET is a revenge tragedy, a form of theatre that was very popular among Elizabethan audiences. Many scholars feel Shakespeare's play owes quite a debt to another popular revenge play: Thomas Kyd's *The Spanish Tragedy*. Both plays feature ghosts, fractured romances, royal courts filled with spies and deceit, and bloody finales. HAMLET and *The Spanish Tragedy* are but two of many, many revenge-themed plays of the time, and it is widely considered that Shakespeare's mastery of language and character far surpassed that of Kyd.

Scholars are unsure of the exact date when HAMLET was written, but it is believed to be sometime between 1599 and 1601. We know the play was first produced for a public audience around 1601, and it was very successful. Since that first production, almost every major theatre company around the world has taken a turn at bringing Shakespeare's complex play to life. It is, without a doubt, the most produced of all of Shakespeare's plays. It might even be the most often produced play in the world. For many of us, the search for the perfect production of HAMLET is like searching for the Holy Grail.

The play takes place in and around the dreary confines of Elsinore castle in Denmark. Prince HAMLET has returned home to find his father dead and his mother married to his uncle, Claudius. The castle guards have reported seeing a ghost lurking around the castle. HAMLET confronts the ghost, only to discover it is the ghost of his dead father, the king. The ghost claims Claudius poisoned him and took everything he had, and he asks HAMLET to avenge his death. Unsure of the legitimacy of the ghost's claims, HAMLET sets out to uncover the truth about his father's death. His quest leads him through a dangerous and bloody web of deceit that involves all of Denmark's royal family.

Food for Thought

As you read the play, consider the following questions:

1. Many critics have accused HAMLET of being a man of **inaction.** Do you think he is a man of action or inaction? Explain your answer.
2. What do you think HAMLET's **tragic flaw** is?
3. Is HAMLET crazy? Look at all the different parts of the play that explore the ideas of **seeming** and **deceit.** Shakespeare seems to have a lot to say about things not being what they seem to be.
4. Of all of Shakespeare's plays, HAMLET deals the most with theatricality. See if you can find the passages where Shakespeare, who was also an actor, seems to be telling us his opinions about the art of theatre and acting.
5. In HAMLET, Shakespeare's mastery of words is on full display. See how many famous quotes you can find as you go through the text.
6. What do you think is the **theme** of the play? See if you can write a theme for this very complex play in a single sentence.
7. What do you think it is about HAMLET that makes the play and the title role so interesting to so many different people?

Fun Facts

1. Did you know that Shakespeare had a son named Hamnet who died a few years before he wrote HAMLET?
2. Did you know that in Shakespeare's time, all the roles were played by men? Female roles were traditionally played by boys. The English considered it immoral for women to appear on stage and also thought that boys could play female roles more effectively than women could. How does this change your perspective on OPHELIA and Gertrude?

Hamlet

Characters

Claudius, KING of Denmark.
HAMLET, son to the former, and nephew
to the present KING.
POLONIUS, Lord Chamberlain.
HORATIO, friend to HAMLET.
LAERTES, son to POLONIUS.
VOLTIMAND,
Cornelius,
ROSENCRANTZ, } courtiers.
GUILDENSTERN,
OSRIC, a courtier.
Another courtier.
A Priest.
Marcellus, an officer.
Bernardo, an officer.

Francisco, a soldier.
REYNALDO, servant to POLONIUS.
A Captain.
An Ambassador.
Ghost of HAMLET's father.
FORTINBRAS, Prince of Norway.
Gertrude, QUEEN of Denmark, and
mother of HAMLET.
OPHELIA, daughter of POLONIUS.
LORDS, Ladies, Officers, Soldiers, PLAYERS,
Grave-diggers, Sailors, Messengers, and
other Attendants.
SCENE.—Elsinore.

Act 1
Scene I—Elsinore. A Platform before the Castle.

FRANCISCO on his post. Enter to him BERNARDO.

BERNARDO. Who's there?

FRANCISCO. Nay, answer me: stand, and unfold[1] Yourself.

BERNARDO. Long live the king!

FRANCISCO. Bernardo?

BERNARDO. He.

FRANCISCO. You come most carefully[2] upon your hour.

BERNARDO. 'Tis now struck twelve: get thee to bed, Francisco.

FRANCISCO. For this relief, much thanks: 'tis bitter cold, And I am sick at heart.

BERNARDO. Have you had quiet guard?

FRANCISCO. Not a mouse stirring.

BERNARDO. Well, good night.

If you do meet Horatio and Marcellus,
The rivals[3] of my watch, bid them make haste.[4]

Enter HORATIO and MARCELLUS.

FRANCISCO. I think I hear them.—Stand! who is there?

HORATIO. Friends to this ground.

MARCELLUS. And liegemen[5] to the Dane.

FRANCISCO. Give you good night.

MARCELLUS. O, farewell, honest soldier: Who hath reliev'd you?

FRANCISCO. Bernardo hath my place. Give you good night.

Exit FRANCISCO.

MARCELLUS. Holla! Bernardo!

BERNARDO. Say. What, is Horatio there?

HORATIO. A piece of him.

BERNARDO. Welcome, Horatio; welcome, good Marcellus.

MARCELLUS. What, has this thing appear'd again to-night?

BERNARDO. I have seen nothing.

[1]*unfold:* reveal
[2]*carefully:* heedfully
[3]*rivals:* partners
[4]*make haste:* be quick
[5]*liegemen:* loyal subjects

From The Works of William Shakespere, Edited by Charles Knight, David McKay Publishers.

MARCELLUS. Horatio says, 'tis but our fantasy;
And will not let belief take hold of him,
Touching this dreaded sight, twice seen of us:
Therefore I have entreated him along
With us to watch the minutes of this night;
That, if again this apparition come,
He may approve our eyes[6] and speak to it.

HORATIO. Tush! tush! 'twill not appear.

BERNARDO. Sit down a while; And let us once again
assail your ears, That are so fortified against our
story, What we two nights have seen.

HORATIO. Well, sit we down
And let us hear Bernardo speak of this.

BERNARDO. Last night of all,
When you same star,
that's westward from the pole,
Had made **his** course to illume that part of heaven
Where now it burns, Marcellus, and myself,
The bell then beating one,—

MARCELLUS. Peace, break thee off; look, where it comes
again!

Enter GHOST.

BERNARDO. In the same figure, like the king that's dead.

MARCELLUS. Thou art a scholar, speak to it, Horatio.

BERNARDO. Looks it not like the king? mark it, Horatio.

HORATIO. Most like:—it harrows[7] me with fear, and
wonder.

BERNARDO. It would be spoke to.

MARCELLUS. Question it, Horatio.

HORATIO. What art thou, that usurp'st this time of night,
Together with that fair and warlike form
In which the majesty of buried Denmark
Did sometimes march? by heaven I charge thee,
speak.
MARCELLUS. It is offended.

BERNARDO. See! it stalks away.

HORATIO. Stay: speak: speak! I charge thee, speak!

Exit GHOST.

MARCELLUS. 'Tis gone, and will not answer.

BERNARDO. How now, Horatio? you tremble, and look
pale:
Is not this something more than fantasy?
What think you on't?

HORATIO. Before my God, I might not this believe,
Without the sensible and true avouch[8]
Of mine own eyes.

MARCELLUS. Is it not like the king?

HORATIO. As thou art to thyself:
Such was the very armour he had on,
When he the ambitious Norway[9] combated;
So frown'd he once, when, in an angry parle,[10] He
smote[11] the sledded Polacks on the ice.
'Tis strange.

MARCELLUS. Thus, twice before, and just at this dead
hour,
With martial stalk[12] hath he gone by our watch.

HORATIO. In what particular thought to work, I know
not;
But, in the gross and scope of my opinion,
This bodes some strange eruption to our state.

MARCELLUS. Good now, sit down, and tell me, he that
knows,
Why this same strict and most observant watch
So nightly toils the subject of the land?
And why such daily cast of brazen cannon,
And foreign mart for implements of war:[13]
Why such impress of shipwrights,[14] whose sore task
Does not divide the Sunday from the week:
What might be toward that this sweaty haste
Doth make the night joint-labourer with the day;
Who is't that can inform me?

HORATIO. That can I;
At least, the whisper goes so. Our last king,
Whose image even but now appear'd to us,

[6]*approve our eyes:* confirm what we saw
[7]*harrows:* distresses
[8]*avouch:* confirm; support
[9]*ambitious Norway:* king of Norway
[10]*parle:* conference with enemy
[11]*smote:* struck; overthrew
[12]*martial stalk:* war-like stride
[13]*daily cast of brazen canon,/And foreign mart for implements of war:* making weapons and trading with other countries in preparation for war
[14]*impress of shipwrights:* forced into service

Was, as you know, by Fortinbras of Norway,
Thereto prick'd on by a most emulate[15] pride,
Dar'd to the combat; in which our valiant Hamlet
(For so this side of our known world esteem'd him)
Did slay this Fortinbras; who, by a seal'd compact,
Well ratified by law, and heraldry,
Did forfeit, with his life, all those his lands,
Which he stood seiz'd on, to the conqueror:
Against the which, a moiety competent[16]
Was gaged by our king; which had return'd
To the inheritance of Fortinbras,
Had he been vanquisher; as, by the same cov'nant
And carriage of the article design'd,
His fell to Hamlet: Now, sir, young Fortinbras,
Of unimproved mettle hot and full,
Hath in the skirts of Norway, here and there,
Shark'd up a list of landless resolutes,[17]
For food and diet, to some enterprise
That hath a stomach in't: which is no other
(And it doth well appear unto our state,)
But to recover of us, by strong hand,
And terms compulsative, those 'foresaid lands
So by his father lost: And this, I take it
Is the main motive of our preparations;
The source of this our watch; and the chief head
Of this pose-haste and romage[18] in the land.

BERNARDO. I think it be no other, but even so:
Well may it sort, that this portentous[19] figure
Comes armed through our watch: so like the king
That was, and is, the question of these wars.

HORATIO. A moth it is to trouble the mind's eye.
In the most high and palmy[20] state of Rome,
A little ere the mightiest Julius fell,
The graves stood tenantless, and the sheeted dead
Did squeak and gibber[21] in the Roman streets:
As stars with trains of fire and dews of blood,
Disasters in the sun; and the moist star,
Upon whose influence Neptune's empire stands,
Was sick almost to dooms-day with eclipse.
And even the like precurse[22] of fierce events,
As harbingers preceding still the fates,

And prologue to the omen coming on,
Have heaven and earth together demonstrated
Unto our climatures[23] and countrymen.—

Re-enter GHOST.

But, soft; behold! lo, where it comes again!
I'll cross it, thought it blast me.—Stay, illusion!
If thou hast any sound, or use of voice,
Speak to me:
If there be any good thing to be done,
That may to thee do ease, and grace to me,
Speak to me:
If thou art privy[24] to thy country's fate,
Which, happily, foreknowing may avoid,
O, speak! Or, if thou hast uphoarded[25] in thy life
Extorted treasure in the womb of earth,
For which, they say, you spirits oft walk in death,

Cock crows.

Speak of it:—stay, and speak.—Stop it, Marcellus.

MARCELLUS. Shall I strike at it with my partizan?[26]

HORATIO. Do, if it will not stand.

BERNARDO. 'Tis here!

HORATIO. 'Tis here!

MARCELLUS. 'Tis gone!

Exit GHOST.

We do it wrong, being so majestical,
To offer it the show of violence;
For it is, as the air, invulnerable,
And our vain blows malicious mockery.

BERNARDO. It was about to speak, when the cock crew.

HORATIO. And then it started like a guilty thing
Upon a fearful summons. I have heard,
The cock, that is the trumpet to the morn,
Doth with his lofty and shrill-sounding throat
Awake the god of day; and, at his warning,
Whether in sea or fire, in earth or air,

[15]*emulate:* competitive
[16]*moiety competent:* equal capacity
[17]*landless resolutes:* criminals
[18]*romage:* hurried activity
[19]*portentous:* solemn; ominous
[20]*palmy:* palm-like; flourishing
[21]*gibber:* utter senseless sounds
[22]*precurse:* precursor; forerunner
[23]*climatures:* region; land
[24]*privy:* knowledgeable about
[25]*uphoarded:* amassed
[26]*partizan:* a weapon with an axe-like blade at the end of a long staff.

The extravagant and erring spirit hies[27]
To his confine: and of the truth herein
This present object made probation.[28]

MARCELLUS. It faded on the crowing of the cock.
Some say, that ever 'gainst that season comes
Wherein our Saviour's birth is celebrated,
The bird of dawning singeth all night long:
And then, they say, no spirit can walk abroad;
The nights are wholesome; then no planets strike,
No fairy takes, nor witch hath power to charm,
So hallow'd and so gracious is the time.

HORATIO. So have I heard, and do in part believe it.
But, look, the morn, in russet mantle clad,[29]
Walks o'er the dew of yon high eastern hill:
Break we our watch up; and, by my advice,
Let us impart what we have seen to-night
Unto young HAMLET: for, upon my life,
This spirit, dumb to us, will speak to him:
Do you consent we shall acquaint him with it,
As needful in our loves, fitting our duty?

MARCELLUS. Let's do't, I pray: and I this morning know
Where we shall find him most conveniently.

Exeunt.[30]

Scene II—The same. A Room of State in the same.

Enter the KING, QUEEN, HAMLET, POLONIUS,
LAERTES, VOLTIMAND, CORNELIUS, and LORDS
ATTENDANTS.

KING. Though yet of HAMLET our dear brother's[1] death
The memory be green[2]; and that it us befitted
To bear our hearts in grief, and our whole kingdom
To be contracted in one brow of woe;
Yet so far hath discretion fought with nature,[3]
That we with wisest sorrow think on him,
Together with remembrance of ourselves.

Therefore our sometime sister,[4] now our queen,
The imperial jointress[5] of this warlike state,
Have we, as 'twere, with a defeated joy,
With one auspicious and one dropping eye;
With mirth in funeral, and with dirge in marriage
In equal scale, weighing delight and dole,
Taken to wife: nor have we herein barr'd
Your better wisdoms which have freely gone
With this affair along:—For all, our thanks.
Now follows, that you know, young Fortinbras,
Holding a weak supposal of our worth;
Or thinking, by our late dear brother's death,
Our state to be disjoint and out of frame,
Colleagued with the dream of his advantage,
He hath not fail'd to pester us with message,
Importing the surrender of those lands
Lost by his father, with all bonds of law,
To our most valiant brother.—So much for him.
Now for ourself, and for this time of meeting.
Thus much the business is: We have here writ
To Norway, uncle of young Fortinbras,
Who, impotent and bed-rid, scarcely hears
Of this his nephew's purpose, to suppress
His further gait[6] herein; in that the levies,
The lists, and full proportions, are all made
Out of his subject: and we here despatch
You, good Cornelius, and you, VOLTIMAND,
For bearing of this greeting to old Norway;
Giving to you no further personal power
To business with the king, more than the scope
Of these dilated articles[7] allow.
Farewell; and let your haste commend your duty.

CORNELIUS. VOLTIMAND. In that, and all things, will we
show our duty.

KING. We doubt it nothing[8]; heartily farewell.

Exeunt VOLTIMAND and CORNELIUS.

And now, Laertes, what's the news with you?
You told us of some suit[9]? What is't, Laertes?

[27]*hies*: hastens
[28]*probation*: proof
[29]*russet mantle clad*: dressed in a coarse, reddish-brown cloak
[30]*exeunt*: exit
[1]*brother's*: the new king is HAMLET's uncle, brother of the dead king.
[2]*green*: new, raw
[3]*discretion fought with nature*: prudence against the nature of things
[4]*our sometime sister*: once my sister-in-law
[5]*jointress*: partner
[6]*gait*: manner of walking
[7]*dilated articles*: expanded correspondence
[8]*nothing*: not
[9]*suit*: petition

You cannot speak of reason to the Dane,
And lose your voice[10]: What wouldst thou beg,
LAERTES,
That shall not be my offer, not thy asking?
The head is not more native to the heart,
The hand more instrumental to the mouth,
Than is the throne of Denmark to thy father.
What wouldst thou have, Laertes?

LAERTES. Dread my lord,
Your leave and favour to return to France;
From whence though willingly I came to Denmark,
To show my duty in your coronation;
Yet now, I must confess, that duty done,
My thoughts and wishes bend again towards
France,
And bow them to your gracious leave and pardon.

KING. Have you your father's leave? What says POLONIUS?

POLONIUS. He hath, my lord, wrung from me my slow leave,
By laboursome petition; and, at last,
Upon his will I seal'd my hard consent:
I do beseech you, give him leave to go.

KING. Take thy fair hour, Laertes; time be thine,
And thy best graces spend it at thy will!
But now, my counsin[11] HAMLET, and my son,—

HAMLET. A little more than kin, and less than kind.[12]
Aside.

KING. How is it that the clouds still hang on you?

HAMLET. Not so, my lord, I am too much i' the sun.[13]

QUEEN. Good HAMLET, cast thy nightly colour off.
And let thine eye look like a friend on Denmark.
Do not, for ever, with thy vailed lids
Seek for thy noble father in the dust:
Thou know'st, 'tis common; all that lives must die,
Passing through nature to eternity.

HAMLET. Ay, madam, it is common.[14]

QUEEN. If it be,
Why seems it so particular with thee?

HAMLET. Seems, madam! nay, it is; I know not seems.
'Tis not alone my inky cloak, good mother,
Nor customary suits of solemn black,
Nor windy suspiration[15] of forc'd breath,
No, nor the fruitful river in the eye,
Nor the dejected haviour of the visage,[16]
Together with all forms, moods, shows of grief,
That can denote me truly: These, indeed, seem,
For they are actions that a man might play:
But I have that within which passeth show;
These, but the trappings and the suits of woe.

KING. 'Tis sweet and commendable in your nature,
Hamlet,
To give these mourning duties to your father:
But, you must know, your father lost a father;
That father lost, lost his; and the survivor bound
In filial[17] obligation, for some term
To do obsequious sorrow: But to persever
In obstinate condolement, is a course
Of impious stubbornness; 'tis unmanly grief:
It shows a will most incorrect to heaven;
A heart unfortified, a mind impatient,
An understanding simple and unschool'd:
For what, we know, must be, and is as common
As any the most vulgar thing to sense,
Why should we, in our peevish opposition,
Take it to heart? Fye! 'tis a fault to heaven,
A fault against the dead, a fault to nature,
To reason most absurd; whose common theme
Is death of fathers, and who still hath cried,
From the first corse,[18] till he that died to-day,
This must be so. We pray you, throw to earth
This unprevailing woe; and think of us
As of a father: for let the world take note,
You are the most immediate to our throne,
And, with no less nobility of love,
Than that which dearest father bears his son,
Do I impart towards you. For your intent
In going back to school in Wittenberg,
It is most retrograde[19] to our desire:
And, we beseech you, bend you to remain

[10]lose your voice: not be heard
[11]cousin: kinsman
[12]A *little more than kin, and less than kind*: HAMLET is both the king's nephew and stepson, which he feels is neither natural nor very pleasant.
[13]sun: word play on "son"
[14]common: HAMLET uses "common" to mean both "general" and "vulgar"
[15]windy suspiration: sighing
[16]havior of the visage: countenance of the face
[17]filial: child's
[18]corse: corpse
[19]retrograde: backward; opposite

Here, in the cheer and comfort of our eye,
Our chiefest courtier, cousin, and our son.

QUEEN. Let not thy mother lose her prayers, HAMLET:
I pray thee, stay with us; go not to Wittenberg.

HAMLET. I shall in all my best obey you, madam.

KING. Why, 'tis a loving and a fair reply;
Be as ourself in Denmark.—Madam come;
This gentle and unforc'd accord of HAMLET
Sits smiling to my heart: in grace whereof,
No jocund health that Denmark drinks to-day,
But the great cannon to the clouds shall tell;
And the king's rouse[20] the heaven shall bruit[21] again,
Re-speaking earthly thunder. Come away.

Exeunt KING, QUEEN, LORDS, &c., POLONIUS, *and*
LAERTES.

HAMLET. O, that this too too solid flesh would melt,
Thaw, and resolve itself into a dew!
Or that the Everlasting had not fix'd
His canon 'gainst self-slaughter[22]! O God! O God!
How weary, stale, flat, and unprofitable
Seem to me all the uses of this world!
Fye on't! O fye! 'tis an unweeded garden,
That grows to seed; things rank, and gross in nature,
Possess it merely. That it should come to this!
But two months dead!—nay, not so much, not two;
So excellent a king; that was, to this,
Hyperion[23] to a satyr[24]: so loving to my mother,
That he might not beteem[25] the winds of heaven
Visit her face too roughly. Heaven and earth!
Must I remember? why, she would hang on him,
As if increase of appetite had grown
By what it fed on: And yet, within a month,—
Let me not think on't;—Frailty, thy name is
woman!—
A little month; or ere those shoes were old,
With which she follow'd my poor father's body,
Like Niobe,[26] all tears;—why she, even she,—

O heaven! a beast, that wants[27] discourse of reason,
Would have mourn'd longer,—married with mine
uncle,
My father's brother; but no more like my father,
Than I to Hercules: Within a month;
Ere yet the salt of most unrighteous tears
Had left the flushing of her galled eyes,
She married:—O most wicked speed, to post
With such dexterity to incestuous[28] sheets;
It is not, nor it cannot come to, good;
But break, my heart: for I must hold my tongue!

Enter HORATIO, BERNARDO, *and* MARCELLUS.

HORATIO. Hail to your lordship!

HAMLET. I am glad to see you well:

HORATIO,—or I do forget myself.[29]

HORATIO. The same, my lord, and your poor servant ever

HAMLET. Sir, my good friend; I'll change that name
with you
And what make you[30] from Wittenberg, Horatio?—
Marcellus?

MARCELLUS. My good lord,—

HAMLET. I am very glad to see you; good even, sir,—
But what, in faith, make you from Wittenberg?

HORATIO. A truant[31] disposition, good my lord.

HAMLET. I would not have your enemy say so;
Nor shall you do mine ear that violence,
To make it truster of your own report
Against yourself: I know, you are no truant.
But what is your affair in Elsinore?
We'll teach you to drink deep, ere you depart.

HORATIO. My lord, I came to see your father's funeral.

HAMLET. I pray thee, do not mock me, fellow-student;
I think it was to see my mother's wedding.

[20]*rouse*: drink
[21]*bruit*: make known
[22]*self-slaughter*: suicide
[23]*Hyperion*: sun god
[24]*satyr*: part man, part goat deity; also refers to lustful person
[25]*beteem*: permit
[26]*Niobe*: a woman who lost her seven children, causing her to cry so much she turned to stone.
[27]*wants*: lacks
[28]*incestuous*: it was considered incest to marry your deceased brother's widow
[29]*forget myself*: misremember
[30]*make you*: takes you
[31]*truant*: leaves duty

HORATIO. Indeed, my lord, it follow'd hard upon.

HAMLET. Thrift,[32] thrift, Horatio! the funeral bak'd meats
Did coldly furnish forth the marriage tables.
Would I had met my dearest foe in heaven
Ere I had ever seen that day, Horatio!—
My father,—Methinks, I see my father.

HORATIO. O, where,
My lord?

HAMLET. In my mind's eye, Horatio.

HORATIO. I saw him once, he was a goodly king.

HAMLET. He was a man, take him for all in all,
I shall not look upon his like again.

HORATIO. My lord, I think I saw him yesternight.

HAMLET. Saw! who?

HORATIO. My lord, the king your father.

HAMLET. The king my father!

HORATIO. Season your admiration for a while
With an attent[33] ear; till I may deliver,
Upon the witness of these gentlemen,
This marvel to you.

HAMLET. For heaven's love, let me hear.

HORATIO. Two nights together had these gentlemen,
Marcellus and Bernardo, on their watch,
In the dead waste and middle of the night,
Been thus encounter'd. A figure like your father,
Arm'd at all points, exactly, cap-à-pé,[34]
Appears before them, and with solemn march,
Goes slow and stately by them; thrice he walk'd,
By their oppress'd and fear-surprised eyes,
Within his truncheon's[35] length; whilst they, bestill'd
Almost to jelly with the act of fear,
Stand dumb, and speak not to him. This to me
In dreadful secrecy impart they did;
And I with them the third night kept the watch:
Where, as they had deliver'd, both in time,
Form of the thing, each word made true and good,
The apparition comes: I knew your father;
These hands are not more like.

HAMLET. But where was this?

MARCELLUS. My lord, upon the platform where we watch'd.

HAMLET. Did you not speak to it?

HORATIO. My lord, I did:
But answer made it none: yet once, methought,
It lifted up its head, and did address
Itself to motion, like as it would speak:
But, even then, the morning cock crew loud;
And at the sound it shrank in haste away,
And vanish'd from our sight.

HAMLET. 'Tis very strange.

HORATIO. As I do live, my honour'd lord, 'tis true;
And we did think it writ down in our duty,
To let you know of it.

HAMLET. Indeed, indeed, sirs, but this troubles me
Hold you the watch to-night?

ALL. We do, my lord.

HAMLET. Arm'd, say you?

ALL. Arm'd, my lord.

HAMLET. From top to toe!

ALL. My lord, from head to foot.

HAMLET. Then saw you not his face.

HORATIO. O, yes, my lord, he wore his beaver[36] up.

HAMLET. What, look'd he frowningly?

HORATIO. A countenance more in sorrow than in anger.

HAMLET. Pale or red?

HORATIO. Nay, very pale.

HAMLET. And fix'd his eyes upon you?

HORATIO. Most constantly.

HAMLET. I would I had been there.

HORATIO. It would have much amazed you.

HAMLET. Very like, very like; stay'd it long?

HORATIO. While one with moderate haste might tell[37]
a hundred.

MARCELLUS. BERNARDO. Longer, longer.

[32]*thrift*: HAMLET muses that the marriage followed the funeral in order to save money on food
[33]*attent*: attentive
[34]*cap-a-pe*: head to foot, usually said of an armed knight
[35]*truncheon's*: a heavy staff
[36]*beaver*: in medieval armor, it is the segment that covers the lower part of the face.
[37]*tell*: count

HORATIO. Not when I saw it.

HAMLET. His beard was grizly? no.

HORATIO. It was, as I have seen it in his life,
 A sable silver'd.

HAMLET. I will watch to-night; Perchance,[38] 'twill walk
 again.

HORATIO. I warrant it will.

HAMLET. If it assume my noble father's person,
 I'll speak to it, though hell itself should gape,
 And bid me hold my peace. I pray you all,
 If you have hitherto conceal'd this sight,
 Let it be tenable[39] in your silence still;
 And whatsoever else shall hap[40] to-night,
 Give it an understanding, but no tongue;
 I will requite[41] your loves. So, fare ye well:
 Upon the platform, 'twist eleven and twelve,
 I'll visit you.

ALL. Our duty to your honour.

HAMLET. Your love, as mine to you: Farewell.

Exeunt HORATIO, MARCELLUS, and BERNARDO.

 My father's spirit in arms! all is not well;
 I doubt[42] some foul play: 'would the night were come!
 Till then sit still, my soul. Foul deeds will rise,
 Though all the earth o'erwhelm them, to men's eyes.

Exit.

Scene III—A Room in Polonius' House.

Enter LAERTES and OPHELIA.

LAERTES. My necessaries[1] are embark'd; farewell:
 And, sister, as the winds give benefit,

And convoy is assistant, do not sleep,
 But let me hear from you.

OPHELIA. Do you doubt that?

LAERTES. For HAMLET, and the trifling of his favours,
 Hold it a fashion,[2] and a toy in blood;
 A violet in the youth of primy[3] nature,
 Forward, not permanent, sweet, not lasting,
 The perfume and suppliance[4] of a minute;
 No more.

OPHELIA. No more but so?

LAERTES. Think it no more:
 For nature, crescent,[5] does not grow alone
 In thews,[6] and bulk; but, as this temple[7] waxes,[8]
 The inward service of the mind and soul
 Grows wide withal. Perhaps, he loves you now;
 And now no soil, nor cautel,[9] doth besmirch
 The virtue of his will: but, you must fear,
 His greatness weigh'd,[10] his will is not his own;
 For he himself is subject to his birth:
 He may not, as unvalued persons do,
 Carve for himself; for on his choice depends,
 The sanctity and health of the whole state;
 And therefore must his choice be circumscrib'd
 Unto the voice and yielding of that body,
 Whereof he is the head: Then if he says, he loves
 you,
 It fits your wisdom so far to believe it,
 As he in his peculiar sect and force
 May give his saying deed; which is no further,
 Than the main voice of Denmark goes withal.
 Then weight what loss your honour may sustain,
 If with too credent[11] ear you list his songs;
 Or lose your heart; or your chaste treasure open
 To his unmaster'd importunity.[12] Fear it,

[38]*perchance*: perhaps
[39]*tenable*: retained
[40]*hap*: happen
[41]*requite*: repay; reward
[42]*doubt*: suspect
[1]*necessaries*: necessities; luggage
[2]*fashion*: temporary trend
[3]*primy*: first (like spring)
[4]*suppliance*: amusement
[5]*crescent*: increasing
[6]*thews*: strength; resolution
[7]*temple*: body
[8]*waxes*: grows
[9]*cautel*: artifice
[10]*weigh'd*: having weight (importance; also, pressure)
[11]*credent*: believing
[12]*importunity*: urgency

OPHELIA, fear it, my dear sister,
And keep within the rear of your affection,
Out of the shot and danger of desire.
The chariest[13] maid is prodigal[14] enough,
If she unmask her beauty to the moon:
Virtue itself scapes not calumnious[15] strokes:
The canker[16] galls[17] the infants of the spring,
Too oft before their buttons be dislos'd;
And in the morn and liquid dew of youth
Contagious blastments[18] are most imminent.
Be wary then: best safety lies in fear:
Youth to itself rebels, though none else near.

OPHELIA. I shall the effect of this good lesson keep,
As watchman to my heart: But, good my brother,
Do not, as some ungracious pastors do,
Show me the steep and thorny way to heaven;
Whilst, like a puff'd and reckless libertine,
Himself the primrose path of dalliance treads,
And recks not[19] his own read.[20]

LAERTES. O fear me not. I stay too long;—But here my
father comes

Enter POLONIUS.

A double blessing is a double grace:
Occasion smiles upon a second leave.

POLONIUS. Yet here, Laertes! aboard, aboard, for shame;
The wind sits in the shoulder of your sail,
And you are staid for.[21] There, my blessing with you!

Laying his hand on LAERTES' head.

And these few precepts[22] in thy memory
See thou character. Give thy thoughts no tongue,
Nor any unproportion'd thought his act.
Be thou familiar, but by no means vulgar.
The friends thou hast, and their adoption tried,
Grapple them to thy soul with hoops of steel;
But do not dull thy palm with entertainment
Of each new-hatch'd, unfledg'd comrade. Beware
Of entrance to a quarrel: but, being in,
Bear't that the opposed may beware of thee.
Give every man thine ear, but few thy voice:
Take each man's censure, but reserve thy judgment.
Costly thy habit[23] as thy purse can buy,
But not express'd in fancy; rich, not gaudy:
For the apparel oft proclaims the man;
And they in France of the best rank and station
Are of a most select and generous chief in that.
Neither a borrower, nor a lender be:
For loan oft loses both itself and friend;
And borrowing dulls the edge of husbandry.[24]
This above all,—To thine ownself be true;

[13]*chariest:* most cautious
[14]*prodigal:* lavish
[15]*scapes not calumnious:* does not escape slanderous
[16]*canker:* ulcerous sore
[17]*galls:* irritates
[12]*importunity:* urgency
[13]*chariest:* most cautious
[14]*prodigal:* lavish
[15]*scapes not calumnious:* does not escape slanderous
[16]*canker:* ulcerous sore
[17]*galls:* irritates
[18]*blastments:* destructive winds
[19]*recks not:* does not care for
[20]*read:* reed; voice
[21]*staid for:* stuck
[22]*precepts:* rules of action; maxims
[23]*coslty thy habit:* buy the best clothes
[12]*importunity:* urgency
[13]*chariest:* most cautious
[14]*prodigal:* lavish
[15]*scapes not calumnious:* does not escape slanderous
[16]*canker:* ulcerous sore
[17]*galls:* irritates
[18]*blastments:* destructive winds
[19]*recks not:* does not care for
[20]*read:* reed; voice
[21]*staid for:* stuck
[22]*precepts:* rules of action; maxims
[23]*coslty thy habit:* buy the best clothes
[24]*husbandry:* thrifty management

And it must follow, as the night the day,
Thou canst not then be false to any man.
Farewell; my blessing season this in thee!

LAERTES. Most humbly do I take my leave, my lord.

POLONIUS. The time invites you; go, your servants tend

LAERTES. Farewell, OPHELIA; and remember well What
I have said to you.

OPHELIA. 'Tis in my memory lock'd, And you yourself
shall keep the key of it.

LAERTES. Farewell.

Exit LAERTES.

POLONIUS. What is 't, OPHELIA, he hath said to you?

OPHELIA. So please you, something touching the lord
HAMLET.

POLONIUS. Marry, well bethought:
'Tis told me, he hath very oft of late
Given private time to you: and you yourself
Have of your audience been most free and bounteous;
If it be so, (as so 'tis put on me,
And that in way of caution,) I must tell you,
You do not understand yourself so clearly,
As it behoves[25] my daughter, and your honour:
What is between you? give me up the truth.

OPHELIA. He hath, my lord, of late, made many tenders
Of his affection to me.

POLONIUS. Affection? puh! you speak like a green[26] girl,
Unsifted in such perilous circumstance.
Do you believe his tenders, as you call them?

OPHELIA. I do not know, my lord, what I should think.

POLONIUS. Marry, I'll teach you: think yourself a baby;
That you have ta'en his tenders for true pay,[27]
Which are not sterling. Tender yourself more dearly;
Or, (not to crack the wind of the poor phrase,
Roaming it thus,) you'll tender me a fool.

OPHELIA. My lord, he hath importun'd me with love,
In honourable fashion.

POLONIUS. Ay, fashion you may call it: go to, go to.

OPHELIA. And hath given countenance to his speech,
my lord, With all the vows of heaven.

POLONIUS. Ay, springes[28] to catch woodcocks.[29] I do
know,
When the blood burns, how prodigal the soul
Gives the tongue vows: these blazes, daughter,
Giving more light than heat,—extinct in both,
Even in their promises, as it is a making,—
You must not take for fire. From this time, daughter
Be somewhat scanter[30] of your maiden presence;
Set your entreatments[31] at a higher rate,
Than a command to parley.[32] For lord Hamlet,
Believe so much in him, that he is young;
And with a larger tether[33] may he walk,
Than may be given you. In few, Ophelia,
Do not believe his vows; for they are brokers;—
Not of the eye which their investments[34] show,
But mere implorators[35] of unholy suits,
Breathing like sanctified and pious bonds,
The better to beguile. This is for all,—
I would not, in plain terms, from this time forth,
Have you so slander any moment's leisure,
As to give words or talk with the lord Hamlet.
Look to 't, I charge you; come your ways.

OPHELIA. I shall obey, my lord.

Exeunt.

Scene IV—The Platform.

Enter HAMLET, HORATIO, and MARCELLUS.

HAMLET. The air bites shrewdly. It is very cold.

HORATIO. It is a nipping and an eager air.

[25]*behoves:* is necessary for
[26]*green:* immature
[27]*tenders for true pay:* POLONIUS speaks of relationships in terms of money and business
[28]*springes:* traps
[29]*woodcocks:* marsh birds with long, straight, flexible bills and are not very intelligent
[30]*scanter:* more meagre
[31]*entreatments:* negotiations
[32]*parley:* engage
[33]*tether:* rope
[34]*investments:* he means vestments (clothing), but uses a financial term
[35]*implorators:* entreaties

HAMLET. What hour now?

HORATIO. I think, it lacks of[1] twelve.

MARCELLIES. No, it is struck.

HORATIO. Indeed? I heard it not; then it draws near the
　　season.
　　　Wherein the spirit held his wont[2] to walk.

A flourish of trumpets, and ordnance shot off, within.

　　What does this mean, my lord?

HAMLET. The king doth **wake** to-night, and takes his rouse[3]
　　Keeps wassels,[4] and the swaggering up-spring reels[5];
　　And, as he drains his draughts of Rhenish down,[6]
　　The kettle-drum and trumpet thus bray out
　　The triumph of his pledge.

HORATIO. Is it a custom?

HAMLET. Ay, marry, is 't:
　　And to my mind, though I am native here,
　　And to the manner born, it is a custom
　　More honour'd in the breach than the observance.[7]
　　This heavy-headed revel, east and west,
　　Makes us traduc'd,[8] and tax'd of other nations:
　　They clep[9] us drunkards, and with swinish[10] phrase
　　Soil our addition; and, indeed, it takes
　　From our achievements, though perform'd at height,
　　The pith and marrow of our attribute.[11]
　　So, oft it chances in particular men,
　　That for some vicious mole of nature in them,
　　As, in their birth, (wherein they are not guilty
　　Since nature cannot choose his origin,)
　　By their o'ergrowth of some complexion,
　　Oft breaking down the pales and forts of reason;
　　Or by some habit, that too much o'er-leavens[12]

The form of plausive manners[13]; that these men,
　　Carrying, I say, the stamp of one defect;
　　Being nature's livery,[14] or fortune's star,
　　Their virtures else (be they as pure as grace,
　　As infinite as man may unde rgo,)
　　Shall in the general censure take corruption
　　From that particular fault: The dram of ill
　　Doth all the noble substance often dout,
　　To his own scandal.

Enter GHOST.

HORATIO. Look, my lord, it comes!

HAMLET. Angels and ministers of grace defend us! —
　　Be thou a spirit of health, or goblin damn'd,
　　Bring with thee airs from heaven, or blasts from hell,
　　Be thy intents wicked, or charitable,
　　Thou com'st in such questionable[15] shape,
　　That I will speak to thee; I'll call thee, HAMLET,
　　KING, father, royal Dane: O, answer me.
　　Let me not burst in ignorance! but tell,
　　Why thy canoniz'd[16] bones, hearsed in death,
　　Have burst their cerements[17]! why the sepulcher,[18]
　　Wherein we saw thee quietly in-urn'd,
　　Hath op'd[19] his ponderous and marble jaws,
　　To cast thee up again! What may this mean,
　　That thou, dead corse,[20] again, in complete steel,
　　Revisit'st thus the glimpses of the moon,
　　Making night hideous; and we fools of nature,
　　So horridly to shake our disposition,
　　With thoughts beyond the reaches of our souls?
　　Say, why is this? wherefore? what should we do?

HORATIO. It beckons you to go away with it,
　　As if it **some impartment did desire**
　　To you alone.

[1]*lacks of:* is not yet
[2]*held his wont:* is accustomed
[3]*rouse:* drinking-bout
[4]*wassels:* wassails (name for festive occasions and the ale used during them)
[5]*up-spring reels:* type of dance
[6]*drains his draughts of Rhenish down:* drinks his wine from Rhine (Germany)
[7]*more honour'd in the breach than the observance:* preferred in theory rather than practice
[8]*makes us traduc'd:* hurts my reputation
[9]*clepe:* declare
[10]*swinish:* lowly
[11]*pith and marrow of our attribute:* essence of my reputation
[12]*o'er-leavens:* over-ferments (influences poorly)
[13]*plausive manners:* worthy-seeming customs
[14]*livery:* dress
[15]*questionable:* suspicious
[16]*canoniz'd:* burial with the church's authority
[17]*cerements:* ceremonial clothes for burial
[18]*sepulchre:* tomb
[19]*op'd:* opened
[20]*corse:* corpse

MARCELLUS. Look, with what courteous action
 It **wafts** you to a more removed ground:
 But do not go with it.

HORATIO. No, by no means.

HAMLET. It will not speak; then will I follow it.

HORATIO. Do not, my lord.

HAMLET. Why, what should be the fear?
 I do not set my life at a pin's fee[21];
 And, for my soul, what can it do to that,
 Being a thing immortal as itself?
 It waves me forth again:—I'll follow it.

HORATIO. What, if it tempt you toward the flood, my
 lord,
 Or to the dreadful summit of the cliff,
 That beetles o'er his base into the sea,
 And there assume some other horrible form,
 Which might deprive your sovereignty of reason,
 And draw you into madness? think of it:
 The very place puts toys of desperation,
 Without more motive, into every brain,
 That looks so many fathoms to the sea,
 And hears it roar beneath.

HAMLET. It wafts me still:—Go on, I'll follow thee.

MARCELLUS. You shall not go, my lord.

HAMLET. Hold off your hand.

HORATIO. Be rul'd, you shall not go.

HAMLET. My fate cries out,
 And makes each petty artery in this body
 As hardy as the Nemean lion's nerve.[22]
 (GHOST *beckons*).
 Still am I call'd;—unhand me, gentlemen;
 (*Breaking from them*).
 By heaven, I'll make a ghost of him that lets[23] me:—
 I say, away:—Go on, I'll follow thee.

Exeunt GHOST *and* HAMLET.

HORATIO. He waxes desperate with imagination.

MARCELLUS. Let's follow; 'tis not fit thus to obey him.

HORATIO. Have after:—To what issue will this come?

MARCELLUS. Something is rotten in the state of Denmark.

HORATIO. Heaven will direct it.

MARCELLUS. Nay, let's follow him.

Exeunt.

Scene V—A more remote part of the Platform.

Re-enter GHOST and HAMLET.

HAMLET. Where wilt thou lead me? Speak, I'll go no
 further.

GHOST. Mark me.

HAMLET. I will.

GHOST. My hour is almost come,
 When I to sulphurous and tormenting flames
 Must render up myself.

HAMLET. Alas, poor ghost!

GHOST. Pity me not, but lend thy serious hearing
 To what I shall unfold.

HAMLET. Speak, I am bound to hear.

GHOST. So art thou to revenge, when thou shalt hear.

HAMLET. What?

GHOST. I am thy father's spirit;
 Doom'd for a certain term to walk the night;
 And, for the day, confin'd to fast in fires,
 Till the foul crimes, done in my days of nature,
 Are burnt and purg'd away. But that I am forbid[1]
 To tell the secrets of my prison-house,
 I could a tale unfold, whose lightest word
 Would harrow up thy soul; freeze thy young blood;
 Make thy two eyes, like stars, start from their spheres;
 Thy knotted and combined locks to part,
 And each particular[2] hair to stand an end,
 Like quills upon the fretful porpentine,[3]
 But this eternal blazon must not be
 To ears of flesh and blood:—List,[4] Hamlet, O list!—
 If thou didst ever thy dear father love,—

[21]*pin's fee*: small amount
[22]*Nemean lion's nerve*: a lion in the woods of Nemaea, and was destroyed by Hercules
[23]*lets*: prevents (also, a play on its opposite, allows)
[1]*forbid*: forbidden
[2]*particular*: individual
[3]*porpentine*: porcupine
[4]*list*: listen; also, engage in combat

HAMLET. O heaven!

GHOST. Revenge his foul and most unnatural murther.[5]

HAMLET. Murther?

GHOST. Murther, most foul, as in the nest it is
But this most foul, strange, and unnatural.

HAMLET. Haste me to know it,[6] that I, with wings as swift
As meditation, or the thoughts of love,
May sweep to my revenge.

GHOST. I find thee apt;
And duller shouldst thou be than the fat weed
That rots itself in ease on Lethe[7] wharf,
Wouldst thou not stir in this. Now Hamlet, hear:
'Tis given out, that sleeping in mine orchard,
A serpent stung me; so the whole ear of Denmark
Is by a forged process of my death
Rankly abus'd: but know, thou noble youth,
The serpent that did sting thy father's life,
Now wears his crown.

HAMLET. O my prophetic soul! mine uncle!

GHOST. Ay, that incestuous, that adulterate[8] beast,
With witchcraft of his wit, with traitorous gifts,
(O wicked wit, and gifts, that have the power
So to seduce!) won to his shameful lust
The will of my most seeming virtuous queen
O, Hamlet, what a falling-off was there!
From me, whose love was of that dignity,
That it went hand in hand even with the vow
I made to her in marriage; and to decline
Upon a wretch, whose natural gifts were poor
To those of mine!
But virtue, as it never will be mov'd,
Though lewdness court it in a shape of heaven;
So lust, though to a radiant angel link'd,
Will state itself in a celestial bed,
And prey on garbage.
But soft! methinks, I scent the morning's air;
Brief let me be:—Sleeping within mine orchard,
My custom always in the afternoon,
Upon my secure hour thy uncle stole,
With juice of cursed hebenon[9] in a vial,
And in the porches of mine ears did pour
The leperous[10] distilment; whose effect
Holds such an enmity with blood of man,
That, swift as quicksilver, it courses through
The natural gates and alleys of the body;
And, with a sudden vigour, it doth posset[11]
And curd, like aigre[12] droppings into milk,
The thin and wholesome blood: so did it mine;
And a most instant tetter[13] bark'd about,
Most lazar-like[14] with vile and loathsome crust,
All my smooth body.
Thus was I, sleeping, by a brother's hand,
Of life, of crown, and queen, at once despatch'd;
Cut off even in the blossoms of my sin,
Unhousel'd,[15] disappointed,[16] unanel'd;[17]
No reckoning made, but sent to my account
With all my imperfections on my head:
O, horrible! O, horrible! most horrible!
If thou hast nature in thee, bear it not;
Let on the royal bed of Denmark be
A couch for luxury and damned incest,
But, howsoever thou pursu'st this act,
Taint not thy mind, nor let thy soul contrive
Against thy mother aught; leave her to heaven,
And to those thorns that in her bosom lodge,
To prick and sting her. Fare thee well at once!
The glow-worm shows the matin[18] to be near,
And gins[19] to pale his uneffectual fire:
Adieu, adieu, HAMLET! remember me. *Exit.*

HAMLET. O all you host of heaven! O earth! What else?
And shall I couple[20] hell?—O fye!—Hold, my heart;

[5]*murther*: murder
[6]*haste me to know it*: tell me quickly
[7]*Lethe*: a river in Hades that causes forgetfulness of the past to those who drink from it.
[8]*adulterate*: adulterous
[9]*hebenon*: a poisonous plant
[10]*leperous*: disease-causing
[11]*posset*: thicken
[12]*aigre*: egret
[13]*tetter*: skin abrasion
[14]*lazar-like*: full of sores (like Lazarus, the beggar)
[15]*unhousel'd*: without communion
[16]*disappointed*: without remission of sins through a priest
[17]*unanel'd*: unanointed
[18]*matin*: morning (specifically, daily morning service of the Church of England)
[19]*gins*: begins
[20]*couple*: join with

And you, my sinews, grow not instant old,
But bear me stiffly up!—Remember thee?
Ay, thou poor ghost, while memory holds a seat
In this distracted globe.[21] Remember thee?
Yea, from the table of my memory
I'll wipe away all trivial fond records,
All saws[22] of books, all forms, all pressures past,
That youth and observation copied there;
And thy commandment all alone shall live
Within the book and volume of my brain,
Unmix'd with baser matter: yes, yes, by heaven.
O most pernicious woman!
O villain, villain, smiling, damned villain!
My tables, my tables,[23]—meet it is I set it down,
That one may smile, and smile, and be a villain;
At least I'm sure it may be so in Denmark; *Writing.*
So, uncle, there you are. Now to my word;
It is, *Adieu, adieu! remember me.*
I have sworn 't.

HORATIO (*within*). My lord, my lord,—

MARCELLUS (*within*). Lord Hamlet,—

HORATIO (*within*). Heaven secure him!

MARCELLUS (*within*). So be it!

HORATIO (*within*). Illo, ho, ho,[24] my lord!

HAMLET Hillo, ho, ho, boy! come, bird, come.

Enter HORATIO *and* MARCELLUS.

MARCELLUS. How is 't, my noble lord?

HORATIO. What news, my lord?

HAMLET. O, wonderful

HORATIO. Good my lord, tell it.

HAMLET. No;
 You'll reveal it.

HORATIO. Not I, my lord, by heaven.

MARCELLUS. Nor I, my lord.

HAMLET. How say you then; would heart of man once
 think it!
 But you'll be secret,—

HORATIO. MARCELLUS. Ay, by heaven, my lord.

HAMLET. There's ne'er a villain, dwelling in all Denmark,
 But he's an arrant knave.[25]

HORATIO. There needs no ghost, my lord, come from
 the grave, To tell us this.

HAMLET. Why, right; you are in the right;
 And so, without more circumstance at all,
 I hold it fit that we shake hands, and part;
 You, as your business and desire shall point you—
 For every man has business and desire,
 Such as it is,—and for mine own poor part,
 Look you, I'll go pray.

HORATIO. These are but wild and hurling words my lord.

HAMLET. I'm sorry they offend you, heartily;
 Yes, 'faith,[26] heartily.

HORATIO. There's no offence, my lord.

HAMLET. Yes, by St. Patrick, but there is, my lord.
 And much offence too, touching this vision here.
 It is an honest ghost, that let me tell you;
 For your desire to know what is between us,
 O'ermaster it as you may. And now, good friends,
 As you are friends, scholars, and soldiers,
 Give me one poor request.

HORATIO. What is 't my lord? We will.

HAMLET. Never make known what you have seen to-night.

HORATIO. MARCELLUS. My, lord, we will not.

HAMLET. Nay, but swear't

HORATIO. In faith, My lord, not I.

MARCELLUS. Nor I, my lord, in faith.

HAMLET. Upon my sword.

MARCELLUS. We have sworn, my lord, already.

HAMLET. Indeed, upon my sword, indeed. (GHOST be-
 neath). Swear.

HAMLET. Ha, ha, boy I say'st thou so? art thou there,
 truepenny[27]?

[21]*distracted globe*: agitated brain
[22]*saws*: sayings
[23]*My tables, my tables*: tablets to write on
[24]*Illo, ho, ho*: Horatio and HAMLET call to one another like falconers to their falcons
[25]*arrant knave*: notoriously deceitful fellow
[26]*'faith*: in faith
[27]*truepenny*: honest person

Come on,—you hear this fellow in the cellarage,[28]
Consent to swear.

HORATIO. Propose the oath, my lord.

HAMLET. Never to speak of this that you have seen,
 Swear by my sword. (GHOST *beneath*). Swear.

HAMLET. *Hic et ubique*[29]? then we'll shift our ground[30]:—
 Come hither, gentlemen,
And lay your hands again upon my sword:
Never to speak of this that you have heard,
Swear by my sword. (GHOST *beneath*). Swear.

HAMLET. Well said, old mole! canst work i' the ground
 so fast? A worthy pioneer!—Once more remove,
 good friends.

HORATIO. O day and night, but this is wondrous
 strange!

HAMLET. And therefore as a stranger give it welcome.
 There are more things in heaven and earth, Horatio,
 Than are dreamt of in our philosophy.
 But come;—
 Here, as before, never, so help you mercy!
 How strange or odd soe'er[31]
 I bear myself, As I, perchance, hereafter shall think
 meet
 To put an antic disposition on—[32]
 That you, at such times seeing me, never shall
 With arms encumber'd thus or thus head shake,
 Or by pronouncing of some doubtful[33] phrase,
 As, 'Well, we know;'—or, 'We could, an if we
 would;'—
 Or, 'If we list to speak;'—or, 'There be, an if there
 might;'—
 Or such ambiguous giving out,[34] to note That you
 know aught of me:—This not to do,
 So grace and mercy at your most need help you,
 Swear.
 (Ghost *beneath*). Swear.

HAMLET. Rest, rest, perturbed spirit! So, gentlemen,
 With all my love I do commend me to you:
 And what so poor a man as Hamlet is

May do, to express his love and friending to you,
God willing, shall not lack. Let us go in together;
And still your fingers on your lips, I pray.
The time is out of joint;[35] O cursed spite!
That ever I was born to set it right!
Nay, come, let's go together.
Exeunt

Act 2
Scene I—A Room in Polonius' House.

Enter POLONIUS and REYNALDO.

POLONIUS. Give him his money, and these notes, Reynaldo.

REYNALDO. I will, my lord.

POLONIUS. You shall do marvelous wisely, good Reynaldo,
 Before you visit him, to make inquiry
 Of his behavior.

REYNALDO. My lord, I did intend it.

POLONIUS. Marry, well said: very well said. Look you, sir.
 Inquire me first what Danskers are in Paris;[1]
 And how, and who, what means, and where they keep,
 What company, at what expense; and finding,
 By this encompassment[2] and drift of question,
 That they do know my son, come you more nearer
 Than your particular demands will touch it:
 Take you, as 'twere, some distant knowledge of him;
 As thus,—'I know his father, and his friends,
 And, in part, him;'—Do you mark this, Reynaldo?

REYNALDO. Ay, very well, my lord.

POLONIUS. 'And, in part, him;—but,' you may say, 'not well:
 But, if't be he I mean, he's very wild;
 Addicted so and so;'—and there put on him
 What forgeries you please; marry, none so rank
 As may dishonour him; take heed of that:
 But, sir, such wanton, wild, and usual slips,
 As are companions noted and most known
 To youth and liberty.[3]

[28]*cellarage*: cellars
[29]*Hic et ubique?*: Here and everywhere
[30]*shift our ground*: move to another spot
[31]*soe'er*: whatsoever
[32]*shall think meet to put an antic disposition on*: think it will be fitting to act insane
[33]*doubtful*: uncertain
[34]*giving out*: announcement
[35]*The time is out of joint*: time is dislocated, disordered
[1]*inquire me first what Danskers are in Paris*: Find out for me who the Danes are living in Paris
[2]*encompassment*: enclosing
[3]*companions noted and most known/ To youth and liberty*: the usual attributes of the young and priveleged

REYNALDO. As gaming, my lord.

POLONIUS. Ay, or drinking, fencing, swearing, quarrelling,
Drabbing[4]:—You may go so far.

REYNALDO. My lord, that would dishonour him.

POLONIUS. 'Faith, no; as you may season[5] it in the charge.
You must not put another scandal on him,
That he is open to incontinency[6];
That's not my meaning: but breathe his faults so quaintly,
That they may seem the taints of liberty:
The flash and out-break of a fiery mind;
A savageness in unreclaimed blood,
Of general assault.

REYNALDO. But, my good lord,—

POLONIUS. Wherefore[7] should you do this?

REYNALDO. Ay, my lord,
I would know that.

POLONIUS. Marry, sir, here's my drift;
And, I believe, it is a fetch of warrant:
You laying these slight sullies on my son,
As 'twere a thing a little soild'd I' the working,
Mark you,
Your party in converse, him you would sound,
Having ever seen, in the prenominate[8] crimes,
The youth you breathe of, guilty, be assur'd,
He closes with you in this consequence:
'Good sir,' or so; or, 'friend, or genetleman,'—
According to the phrase and the addition,
Of man and country.

REYNALDO. Very good, my lord.

POLONIUS. And then, sir, does he this,—He does—
What was I about to say?
I was about to say something:—Where did I leave?

REYNALDO. At, 'closes in the consequence.
At friend, or so, and gentleman.'

POLONIUS. At, closes in the consequence,—Ay, marry;
He closes with you thus:—'I know the gentleman;
I saw him yesterday, or t' other day,
Or then, or then; with such, and such; and, as you say,
There was he gaming: there o'ertook in his rouse:[9]
There falling out at[10] tennis; or, perchance,
I saw him enter such a house of sale
(Videlicet,[11] a brothel,) or so forth.'—
See you now;
Your bait of falsehood takes this carp of truth:
And thus do we of wisdom and of reach,
With windlaces,[12] and with assays of bias,
By indirections find directions out;
So, by my former lecture and advice,
Shall you my son: You have me, have you not?

REYNALDO. My lord, I have.

POLONIUS. God be wi' you; fare you well.

REYNALDO. Good my lord,—

POLONIUS. Observe his inclination in yourself.

REYNALDO. I shall, my lord.

POLONIUS. And let him play his music.

REYNALDO. Well, my lord. *Exit.*

Enter OPHELIA.

POLONIUS. Farewell!—How now, OPHELIA? What's the matter?

OPHELIA. Alas, my lord I have been so affrighted!

POLONIUS. With what, in the name of heaven?

OPHELIA. My lord, as I was sewing in my chamber,
LORD HAMLET,—with his doublet all unbrac'd:[13]
No hat upon his head: his stockings foul'd,
Ungarter'd, and down-gyved to his ancle;[14]
Pale as his shirt: his knees knocking each other;
And with a look so piteous in purport,
As if he had been loosed out of hell,
To speak of horrors,—he comes before me.

POLONIUS. Mad for thy love?

[4]*drabbing*: frequenting the company of prostitutes
[5]*season*: temper
[6]*incontinency*: unrestrained passions
[7]*Wherefore*: why
[8]*prenominate*: previously listed
[9]*rouse*: drinking-bout
[10]*falling out at*: quarelling at
[11]*Videlicet*: that is to say (Latin)
[12]*windlaces*: round-about methods
[13]*doublet all unbrac'd*: short coat undone
[14]*down-gyved*: around his ankles (like shackles)

OPHELIA. My lord, I do not know:
But, truly, I do fear it.

POLONIUS. What said he?

OPHELIA. He took me by the wrist, and held
me hard,
Then goes he to the length of all his arm;
And, with his other hand thus, o'er his brow,
He falls to such perusal of my face,
As he would draw it.[15] Long stay'd he so;
At last,—a little shaking of mine arm,
And thrice his head thus waving up and down,—
He rais'd a sigh so piteous and profound,
That it did seem to shatter all his bulk,
And end his being: That done, he lets me go:
And, with his head over his shoulder turn'd,
He seem'd to find his way without his eyes;
For out o' doors he went without their help,
And, to the last, bended their light on me.[16]

POLONIUS. Go with me; I will go seek the king.
This is the very ecstasy of love;[17]
Whose violent property fordoes itself,
And leads the will to desperate undertakings,
As oft as any passion under heaven,
That does afflict our natures. I am sorry,—
What, have you given him any hard words of late?

OPHELIA. No, my good lord; but, as you did command,
I did repel his letters, and denied
His access to me.

POLONIUS. That hath made him mad.[18]
I am sorry that with better heed and judgment,
I had not quoted[19] him: I fear'd he did but trifle,
And[20] meant to wrack[21] thee; but, beshrew[22] my jealousy!
It seems it is as proper to our age
To cast beyond ourselves in our opinions,
As it is common for the younger sort
To lack discretion. Come, go we to the king:
This must be known; which, being kept close,

might move
More grief to hide than hate to utter love.

Exeunt.

Scene II—A Room in the Castle.

Enter KING, QUEEN, ROSENCRANTZ, GUILDENSTERN, and Attendants.

KING. Welcome, dear Rosencrantz, and Guildenstern!
Moreover that we much did long to see you,
The need we have to use you did provoke
Our hasty sending. Something have you heard
Of Hamlet's transformation: so I call it,
Since not the exterior nor the inward man
Resembles that[1] it was: What it should be,
More than his father's death, that thus hath put him,
So much from the understanding of himself,
I cannot deem of: I entreat you both,
That, being of so young days brought up with him,[2]
And, since, so neighbour'd to his youth and humour,
That you vouchsafe your rest here in our court
Some little time: so by your companies
To draw him on to pleasures; and to gather,
So much as from occasions you may glean,
Whether aught, to us unknown, afflicts him thus,
That, open'd, lies within our remedy.

QUEEN. Good gentlemen, he hath much talk'd of you;
And, sure I am, two men there are not living
To whom he more adheres. If it will please you
To show us so much gentry[3] and good will,
As to expend your time with us a while,
For the supply and profit of our hope,
Your visitation[4] shall receive such thanks
As fits a king's remembrance.

ROSENCRANTZ. Both your majesties
Might, by the sovereign power you have of us,
Put your dread[5] pleasures more into command
Than to entreaty.

[15]*perusal of my face / As he would draw it*: examine in detail as if he meant to draw it
[16]*bended their light on me*: kept his eyes focused on me
[17]*fordoes*: unravels
[18]*mad*: insane
[19]*quoted*: noted; also, continuing allusions to money, took him at face value
[20]*trifle / And*: play, but
[21]*wrack*: destroy; torment
[22]*beshrew*: curse
[1]*that*: what
[2]*young days brought up with him*: grew up with him
[3]*gentry*: gentle
[4]*visitation*: refers both to the act of visiting and to the receiving of a divine favor
[5]*dread*: revered

GUILDENSTERN. We both obey;
 And here give up ourselves, in the full bent,
 To lay our services freely at your feet,
 To be commanded.

KING. Thanks, Rosencrantz, and gentle Guildenstern.

QUEEN. Thanks, Guildenstern, and gentle Rosencrantz:
 And I beseech you instantly to visit
 My too much changed son. Go some of you,
 And bring the gentlemen where HAMLET is.

GUILDENSTERN. Heavens make our presence, and our
 practices,
 Pleasant and helpful to him!

QUEEN. Amen!

Exeunt ROSENCRANTZ, GUILDENSTERN, *and some*
ATTENDANTS.

Enter POLONIUS.

POLONIUS. The ambassadors from Norway, my good
 lord,
 Are joyfully return'd

KING. Thou still hast been the father of good news.

POLONIUS. Have I, my lord? Assure you, my good liege,
 I hold my duty, as I hold my soul,
 BOTH to my God, one to my gracious king:
 And I do think, (or else this brain of mine
 Hunts not the trail of policy so sure
 As I have us'd to do,) that I have found
 The very cause of HAMLET's lunacy.

KING. O, speak of that; that I do long to hear.

POLONIUS. Give first admittance[6] to the ambassadors;
 My news shall be the fruit to that great feast.

KING. Thyself do grace to them, and bring them in.

Exit POLONIUS.

 He tells me, my sweet queen, that he hath found
 The head and source of all your son's distemper.

QUEEN. I doubt, it is no other but the main;
 His father's death, and our o'erhasty marriage

Re-enter POLONIUS, *with* VOLTIMAND *and* CORNELIUS.

KING. Well, we shall shift him.—Welcome, good friends!
 Say, Voltimand, what from our brother Norway?

VOLTIMAND. Most fair return of greetings and desires.
 Upon our first, he sent out to suppress
 His nephew's levies, which to him appear'd
 To be a preparation 'gainst the Polack;
 But, better look'd into, he truly found
 It was against your highness: Whereat griev'd,—
 That so his sickness, age, and impotence,
 Was falsely borne in hand,—sends out arrests
 On Fortinbras, which he, in brief, obeys;
 Receives rebuke from Norway; and, in fine,
 Makes vow before his uncle, never more
 To give the assay[7] of arms against your majesty.
 Whereon old Norway, overcome with joy,
 Gives him three thousand crowns in annual fee;
 And his commission, to employ those soldiers,
 So levied as before, against the Polack:
 With an entreaty, herein further shown, *Gives a paper*
 That it might please you to give quiet pass
 Through your dominions for his enterprise;
 On such regards of safety, and allowance,
 As therein are set down.

KING. It likes us well;
 And, at our more consider'd time, we'll read,
 Answer, and think upon this business.
 Mean time, we thank you for your well-took labour:
 Go to your rest; at night we'll feast together:
 Most welcome home!

Exeunt VOLTIMAND *and* CORNELIUS.

POLONIUS. This business is very well ended.
 My liege, and madam, to expostulate
 What majesty should be, what duty is,
 Why day is day, night, night, and time is time,
 Were nothing but to waste night, day, and time.
 Therefore, since brevity is the soul of wit,
 And tediousness the limbs and outward flourishes,
 I will be brief: Your noble son is mad:
 Mad call I it: for, to define true madness,
 What is't, but to be nothing else but mad:
 But let that go.

QUEEN. More matter, with less art.

POLONIUS. Madam, I swear, I use no art at all.
 That he is mad, 'tis true; 'tis true, 'tis pity;
 And pity'tis, 'tis true: a foolish figure;
 But farewell it, for I will use no art.
 Mad let us grant him then: and now remains,

[6]*admittance:* leave to enter; hearin
[7]*assay:* test

That we find out the cause of this effect;
Or, rather say, the cause of this defect;
For this effect, defective, comes by cause:
Thus it remains, and the remainder thus.
Perpend.[8]
I have a daughter; have, whilst she is mine;
Who, in her duty and obedience, mark,
Hath given me this: Now gather, and surmise.
—'To the celestial, and my soul's idol, the most beautified
Ophelia,'_____
That's an ill phrase, a vile phrase; beautified is a
vile phrase; but you shall hear.
'These. In her excellent white bosom, these.'

QUEEN. Came this from HAMLET to her?

POLONIUS. Good madam, stay[9] a while; I will be faithful.
 'Doubt thou, the stars are fire; (Reads)
 Doubt that the sun doth move;
 Doubt truth to be a liar;
 But never doubt, I love.
 O dear OPHELIA, I am ill at these numbers; I have not
 heart to reckon my groans: but that I love thee best,
 O most best, believe it. Adieu.
 'Thine evermore, most dear lady, whilst
 this machine[10] is to him, HAMLET.'
 This, in obedience, hath my daughter showed me:
 And more above, hath his solicitings,
 As they fell out by time, by means, and place,
 All given to mine ear.

KING. But how hath she
 Receiv'd his love?

POLONIUS. What do you think of me?

KING. As of a man faithful and honourable.

POLONIUS. I would fain prove so. But what might you
 think,
 When I had seen this hot love on the wing,
 (As I perceiv'd it, I must tell you that,
 Before my daughter told me,) what might you,
 Or my dear majesty your queen here, think,
 If I had play'd the desk, or table-book;[11]

Or given my heart a winking, mute and dumb;
Or look'd upon this love with idle sight;
What might you think? no, I went round to work,
And my young mistress thus I did bespeak;
'Lord HAMLET is a prince out of thy star;
This must not be:' and then I precepts gave her,
That she should lock herself from his resort,[12]
Admit no messengers, receive no tokens.
Which done, she took the fruits of my advice;
And he, repulsed, (a short tale to make,)
Fell into a sadness; then into a fast;
Thence to a watch; thence into a weakness;
Thence to a lightness; and, by this declension,[13]
Into the madness whereon now he raves,
And all we wail for.

KING. Do you think 'tis this?

QUEEN. It may be, very likely.

POLONIUS. Hath there been such a time, (I'd fain know that,)
 That I have positively said 'Tis so,
 When it prov'd otherwise?

KING. Not that I know.

POLONIUS. Take this from this, if this be otherwise:

Pointing to his head and shoulder.

 If circumstances lead me, I will find
 Where truth is hid, through it were hid indeed
 Within the centre.

 KING. How may we try[14] it further?

POLONIUS. You know, sometimes he walks four hours
 together,
 Here in the lobby.

QUEEN. So he has, indeed.

POLONIUS. At such a time I'll loose my daughter to him.
 Be you and I behind an arras[15] then;
 Mark[16] the encounter: if he love her not,
 And be not from his reason fallen thereon,
 Let me be no assistant for a state,
 And keep a farm, and carters.[17]

[8]*perpend*: weigh carefully
[9]*stay*: wait
[10]*machine*: an instrument for converting motion (and carrying out orders); his body
[11]*play'd the desk, or table-book*: kept the secrets to himself
[12]*resort*: recourse; or also, haunts
[13]*declension*: deterioration
[14]*try*: test
[15]*arras*: wall hanging; a tapestry
[16]*mark*: take note of
[17]*And keep a farm, and carters*: but instead be a farmer and supervise those who drive carts

KING. We will try[18] it.

ENTER. HAMLET, *reading.*

QUEEN. But, look, where sadly the poor wretch comes reading.

POLONIUS. Away, I do beseech[19] you, both away; I'll boord[20] him presently:—O, give me leave.—

Exeunt KING, QUEEN, *and* ATTENDANTS.

How does my good lord Hamlet?

HAMLET. Well, god a mercy.

POLONIUS. Do you know me, my lord?

HAMLET. Excellent well; you are a fishmonger.[21]

POLONIUS. Not I, my lord.

HAMLET. Then I would you were so honest a man.

POLONIUS. Honest, my lord?

HAMLET. Ay, sir; to be honest, as this world goes, is to be one man picked out of two thousand.

POLONIUS. That's very true, my lord.

HAMLET. For if the sun breed maggots in a dead dog, being a god kissing carrion,—Have you a daughter?

POLONIUS. I have, my lord.

HAMLET. Let her not walk i' the sun: conception[22] is a blessing; but not as your daughter may conceive,—friend, look to 't.

POLONIUS. How say you by that? [*Aside.*] Still harping on my daughter:—yet he knew me not at first; he said I was a fishmonger: He is far gone, far gone: and truly in my youth I suffered much extremity for love; very near this. I'll speak to him again.—What do you read, my lord?

HAMLET. Words, words, words!

POLONIUS. What is the matter, my lord?

HAMLET. Between who?

POLONIUS. I mean the matter[23] that you read, my lord?

HAMLET. Slanders, sir: for the satirical slave says here, that old men have grey beards; that their faces are wrinkled; their eyes purging thick amber, or plum-tree gum; and that they have a plentiful lack of wit, together with weak hams: All of which, sir, though I most powerfully and potently believe, yet I hold it not honesty to have it thus set down; for you yourself, sir, should be old as I am, if, like a crab, you could go backward.

POLONIUS. Though this be madness, yet there is method in it. *(Aside).* Will you walk out of the air, my lord?

HAMLET. Into my grave?

POLONIUS. Indeed, that is out o' the air.—How pregnant[24] sometimes his replies are! a happiness that often madness hits on, which reason and sanity could not so prosperously be delivered of. I will leave him, and suddenly contrive the means of meeting between him and my daughter.—My honourable lord, I will most humbly take my leave of you.

HAMLET. You cannot, sir, take from me any thing that I will more willingly part withal; except my life, my life.

POLONIUS. Fare you well, my lord.

HAMLET. These tedious old fools!

Enter ROSENCRANTZ *and* GUILDENSTERN.

POLONIUS. You go to seek my lord HAMLET; there he is,

ROSENCRANTZ. God save you, sir! *(To* POLONIUS).

Exit POLONIUS.

GUILDENSTERN. Mine honour'd lord!—

ROSENCRANTZ. My most dear lord!

HAMLET. My excellent good friends! How dost thou, Guildenstern? Ah, Rosencrantz! Good lads, how do ye both?

ROSENCRANTZ. As the indifferent[25] children of the earth.

[18]*try:* attempt; also, test
[19]*beseech:* beg
[20]*boord:* speak to him first
[21]*fishmonger:* a dealer of fish
[22]*conception:* refers both to understanding and to pregnancy
[23]*matter:* material; substance
[24]*pregnant:* full of meaning
[25]*indifferent:* unimportant

GUILDENSTERN. Happy, in that we are not overhappy;
On fortune's cap we are not the very button.

HAMLET. Nor the soles of her shoe?

ROSENCRANTZ. Neither, my lord.

HAMLET. Then you live about her waist, or in the middle of her favour?

GUILDENSTERN. 'Faith, her privates we.

HAMLET. In the secret parts of fortune? O, most true; she is a strumpet.[26] What's the news?

ROSENCRANTZ. None, my lord; but that the world's grown honest.

HAMLET. Then is dooms-day near: But your news is not true. Let me question more in particular.[27] What have you, my good friends, deserved at the hands of fortune, that she sends you to prison hither?

GUILDENSTERN. Prison, my lord?

HAMLET. Denmark's a prison.

ROSENCRANTZ. Then is the world one.

HAMLET. A goodly one; in which there are many confines, wards, and dungeons; Denmark being one of the worst.

ROSENCRANTZ. We think not so, my lord.

HAMLET. Why, then 'tis none to you: for there is nothing either good or bad but thinking makes it so: to me it is a prison.

ROSENCRANTZ. Why, then your ambition makes it one; 'tis too narrow for your mind.

HAMLET. O God! I could be bounded in a nutshell, and count myself a king of infinite space; were it not that I have bad dreams.

GUILDENSTERN. Which dreams, indeed, are ambition; for the very substance of the ambitious is merely the shadow of a dream.

HAMLET. A dream itself is but a shadow.

ROSENCRANTZ. Truly, and I hold ambition of so airy and light a quality, that it is but a shadow's shadow.

HAMLET. Then are our beggars, bodies; and our monarchs and outstretch'd heroes the beggars' shadows: Shall we to the court? for by my fay[28] I cannot reason.

ROSENCRANTZ. GUILDENSTERN. We'll wait upon you.

HAMLET. No such matter: I will not sort you with the rest of my servants; for, to speak to you like an honest man, I am most dreadfully attended. But, in the beaten way of friendship, what make you[29] at Elsinore?

ROSENCRANTZ. To visit you, my lord; no other occasion.

HAMLET. Beggar that I am, I am even poor in thanks; but I thank you: and sure, dear friends, my thanks are too dear, a half-penny. Were you not sent for? Is it your own inclining? Is it a free visitation? Come; deal justly with me: come, come; nay, speak.

GUILDENSTERN. What should we say, my lord?

HAMLET. Why anything. But to the purpose. You were sent for; and there is a kind of confession in your looks, which your modesties have not craft enough to colour: I know, the good king and queen have sent for you.

ROSENCRANTZ. To what end, my lord?

HAMLET. That you must teach me. But let me conjure[30] you, by the rights of our fellowship, by the consonancy of our youth, by the obligation of our ever-preserved love, and by what more dear a better proposer could charge you withal, be even and direct with me, whether you were sent for, or no.

ROSENCRANTZ. What say you? (To GUILDENSTERN).

HAMLET. Nay, then I have an eye of you; (Aside).—if you love me, hold not off.

GUILDENSTERN. My lord, we were sent for.

HAMLET. I will tell you why; so shall my anticipation prevent your discovery of your secrecy to the king and queen. Moult no feather. I have of late, (but, wherefore, I know not,) lost all my mirth, foregone all custom of exercises: and, indeed, it goes so heavily with my disposition, that this goodly frame, the earth, seems to me a steril promontory;

[26]*strumpet*: harlot, prostitute
[27]*in particular*: in more detail
[28]*fay*: faith
[29]*make you*: brings you
[30]*conjure*: compel

this most excellent canopy, the air, look you,—this brave o'erhanging firmament—this majestical roof fretted[31] with golden fire, why, it appears no other thing to me than a foul and pestilent congregation of vapours. What a piece of work is a man! How noble in reason! how infinite in faculty! in form and moving, how express and admirable! In action, how like an angel! in apprehension, how like a god! the beauty of the world! the paragon of animals! And yet, to me, what is this quintessence of dust? man delights not me; no, nor woman neither, though, by your smiling, you seem to say so.

ROSENCRANTZ. My lord, there was no such stuff in my thoughts.

HAMLET. Why did you laugh then, when I said, 'Man delights not me?'

ROSENCRANTZ. To think, my lord, if you delight not in man, what lenten[32] entertainment the players shall receive from you: we coted[33] them on the way; and hither are they coming, to offer you service.

HAMLET. He that plays the king shall be welcome; his majesty shall have tribute of me: the adventurous knight shall use his foil and target: the lover shall not sigh gratis[34]; the humorous man shall end his part in peace; the clown shall make those laugh whose lungs are tickled o' the sere[35]; and the lady shall say her mind freely, or the blank verse shall halt for 't.—What players are they?

ROSENCRANTZ. Even those you were wont to take delight in, the tragedians of the city.

HAMLET. How chances it they travel? their residence, both in reputation and profit, was better both ways.

ROSENCRANTZ. I think, their inhibition comes by the means of the late innovation.[36]

HAMLET. Do they hold the same estimation they did when I was in the city? Are they so followed?

ROSENCRANTZ. No, indeed, they are not.

HAMLET. How comes it? Do they grow rusty?

ROSENCRANTZ. Nay, their endeavour keeps in the wonted pace: But there is, sir, an aiedry[37] of children, little eyases,[38] that cry out on the top of question, and are most tyrannically clapped[39] for 't: these are now the fashion; and so berattle the common stages, (so they call them,) that many, wearing rapiers, are afraid of goose quills, and dare scarce come thither.

HAMLET. What, are they children? who maintains them? how are they escoted?[40] Will they pursue the quality no longer than they can sing? will they will they not say afterwards, if they should grow themselves to common players, (as it is most like, if their means are no better,) their writers do them wrong, to make them exclaim against their own succession?

ROSENCRANTZ. 'Faith, there has been much to do on both sides; and the nation holds it no sin, to tarre[41] them to controversy: there was, for a while, no money bid for argument, unless the poet and the player went to cuffs in the question.

HAMLET. Is 't possible?

GUILDENSTERN. O, there has been much throwing about of brains.

HAMLET. Do the boys carry it away?

ROSENCRANTZ. Ay, that they do, my lord; Hercules and his load too.

HAMLET. It is not strange; for mine uncle is king of Denmark; and those that would make mowes[42] at him while my father liv'd, give twenty, forty, an hundred ducats a-piece, for his picture in little. There is something in this more than natural, if philosophy could find it out. (*Flourish of trumpets within*).

GUILDENSTERN. There are the players.

[31]*fretted*: furnished with ornaments
[32]*lenten*: frugal
[33]*coted*: came upon
[34]*gratis*: for nothing (literal translation from Latin, "freely")
[35]*sere*: dryness; withering
[36]*inhibition comes by means of the late innovation*: they are inhibited by the latest novelty
[37]*aiery*: a nest of a bird of prey (also spelled aery, eyrie, and eyry)
[38]*eyases*: unfledged hawks
[39]*clapped*: applauded
[40]*escoted*: maintained
[41]*tarre*: stimulate
[42]*mowes*: faces

HAMLET. Gentlemen, you are welcome to Elsinore. Your hands. Come: the appurtgenance of[43] welcome is fashion and ceremony: let me comply with you in the garb; lest my extent t. the players, which, I tell you, must show fairly outward, should more appear like entertainment than yours. You are welcome: but my uncle-father, and aunt-mother, are deceived.

GUILDENSTERN. In what, my dear lord?

HAMLET. I am but mad north-north-west: when the wind is southerly, I know a hawk from a handsaw.

Enter POLONIUS.

POLONIUS. Well be with you, gentlemen!

HAMLET. Hark you, GUILDENSTERN,—and you too;—at each ear a hearer; that great baby you see there is not yet out of his swathing clouts.[44]

ROSENCRANTZ. Happily, he's the second time come to them; for, they say, an old man is twice a child.

HAMLET. I will prophesy. He comes to tell me of the players; mark it.—You say right, sir; o' Monday morning; 'twas so, indeed.

POLONIUS. My lord, I have news to tell you.

HAMLET. My lord, I have news to tell you. When Roscius[45] was an actor in Rome,—

POLONIUS. The actors are come hither, my lord.

HAMLET. Buz, buz!

POLONIUS. Upon mine honour,—

HAMLET. Then came each actor on his ass,—

POLONIUS. The best actors in the world, either for tragedy, comedy, history, pastoral, pastorical-comical, historical-pastoral, tragical-historical, tragical-comical-historical-pastoral, scene individable,[46] or poem unlimited: Seneca[47] cannot be too heavy, nor Plautus[48] too light. For the law of writ, and the liberty, these are the only men.

HAMLET. O Jepthah,[49] judge of Israel,—what a treasure hadst thou!

POLONIUS. What a treasure had he, my lord?

HAMLET. Why—

One fair daughter, and no more,
The which he loved passing well.

POLONIUS. Still on my daughter. *(Aside).*

HAMLET. Am I not i' the right, old Jephthah?

POLONIUS. If you call me Jephthah, my lord, I have a daughter, that I love passing well.

HAMLET. Nay, that follows not.

POLONIUS. What follows then, my lord?

HAMLET. Why, 'As by lot, God wot,'

and then you know,

'It came to pass, as most like it was.'

The first row of the pious chanson[50] will show you more: for look, where my abridgments[51] come.

Enter FOUR OF FIVE PLAYERS.

You are welcome, masters; welcome all:—I am glad to see thee well:—welcome, good friends.—O, my old friend! Thy face is valiant since I saw thee last. Com'st thou to beard[52] me in Denmark?—What! my young lady and mistress![53] By 'r lady, your ladyship is nearer heaven, than when I saw you last, by the altitude of a chopine.[54] Pray God, your voice, like a piece of uncurrent gold, be not cracked within the ring.[55]—Masters, your are all welcome. We'll e'en to 't like French falconers, fly at any thing we see: We'll have a speech straight: Come, give us a taste of your quality; come, a passionate speech.

[43]*appurtenance of*: appropriate
[44]*clouts*: clothes
[45]*Roscius*: a Roman comedic actor
[46]*scene individable*: plays that converge action, place, and time
[47]*Seneca*: Roman dramatist of tragedy
[48]*Plautus*: Roman dramatist of comedy
[49]*Jephthah*: a Hebrew judge who sacrificied his daughter
[50]*chanson*: song
[51]*abridgements*: gap bridgers
[52]*beard*: to grow a beard before him (oppose him)
[53]*young lady and mistress*: boys who play female roles
[54]*chopine*: high cork shoes for short (low) women
[55]*uncurrent gold be not cracked within the ring*:

I Play. What speech, my lord?

Hamlet. I heard thee speak me a speech once,—but it was never acted; or, if it was, not above once; for the play, I remember, pleased not the million; 'twas caviare to the general:[56] but it was (as I received it, and others, whose judgments, in such matters, cried in the top of mine,) an excellent play; well digested in the scenes; set down with as much modesty as cunning. I remember, one said, there were no sallets[57] in the lines to make the matter savoury; nor no matter in the phrase the might indite the author of affectation; but called it, an honest method as wholesome as sweet, and by very much more handsome than fine. One chief speech in it I chiefly loved; 'twas Æneas' tale to Dido;[58] and there-about of it especially, where he speaks of Priam's[59] slaughter: If it live in your memory, begin at this line; let me see, let me see;—

The rugged Pyrrhus, like the Hyrcanian beast,[60] 'tis not so; it begins with Pyrrhus.

The rugged Pyrrhus, he, whose sable arms,
Black as his purpose, did the night resemble
When he lay couched in the ominous horse,
Hath now this dread and black complexion smear'd
With heraldry more dismal; head to foot
Now is he total gules,[61] horridly trick'd
With blood of fathers, mothers daughtes,sons;
Bak'd and impasted with the parching street,
That lend a tyrannous and dammed light
To their vile murthers[62]: Roasted in wrath and fire,
And thus o'er-sized with coagulate gore,[63]
With eyes like carbuncles,[64] the hellish Pyrrhus
Old grandsire Priam seeks.

Polonius. 'Fore God, my lord well spoken; with good accent, and good discretion.

I Play. Anon he finds him
Striking too short at Greeks; his antique sword,
Rebellious to his arm, lies where it falls,
Repugnant to command:[65] Unequal match'd,
Pyrrhus at Priam drives; in rage strikes wide,
But with the whiff and wind of his fell sword
The unnerved father falls. Then senseless Ilium,[66]
Seeming to feel his blow, with flaming top
Stoops to his base; and with a hideous crash
Takes prisoner Pyrrhus' ear: for, lo! his sword,
Which was declining on the milky head
Of reverend Priam, seem'd i' the air to stick:
So, as a painted tyrant, Pyrrhus stood;
And, like a neutral to his will and matter,
Did nothing.
But, as we often see, against[67] some storm,
A silence in the heavens, the rack stand still,
The bold winds speechless, and the orb below
As hush as death: anon the dreadful thunder
Doth rend the region: So, after Pyrrhus' pause
A roused vengeance sets him new a work;
And never did the Cyclops' hammers[68] fall
On Mars's[69] armours, forg'd for proof eterne,[70]
With less remorse than Pyrrhus' bleeding sword
Now falls on Priam.—
Out, out, thou strumpet, Fortune! All you gods,
In general synod, take away her power;
Break all the spokes and fellies[71] from her wheel,
And bowl the round nave down the hill of heaven,
As low as to the fiends.

Polonius. This is too long.

Hamlet. It shall to the barber's, with your beard.— Prithee, say on:—He's for a jig, or a tale of bawdry, or he sleeps:—say on: come to Hecuba.[72]

I Play. But who, O who, had seen the mobled[73] queen_____

[56]*caviare to the general*: something too fine for vulgar taste
[57]*sallets*: salty jokes
[58]*Eneas' tale to Dido*: Dido, a Carthage princess, fell in love with Eneas, the Trojan hero, but she killed herself when she learned he did not love her in return.
[59]*Priam's*: the last king of Troy, killed by Achilles' son, Pyrrhus.
[60]*Hyrcanian beast*: Asian tiger
[61]*gules*: marked by red color (usually in engraved figures)
[62]*murthers*: murders
[63]*coagulate gore*: congealed blood
[64]*carbuncles*: fiery-red precious stones; garnets. Also, inflamed ulcers.
[65]*repugnant to demand*: does not obey
[66]*Illium*: Troy (Priam)
[67]*against*: before
[68]*Cyclops' hammers*: In Greek mythology, one-eyed giants who forged thunderbolts for Zeus.
[69]*Mars's*: Roman god of war, son of Jupiter and Juno.
[70]*proof-eterne*: eternal proof
[71]*fellies*: circular rims
[72]*Hecuba*: Priam's wife and Hector's mother, noted for her misfortunes after Troy fell.
[73]*mobled*: concealed (wrapped up)

HAMLET. The mobled queen?

POLONIUS. That's good: mobled queen is good.

I PLAY. Run barefoot up and down, threat'ning the flame
With bisson rheum[74]; a clout about that head,
Where late the diadem[75] stood; and, for a robe,
About her lank and all o'er-teemed[76] loins,
A blanket, in the alarum[77] of rear caught up;
Who this had seen, with tongue is venom steep'd,
'Gainst Fortune's state would treason have pronounc'd.
But if the gods themselves did see her then,
When she saw Pyrrhus make malicious sport
In mincing with his sword her husband's limbs,
The instant burst of clamour that she made
(Unless things mortal move them not at all,)
Would have made milch[78] the burning eyes of heaven,
And passion in the gods.

POLONIUS. Look, whether he has not turn'd his colour, and has tears in's eyes.—Pray you, no more.

HAMLET. 'Tis well; I 'll have thee speak out the rest soon.—Good my lord, will you see the players well bestow'd? Do you hear, let them be well used; for they are the abstracts, and brief chronicles, of the time: After you death you were better have a bad epitaph, than their ill report while you lived.

POLONIUS. My lord, I will use them according to their desert.[79]

HAMLET. Odd's bodikin[80] man, better: Use every man after his desert, and who should 'scape whipping? Use them after your own honour and dignity: The less they deserve, the more merit is in your bounty. Take them in.

POLONIUS. Come, sirs.

Exit POLONIUS with some of the PLAYERS.

HAMLET. Follow him, friends: we'll hear a play to-morrow.—Dost thou hear me, old friend; can you play the murther of Gonzago?

I PLAY. Ay, my lord.

HAMLET. We'll have't to-morrow night. You could, for a need, study a speech of some dozen or sixteen lines, which I would set down and insert in't? could you not?

I PLAY. Ay, my lord.

HAMLET. Very well.—Follow that lord; and look you mock him not. *(Exit PLAYER).* My good friends, *(To ROS. and GUIL).* I'll leave you till night; you are welcome to Elsinore.

ROSENCRANTZ. Good my lord!

Exeunt ROSENCRANTZ and GUILDENSTERN.

HAMLET. Ay, so, God be wi' you: Now I am alone.
O, what a rogue and peasant slave am I!
Is it not monstrous, that this player here,
But in a fiction, in a dream of passion,
Could force his soul so to his whole conceit,[81]
That from her working, all his visage wann'd;
Tears in his eyes, distraction in 's aspect,
A broken voice, and his whole function suiting
With forms to his conceit? And all for nothing!
For Hecuba!
What's Hecuba to him, or he to Hecuba,
That he should weep for her? What would he do,
Had he the motive and the cue for passion
That I have? He would drown the stage with tears,
And cleave the general ear[82] with horrid speech;
Make mad the guilty, and appal the free,
Confound the ignorant; and amaze, indeed,
The very faculties of eyes and ears.
Yet I,
A dull and muddy-mettled rascal,[83] peak,
Like John-a-dreams,[84] unpregnant of my cause,[85]
And can say nothing; no, not for a king,

[74]*bisson rheum*: blind discharge (tears)
[75]*diadem*: crown
[76]*o'er-teemed*: stressed by childbirth
[77]*alarum*: alarm
[78]*milch*: milk of
[79]*desert*: merit
[80]*Odd's bodikin*: God's dear body, an interjection
[81]*conceit*: imagination
[82]*cleave the general ear*: divide what the common public hears
[83]*dull and muddy-mettled rascal*: clouded and confused-minded rogue
[84]*John-a-dreams*: an idler
[85]*unpregnant of my cause*: as if without significance or promise with what he needs to do

Upon whose property, and most dear life,
A damn'd defeat was made. Am I a coward?
Who calls me villain? breaks my pate across?[86]
Pluks off my beard, and blows it in my face?
Tweaks me by the nose? gives me the lie i' the throat,
As deep as to the lungs? Who does me this?
Ha!
Why, I should take it: for it cannot be,
But I am pigeon-liver'd, and lack gall
To make oppression bitter; or, ere this,
I should have fatted all the region kites[87]
With this slave's offal.[88] Bloody, bawdy villain!
Remorseless, treacherous, leacherous, kindles villain!
O vengeance!
What an ass am I! ay, sure, this is most brave;
That I, the son of the dear murthered,
Prompted to my revenge by heaven and hell,
Must, like a whore, unpack my heart with words,
And fall a cursing, like a very drab,
A scullion[89]!
Fye upon't! foh! About,[90] my brains! I have heard,
That guilty creatures, sitting at a play,
Have by the very cunning of the scene
Been struck so to the soul, that presently
They have proclaim'd their malefactions;[91]
For murther, though it have no tongue, will speak
With most miraculous organ. I'll have these players
PLAY something like the murder of my father
Before mine uncle: I'll observe his looks:
I'll tent[92] him to the quick; if he but blench,[93]
I know my course. The spirit that I have seen
May be the devil: and the devil hath power
To assume a pleasing shape; yea, and, perhaps,
Out of my weakness, and my melancholy,
(As he is very potent with such spirits,)
Abuses me to damn me: I'll have grounds
More relative[94] than this: The play's the thing,
Wherein I'll catch the conscience of the king.
Exit.

Act 3
Scene I—A Room in the Castle.

Enter KING, QUEEN, POLONIUS, OPHELIA, ROSENCRANTZ, and GUILDENSTERN.

KING. And can you, by no drift of circumstance,
 Get from him, why he puts on this confusion;
 Grating so harshly all his days of quiet
 With turbulent and dangerous lunacy?

ROSENCRANTZ. He does confess he feels himself distracted;
 But from what cause he will by no means speak.

GUILDENSTERN. Nor do we find him forward to be sounded[1];
 But, with a crafty madness, keeps aloof,
 When we would bring him on to some confession
 Of his true state.

QUEEN. Did he receive you well?

ROSENCRANTZ. Most like a gentleman.

GUILDENSTERN. But with much forcing of his disposition.

ROSENCRANTZ. Niggard of question[2]; but, of our demands,
 Most free in his reply.

QUEEN. Did you assay[3] him
 To any pastime?

ROSENCRANTZ. Madam, it so fell out, that certain players
 We o'er-raught[4] on the way: of these we told him
 And there did seem in him a kind of joy
 To hear of it: They are about[5] the court;
 And, as I think, they have already order[6]
 This night to play before him.

POIONIUS. 'Tis most true.
 And he beseech'd me to entreat your majesties
 To hear and see the matter.[7]

[86]*breaks my pate across:* strikes me on the head
[87]*kites:* rapacious hawks
[88]*offal:* entrails
[89]*A scullion:* a menial laborer
[90]*About:* turn about (from feeling pity to taking action)
[91]*malefactions:* evil doings
[92]*tent:* probe
[93]*blench:* shrink back
[94]*relative:* relevant
[1]*forward to be sounded:* willing to answer questions
[2]*niggard of question:* stingey with his own remarks
[3]*assay:* attempt to lure
[4]*o'er-raught:* came upon
[5]*about:* around
[6]*have already order:* have been arranged to
[7]*matter:* the play

KING. With all my heart; and it doth much content me
 To hear him so inclin'd.
 Good gentlemen, give him a further edge,[8]
 And drive his purpose on to these delights).

ROSENCRANTZ. We shall, my lord.

Exeunt ROSENCRANTZ and GUILDENSTERN

KING. Sweet Gertrude, leave us too:

 For we have closely[9] sent for HAMLET hither;
 That he, as 'twere by accident, may here
 Affront Ophelia.
 Her father, and myself (lawful espials,)[10]
 Will so bestow ourselves, that, seeing, unseen,
 We may of their encounter frankly judge;
 And gather by him, as he is behav'd,
 If't be the affliction of his love or no,
 That thus he suffers for.

QUEEN. I shall obey you:
 And for your part, Ophelia, I do wish.
 That your good beauties be the happy cause
 Of Hamlet's wildness; so shall I hope your virtues
 Will bring him to his wonted[11] way again,
 To both your honours.

OPHELIA. Madam, I wish it may.

Exit QUEEN.

POLONIUS. Ophelia, walk you here:—Gracious, so please you, We will bestow ourselves:—Read on this book;

To OPHELIA.
 That show of such an exercise may colour
 Your loneliness.[12] We are oft to blame in this,—
 'Tis too much prov'd, that, with devotion's visage,
 And pious action, we do sugar o'er
 The devil himself.

KING. O, 'tis too true!
 How smart a lash that speech doth give my conscience!

 The harlot's cheek, beautied with plast'ring art,
 Is not more ugly to the thing that helps it,
 Than is my deed to my most painted word:
 O heavy burden!

Aside.

POLONIUS. I hear him coming; let's withdraw, my lord.

Exeunt KING and POLONIUS.

Enter HAMLET.

HAMLET. To be, or not to be, that is the question:
 Whether 'tis nobler in the mind, to suffer
 The slings and arrows of outrageous fortune,
 Or to take arms against a sea of troubles,
 And, by opposing end them?—To die,—to sleep,—
 No more; and, by a sleep, to say we end
 The heartache, and the thousand natural shocks
 That flesh is heir to,—'tis a consummation[13]
 Devoutly to be wish'd. To die,—to sleep;—
 To sleep! perchance to dream;—ay, there's the rub;[14]
 For in that sleep of death what dreams may come,
 When we have shuffled off this mortal coil,
 Must give us pause: there's the respect,
 That makes calamity of so long life:[15]
 For who would bear the whips and scorns of time,
 The oppressor's wrong, the proud man's contumely,[16]
 The pangs of disprizd[17] love, the law's delay,
 The insolence of office, and the spurns
 That patient merit of the unworthy takes,
 When he himself might his quietus[18] make
 With a bare bodkin[19]? Who would these fardels bear,[20]
 To grunt and sweat under a weary life:
 But that the dread of something after death,
 The undiscovered country, from whose bourn
 No traveller returns, puzzles the will;
 And makes us rather bear those ills we have,
 Than fly to others that we know not of?
 Thus conscience does make cowards of us all;
 And thus the native hue of resolution
 Is sicklied o'er with the pale cast of thought;

[8]*a further edge*: more of a push
[9]*closely*: carefully, secretly
[10]*espials*: spies
[11]*wonted*: usual
[12]*show of such an exercise may colour/Your loneliness*: reading (a devotional) will highlight your melancholy
[13]*consummation*: perfection
[14]*rub*: irritation
[15]*makes calamity of so long life*: both gives calamity itself a long life and makes a long life calamitous
[16]*contumely*: reproach
[17]*dispriz'd*: removed
[18]*quietus*: release from life
[19]*bare bodkin*: unsheathed, unadorned dagger
[20]*these fardels bear*: bear these burdens (of sorrow or sin)

And enterprises of great pith[21] and moment,
With this regard, their currents turn away,
And lose the name of action.—Soft you, now!
The fair OPHELIA:—Nymph, in thy orisons[22]
Be all my sins remember'd.

OPHELIA. Good my lord,
How does your honour for this many a day?

HAMLET. I humbly thank you; well, well, well.

OPHELIA. My lord, I have remembrances of yours.
That I have longed long to re-deliver;
I pray you, now receive them.

HAMLET. No, no. I never gave you aught.[23]

OPHELIA. My honour'd lord, I know right well you did;
And, with them, words of so sweet breath compos'd
As made the things more rich: their perfume lost,
Take these, again; for to the noble mind,
Rich gifts wax poor, when givers prove unkind.
There, my lord.

HAMLET. Ha, ha! Are you honest[24]

OPHELIA. My lord?

HAMLET. Are you fair?

OPHELIA. What means your lordship?

HAMLET. That if you be honest, and fair, your honesty
should admit no discourse to[25] your beauty.

OPHELIA. Could beauty, my lord, have better commerce than with honesty?

HAMLET. Ay, truly; for the power of beauty will sooner
transform honesty from what it is to a bawd, than
the force of honesty can translate beauty into his
likeness: this was some time a paradox, but now
the time gives it proof. I did love you once.

OPHELIA. Indeed, my lord, you made me believe so.

HAMLET. You should not have believed me: for virtue
cannot so inoculate[26] our old stock, but we shall
relish of it: I lov'd you not.

OPHELIA. I was the more deceived.

HAMLET. Get thee to a nunnery.[27] Why wouldst thou
be a breeder of sinners? I am myself indifferent
honest[28]: but yet I could accuse me of such things,
that it were better my mother had not borne me:
I am very proud, revengeful, ambitious; with more
offences at my beck, than I have thoughts to put
them in, imagination to give them shape, or time
to act them in; What should such fellows as I do
crawling between heaven and earth? We are arrant
knaves,[29] all; believe none of us; Go thy ways to a
nunnery. Where's your father?

OPHELIA. At home, my lord.

HAMLET. Let the doors be shut upon him, that he
may play the fool no where but in 's own house.
Farewell.

OPHELIA. O, help him, you sweet heavens!

HAMLET. If thou dost marry, I'll give thee this plague
for thy dowry: Be[30] thou as chaste as ice, as pure as
snow, thou shalt not escape calumny.[31] Get thee to
a nunnery, go; farewell: Or, if thou wilt needs marry, marry a fool; for wise men know well enough
what monsters you make of them. To a nunnery,
go; and quickly too. Farewell.

OPHELIA. O heavenly powers, restore him[32]!

HAMLET. I have heard of your paintings too, well
enough. God hath given you one face, and you
make yourselves another; you jig, you amble, and
you lisp, and nick-name God's creatures, and
make your wantonness your ignorance: Go to, I'll
no more on't; it hath made me mad. I say, we will
have no more marriages: those that are married already, all but one, shall live; the rest shall keep as
they are. To a nunnery, go. [*Exit* HAMLET].

OPHELIA. O, what a noble mind is here o'erthrown!
The courtier's, soldier's, scholar's, eye, tongue, sword:
The expectancy and rose of the fair state,
The glass of fashion, and the mould of form,

[21]*pith*: importance; vigor

[22]*orisons*: prayers

[23]*aught*: anything

[24]*honest*: multiple meanings—truthful, honorable, and chaste

[25]*discourse to*: conversation with

[26]*inoculate*: graft

[27]*nunnery*: a house for nuns; with a second meaning of house for women, a brothel

[28]*indifferent honest*: tolerably honorable

[29]*arrant knaves*: notorious rogues

[30]*be*: even if

[31]*calumny*: false accusation

[32]*restore him*: make him what he was

The observ'd of all observers! quite, quite, down:
And I, of ladies most deject and wretched,
That suck'd the honey of his music vows,
Now see that noble and most sovereign reason,
Like sweet bells jangled, out of tune and harsh;
That unmatch'd form and feature of blown youth,
Blasted with ecstasy: O, woe is me!
To have seen what I have seen, see what I see!

Re-enter KING *and* POLONIUS.

KING. Love! his affections do not that way tend;
 Nor what he spake, though it lack'd form a little,
 Was not like madness. There's something in his soul,
 O'er which his melancholy sits on brood,[33]
 And, I do doubt, the hatch,[34] and the disclose,
 Will be some danger: Which to prevent,
 I have, in quick determination,
 Thus set it down; He shall with speed to England,
 For the demand of our neglected tribute:
 Haply, the seas, and countries different,
 With variable objects[35] shall expel
 This something-settled matter in his heart;
 Whereon his brains still beating, puts him thus
 From fashion of himself. What think you on't?

POLONIUS. It shall do well; but yet do I believe,
 The origin and commencement of this grief
 Sprung from neglected love.—How now, Ophelia,
 You need not tell us what lord Hamlet said;
 We heard it all.—My lord, do as you please;
 But, if you hold it fit, after the play,
 Let his queen mother all alone entreat him
 To show his griefs; let her be round[36] with him;
 And I'll be plac'd, so please you, in the ear
 Of all their conference.[37] If she find him not,
 To England send him: or confine him, where
 Your wisdom best shall think.

KING. It shall be so:
 Madness in great ones must not unwatch'd go.

Exeunt.

Scene II—A Hall in the same.

Enter HAMLET, *and certain* PLAYERS.

HAMLET. Speak the speech, I pray you, as I pronounced it to you, trippingly on the tongue: but if you mouth it, as many of your players do, I had as lief[1] the town-crier had spoke my lines. Nor do not saw the air too much—your hand thus: but use all gently: for in the very torrent, tempest, and (as I may say) the whirlwind of passion, you must acquire and beget a temperance, that may give it smoothness. O, it offends me to the soul, to see a robustious periwig-pated fellow[2] tear a passion[3] to tatters, to very rags, to split the ears of the groundlings[4]; who, for the most part, are capable of nothing but inexplicable dumb shows and noise: I could have such a fellow whipped for o'erdoing Termagant[5]; it out-herods Herod[6]: pray you, avoid it.

I PLAY. I warrant[7] your honour.

HAMLET. Be not too tame neither, but let your own discretion be your tutor: suit the action to the word, the word to the action; with this special observance, that you o'er-step not the modesty of nature; for anything so overdone is from the purpose of playing, whose end, both at the first, and now, was, and is, to hold, as 'twere, the mirror up to nature; to show virtue her own feature, scorn her own image, and the very age and body of the time, his form and pressure. Now this, overdone, or come tardy off,[8] though it make the unskilful laugh, cannot but make the judicious grieve; the censure of the which one, must, in your allowance, o'er-weigh a whole theatre of others. O, there be players, that I have seen play, and heard others praise, and that highly, not to speak it profanely, that, neither having the accent of Christians, nor the gait of Christian, pagan, nor man, have so strutted, and bellowed, that

[33] *sits on brood:* broods on (like a hen on her eggs)
[34] *doubt the hatch:* fear what hatches
[35] *variable objects:* varied distractions
[36] *be round:* talk without mincing words; be straight
[37] *in the ear/Of all their conference:* within earshot of their meaning
[1] *as lief:* as willingly have
[2] *robustious periwig-pated fellow:*
[3] *passion:* mystery play
[4] *groundlings:* in the theatre, audience members who stood on the floor before the stage. (They could only afford the cheapest tickets, were rowdy, and not very educated).
[5] *Termagant:* a female character in a mystery play who is a terrible scold
[6] *Herod:* Herod Antipas, the ruler that Pontius Pilate sent Jesus to for questioning. Also plays prominantly in mystery plays.
[7] *warrant:* justify
[8] *come tardy off:* miss your cue

I have thought some of Nature's journeymen[9] had made men, and not made them well, they imitated humanity so abominably.

I PLAY. I hope, we have reformed that indifferently[10] with us, sir.

HAMLET. O, reform it altogether. And let those that play your clowns, speak no more than is set down for them: for there be of them, that will themselves laugh, to set on some quantity of barren spectators to laugh too; though, in the mean time, some necessary question of the play be then to be considered: that's villainous; and shows a most pitiful ambition in the fool that uses it. Go, make you ready.

Exeunt PLAYERS.

Enter POLONIUS, ROSENCRANTZ, and GUILDENSTERN.

How now, my lord? will the king hear this piece of work?

POLONIUS. And the queen too, and that presently.

HAMLET. Bid the players make haste.

Exit POLONIUS.

Will you too help to hasten them?

BOTH. We will, my lord.

Exeunt ROSENCRANTZ and GUILDENSTERN.

HAMLET. What, ho; Horatio?

Enter HORATIO.

HORATIO. Here, sweet lord, at your service.

HAMLET. Horatio, thou art e'en as just a man
As e'er my covversation cop'd[11] withal.

HORATIO. O, my dear Lord,—

HAMLET. Nay, do not think I flatter:
For what advancement may I hope from thee,
That no revenue hast but thy good spirits,
To feed and clothe thee? Why should the poor be flatter'd?

No, let the candied tongue lick absured pomp;
And crook the pregnant hinges[12] of the knee,
Where thrift may follow fawning. Dost thou hear?
Since my dear soul was mistress of my choice,
And could of mean distinguish, her election
Hath seal'd thee for herself: for thou hast been
As one, in suffering all, that suffers nothing;
A man, that fortune's buffets and rewards
Has ta'en with equal thanks: and bless'd are those,
Whose blood and judgment are so well co-mingled,
That they are not a pipe for fortune's finger
To sound what stop she please: Give me that man
That is not passion's slave, and I will wear him
In my heart's core, ay, in my heart of heart,
As I do thee.—Something too much of this.—
There is a play to-night before the king;
One scene of it comes near the circumstances
Which I have told theee of my father's death.
I prithee,[13] when thou see'st that act a-foot,
Even with the very comment of my soul
Observe mine uncle: if his occulted[14] guilt
Do not itself unkennel in one speech,
It is a damned ghost that we have seen;
And my imaginations are as foul
As Vulcan's stithe.[15] Give him heedful note:
For I mine eyes will rivet to his face;
And, after, we will both our judgments join
To censure of his seeming.

HORATIO. Well, my lord:
If he steal aught, the whilst this play is playing,
And scape detecting, I will pay the theft.

HAMLET. They are coming to the play; I must be idle:
Get you a place.

Enter KING, QUEEN, POLONIUS, OPHELIA, ROSENCRANTZ, GUILDENSTERN, and other Lords attendant, with his Guard, carrying torches. Danish March. Sound a flourish.

KING. How fares our cousin Hamlet?

HAMLET. Excellent, i' faith; of the cameleon's dish[16]: I eat the air, promise-crammed: You cannot feed capons[17] so.

[9]*journeymen:* (mere) apprentices
[10]*indifferently:* passably
[11]*cop'd:* contended with successfully
[12]*pregnant hinges:* flexible joints
[13]*prithee:* pray you
[14]*occulted:* concealed
[15]*Vulcan's stithe:* Roman god of fire's workshop
[16]*chameleon's dish:* air (as food)
[17]*capons:* castrated cocks

KING. I have nothing with this answer, HAMLET; these words are not mine.[18]

HAMLET. No, nor mine now. My lord,—you played once in the university, you say? (*To POLONIUS*).

POLONIUS. That I did, my lord; and was accounted a good actor.

HAMLET. And what did you enact?

POLONIUS. I did enact Julius Caesar: I was killed i' the Capitol: Brutus killed me.

HAMLET. It was a brute part of him, to kill so capital a calf there.
—Be the players ready?

ROSENCRANTZ. Ay, my lord; they stay upon your patience.

QUEEN. Come hither, my good HAMLET, sit by me.

HAMLET. No, good mother, here's metal more attractive.[19]

POLONIUS. O ho! do you mark that? (*To the KING*).

HAMLET. Lady, shall I lie in your lap?

Lying down at OPHELIA's feet.

OPHELIA. No, my lord.

HAMLET. I mean, my head upon your lap?

OPHELIA. Ay, my lord.

HAMLET. Do you think I meant country[20] matters?

OPHELIA. I think nothing, my lord.

HAMLET. That's a fair thought to lie between maids' legs.

OPHELIA. What is, my lord?

HAMLET. Nothing.

OPHELIA. You are merry, my lord.

HAMLET. Who, I?

OPHELIA. Ay, my lord.

HAMLET. O God! your only jig-maker. What should a man do, but be merry? for, look you, how cheerfully my mother looks, and my father died within these two hours.

OPHELIA. Nay, 'tis twice two months, my lord.

HAMLET. So long? Nay, then let the devil wear black, for I'll have a suit of sables. O heavens! die two months ago, and not forgotten yet? Then there's hope a great man's memory may outlive his life half a year: But, by 'r-lady, he must build churches then: or else shall he suffer not thinking on, with the hobby-horse; whose epitaph is, *For, O, for, O, the hobby-horse is forgot.*

Hautboys[21] play. The dumb show enters.

Enter a KING and a QUEEN, very lovingly; the QUEEN embracing him. She kneels, and makes show of protestation unto him. He takes her up, and declines his head upon her neck: lays him down upon a bank of flowers; she, seeing him asleep, leaves him. Anon comes in a fellow, takes off his crown, kisses it and pours poison in the KING's ears, and exit. The QUEEN returns; finds the KING dead, and makes passionate action. The poisoner, with some two or three mutes, comes in again, seeming to lament with her. The dead body is carried away. The poisoner woos the QUEEN with gifts; she seems loth and unwilling a while, but, in the end, accepts his love.

Exeunt.

OPHELIA. What mean this, my lord?

HAMLET. Marry, this is miching mallecho[22]; it means mischief.

OPHELIA. Belike, this show imports the argument of the play.

Enter PROLOGUE.

HAMLET. We shall know by this fellow: the players cannot keep counsel; they'll tell all.

OPHELIA. Will he tell us what this show meant?

HAMLET. Ay, or any show that you'll show him: Be not you ashamed to show, he'll not shame to tell you what it means.

OPHELIA. You are naught, you are naught; I'll mark the play.

POLONIUS. For us, and for our tragedy
Here stopping to your clemency,
We beg your hearing patiently.

HAMLET. Is this a prologue, or the poesy of a ring[23]?

[18]*mine*: meant for me
[19]*attractive*: magnetic
[20]*country*: characteristic of the country; bawdy
[21]*Hautboys*: oboes (in French, *haut* = high, *bois* = wood)
[22]*miching mallecho*: furtive injury

OPHELIA. 'Tis brief, my lord.

HAMLET. As woman's love.

Enter KING *and his* QUEEN.

P. KING. Full thirty times hath Phoebus' cart[24] gone
 round
 Neptune's salt wash,[25] and Tellus' or bed ground;[26]
 And thirty dozen moons with borrow'd sheen,
 About the world have times twelve thirties been;
 Since love our hearts, and Hymen[27] did our hands,
 Unite commutual in most sacred bands.

P. QUEEN. So many journeys may the sun and moon
 Make us again count o'er, ere love be done!
 But, woe is me, you are so sick of late,
 So far from cheer, and from your former state,
 That I distrust you. Yet, though I distrust,
 Discomfort you, my lord, it nothing must;
 For women's fear and love holds quantity;
 In neither aught, or in extremity.
 Now, what my love is, proof hath made you know;
 And as my love is siz'd, my fear is so.
 Where love is great, the littlest doubts are fear;
 Where little fears grow great, great love grows there.

P. KING. 'Faith, I must leave thee, love, and shortly too;
 My operant[28] powers my functions leave to do:
 And thou shalt live in this fair world behind,
 Honour'd, belov'd; and haply, one as kind
 For husband shalt thou____

P. QUEEN. O, confound the rest!
 Such love must needs be treason in my breast:
 In second husband let me be accurst!
 None wed the second but who kill'd the first.

HAMLET. Wormwood,[29] wormwood.

P. QUEEN. The instances that second marriage move,
 Are base respects of thrift, but none of love;
 A second time I kill my husband dead,
 When second husband kisses me in bed.

P. KING. I do believe, you think what now you
 speak;

But what we do determine oft we break.
Purpose is but the slave to memory;
Of violent birth, but poor validity:
Which now, like fruit unripe, sticks on the tree;
But fall, unshaken, when they mellow be.
Most necessary 'tis, that we forget
To pay ourselves what to ourselves is debt;
What to ourselves in passion we propose,
The passion ending, doth the purpose lose.
The violence of either grief or joy
Their own enactures with themselves destroy:
Where joy most revels, grief doth most lament,
Grief joys, joy grieves, on slender accident.
This world is not for aye,[30] nor 'tis not strange,
That even our loves should with our fortunes
 change;
For 'tis a question left us yet to prove,
Whether love lead fortune, or else fortune love.
The great man down, you mark, his favourite
 flies;
The poor advanc'd makes friends of enemies.
And hitherto doth love on fortune tend:
For who not needs shall never lack a friend;
And who in want a hollow friend doth try,
Directly seasons him his enemy.
But, orderly to end where I begun,—
Our wills and fates do so contrary run,
That our devices still are overthrown;
Our, thoughts are ours, their ends none of our own;
So think thou wilt no second husband wed;
But die thy thoughts, when thy first lord is dead.

P. QUEEN. Nor earth to give me food, nor heaven
 light!
 Sport and repose lock[31] from me, day, and night!
 To desperation turn my trust and hope!
 An anchor's cheer[32] in prison be my scope!
 Each opposite, that blanks the face of joy,
 Meet what I would have well, and it destroy!
 BOTH here, and hence, pursue me lasting strife,
 If, once a widow, ever I be wife!

HAMLET. If she should break it now,—— [*To* OPHELIA].

[23]*poesy of a ring*: a light phrase inscribed on a ring
[24]*Phoebus' cart*: Apollo (the sun god) and his chariot; the sun
[25]*Neptune's salt wash*: the sea (Neptune is the god of the sea)
[26]*Tellus' orbed ground*: the earth
[27]*Hymen*: god of marriage
[28]*operant*: operating
[29]*wormwood*: a bitter plant, medically used to destroy intestinal worms
[30]*aye*: always
[31]*lock*: keep away
[32]*anchor's cheer*: her frame of mind will be like a hermit's (an anchorite)

P. KING. 'Tis deeply sworn. Sweet, leave me here a while;
My spirits grow dull, and fain would beguile[33]
The tedious day with sleep. (*Sleeps*).

P. QUEEN. Sleep rock thy brain
And never come mischance between us twain!

Exit.

HAMLET. Madam, how like you this play?

QUEEN. The lady protests too much, methinks,

HAMLET. O, but she 'll keep her word.

KING. Have you heard the arguyment? Is there no offence in't?

HAMLET. No, no, they do but jest, poison in jest; no offence i' the world.

KING. What do you call the play?

HAMLET. The mouse-trap. Marry, how? Tropically.[34] This play is the image of a murder dome in Vienna: Gonzago is the Duke's name; his wife, Baptista: you shall see anon; 'tis a knavish piece of work: But what of that? your majesty, and we that have free souls; it touches us not: Let the galled jade[35] wince our withers[36] are unwrung.[37]

Enter LUCIANUS.

This is one Lucianus, nephew to the king.

OPHELIA. You are a good chorus, my lord.

HAMLET. I could interpret between you and your love, if I could see the puppets dallying.

OPHELIA. You are keen[38] my lord, you are keen.

HAMLET. It would cost you a groaning,[39] to take off my edge.

OPHELIA. Still better, and worse.

HAMLET. So you must take husbands.—Begin, murderer; leave thy dimmable faces, and begin. Come; ___

___ The croaking raven
Doth bellow for revenge.

LUCIANUS. Thoughts black, hands apt, drugs fit, and time agreeing;
Confederate[40] season, else no creature seeing;
Thou mixture rank, of midnight weeds[41] collected,
With Hecate's[42] ban thrice blasted, thrice infected,
Thy natural magic and dire property,
On wholesome life usurp immediately. (*Pours the poison in his ears*).

HAMLET. He poisons him i' the garden for his estate. His name's Gonzago; the story is extant, and writ in choice Italian: You shall see anon, how the murtherer gets the love of Gonzago's wife.

OPHELIA. The king rises.

HAMLET. What I frighted with false fire.

QUEEN. How fares my lord?

POLONIUS. Give o'er the play.

KING. Give me some light:—away!

ALL. Lights, lights, lights!

Exeunt all but HAMLET and HORATIO.

HAMLET. Why, let the stricken deer go weep,
The hart ungalled play:
For some must watch, while some must sleep;
So runs the world away.—Would not this, sir, and a forest of feathers, (if the rest of my fortunes turn Turk[43] with me,) with
Provincial roses on my razed[44] shoes, get me a fellowship in a cry of players, sir?

HORATIO. Half a share.

HAMLET. A whole one I.
For thou dost know, O Damon[45] dear,
This realm dismantled was
Of Jove himself; and now reigns here
A very, very—Paiocke.[46]

[33]*fain I would beguile*: gladly I would trick
[34]*Tropically*: relating to a turning
[35]*galled jade*: irritated (from chafing) mare (or nag)
[36]*withers*: a horse's shoulder-bones
[37]*unwrung*: untwisted
[38]*keen*: sharp
[39]*groaning*: a deep moan (with possible word play on "groat," a silver coin of small sum)
[40]*confederate*: allied
[41]*midnight weeds*: it was thought that herbs collected at midnight were bewitching, and often poisonous (due to Hecate's ban).
[42]*Hecate's*: a three-headed goddess (associated with Diana (earth), Luna (heavens), and Proserpine (the lower world).
[43]*turn Turk*: turn savage
[44]*razed*: intentionally cut (a trend)
[45]*Damon*: calls his friend Damon as if he himself were Phintias, two friends of ancient Syracuse known for their faithfulness to one another.
[46]*Paiocke*: peacock

HORATIO. You might have rhymed.

HAMLET. O good Horatio, I'll take the ghost's word for a thousand pound. Didst perceive?

HORATIO. Very well, my lord.

HAMLET. Upon the talk of the poisoning,—

HORATIO. I did very well note him.

HAMLET. Ah, ha!—Come, some music; come, the recorders.—
For if the king like not the comedy,
Why then, belike, he likes it not, perdy[47]

Enter ROSENCRANTZ and GUILDENSTERN.

Come, some music.

GUILDENSTERN. Good my lord, vouchsafe me a word with you.

HAMLET. Sir, a whole history.

GUILDENSTERN. The king, sir,—

HAMLET. Ay, sir what of him?

GUILDENSTERN. Is, in his retirement, marvelous distempered.

HAMLET. With drink, sir?

GUILDENSTERN. No, my lord, rather with choler.[48]

HAMLET. Your wisdom should show itself more richer, to signify this to his doctor; for, for me to put him to his purgation, would, perhaps, plunge him into far more choler.

GUILDENSTERN. Good my lord, put your discourse into some frame, and start not so wildly from my affair.

HAMLET. I am tame, sir, pronounce.

GUILDENSTERN. The queen, your mother, in most great affliction of spirit, hath sent me to you.

HAMLET. You are welcome.

GUILDENSTERN. Nay, good my lord, this courtesy is not of the right breed. If it shall please you to make me a wholesome answer, I will do your mother's commandment: if not, you pardon, and my return, shall be the end of my business.

HAMLET. Sir, I cannot.

GUILDENSTERN. What, my lord?

HAMLET. Make you a wholesome answer; my wit's diseased: But, sir, such answers as I can make you shall command; or rather, you say, my mother: therefore, no more, but to the matter; My mother, you say,—

ROSENCRANTZ. Then thus she says: Your behaviour hath struck her struck her into amazement and admiration.

HAMLET. O wonderful son, that can so astonish a mother!—But is there no sequel at the heels of this mother's admiration?

ROSENCRANTZ. She desires to speak with you in her closet,[49] ere[50] you go to bed.

HAMLET. We shall obey, were she ten times our mother. Have you any further trade with us?

ROSENCRANTZ. My lord, you once did love me.

HAMLET. So I do still, by these pickers and stealers.[51]

ROSENCRANTZ. Good my lord, what is your cause of distemper? you do freely bar the door of your own liberty, if you deny your griefs to your friend.

HAMLET. Sir, I lack advancement.

ROSENCRANTZ. How can that be, when you have the voice of the king himself for your succession in Denmark?

HAMLET. Ay, but *While the grass grows*,[52]—the proverb is something musty.

Enter one with a recorder.

O, the recorder: let me see—To withdraw with you:—Why do you go about to recover the wind of me, as if you would drive me into a toil?

GUILDENSTERN. O, my lord, if my duty be too bold, my love is too unmannerly.

HAMLET. I do not well understand that. Will you play upon this pipe?

GUILDENSTERN. My lord, I cannot.

[47]*perdy:* by God (in French, *par dieu*)
[48]*choler:* Guildernstern means "anger," but HAMLET uses it to mean a sickness
[49]*closet:* bedroom
[50]*ere:* before
[51]*pickers and stealers:* fingers and hands
[52]*While the grass grows:* part of a proverb which ends ". . . the horse starves."

HAMLET. I pray you.

GUILDENSTERN. Believe me, I cannot.

HAMLET. I do beseech you.

GUILDENSTERN. I know no touch of it, my lord.

HAMLET. 'Tis as easy as lying: govern these ventages[53] with your fingers and thumb, give it breath with your mouth, and it will discourse most excellent music. Look you, theses are the stops.

GUILDENSTERN. But these cannot I command to any utterance of harmony; I have not the skill.

HAMLET. Why, look you now, how unworthy a thing you make of me. You would play upon me: you would seem to know my stops; you would pluck out the heart of my mystery; you would sound me from my lowest note to the top of my compass:[54] and there is much music, excellent voice, in this little organ; yet cannot you make it speak. Why, do you think that I am easier to be played on than a pipe? Call me what instrument you will, though you can fret me, you cannot play upon me.

Enter POLONIUS.

God bless you, sir.

POLONIUS. My lord, the queen would speak with you, and presently.

HAMLET. Do you see that cloud, that's almost in shape like a camel?

POLONIUS. By the mass, and 'tis like a camel, indeed.

HAMLET. Methinks, it is like a weasel.

POLONIUS. It is backed like a weasel.

HAMLET. Or, like a whale?

POLONIUS. Very like a whale.

HAMLET. Then will I come to my mother by and by. — They fool me to the top of my bent. — I will come by and by.

POLONIUS. I will say so.

Exit POLONIUS.

HAMLET. By and by is easily said. — Leave me, friends.

Exeunt Ros. Guil. Hor., &c.

'Tis now the very witching time of night;
When churchyards yawn, and hell itself breathes out
Contagion to this world: Now could I drink hot blood,
And do such bitter business as the day
Would quake to look on. Soft; now to my mother. —
O, heart, lose not thy nature; let not ever
The soul of Nero[55] enter this firm bosom:
Let me be cruel, not unnatural:
I will speak daggers to her, but use none;
My tongue and soul in this be hypocrites:
How in my words soever she be shent,[56]
To give them seals never, my soul, consent!

Exit.

Scene III—A Room in the same.

Enter KING, ROSENCRANTZ, and GUILDENSTERN.

KING. I like him not; not stands it safe with us,
To let his madness range. Therefore, prepare you;
I your commission will forthwith dispatch,
And he to England shall along with you;
The terms of our estate may not endure
Hazard so dangerous, as doth hourly grow
Out of his lunacies.

GUILDENSTERN. We will ourselves provide:
Most holy and religious fear it is,
To keep those many many bodies safe,
That live and feed upon your majesty.

ROSENCRANTZ. The single and peculiar life is bound,
With all the strength and armour of them mind,
To keep itself from 'noyance[1]; but much more
That spirit, upon whose spirit depend and rest
The lives of many. The cease of majesty
Dies not alone; but, like a gulf,[2] doth draw
What's near it with it: it is a massy wheel,
Fix'd on the summit of the highest mount,
To whose huge spokes ten thousand lesser things
Are mortis'd and adjoin'd;[3] which, when it falls.

[53]*ventages*: apertures
[54]*top of my compass*: my highest range
[55]*Nero*: a despotic Roman ruler who murdered his mother, Agrippina. He later committed Suicide.
[56]*shent*: shamed
[1]*'noyance*: annoyance
[2]*gulf*: whirlpool
[3]*mortis'd and adjoin'd*: cut out and joined together

Each small annexment,[4] petty consequence,
Attends the boist'rous ruin. Never alone
Did the king sigh, but with a general groan.
KING. Arm you, I pray you, to this speedy voyage;
For we will fetters[5] put upon this fear,
Which now goes too free-footed.

ROSENCRANTZ. GUIL. We will haste us.[6]

Exeunt ROSENCRANTZ and GUILDENSTERN.

Enter POLONIUS.

POLONIUS. My lord, he's going to his mother's closet:

Behind the arras[7] I'll convey myself,
To hear the process; I'll warrant, she'll tax him
home.[8]
And, as you said, and wisely was it said,
'Tis meet, that some more audience than a mother,
Since nature makes them partial, should o' erchear
The speech of vantage.[9] Fare you well, my liege:
I'll call upon you ere you go to bed,
And tell you what I know.

KING. Thanks, dear my lord.

Exit POLONIUS.

O, my offence is rank, it smells to heaven;
It hath the primal eldest[10] curse upon't,
A brother's murther!—Pray can I not,
Though inclination be as sharp as will;
My stronger guilt defeats my strong intent;
And, like a man to double business bound,
I stand in pause where I shall first begin,
And both neglect. What if this cursed hand
Were thicker than itself with brother's blood?
Is there not rain enough in the sweet heavens,
To wash it white as now? Whereto[11] serves mercy,
But to confront the visage of offence?
And what's in prayer, but this two-fold force,—
To be forestalled, ere we come to fall,

Or pardon'd, being down? Then I'll look up;
My fault is past. But, O, what form of prayer
Can serve my turn?[12] Forgive me my foul
murther!—
That cannot be; since I am still possess'd
Of those effects for which I did the murther,
My crown, mine own ambition, and my queen.
May one be pardon'd, and retain the offence?
In the corrupted currents of this world,
Offence's gilded hand may shove by justice;
And oft 'tis seen, the wicked prize itself
Buys out the law: but 'tis not so above:
There is no shuffling,[13] there the action lies
In his true nature; and we ourselves compell'd,
Even to the teeth and forehead of our faults,
To give in evidence. What then? What rests?
Try what repentance can: What can it not?
Yet what can it, when one can not repent?
O wretched state! O bosom, black as death!
O limed[14] soul; that struggling to be free,
Art more engag'd! Help, angels, make assay[15]!
Bow, stubborn knees! and, heart, with strings of steel,
Be soft as sinews of the new-born babe:
All may be well! *(Retires, and kneels).*

Enter HAMLET.

HAMLET. Now might I do it, pat,[16] now he is praying,
And now I'll do't;—and so he goes to heaven:
And so am I reveng'd? That would be scann'd[17]:
A villain kills my father; and, for that,
I, his sole son, do this same villain send
To heaven.
O, this is hire and salary, not revenge.
He took my father grossly, full of bread;
With all his crimes broad blown, as fresh as May;
And, how his audit[18] stands, who knows, save
heaven?
But, in our circumstance and course of thought,

[4]*annexment:* adjoined
[5]*fetters:* restraints
[6]*haste us:* be speedy
[7]*arras:* tapestry
[8]*tax him home:* reprove him sternly
[9]*vantage:* place with advantage (to hear)
[10]*primal eldest:* Cain who murders his brother, Abel, in the old testament
[11]*Whereto:* to what
[12]*serve my turn:* help me
[13]*shuffling:* evasion
[14]*limed:* ensnared
[15]*make assay:* make an attempt
[16]*pat:* promptly
[17]*scann'd:* examined
[18]*audit:* take account, here a moral accounting

'Tis heavy with him: And am I then reveng'd,
To take him in the purging of his soul,
When he is fit and season'd for his passage?
No.
Up, sword; and know thou a more horrid hent[19]:
When he is drunk, asleep, or in his rage:
Or in the incestuous pleasure of his bed;
At gaming, swearing; or about some act
That has no relish of salvation in't:
Then trip him, that his heels may kick at heaven;
And that his soul may be as damn'd, and black,
As hell, whereto it goes. My mother stays:
This physic[20] but prolongs thy sickly days.

Exit.

The KING rises and advances.

KING. My words fly up, my thoughts remain below:
 Words, without thoughts, never to heaven go.

Exit.

Scene IV—Another Room in the same

Enter QUEEN and POLONIUS.

POLONIUS. He will come straight. Look, you lay home
 to him:
 Tell him, his pranks have been too broad to bear
 with;
 And that your grace hath screen'd and stood between
 Much heat and him. I'll silence me e'en here.
 Pray you, be round with him.

HAMLET (*within*). Mother! mother! mother!

QUEEN. I'll warrant you:
 Fear me not:—withdraw, I hear him coming.

POLONIUS hides himself.

Enter HAMLET.

HAMLET. Now, mother; what's the matter?

QUEEN. HAMLET, thou hast thy father much offended.

HAMLET. Mother, you have my father much offended.

QUEEN. Come, come, you answer with an idle[1] tongue.

HAMLET. Go, go, you question with an idle tongue.

QUEEN. Why, how now, HAMLET?

HAMLET. WHAT'S THE MATTER NOW?

QUEEN. Have you forgot me?

HAMLET. No, by the rood[2], not so:
 You are the queen, your husband's brother's wife;
 But would you were not so! You are my mother.

QUEEN. Nay, then I'll set those to you that can speak.

HAMLET. Come, come, and sit you down; you shall not
 budge;
 You go not, till I set you up a glass[3]
 Where you may see inmost part of you.

QUEEN. What wilt thou do? Thou wilt not murder me?
 Help, help, ho!

POLONIUS (*behind*). What, ho! help! help! help!

HAMLET. How now! a rat? (*Draws*).
 Dead, for a ducat,[4] dead. (*HAMLET makes a pass
 through the arras*).

POLONIUS (*behind*). O I am slain. (*Falls and dies*).

QUEEN. O me, what hast thou done?

HAMLET. Nay, I know not:
 Is it the king? (*Lifts up the arras, and draws forth
 POLONIUS*).

QUEEN. O, what a rash and bloody deed is this!

HAMLET. A Bloody Deed;—almost as bad, good mother,
 As kill a king, and marry with his brother.

QUEEN. As kill a king!

HAMLET. Ay, lady, 'twas my word.—
 Thou wretched, rash, intruding fool, farewell!
 (*To POLONIUS*).
 I took thee for thy betters; take thy fortune:
 Thou find'st, to be too busy is some danger.—
 Leave wringing of your hands: Peace, sit you down,
 And let me wring your heart: for so I shall,
 If it be made of penetrable stuff;
 If damned custom have not braz'd[5] it so,
 That it is proof and bulwark[6] against sense.

[19]*horrid hent*: horrible capture
[20]*physic*: remedy
[1]*idle*: baseless
[2]*rood*: cross
[3]*glass*: mirror
[4]*ducat*: gold coin
[5]*braz'd*: made like brass
[6]*proof and bulwark*: invulnerable and defended

QUEEN. What have I done, that thou dar'st wag thy tongue
In noise so rude against me?

HAMLET. Such an act,
That blurs the grace and blush of modesty;
Calls virtue, hypocrite; takes off he rose
From the fair forehead of an innocent love,
And sets a blister there; makes marriage vows
As false as dicers'[7] baths; O, such a deed
As from the body of contraction[8] plucks
The very soul; and sweet religion makes
A rhapsody of words: Heaven's face doth glow;
Yea, this solidity and compound mass,
With tristful visage,[9] as against the doom,[10]
Is thought-sick at the act.

QUEEN. Ah me, what act,
That roars so loud, and thunders in the index?

HAMLET. Look here, upon this picture, and on this;
The counterfeit presentment[11] of two brothers.
See what a grace was seated on his brow:
Hyperion's[12] curls; the front of Jove[13] himself;
An eye like Mars,[14] to threaten or command;
A station like the herald Mercury,[15]
New-lighted on a heaven-kissing hill;
A combination, and a form, indeed,
Where every god did seem to set his seal,
To give the world assurance of a man:
This was your husband,—look you now, what follows:
Here is your husband; like a mildew'd ear,
Blasting his wholesome brother. Have you eyes?
Could you on this fair mountain leave to feed,
And batten[16] on this moor? Ha! Have you eyes?
You cannot call it love: for, at your age,
The hey-day in the blood is tame, it's humble,

And waits upon the judgment: and what judgment
Would step from this to this? Sense, sure, you have,
Else, could you not have motion: But sure, that sense
Is apoplex'd:[17] for madness would not err;
Nor sense to ecstasy was ne'er so thrall'd,[18]
But it reserv'd some quantity of choice,
To serve in such a difference. What devil was't,
That thus hath cozen'd you at hoodman-blind?[19]
Eyes without feeling, felling without sight,
Ears without hands or eyes, smelling sans[20] all,
Or but a sickly part of one true sense
Could not so mope.
O shame! Where is thy blush? Rebellious hell,
If thou canst mutine[21] in a matron's bones,
To flaming youth let virtue be as wax,
And melt in her own fire: proclaim no shame,
When the compulsive ardour gives the charge;
Since frost itself as actively doth burn,
And reason panders will.

QUEEN. O Hamlet, speak no more:
Thou turn'st mine eyes into my very soul;
And there I see such black and grained spots,
As will not leave their tinct.[22]

HAMLET. Nay, but to live
In the rank sweat of an enseam'd[23] bed;
Stew'd in corruption; honeying, and making love
Over the nasty stye;—

QUEEN. O, speak to me no more;
These words, like daggers, enter in mine ears;
No more, sweet Hamlet.

HAMLET. A murderer, and a villain:
A slave, that is not twentieth part the tythe[24]

[7]*dicers'*: gamblers
[8]*contraction*: marriage contract
[9]*tristful visage*: sorrowful face
[10]*the doom*: doomsday
[11]*counterfeit presentment*: forged image
[12]*Hyperion's*: a Titan, father of the sun
[13]*Jove*: the chief god
[14]*Mars*: god of war
[15]*Mercury*: god of commerce and gain (also, messenger of the gods)
[16]*batten*: feed abundantly on; grow fat
[17]*apoplex'd*: hemorrhaged
[18]*thrall'd*: enslaved
[19]*cozen'd you at hoodman-blind*: deceived you at blind-man's bluff (a game)
[20]*sans*: without
[21]*mutine*: revolt
[22]*leave their tinct*: abandon their shade (of color)
[23]*enseam'd*: loaded with grease; greasy
[24]*tythe*: tax

Of your precedent lord:—a vice of kings:
A cutpurse of the empire and the rule;
That from a shelf the precious diadem[25] stole,
And put it in his pocket!

QUEEN. No more.

Enter GHOST.

HAMLET. A king of shreds and patches:—
Save me, and hover o'er me with your wings,
You heavenly guards!—What would you, gracious figure?

QUEEN. Alas! he's mad.

HAMLET. Do you not come your tardy son to chide,
That, laps'd in time and passion, lets go by
The important acting of your dread command? O, say.

GHOST. Do not forget: This visitation
Is but to whet[26] thy almost blunted purpose.
But, Look! amazement on thy mother sits:
O, step between her and her fighting soul;
Conceit[27] in weakest bodies strongest works:
Speak to her, Hamlet.

HAMLET. How is it with you, lady?

QUEEN. Alas, how is 't with you?
That you do bend your eye on vacancy,
And with the incorporal[28] air do hold discourse?
Forth at your eyes your spirits wildly peep;
And as the sleeping soldiers in the alarm,
Your bedded hair, like life in excrements,[29]
Starts up, and stands on end. O gentle son,
Upon the heat and flame of thy distemper
Sprinkle cool patience. Whereon do you look?

HAMLET. On him! On him!—Look you, how pale he glares!
His form and cause conjoin'd, preaching to stones,
Would make them capable.—Do not look upon me;
Lest, with this piteous action, you convert
My stern effects: then what I have to do

Will want[30] true colour; tears, perchance, for blood.

QUEEN. To whom do you speak this?

HAMLET. Do you see nothing there?

QUEEN. Nothing at all; yet all that is I see.

HAMLET. Nor did you nothing hear?

QUEEN. No, nothing, but ourselves.

HAMLET. Why, look you there! look how it steals away!
My father, in his habit as he lived!
Look, where he goes, even now, out at the portal!

Exit GHOST.

QUEEN. This is the very coinage[31] of your brain:
This bodiless creation ecstasy
Is very cunning in.

HAMLET. Ecstasy!
My pulse, as yours, doth temperately keep time,
And makes as healthful music: It is not madness
That I have uttered: bring me to the test,
And I the matter will re-word; which madness
Would gambol[32] from. Mother, for love of grace,
Lay not that flattering unction[33] to your soul,
That not your trespass, but my madness, speaks:
It will but skin and film the ulcerous place;
Whiles rank corruption, mining all within,
Infects unseen. Confess yourself to heaven;
Repent what's past: avoid what is to come;
And do not spread the compost o'er the weeds,
To make them rank.[34] Forgive me this my virtue:
For in the fatness of these pursy[35] times,
Virtue itself of vice must pardon beg;
Yea, curb and woo, for leave to do him good.

QUEEN. O Hamlet! thou hast cleft my heart in twain.

HAMLET. O throw away the worser part of it,
And live the purer[36] with the other half.
Good night: but go not to mine uncle's bed;
Assume a virtue, if you have it not.

[25]*diadem:* crown
[26]*whet:* make keen
[27]*conceit:* a favorable opinion
[28]*incorporal:* unembodied
[29]*excrements:* waste matter
[30]*want:* lack
[31]*coinage:* currency
[32]*gambol:* leap
[33]*unction:* ointment
[34]*rank:* overgrown; strong-scented
[35]*pursy:* fat (with wind)
[36]*the purer:* more pure

That monster, custom, who all sense doth eat—
Of habits devil,—is angel yet in this,—
That to the use of actions fair and good
He likewise gives a frock, or livery,
That aptly is put on: Refrain to-night:
And that shall lend a kind of easiness
To the next abstinence: the next more easy;
For use[37] almost can change the stamp of nature,
And master the devil, or throw him out
With wondrous potency. Once more, good night:
And when you are desirous to be bless'd,
I'll blessing beg of you.—For this same lord,
(Pointing to POLONIUS*)*.
I do repent. But heaven hath pleas'd it so,—
To punish me with this, and this with me,
That I must be their scourge and minister.
I will bestow[38] him, and will answer well
The death I gave him. So again, good night!
I must be cruel, only to be kind:
Thus bad begins, and worse remains behind.—
One word more, good lady.

QUEEN. What shall I do?

HAMLET. Not this, by no means, that I bid you do:
Let the bloat king tempt you again to bed;
Pinch wanton on your cheek; call you his mouse;
And let him, for a pair of reechy[39] kisses,
Or padling in your neck with his damn'd fingers,
Make you to ravel[40] all this matter out,
That I essentially am not in madness,
But mad in craft.[41] 'Twere good you let him know:
For, who, that's but a queen, fair, sober, wise,
Would from a paddock,[42] from a bat, a gib,[43]
Such dear concernings hide? who would do so?
No, in despite of sense, and secrecy,
Unpeg the basket on the house's top,
Let the birds fly; and, like the famous ape,
To try conclusions, in the basket creep,
And break your own neck down.

QUEEN. Be thou assur'd, if words be made of breath,
And breath of life, I have no life to breathe
What thou hast said to me.

HAMLET. I must to England; you know that?

QUEEN. Alack.
I had forgot; 'tis so concluded on.

HAMLET. There's letters seal'd: and my two schoolfellows,—
Whom I will trust, as I will adders fang'd,—
They bear the mandate; they must sweep my way,
And marshal me to knavery: Let it work,
For 'tis the sport, to have the engineer
Hoist with his own petar:[44] and't shall go hard,
But I will delve one yard below their mines,
And blow them at the moon: O, 'tis most sweet,
When in one line two crafts directly meet.
This man shall set me packing.
I'll lug the guts[45] into the neighbour room:
Mother, good night.—Indeed, this counselor
Is now most still, most secret, and most grave
Who was in life a foolish prating knave.
Come, sir, to draw toward an end with you:
Good night, mother.

Exeunt severally; HAMLET *dragging in the body of* POLONIUS.

Act 4
Scene I—The same.

Enter KING and QUEEN.

KING. There's matter in these sighs: these profound
 heaves;
 You must translate: 'tis fit[1] we understand them:
 Where is your son?

QUEEN. Ah, my good lord, what have I seen to-night!

KING. What, Gertrude? How does Hamlet?

QUEEN. Mad as the seas, and wind, when both contend
 Which is the mightier: In his lawless fit,
 Behind the arras hearing something stir,
 He whips his rapier out, and cries, A *rat! a rat!*
 And, in his brainish[2] apprehension, kills
 The unseen good old man.

[37]*use*: habit
[38]*bestow*: stow
[39]*reechy*: smelly
[40]*ravel*: untangle
[41]*mad in craft*: acting mad on purpose
[42]*paddock*: toad
[43]*gib*: a male cat
[44]*Hoist with one's own petar*: beaten with one's own weapon
[45]*the guts*: that is, Polonius
[1]*fit*: fitting
[2]*brainish apprehension*: insane perception

KING. O heavy deed!
It had been so with us,[3] had we been there:
His liberty is full of threats to all;
To you yourself, to us, to every one.
Alas! how shall this bloody deed be answer'd?
It will be laid to us, whose providence[4]
Should have kept short, restrain'd, and out of
haunt,[5]
This mad young man: but, so much was our love,
We would not understand what was most fit;
But, like the owner of a foul disease,
To keep it from divulging,[6] let it feed
Even on the pith[7] of life. Where is he gone?

QUEEN. To draw apart[8] the body he hath kill'd:
Oer whom his very madness, like some ore,
Among a mineral of metals base,
Shows itself pure; he weeps for what is done.

KING. O, Gertrude, come away!
The sun no sooner shall the mountains touch,
But we will ship him hence: and this vile deed
We must, with all our majesty and skill,
BOTH countenance[9] and excuse,—Ho! Guildenstern!

Enter ROSENCRANTZ and GUILDENSTERN.

Friends both, go join you with some further aid:
Hamlet in madness hath Polonius slain,
And from his mother's closet hath he dragg'd him:
Go, seek him out; speak fair, and bring the body
Into the chapel. I pray you haste in this.

Exeunt ROS. and GUIL.

Come, Gertrude, we'll call up out wisest friends;
And let them know, both what we mean to do,
And what's untimely done: so haply,[10] slander,
Whose whisper o'er the world's diameter,
As level as the cannon to his blank,[11]
Transports his poison'd shot, may miss our name,
And hit the woundless air. O come away!
My soul is full of discord, and dismay.

Exeunt.

Scene II—Another Room in the same.

Enter HAMLET.

HAMLET. _____ Safely stowed,

ROS. & c. within. Hamlet! Lord Hamlet!

HAMLET. What noise? who calls on Hamlet? O, here
they come.

Enter ROSENCRENTZ and GUILDENSTERN.

ROSENCRANTZ. What have you done, my lord, with the
dead body?

HAMLET. Compounded it with dust, whereto 'tis kin.

ROSENCRANTZ. Tell us where 'tis; that we may take it
thence,
And bear it to the chapel.

HAMLET. Do not believe it.

ROSENCRANTZ. Believe what?

HAMLET. That I can keep your counsel, and not mine
own. Besides, to be demanded of a sponge!—what
replication[1] should be made by the son of a king?

ROSENCRANTZ. Take you me for a sponge, my lord?

HAMLET. Ay, sir! that soaks up the king's countenance,
his rewards, his authorities. But such officers do
the king best service in the end. He keeps them,
like an ape, in the corner of his jaw; first mouthed,
to be last swallowed: When he needs what you
have gleaned, it is but squeezing you, and, sponge,
you shall be dry again.

ROSENCRANTZ. I understand you not, my lord.

HAMLET. I am glad of it: A knavish speech sleeps in a
foolish ear.

ROSENCRANTZ. My lord, you must tell us where the body
is, and go with us to the king.

[3]*us*: me (the royal 'I')
[4]*providence*: divine foresight
[5]*out of haunt*: away from where others frequent
[6]*divulging*: making public
[7]*pith*: essence
[8]*draw apart*: hide
[9]*countenance*: approve
[10]*haply*: by chance
[11]*blank*: target's center
[1]*replication*: reply

HAMLET. The body is with the king, but the king is not with the body. The king is a thing—

GUILDENSTERN. A thing, my lord?

HAMLET. Of nothing: bring me to him. Hide fox, and all after.[2]

Exeunt.

Scene III—Another Room in the same.

Enter KING, *attended.*

KING. I have sent to seek him, and to find the body.
How dangerous is it that this man goes loose!
Yet must not we put the strong law on him:
He's lov'd of the distracted multitude,[1]
Who like not in their judgment, but their eyes;
And, where 'tis so, the offender's scourge[2] is weigh'd,
But never the offence. To bear[3] all smooth and even,
This sudden sending him away must seem
Deliberate pause[4]: Diseases, desperate grown,
By desperate appliance[5] are reliev'd,

Enter ROSENCRANTZ.

Or not at all.—How now? what hath befallen?

ROSENCRANTZ. Where the dead body is bestow'd, my lord,
We cannot get from him.

KING. But where is he?

ROSENCRANTZ. Without, my lord; guarded, to know your pleasure.

KING. Bring him before us.

ROSENCRANTZ. Ho, Guildenstern! Bring in my lord.

Enter HAMLET *and Guildenstern.*

KING. Now, Hamlet, where's Polonius?

HAMLET. At supper.

KING. At supper? Where?

HAMLET. Not where he eats, but where he is eaten: a certain convocation[6] of politic[7] worms are e'en at him. Your worm is your only emperor for diet: we fat all creatures else, to fat us; and we fat ourselves for maggots: Your fat king, and your lean beggar, is but variable service,[8] two dishes, but to one table; that's the end.

KING. Alas, alas!

HAMLET. A man may fish with the worm that hath eat of a king; and eat of the fish that hath fed of that worm.

KING. What dost thou mean by this?

HAMLET. Nothing but to show you how a king may go a progress[9] through the guts of a beggar.

KING. Where is Polonius?

HAMLET. In heaven, send thither to see: if your messenger find him not there, seek him i' the other place yourself. But indeed, if you find him not this month, you shall nose[10] him as you go up the stairs into the lobby.

KING. Go seek him there. *(To some* ATTENDANTS*).*

HAMLET. He will stay till you come.

Exeunt ATTENDANTS.

KING. HAMLET, this deed of thine[11] for thine especial safety,
Which we do tender, as we dearly grieve
For that which thou hast done, must send thee hence
With fiery quickness: Therefore, prepare thyself;
The bark[12] is ready, and the wind at help,
The associates tend, and everything is bent
For England.

HAMLET. For England?

[2]*Hide fox, and all after:* HAMLET refers to himself as a fox that must hide from those who would seek him out
[1]*of the distracted multitude:* by the confused people
[2]*scourge:* affliction
[3]*bear:* carry out
[4]*pause:* hesitation (due to planning)
[5]*by desperate appliance:* with desperate applications
[6]*convocation:* assembly
[7]*politic:* political; cunning
[8]*variable service:* varied dishes (of food)
[9]*go a progress:* travel
[10]*nose:* smell
[11]*thine:* yours
[12]*bark:* ship

KING. Ay, HAMLET.

HAMLET. Good.

KING. So is it, if thou knew'st our purposes.

HAMLET. I see a cherub, that sees him.—But, come; for England!—Farewell, dear mother.

KING. Thy loving father, HAMLET.

HAMLET. My mother: Father and mother is man and wife; man and wife is one flesh; and so, my mother. Come, for England.

Exit.

KING. Follow him at foot; tempt him with speed aboard; Delay it not, I'll have him hence[13] to-night: Away; for everything is seal'd and done That else leans[14] on the affair: Pray you, make haste.

Exeunt Ros. *and* GUIL.
And, England, if my love thou hold'st at aught,[15]
(As my great power thereof may give thee sense;
Since yet thy cicatrice[16] looks raw and red
After the Danish sword, and thy free awe
Pays homage to us,) thou mayst not coldly set
Our sovereign process; which imports at full,
By letters conjuring to that effect,
The present[17] death of HAMLET. Do it, England;
For like the hectic[18] in my blood he rages,
And thou must cure me: Till I know 'tis done,
Howe'er my haps, my joys were ne'er begun.

Exit.

Scene IV—A Plain in Denmark.

Enter FORTINBRAS, and Forses, marching.

FORTINBRAS. Go, captain, from me great the Danish king;
Tell him, that, by his licence, Fortinbras
Claims the conveyance of[1] a promis'd march
Over his kingdom. You know the rendezvous.
If that his majesty would aught with us,

We shall express our duty in his eye,
And let him know so.

CAPTAIN. I will do't, my lord.

FORTINBRAS. Go safety on. (*Exeunt* FORTINBRAS *and* FORCES).

Enter HAMLET, ROSENCRENTZ GUILDENSTERN. *&c.*

HAMLET. Good sir, whose powers are these?

CAPTAIN. They are of Norway, sir.

HAMLET. How proposed, sir, I pray you?

CAPTAIN. Against some part of Poland.

HAMLET. Who Commends them, sir?

CAPTAIN. The nephew to old Norway, Fortinbras.

HAMLET. Goes it against the main of Poland, sir, Or for some frontier?

CAPTAIN. Truly to speak, and with no addition,
We go to gain a little patch of ground,
That hath in it no profit but the name.
To pay five ducats, five, I would nor farm it;
Nor will it yield to Norway, or the Pole,
A ranker rate,[2] should it be sold in fee.

HAMLET. Why, then the Polack never will defend it.

CAPTAIN. Yes, 'tis already garrison'd[3]

HAMLET. Two thousand souls, and twenty thousand ducats,
Will not debate the question of this straw:
This is the imposthume[4] of much wealth and peace;
That inward breaks, and shows no cause without
Why the man dies.—I humbly thank you, sit.

CAPTAIN. God be wi' you, sir.

Exit CAPTAIN.

ROSENCRANTZ. Will't please you go, my lord?

HAMLET. I will be with you straight. Go a little before.

[13]*hence:* gone
[14]*leans:* relies
[15]*at aught:* at anything
[16]*cicatrice:* scar
[17]*present:* immediate
[18]*hectic:* intensity; fever
[1]*conveyance of:* transport of
[2]*ranker rate:* higher cost
[3]*garrison'd:* supplied with soldiers
[4]*imposthume:* festering sore

Exeunt Ros. and Guil.

How all occasions do inform against me,
And spur[5] my dull revenge! What is a man,
If his chief good, and market of his time,
Be but to sleep and feed? a beast, no more.
Sure, he, that made us with such large discourse,[6]
Looking before, and after, gave us not
That capability and godlike reason
To fust[7] in us unus'd. Now, whether it be
Bestial oblivion, or some craven[8] scruple
Of thinking too precisely, on the event,—
A thought, which, quarter'd, hath but one part
 wisdom,
And ever, three parts coward,—I do not know
Why yet I live to say, *This thing's to do;*
Sith[9] I have cause, and will, and strength, and means,
To do't. Examples, gross as earth, exhort me:
Witness, this army of such mass and charge,
Led by a delicate and tender prince;
Whose spirit, with divine ambition puff'd,
Makes mouths at the invisible event;[10]
Exposing what is mortal, and unsure,
To all that fortune, death, and danger, dare,
Even for an egg-shell. Rightly to be great,
Is, not to stir without great argument,
But greatly to find quarrel in a straw,
When honour's at the stake. How stand I then,
That have, a father kill'd, a mother stain'd,
Excitements of my reason, and my blood,
And let all sleep? while, to my shame, I see,
The imminent death of twenty thousand men,
That, for a fantasy and trick of fame,
Go to their graves like beds; fight for a plot[11]
Whereon the numbers cannot try the cause,[12]
Which is not tomb enough, and continent,
To hide the slain?—O, from this time forth,
My thoughts be bloody, or be nothing worth!

Exit.

Scene V—Elsinore. A Room in the Castle.

Enter QUEEN and HORATIO.

QUEEN. I will not speak with her.

HORATIO. She is importunate;[1] indeed, distract;[2]
 Her mood will needs be pitied.

QUEEN. What would she have?

HORATIO. She speaks much of her father; says, she
 hears,
 There's tricks i' the world; and hems, and beats her
 heart;
 Spurns enviously at straws;[3] speaks things in doubt,
 That carry but half sense; her speech is nothing,
 Yet the unshaped use of it doth move
 The hearers to collection;[4] they aim at it,
 And botch the words up fit to their own thoughts;
 Which, as her winks, and nods, and gestures yield
 them,
 Indeed would make one think there would be
 thought,
 Though nothing sure, yet much unhappily.

QUEEN. 'Twere good she were spoken with; for she may
 strew
 Dangerous conjectures in ill-breeding minds:
 Let her come in.

Exit HORATIO.

 To my sick soul, as sin's true nature is,
 Each toy[5] seems prologue to some great amiss:
 So full of artless jealousy is guilt,
 It spills itself, in fearing to be spilt.

Re-enter HORATIO with OPHELIA.

OPHELIA. Where is the beauteous majestry of Denmark?

[5]*spur:* both to spur on (incite) and spurn (kick)
[6]*discourse:* reasoning
[7]*fust:* grow moldy
[8]*craven:* cowardly
[9]*sith:* since
[10]*makes mouths at the invisible event:* taunts the unknown result
[11]*plot:* of land
[12]*number cannot try the cause:* the number of people who die cannot justify the motive
[1]*importunate:* troublesomely urgent
[2]*distract:* distracted; mad
[3]*spurns enviously at straws:* kicks against small matters
[4]*collection:* infer
[5]*toy:* trifle

QUEEN. How now, OPHELIA?

OPHELIA (sings). How should I your true love know
 From another one?
 By his cockle hat[6] and staff.
 And his sandal shoon.

QUEEN. Alas, sweet lady, what imports[7] this song?

OPHELIA. Say you? nay, pray you, mark.
 He is dead and gone, lady,
 He is dead and gone;
 At his head a grass-green turf,
 At his heels a stone.

QUEEN. Nay, but Ophelia,—

OPHELIA. Pray you, mark.
 White his shroud as the mountain snow.

Enter KING.

QUEEN. Alas, look here, my lord.

OPHELIA. Larded with sweet flowers:
 Which bewept to the grave did not go,
 With true-love showers.

KING. How do you, pretty lady?

OPHELIA. Well, God 'ield[8] you! They say, the owl was a baker's daughter.[9] Lord, we know what we are, but, know not what we may be. God be at your table!

KING. Conceit[10] upon her father.

OPHELIA. Pray you, let us have no words of this; but when they ask you what it means, say you this:
 To-morrow is Saint Valentine's day
 All in the morning betime,
 And I a maid at your window,
 To be your Valentine:
 Then up he rose, and donn'd his clothes
 And dupp'd[11] the chamber-door;
 Let in the maid, that out a maid
 Never departed more.

KING. Pretty Ophelia!

OPHELIA. Indeed, la, without an oath, I'll make an end
 on 't:
 By Gis,[12] and by Saint Charity,
 Alack, and fye for shame!
 Young men will do 't, if they come to 't;
 By cock[13] they are to blame.
 Quoth she, before you tumbled me,
 You promised me to wed:
 So would I ha' done, by yonder sun,
 An thou hadst not come to my bed.

KING. How long has she been thus?

OPHELIA. I hope, all will be well. We must be patient: but I cannot choose but weep, to think they should lay him i' the cold ground: My brother shall know of it, and so I thank you for your good counsel. Come, my coach! Good night, ladies; good night, sweet ladies; good night, good night. [*Exit*].

KING. Follow her close; give her good watch, I pray you.

Exit HORATIO.

 O! this is the poison of deep grief; it springs
 All from her father's death: O Gertrude, Gertrude,
 When sorrows come, they come not single spies,
 But in battalions! First, her father slain;
 Next, your son gone; and he most violent author
 Of his own just remove: The people muddied,
 Thick and unwholesome in their thoughts and whispers,
 For good Polonius' death; and we have done but greenly,
 In hugger-mugger[14] to inter him; Poor Ophelia,
 Divided from herself, and her fair judgment
 Without the which we are pictures, or mere beasts.
 Last, and as much containing as all these,
 Her brother is in secret come from France:
 Feeds on his wonder, keeps himself in clouds,
 And wants not buzzers[15] to infect his ear
 With pestilent speeches of his father's death;
 Wherein necessity, of matter beggar'd,
 Will nothing stick our persons to arraign

[6]*cockle hat*: a hat with a scallop shell on it, worn by pilgrims as a sign of their visit to St. James in Spain.
[7]*imports*: means
[8]*'ield*: yield; grant
[9]*owl was a baker's daughter*: refers to a folktale about a girl who was told to bake a cake for a stranger (who happened to be Christ) at the bakery, but baked only half a cake and was turned into an owl for making less.
[10]*conceit*: affection
[11]*dupp'd*: opened up
[12]*Gis*: short for Jesus
[13]*cock*: refers to both God and phallus
[14]*hugger-mugger*: secret confusion
[15]*buzzers*: bees; gossips

In ear and ear. O my dear Gertrude, this,
Like to a murdering piece, in many places
Gives me superfluous death. [*A noise within*].

QUEEN. Alack! what noise is this?

Enter a GENTLEMAN.

KING. Where are my switzers?[16] Let them guard the
 door:
What is the matter?

GENTLEMAN. Save yourself, my lord;
 The ocean, overpeering of his list,
 Eats not the flats with more impitious[17] haste,
 Than young Laertes, in a riotous head,[18]
 O'erbears your officers. The rabble call him, lord;
 And as the world were now but to begin,
 Antiquity forgot, custom not known,
 The ratifiers and props of every word,
 They cry, 'Choose we; Laertes shall be KING!'
 Caps, hands, and tongues, applaud it to the clouds,
 'Laertes shall be king, Laertes king!'

QUEEN. How cheerfully on the false trail they cry!
 O, this is counter,[19] you false Danish dogs.

KING. The doors are broke. [*Noise within*].

Enter LAERTES, *armed;* DANES *following.*

LAERTES. Where is the king?—Sirs, stand you all without.

DANES. No, let's come in.

LAERTES. I pray you, give me leave.

DANES. We will, we will (*They retire without the door*).

LAERTES. I thank you:—keep the door.—O thou vile
 king,
Give me my father.

QUEEN. Calmly, good Laertes.

LAERTES. That drop of blood that's calm, proclaims me
 bastard;
Cries, cuckold[20] to my father; brands the harlot
Even here, between the chaste unsmirched brow
Of my true mother.

KING. What is the cause, Laertes,
 That thy rebellion looks so giant-like?
 Let him go, Gertrude; do not fear our person;
 There's such divinity doth hedge[21] a king,
 That treason can but peep to what it would,
 Acts little of his will. Tell me, Laertes,
 Why thou art thus incensed;—Let him go,
 Gertrude;—
 Speak, man.

LAERTES. Where is my father?

KING. Dead.

QUEEN. But not by him

KING. Let him demand his fill.

LAERTES. How came he dead? I'll not be juggled with:
 To hell, allegiance! vows, to the blackest devil!
 Conscience, and grace, to the profoundest pit!
 I dare damnation: To this point I stand,—
 That both the worlds I give to negligence,
 Let come what comes; only I'll be revenged
 Most thoroughly for my father.

KING. Who shall stay[22] you?

LAERTES. My will, not all the world:
 And, for my means, I'll husband them so well,
 They shall go far with little.

KING. Good Laertes, If you desire to know the certainly
 Of your dear father's death, is't writ in your revenge,
 That, sweepstake,[23] you will draw both friend and foe,
 Winner and loser?

LAERTES. None but his enemies.

KING. Will you know them then?

LAERTES. To his good friends thus wide I'll ope my arms;
 And, like the kind life-rend'ring pelican[24]
 Repast[25] them with my blood.

KING. Why, now you speak
 Like a good child, and a true gentleman.
 That I am guiltless of your father's death,
 And am most sensibly in grief for it,

[16]*switzers:* Swiss men
[17]*impitious:* impiteous; lacking pity
[18]*in a riotous head:* in a disturbed frame of mind
[19]*counter:* contrary
[20]*cuckold:* a man whose wife has proved unfaithful
[21]*doth hedge:* that does surround
[22]*stay:* prevent
[23]*sweepstake:* all at once
[24]*pelican:* it was thought that pelicans fed their blood to their young
[25]*repast:* feed

It shall as level to your judgment pierce,
As day does to your eye.

DANES (*within*). Let her come in.

LAERTES. How now! what noise is that?

Enter OPHELIA, *fantastically dressed with straws and flowers.*

O heat, dry up my brains! tears, seven times salt,
Burn out the sense and virtue of mine eye!—
By heaven, thy madness shall be paid by weight,
Till out scale turns the beam.[26] O rose of May!
Dear maid, kind sister, sweet Ophelia!—
O heavens! is't possible, a young maid's wits
Should be as mortal as an old man's life?
Nature is fine in love: and, where 'tis fine,
It sends some precious instance of itself
After the thing it loves.

OPHELIA. They bore him barefac'd on the bier;
Hey non nonny, nonny, hey nonny;
And on his grave rains many a tear;—
Fare you well, my dove!

LAERTES. Hadst thou thy wits, and didst persuade revenge,
It could not move thus.

OPHELIA. You must sing, *Down-a down, an you call him a-down-a.*
O, how the wheel[27] becomes it! It is the false steward, that stole his master's daughter.

LAERTES. This nothing's more than matter.[28]

OPHELIA. There's rosemary, that's for remembrance; pray, love, remember: and there is pansies, that's for thoughts.

LAERTES. A document in madness; thoughts and remembrance fitted.

OPHELIA. There's fennel[29] for you, and columbines:[30]— there's rue for you and here's some for me:—we

may call it, herb-grace o' Sundays:[31]—oh you must wear your rue with a difference.—There's a daisy:[32]—I would give you some violets;[33] but they withered all, when my father died:—They say, he made a good end,—
For bonny sweet Robin is all my joy,—

LAERTES. Though and affiction, passion, hell, itself,
She turns to favour, and to prettiness.

OPHELIA. And will he not come again?
And will he not come again?
No, no, he is dead,
Go to thy death-bed,
He never will come again.
His beard is white as snow,
All flaxen was his poll:
He is gone, he is gone,
And we cast away moan;
Grammercy[34] on his soul!
And of all Christian souls! I pray God. God be wi' you!

Exit OPHELIA.

LAERTES. Do you see this, O God?

KING. Laertes, I must common[35] with your grief,
Or you deny me right. Go but apart,
Make choice of whom your wisest friends you will,
And they shall hear and judge 'twixt you and me:
If by the direct or by collateral hand
They find us touch'd, we will our kingdom give,
Our crown, our life, and all that we call ours,
To you in satisfaction; but, if not,
Be you content to lend your patient to us,
And we shall jointly labour with your soul
To give it due content.[36]

LAERTES. Let this be so.
His means of death, his obscure burial—
No trophy, sword, nor hatchment,[37] o'er his bones,
No noble rite, nor formal ostentation,—

[26]*scale turns the beam:* placing something on the scale moves the bar to indicate the weight
[27]*wheel:* dance
[28]*nothing's more than matter:* her nonsensical statements mean more than what usually matters
[29]*fennel:* may symbolize false praise
[30]*columbines:* an English plant that often connotes cuckoldry
[31]*herb-grace o' Sundays:* same as rue
[32]*daisy:* a common flower that may symbolize hypocrisy
[33]*violets:* may symbolize fidelity
[34]*grammercy:* God have mercy
[35]*common:* converse
[36]*content:* both satisfaction and substance
[37]*hatchment:* a shield depicting coat of arms

Cry to be heard, as 'twere from heaven to earth,
That I must call 't in question.

KING. So you shall;
And, where the offence is, let the great axe fall.
I pray you, go with me.

Exeunt.

Scene VI—Another Room in the same.

Enter HORATIO, *and a Servant.*

HORATIO. What are they that would speak with me?

SERVANT. Sailors, sir;
They say, they have letters for you

HORATIO. Let them come in. —

Exit Servant.

I do know from what part of the world
I should be greeted, if not from Lord Hamlet.

Enter Sailors.

I SAILOR. God bless you, sir.

HORATIO. Let him bless thee too.

I SAILOR. He shall, sir, an't please him. There's a letter
for you, sir, it comes from the ambassador that was
bound for England; if your name be Horatio, as I
am let to know it is.

HORATIO (*reads*). *Horatio*, when thou shalt have over-
looked[38] this, give these follows some means to the
kings; they have letters for him. Ere we were two
days old at sea, a pirate of very warlike appoint-
ment gave us chace:[39] Finding ourselves too slow
of sail, we put on a compelled valour; in the grap-
ple I boarded them: on the instant, they got clear
of our ship; so I alone became their prisoner. They
have dealt with me like thieves of mercy; but they
knew what they did; I am to do a good turn for
them. Let the king have the letters I have sent; and
repair thou to me[40] with as much haste as thou
wouldst fly death. I have words to speak in thine

ear, will make thee dumb; yet are they much too
light for the bore[41] of the matter. These good
fellows will bring thee where I am. *Rosencrantz*
and *Guildenstern* hold their course for England; of
them I have much to tell thee. Farewell.
He that thou knowest thine, *Hamlet.*
Come, I will give you way for these your letters;
And do't the speedier, that you may direct me
To him from whom you brought them.

Exeunt.

Scene VII—Another Room in the same.

Enter KING *and* LAERTES.

KING. Now must your conscience my acquittance seal,
And you must put me in your heart for friend;
Sith[1] you have heard, and with a knowing ear,
That he which hath your noble father slain,
Pursu'd my life.

LAERTES. It well appears: —But tell me,
Why you proceeded not against these feats,
So crimeful and so capital[2] in nature,
As by your safety, wisdom, all things else,
You mainly were stirred up.

KING. O, for two special reasons;
Which may to you, perhaps, seem much unsinew'd,
And yet to me they are strong. The queen, his
mother,
Lives almost by his looks; and for myself,
(My virtue, or my plague, be it either which,)
She's so conjunctive[3] to my life and soul,
That, as the star moves not but in his sphere,
I could not but by her.[4] The other motive,
Why to a public count I might not go,
Is the great love the general gender bear him:
Who, dipping all his faults in their affection,
Would, like the spring that turneth wood to stone,
Convert his gyves[5] to graces; so that my arrows,
Too slightly timber'd for so loud a wind,
Would have reverted to my bow again,
And not where I had aim'd them.

[38]*overlooked:* looked over
[39]*chace:* chase
[40]*repair thou to me:* meet me
[41]*bore:* deepness
[1]*sith:* since
[2]*capital:* a serious crime, deserving death as punishment
[3]*conjunctive:* conjoined
[4]*could not buy by her:* could not but go along with her
[5]*gyves:* fetters

LAERTES. And so have I a noble father lost;
A sister driven into desperate terms;
Whose worth, if praises may go back again,
Stood challenger on mount of all the age
For her perfections:—But my revenge will come.

KING. Break not your sleeps for that: you must not think
That we are made of stuff so flat and dull.
That we can let our beard be shook with danger,
And think it pastime. You shortly shall hear more:
I loved your father, and we love ourself;
And that, I hope, will teach you to imagine,—
How now? what news?

Enter a MESSENGER.

MESSENGER. Letters, my lord, from HAMLET;
This your majesty; this to the queen.

KING. From HAMLET! Who brought them?

MESSENGER. Sailors, my lord, they say: I saw them not.
They were given to me by Claudio, he receiv'd
them.

KING. Laertes, you shall hear them;—Leave us.

Exit Messenger.

(*Reads*). High and mighty, you shall know, I am
set naked on your kingdom. To-morrow shall I beg
leave to see your kingly eyes: when I shall, first ask-
ing your pardon thereunto, recount the occasions
of my sudden and more strange return.

HAMLET. What should this mean? Are all the rest come
back?
Or is it some abuse, or no such thing?

LAERTES. Know you the hand?

KING. 'Tis Hamlet's character. 'Naked,'—
And, in a postscript here, he says, 'alone:'
Can you advise me?

LAERTES. I am lost in it, my lord. But let him come:
It warms the very sickness in my heart,
That I shall live and tell him to his teeth.
Thus diddest thou.

KING. If it be so, Laertes,
As how should it be so? how otherwise?
Will you be rul'd by me?

LAERTES. If so you'll not o'er-rule me to a peace.

KING. To thine own peace. If he be now return'd,—
As checking at[6] his voyage, and that he means
No more to undertake it,—I will work him
To an exploit, now ripe in my device,
Under the which he shall not choose but fall;
And for his death no wind of blame shall breathe;
But even his mother shall uncharged the practice,
And call it, accident.

LAERTES. My lord, I will be rul'd:
The rather, if you could devise it so,
That I might be the organ.

KING. It falls right.
You have been talk'd of since your travel much,
And that in Hamlet's hearing, for a quality
Wherein, they say, you shine: your sum of parts
Did not together pluck such envy from him,
As did that one; and that, in my regard,
Of the unworthiest siege.

LAERTES. What part is that, my lord?

KING. A very riband[7] in the cap of youth,
Yet needful too; for youth no less becomes
The light and careless livery that it wears,
Than settled age his sables, and his weeds,
Importing health and graveness.—Some two
months hence,
Here was a gentleman of Normandy,—
I have seen myself, and serv'd against the French,
And they can well on horseback: but this gallant
Had witchcraft in't; he grew into his seat;
And to such wondrous doing brought his horse,
As he had been incorps'd and demi-natur'd[8]
With the brave beast: so far pass'd my thought,
That I, in forgery of shapes and tricks,
Come short of what he did.

LAERTES. A Norman, was't?

KING. A Norman.

LAERTES. Upon my life, Lamound.

KING. The very same.

LAERTES. I know him well: he is the brooch,[9] indeed,
And gem of all the nation.

[6]*checking at*: sharply turning from, as hawks turn in flight
[7]*riband*: ribbon
[8]*as he had been incorps'd and demi-natur'd*: as if he had been combined and showing half of his nature
[9]*brooch*: broach

KING. He made confession of you;
 And gave you such a masterly report,
 For art and exercise in your defence,
 And for your rapier most especially,
 That he cried out, 'twould be a sight indeed,
 If one could match you: the scrimers[10] of their nation,
 He swore, had neither motion, guard, nor eye,
 If you oppos'd them: Sir, this report of his
 Did Hamlet so envenom with his envy,
 That he could nothing do, but wish and beg
 Your sudden coming o'er, to play with him.
 Now, out of this,——

LAERTES. Why out of this, my lord?

KING. Laertes, was your father dear to you?
 Or are you like the painting of a sorrow,
 A face without a heart?

LAERTES. Why ask you this?

KING. Not that I think you did not love your father;
 But that I know love is begun by time;
 And that I see, in passages of proof,
 Time qualifies the spark and fire of it.
 There lives within the very flame of love
 A kind of wick, or snuff, that will abate it;
 And nothing is at a like goodness still;
 For goodness, growing to a plurisy[11]
 Dies in his own too-much: That we would do,
 We should do when we would; for this *would* changes,
 And hath abatements[12] and delays as many,
 As there are tongues, are hands, are accidents;
 And then this *should* is like a spendthrift sigh,
 That hurts by easing. But, to the quick o' the ulcer:[13]
 HAMLET comes back: What would you undertake,
 To show yourself your father's son in deed
 More than in words?

LAERTES. To cut his throat i' the church.

KING. No place, indeed, should murder sanctuarize;
 Revenge should have no bounds. But, good Laertes,
 Will you do this, keep close within your chamber?

Hamlet, return'd, shall know you are come home:
 We'll put on those shall praise your excellence,
 And set a double varnish on the fame
 The Frenchman gave you; bring you, in fine, together
 And wager on your heads: he, being remiss,
 Most generous, and free from all contriving,
 Will not peruse[14] the foils; so that, with ease,
 Or with a little shuffling, you may choose
 A sword unbated,[15] and, in a pass of practice,
 Requite him for your father.

LAERTES. I will do 't:
 And, for that purpose, I'll anoint my sword.
 I bought an unction of a mountebank,[16]
 So mortal, that but dip a knife in it,
 Where it draws blood, no cataplasm[17] so rare,
 Collected from all simples[18] that have virtue
 Under the moon, can save the thing from death,
 That is but scratch'd withal: I 'll touch my point
 With this contagion; that, if I gall him slightly,
 It may be death.

KING. Let's further think of this;
 Weigh, what convenience, both of time and means,
 May fit us to our shape: if this should fail,
 And that our drift look through our bad performance,
 'Twere beter not essay'd;[19] therefore this project
 Should have a back, or second, that might hold,
 If this should blast in proof. Soft;—let me see:—
 We'll make a solemn wager on your commings,[20]—
 I ha 't.
 When in your motion you are hot and dry,
 (As make your bouts more violent to that end,)
 And that he calls for drink, I'll have prepar'd him
 A chalice for the nonce;[21] whereon but sipping,
 If he by chance escape your venom'd stuck,
 Our purpose may hold there.

Enter QUEEN.
 How now, sweet queen?

QUEEN. One woe doth tread upon another's heel,
 So fast they follow:—Your sister 's drown'd, Laertes.

[10]*scrimers:* fencers
[11]*plurisy:* dangerous inflammation
[12]*abatements:* deductions
[13]*ulcer:* infection; problem
[14]*peruse:* examine
[15]*unbated:* not blunted
[16]*an unction of a mountebank:* an ointment from a quack
[17]*cataplasm:* a poultice; plaster
[18]*simples:* herbs used for medicine
[19]*essay'd:* tested
[20]*commings:* craftiness
[21]*nonce:* occasion

LAERTES. Drown'd!—O, where?

QUEEN. There is a willow grows aslant a brook,
That shows his hoar leaves in the glassy stream;
There, with fantastic garlands did she come,
Of crow-flowers, nettles, daisies, and long purples,
That liberal²² shepherds give a grosser name,
But our cold maids do dead men's fingers call
them:
There, on the pendent boughs her coronet weeds
Clambering to hang, an envious sliver broke;
When down the weedy trophies, and herself,
Fell in the weeping brook. Her clothes spread
wide;
And, mermaid-like, a while they bore her up:
Which time, she changed snatches of old tunes;
As one incapable of her own distress,
Or like a creature native and indued
Unto that element: but long it could not be,
Till that her garments, heavy with their drink,
Pull'd the poor wretch from her melodious lay²³
To muddy death.

LAERTES. Alas then, is she drown'd?

QUEEN. Drown'd, drown'd.

LAERTES. Too much of water hast thou, poor OPHELIA,
And therefore I forbid my tears: But yet
It is our trick; nature her custom holds,
Let shame say what it will: when these are gone,
The woman will be out.—Adieu, my lord !
I have a speech of fire that fain would blaze,
But that this folly douts²⁴ it.

Exit.

KING. Let's follow, Gertrude;
How much I had to do to calm his rage!
Now fear I this will give it start again;
Therefore let's follow.

Exeunt.

ACT 5.
Scene I—A Churchyard.

Enter two CLOWNS,¹ with SPADES, &c.

1 CLOWN. Is she to be buried in Christian burial, that wilfully seeks her own salvation?²

2 CLOWN. I tell thee, she is; and therefore make her grave straight: the crowner has sate³ on her, and finds it a Christian burial.

1 CLOWN. How can that be, unless she drowned herself in her own defence?

2 CLOWN. Why, 'tis found so.

1 CLOWN. It must be *se offendendo;*⁴ it cannot be else. For here lies the point: If I drown myself wittingly, it argues an act: and an act hath three branches; it is, to act, to do, and to perform: argal,⁵ she drowned herself wittingly.

2 CLOWN. Nay, but hear you, goodman delver.⁶

1 CLOWN. Give me leave. Here lies the water; good: here stands the man; good: If the man go to this water, and drown himself, it is, will he, nill he,⁷ he goes; mark you that? but if the water come to him, and drown him, he drowns not himself: argal, he, that is not guilty of his own death, shortens not his own life.

2 CLOWN. But is this law?

1 CLOWN. Ay, marry is't; crowner's-quest law.⁸

2 CLOWN. Will you ha' the truth on 't? If this had not been a gentlewoman, she should have been buried out of⁹ Christian burial.

1 CLOWN. Why, there thou say'st: And the more pity, that great folks should have countenance in this

²²*liberal:* crude
²³*lay:* song
²⁴*douts:* douses
¹*clowns:* country fellows
²*that willfully seeks her own salvation:* who commits suicide
³*crowner has sate:* coroner has say over
⁴*se offendendo:* that is, se defendendo, Latin for "in self defense"
⁵*argal:* ergo; therefore
⁶*delver:* digger (with a spade)
⁷*will he, nill he:* willynilly (whether one wishes it or not)
⁸*crowner's-quest law:* coroner's inquest law
⁹*out of:* outside of; without

would to drown or hang themselves more than their even Christian.[10] Come, my spade. There is no ancient gentlemen but gardeners, ditchers, and grave-makers; they hold up Adam's profession.

2 CLOWN. Was he a gentleman?

1 CLOWN. He was the first that ever bore arms.

2 CLOWN. Why, he had none.

1 CLOWN. What, art a heathen? How dost thou understand the scripture? The scripture says, Adam digged; Could he dig without arms? I 'll put another question to thee: If thou answerest me not to the purpose, confess thyself—

2 CLOWN. Go to.

1 CLOWN. What is he, that builds stronger than either the mason, the shipwright, or the carpenter?

2 CLOWN. The gallows-maker; for that frame outlives a thousand tenants.

1 CLOWN. I like thy wit well, in good faith; the gallows does well: but how does it well? it does well to those that do ill: now thou dost ill to say, the gallows is built stronger than the church; argal, the gallows may do well to thee. To't again; come.

2 CLOWN. Who builds stronger than a mason, a shipwright, or a carpenter?

1 CLOWN. Ay, tell me that, and unyoke.[11]

2 CLOWN. Marry, now I can tell.

1 CLOWN. To 't.

2 CLOWN. Mass,[12] I cannot tell.

Enter HAMLET *and* HORATIO *at a distance.*

1 CLOWN. Cudgel thy brains no more about it; for your dull ass will not mend his pace with beating: and when you are asked this question next, say a grave-maker; the houses that he makes last til doomsday. Go, get thee to Yaughan; fetch me a stoup[13] of liquor.

Exit 2 CLOWN.

1 CLOWN *digs, and sings.*

> In youth, when I did love, did love,
> Methought, it was very sweet,
> To contract, O, the time, for, ah, my behove
> O, methought, there was nothing meet.

HAMLET. Hath this fellow no feeling of his business, that he sings at grave-making?

HORATIO. Custom[14] hath made it in him a property of easiness.

HAMLET. 'Tis e'en so: the hand of little employment hath the daintier sense.

1 CLOWN. But age with his stealing steps,
> Hath caught me in his clutch,
> And hath shipped me intill the land,
> As if I had never been such.

Throws up a scull.

HAMLET. That scull[15] had a tongue in it, and could sing once: How the knave jowls[16] it to the ground as if it were Cain's jaw-bone, that did the first murther! It might be the pate of a politician, which this ass o'er-offices;[17] one that could circumvent God, might it not?

HORATIO. It might, my lord.

HAMLET. Or of a courtier; which could say, 'Good-morrow, sweet lard! How dost thou, good lord?' This might be my lord Such-a-one, that praised my lord Such-a-one's horse, when he meant to beg it; might it not?

HORATIO. Ay, my lord.

HAMLET. Why, e'en so: and now my lady Worm's; chapless, and knocked about the mazzard[18] with a sexton's spade: Here's fine revolution, if we had the trick to see't. Did these bones cost no more the breeding, but to play at loggats[19] with them? mine ache to think on't.

[10]*even Christian:* fellow Christian
[11]*unyoke:* disjoin
[12]*mass:* by the mass
[13]*stoup:* flask
[14]*custom:* frequent repetition
[15]*scull:* skull
[16]*jowls:* tosses
[17]*o'er-offices:* holds office over; towers over
[18]*muzzard:* muzzle; head
[19]*loggats:* a game with wooden pieces

1 CLOWN. A pick-axe, and a spade, a spade,
For—and a shrouding sheet:
O, a pit of clay for to be made
For such a guest is meet. *(Throws up a scull).*

HAMLET. There's another! Why might not that be the scull of a lawyer? Where be his quiddits[20] now, his quillets,[21] his cases, his tenures, and his tricks? Why does he suffer this rude knave now to knock him about the sconce with a dirty shovel, and will not tell him of his action of battery? Humph! This fellow might be in's time a great buyer of land, with his statutes, his recognizances, his fines, his double vouchers, his recoveries: Is this the fine of his fines, and the recovery of his recoveries, to have his fine pate full of fine dirt? will his vouchers vouch him no more of his purchases, and double ones too, than the length and breadth of a pair of indentures? The very conveyances of his lands will hardly lie in this box; and must the inheritor himself have no more? ha!

HORATIO. Not a jot more, my lord.

HAMLET. Is not parchment made of sheep-skins?

HORATIO. Ay, my lord, and of calves'-skins too.

HAMLET. They are sheep, and calves, that seek out assurance in that. I will speak to this fellow:—Whose grave's this, sir?

1 CLOWN. Mine, sir.—
O, a pit of clay for to be made For such a guest is meet.

HAMLET. I think it be thine, indeed; for thou liest[22] in't.

1 CLOWN. You lie out on't, sir, and therefore it is not yours: for my part, I do not lie in 't, and yet it is mine.

HAMLET. tThou dost lie in't to be in 't, and say it is thine: 'tis for the dead, not for the quick;[23] therefore thou liest.

1 CLOWN. 'Tis a quick lie, sir; 'twill away again, from me to you.

HAMLET. What man dost thou dig it for?

1 CLOWN. For no man, sir.

HAMLET. What woman then?

1 CLOWN. For none neither.

HAMLET. Who is to be buried in't?

1 CLOWN. One that was a woman, sir; but, rest her soul, she's dead.

HAMLET. How absolute the knave is! we must speak by the card, or equivocation[24] will undo us. By the lord, Horatio, these three years I have taken not of it; the age is grown so picked,[25] that the toe of the peasant comes so near the heel of the courtier, he galls his kibe.[26]—How long hast thou been a grave-maker?

1 CLOWN. Of all the days I' the year, I' came to 't that day that our last king Hamlet o'ercame Fortinbras.

HAMLET. How long is that since?

1 CLOWN. Cannot you tell that? every fool can tell that: It was the very day that young Hamlet was born: he that was mad, and sent into England.

HAMLET. Ay, marry, why was he sent into England?

1 CLOWN. Why, because he was mad: he shall recover his wits there; or, if he do not, it's no great matter there!

HAMLET. Why?

1 CLOWN. 'Twill not be seen in him; there the men are as mad as he.

HAMLET. How came he mad?

1 CLOWN. Very strangely, they say.

HAMLET. How strangely?

1 CLOWN. 'Faith, e'en with losing his wits.

HAMLET. Upon what ground?

1 CLOWN. Why, here in Denmark. I have been sexton here, man and boy, thirty years.

HAMLET. How long will a man lie i' the earth ere he rot?

[20]*quiddits:* "whatness," that which is described in a definition
[21]*quillets:* subtle distinctions; essence of a thing
[22]*liest:* lies, both inside it and not telling the truth
[23]*quick:* living
[24]*equivocation:* using words that mean more than one thing
[25]*picked:* choice (best)
[26]*galls his kibe:* irritates a painful swelling on the heel (usually due to cold weather)

1 CLOWN. 'Faith, if he be not rotten before he die, (as we have many pocky corses[27] now-a-days, that will scarce hold the laying in,) he will last you some eight year, or nine year: a tanner will last you nine year.

HAMLET. Why he more than another?

1 CLOWN. Why, sir, his hide is so tanned with his trade, that he will keep out water a great while; and your water is a sore decayer of your whoreson dead body. Here's a scull now: this scull has lain in the earth three-and-twenty years.

HAMLET. Whose was it?

1 CLOWN. A whoreson mad fellow's it was; Whose do you think it was?

HAMLET. Nay, I know not.

1 CLOWN. A pestilence on him for a mad rogue! a poured a flagon of Rhenish[28] on my head once. This same scull, sir; this same scud, sir, was Yorick's scull, the king's jester.

HAMLET. This?

1 CLOWN. E'en that.

HAMLET. Let me see. Alas, poor Yorick!—I knew him, Horatio; a fellow of infinite jest, of most excellent fancy: he hath borne me on his back a thousand times; and now how abhorred my imagination is! my gorge[29] rises at it. Here hung those lips that I have kissed I know not how oft. Where be your gibes[30] now? Your gambols?[31] your songs? your flashes of merriment, that were wont to set the table on a roar? Not one now, to mock your own jeering? quite chapfallen?[32] Now get you to my lady's chamber, and tell her, let her paint an inch thick, to this favour she must come; make her laugh at that.—Prithee, Horatio, tell me one thing.

HORATIO. What's that, my lord?

HAMLET. Dost thou think Alexander looked o' this fashion i' the earth?

HORATIO. E'en so.

HAMLET. And smelt so? pah! (Throws down the scull).

HORATIO. E'en so, my lord.

HAMLET. To what base uses we may return, Horatio! Why may not imagination trace the noble dust of Alexander, till he find it stopping a bung-hole?[33]

HORATIO. 'Twere to consider too curiously, to consider so.

HAMLET. No, faith, not a jot; but to follow him thither with modesty enough, and likelihood to lead it. As thus; Alexander died. Alexander was buried, Alexander returneth into dust; the dust is earth; of earth we make loam: And why of that loam, whereto he was converted, might they not stop a beer-barrel?
Imperial Caesar, dead, and turn'd to clay,
Might stop a hole to keep the wind away:
O, that that earth, which kept the world in awe,
Should patch a wall to expel the winter's flaw![34]
But soft! but soft! aside:—Here comes the king.

Enter Priests, &c. in procession; the corpse of OPHELIA, LAERTES and Mourners following; KING, QUEEN, their Trains, &c.

The queen, the courtiers: Who is that they follow?
And with such maimed[35] rites! This doth betoken,
The corse they follow did with desperate hand
Fordo[36] its won life. 'Twas of some estate:
Couch we a while, and mark (Retiring with HORATIO).

LAERTES. What ceremony else?

HAMLET. This is Laertes,
A very noble youth: Mark.

LAERTES. What ceremony else?

[27]*pocky corses*: people (now corpses) who died from smallpox (with signs of skin eruptions)
[28]*a poured a flagon of Rhenish*: he poured a flask of Rhein wine
[29]*gorge*: throat
[30]*gibes*: taunts (perhaps also refers to giblets, entrails)
[31]*gambols*: leaps (in Latin *gamba* _ leg)
[32]*chapfallen*: variant of chopfallen (fallen jaw); cast down
[33]*bung-hole*: hole in a barrel for a cork
[34]*flaw*: a gust of wind
[35]*maimed*: curtailed
[36]*fordo*: undid

1 PRIEST. Her obsequies have been as far enlarg'd
 As we have warrantise:[37] her death was doubtful;[38]
 And, but that great command o'ersways the order,
 She should in ground unsanctified have logd'd
 Till the last trumpet; for charitable prayers,
 Shards, flints, and pebbles should be thrown on her,
 Yet here she is allowed her virgin rites,
 Her maiden strewments, and the bringing home
 Of bell and burial.

LAERTES. Must there no more be done?

1 PRIEST. No more be done
 We should profane the service of the dead,
 To sing sage[39] *requiem*, and such rest to her,
 As to peace-parted souls.

LAERTES. Lay her i' the earth;
 And from her fair and unpolluted flesh
 May violets spring! I tell thee, churlish priest,
 A minist'ring angel shall my sister be,
 When thou liest howling.

HAMLET. What, the fair Ophelia!

QUEEN. Sweets to the sweet: Farewell! (*Scattering flowers*).
 I hop'd thou shouldst have been my Hamlet's wife;
 I thought thy bride-bed to have deck'd,[40] sweet maid,
 And not t' have strew'd thy grave.

LAERTES. O, treble woe
 Fall ten times treble[41] on that cursed head,
 Whose wicked deed thy most ingenious sense
 Deprived thee of!—Hold off the earth a while,
 Till I have caught her once more in mine arms:

Leaps into the grave.

 Now pile your dust upon the quick and dead;
 Till of this flat a mountain you have made,
 To o'er-top old Pelion,[42] or the skyish head
 Of blue Olympus.[43]

HAMLET (*advancing*). What is he, whose grief
 Bears such an emphasis? whose phrase of sorrow

Conjures the wand'ring stars, and makes them stand
 Like wonder-wounded hearers? this is I,
 Hamlet the Dane. (*Leaps int the grave*).

LAERTES. The devil take thy soul! (*Grappling with him*).

HAMLET. Thou pray'st not well.
 I prithee,[44] take thy fingers from my throat;
 Sir, though I am not splenetive[45] and rash,
 Yet have I something in me dangerous,
 Which let thy wiseness fear: Away thy hand.

KING. Pluck them asunder.

QUEEN. Hamlet, Hamlet!

GENTLEMEN. Good my lord, be quiet.

The ATTENDANTS part them, and they come out of the grave.

HAMLET. Why, I will fight with him upon this theme,
 Until my eyelids will no longer wag.

QUEEN. O my son! What theme?

HAMLET. I lov'd Ophelia; forty thousand brothers
 Could not, with all their quantity of love,
 Make up my sum.—What wilt thou do for her?

KING. O, he is mad, Laertes.

QUEEN. For love of God, forbear him.

HAMLET. Come, show me what thou 'it do:
 Woul't weep? Woul't fight? Woul't fast? Woul't tear thyself?
 Woul't drink up Esil?[46] eat a crocodile?
 I'll do 't.—Dost thou come here to whine?
 To outface me with leaping in her grave?
 Be buried quick with her, and so will I;
 And, if thou prate of mountains, let them throw
 Millions of acres on us; till our ground,
 Singeing his pate against the burning zone,
 Make Ossa like a wart![47] Nay, an thou'lt mouth,
 I'll rant as well as thou.

[37]*warrantise*: judged
[38]*doubtful*: undetermined; suspicious
[39]*sage*: wise
[40]*I thought they bride-bed to have deck'd*: I imagined I would be strewing flowers over your bridal bed instead
[41]*treble*: triple
[42]*Pelion*: a mountain of Thessaly which giants placed on Mt. Ossa in order to attack Mt. Olympus
[43]*Olympus*: mountain where the Olympian gods live
[44]*prithee*: pray you
[45]*splenetive*: from the spleen, the organ from which anger and melancholy was once thought to reside.
[46]*Esil*: vinegar (also spelled eisell, from the Latin of acetum and Old French, aisil)
[47]*Make Ossa like a wart*: make Mt. Ossa seem small

QUEEN. This is mere madness:
And thus a while the fit will work on him;
Anon, as patient as the female dove,
When that her golden couplets are disclos'd,[48]
His silence will sit dropping.

HAMLET. Hear you, sir;
What is the reason that you use me thus?
I lov'd you ever: But it is no matter;
Let Hercules himself do what he may,
The cat will mew, and dog will have his day.

Exit.

KING. I pray you, good Horatio, wait upon him.[49]—.

Exit HORATIO.

Strengthen your patience in our last night's speech;

(To LAERTES).

We'll put the matter to the present push.—
Good Gertrude, set some watch over your son.—
This grave shall have a living monument:
An hour of quiet shortly shall we see;
Till then, in patience our proceeding be.

Exeunt.

Scene II—A Hall in the Castle.

Enter HAMLET and HORATIO.

HAMLET. So much for this, sir: now let me see the other;
You do remember all the circumstance?

HORATIO. Remember it, my lord!

HAMLET. Sir, in my heart there was a kind of fighting,
That would not let me sleep: methought, I lay
Worse than the mutines in the bilboes.[1] Rashly
And praised be rashness for it,—Let us know,
Our indiscretion sometimes serves us well,
When our dear plots do pall[2]; and that should
teach us,

There's a divinity that shapes our ends,
Rough-hew them how we will.

HORATIO. That is most certain.

HAMLET. Up from my cabin,
My sea-gown scarf'd about me, in the dark
Grop'd I to find out them: had my desire;
Finger'd[3] their packed; and, in fine, withdrew
To mine own room again: making so bold,
My fears forgetting manners, to unseal
Their grand commission; where I found, Horatio,
O royal knavery, an exact command,
Larded with many several sorts of reasons.
Importing Denmark's health, and England's too,
With, ho! such bugs and goblins in my life,
That, on the supervise,[4] no leisure bated.[5]
No, not to stay[6] the grinding of the axe,
My head should be struck off.

HORATIO. Is't possible?

HAMLET. Here's the commission; read it at more
leisure.
But wilt thou hear me how I did proceed?

HORATIO. Ay. 'beseech you.

HAMLET. Being thus benetted[7] round with villains,
Ere[8] I could make a prologue to my brains,
They had begun the play; I sat me down;
Devis'd new commission; wrote it fair:[9]
I once did hold it, as our statists do,
A baseness to write fair, and labour'd much
How to forget that learning; but, sir, now
It did me yeoman's[10] service: Wilt thou know
The effects of what I wrote?

HORATIO. Ay, good my lord.

HAMLET. An earnest conjuration[11] from the king,—
As England was his faithful tributary;
As love between them as the palm should flourish;
As peace should still her wheaten garland wear,

[48]*disclos'd:* hatched
[49]*wait upon him:* wait to do anything regarding him
[1]*mutines in the bilboes:* mutineers in shackles
[2]*pall:* become insipid; dull
[3]*finger'd:* stole
[4]*supervise:* inspection of the letter
[5]*bated:* allowed
[6]*stay:* prevent
[7]*benetted:* trapped
[8]*ere:* before
[9]*fair:* in an exalted style, as a king would write
[10]*yeoman's:* powerful aid
[11]*conjuration:* a solemn invocation

And stand a comma 'tween their amities;[12]
And many such like as's[13] of great charge,—
That on the view and know of these contents,
Without debatement further, more, or less,
He should the bearers put to sudden death,
Not shriving-time[14] allow'd.

HORATIO. How was this seal'd?[15]

HAMLET. Why, even in that was heaven ordinate;
I had my father's signet[16] in my purse,
Which was the model of that Danish seal:
Folded the writ up in form of the other;
Subscrib'd it; gave't the impression; plac'd it safely,
The changeling never known:[17] Now, the next day
Was our sea-fight: and what to this was sequent[18]
Thou know'st already.

HORATIO. So Guildenstern and Rosencrantz go to 't.

HAMLET. Why, man, they did make love to this employment;
They are not near my conscience; their defeat
Does by their own insinuation grow:
'Tis dangerous, when the baser nature comes
Between the pass and fell incensed points[19]
Of mighty opposites.

HORATIO. Why, what a king is this!

HAMLET. Does it not, think'st thee, stand me now upon—
He that bath kill'd my king, and whor'd my mother;
Popp'd in between the election[20] and my hopes;
Thrown out his angle[21] for my proper life,
And with such cozenage;[22] is't not perfect conscience,
To quit him[23] with this arm? and is't not to be damn'd,
To let this canker of our nature come
In[24] further evil?

HORATIO. It must be shortly known to him from England,
What is the issue of the business there.

HAMLET. It will be short: the interim is mine;
And a man's life's no more than to say, one.
But I am very sorry, good Horatio,
That to Laertes I forgot myself;
For by the image of my cause, I see
The portraiture of his: I'll count his favours:
But, sure, the bravery of his grief did put me
Into a towering passion.

HAMLET. Peace; who comes here?

Enter OSRIC.

OSRIC. Your lordship is right welcome back to Denmark.

HAMLET. I humbly thank you, sir.—Dost know this water-fly?

HORATIO. No, my good lord.

HAMLET. Thy state is the more gracious; for 'tis a vice to know him: He hath much land, and fertile; let a beast be lord of beasts, and his crib shall stand at the king's mess:[25] 'Tis a chough;[26] but, as I say, spacious in the possession of dirt.

OSRIC. Sweet lord, if your friendship were at leisure, I should impart a thing to you from his majesty.

HAMLET. I will receive it with all diligence of spirit: Put your bonnet[27] to his right use; 'tis for the head.

OSRIC. I thank your lordship, 'tis very hot.

HAMLET. No, believe me, 'tis very cold; the wind is northerly.

OSRIC. It is indifferent cold, my lord, indeed.

[12]*amities:* friendship
[13]*as's:* pun on assess
[14]*shriving-time:* time to hear confessions and give absolutions
[15]*seal'd:* official letters had to bear the wax seal of the king
[16]*signet:* a royal seal
[17]*changeling never known:* no one knew of the switched letter
[18]*was sequent:* followed
[19]*pass and fell incensed points:* thrust and very angered jabs
[20]*election:* electing a successor (as was done in Denmark)
[21]*his angle:* line and hook
[22]*cozenage:* deception
[23]*quit him:* requite; repay
[24]*canker of our nature come in:* ulcerous sore of our established order commit
[25]*crib shall stand at the king's mess:* oxen-stall shall stand in for the king's dining room
[26]*chough:* crow
[27]*bonnet:* cap

HAMLET. Methinks it is very sultry and hot, for my complexion.

OSRIC. Exceedingly, my lord; it is very sultry,—as 'twere,—I cannot tell how.—But, my lord, his majesty bade me signify to you, that he has laid a great wager on your head: Sir, this is the matter.

HAMLET. I beseech you, remember—

HAMLET moves him to put on his hat.

OSRIC. Nay, in good faith; for mine ease, in good faith. Sir, here is newly come to court, Laertes: believe me, an absolute gentleman, full of most excellent differences, of very soft society, and great showing: Indeed, to speak feelingly of him, he is the card or calendar of gentry, for you shall find in him the continent of what part a gentleman would see.

HAMLET. Sir, his definement suffers no perdition[28] in you;—though, I know, to divide him inventorially, would dizzy the arithmetic of memory; and yet but raw neither,[29] in respect of his quick sail. But, in the verity of extolment,[30] I take him to be a soul of great article; and his infusion so such dearth and rareness, as, to make true diction of him, his semblable[31] is his mirror; and, who else would trace him, his umbrage,[32] nothing more.

OSRIC. Your lordship speaks most infallibly of him.

HAMLET. The concernancy,[33] sir? why do we wrap the gentleman in our more rawer breath?

OSRIC. Sir?

HORATIO. Is't not possible to understand in another tongue? You will do't, sir, really.

HAMLET. What imports the nomination of this gentleman?

OSRIC. Of Laertes?

HORATIO. His purse is empty already; all his golden words are spent.

HAMLET. Of him, sir.

OSRIC. I know, you are not ignorant—

HAMLET. I would, you did sir; yet, in faith, if you did, it would not much approve[34] me.—Well, sir.

OSRIC. You are not ignorant of what excellence Laertes is at his weapon.

HAMLET. I dare not confess that, lest I should compare with him in excellence; but, to know a man well, were to know himself.

OSRIC. I mean, sir, for his weapon; but in the imputation[35] laid on him by them, in his meed[36] he's unfellowed.

HAMLET. What's his weapon?

OSRIC. Rapier and dagger.

HAMLET. That' two of his weapons: but, well.

OSRIC. The king, sir, hath waged with him six Barbary horses: against the which he has imponed,[37] as I take it, six French rapiers and poniards, with their assigns,[38] as girdle, hangers, or so: Three of the carriages, in faith, are very dear to fancy, very responsive to the hilts, most delicate carriages, and of very liberal conceit.[39]

HAMLET. What call you the carriages?[40]

HORATIO. I knew you must be edified by the margent,[41] ere you had done.

OSRIC. The carriages, sir, are the hangers.

HAMLET. The phrase would be more german[42] to the matter, if we could carry cannon by our sides: I would it might be hangers[43] till then. But, on: Six

[28]*perdition:* ruin
[29]*yet but raw neither:* yet not inexperienced
[30]*verity of extolment:* truth of praise
[31]*semblable:* image
[32]*umbrage:* shadow (from Latin, *umbra*)
[33]*concernancy:* concern; business regarding Laertes
[34]*approve:* commend
[35]*imputation:* charges; attributes
[36]*meed:* merit
[37]*imponed:* pledged
[38]*assigns:* supplements
[39]*of very liberal conceit:* generously fanciful
[40]*carriages:* used to transport cannons and other heavy artillery
[41]*edified by the margent:* would need to be eased to the limit
[42]*german:* germane; relevant
[43]*hangers:* a strap on the swordbelt from which the sword was hung, usually ornamented

Barbary horses against six French swords, their assigns, and three liberal conceited carriages; that's the French bet against the Danish: Why is this imponed, as you call it?

OSRIC. The king, sir, hath laid, that in a dozen passes between you and him, he shall not exceed you three hits; he hath laid on twelve for nine; and that would come to immediate trial, if your lordship would vouchsafe the answer.

HAMLET. How, if I answer no?

OSRIC. I mean, my lord, the opposition of your person in trial.

HAMLET. Sir. I will walk here in the hall. If it please his majesty, it is the breathing time[44] of day with me: let the foils be brought, the gentleman willing, and the king hold his purpose. I will win for him, if I can; if not, I will gain nothing but my shame, and the odd hits.

OSRIC. Shall I re-deliver you e'en so?

HAMLET. To this effect, sir; after what flourish you nature will.

OSRIC. I commend my duty to your lordship.

Exit.

HAMLET. Yours, yours. He does well to commend it himself; there are no tongues else for's turn.[45]

HORATIO. This lapwing[46] runs away with the shell on his head.

HAMLET. He did comply with[47] his dug,[48] before he sucked it. Thus has he (and many more of the same bevy,[49] that, I know, the drossy[50] age dotes on,) only got the tune of the time, and outward habit of encounter; a kind of yesty[51] collection, which carries them through and through the most fond and winnowed opinions; and do but blow them to their trials,[52] the bubbles are out.

Enter a LORD.

LORD. My lord, his majesty commended him to you by young Osric, who brings back to him, that you attend him in the hall: He sends to know, if your pleasure hold to play with Laertes, or that you will take longer time.

HAMLET. I am constant to my purposes, they follow the king's pleasure: if he fitness speaks, mine is ready: now, or whensoever, provided I be so able as now.

LORD. The king, and queen, and all coming down.

HAMLET. In happy time.

LORD. The queen desires you to use some gentle entertainment to Laertes, before you go to play.

HAMLET. She well instructs me.

Exit LORD.

HORATIO. You will lose this wager, my lord.

HAMLET. I do not think so; since he went into France, I have been in continual practice; I shall win at the odds. But thou wouldst not think, how ill all's he reabout[53] my heart: but it is no matter.

HORATIO. Nay, good my lord,—

HAMLET. It is but foolery; but it is such a kind of gain-giving,[54] as would, perhaps, trouble a woman.

HORATIO. If your mind dislike anything, obey: I will forestall their repair hither, and say, you are not fit.

HAMLET. Not a whit, we defy augury;[55] there's a special providence in the fall of a sparrow.[56] If it be now, 'tis not to come; if it be not to come, it will be now;

[44]*breathing time*: takes time *to go* out in the air; going outdoors

[45]*no tongue's else for's turn*: no one else will say so

[46]*lapwing*: a plume-crested species of plover, a kind of bird named from Latin 'pluria' meaning rain, possibly from their restlessness from their restlessbefore it rains.

[47]*comply with*: offered courtesies to

[48]*dug*: a nipple or udder of a cow or other animal

[49]*bevy*: group of birds; also, a drinking party (from the Old French, *bevee*, drink)

[50]*drossy*: wasteful

[51]*yesty*: yebasty; foamy

[52]*blow them to their trials*: examine them further

[53]*reabout*: roundabout

[54]*gain-giving*: misgiving

[55]*augury*: foreboding

[56]*special providence in the fall of sparrows*: refers to Matthew 10:29—"Are not two sparrows sold for a farthing? and one of them shall not fall on the ground

if it be not now, yet it will come: the readiness is all: Since no man has aught of what he leaves, what is't to leave betimes?[57]

Enter KING, QUEEN, LAERTES, LORDS, OSRIC, *and* Attendants *with foils &c.*

KING. Come, HAMLET, come, and take this hand from me.

The KING *puts the hand of* LAERTES *into that of* HAMLET.

HAMLET. Give me your pardon, sir: I have done you wrong;
But pardon, 't as you are a gentleman.
This presence knows, and you must needs have heard,
How I am punish'd with a score distraction.
What I have done
That might your nature, honour, and exception,
Roughly awaked, I here proclaim was madness.
Was't Hamlet wrong'd Laertes? Never, Hamlet.
If Hamlet from himself be ta'en[58] away,
And, when he's not himself, does wrong Laertes,
Then Hamlet does it not, Hamlet denies it.
Who does it then? His madness: If't be so,
Hamlet is of the faction that is wrong'd;
His madness is poor Hamlet's enemy.
Sir, in this audience,
Let my disclaiming from a purpos'd evil
Free me so far in your most generous thoughts,
That I have shot mine arrow o'er the house,
And hurt my brother.

LAERTES. I am satisfied in nature,
Whose motive, in this case, should stir me most
To my revenge; but in my terms of honour,
I stand aloof; and will no reconcilement,
Till by[59] some elder masters, of known honour,
I have a voice and precedent of peace,
To Keep my name ungor'd:[60] But till that time,
I do receive your offer'd love like love,
And will not wrong it.

HAMLET. I embrace it freely;
And will this brother's wager frankly play.
Give us the foils; come on.

LAERTES. Come, one for me.

HAMLET. I'll be your foil, Laertes; in mine ignorance
Your skill shall, like a star i' the darkest night,
Stick fiery off[61] indeed.

LAERTES. You mock me, sir.

HAMLET. No, by this hand.

KING. Give them the foils, young Osric. Cousin Hamlet,
You know the wager?

HAMLET. Very well, my lord;
Your grace hath laid the odds o' the weaker side.

KING. I do not fear it: I have seen you both.
But since he's better'd, we have therefore odds.

LAERTES. This is too heavy, let me see another.

HAMLET. This likes me well: These foils have all a length!

They prepare to play.

OSRIC. Ay, my good lord.

KING. Set me the stoups of wine upon that table:
If Hamlet give the first or second hit,
Or quit in answer of the third exchange,
Let all the battlements their ordnance fire;
The king shall drink to Hamlet's better breath;
And in the cup an union shall be throw,
Richer than that which four successive kings
In Denmark's crown have worn. Give me the cups;
And let the kettle to the trumpet speak,
The trumpet to the cannoneer without,
The cannons to the heavens, the heaven to earth,
Now the king drinks to Hamlet. —Come, begin;—
And you, the judges,bear a wary eye.

HAMLET. Come on sir.

LAERTES. Come on, sir. *(They play).*

HAMLET. One.

LAERTES. No.

HAMLET. Judgment.

without your Father."
[57]*betimes:* in good time
[58]*ta'en:* taken
[59]*by:* before
[60]*ungor'd:* unbloodied; unmarred
[61]*stick fiery off:* stand out brightly

OSRIC. A hit, a very palpable hit.

LAERTES. Well,—again.

KING. Stay, give me drink: HAMLET, this pearl[62] is thine;
 Here's to thy health. Give him the cup,

Trumpets sound; and cannon shot off within.

HAMLET. I'll play this bout first, set it by a while.
 Come.—Another hit; What say you? *(They play).*

LAERTES. A touch, a touch, I do confess.

KING. Our son shall win.

QUEEN. He's fat, and scant or breath.
 Here, Hamlet, take my napkin, rub thy brows:
 The queen carouses[63] to thy fortune, Hamlet.

HAMLET. Good, madam.

KING. Gertrude, do not drink.

QUEEN. I will, my lord;—I pray you, pardon me.

KING. It is the poison'd cup: it is too late. *(Aside).*

HAMLET. I dare not drink yet, madam; by and by.

QUEEN. Come, let me wipe thy face.

LAERTES. My lord, I'll hit him now.

KING. I do not think it.

LAERTES. And yet it is almost against my conscience.
 (Aside).

HAMLET. Come, for the third, Laertes: You but dally;
 I pray you, pass with your best violence;
 I am afeard you make a wanton of me.

LAERTES. Say you so? come on. *(They play).*

OSRIC. Nothing neither way.

LAERTES. Have at you now.

*LAERTES wounds HAMLET; then, in scuffling, they change
rapiers, and HAMLET wounds LAERTES.*

KING. Part them, they are incens'd.[64]

HAMLET. Nay, come again. *(The QUEEN falls).*

OSRIC. Look to the queen there, ho!

HORATIO. They bleed on both sides:—How is it, my
 lord?

OSRIC. How is't, Laertes?

LAERTES. Why, as a woodcock to mine own springe,
 Osric; I am justly kill'd with mine own treachery.

HAMLET. How does the queen?

KING. She swoons to see them bleed.

QUEEN. No, no, the drink, the drink,—O my dear
 Hamlet:—
 The drink, the drink;—I am poison'd! *(Dies).*

HAMLET. O villainy! Ho! Let the door be lock'd:
 Treachery! seek it out. *(LAERTES falls).*

LAERTES. It is here, Hamlet: Hamlet, thou art slain;
 No medicine in the world can do thee good,
 In thee there is not half an hour of life;
 The treacherous instrument is in thy hand,
 Unbated,[65] and envenom'd: the foul practice
 Hath turn'd itself on me; lo, here I lie,
 Never to rise again. Thy mother's poison'd;
 I can no more; the king, the king's to blame.

HAMLET. The point
 Envenom'd too!—Then, venom, to thy work.

 (Stabs the KING).

OSRIC AND LORDS. Treason! treason!

KING. O, yet defend me, friends; I am but hurt.

HAMLET. Here, thou incestuous, murd'rous, damned Dane,
 Drink off this potion:—Is thy union here?
 Follow my mother. *(KING dies).*

LAERTES. He is justly served;
 It is a poison temper'd[66] by himself.
 Exchange forgiveness with me, noble HAMLET:
 Mine and my father's death come not upon thee,
 Nor thine on me! *(Dies).*

HAMLET. Heaven make thee free of it! I follow thee.
 I am dead, Horatio:—Wretched queen, adieu!
 You that look pale and tremble at this chance,
 That are but mutes or audience to this act,
 Had I but time, (as this fell sergeant, death,
 Is strict in his arrest,) O, I could tell you,—

[62]*pearl:* cup adorned with pearls
[63]*carouses:* drinks
[64]*incens'd:* iinflamed with anger
[65]*unbated:* unblunted
[66]*temper'd:* mixed

But let it be:—Horatio, I am dead;
Thou liv'st; report me and my cause aright
To the unsatisfied.[67]

HORATIO. Never believe it.
I am more an antique Roman[68] than a Dane,
Here's yet some liquor left.

HAMLET. As thou'rt a man,
Give me the cup; let go; by heaven I'll have it.
O, good Horatio, what a wounded name,
Things standing thus unknown, shall live behind me?
If thou didst ever hold me in thy heart,
Absent thee from felicity[69] a while,
And in this harsh world draw thy breath in pain,
To tell my story. *(March afar off, and shot within).*
What warlike noise is this?

OSRIC. Young Fortinbras, with conquest come from
Poland,
To the ambassadors of England gives
This warlike volley.

HAMLET. O, I die, Horatio;
The potent poison quite o'er-crows[70] my spirit;
I cannot live to hear the news from England;
But I do prophesy the election lights
On Fortinbras; he has my dying voice;
So tell him, with the occurrents,[71] more and less,
Which have solicited.—The rest is silence.
(Dies).

HORATIO. Now cracks a noble heart. Good night, sweet
prince;
And flights of angels sing thee to thy rest!
Why does the drum come hither? *(March within).*

Enter FORTINBRAS, *the* English Ambassadors, *and
others.*

FORTINBRAS. Where is this sight?

HORATIO. What is it ye would see?
If aught of woe, or wonder, cease your search.

FORTINBRAS. This quarry[72] cries on havoc—O proud
death!
What feast is toward[73] in thine eternal cell,
That thou so many princes, at a shoot,
So bloodily hast struck?

I AMBASSADOR. The sight is dismal;
And our affairs from England come too late:
The ears are senseless that should give us hearing,
To tell him, his commandment is fulfill'd,
That ROSENCRANTZ and GUILDENSTERN are dead:
Where should we have our thanks?

HORATIO. Not from his mouth,
Had it the ability of life to thank you;
He never gave commandment for their death.
But since, so jump[74] upon this bloody question.
You from the Polack wars, and you from England
Are here arriv'd, give order, that these bodies
High on a stage be placed to the view;
And let me speak, to the yet unknowing world,
How these things came about: So shall you hear
Of carnal, bloody, and unnatural acts;
Of accidental judgments, casual[75] slaughters;
Of deaths put on by cunning, and forc'd cause;
And, in this upshot,[76] purposes mistook
Fall'n on the inventors' heads: all this can I
Truly deliver.

FORTINBRAS. Let us haste to hear it,
And call the noblest to the audience.
For me, with sorrow I embrace my fortune;
I have some rights of memory[77] in this kingdom,
Which now to claim my vantage doth invite me.

HORATIO. Of that I shall have always cause to speak,
And from his mouth whose voice will draw on
more:[78]

[67]*the unsatisfied*: those who are curious or unconvinced
[68]*antique Roman*: ancient Roman who would commit suicide
[69]*felicity*: happiness of death
[70]*o'er crows*: shadows, like crows shadow carrion
[71]*occurrents*: incidentals
[72]*quarry*: pile of victims. (The word referred to deer entrails give to dogs after a chase.)
[73]*jump*: sudden
[74]*toward*: coming
[75]*casual*: accidental
[76]*upshot*: end (last shot in archery match)
[77]*rights of memory*:
[78]*voice will draw on more*: his vote will influence others to vote with him

But let this same be presently perform'd,
E'en while men's minds are wild; lest more
 mischance
 On plots, and errors, happen.

FORTINBRAS. Let four captains
Bear HAMLET, like a soldier, to the stage;
 For he was likely, had he been put on,[79]
 To have prov'd most royally: and, for his passage,

The soldiers' music, and the rights of war,
Speak loudly for him.
Take up the body:—Such a sight as this
Becomes the field,[80] but here shows much amiss.
Go, bid the soldiers shoot. (A *dead March*).

Exeunt, marching; after which a peal of ordnance is
shot off.

[79]*put on*: elected; made king
[80]*becomes the field*: resembles a battlefield

Tartuffe

Molière: France's Original Rebel

While theatre was flourishing in Elizabethan England, major theatrical development in France was delayed by civil wars and religious controversy during the sixteenth and seventeenth centuries. Once King Louis XIII was settled on the throne, religion again had a profound influence on the development of theatre. In 1625, Cardinal Richelieu, the king's prime minister, was determined to turn France into the cultural center of all of Europe. Richelieu and the French borrowed heavily from the Renaissance theatre of Italy.

The Italians certainly influenced technical choices made on the French stage, but their biggest influence was in dramatic theory. France, like Italy, employed a set of theoretical principles, which were heavily based on the dramatic ideas Aristotle outlined in *The Poetics*. These principles came to be called the **neoclassical ideal.** Neoclassicists believed that the purpose of all drama was to both instruct and please an audience. To do this, they believed that certain rules had to be followed. These rules included the idea that there were only two forms of drama—tragedy and comedy—and the two were never to be mixed. Tragedy was to deal with characters from nobility, while comedy was to be peopled with characters from the middle and lower classes. Perhaps most important to the neoclassicists were what we call the unities of time, place, and action. The unity of time means that all the action in the play should occur within twenty-four hours. Unity of place requires all the play's action to occur in the same place. Finally, the unity of action demands that the play has a singular plot without any subplots. Once again, one can look back to Sophocles' *Oedipus the King* as a perfect example of following the three unities.

Seventeenth-century France produced several outstanding dramatists. Both Pierre Corneille and Jean Racine were praised for their outstanding dramas, and their work is still studied today. However, no playwright in French history has had both the profound effect and enduring fame of the man who called himself Molière.

Molière was born Jean-Baptiste Poquelin in 1622. His father, a prosperous merchant who became the court upholsterer, made sure his son received the best education available to him. The young Poquelin was schooled in philosophy, classics, and the humanities as his father groomed him for a life at court. Unfortunately for his father, his promising son had other plans.

Poquelin's rebelliousness really began when, at the age of twenty-one, he abandoned his future with the court in favor of founding a traveling theatre troupe. The troupe, known as the Theatre Illustre, spent several difficult years touring the French provinces. During this time, Poquelin took the stage name Molière. Many believe it was during these touring years that he also mastered the techniques of commedia dell'arte, a very physical, highly improvisational, Italian performance style. Much of Molière's work is heavily influenced by commedia dell'arte.

In 1660, Molière returned to the court and received the position of upholsterer once held by both his father and his brother. He began writing and acting in a series of plays that poked fun at the elegant and mannered society, which he was part of. Some of his most successful plays include: *School for Husbands, School for Wives, Don Juan, The Misanthrope, The Miser,* and *The Imaginary Invalid.* The satirical nature of these plays often caused great controversy among the elite and the religious.

Like Shakespeare, Molière was a skilled actor (he often played the leading roles in his plays) who also ran his own theatre company. He was held in very high regard in the court, but his status as an actor often led to unfavorable treatment. In Molière's time, the French church actually regarded actors as unholy outcasts who were not permitted to receive the sacraments. A thespian to the last, Molière virtually died on stage. In 1673, he collapsed on stage while performing in *The Imaginary Invalid* and died a few hours later. Perhaps the greatest insult to this wonderful talent and member of the court was that the church refused to bury Molière in sacred ground. Louis XIV, an ardent supporter of Molière, intervened, but the best he could do was persuade the archbishop to bury the playwright in a parish cemetery. As if this weren't enough of an insult, no funeral ceremony was held, and Molière was buried in an unmarked grave under cover of night.

In spite of his poor treatment at the hands of church, Molière has transcended time to become one of history's most beloved playwrights. His satiric humor continues to resonate with modern society around the world. Molière is the most produced playwright from his time and, next to Shakespeare, he is undoubtedly the most enduring playwright of the European Renaissance.

Tartuffe

Tartuffe is Molière's best-known and most produced play. It might well be his most controversial, too. Some critics believe this play was a direct cause of the clergy's refusal to permit Molière a Christian burial.

The play takes a satiric look at religious hypocrisy. Molière takes many of the familiar stock characters of the commedia dell'arte and uses them to explore how much we tend to deceive ourselves. While *Tartuffe* is ridiculous and hilarious, it also begs us to take a serious look at what it really means to lead a pious life.

Tartuffe takes place in the home of Orgon, who is so enamored of the pious Tartuffe that he announces his intention of marrying his daughter off to the title character, even though she is already promised to another man. Offended by rumors of Tartuffe's attempts to seduce his wife, Elmire, Orgon goes so far as to sign over all his property to Tartuffe as proof of his belief in the man's nobility. When Elmire hatches a plot to convince her husband of Tartuffe's unwholesome behavior, the stage is set for a classic comedic finale.

Molière employs the suspenseful tactic of not showing us the title character until the third act. We learn about the man through the other characters' varying and conflicting descriptions and accounts. The conflict of the play is immediate. Tartuffe's piety is hotly contested. In one corner stand those who firmly believe in Tartuffe's righteousness and, in the other corner, we find those who have seen his less-than-admirable behavior and know better. The audience is eager to meet this much-talked about character so that they may determine for themselves what kind of a man he is based on his actions.

It is interesting to note that Molière, who normally played the leading roles in his plays, played the part of Orgon rather than the title character. This has led many critics and scholars to believe that Molière's play is not only an indictment of the falsely pious but also of those who allow such nefarious characters to retain their power and prestige through such blind admiration.

Some critics have faulted Molière for his contrived ending to *Tartuffe*. Many feel the playwright backed his characters into such a corner that the only way to tie up the play was to bring in a previously unseen resolving power. Such a convenient ending is given the name *deus ex machina*, which literally means "God from the machine." The term comes from the theatre of ancient Greece, where playwrights would often "fly in" gods with a crane to resolve their plays.

Molière was a clever man, however, and there might be another reason for his choice to end the play in this manner. Many believe *Tartuffe* was a direct attack on a secret

society called the Company of the Holy Sacrament. The Company is said to have spied on people's private lives in an attempt to police society's morals. Even before the play was produced in 1664, various religious groups joined together to protest *Tartuffe*. It was frequently banned from being performed, and Molière was forced to revise the text of the play on numerous occasions. His good friend, King Louis XIV, often came to Molière's defense. Theatre scholars believe that Molière's *deus ex machina* is his way of both tipping his hat to the king and also taking a not-so-thinly-veiled pot shot at those in the clergy who so adamantly attacked him and his play.

The controversy over *Tartuffe* has long since died off, but the play continues to entertain audiences throughout the world. Richard Wilbur's translation of the play, which is the version appearing in this text, is widely considered to be the definitive English translation of Molière's classic comedy. When this translation debuted on Broadway in 1965, the *New York Times* called it "the comic equivalent of King Lear."

Food for Thought

As you read the play, consider the following questions:

1. In your opinion, who is the protagonist in *Tartuffe*?
2. Why is it so important to the plot of this play that the character of Tartuffe does not actually appear until the third act?
3. Why do you think Orgon is so fond of Tartuffe?
4. What happens at the play's conclusion that has caused critics to call the end of *Tartuffe* a deus ex machina?
5. One of the themes of this play could deal with religious hypocrisy. Based on *Tartuffe*, how do you think Molière would define religious hypocrisy?

Fun Facts

1. Did you know that for a period of time while Molière was writing plays, certain wealthy audience members were allowed to sit onstage during performances? Apparently this practice didn't last long because these "privileged" spectators had a tendency to be late, intoxicated, and very noisy.
2. Molière's very first acting company failed. It actually landed him in debtor's prison for a brief spell until his father bailed him out.
3. At one point in time, the archbishop of Paris declared that anyone who saw *Tartuffe* would be excommunicated from the church.

For more information about Molière and *Tartuffe*, check out www.courttheatre.org/home/plays/9697/tartuffe/PNtartuffe.shtml.

Tartuffe

Molière

Translated by Richard Wilbur

Characters

Madame Pernelle, Orgon's mother
Orgon, Elmire's husband
Elmire, Orgon's wife
Damis, Orgon's son, Elmire's stepson
Mariane, Orgon's daughter, Elmire's stepdaughter, in love with Valère
Valère, in love with Mariane

Cléante, Orgon's brother-in-law
Tartuffe, a hypocrite
Dorine, Mariane's lady's-maid
M. Loyal, a bailiff
A Police Officer
Flipote, Madame Pernelle's maid

The scene throughout: Orgon's house in Paris

Act 1

Scene I. Madame Pernelle and Flipote, her maid, Elmire, Mariane, Dorine Damis, Cléante.

Madame Pernelle. Come, come, Flipote; it's time
 I left this place.

Elmire. I can't keep up, you walk at such a pace.

Madame Pernelle. Don't trouble, child; no need to
 show me out.
 It's not your manners I'm concerned about.

Elmire. We merely pay you the respect we owe.
 But, Mother, why this hurry? Must you go?

Madame Pernelle. I must. This house appalls me.
 No one in it
 Will pay attention for a single minute.
 Children, I take my leave much vexed in spirit.
 I offer good advice, but you won't hear it.
 You all break in and chatter on and on.
 It's like a madhouse with the keeper gone.

Dorine. If . . .

Madame Pernelle. Girl, you talk too much, and I'm
 afraid
 You're far too saucy for a lady's-maid.
 You push in everywhere and have your say.

Damis. But . . .

Madame Pernelle. You, boy, grow more foolish every
 day.

To think my grandson should be such a dunce!
I've said a hundred times, if I've said it once,
That if you keep the course on which you've started,
You'll leave your worthy father broken-hearted.

Mariane. I think . . .

Madame Pernelle. And you, his sister, seem so pure,
 So shy, so innocent, and so demure.
 But you know what they say about still waters.
 I pity parents with secretive daughters.

Elmire. Now, Mother . . .

Madame Pernelle. And as for you, child, let me add
 That your behavior is extremely bad,
 And a poor example for these children, too.
 Their dear, dead mother did far better than you.
 You're much too free with money, and I'm distressed
 To see you so elaborately dressed.
 When it's one's husband that one aims to please,
 One has no need of costly fripperies.

Cléante. Oh, Madam, really . . .

Madame Pernelle. You are her brother, Sir,
 And I respect and love you; yet if I were
 My son, this lady's good and pious spouse,
 I wouldn't make you welcome in my house.
 You're full of worldly counsels which, I fear,
 Aren't suitable for decent folk to hear.
 I've spoken bluntly, Sir; but it behooves us
 Not to mince words when righteous fervor moves us.

Damis. Your man Tartuffe is full of holy speeches . . .

MADAME PERNELLE. And practises precisely what he preaches.
 He's a fine man, and should be listened to.
 I will not hear him mocked by fools like you.

DAMIS. Good God! Do you expect me to submit
 To the tyranny of that carping hypocrite?
 Must we forgo all joys and satisfactions
 Because that bigot censures all our actions?

DORINE. To hear him talk—and he talks all the time—
 There's nothing one can do that's not a crime.
 He rails at everything, your dear Tartuffe.

MADAME PERNELLE. Whatever he reproves deserves reproof.
 He's out to save your souls, and all of you
 Must love him, as my son would have you do.

DAMIS. Ah no, Grandmother, I could never take
 To such a rascal, even for my father's sake.
 That's how I feel, and I shall not dissemble.
 His every action makes me seethe and tremble
 With helpless anger, and I have no doubt
 That he and I will shortly have it out.

DORINE. Surely it is a shame and a disgrace
 To see this man usurp the master's place—
 To see this beggar who, when first he came,
 Had not a shoe or shoestring to his name
 So far forget himself that he behaves
 As if the house were his, and we his slaves.

MADAME PERNELLE. Well, mark my words, your souls would fare far better
 If you obeyed his precepts to the letter.

DORINE. You see him as a saint. I'm far less awed;
 In fact, I see right through him. He's a fraud.

MADAME PERNELLE. Nonsense!

DORINE. His man Laurent's the same, or worse;
 I'd not trust either with a penny purse.

MADAME PERNELLE. I can't say what his servant's morals may be;
 His own great goodness I can guarantee.
 You all regard him with distaste and fear
 Because he tells you what you're loath to hear,
 Condemns your sins, points out your moral flaws,
 And humbly strives to further Heaven's cause.

DORINE. If sin is all that bothers him, why is it
 He's so upset when folk drop in to visit?
 Is Heaven so outraged by a social call
 That he must prophesy against us all?
 I'll tell you what I think: if you ask me,
 He's jealous of my mistress' company.

MADAME PERNELLE. Rubbish! (To ELMIRE). He's not alone, child, in complaining
 Of all of your promiscuous entertaining.
 Why, the whole neighborhood's upset, I know,
 By all these carriages that come and go,
 With crowds of guests parading in and out
 And noisy servants loitering about.
 In all of this, I'm sure there's nothing vicious;
 But why give people cause to be suspicious?

CLÉANTE. They need no cause; they'll talk in any case.
 Madam, this world would be a joyless place
 If, fearing what malicious tongues might say,
 We locked our doors and turned our friends away.
 And even if one did so dreary a thing,
 D'you think those tongues would cease their chattering?
 One can't fight slander; it's a losing battle;
 Let us instead ignore their tittle-tattle.
 Let's strive to live by conscience' clear decrees,
 And let the gossips gossip as they please.

DORINE. If there is talk against us, I know the source:
 It's Daphne and her little husband, of course.
 Those who have greatest cause for guilt and shame
 Are quickest to besmirch a neighbor's name.
 When there's chance for libel, they never miss it;
 When something can be made to seem illicit
 They're off at once to spread the joyous news,
 Adding to fact what fantasies they choose.
 By talking up their neighbor's indiscretions
 They seek to camouflage their own transgressions,
 Hoping that others' innocent affairs
 Will lend a hue of innocence to theirs,
 Or that their own black guilt will come to seem
 Part of a general shady color-scheme.

MADAME PERNELLE. All that is quite irrelevant. I doubt
 That anyone's more virtuous and devout
 Than dear Orante; and I'm informed that she
 Condemns your mode of life most vehemently.

DORINE. Oh, yes, she's strict, devout, and has no taint
 Of worldliness; in short, she seems a saint.
 But it was time which taught her that disguise;
 She's thus because she can't be otherwise.
 So long as her attractions could enthrall,
 She flounced and flirted and enjoyed it all,
 But now that they're no longer what they were
 She quits a world which fast is quitting her,
 And wears a veil of virtue to conceal
 Her bankrupt beauty and her lost appeal.
 That's what becomes of old coquettes today:
 Distressed when all their lovers fall away,
 They see no recourse but to play the prude,

And so confer a style on solitude.
Thereafter, they're severe with everyone,
Condemning all our actions, pardoning none,
And claiming to be pure, austere, and zealous
When, if the truth were known, they're merely jealous,
And cannot bear to see another know
The pleasures time has forced them to forgo.

MADAME PERNELLE (*initially to* ELMIRE). That sort of
 talk is what you like to hear;
Therefore you'd have us all keep still, my dear,
While Madam rattles on the livelong day.
Nevertheless, I mean to have my say.
I tell you that you're blest to have Tartuffe
Dwelling, as my son's guest, beneath this roof;
That Heaven has sent him to forestall its wrath
By leading you, once more to the true path;
That all he reprehends is reprehensible,
And that you'd better heed him, and be sensible.
These visits, balls, and parties in which you revel
Are nothing but inventions of the Devil.
One never hears a word that's edifying:
Nothing but chaff and foolishness and lying,
As well as vicious gossip in which one's neighbor
Is cut to bits with épée, foil, and saber.
People of sense are driven half-insane
At such affairs, where noise and folly reign
And reputations perish thick and fast.
As a wise preacher said on Sunday last,
Parties are Towers of Babylon, because
The guests all babble on with never a pause;
And then he told a story which, I think . . .

To CLÉANTE.

I heard that laugh, Sir, and I saw that wink!
Go find your silly friends and laugh some more!
Enough; I'm going; don't show me to the door.
I leave this household much dismayed and vexed;
I cannot say when I shall see you next.

Slapping FLIPOTE.

Wake up, don't stand there gaping into space!
I'll slap some sense into that stupid face.
Move, move, you slut.

Scene II.

CLÉANTE, DORINE.

CLÉANTE. I think I'll stay behind;
 I want no further pieces of her mind.
 How that old lady . . .

DORINE. Oh, what wouldn't she say
 If she could hear you speak of her that way!
 She'd thank you for the *lady*, but I'm sure
 She'd find the *old* a little premature.

CLÉANTE. My, what a scene she made, and what a din!
 And how this man Tartuffe has taken her in!

DORINE. Yes, but her son is even worse deceived:
 His folly must be seen to be believed.
 In the late troubles, he played an able part
 And served his king with wise and loyal heart,
 But he's quite lost his senses since he fell
 Beneath Tartuffe's infatuating spell.
 He calls him brother, and loves him as his life,
 Preferring him to mother, child, or wife.
 In him and him alone will he confide;
 He's made him his confessor and his guide;
 He pets and pampers him with love more tender
 Than any pretty mistress could engender,
 Gives him the place of honor when they dine,
 Delights to see him gorging like a swine,
 Stuffs him with dainties till his guts distend,
 And when he belches, cries "God bless you, friend!"
 In short, he's made; he worships him; he dotes;
 His deeds he marvels at, his words he quotes,
 Thinking each act a miracle, each word
 Oracular as those that Moses heard.
 Tartuffe, much pleased to find so easy a victim,
 Has in a hundred ways beguiled and tricked him,
 Milked him of money, and with his permission
 Established here a sort of Inquisition.
 Even Laurent, his lackey, dares to give
 Us arrogant advice on how to live;
 He sermonizes us in thundering tones
 And confiscates our ribbons and colognes.
 Last week he tore a kerchief into pieces
 Because he found it pressed in a *Life of Jesus*:
 He said it was a sin to juxtapose
 Unholy vanities and holy prose.

Scene III.

ELMIRE, MARIANE, DAMIS, CLÉANTE, DORINE.

ELMIRE (*to* CLÉANTE). You did well not to follow; she
 stood in the door
 And said *verbatim* all she'd said before.
 I saw my husband coming. I think I'd best
 Go upstairs now, and take a little rest.

CLÉANTE. I'll wait and greet him here; then I must go.
 I've really only time to say hello.

DAMIS. Sound him about my sister's wedding, please.
 I think Tartuffe's against it, and that he's
 Been urging Father to withdraw his blessing.
 As you well know, I'd find that most distressing.
 Unless my sister and Valère can marry,
 My hopes to wed *his* sister will miscarry,
 And I'm determined . . .

DORINE. He's coming.

Scene IV.

ORGON, CLÉANTE, DORINE.

ORGON. Ah, Brother, good-day.

CLÉANTE. Well, welcome back. I'm sorry I can't stay.
 How was the country? Blooming, I trust, and green?

ORGON. Excuse me, Brother; just one moment.

To DORINE.

 Dorine . . .

To CLÉANTE.

 To put my mind at rest, I always learn
 The household news the moment I return.

To DORINE.
 Has all been well, these two days I've been gone?
 How are the family? What's been going on?

DORINE. Your wife, two days ago, had a bad fever,
 And a fierce headache which refused to leave her.

ORGON. Ah. And Tartuffe?

DORINE. Tartuffe? Why, he's round and red,
 Bursting with health, and excellently fed.

ORGON. Poor fellow!

DORINE. That night, the mistress was unable
 To take a single bite at the dinner-table.
 Her headache-pains, she said, were simply hellish.

ORGON. Ah. And Tartuffe?

DORINE. He ate his meal with relish,
 And zealously devoured in her presence
 A leg of mutton and a brace of pheasants.

ORGON. Poor fellow!

DORINE. Well, the pains continued strong,
 And so she tossed and tossed the whole night long,
 Now icy-cold, now burning like a flame.
 We sat beside her bed till morning came.

ORGON. Ah. And Tartuffe?

DORINE. Why, having eaten, he rose
 And sought his room, already in a doze,
 Got into his warm bed, and snored away
 In perfect peace until the break of day.

ORGON. Poor fellow!

DORINE. After much ado, we talked her
 Into dispatching someone for the doctor.
 He bled her, and the fever quickly fell.

ORGON. Ah. And Tartuffe?

DORINE. He bore it very well.
 To keep his cheerfulness at any cost,
 And make up for the blood *Madame* had lost,
 He drank, at lunch, four beakers full of port.

ORGON. Poor fellow!

DORINE. Both are doing well, in short.
 I'll go and tell *Madame* that you've expressed
 Keen sympathy and anxious interest.

Scene V.

ORGON, CLÉANTE.

CLÉANTE. That girl was laughing in your face, and
 though
 I've no wish to offend you, even so
 I'm bound to say that she had some excuse.
 How can you possibly be such a goose?
 Are you so dazed by this man's hocus-pocus
 That all the world, save him, is out of focus?
 You've given him clothing, shelter, food, and care;
 Why must you also . . .

ORGON. Brother, stop right there.
 You do not know the man of whom you speak.

CLÉANTE. I grant you that. But my judgment's not so weak
 That I can't tell, by his effect on others . . .

ORGON. Ah, when you meet him, you two will be like
 brothers!
 There's been no loftier soul since time began.
 He is a man who . . . a man who . . . an excellent man.
 To keep his precepts is to be reborn,
 And view this dunghill of a world with scorn.
 Yes, thanks to him I'm a changed man indeed.
 Under his tutelage my soul's been freed
 From earthly loves, and every human tie:
 My mother, children, brother, and wife could die,
 And I'd not feel a single moment's pain.

CLÉANTE. That's fine sentiment, Brother; most humane.

ORGON. Oh, had you seen Tartuffe as I first knew him,
Your heart, like mine, would have surrendered to him.
He used to come into our church each day
And humbly kneel nearby, and start to pray.
He'd draw the eyes of everybody there
By the deep fervor of his heartfelt prayer;
He'd sigh and weep, and sometimes with a sound
Of rapture he would bend and kiss the ground;
And when I rose to go, he'd run before
To offer me holy-water at the door.
His serving-man, no less devout than he,
Informed me of his master's poverty;
I gave him gifts, but in his humbleness
He'd beg me every time to give him less.
"Oh, that's too much," he'd cry, "too much by twice!
I don't deserve it. The half, Sir, would suffice."
And when I wouldn't take it back, he'd share
Half of it with the poor, right then and there.
At length, Heaven prompted me to take him in
To dwell with us, and free our souls from sin.
He guides our lives, and to protect my honor
Stays by my wife, and keeps an eye upon her;
He tells me whom she sees, and all she does,
And seems more jealous than I ever was!
And how austere he is! Why, he can detect
A mortal sin where you would least suspect;
In smallest trifles, he's extremely strict.
Last week, his conscience was severely pricked
Because, while praying, he had caught a flea
And killed it, so he felt, too wrathfully.

CLÉANTE. Good God, man! Have you lost your common sense—
Or is this all some joke at my expense?
How can you stand there and in all sobriety . . .

ORGON. Brother, your language savors of impiety.
Too much free-thinking's made your faith unsteady,
And as I've warned you many times already,
'Twill get you into trouble before you're through.

CLÉANTE. So I've been told before by dupes like you:
Being blind, you'd have all others blind as well;
The clear-eyed man you call an infidel,
And he who sees through humbug and pretense
Is charged, by you, with want of reverence.
Spare me your warnings, Brother; I have no fear
Of speaking out, for you and Heaven to hear,
Against affected zeal and pious knavery.
There's true and false in piety, as in bravery,
And just as those whose courage shines the most
In battle, are the least inclined to boast.
So those whose hearts are truly pure and lowly
Don't make a flashy show of being holy.
There's a vast difference, so it seems to me.
Between true piety and hypocrisy:
How do you fail to see it, may I ask?
Is not a face quite different from a mask?
Cannot sincerity and cunning art,
Reality and semblance, be told apart?
Are scarecrows just like men, and do you hold
That a false coin is just as good as gold?
Ah, Brother, man's a strangely fashioned creature
Who seldom is content to follow Nature,
But recklessly pursues his inclination
Beyond the narrow bounds of moderation,
And often, by transgressing Reason's laws,
Perverts a lofty aim or noble cause.
A passing observation, but it applies.

ORGON. I see, dear Brother, that you're profoundly wise;
You harbor all the insight of the age.
You are our one clear mind, our only sage,
The era's oracle, its Cato too,
And all mankind are fools compared to you.

CLÉANTE. Brother, I don't pretend to be a sage,
Nor have I all the wisdom of the age.
There's just one insight I would dare to claim:
I know that true and false are not the same;
And just as there is nothing I more revere
Than a soul whose faith is steadfast and sincere,
Nothing that I more cherish and admire
Than honest zeal and true religious fire,
So there is nothing that I find more base
Than specious piety's dishonest face—
Than these bold mountebanks, these histrios
Whose impious mummeries and hollow shows
Exploit our love of Heaven, and make a jest
Of all that men think holiest and best;
These calculating souls who offer prayers
Not to their Maker, but as public wares,
And seek to buy respect and reputation
With lifted eyes and sighs of exaltation;
These charlatans, I say, whose pilgrim souls
Proceed, by way of Heaven, toward earthly goals,
Who weep and pray and swindle and extort,
Who preach the monkish life, but haunt the court,
Who make their zeal the partner of their vice-
Such men are vengeful, sly, and cold as ice,
And when there is an enemy to defame

They cloak their spite in fair religion's name,
Their private spleen and malice being made
To seem a high and virtuous crusade,
Until, to mankind's reverent applause,
They crucify their foe in Heaven's cause.
Such knaves are all too common; yet, for the wise,
True piety isn't hard to recognize,
And, happily, these present times provide us
With bright examples to instruct and guide us.
Consider Ariston and Périandre;
Look at Oronte, Alcidamas, Clitandre;
Their virtue is acknowledged; who could doubt it?
But you won't hear them beat the drum about it.
They're never ostentatious, never vain,
And their religion's moderate and humane;
It's not their way to criticize and chide:
They think censoriousness a mark of pride,
And therefore, letting others preach and rave,
They show, by deeds, how Christians should behave.
They think no evil of their fellow man.
But judge of him as kindly as they can.
They don't intrigue and wangle and conspire;
To lead a good life is their one desire:
The sinner wakes no rancorous hate in them:
It is the sin alone which they condemn;
Nor do they try to show a fiercer zeal
For Heaven's cause than Heaven itself could feel.
These men I honor, these men I advocate
As models for us all to emulate.
Your man is not their sort at all, I fear:
And, while your praise of him is quite sincere,
I think that you've been dreadfully deluded.

ORGON. Now then, dear Brother, is your speech concluded?

CLÉANTE. Why, yes.

ORGON. Your servant, Sir.

He turns to go.

CLÉANTE. No, Brother; wait.
There's one more matter. You agreed of late
That young Valère might have your daughter's hand.

ORGON. I did.

CLÉANTE. And set the date, I understand.

ORGON. Quite so.

CLÉANTE. You've now postponed it; is that true?

ORGON. No doubt.

CLÉANTE. The match no longer pleases you?

ORGON. Who knows?

CLÉANTE. D'you mean to go back on your word?

ORGON. I won't say that.

CLÉANTE. Has anything occurred
Which might entitle you to break your pledge?

ORGON. Perhaps.

CLÉANTE. Why must you hem, and haw, and hedge?
The boy asked me to sound you in this affair . . .

ORGON. It's been a pleasure.

CLÉANTE. But what shall I tell Valère?

ORGON. Whatever you like.

CLÉANTE. But what have you decided?
What are your plans?

ORGON. I plan, Sir, to be guided By Heaven's will.

CLÉANTE. Come, Brother, don't talk rot.
You've given Valère your word; will you keep it, or not?

ORGON. Good day.

CLÉANTE. This looks like poor Valère's undoing;
I'll go and warn him that there's trouble brewing.

Act 2
Scene I.

ORGON, MARIANE.

ORGON. Mariane.

MARIANE. Yes, Father?

ORGON. A word with you; come here.

MARIANE. What are you looking for?

ORGON (*peering into a small closet*).
Eavesdroppers, dear.
I'm making sure we shan't be overheard.
Someone in there could catch our every word.
Ah, good, we're safe. Now, Mariane, my child,
You're a sweet girl who's tractable and mild,
Whom I hold dear, and think most highly of.

MARIANE. I'm deeply grateful, Father, for your love.

ORGON. That's well said, Daughter; and you can repay
me If, in all things, you'll cheerfully obey me.

MARIANE. To please you, Sir, is what delights me best.

ORGON. Good, good. Now, what d'you think of Tartuffe, our guest?

MARIANE. I, Sir?

ORGON. Yes. Weigh your answer; think it through.

MARIANE. Oh, dear. I'll say whatever you wish me to.

ORGON. That's wisely said, my Daughter. Say of him,
 then,
 That he's the very worthiest of men,
 And that you're fond of him, and would rejoice
 In being his wife, if that should be my choice. Well?

MARIANE. What?

ORGON. What's that?

MARIANE. I . . .

ORGON. Well?

MARIANE. Forgive me, pray.

ORGON. Did you not hear me?

MARIANE. Of *whom*, Sir, must I say
 That I am fond of him, and would rejoice
 In being his wife, if that should be your choice?

ORGON. Why, of Tartuffe.

MARIANE. But, Father, that's false, you know.
 Why would you have me say what isn't so?

ORGON. Because I am resolved it shall be true.
 That it's my wish should be enough for you.

MARIANE. You can't mean, Father . . .

ORGON. Yes, Tartuffe shall be
 Allied by marriage to this family,
 And he's to be your husband, is that clear?
 It's a father's privilege . . .

Scene II.

DORINE, ORGON, MARIANE.

ORGON (*to* DORINE). What are you doing in here?
 Is curiosity so fierce a passion
 With you, that you must eavesdrop in this fashion?

DORINE. There's lately been a rumor going about—
 Based on some hunch or chance remark, no
 doubt—
 That you mean Mariane to wed Tartuffe.
 I've laughed it off, of course, as just a spoof.

ORGON. You find it so incredible?

DORINE. Yes, I do.
 I won't accept that story, even from you.

ORGON. Well, you'll believe it when the thing is done.

DORINE. Yes, yes, of course. Go on and have your fun.

ORGON. I've never been more serious in m

DORINE. Ha!

ORGON. Daughter, I mean it; you're to

DORINE. No, don't believe your father; it's a

ORGON. See here, young woman . . .

DORINE. Come, Sir, no more jokes; You can't fool us.

ORGON. How dare you talk that way?

DORINE. All right, then: we believe you, sad to say.
 But how a man like you, who looks so wise
 And wears a moustache of such splendid size,
 Can be so foolish as to . . .

ORGON. Silence, please!
 My girl, you take too many liberties.
 I'm master here, as you must not forget.

DORINE. Do let's discuss this calmly; don't be upset.
 You can't be serious, Sir, about this plan.
 What should that bigot want with Mariane?
 Praying and fasting ought to keep him busy.
 And then, in terms of wealth and rank, what is he?
 Why should a man of property like you
 Pick out a beggar son-in-law?

ORGON. That will do.
 Speak of his poverty with reverence.
 His is a pure and saintly indigence
 Which far transcends all worldly pride and pelf.
 He lost his fortune, as he says himself,
 Because he cared for Heaven alone, and so
 Was careless of his interests here below.
 I mean to get him out of his present straits
 And help him to recover his estates—
 Which, in his part of the world, have no small fame.
 Poor though he is, he's a gentleman just the same.

DORINE. Yes, so he tells us; and, Sir, it seems to me
 Such pride goes very ill with piety.
 A man whose spirit spurns this dungy earth
 Ought not to brag of lands and noble birth;
 Such worldly arrogance will hardly square
 With meek devotion and the life of prayer
 But this approach, I see, has drawn a blank;
 Let's speak, then, of his person, not his rank.
 Doesn't it seem to you a trifle grim
 To give a girl like her to a man like him?
 When two are so ill-suited, can't you see

What the sad consequences is bound to be?
A young girl's virtue is imperiled, Sir,
When such a marriage is imposed on her;
For if one's bridegroom isn't to one's taste,
It's hardly an inducement to be chaste,
And many a man with horns upon his brow
Has made his wife the thing that she is now.
It's hard to be a faithful wife, in short,
To certain husbands of a certain sort,
And he who gives his daughter to a man she hates
Must answer for her sins at Heaven's gates.
Think, Sir, before you play so risky a role.

ORGON. This servant-girl presumes to save my soul!

DORINE. You would do well to ponder what I've said.

ORGON. Daughter, we'll disregard this dunderhead.
Just trust your father's judgment. Oh, I'm aware
That I once promised you to young Valère;
But now I hear he gambles, which greatly shocks me;
What's more, I've doubts about his orthodoxy.
His visits to church, I note, are very few.

DORINE. Would you have him go at the same hours as you;
And kneel nearby, to be sure of being seen?

ORGON. I can dispense with such remarks, Dorine.
Tartuffe, however, is sure of Heaven's blessing,
And that's the only treasure worth possessing.
This match will bring you joys beyond all measure;
Your cup will overflow with every pleasure;
You two will interchange your faithful loves
Like two sweet cherubs, or two turtle-doves.
No harsh word shall be heard, no frown be seen,
And he shall make you happy as a queen.

DORINE. And she'll make him a cuckold, just wait and see.

ORGON. What language!

DORINE. Oh, he's a man of destiny;
He's *made* for horns, and what the stars demand
Your daughter's virtue surely can't withstand.

ORGON. Don't interrupt me further. Why can't you learn
That certain things are none of your concern?

DORINE. It's for your own sake that I interfere.

She repeatedly interrupts ORGON *just as he is turning to speak to his daughter.*

ORGON. Most kind of you. Now, hold your tongue, d'you hear?

DORINE. If I didn't love you . . .

ORGON. Spare me your affection.

DORINE. I'll love you, Sir, in spite of your objection.

ORGON. Blast!

DORINE. I can't bear, Sir, for your honor's sake,
To let you make this ludicrous mistake.

ORGON. You mean to go on talking?

DORINE. If I didn't protest
This sinful marriage, my conscience couldn't rest.

ORGON. If you don't hold your tongue, you little shrew . . .

DORINE. What, lost your temper? A pious man like you?

ORGON. Yes! Yes! You talk and talk. I'm maddened by it.
Once and for all, I tell you to be quiet.

DORINE. Well, I'll be quiet. But I'll be thinking hard.

ORGON. Think all you like, but you had better guard
That saucy tongue of yours, or I'll . . .

Turning back to MARIANE.

Now, child,
I've weighed this matter fully.

DORINE *(aside)*. It drives me wild
That I can't speak.

ORGON *turns his head, and she is silent.*

ORGON. Tartuffe is no young dandy,
But, still, his person . . .

DORINE *(aside)*. Is as sweet as candy.

ORGON. Is such that, even if you shouldn't care
For his other merits . . .

He turns and stands facing DORINE, *arms crossed.*

DORINE *(aside)*. They'll make a lovely pair.
If I were she, no man would marry me
Against my inclination, and go scot-free.
He'd learn, before the wedding-day was over,
How readily a wife can find a lover.

ORGON *(to* DORINE*)*. It seems you treat my orders as a joke.

DORINE. Why, what's the matter? 'Twas not to you I spoke.

ORGON. What *were* you doing?

DORINE. Talking to myself, that's all.

ORGON. Ah! (*Aside*). One more bit of impudence and gall.
And I shall give her a good slap in the face.

(*He puts himself in position to slap her; DORINE, whenever he glances at her, stands immobile and silent*).

Daughter, you shall accept, and with good grace,
The husband I've selected . . . Your wedding-day . . .

(*To DORINE*).

Why don't you talk to yourself?

DORINE. I've nothing to say.

ORGON. Come, just one word.

DORINE. No thank you, Sir. I pass.

ORGON. Come, speak; I'm waiting.

DORINE. I'd not be such an ass.

ORGON (*turning to MARIANE*). In short, dear Daughter, I mean to be obeyed,
And you must bow to the sound choice I've made.

DORINE (*moving away*). I'd not wed such a monster even in jest.

(ORGON *attempts to slap her, but misses*).

ORGON. Daughter, that maid of yours is a thorough pest;
She makes me sinfully annoyed and nettled.
I can't speak further; my nerves are too unsettled.
She's so upset me by her insolent talk.
I'll calm myself by going for a walk.

Scene III.

DORINE, MARIANE

DORINE (*returning*). Well, have you lost your tongue, girl? Must I play
Your part, and say the lines you ought to say?
Faced with a fate so hideous and absurd,
Can you not utter one dissenting word?

MARIANE. What good would it do? A father's power is great.

DORINE. Resist him now, or it will be too late.

MARIANE. But . . .

DORINE. Tell him one cannot love at a father's whim;
That you shall marry for yourself, not him;
That since it's you who are to be the bride,
It's you, not he, who must be satisfied;
And that if his Tartuffe is so sublime,
He's free to marry him at any time.

MARIANE. I've bowed so long to Father's strict control,
I couldn't oppose him now to save my soul.

DORINE. Come, come, Mariane. Do listen to reason, won't you?
Valère has asked your hand. Do you love him, or don't you?

MARIANE. Oh, how unjust of you! What can you mean
By asking such a question, dear Dorine?
You know the depth of my affection for him;
I've told you a hundred times how I adore him.

DORINE. I don't believe in everything I hear;
Who knows if your professions were sincere?

MARIANE. They were, Dorine, and you do me wrong to doubt it;
Heaven knows that I've been all too frank about it.

DORINE. You love him, then?

MARIANE. Oh, more than I can express.

DORINE. And he; I take it, cares for you no less?

MARIANE. I think so.

DORINE. And you both, with equal fire.
Burn to be married?

MARIANE. That is our one desire.

DORINE. What of Tartuffe, then? What of your father's plan?

MARIANE. I'll kill myself, if I'm forced to wed that man.

DORINE. I hadn't thought of that recourse. How splendid!
Just die, and all your troubles will be ended!
A fine solution. Oh, it maddens me
To hear you talk in that self-pitying key.

MARIANE. Dorine, how harsh you are! It's most unfair.
You have no sympathy for my despair.

DORINE. I've none at all for people who talk drivel.
And, faced with difficulties, whine and snivel.

MARIANE. No doubt I'm timid, but it would be wrong
. . .

DORINE. True love requires a heart that's firm and strong.

MARIANE. I'm strong in my affection for Valère,
But coming with my father is his affair.

DORINE. But if your father's brain has grown so cracked
Over his dear Tartuffe that he can retract
His blessing, through your wedding-day was named,
It's surely not Valère to be blamed.

MARIANE. If I defied my father, as you suggest,
Would it not seem unmaidenly, at best?
Shall I defend my love at the expense
Of brazenness and disobedience?
Shall I parade my heart's desires, and flaunt . . .

DORINE. No, I ask nothing of you. Clearly you want
To be Madame Tartuffe, and I feel bound
Not to oppose a wish so very sound.
What right have I to criticize the match?
Indeed, my dear, the man's a brilliant catch.
Monsieur Tartuffe! Now, there's a man of weight!
Yes, yes, Monsieur Tartuffe, I'm bound to state,
Is quite a person; that's not to be denied;
'Twill be no little thing to be his bride.
The world already rings with his renown;
He's a great noble—in his native town;
His ears are red, he has a pink complexion,
And all in all, he'll suit you to perfection.

MARIANE. Dear God!

DORINE. Oh, how triumphant you will feel
At having caught a husband so ideal!

MARIANE. Oh, do stop teasing, and use your cleverness
To get me out of this appalling mess.
Advise me, and I'll do whatever you say.

DORINE. Ah no, a dutiful daughter must obey
Her father, even if he weds her to an ape.
You've got a bright future; why struggle to escape?
Tartuffe will take you back where his family lives,
To a small town aswarm with relatives—
Uncles and cousins whom you'll be charmed to meet.
You'll be received at once by the elite,
Calling upon the bailiff's wife, no less—
Even, perhaps, upon the mayoress,
Who'll sit you down in the *best* kitchen chair.
Then, once a year, you'll dance at the village fair
To the drone of bagpipes—two of them, in fact—
And see a puppet-show, or an animal act.
Your husband . . .

MARIANE. Oh, you turn my blood to ice!
Stop torturing me, and give me your advice.

DORINE (*threatening to go*). Your servant, Madam.

MARIANE. Dorine, I beg of you . . .

DORINE. No, you deserve it; this marriage must go through.

MARIANE. Dorine!

DORINE. No.

MARIANE. Not Tartuffe! You know I think him . . .

DORINE. Tartuffe's your cup of tea, and you shall drink him.

MARIANE. I've always told you everything, and relied . . .

DORINE. No. You deserve to be tartuffified.

MARIANE. Well, since you mock me and refuse to care,
I'll henceforth seek my solace in despair:
Despair shall be my counsellor and friend,
And help me bring my sorrows to an end.
(*She starts to leave*).

DORINE. There now, come back; my anger has subsided.
You do deserve some pity, I've decided.

MARIANE. Dorine, if Father makes me undergo
This dreadful martyrdom, I'll die, I know.

DORINE. Don't fret; it won't be difficult to discover
Some plan of action . . . But there's Valère, your lover.

Scene IV.

VALÈRE, MARIANE, DORINE

VALÈRE. Madam, I've just received some wondrous news
Regarding which I'd like to hear your views.

MARIANE. What news?

VALÈRE. You're marrying Tartuffe.

MARIANE. I find That Father does have such a match in mind.

VALÈRE. Your father, Madam . . .

MARIANE. . . . has just this minute said That it's Tartuffe he wishes me to wed.

VALÈRE. Can he be serious?

MARIANE. Oh, indeed he can; He's clearly set his heart upon the plan.

VALÈRE. And what position do you propose to take, Madam?

MARIANE. Why—I don't know.

VALÈRE. For heaven's sake— You don't know?

MARIANE. No.

VALÈRE. Well, well!

MARIANE. Advise me, do.

VALÈRE. Marry the man. That's my advice to you.

MARIANE. That's your advice?

VALÈRE. Yes.

MARIANE. Truly?

VALÈRE. Oh, absolutely. You couldn't choose more wisely, more astutely.

MARIANE. Thanks for this counsel; I'll follow it, of course.

VALÈRE. Do, do; I'm sure 'twill cost you no remorse.

MARIANE. To give it didn't cause your heart to break.

VALÈRE. I gave it, Madam, only for your sake.

MARIANE. And it's for your sake that I take it, Sir.

DORINE (*withdrawing to the rear of the stage*). Let's see which fool will prove the stubborner.

VALÈRE. So! I am nothing to you, and it was flat Deception when you . . .

MARIANE. Please, enough of that.
You've told me plainly that I should agree
To wed the man my father's chosen for me,
And since you've deigned to counsel me so wisely,
I promise, Sir, to do as you advise me.

VALÈRE. Ah, no 'twas not by me that you were swayed.
No, your decision was already made;
Though, now, to save appearances, you protest
That you're betraying me at my behest.

MARIANE. Just as you say.

VALÈRE. Quite so. And I now see
That you were never truly in love with me.

MARIANE. Alas, you're free to think so if you choose.

VALÈRE. I choose to think so, and here's a bit of news:
You've spurned my hand, but I know where to turn
For kinder treatment, as you shall quickly learn.

MARIANE. I'm sure you do. Your noble qualities
Inspire affection . . .

VALÈRE. Forget my qualities, please.
They don't inspire you overmuch, I find.
But there's another lady I have in mind
Whose sweet and generous nature will not scorn
To compensate me for the loss I've borne.

MARIANE. I'm no great loss, and I'm sure that you'll transfer
Your heart quite painlessly from me to her.

VALÈRE. I'll do my best to take it in my stride.
The pain I feel at being cast aside.
Time and forgetfulness may put an end to.
Or if I can't forget, I shall pretend to.
No self-respecting person is expected
To go on loving once he's been rejected.

MARIANE. Now, that's a fine, high-minded sentiment.

VALÈRE. One to which any sane man would assent.
Would you prefer it if I pined away
In hopeless passion till my dying day?
Am I to yield you to a rival's arms
And not console myself with other charms?

MARIANE. Go then: console yourself; don't hesitate.
I wish you to; indeed, I cannot wait.

VALÈRE. You wish me to?

MARIANE. Yes.

VALÈRE. That's the final straw. Madam, farewell.
Your wish shall be my law.

(*He starts to leave, and then returns: this repeatedly*).

MARIANE. Splended.

VALÈRE (*coming back again*).
This breach, remember, is of your making:
It's you who have driven me to the step I'm taking.

MARIANE. Of course.

VALÈRE (*coming back again*).
Remember, too, that I am merely
Following your example.

MARIANE. I see that clearly.

VALÈRE. Enough. I'll go and do your bidding, then.

MARIANE. Good.

VALÈRE (*coming back again*).
You shall never see my face again.

MARIANE. Excellent.

VALÈRE (*walking to the door, then turning about*). Yes?

MARIANE. What?

VALÈRE. What's that? What did you say?

MARIANE. Nothing. You're dreaming.

VALÈRE. Ah. Well, I'm on my way. Farewell, *Madame*.

He moves slowly away.

MARIANE. Farewell.

DORINE (*to* MARIANE). If you ask me,
Both of you are as mad as mad can be.
Do stop this nonsense, now. I've only let you
Squabble so long to see where it would get you.
Whoa there, Monsieure Valère!

She goes and seizes VALÈRE *by the arm; he makes a
great show of resistance.*

VALÈRE. What's this, Dorine?

DORINE. Come here.

VALÈRE. No, no, my heart's too full of spleen.
Don't hold me back; her wish must be obeyed.

DORINE. Stop!

VALÈRE. It's too late now; my decision's made.

DORINE. Oh, pooh!

MARIANE (*aside*).
He hates the sight of me, that's plain.
I'll go, and so deliver him from pain.

DORINE (*leaving* VALÈRE, *running after* MARIANE).
And now *you* run away! Come back.

MARIANE. No, no.
Nothing you say will keep me here. Let go!

VALÈRE (*aside*). She cannot bear my presence, I perceive.
To spare her further torment, I shall leave.

DORINE (*leaving* MARIANE, *running after* VALÈRE).
Again!
You'll not escape, Sir; don't you try it.
Come here, you two. Stop fussing, and be quiet.

She takes VALÈRE *by the hand, then* MARIANE, *and
draws them together.*

VALÈRE (*to* DORINE). What do you want of me?

MARIANE (*to* DORINE). What is the point of this?

DORINE. We're going to have a little armistice.

To VALÈRE.

Now, weren't you silly to get so overheated?

VALÈRE. Didn't you see how badly I was treated?

DORINE (*to* MARIANE). Aren't you a simpleton, to have
lost your head?

MARIANE. Didn't you hear the hateful things he said?

DORINE (*to* VALÈRE). You're both great fools. Her sole
desire. Valère.
Is to be yours in marriage. To that I'll swear.

To MARIANE.

He loves you only, and he wants no wife
But you. Mariane. On that I'll stake my life.

MARIANE (*to* VALÈRE). Then why you advised me so,
I cannot see.

VALÈRE (*to* MARIANE). On such a question, why ask
advice of *me?*

DORINE. Oh, you're impossible. Give me your hands,
you two.

To VALÈRE.

Yours first.

VALÈRE (*giving* DORINE *his hand*).
But why?

DORINE (*to* MARIANE).
And now a hand from you.

MARIANE (*also giving* DORINE *her hand*).
What are you doing?

DORINE. There: a perfect fit.
You suit each other better than you'll admit.

VALÈRE *and* MARIANE *hold hands for some time without
looking at each other.*

VALÈRE (*turning toward* MARIANE). Ah, come, don't be
so haughty.
Give a man A look of kindness, won't you, Mariane?

MARIANE *turns toward* VALÈRE *and smiles.*

DORINE. I tell you lovers are completely mad!

VALÈRE (*to* MARIANE). Now come, confess that you
were very bad
To hurt my feelings as you did just now.
I have a just complaint, you must allow.

MARIANE. *You* must allow that you were most
unpleasant . . .

DORINE. Let's table that discussion for the present;
Your father has a plan which must be stopped.

MARIANE. Advise us, then; what means must we adopt?

DORINE. We'll use all manner of means, and all at once.

To MARIANE.

Your father's addled; he's acting like a dance.
Therefore you'd better humor the old fossil.
Pretend to yield to him, be sweet and docile,
And then postpone, as often as necessary,
The day on which you have agreed to marry.

You'll thus gain time, and time will turn the
 trick.
Sometimes, for instance, you'll be taken sick,
And that will seem good reason for delay;
Or some bad omen will make you change the
 day—
You'll dream of muddy water, or you'll pass
A dead man's hearse, or break a looking-glass.
If all else fails, no man can marry you
Unless you take his ring and say "I do."
But now, let's separate. If they should find
Us talking here, our plot might be divined.

To VALÈRE.

Go to your friends, and tell them what's occurred,
And have them urge her father to keep his word.
Meanwhile, we'll stir her brother into action,
And get Elmire, as well, to join our faction.
Good-bye.

VALÈRE (*to* MARIANE).
 Though each of us will do his best,
 It's your true heart on which my hopes shall rest.

MARIANE (*to* VALÈRE). Regardless of what Father may
 decide,
 None but Valère shall claim me as his bride.

VALÈRE. Oh, how those words content me! Come what
 will . . .

DORINE. Oh, lover, lovers! Their tongues are never still.
 Be off, now.

VALÈRE (*turning to go, then turning back*).
 One last word . . .

DORINE. No time to chat:
 You leave by this door; and *you* leave by that.

DORINE *pushes them, by the shoulders, toward opposing*
doors.

Act 3
Scene I.

DAMIS, DORINE.

DAMIS. May lightning strike me even as I speak,
 May all men call me cowardly and weak,
 If any fear or scruple holds me back
 From settling things, at once, with that great
 quack!

DORINE. Now, don't give way to violent emotion.
 Your father's merely talked about this notion,
 And words and deeds are far from being one.
 Much that is talked about is left undone.

DAMIS. No, I must stop that scoundrel's machinations;
 I'll go and tell him off; I'm out of patience.

DORINE. Do calm down and be practical. I had
 rather
 My mistress dealt with him—and with your father.
 She has some influence with Tartuffe, I've noted.
 He hangs upon her words, seems most devoted,
 And may, indeed, be smitten by her charm.
 Pray Heaven it's true! 'Twould do our cause no
 harm.
 She sent for him, just now, to sound him out
 On this affair you're so incensed about;
 She'll find out where he stands, and tell him, too,
 What dreadful strife and trouble will ensue
 If he lends countenance to your father's plan.
 I couldn't get in to see him, but his man
 Says that he's almost finished with his prayers.
 Go, now, I'll catch him when he comes
 downstairs.

DAMIS. I want to hear this conference, and I will.

DORINE. No, they must be alone.

DAMIS. Oh, I'll keep still.

DORINE. Not you. I know your temper. You'd start a
 brawl,
 And shout and stamp your foot and spoil it all.
 Go on.

DAMIS. I won't; I have a perfect right . . .

DORINE. Lord, you're a nuisance! He's coming: get out
 of sight.

DAMIS *conceals himself in a closet at the rear of the*
stage.

Scene II.

TARTUFFE, DORINE.

TARTUFFE (*observing* DORINE, *and calling to his*
 manservant offstage).
 Hang up my hair-shirt, put my scourge in place,
 And pray, Laurent, for Heaven's perpetual grace.
 I'm going to the prison now, to share
 My last few coins with the poor wretches there.

DORINE. *(aside).* Dear God, what affectation! What a fake!

TARTUFFE. You wished to see me?

DORINE. Yes . . .

TARTUFFE. *(taking a handkerchief from his pocket).*
For mercy's sake,
Please take this handkerchief, before you speak.

DORINE. What?

TARTUFFE. Cover that bosom, girl. The flesh is weak,
And unclean thoughts are difficult to control.
Such sights as that can undermine the soul.

DORINE. Your soul, it seems, has very poor defenses,
And flesh makes quite an impact on your senses.
It's strange that you're so easily excited;
My own desires are not so soon ignited,
And if I saw you naked as a beast,
Not all your hide would tempt me in the least.

TARTUFFE. Girl, speak more modestly; unless you do,
I shall be forced to take my leave of you.

DORINE. Oh, no, it's I who must be on my way;
I've just one little message to convey.
Madame is coming down, and begs you, Sir,
To wait and have a word or two with her.

TARTUFFE. Gladly

DORINE. *(aside). That* had a softening effect!
I think my guess about him was correct.

TARTUFFE. Will she be long?

DORINE. No: that's her step I hear.
Ah, here she is, and I shall disappear.

Scene III.

ELMIRE, TARTUFFE.

TARTUFFE. May Heaven, whose infinite goodness we adore,
Preserve your body and soul forevermore,
And bless your days, and answer thus the plea
Of one who is its humblest votary.

ELMIRE. I thank you for that pious wish. But please,
Do take a chair and let's be more at ease.

They sit down.

TARTUFFE. I trust that you are once more well and strong?

ELMIRE. Oh, yes: the fever didn't last for long.

TARTUFFE. My prayers are too unworthy. I am sure,
To have gained form Heaven this most gracious cure:
But lately, Madam, me every supplication
Has had for object your recuperation.

ELMIRE. You shouldn't have troubled so. I don't deserve it.

TARTUFFE. Your health is priceless, Madam, and to preserve it
I'd gladly give my own, in all sincerity.

ELMIRE. Sir, you outdo us all in Christian charity.
You've been most kind. I count myself your debtor.

TARTUFFE. 'Twas nothing, Madam. I long to serve you better.

ELMIRE. There's a private matter I'm anxious to discuss.
I'm glad there's no one here to hinder us.

TARTUFFE. I too am glad; it floods my heart with bliss
To find myself alone with you like this.
For just this chance I've prayed with all my power—
But prayed in vain, until this happy hour.

ELMIRE. This won't take long, Sir, and I hope you'll be
Entirely frank and unconstrained with me.

TARTUFFE. Indeed, there's nothing I had rather do
Than bare my inmost heart and soul to you.
First, let me say that what remarks I've made
About the constant visits you are paid
Were prompted not by any mean emotion,
But rather by a pure and deep devotion,
A fervent zeal . . .

ELMIRE. No need for explanation.
Your sole concern, I'm sure, was my salvation.

TARTUFFE *(taking ELMIRE's hand and pressing her fingertips).*
Quite so; and such great fervor do I feel . . .

ELMIRE. Ooh! Please! You're pinching!

TARTUFFE. 'Twas from excess of zeal.
I never meant to cause you pain, I swear.
I'd rather . . .

He places his hand on ELMIRE's knee.

ELMIRE. What can your hand be doing there?

TARTUFFE. Feeling your gown; what soft, fine-woven stuff!

ELMIRE. Please, I'm extremely ticklish. That's enough.
(She draws her chair away; TARTUFFE pulls his after her).

TARTUFFE (*Fondling the lace collar of her gown*).
 My, my, what lovely lacework on your dress!
 The workmanship's miraculous, no less.
 I've not seen anything to equal it.

ELMIRE. Yes, quite. But let's talk business for a bit.
 They say my husband means to break his word
 And give his daughter to you, Sir. Had you heard?

TARTUFFE. He did once mention it. But I confess
 I dream of quite a different happiness.
 It's elsewhere, Madam, that my eyes discern
 The promise of that bliss for which I yearn.

ELMIRE. I see: you care for nothing here below.

TARTUFFE. Ah, well—my heart's not made of stone, you
 know.

ELMIRE. All your desires mount heavenward, I'm sure,
 In scorn of all that's earthly and impure.

TARTUFFE. A love of heavenly beauty does not preclude
 A proper love for earthly pulchritude;
 Our senses are quite rightly captivated
 By perfect works our Marker has created.
 Some glory clings to all that Heaven has made;
 In you, all Heaven's marvels are displayed.
 On that fair face, such beauties have been lavished,
 The eyes are dazzled and the heart is ravished;
 How could I look on you, O flawless creature,
 And not adore the Author of all Nature.
 Feeling a love both passionate and pure
 For you, his triumph of self-portraiture?
 At first. I trembled lest that love should be
 A subtle snare that Hell had laid for me;
 I vowed to flee the sight of you, eschewing
 A rapture that might prove my soul's undoing;
 But soon, fair being, I became aware
 That my deep passion could be made to square
 With rectitude, and with my bounden duty.
 I thereupon surrendered to your beauty.
 It is, I know, presumptuous on my part
 To bring you this poor offering of my heart,
 And it is not my merit, Heaven knows,
 But your compassion on which my hopes repose.
 You are my peace, my solace, my salvation;
 On you depends my bliss—or desolation;
 I bide your judgment and, as you think best,
 I shall be either miserable or blest.

ELMIRE. Your declaration is most gallant, Sir,
 But don't you think it's out of character?
 You'd have done better to restrain your passion
 And think before you spoke in such a fashion.
 It ill becomes a pious man like you . . .

TARTUFFE. I may be pious, but I'm human too:
 With your celestial charms before his eyes,
 A man has not the power to be wise.
 I know such words sound strangely, coming from me,
 But I'm no angel, nor was meant to be,
 And if you blame my passion, you must needs
 Reproach as well the charms on which it feeds.
 Your loveliness I had no sooner seen
 Than you became my soul's unrivalled queen;
 Before your seraph glance, divinely sweet,
 My heart's defenses crumbled in defeat,
 And nothing fasting, prayer, or tears might do
 Could stay my spirit from adoring you.
 My eyes, my sighs have told you in the past
 What now my lips make bold to say at last,
 And if, in your great goodness, you will deign
 To look upon your slave, and ease his pain,—
 If, in compassion for my soul's distress,
 You'll stoop to comfort my unworthiness,
 I'll raise to you, in thanks for that sweet manna,
 An endless hymn, an infinite hosanna.
 With me, of course, there need be no anxiety.
 No fear of scandal or of notoriety.
 These young court gallants, whom all the ladies
 fancy,
 Are vain in speech, in action rash and chancy;
 When they succeed in love, the world soon knows it;
 No favor's granted them but they disclose it
 And by the looseness of their tongues profane
 The very altar where their hearts have lain.
 Men of my sort, however, love discreetly,
 And one may trust our reticence completely.
 My keen concern for my good name insures
 The absolute security of yours;
 In short, I offer you, my dear Elmire,
 Love without scandal, pleasure without fear.

ELMIRE. I've heard your well-turned speeches to the
 end,
 And what you urge I clearly apprehend.
 Aren't you afraid that I may take a notion
 To tell my husband of your warm devotion,
 And that, supposing he were duly told,
 His feelings toward you might grow rather cold?

TARTUFFE. I know, dear lady, that your exceeding charity
 Will lead your heart to pardon my temerity;
 That you'll excuse my violent affection
 As human weakness, human imperfection;
 And that—O fairest!—you will bear in mind
 That I'm but flesh and blood, and am not blind.

ELMIRE. Some women might do otherwise, perhaps,
 But I shall be discreet about your lapse;

I'll tell my husband nothing of what's occurred
If, in return, you'll give your solemn word
To advocate as forcefully as you can
The marriage of Valere and Mariane,
Renouncing all desire to dispossess
Another of his rightful happiness,
And . . .

Scene IV.

DAMIS, ELMIRE, TARTUFFE.

DAMIS *(emerging from the closet where he has been hiding)*.
No! We'll not hush up this vile affair;
I heard it all inside that closet there,
Where Heaven, in order to confound the pride
Of this great rascal, prompted me to hide.
Ah, now I have my long-awaited chance
To punish his deceit and arrogance,
And give my father clear and shocking proof
Of the black character of his dear Tartuffe.

ELMIRE. Ah no, Damis; I'll be content if he
Will study to deserve my leniency.
I've promised silence—don't make me break my word;
To make a scandal would be too absurd.
Good wives laugh off such trifles, and forget them;
Why should they tell their husbands, and upset
 them?

DAMIS. You have your reasons for taking such a course,
And I have reasons, too, of equal force.
To spare him now would be insanely wrong.
I've swallowed my just wrath for far too long
And watched this insolent bigot bringing strife
And bitterness into our family life.
Too long he's meddled in my father's affairs,
Thwarting my marriage-hopes, and poor Valère's.
It's high time that my father was undeceived,
And now I've proof that can't be disbelieved—
Proof that was furnished me by Heaven above.
It's too good not to take advantage of.
This is my chance, and I deserve to lose it
If, for one moment, I hesitate to use it.

ELMIRE. Damis . . .

DAMIS. No, I must do what I think right.
Madam, my heart is bursting with delight,
And, say whatever you will, I'll not consent
To lose the sweet revenge on which I'm bent.
I'll settle matters without more ado;
And here, most opportunely, is my cue.

Scene V.

ORGON, DAMIS, TARTUFFE, ELMIRE.

DAMIS. Father, I'm glad you've joined us. Let us advise you
Of some fresh news which doubtless will surprise you.
You've just now been repaid with interest
For all your loving-kindness to our guest.
He's proved his warm and grateful feelings toward
 you;
It's with a pair of horns he would reward you.
Yes, I surprised him with your wife, and heard
His whole adulterous offer, every word.
She, with her all too gentle disposition,
Would not have told you of his proposition;
But I shall not make terms with brazen lechery,
And feel that not to tell you would be treachery.

ELMIRE. And I hold that one's husband's peace of mind
Should not be spoilt by tattle of this kind.
One's honor doesn't require it: to be proficient
In keeping men at bay is quite sufficient.
These are my sentiments, and I wish, Damis,
That you had heeded me and held your peace.

Scene VI.

ORGON, DAMIS, TARTUFFE.

ORGON. Can it be true, this dreadful thing I hear?

TARTUFFE. Yes, Brother, I'm a wicked man, I fear:
A wretched sinner, all depraved and twisted,
The greatest villain that has ever existed.
My life's one heap of crimes, which grows each
 minute;
There's naught but foulness and corruption in it;
And I perceive that Heaven, outraged by me,
Has chosen this occasion to mortify me.
Charge me with any deed you wish to name;
I'll not defend myself, but take the blame.
Believe what you are told, and drive Tartuffe
Like some base criminal from beneath your roof;
Yes, drive me hence, and with a parting curse:
I shan't protest for I deserve far worse.

ORGON *(to DAMIS)*. Ah, you deceitful boy, how dare you try
To stain his purity with so foul a lie?

DAMIS. What! Are you taken in by such a bluff?
Did you not hear . . .?

ORGON. Enough, you rogue, enough!

TARTUFFE. Ah, Brother, let him speak: you're being unjust.
Believe his story; the boy deserves your trust.
Why, after all, should you have faith in me?
How can you know what I might do, or be?
Is it on my good actions that you base
Your favor? Do you trust my pious face?
Ah, no, don't be deceived by hollow shows;
I'm far, alas, from being what men suppose;
Though the world takes me for a man of worth,
I'm truly the most worthless man on earth.

To DAMIS.

Yes, my dear son, speak out now: call me the chief
Of sinners, a wretch, a murderer, a thief;
Load me with all the names men most abhor;
I'll not complain: I've earned them all, and more;
I'll kneel here while you pour them on my head
As a just punishment for the life I've led.

ORGON *(to* TARTUFFE*)*.
This is too much, dear Brother.

To DAMIS.

Have you no heart?

DAMIS. Are you so hoodwinked by this rascal's art. . .?

ORGON. Be still, you monster.

To TARTUFFE.

Brother, I pray you, rise.

To DAMIS.

Villain!

DAMIS. But . . .

ORGON. Silence!

DAMIS. Can't you realize . . .?

ORGON. Just one word more, and I'll tear you limb from limb.

TARTUFFE. In God's name, Brother, don't be harsh with him.
I'd rather far be tortured at the stake
Than see him bear one scratch for my poor sake.

ORGON *(to* DAMIS*)*.
Ingrate!

TARTUFFE. If I must beg you, on bended knee,
To pardon him . . .

ORGON *(falling to his knees, addressing* TARTUFFE*)*.
Such goodness cannot be!

To DAMIS.

Now, *there's* true charity!

DAMIS. What, you . . .?

ORGON. Villain, be still!
I know your motives; I know you wish him ill:
Yes, all of you—wife, children, servants, all—
Conspire against him and desire his fall,
Employing every shameful trick you can
To alienate me from this saintly man.
Ah, but the more you seek to drive him away,
The more I'll do to keep him. Without delay,
I'll spite this household and confound its pride
By giving him my daughter as his bride.

DAMIS. You're going to force her to accept his hand?

ORGON. Yes, and this very night, d'you understand?
I shall defy you all, and make it clear
That I'm the one who gives the orders here.
Come, wretch, kneel down and clasp his blessed feet,
And ask his pardon for your black deceit.

DAMIS. I ask that swindler's pardon? Why, I'd rather . . .

ORGON. So! You insult him, and defy your father!
A stick! A stick! *(To* TARTUFFE*)*. No, no—release me, do.

To DAMIS.

Out of my house this minute! Be off with you,
And never dare set foot in it again.

DAMIS. Well, I shall go, but . . .

ORGON. Well, go quickly, then.
I disinherit you; an empty purse
Is all you'll get from me—except my curse!

Scene VII.

ORGON, TARTUFFE.

ORGON. How he blasphemed your goodness! What a son!

TARTUFFE. Forgive him, Lord, as I've already done.

To ORGON.

You can't know how it hurts when someone tries
To blacken me in my dear Brother's eyes.

ORGON. Ahh!

TARTUFFE. The mere thought of such ingratitude
 Plunges my soul into so dark a mood . . .
 Such horror grips my heart . . .
 I gasp for breath,
 And cannot speak, and feel myself near death.

ORGON.

He runs, in tears, to the door through which he has just driven his son.

 You blackguard! Why did I spare you? Why did
 I not
 Break you in little pieces on the spot?
 Compose yourself, and don't be hurt, dear friend.

TARTUFFE. These scenes, these dreadful quarrels, have
 got to end.
 I've much upset your household, and I perceive
 That the best thing will be for me to leave.

ORGON. What are you saying!

TARTUFFE. They're all against me here;
 They'd have you think me false and insincere.

ORGON. Ah, what of that? Have I ceased believing in
 you?

TARTUFFE. Their adverse talk will certainly continue,
 And charges which you now repudiate You may
 find credible at a later date.

ORGON. No, Brother, never.

TARTUFFE. Brother, a wife can sway
 Her husband's mind in many a subtle way.

ORGON. No, no.

TARTUFFE. To leave at once is the solution;
 Thus only can I end their persecution.

ORGON. No, no, I'll not allow it; you shall remain.

TARTUFFE. Ah, well; 'twill mean much martyrdom and
 pain,
 But if you wish it . . .

ORGON. Ah!

TARTUFFE. Enough; so be it.
 But one thing must be settled, as I see it.
 For your dear honor, and for our friendship's sake,
 There's one precaution I feel bound to take.
 I shall avoid your wife, and keep away . . .

ORGON. No, you shall not, whatever they may say.
 It pleases me to vex them, and for spite
 I'd have them see you with her day and night.
 What's more, I'm going to drive them to despair
 By making you my only son and heir;

This very day, I'll give to you alone
Clear deed and title to everything I own.
A dear, good friend and son-in-law-to-be
Is more than wife, or child, or kin to me.
Will you accept my offer, dearest son?

TARTUFFE. In all things, let the will of Heaven be done.

ORGON. Poor fellow! Come, we'll go draw up the
 deed.
 Then let them burst with disappointed greed!

Act 4
Scene I.

CLÉANTE, TARTUFFE.

CLÉANTE. Yes, all the town's discussing it, and truly,
 Their comments do not flatter you unduly.
 I'm glad we've met, Sir, and I'll give my view
 Of this sad matter in a word or two.
 As for who's guilty, that I shan't discuss;
 Let's say it was Damis who caused the fuss;
 Assuming, then, that you have been ill-used
 By young Damis, and groundlessly accused,
 Ought not a Christian to forgive, and ought
 He not to stifle every vengeful thought?
 Should you stand by and watch a father make
 His only son an exile for your sake?
 Again I tell you frankly, be advised:
 The whole town, high and low, is scandalized;
 This quarrel must be mended, and my advice is
 Not to push matters to a further crisis.
 No, sacrifice your wrath to God above,
 And help Damis regain his father's love.

TARTUFFE. Alas, for my part I should take great joy
 In doing so. I've nothing against the boy.
 I pardon all, I harbor no resentment;
 To serve him would afford me much contentment.
 But Heaven's interest will not have it so:
 If he comes back, then I shall have to go.
 After his conduct—so extreme, so vicious—
 Our further intercourse would look suspicious.
 God knows what people would think! Why, they'd
 describe
 My goodness to him as a sort of bribe;
 They'd say that out of guilt I made pretense
 Of loving-kindness and benevolence—
 That, fearing my accuser's tongue, I strove
 To buy his silence with a show of love.

CLÉANTE. Your reasoning is badly warped and stretched,
And these excuses, Sir, are most far-fetched.
Why put yourself in charge of Heaven's cause?
Does Heaven need our help to enforce its laws?
Leave vengeance to the Lord, Sir; while we live,
Our duty's not to punish, but forgive;
And what the Lord commands, we should obey
Without regard to what the world may say.
What! Shall the fear of being misunderstood
Prevent our doing what is right and good?
No, no; let's simply do what Heaven ordains,
And let no other thoughts perplex our brains.

TARTUFFE. Again, Sir, let me say that I've forgiven
Damis, and thus obeyed the laws of Heaven;
But I am not commanded by the Bible
To live with one who smears my name with libel.

CLÉANTE. Were you commanded. Sir, to indulge the whim
Of poor Orgon, and to encourage him
In suddenly transferring to your name
A large estate to which you have no claim?

TARTUFFE. 'Twould never occur to those who know me best
To think I acted from self-interest.
The treasures of this world I quite despise;
Their specious glitter does not charm my eyes;
And if I have resigned myself to taking
The gift which my dear Brother insists on making,
I do so only, as he well understands,
Lest so much wealth fall into wicked hands,
Lest those to whom it might descend in time
Turn it to purposes of sin and crime,
And not, as I shall do, make use of it.
For Heaven's glory and mankind's benefit.

CLÉANTE. Forget these trumped-up fears. Your argument
Is one the rightful heir might well resent;
It is a moral burden to inherit
Such wealth, but give Damis a chance to bear it.
And would it not be worse to be accused
Of swindling, than to see that wealth misused?
I'm shocked that you allowed Orgon to broach
This matter, and that you feel no self-reproach;
Does true religion teach that lawful heirs
May freely be deprived of what is theirs?
And if the Lord has told you in your heart
That you and young Damis must dwell apart,
Would it not be the decent thing to beat
A generous and honorable retreat,
Rather than let the son of the house be sent,

For your convenience, into banishment?
Sir, if you wish to prove the honesty
Of your intentions . . .

TARTUFFE. Sir, it is half-past three.
I've certain pious duties to attend to,
And hope my prompt departure won't offend you.

CLÉANTE (alone). Damn.

Scene II.

ELMIRE, MARIANE, CLÉANTE, DORINE.

DORINE. Stay, Sir, and help Mariane, for Heaven's sake!
She's suffering so, I fear her heart will break.
Her father's plan to marry her off tonight
Has put the poor child in a desperate plight.
I hear him coming. Let's stand together, now,
And see if we can't change his mind, somehow,
About this match we all deplore and fear.

Scene III.

ORGON, ELMIRE, MARIANE, CLÉANTE, DORINE.

ORGON. Hah! Glad to find you all assembled here.

To MARIANE.

This contract, child, contains your happiness,
And what it says I think your heart can guess.

MARIANE (falling to her knees). Sir, by that Heaven which sees me here distressed.
And by whatever else can move your breast,
Do not employ a father's power, I pray you,
To crush my heart and force it to obey you,
Nor by your harsh commands oppress me so
That I'll begrudge the duty which I owe—
And do not so embitter and enslave me
That I shall hate the very life you gave me.
If my sweet hopes must perish, if you refuse
To give me to the one I've dared to choose,
Spare me at least—I beg you, I implore—
The pain of wedding one whom I abhor;
And do not, by a heartless use of force,
Drive me to contemplate some desperate course.

ORGON (feeling himself touched by her). Be firm, my soul.
No human weakness, now.

MARIANE. I don't resent your love for him. Allow
 Your heart free rein, Sir; give him your property,
 And if that's not enough, take mine from me;
 He's welcome to my money; take it, do,
 But don't, I pray, include my person too.
 Spare me, I beg you; and let me end the tale
 Of my sad days behind a convent veil.

ORGON. A convent! Hah! When crossed in their
 amours,
 All lovesick girls have the same thought as yours.
 Get up! The more you loathe the man, and dread
 him,
 The more ennobling it will be to wed him.
 Marry Tartuffe, and mortify your flesh!
 Enough; don't start that whimpering afresh.

DORINE. But why . . .?

ORGON. Be still, there. Speak when you're spoken to.
 Not one more bit of impudence out of you.

CLÉANTE. If I may offer a word of counsel here . . .

ORGON. Brother, in counseling you have no peer;
 All your advice is forceful, sound, and clever;
 I don't propose to follow it, however.

ELMIRE (to ORGON). I am amazed, and don't know
 what to say;
 Your blindness simply takes my breath away.
 You are indeed bewitched, to take no warning
 From our account of what occurred this morning.

ORGON. Madam, I know a few plain facts, and one
 Is that you're partial to my rascal son;
 Hence, when he sought to make Tartuffe the victim
 Of a base lie, you dared not contradict him.
 Ah, but you underplayed your part, my pet;
 You should have looked more angry, more upset.

ELMIRE. When men make overtures, must we reply
 With righteous anger and a battle-cry?
 Must we turn back their amorous advances
 With sharp reproaches and with fiery glances?
 Myself, I find such offers merely amusing,
 And make no scenes and fusses in refusing;
 My taste is for good-natured rectitude,
 And I dislike the savage sort of prude
 Who guards her virtue with her teeth and claws,
 And tears men's eyes out for the slightest cause;
 The Lord preserve me from such honor as that,
 Which bites and scratches like an alley-cat!
 I've found that a polite and cool rebuff
 Discourages a lover quite enough.

ORGON. I know the facts, and I shall not be shaken.

ELMIRE. I marvel at your power to be mistaken.
 Would it, I wonder, carry weight with you
 If I could *show* you that our tale was true?

ORGON. Show me?

ELMIRE. Yes.

ORGON. Rot.

ELMIRE. Come, what if I found a way
 To make you see the facts as plain as day?

ORGON. Nonsense.

ELMIRE. Do answer me; don't be absurd.
 I'm not now asking you to trust our word.
 Suppose that from some hiding-place in here
 You learned the whole sad truth by eye and ear—
 What would you say of your good friend, after
 that?

ORGON. Why, I'd say . . . nothing, by Jehoshaphat!
 It can't be true.

ELMIRE. You've been too long deceived,
 And I'm quite tired of being disbelieved.
 Come now: let's put my statements to the test,
 And you shall see the truth made manifest.

ORGON. I'll take that challenge. Now do your uttermost.
 We'll see how you make good your empty boast.

ELMIRE (to DORINE). Send him to me.

DORINE. He's crafty; it may be hard
 To catch the cunning scoundrel off his guard.

ELMIRE. No, amorous men are gullible. Their conceit
 So blinds them that they're never hard to cheat.
 Have him come down. (To CLÉANTE and MARIANE).
 Please leave us, for a bit.

Scene IV.

ELMIRE, ORGON.

ELMIRE. Pull up this table, and get under it.

ORGON. What?

ELMIRE. It's essential that you be well-hidden.

ORGON. Why there?

ELMIRE. Oh, Heavens! Just do as you are bidden
 I have my plans; we'll soon see how they fare.
 Under the table, now; and once you're there,
 Take care that you are neither seen nor heard.

ORGON. Well, I'll indulge you, since I gave my word
 To see you through this infantile charade.

ELMIRE. Once it is over, you'll be glad we played.

To her husband, who is now under the table.

 I'm going to act quite strangely, now, and you
 Must not be shocked at anything I do.
 Whatever I may say, you must excuse
 As part of that deceit I'm forced to use.
 I shall employ sweet speeches in the task
 Of making that impostor drop his mask;
 I'll give encouragement to his bold desires,
 And furnish fuel to his amorous fires.
 Since it's for your sake, and for his destruction,
 That I shall seem to yield to his seduction,
 I'll gladly stop whenever you decide
 That all your doubts are fully satisfied.
 I'll count on you, as soon as you have seen
 What sort of man he is, to intervene,
 And not expose me to his odious lust
 One moment longer than you feel you must.
 Remember: you're to save me from my plight
 Whenever . . . He's coming! Hush! Keep out of
 sight!

Scene V.

TARTUFFE, ELMIRE, ORGON.

TARTUFFE. You wish to have a word with me, I'm told.

ELMIRE. Yes. I've a little secret to unfold.
 Before I speak, however, it would be wise
 To close that door, and look about for spies.

TARTUFFE goes to the door, closes it, and returns.

 The very last thing that must happen now
 Is a repetition of this morning's row.
 I've never been so badly caught off guard.
 Oh, how I feared for you! You saw how hard
 I tried to make that troublesome Damis
 Control his dreadful temper, and hold his peace.
 In my confusion, I didn't have the sense
 Simply to contradict his evidence;
 But as it happened, that was for the best,
 And all has worked out in our interest.
 This storm has only bettered your position;
 My husband doesn't have the least suspicion,
 And now, in mockery of those who do,
 He bids me be continually with you.
 And that is why, quite fearless of reproof,

 I now can be alone with my Tartuffe,
 And why my heart—perhaps too quick to
 yield—
 Feels free to let its passion be revealed.

TARTUFFE. Madam, your words confuse me. Not long
 ago,
 You spoke in quite a different style, you know.

ELMIRE. Ah, Sir, if that refusal made you smart,
 It's little that you know of woman's heart,
 Or what that heart is trying to convey
 When it resists in such a feeble way!
 Always, at first, our modesty prevents
 The frank avowal of tender sentiments;
 However high the passion which inflames us,
 Still, to confess its power somehow shames us.
 Thus we reluct, at first, yet in a tone
 Which tells you that our heart is overthrown,
 That what our lips deny, our pulse confesses,
 And that, in time, all noes will turn to yesses.
 I fear my words are all too frank and free,
 And a poor proof of woman's modesty;
 But since I'm started, tell me, if you will—
 Would I have tried to make Damis be still,
 Would I have listened, calm and unoffended.
 Until your lengthy offer of love was ended.
 And been so very mild in my reaction.
 Had your sweet words not given me satisfaction?
 And when I tried to force you to undo
 The marriage-plans my husband has in view,
 What did my urgent pleading signify
 If not that I admired you, and that I
 Deplored the thought that someone else might
 own
 Part of a heart I wished for mine alone?

TARTUFFE. Madam, no happiness is so complete
 As when, from lips we love, come words so
 sweet;
 Their nectar floods my every sense, and drains
 In honeyed rivulets through all my veins.
 To please you is my joy, my only goal;
 Your love is the restorer of my soul;
 And yet I must beg leave, now, to confess
 Some lingering doubts as to my happiness
 Might this not be a trick? Might not the catch
 Be that you wish me to break off the match
 With Mariane, and so have feigned to love me?
 I shan't quite trust your fond opinion of me
 Until the feelings you've expressed so sweetly
 Are demonstrated somewhat more concretely,
 And you have shown, by certain kind concessions,
 That I may put my faith in your professions.

ELMIRE.

She coughs, to warn her husband.

Why be in such a hurry? Must my heart
Exhaust its bounty at the very start?
To make that sweet admission cost me dear,
But you'll not be content, it would appear,
Unless my store of favors is disbursed
To the last farthing, and at the very first.

TARTUFFE. The less we merit, the less we dare to hope,
And with our doubts, mere words can never cope.
We trust no promised bliss till we receive it;
Not till a joy is ours can we believe it.
I, who so little merit your esteem,
Can't credit this fulfillment of my dream,
And shan't believe it, Madam, until I savor
Some palpable assurance of your favor.

ELMIRE. My, how tyrannical your love can be,
And how it flusters and perplexes me!
How furiously you take one's heart in hand,
And make your every wish a fierce command!
Come, must you hound and harry me to death?
Will you not give me time to catch my breath?
Can it be right to press me with such force,
Give me no quarter, show me no remorse,
And take advantage, by your stern insistence,
Of the fond feelings which weaken my resistance?

TARTUFFE. Well, if you look with favor upon my love,
Why, then, begrudge me some clear proof
 thereof?

ELMIRE. But how can I consent without offense
To Heaven, toward which you feel such reverence?

TARTUFFE. If Heaven is all that holds you back, don't
 worry.
I can remove that hindrance in a hurry.
Nothing of that sort need obstruct our path.

ELMIRE. Must one not be afraid of Heaven's wrath?
Tartuffe. Madam, forget such fears, and be my pupil,
And I shall teach you how to conquer scruple.
Some joys, it's true, are wrong in Heaven's eyes;
Yet Heaven is not averse to compromise;
There is a science, lately formulated,
Whereby one's conscience may be liberated,
And any wrongful act you care to mention
May be redeemed by purity of intention.
I'll teach you, Madam, the secrets of that science:
Meanwhile, just place on me your full reliance.
Assuage my keen desires, and feel no dread:
The sin, if any, shall be on my head.

ELMIRE coughs, this time more loudly.

You've a bad cough.

ELMIRE. Yes, yes. It's bad indeed.

TARTUFFE (*producing a little paper bag*). A bit of licorice
 may be what you need.

ELMIRE. No, I've a stubborn cold, it seems. I'm sure it
Will take much more than licorice to cure it.

TARTUFFE. How aggravating.

ELMIRE. Oh, more than I can say.

TARTUFFE. If you're still troubled, think of things this way:
No one shall know our joys, save us alone,
And there's no evil till the act is known;
It's scandal, Madam, which makes it an offense,
And it's no sin to sin in confidence.

ELMIRE (*having coughed once more*). Well, clearly I
 must do as you require,
And yield to your importunate desire.
It is apparent, now, that nothing less
Will satisfy you, and so I acquiesce.
To go so far is much against my will;
I'm vexed that it should come to this; but still,
Since you are so determined on it, since you
Will not allow mere language to convince you,
And since you ask for concrete evidence,
I See nothing for it, now, but to comply.
If this is sinful, if I'm wrong to do it,
So much the worse for him who drove me to it.
The fault can surely not be charged to me.

TARTUFFE. Madam, the fault is mine, if fault there be,
And . . .

ELMIRE. Open the door a little, and peek out;
I wouldn't want my husband poking about.

TARTUFFE. Why worry about the man? Each day he grows
More gullible; one can lead him by the nose.
To find us here would fill him with delight,
And if he saw the worst, he'd doubt his sight.

ELMIRE. Nevertheless, do step out for a minute
Into the hall, and see that no one's in it.

Scene VI.

ORGON, ELMIRE.

ORGON (*coming out from under the table*). That man's a
 perfect monster, I must admit!
I'm simply stunned. I can't get over it.

ELMIRE. What, coming out so soon? How premature!
 Get back in hiding, and wait until you're sure.
 Stay till the end, and be convinced completely;
 We mustn't stop till things are proved concretely.

ORGON. Hell never harbored anything so vicious!

ELMIRE. Tut, don't be hasty. Try to be judicious.
 Wait, and be certain that there's no mistake.
 No jumping to conclusions, for Heaven's sake!

She places ORGON *behind her, as* TARTUFFE *re-enters.*

Scene VII.

TARTUFFE, ELMIRE, ORGON.

TARTUFFE (*not seeing Orgon*). Madam, all things have
 worked out to perfection;
 I've given the neighboring rooms a full inspection;
 No one's about; and now I may at last . . .

ORGON (*intercepting him*). Hold on, my passionate fel-
 low, not so fast!
 I should advise a little more restraint.
 Well, so you thought you'd fool me, my dear saint!
 How soon you wearied of the saintly life—
 Wedding my daughter, and coveting my wife!
 I've long suspected you, and had a feeling
 That soon I'd catch you at your double-dealing.
 Just now, you've given me evidence galore;
 It's quite enough; I have no wish for more.

ELMIRE (*to* TARTUFFE). I'm sorry to have treated you so
 slyly.
 But circumstances forced me to be wily.

TARTUFFE. Brother, you can't think . . .

ORGON. No more talk from you;
 Just leave this household, without more ado.

TARTUFFE. What I intended . . .

ORGON. That seems fairly clear.
 Spare me your falsehoods and get out of here.

TARTUFFE. No, I'm the master, and you're the one
 to go!
 This house belongs to me, I'll have you know,
 And I shall show you that you can't hurt *me*
 By this contemptible conspiracy,
 That those who cross me know not what they do,
 And that I've means to expose and punish you,
 Avenge offended Heaven, and make you grieve
 That ever you dared order me to leave.

Scene VIII.

ELMIRE, ORGON.

ELMIRE. What was the point of all that angry chatter?

ORGON. Dear God, I'm worried. This is no laughing
 matter.

ELMIRE. How so?

ORGON. I fear I understood his drift.
 I'm much disturbed about that deed of gift.

ELMIRE. You gave him . . .?

ORGON. Yes, it's all been drawn and signed.
 But one thing more is weighing on my mind.

ELMIRE. What's that?

ORGON. I'll tell you; but first let's see if there's
 A certain strong-box in his room upstairs.

Act 5
Scene I.

ORGON, CLÉANTE.

CLÉANTE. Where are you going so fast?

ORGON. God knows!

CLÉANTE. Then wait;
 Let's have a conference, and deliberate
 On how this situation's to be met.

ORGON. That strong-box has me utterly upset;
 This is the worst of many, many shocks.

CLÉANTE. Is there some fearful mystery in that box?

ORGON. My poor friend Argas brought that box to me
 With his own hands, in utmost secrecy;
 'Twas on the very morning of his flight.
 It's full of papers which, if they came to light,
 Would ruin him—or such is my impression.

CLÉANTE. Then why did you let it out of your possession?

ORGON. Those papers vexed my conscience, and it
 seemed best
 To ask the counsel of my pious guest.
 The cunning scoundrel got me to agree
 To leave the strong-box in his custody,
 So that, in case of an investigation,

I could employ a slight equivocation
And swear I didn't have it, and thereby,
At no expense to conscience, tell a lie.

CLÉANTE. It looks to me as if you're out on a limb.
Trusting him with that box, and offering him
That deed of gift, were actions of a kind
Which scarcely indicate a prudent mind.
With two such weapons, he has the upper hand,
And since you're vulnerable, as matters stand,
You erred once more in bringing him to bay.
You should have acted in some subtler way.

ORGON. Just think of it: behind that fervent face,
A heart so wicked, and a soul so base!
I took him in, a hungry beggar, and then . . .
Enough, by God! I'm through with pious men:
Henceforth I'll hate the whole false brotherhood.
And persecute them worse than Satan could.

CLÉANTE. Ah, there you go—extravagant as ever.
Why can you not be rational? You never
Manage to take the middle course, it seems,
But jump, instead, between absurd extremes
You've recognized your recent grave mistake
In falling victim to a pious fake;
Now, to correct that error, must you embrace
An even greater error in its place,
And judge our worthy neighbors as a whole
By what you've learned of one corrupted soul?
Come, just because one rascal made you swallow
A show of zeal which turned out to be hollow,
Shall you conclude that all men are deceivers,
And that, today, there are no true believers?
Let atheists make that foolish inference;
Learn to distinguish virtue from pretense,
Be cautious in bestowing admiration,
And cultivate a sober moderation.
Don't humor fraud, but also don't asperse
True piety; the latter fault is worse,
And it is best to err, if err one must,
As you have done, upon the side of trust.

Scene II.

DAMIS, ORGON, CLÉANTE.

DAMIS. Father, I hear that scoundrel's uttered threats
Against you; that he pridefully forgets
How, in his need, he was befriended by you,
And means to use your gifts to crucify you.

ORGON. It's true, my boy. I'm too distressed for tears.

DAMIS. Leave it to me, Sir; let me trim his ears.
Faced with such insolence, we must not waver.
I shall rejoice in doing you the favor
Of cutting short his life, and your distress.

CLÉANTE. What a display of young hotheadedness!
Do learn to moderate your fits of rage.
In this just kingdom, this enlightened age,
One does not settle things by violence.

Scene III.

MADAME PERNELLE, MARIANE, ELMIRE, DORINE,
DAMIS, ORGON, CLÉANTE.

MADAME PERNELLE. I hear strange tales of very strange
events.

ORGON. Yes, strange events which these two eyes be-
held.
The man's ingratitude is unparalleled.
I save a wretched pauper from starvation.
House him, and treat him like a blood relation,
Shower him every day with my largesse,
Give him my daughter, and all that I possess;
And meanwhile the unconscionable knave
Tries to induce my wife to misbehave;
And not content with such extreme rascality,
Now threatens me with my own liberality,
And aims, by taking base advantage of
The gifts I gave him out of Christian love,
To drive me from my house, a ruined man,
And make me end a pauper, as he began.

DORINE. Poor fellow!

MADAME PERNELLE. No, my son, I'll never bring
Myself to think him guilty of such a thing.

ORGON. How's that?

MADAME PERNELLE. The righteous always were maligned.

ORGON. Speak clearly, Mother. Say what's on your mind.

MADAME PERNELLE. I mean that I can smell a rat, my
dear. You know how everybody hates him, here.

ORGON. That has no bearing on the case at all.

MADAME PERNELLE. I told you a hundred times, when
you were small,
That virtue in this world is hated ever;
Malicious men may die, but malice never.

ORGON. No doubt that's true, but how does it apply?

MADAME PERNELLE. They've turned you against him by
 a clever lie.

ORGON. I've told you, I was there and saw it done.

MADAME PERNELLE. Ah, slanderers will stop at nothing.
 Son.

ORGON. Mother, I'll lose my temper . . . For the last
 time,
 I tell you I was witness to the crime.

MADAME PERNELLE. The tongues of spite are busy night
 and noon
 And to their venom no man is immune.

ORGON. You're talking nonsense. Can't you realize
 I saw it; saw it; saw it with my eyes?
 Saw, do you understand me? Must I shout it
 Into your ears before you'll cease to doubt it?

MADAME PERNELLE. Appearances can deceive, my son.
 Dear me,
 We cannot always judge by what we see.

ORGON. Drat! Drat!

MADAME PERNELLE. One often interprets things awry;
 Good can seem evil to a suspicious eye.

ORGON. Was I to see his pawing at Elmire
 As an act of charity?

MADAME PERNELLE. Till his guilt is clear,
 A man deserves the benefit of the doubt.
 You should have waited, to see how things turned
 out.

ORGON. Great God in Heaven, what more proof did I
 need?
 Was I to sit there, watching, until he'd . . .
 You drive me to the brink of impropriety.

MADAME PERNELLE. No, no, a man of such surpassing
 piety
 Could not do such a thing.
 You cannot shake me.
 I don't believe it, and you shall not make me.

ORGON. You vex me so that, if you weren't my mother,
 I'd say to you . . . some dreadful thing or other.

DORINE. It's your turn now, Sir, not to be listened to;
 You'd not trust us, and now she won't trust you.

CLÉANTE. My friends, we're wasting time which should
 be spent
 In facing up to our predicament.
 I fear that scoundrel's threats weren't made in sport.

DAMIS. Do you think he'd have the nerve to go to court?

ELMIRE. I'm sure he won't: they'd find it all too crude
 A case of swindling and ingratitude.

CLÉANTE. Don't be too sure. He won't be at a loss
 To give his claims a high and righteous gloss;
 And clever rogues with far less valid cause
 Have trapped their victims in a web of laws.
 I say again that to antagonize
 A man so strongly armed was most unwise.

ORGON. I know it; but the man's appalling cheek
 Outraged me so, I couldn't control my pique.

CLÉANTE. I wish to Heaven that we could devise
 Some truce between you, or some compromise.

ELMIRE. If I had known what cards he held, I'd not
 Have roused his anger by my little plot.

ORGON (to DORINE, as M. LOYAL enters). What is that
 fellow looking for? Who is he?
 Go talk to him—and tell him that I'm busy.

Scene IV.

MONSIEUR LOYAL, MADAME PERNELLE, ORGON, DAMIS, MARIANE, DORINE, ELMIRE, CLÉANTE.

MONSIEUR LOYAL. Good day, dear sister. Kindly let me
 see Your master.

DORINE. He's involved with company,
 And cannot be disturbed just now. I fear.

MONSIEUR LOYAL. I hate to intrude; but what has brought
 me here
 Will not disturb your master, in any event.
 Indeed, my news will make him most content.

DORINE. Your name?

MONSIEUR LOYAL. Just say that I bring greetings from
 Monsieur Tartuffe, on whose behalf I've come.

DORINE (to ORGON). Sir, he's a very gracious man, and
 bears
 A message from Tartuffe, which, he declares,
 Will make you most content.

CLÉANTE. Upon my word,
 I think this man had best be seen, and heard.

ORGON. Perhaps he has some settlement to suggest.
 How shall I treat him?
 What manner would be best?

CLÉANTE. Control your anger, and if he should mention
 Some fair adjustment, give him your full attention.

MONSIEUR LOYAL. Good health to you, good Sir. May Heaven confound
Your enemies, and may your joys abound.

ORGON (*aside, to* CLÉANTE). A gentle salutation: it confirms
My guess that he is here to offer terms.

MONSIEUR LOYAL. I've always held your family most dear;
I served your father, Sir, for many a year.

ORGON. Sir, I must ask your pardon; to my shame,
I cannot now recall your face or name.

MONSIEUR LOYAL. Loyal's my name; I come from Normandy,
And I'm a bailiff, in all modesty.
For forty years, praise God, it's been my boast
To serve with honor in that vital post,
And I am here, Sir, if you will permit
The liberty, to serve you with this writ . . .

ORGON. To—*what?*

MONSIEUR LOYAL. Now, please, Sir, let us have no friction:
It's nothing but an order of eviction.
You are to move your goods and family out
And make way for new occupants, without
Deferment or delay, and give the keys . . .

ORGON. I? Leave this house?

MONSIEUR LOYAL. Why yes, Sir, if you please.
This house, Sir, from the cellar to the roof,
Belongs now to the good Monsieur Tartuffe,
And he is lord and master of your estate
By virtue of a deed of present date,
Drawn in due form, with clearest legal phrasing . . .

DAMIS. Your insolence is utterly amazing!

MONSIEUR LOYAL. Young man, my business here is not with you,
But with your wise and temperate father, who,
Like every worthy citizen, stands in awe
Of justice, and would never obstruct the law.

ORGON. But . . .

MONSIEUR LOYAL. Not for a million, Sir, would you rebel
Against authority; I know that well.
You'll not make trouble, Sir, or interfere
With the execution of my duties here.

DAMIS. Someone may execute a smart tattoo
On that black jacket of yours, before you're through.

MONSIEUR LOYAL. Sir, bid your son be silent. I'd much regret
Having to mention such a nasty threat
Of violence, in writing my report.

DORINE (*aside*). This man Loyal's a most disloyal sort!

MONSIEUR LOYAL. I love all men of upright character,
And when I agreed to serve these papers, Sir,
It was your feelings that I had in mind.
I couldn't bear to see the case assigned
To someone else, who might esteem you less
And so subject you to unpleasantness.

ORGON. What's more unpleasant than telling a man to leave
His house and home?

MONSIEUR LOYAL. You'd like a short reprieve?
If you desire, Sir, I shall not press you,
But wait until tomorrow to dispossess you.
Splendid. I'll come and spend the night here, then,
Most quietly, with half a score of men.
For form's sake, you might bring me, just before
You go to bed, the keys to the front door.
My men, I promise, will be on their best
Behavior, and will not disturb your rest.
But bright and early, Sir, you must be quick
And move out all your furniture, every stick;
The men I've chosen are both young and strong,
And with their help it shouldn't take you long.
In short, I'll make things pleasant and convenient,
And since I'm being so extremely lenient,
Please show me, Sir, a like consideration,
And give me your entire cooperation.

ORGON (*aside*). I may be all but bankrupt, but I vow
I'd give a hundred louis, here and now,
Just for the pleasure of landing one good clout
Right on the end of that complacent snout.

CLÉANTE. Careful; don't make things worse.

DAMIS. My bootsole itches
To give that beggar a good kick in the breeches.

DORINE. Monsieur Loyal, I'd love to hear the whack
Of a stout stick across your fine broad back.

MONSIEUR LOYAL. Take care: a woman too may go to jail if
She uses threatening language to a bailiff.

CLÉANTE. Enough, enough, Sir. This must not go on.
Give me that paper, please, and then begone.

MONSIEUR LOYAL. Well, *au revoir.* God give you all good cheer!

ORGON. May God confound you, and him who sent
 you here!

Scene V.

ORGON, CLÉANTE, MARIANE, ELMIRE, MADAME
PERNELLE, DORINE, DAMIS.

ORGON. Now, Mother, was I right or not? This writ
 Should change your notion of Tartuffe a bit.
 Do you perceive his villainy at last?

MADAME PERNELLE. I'm thunderstruck. I'm utterly
 aghast.

DORINE. Oh, come, be fair. You mustn't take offense
 At this new proof of his benevolence.
 He's acting out of selfless love, I know.
 Material things enslave the soul, and so
 He kindly has arranged your liberation
 From all that might endanger your salvation.

ORGON. Will you not ever hold your tongue, you dunce?

CLÉANTE. Come, you must take some action, and at
 once.

ELMIRE. Go tell the world of the low trick he's tried.
 The deed of gift is surely nullified
 By such behavior, and public rage will not
 Permit the wretch to carry out his plot.

Scene VI.

VALÈRE, ORGON, CLÉANTE, ELMIRE, MARIANE,
MADAME PERNELLE, DAMIS, DORINE.

VALÈRE. Sir, though I hate to bring you more bad
 news,
 Such is the danger that I cannot choose.
 A friend who is extremely close to me
 And knows my interest in your family
 Has, for my sake, presumed to violate
 The secrecy that's due to things of state,
 And sends me word that you are in a plight
 From which your one salvation lies in flight.
 That scoundrel who's imposed upon you so
 Denounced you to the King an hour ago
 And, as supporting evidence, displayed
 The strong-box of a certain renegade
 Whose secret papers, so he testified,
 You had disloyally agreed to hide.
 I don't know just what charges may be pressed,

But there's a warrant out for your arrest;
 Tartuffe has been instructed, furthermore,
 To guide the arresting officer to your door.

CLÉANTE. He's clearly done this to facilitate
 His seizure of your house and your estate.

ORGON. That man, I must say, is a vicious beast!

VALÈRE. Quick, Sir; you mustn't tarry in the least.
 My carriage is outside, to take you hence;
 This thousand louis should cover all expense.
 Let's lose no time, or you shall be undone;
 The sole defense, in this case, is to run.
 I shall go with you all the way, and place you
 In a safe refuge to which they'll never trace you.

ORGON. Alas, dear boy, I wish that I could show you
 My gratitude for everything I owe you.
 But now is not the time; I pray the Lord
 That I may live to give you your reward.
 Farewell, my dears; be careful . . .

CLÉANTE. Brother, hurry.
 We shall take care of things; you needn't worry.

Scene VII.

THE OFFICER, TARTUFFE, VALÈRE, ORGON,
ELMIRE, MARIANE, MADAME PERNELLE, DORINE,
CLÉANTE, DAMIS.

TARTUFFE. Gently, Sir, gently; stay right where you are.
 No need for haste; your lodging isn't far.
 You're off to prison, by order of the Prince.

ORGON. This is the crowning blow, you wretch; and since
 It means my total ruin and defeat,
 Your villainy is now at last complete.

TARTUFFE. You needn't try to provoke me; it's no use.
 Those who serve Heaven must expect abuse.

CLÉANTE. You are indeed most patient, sweet, and
 blameless.

DORINE. How he exploits the name of Heaven! It's
 shameless.

TARTUFFE. Your taunts and mockeries are all for
 naught;
 To do my duty is my only thought.

MARIANE. Your love of duty is more meritorious,
 And what you've done is little short of glorious.

TARTUFFE. All deeds are glorious, Madam, which obey
 The sovereign prince who sent me here today.

when you were destitute,
n that, you thankless brute?

well remember everything;
is to serve my King.
That obliga~~tion~~ is so paramount
That other claims, beside it, do not count;
And for it I would sacrifice my wife,
My family, my friend, or my own life.

ELMIRE. Hypocrite!

DORINE. All that we most revere, he uses
 To cloak his plots and camouflage his ruses.

CLÉANTE. If it is true that you are animated
 By pure and loyal zeal, as you have stated,
 Why was this zeal not roused until you'd sought
 To make Orgon a cuckold, and been caught?
 Why weren't you moved to give your evidence
 Until your outraged host had driven you hence?
 I shan't say that the gift of all his treasure
 Ought to have damped your zeal in any measure;
 But if he is a traitor, as you declare,
 How could you condescend to be his heir?

TARTUFFE (to the OFFICER). Sir, spare me all this clam-
 or; it's growing shrill.
 Please carry out your orders, if you will.

OFFICER. Yes, I've delayed too long, Sir. Thank you kindly.
 You're just the proper person to remind me.
 Come, you are off to join the other boarders
 In the King's prison, according to his orders.

TARTUFFE. Who? I, Sir?

OFFICER. Yes.

TARTUFFE. To prison? This can't be true!

OFFICER. I owe an explanation, but not to you.

To ORGON.

 Sir, all is well; rest easy, and be grateful.
 We serve a Prince to whom all sham is hateful,
 A Prince who sees into out inmost hearts,
 And can't be fooled by any trickster's arts.
 His royal soul, though generous and human,
 Views all things with discernment and acumen;
 His sovereign reason is not lightly swayed,
 And all his judgments are discreetly weighed.
 He honors righteous men of every kind,
 And yet his zeal for virtue is not blind,
 Nor does his love of piety numb his wits
 And make him tolerant of hypocrites
 'Twas hardly likely that this man could cozen

A King who's foiled such liars by the dozen.
With one keen glance, the King perceived the whole
Perverseness and corruption of his soul.
And thus high Heaven's justice was displayed:
Betraying you, the rogue stood self-betrayed.
The King soon recognized Tartuffe as one
Notorious by another name, who'd done
So many vicious crimes that one could fill
Ten volumes with them, and be writing still.
But to be brief: our sovereign was appalled
By this man's treachery toward you, which he called
The last, worst villainy of a vile career,
And bade me follow the impostor here
To see how gross his impudence could be,
And force him to restore your property.
Your private papers, by the King's command,
I hereby seize and give into your hand.
The King, by royal order, invalidates
The deed which gave this rascal your estates,
And pardons, furthermore, your grave offense
In harboring an exile's documents.
By these decrees, our Prince rewards you for
Your loyal deeds in the late civil war,
And shows how heartfelt is his satisfaction
In recompensing any worthy action,
How much he prizes merit, and how he makes
More of men's virtues than of their mistakes.

DORINE. Heaven be praised!

MADAME PERNELLE. I breathe again, at last.

ELMIRE. We're safe.

MARIANE. I can't believe the danger's past.

ORGON (to TARTUFFE).
 Well, traitor, now you see . . .

CLÉANTE. Ah, Brother, please,
 Let's not descend to such indignities.
 Leave the poor wretch to his unhappy fate,
 And don't say anything to aggravate
 His present woes; but rather hope that he
 Will soon embrace an honest piety,
 And mend his ways, and by a true repentance
 Move our just King to moderate his sentence.
 Meanwhile, go kneel before your sovereign's throne
 And thank him for the mercies he has shown.

ORGON. Well said: let's go at once and, gladly kneeling,
 Express the gratitude which all are feeling.
 Then, when that first great duty has been done,
 We'll turn with pleasure to a second one,
 And give Valère, whose love has proven so true,
 The wedded happiness which is his due.

A Doll's House

Henrik Ibsen: The Father of Modern Drama

As it did during the Renaissance, science and knowledge changed the scope of theatre in the latter half of the 1800s. Charles Darwin's evolutionary theories and Sigmund Freud's groundbreaking psychological studies suddenly made scientists, artists, and the general public much less interested in fantasy and much more interested in human beings and how they work. Theatrical realism first appeared in Europe during the 1850s. The idea of cause and effect became much more popular. Making the setting of a play realistic would have an effect on the characters because their environment would dictate what they did. Playwrights began to write about the world around them, which they could observe firsthand. Rather than writing about exotic locales and imperial courts, this new breed of playwright tackled subject matter that had never been openly brought to the stage before. Poverty, disease, prostitution, infidelity, and illegitimate children became popular subject matter. Many critics of realism said the movement was turning the stage into a sewer, but realists felt they were doing society a favor by depicting the truth instead of some idealized version of the world.

Perhaps the one playwright from this era who best embodies the groundbreaking and controversial realism movement is the Norwegian dramatist Henrik Ibsen, who began his playwriting career writing history plays and fantasies. His early work showed no hint of the great realistic trailblazer he would later become. Nevertheless, earlier pieces like *The Vikings at Helgeland*, *Brand*, and *Peer Gynt* were quite popular with European audiences.

In 1877, Ibsen's writing took a sharp turn in direction. With *Pillars of Society*, Ibsen abandoned the poetic fantasy of his history plays in favor of prose drama that held an uncompromising mirror up to modern life. A string of controversial and groundbreaking realistic plays followed. These included *A Doll's House*, *Ghosts*, *The Wild Duck*, and *Hedda Gabler*. These plays caused worldwide controversy with their explorations of broken homes, venereal diseases, and other unsettling subject matter. Many theatres refused to stage Ibsen's works because they were thought to be immoral and corrupting.

Ibsen's realistic plays had an immediate and profound effect on modern drama. His plays were rapidly translated and became hot topics for discussion and debate throughout Europe. Although the period in which he wrote coincides with the creative periods of other great realistic playwrights, such as Anton Chekhov and August Strindberg, Ibsen is the only one of these magnificent writers to be frequently referred to as the father of modern drama.

In his later years, Ibsen began to drift away from realism and toward more symbolic plays, such as *The Master Builder* and *When We Dead Awaken*. Ibsen died in 1906, but his influence on world theatre is just as tangible today as it was one hundred years ago. Although his plays are not as frequently produced as other modern playwrights, any student of modern drama must look first to Ibsen in order to understand where the seeds of twentieth-century theatre were sown.

A Doll's House

Late in 1879, *A Doll's House* opened in Copenhagen's Royal Theatre. The world would never be the same. Many critics believe this play marked the beginning of modern theatre.

To help structure his early domestic dramas, Ibsen borrowed heavily from the form of the Well-Made Play. The Well-Made Play is a genre of theatre from the nineteenth century that was popularized around Europe by two French playwrights: Eugene Scribe and Victorien Sardou. Well-Made Plays have a strong neoclassical flavor; featuring a very tight plot and a climax that occurs very close to the play's conclusion. In these plays, most of the action actually takes place before the curtain even rises on the first act. The opening scene of the play usually catches us up on events through exposition thinly veiled as conversation. Once the audience is caught up, a series of causally related plot complications arise. Plot devices are a trademark of Well-Made Plays. Often these plays use important letters or documents that fall into the wrong hands in order to bring about plot twists and climaxes. *A Doll's House* follows much of the form of the Well-Made Play, but its surprising ending shatters the form's more conventional endings.

Inspired by real-life events in Ibsen's life, *A Doll's House* tells the story of Torvald and Nora Helmer, a happily married husband and wife who are parents to three small children. In a time when it was illegal for women to take out loans, Nora forges her father's signature in order to borrow funds to help her ailing husband. This is a secret she keeps from Torvald even after he has recovered, for fear of ruining his reputation in the community. When Torvald plans to fire Krogstad, one of his employees at the bank, Krogstad reveals to Nora that he is aware of Nora's deceit. He threatens to expose Nora if she doesn't convince her husband to keep him employed. Much of the play's suspense deals with Nora's efforts to escape her predicament, until the truth comes to light, and she makes a decision unheard of for a woman in her day.

The entire play takes place in a single room: the Helmer's drawing room. At first the room seems to symbolize the upward mobility of the married couple, but as time wears on, it seems more and more like a four-walled prison cell for Nora. The room comes to symbolize the societal constraints being imposed upon her.

"Nora's revolt is the end of a chapter in human history." So wrote the great playwright and critic George Bernard Shaw. Ibsen's exploration of the dissolution of a middle-class marriage shocked audiences and had them contemplating their marriages and society's laws. Mistakenly called a feminist play by many, Ibsen was quick to explain that his play was a modern tragedy that affected both parties. He felt Torvald suffered just as much as Nora did by the play's end. In his preliminary notes to the play, Ibsen wrote about "two kinds of conscience, one in man and another, altogether different in a woman. They do not understand each other. . . ."

Somewhat tame by modern comparisons, Ibsen's *A Doll's House* continues to spark intense debate and heated discussion. Though he shied away from politics, Ibsen would smile at how much controversy his play continues to stir up. Nora is considered one of the great female roles in dramatic literature. It is a little play, with ordinary characters, but the impact of this drama still resonates around the world today. Perhaps the translator, Rolf Fjelde, said it best in his introduction to the play: "When the troubled applause died away, and the first audience for Ibsen's *A Doll's House* rose to their somewhat unsteady feet and filed up the aisles, no one among them could have known that he had participated . . . in the birth of modern drama."

Food for Thought

As you read the play, consider the following questions:

1. What plot devices does Ibsen use in *A Doll's House*?
2. Although these plays are considered realistic, Ibsen often uses symbolism in his plays. What do you think Nora's dance, the tarantella, symbolizes? Are there any other symbols in the play?

3. At what point does Nora make the decision to leave?
4. At the end of the play, has Nora done the right thing? Why or why not?
5. What do you think will become of Nora after this?
6. Is Torvald a sympathetic character? Why or why not?
7. Ibsen is famous for his ability to use personal props as a means to further define a character's psychological plight. One example of this is Nora's macaroons. What is Ibsen trying to say about Nora through her obsession with macaroons?

Fun Facts

1. In the 1880s, audiences tended to sympathize with Torvald when they watched the play. He was considered a romantic leading man who was wronged by his wife.
2. Ibsen kept a portrait of the playwright August Strindberg over his writing desk. Strindberg was an emotionally unstable man who often publicly criticized Ibsen's plays. When asked why he kept a portrait of his rival over his writing desk, Ibsen responded that he liked having a madman staring down at him while he worked. He found it inspirational.
3. Critics and theatre artists continue to debate the correct title of this play. Many argue the correct translation of the title is *A Doll House* not *A Doll's House*. What's the big deal? Well, some say *A Doll's House* implies ownership by the doll (in other words, Nora) and she really doesn't have any ownership of the house. Both titles are still used today, depending upon the translation of the script.
4. In 2006, the award-winning Mabou Mines theatre company mounted a production of *A Doll House* with a twist. As a means of symbolizing the play's gender power shift, director Lee Breuer directed a version of the play where all the male roles were played by actors who were under four feet six inches, while the women in the play were all at least six feet tall. The set for the play included giant plastic furniture and was decorated to resemble the interior of a doll house.

A Doll's House

Henrik Ibsen

Characters

Torvald Helmer
Nora, his wife
Doctor Rank
Mrs. Linde
Nils Krogstad

Helmer's three young children
Anne, their nurse
A Housemaid
A Porter

The action takes place in Helmer's house.

Act 1

Scene: —A room furnished comfortably and tastefully, but not extravagantly. At the back, a door to the right leads to the entrance-hall, another to the left leads to Helmer's study. Between the doors stands a piano. In the middle of the left-hand wall is a door, and beyond it a window. Near the window are a round table, armchairs and a small sofa. In the right-hand wall, at the farther end, another door; and on the same side, nearer the footlights, a stove, two easy chairs and a rocking-chair; between the stove and the door, a small table. Engravings on the wall; a cabinet with china and other small objects; a small book-case with well-bound books. The floors are carpeted, and a fire burns in the stove. It is winter.

A bell rings in the hall; shortly afterwards the door is heard to open. Enter Nora, humming a tune and in high spirits. She is in out-door dress and carries a number of parcels; these she lays on the table to the right. She leaves the outer door open after her, and through it is seen a PORTER who is carrying a Christmas Tree and a basket, which he gives to the Maid who has opened the door.

Nore. Hide the Christmas Tree carefully, Helen. Be sure the children do not see it till this evening, when it is dressed. (*To the* PORTER, *taking out her purse*). How much?

Porter. Sixpence.

Nora. There is a shilling. No, keep the change. (*The* Porter *thanks her, and goes out. Nora shuts the door. She is laughing to herself, as she takes off her hat and coat. She takes a packet of macaroons from her pocket and eats one or two; then goes cautiously to her husband's door and listens*). Yes, he is in. (*Still humming, she goes to the table on the right*).

Helmer (*calls out from his room*). Is that my little lark twittering out there?

Nora. (*busy opening some of the parcels*). Yes, it is!

Helmer. Is it my little squirrel bustling about?

Nora. Yes!

Helmer. When did my squirrel come home?

Nora. Just now. (*Puts the bag of macaroons into her pocket and wipes her mouth*). Come in here, Torvald, and see what I have bought.

Helmer. Don't disturb me. (*A little later, he opens the door and looks into the room, pen in hand*). Bought, did you say? All these things? Has my little spendthrift been wasting money again?

Nora. Yes, but, Torvald, this year we really can let ourselves go a little. This is the first Christmas that we have not needed to economize.

Helmer. Still, you know, we can't spend money recklessly.

Nora. Yes, Torvald, we may be a wee bit more reckless now, mayn't we? Just a tiny wee bit! You are going to have a big salary and earn lots and lots of money.

HELMER. Yes, after the New Year; but then it will be a whole quarter before the salary is due.

NORA. Pooh! we can borrow till then.

HELMER. Nora! (*Goes up to her and takes her playfully by the ear*). The same little featherhead! Suppose, now, that I borrowed fifty pounds today, and you spent it all in the Christmas week, and then on New Year's Eve a slate fell on my head and killed me, and—

NORA (*putting her hands over his mouth*). Oh! don't say such horrid things.

HELMER. Still, suppose that happened,—what then?

NORA. If that were to happen, I don't suppose I should care whether I owed money or not.

HELMER. Yes, but what about the people who had lent it?

NORA. They? Who would bother about them? I should not know who they were.

HELMER. That is like a woman! But seriously, Nora, you know what I think about that. No debt, no borrowing. There can be no freedom or beauty about a home life that depends on borrowing and debt. We two have kept bravely on the straight road so far, and we will go on the same way for the short time longer that there need be any struggle.

NORA (*moving towards the stove*). As you please, Torvald.

HELMER (*following her*). Come, come, my little skylark must not droop her wings. What is this! Is my little squirrel out of temper? (*Taking out his purse*). Nora, what do you think I have got here?

NORA (*turning round quickly*). Money!

HELMER. There you are. (*Gives her some money*). Do you think I don't know what a lot is wanted for housekeeping at Christmas-time?

NORA (*counting*). Ten shillings—a pound—two pounds! Thank you, thank you, Torvald; that will keep me going for a long time.

HELMER. Indeed it must.

NORA. Yes, yes, it will. But come here and let me show you what I have bought. And ah so cheap! Look, here is a new suit for Ivar, and a sword; and a horse and a trumpet for Bob; and a doll and dolly's bedstead for Emmy.—they are very plain, but anyway she will soon break them in pieces. And here are dress-lengths and handkerchiefs for the maids; old Anne ought really to have something better.

HELMER. And what is in this parcel?

NORA (*crying out*). No, no! you mustn't see that till this evening.

HELMER. Very well. But now tell me, you extravagant little person, what would you like for yourself?

NORA. For myself? Oh, I am sure I don't want anything.

HELMER. Yes, but you must. Tell me something reasonable that you would particularly like to have.

NORA. No, I really can't think of anything—unless, Torvald—

HELMER. Well?

NORA (*playing with his coat buttons, and without raising her eyes to his*). If you really want to give me something, you might—you might—

HELMER. Well, out with it!

NORA (*speaking quickly*). You might give me money, Torvald. Only just as much as you can afford; and then one of these days I will buy something with it.

HELMER. But, Nora—

NORA. Oh, do! dear Torvald; please, please do! Then I will wrap it up in beautiful gilt paper and hang it on the Christmas Tree. Wouldn't that be fun?

HELMER. What are little people called that are always wasting money?

NORA. Spendthrifts—I know. Let us do as you suggest, Torvald, and then I shall have time to think what I am most in want of. That is a very sensible plan, isn't it?

HELMER (*smiling*). Indeed it is—that is to say, if you were really to save out of the money I give you, and then really buy something for yourself. But if you spend it all on the housekeeping and any number of unnecessary things, then I merely have to pay up again.

NORA. Oh but, Torvald—

HELMER. You can't deny it, my dear, little Nora. (*Puts his arm round her waist*). It's a sweet little spendthrift, but she uses up a deal of money. One would hardly believe how expensive such little persons are!

NORA. It's a shame to say that. I do really save all I can.

HELMER (*laughing*). That's very true,—all you can. But you can't save anything!

NORA (*smiling quietly and happily*). You haven't any idea how many expenses we skylarks and squirrels have, Torvald.

HELMER. You are an odd little soul. Very like your father. You always find some new way of wheedling money out of me, and, as soon as you have got it, it seems to melt in your hands. You never know where it has gone. Still, one must take you as you are. It is in the blood; for indeed it is true that you can inherit these things, Nora.

NORA. Ah, I wish I had inherited many of papa's qualities.

HELMER. And I would not wish you to be anything but just what you are, my sweet little skylark. But, do you know, it strikes me that you are looking rather—what shall I say—rather uneasy today?

NORA. Do I?

HELMER. You do, really. Look straight at me.

NORA (*looks at him*). Well?

HELMER (*wagging his finger at her*). Hasn't Miss Sweet-Tooth been breaking rules in town today?

NORA. No; what makes you think that?

HELMER. Hasn't she paid a visit to the confectioner's?

NORA. No, I assure you, Torvald—

HELMER. Not been nibbling sweets?

NORA. No, certainly not.

HELMER. Not even taken a bite at a macaroon or two?

NORA. No, Torvald, I assure you really—

HELMER. There, there, of course I was only joking.

NORA (*going to the table on the right*). I should not think of going against your wishes.

HELMER. No, I am sure of that; besides, you gave me your word—(*Going up to her*). Keep your little Christmas secrets to yourself, my darling. They will all be revealed tonight when the Christmas Tree is lit, no doubt.

NORA. Did you remember to invite Doctor Rank?

HELMER. No. But there is no need; as a matter of course he will come to dinner with us. However, I will ask him when he comes in this morning. I have ordered some good wine. Nora, you can't think how I am looking forward to this evening.

NORA. So am I! And how the children will enjoy themselves, Torvald!

HELMER. It is splendid to feel that one has a perfectly safe appointment, and a big enough income. It's delightful to think of, isn't it?

NORA. It's wonderful!

HELMER. Do you remember last Christmas? For a full three weeks beforehand you shut yourself up every evening till long after midnight, making ornaments for the Christmas Tree and all the other fine things that were to be a surprise to us. It was the dullest three weeks I ever spent!

NORA. I didn't find it dull.

HELMER (*smiling*). But there was precious little result, Nora.

NORA. Oh, you shouldn't tease me about that again. How could I help the cat's going in and tearing everything to pieces?

HELMER. Of course you couldn't, poor little girl. You had the best of intentions to please us all, and that's the main thing. But it is a good thing that our hard times are over.

NORA. Yes, it is really wonderful.

HELMER. This time I needn't sit here and be dull all alone, and you needn't ruin your dear eyes and your pretty little hands—

NORA (*clapping her hands*). No, Torvald, I needn't any longer, need I! It's wonderfully lovely to hear you say so! (*Taking his arm*). Now I will tell you how I have been thinking we ought to arrange things, Torvald. As soon as Christmas is over—(*A bell rings in the hall*). There's the bell. (*She tidies the room a little*). There's someone at the door. What a nuisance!

HELMER. If it is a caller, remember I am not at home.

MAID (*in the doorway*). A lady to see you, ma'am,—a stranger.

NORA. Ask her to come in.

MAID (*to* Helmer). The doctor came at the same time, sir.

HELMER. Did he go straight into my room?

MAID. Yes, sir.

HELMER *goes into his room. The* Maid *ushers in* Mrs. LINDE, *who is in traveling dress, and shuts the door.*

MRS. LINDE (*in a dejected and timid voice*). How do you do, Nora?

NORA (*doubtfully*). How do you do—

MRS. LINDE. You don't recognize me, I suppose.

NORA. No, I don't know—yes, to be sure, I seem to— (*Suddenly*). Yes! Christine! Is it really you?

MRS. LINDE. Yes, it is I.

NORA. Christine! To think of my not recognising you! And yet how could I—(*In a gentle voice*). How you have altered, Christine!

MRS. LINDE. Yes, I have indeed. In nine, ten long years—

NORA. Is it so long since we met? I suppose it is. The last eight years have been a happy time for me, I can tell you. And so now you have come into the town, and have taken this long journey in winter—that was plucky of you.

MRS. LINDE. I arrived by steamer this morning.

NORA. To have some fun at Christmas-time, of course. How delightful! We will have such fun together! But take off your things. You are not cold, I hope. (*Helps her*). Now we will sit down by the stove, and be cosy. No, take this arm-chair; I will sit here in the rocking-chair. (*Takes her hands*). Now you look like your old self again; it was only the first moment—You are a little paler, Christine, and perhaps a little thinner.

MRS. LINDE. And much, much older, Nora.

NORA. Perhaps a little older; very, very little; certainly not much. (*Stops suddenly and speaks seriously*). What a thoughtless creature I am, chattering away like this. My poor, dear Christine, do forgive me.

MRS. LINDE. What do you mean, Nora?

NORA (*gently*). Poor Christine, you are a widow.

MRS. LINDE. Yes; it is three years ago now.

NORA. Yes, I knew; I saw it in the papers. I assure you, Christine, I meant ever so often to write to you at the time, but I always put it off and something always prevented me.

MRS. LINDE. I quite understand, dear.

NORA. It was very bad of me, Christine. Poor thing, how you must have suffered. And he left you nothing?

MRS. LINDE. No.

NORA. And no children?

MRS. LINDE. No.

NORA. Nothing at all, then?

MRS. LINDE. Not even any sorrow or grief to live upon.

NORA (*looking incredulously at her*). But, Christine, is that possible?

MRS. LINDE (*smiles sadly and strokes her hair*). It sometimes happens, Nora.

NORA. So you are quite alone. How dreadfully sad that must be. I have three lovely children. You can't see them just now, for they are out with their nurse. But now you must tell me all about it.

MRS. LINDE. No, no; I want to hear about you.

NORA. No, you must begin. I mustn't be selfish today; today I must only think of your affairs. But there is one thing I must tell you. Do you know we have just had a great piece of good luck?

MRS. LINDE. No, what is it?

NORA. Just fancy, my husband has been made manager of the Bank!

MRS. LINDE. Your husband? What good luck!

NORA. Yes tremendous! A barrister's profession is such an uncertain thing, especially if he won't undertake unsavoury cases; and naturally Torvald has never been willing to do that, and I quite agree with him. You may imagine how pleased we are! He is to take up his work in the Bank at the New Year, and then he will have a big salary and lots of commissions. For the future we can live quite differently—we can do just as we like. I feel so relieved and so happy, Christine! It will be splendid to have heaps of money and not need to have any anxiety, won't it?

MRS. LINDE. Yes, anyhow I think it would be delightful to have what one needs.

NORA. No, not only what one needs, but heaps and heaps of money.

MRS. LINDE (*smiling*). Nora, Nora, haven't you learnt sense yet? In our schooldays you were a great spendthrift.

NORA (*laughing*). Yes, that is what Torvald says now. (*Wags her finger at her*). But "Nora, Nora" is not so silly as you think. We have not been in a position for me to waste money. We have both had to work.

MRS. LINDE. You too?

NORA. Yes; odds and ends, needlework, crochet-work, embroidery, and that kind of thing. (*Dropping her voice*). And other things as well. You know Torvald left his office when we were married? There was no prospect of promotion there, and he had to try and earn more than before. But during the first year he overworked himself dreadfully. You see, he had to make money every way he could, and he worked early and late; but he couldn't stand it, and fell dreadfully ill, and the doctors said it was necessary for him to go south.

MRS. LINDE. You spent a whole year in Italy, didn't you?

NORA. Yes. It was no easy matter to get away, I can tell you. It was just after Ivar was born; but naturally we had to go. It was a wonderfully beautiful journey, and it saved Torvald's life. But it cost a tremendous lot of money, Christine.

MRS. LINDE. So I should think.

NORA. It cost about two hundred and fifty pounds. That's a lot, isn't it?

MRS. LINDE. Yes, and in emergencies like that it is lucky to have the money.

NORA. I ought to tell you that we had it from papa.

MRS. LINDE. Oh, I see. It was just about that time that he died, wasn't it?

NORA. Yes; and, just think of it, I couldn't go and nurse him. I was expecting little Ivar's birth every day and I had my poor sick Torvald to look after. My dear, kind father—I never saw him again, Christine. That was the saddest time I have known since our marriage.

MRS. LINDE. I know how fond you were of him. And then you went off to Italy?

NORA. Yes; you see we had money then, and the doctors insisted on our going, so we started a month later.

MRS. LINDE. And your husband came back quite well?

NORA. As sound as a bell!

MRS. LINDE. But—the doctor?

NORA. What doctor?

MRS. LINDE. I thought your maid said the gentleman who arrived here just as I did, was the doctor?

NORA. Yes, that was Doctor Rank, but he doesn't come here professionally. He is our greatest friend, and comes in at least once every day. No, Torvald has not had an hour's illness since then, and our children are strong and healthy and so am I. (*Jumps up and claps her hands*). Christine! Christine! it's good to be alive and happy!—But how horrid of me; I am talking of nothing but my own affairs. (*Sits on a stool near her, and rests her arms on her knees*). You mustn't be angry with me. Tell me, is it really true that you did not love your husband? Why did you marry him?

MRS. LINDE. My mother was alive then, and was bedridden and helpless, and I had to provide for my two younger brothers; so I did not think I was justified in refusing his offer.

NORA. No, perhaps you were quite right. He was rich at that time, then?

MRS. LINDE. I believe he was quite well off. But his business was a precarious one; and, when he died, it all went to pieces and there was nothing left.

NORA. And then?—

MRS. LINDE. Well, I had to turn my hand to anything I could find—first a small shop, then a small school, and so on. The last three years have seemed like one long working-day, with no rest. Now it is at an end, Nora. My poor mother needs me no more, for she is gone; and the boys do not need me either; they have got situations and can shift for themselves.

NORA. What a relief you must feel it—

MRS. LINDE. No, indeed; I only feel my life unspeakably empty. No one to live for any more. (*Gets up restlessly*). That is why I could not stand the life in my little backwater any longer. I hope it may be easier here to find something which will busy me and occupy my thoughts. If only I could have the good luck to get some regular work—office work of some kind—

NORA. But, Christine, that is so frightfully tiring, and you look tired out now. You had far better go away to some watering-place.

MRS. LINDE (*walking to the window*). I have no father to give me money for a journey, Nora.

NORA (*rising*). Oh, don't be angry with me.

MRS. LINDE (*going up to her*). It is you that must not be angry with me, dear. The worst of a position like mine is that it makes one so bitter. No one to work for, and yet obliged to be always on the look-out for chances. One must live, and so one becomes selfish. When you told me of the happy turn your fortunes have taken—you will hardly believe it—I was delighted not so much on your account as on my own.

NORA. How do you mean?—Oh, I understand. You mean that perhaps Torvald could get you something to do.

MRS. LINDE. Yes, that was what I was thinking of.

NORA. He must, Christine. Just leave it to me; I will broach the subject very cleverly—I will think of something that will please him very much. It will make me so happy to be of some use to you.

MRS. LINDE. How kind you are, Nora, to be so anxious to help me! It is doubly kind in you, for you know so little of the burdens and troubles of life.

NORA. I—? I know so little of them?

MRS. LINDE (*smiling*). My dear! Small household cares and that sort of thing!—You are a child, Nora.

NORA (*tosses her head and crosses the stage*). You ought not to be so superior.

MRS. LINDE. No?

NORA. You are just like all the others. They all think that I am incapable of anything really serious—

MRS. LINDE. Come, come—

NORA. —that I have gone through nothing in this world of cares.

MRS. LINDE. But, my dear Nora, you have just told me all your troubles.

NORA. Pooh!—those were trifles. (*Lowering her voice*). I have not told you the important thing.

MRS. LINDE. The important thing? What do you mean?

NORA. You look down upon me altogether, Christine—but you ought not to. You are proud, aren't you, of having worked so hard and so long for your mother?

MRS. LINDE. Indeed, I don't look down on any one. But it is true that I am both proud and glad to think that I was privileged to make the end of my mother's life almost free from care.

NORA. And you are proud to think of what you have done for your brothers.

MRS. LINDE. I think I have the right to be.

NORA. I think so, too. But now, listen to this; I too have something to be proud and glad of.

MRS. LINDE. I have no doubt you have. But what do you refer to?

NORA. Speak low. Suppose Torvald were to hear! He mustn't on any account—no one in the world must know, Christine, except you.

MRS. LINDE. But what is it?

NORA. Come here. (*Pulls her down on the sofa beside her*). Now I will show you that I too have something to be proud and glad of. It was I who saved Torvald's life.

MRS. LINDE. "Saved"? How?

NORA. I told you about our trip to Italy. Torvald would never have recovered if he had not gone there—

MRS. LINDE. Yes, but your father gave you the necessary funds.

NORA (*smiling*). Yes, that is what Torvald and all the others think, but—

MRS. LINDE. But—

NORA. Papa didn't give us a shilling. It was I who procured the money.

MRS. LINDE. You? All that large sum?

NORA. Two hundred and fifty pounds. What do you think of that?

MRS. LINDE. But, Nora, how could you possibly do it? Did you win a prize in the Lottery?

NORA (*contemptuously*). In the Lottery? There would have been no credit in that.

MRS. LINDE. But where did you get it from, then?

NORA (*humming and smiling with an air of mystery*). Hm, hu! Aha!

MRS. LINDE. Because you couldn't have borrowed it.

NORA. Couldn't I? Why not?

MRS. LINDE. No, a wife cannot borrow without her husband's consent.

NORA (*tossing her head*). Oh, if it is a wife who has any head for business—a wife who has the wit to be a little bit clever—

MRS. LINDE. I don't understand it at all, Nora.

NORA. There is no need you should. I never said I had borrowed the money. I may have got it some other way. (*Lies back on the sofa*). Perhaps I got it from some other admirer. When anyone is as attractive as I am—

MRS. LINDE. You are a mad creature.

NORA. Now, you know you're full of curiosity, Christine.

MRS. LINDE. Listen to me, Nora dear. Haven't you been a little bit imprudent?

NORA (*sits up straight*). Is it imprudent to save your husband's life?

MRS. LINDE. It seems to me imprudent, without his knowledge, to—

NORA. But it was absolutely necessary that he should not know! My goodness, can't you understand that? It was necessary he should have no idea what a dangerous condition he was in. It was to me that the doctors came and said that his life was in danger, and that the only thing to save him was to live in the south. Do you suppose I didn't try, first of all, to get what I wanted as if it were for myself? I told him how much I should love to travel abroad like other young wives; I tried tears and entreaties with him; I told him that he ought to remember the condition I was in, and that he ought to be kind and indulgent to me; I even hinted that he might raise a loan. That nearly made him angry, Christine. He said I was thoughtless, and that it was his duty as my husband not to indulge me in my whims and caprices—as I believe he called them. Very well, I thought, you must be saved—and that was how I came to devise a way out of the difficulty—

MRS. LINDE. And did your husband never get to know from your father that the money had not come from him?

NORA. No, never. Papa died just at that time. I had meant to let him into the secret and beg him never to reveal it. But he was so ill then—alas, there never was any need to tell him.

MRS. LINDE. And since then have you never told your secret to your husband?

NORA. Good Heavens, no! How could you think so? A man who has such strong opinions about these things! And besides, how painful and humiliating it would be for Torvald, with his manly independence, to know that he owed me anything! It would upset our mutual relations altogether; our beautiful happy home would no longer be what it is now.

MRS. LINDE. Do you mean never to tell him about it?

NORA (*meditatively, and with a half smile*). Yes—some day, perhaps, after many years, when I am no longer as nice-looking as I am now. Don't laugh at me! I mean, of course, when Torvald is no longer as devoted to me as he is now; when my dancing and dressing-up and reciting have palled on him; then it may be a good thing to have something in reserve—(*Breaking off,*) What nonsense! That time will never come. Now, what do you think of my great secret, Christine? Do you still think I am of no use? I can tell you, too, that this affair has caused me a lot of worry. It has been by no means easy for me to meet my engagements punctually. I may tell you that there is something that is called, in business, quarterly interest, and another thing called payment in installments, and it is always so dreadfully difficult to manage them. I have had to save a little here and there, where I could, you understand. I have not been able to put aside much from my housekeeping money, for Torvald must have a good table. I couldn't let my children be shabbily dressed; I have felt obliged to use up all he gave me for them, the sweet little darlings!

MRS. LINDE. So it has all had to come out of your own necessaries of life, poor Nora?

NORA. Of course. Besides, I was the one responsible for it. Whenever Torvald has given me money for new dresses and such things, I have never spent more than half of it; I have always bought the simplest and cheapest things. Thank Heaven, any clothes look well on me, and so Torvald has never noticed it. But it was often very hard on me, Christine—because it is delightful to be really well dressed, isn't it?

MRS. LINDE. Quite so.

NORA. Well, then I have found other ways of earning money. Last winter I was lucky enough to get a lot of copying to do; so I locked myself up and sat writing every evening until quite late at night. Many a time I was desperately tired; but all the same it

was a tremendous pleasure to sit there working and earning money. It was like being a man.

MRS. LINDE. How much have you been able to pay off in that way?

NORA. I can't tell you exactly. You see, it is very difficult to keep an account of a business matter of that kind. I only know that I have paid every penny that I could scrape together. Many a time I was at my wits' end. (*Smiles*). Then I used to sit here and imagine that a rich old gentleman had fallen in love with me—

MRS. LINDE. What! Who was it?

NORA. Be quiet!—that he had died; and that when his will was opened it contained, written in big letters, the instruction: "The lovely Mrs. Nora Helmer is to have all I possess paid over to her at once in cash."

MRS. LINDE. But, my dear Nora—who could the man be?

NORA. Good gracious, can't you understand? There was no old gentleman at all; it was only something that I used to sit here and imagine, when I couldn't think of any way of procuring money. But it's all the same now; the tiresome old person can stay where he is, as far as I am concerned; I don't care about him or his will either, for I am free from care now. (*Jumps up*). My goodness, it's delightful to think of, Christine! Free from care! To be able to be free from care, quite free from care; to be able to play and romp with the children; to be able to keep the house beautifully and have everything just as Torvald likes it! And, think of it, soon the spring will come and the big blue sky! Perhaps we shall be able to take a little trip—perhaps I shall see the sea again! Oh, it's a wonderful thing to be alive and be happy. (*A bell is heard in the hall*).

MRS. LINDE (*rising*). There is the bell; perhaps I had better go.

NORA. No, don't go; no one will come in here; it is sure to be for Torvald.

SERVANT (*at the hall door*). Excuse me, ma'am—there is a gentleman to see the master, and as the doctor is with him—

NORA. Who is it?

KROGSTAD (*at the door*). It is I, Mrs. Helmer. (*Mrs. Linde starts, trembles, and turns to the window*).

NORA (*takes a step towards him, and speaks in a strained low voice*). You? What is it? What do you want to see my husband about?

KROGSTAD. Bank business—in a way. I have a small post in the Bank, and I hear your husband is to be our chief now—

NORA. Then it is—

KROGSTAD. Nothing but dry business matters, Mrs. Helmers; absolutely nothing else.

NORA. Be so good as to go into the study then. (*She bows indifferently to him and shuts the door into the hall; then comes back and makes up the fire in the stove*).

MRS. LINDE. Nora—who was that man?

NORA. A lawyer, of the name of Krogstad.

MRS. LINDE. Then it really was he.

NORA. Do you know the man?

MRS. LINDE. I used to—many years ago. At one time he was a solicitor's clerk in our town.

NORA. Yes, he was.

MRS. LINDE. He is greatly altered.

NORA. He made a very unhappy marriage.

MRS. LINDE. He is a widower now, isn't he?

NORA. With several children. There now, it is burning up. (*Shuts the door of the stove and moves the rocking-chair aside*).

MRS. LINDE. They say he carries on various kinds of business.

NORA. Really! Perhaps he does; I don't know anything about it. But don't let us think of business; it is so tiresome.

DOCTOR RANK (*comes out of Helmer'S study. Before he shuts the door he calls to him*). No, my dear fellow, I won't disturb you; I would rather go in to your wife for a little while. (*Shuts the door and sees Mrs. Linde*). I beg your pardon; I am afraid I am disturbing you too.

NORA. No, not at all. (*Introducing him*). Doctor Rank, Mrs. Linde.

RANK. I have often heard Mrs. Linde's name mentioned here. I think I passed you on the stairs when I arrived, Mrs. Linde?

MRS. LINDE. Yes, I go up very slowly; I can't manage stairs well.

RANK. Ah! some slight internal weakness?

MRS. LINDE. No, the fact is I have been overworking myself.

RANK. Nothing more than that? Then I suppose you have come to town to amuse yourself with our entertainments?

MRS. LINDE. I have come to look for work.

RANK. Is that a good cure for overwork?

MRS. LINDE. One must live, Doctor Rank.

RANK. Yes, the general opinion seems to be that it is necessary.

NORA. Look here, Doctor Rank—you know you want to live.

RANK. Certainly. However wretched I may feel, I want to prolong the agony as long as possible. All my patients are like that. And so are those who are morally diseased; one of them, and a bad case, too, is at this very moment with Helmer—

MRS. LINDE (*sadly*). Ah!

NORA. Whom do you mean?

RANK. A lawyer of the name of Krogstad, a fellow you don't know at all. He suffers from a diseased moral character, Mrs. Helmer; but even he began talking of its being highly important that he should live.

NORA. Did he? What did he want to speak to Torvald about?

RANK. I have no idea; I only heard that it was something about the Bank.

NORA. I didn't know this—what's his name—Krogstad had anything to do with the Bank.

RANK. Yes, he has some sort of appointment there. (*To Mrs. Linde*). I don't know whether you find also in your part of the world that there are certain people who go zealously snuffing about to smell out moral corruption, and, as soon as they have found some, put the person concerned into some lucrative position where they can keep their eye on him. Healthy natures are left out in the cold.

MRS. LINDE. Still I think the sick are those who most need taking care of.

RANK (*shrugging his shoulders*). Yes, there you are. That is the sentiment that is turning Society into a sick-house.

NORA, *who has been absorbed in her thoughts, breaks out into smothered laughter and claps her hands.*

RANK. Why do you laugh at that? Have you any notion what Society really is?

NORA. What do I care about tiresome Society? I am laughing at something quite different, something extremely amusing. Tell me, Doctor Rank, are all the people who are employed in the Bank dependent on Torvald now?

RANK. Is that what you find so extremely amusing?

NORA (*smiling and humming*). That's my affair! (*Walking about the room*). It's perfectly glorious to think that we have—that Torvald has so much power over so many people. (*Takes the packet from her pocket*). Doctor Rank, what do you say to a macaroon?

RANK. What, macaroons? I thought they were forbidden here.

NORA. Yes, but these are some Christine gave me.

MRS. LINDE. What! I?—

NORA. Oh, well, don't be alarmed! You couldn't know that Torvald had forbidden them. I must tell you that he is afraid they will spoil my teeth. But, bah!—once in a way—That's so, isn't it, Doctor Rank? By your leave! (*Puts a macaroon into his mouth*). You must have one too, Christine. And I shall have one, just a little one—or at most two. (*Walking about*). I am tremendously happy. There is just one thing in the world now that I should dearly love to do.

RANK. Well, what is that?

NORA. It's something I should dearly love to say, if Torvald could hear me.

RANK. Well, why can't you say it?

NORA. No, I daren't; it's so shocking.

MRS. LINDE. Shocking?

RANK. Well, I should not advise you to say it. Still, with us you might. What is it you would so much like to say if Torvald could hear you?

NORA. I should just love to say—Well, I'm damned!

RANK. Are you mad?

MRS. LINDE. Nora, dear—!

RANK. Say it, here he is!

NORA (*hiding the packet*). Hush! Hush! Hush! (Helmer *comes out of his room, with his coat over his arm and his hat in his hand*).

NORA. Well, Torvald dear, have you got rid of him?

HELMER. Yes, he has just gone.

NORA. Let me introduce you—this is Christine, who has come to town.

HELMER. Christine—? Excuse me, but I don't know—

NORA. Mrs. Linde, dear; Christine Linde.

HELMER. Of course. A school friend of my wife's, I presume?

MRS. LINDE. Yes, we have known each other since then.

NORA. And just think, she has taken a long journey in order to see you.

HELMER. What do you mean?

MRS. LINDE. No, really, I—

NORA. Christine is tremendously clever at book-keeping, and she is frightfully anxious to work under some clever man, so as to perfect herself—

HELMER. Very sensible, Mrs. Linde.

NORA. And when she heard you had been appointed manager of the Bank—the news was telegraphed, you know—she traveled here as quick as she could, Torvald, I am sure you will be able to do something for Christine, for my sake, won't you?

HELMER. Well, it is not altogether impossible. I presume you are a widow, Mrs. Linde?

MRS. LINDE. Yes.

HELMER. And have had some experience of bookkeeping?

MRS. LINDE. Yes, a fair amount.

HELMER. Ah! well it's very likely I may be able to find something for you—

NORA (*clapping her hands*). What did I tell you? What did I tell you?

HELMER. You have just come at a fortunate moment, Mrs. Linde.

MRS. LINDE. How am I to thank you?

HELMER. There is no need. (*Puts on his coat*). But today you must excuse me—

RANK. Wait a minute; I will come with you. (*Brings his fur coat from the hall and warms it at the fire*).

NORA. Don't be long away, Torvald dear.

HELMER. About an hour, not more.

NORA. Are you going too, Christine?

MRS. LINDE (*putting on her cloak*). Yes, I must go and look for a room.

HELMER. Oh, well then, we can walk down the street together.

NORA (*helping her*). What a pity it is we are so short of space here; I am afraid it is impossible for us—

MRS. LINDE. Please don't think of it! Good-bye, Nora dear, and many thanks.

NORA. Good-bye for the present. Of course you will come back this evening. And you too, Dr. Rank. What do you say? If you are well enough? Oh, you must be! Wrap yourself up well. (*They go to the door all talking together. Children's voices are heard on the staircase*).

NORA. There they are. There they are! (*She runs to open the door. The* Nurse *comes in with the children*). Come in! Come in! (*Stoops and kisses them*). Oh, you sweet blessings! Look at them, Christine! Aren't they darlings?

RANK. Don't let us stand here in the draught.

HELMER. Come along, Mrs. Linde; the place will only be bearable for a mother now!

RANK, HELMER, *and* MRS. LINDE *go downstairs. The* NURSE *comes forward with the children;* NORA *shuts the hall door.*

NORA. How fresh and well you look! Such red cheeks!— like apples and roses. (*The children all talk at once while she speaks to them*). Have you had great fun? That's splendid! What, you pulled both Emmy and Bob along on the sledge?—both at once?— that *was* good. You are a clever boy, Ivar. Let me take her for a little, Anne. My sweet little baby doll! (*Takes the baby from the* Maid *and dances it up and down*). Yes, yes, mother will dance with Bob too. What! Have you been snow-balling? I wish I had been there too! No, no, I will take

their things off, Anne; please let me do it, it is such fun. Go in now, you look half frozen. There is some hot coffee for you on the stove.

The NURSE *goes into the room on the left.* NORA *takes off the children's things and throws them about, while they all talk to her at once.*

NORA. Really! Did a big dog run after you? But it didn't bite you? No, dogs don't bite nice little dolly children. You mustn't look at the parcels, Ivar. What are they? Ah, I daresay you would like to know. No, no—it's something nasty! Come, let us have a game. What shall we play at? Hide and Seek? Yes, we'll play Hide and Seek. Bob shall hide first. Must I hide? Very well, I'll hide first. (*She and the children laugh and shout, and romp in and out of the room; at last Nora hides under the table the children rush in and look for her, but do not see her; they hear her smothered laughter run to the table, lift up the cloth and find her. Shouts of laughter. She crawls forward and pretends to frighten them. Fresh laughter. Meanwhile there has been a knock at the hall door, but none of them has noticed it. The door is half opened, and Krogstad appears. He waits a little; the game goes on*).

KROGSTAD. Excuse me, Mrs. Helmer.

NORA (*with a stifled cry, turns round and gets up on to her knees*). Ah! what do you want?

KROGSTAD. Excuse me, the outer door was ajar; I suppose someone forgot to shut it.

NORA (*rising*). My husband is out, Mr. Krogstad.

KROGSTAD. I know that.

NORA. What do you want here, then?

KROGSTAD. A word with you.

NORA. With me?—(*To the children, gently*). Go in to nurse. What? No, the strange man won't do mother any harm. When he has gone we will have another game. (*She takes the children into the room on the left, and shuts the door after them*). You want to speak to me?

KROGSTAD. Yes, I do.

NORA. Today? It is not the first of the month yet.

KROGSTAD. No, it is Christmas Eve, and it will depend on yourself what sort of a Christmas you will spend.

NORA. What do you want? Today it is absolutely impossible for me—

KROGSTAD. We won't talk about that till later on. This is something different. I presume you can give me a moment?

NORA. Yes—yes, I can—although—

KROGSTAD. Good. I was in Olsen's Restaurant and saw your husband going down the street—

NORA. Yes?

KROGSTAD. With a lady.

NORA. What then?

KROGSTAD. May I make so bold as to ask if it was a Mrs. Linde?

NORA. It was.

KROGSTAD. Just arrived in town?

NORA. Yes, today.

KROGSTAD. She is a great friend of yours, isn't she?

NORA. She is. But I don't see—

KROGSTAD. I knew her too, once upon a time.

NORA. I am aware of that.

KROGSTAD. Are you? So you know all about it; I thought as much. Then I can ask you, without beating about the bush—is Mrs. Linde to have an appointment in the Bank?

NORA. What right have you to question me, Mr. Krogstad?—You, one of my husband's subordinates! But since you ask, you shall know. Yes, Mrs. Linde is to have an appointment. And it was I who pleaded her cause, Mr. Krogstad, let me tell you that.

KROGSTAD. I was right in what I thought, then.

NORA (*walking up and down the stage*). Sometimes one has a tiny little bit of influence, I should hope. Because one is a woman, it does not necessarily follow that—. When anyone is in a subordinate position, Mr. Krogstad, they should really be careful to avoid offending anyone who—who—

KROGSTAD. Who has influence?

NORA. Exactly.

KROGSTAD (*changing his tone*). Mrs. Helmer, you will be so good as to use your influence on my behalf.

NORA. What? What do you mean?

KROGSTAD. You will be so kind as to see that I am allowed to keep my subordinate position in the Bank.

NORA. What do you mean by that? Who proposes to take your post away from you?

KROGSTAD. Oh, there is no necessity to keep up the pretence of ignorance. I can quite understand that your friend is not very anxious to expose herself to the chance of rubbing shoulders with me; and I quite understand, too, whom I have to thank for being turned off.

NORA. But I assure you—

KROGSTAD. Very likely; but, to come to the point, the time has come when I should advise you to use your influence to prevent that.

NORA. But, Mr. Krogstad, I *have* no influence.

KROGSTAD. Haven't you? I thought you said yourself just now—

NORA. Naturally I did not mean you to put that construction on it. I! What should make you think I have any influence of that kind with my husband?

KROGSTAD. Oh, I have known your husband from our student days. I don't suppose he is any more unassailable than other husbands.

NORA. If you speak slightly of my husband, I shall turn you out of the house.

KROGSTAD. You are bold, Mrs. Helmer.

NORA. I am not afraid of you any longer, As soon as the New Year comes, I shall in a very short time be free of the whole thing.

KROGSTAD (*controlling himself*). Listen to me, Mrs. Helmer. If necessary, I am prepared to fight for my small post in the Bank as if I were fighting for my life.

NORA. So it seems.

KROGSTAD. It is not only for the sake of the money; indeed, that weighs least with me in the matter. There is another reason—well, I may as well tell you. My position is this. I daresay you know, like everybody else, that once, many years ago, I was guilty of an indiscretion.

NORA. I think I have heard something of the kind.

KROGSTAD. The matter never came into court; but every way seemed to be closed to me after that. So I took to the business that you know of. I had to

do something; and, honestly, don't think I've been one of the worst. But now I must cut myself free from all that. My sons are growing up; for their sake I must try and win back as much respect as I can in the town. This post in the Bank was like the first step up for me—and now your husband is going to kick me downstairs again into the mud.

NORA. But you must believe me, Mr. Krogstad; it is not in my power to help you at all.

KROGSTAD. Then it is because you haven't the will; but I have means to compel you.

NORA. You don't mean that you will tell my husband that I owe you money?

KROGSTAD. Hm!—suppose I were to tell him?

NORA. It would be perfectly infamous of you. (*Sobbing*). To think of his learning my secret, which has been my joy and pride, in such an ugly, clumsy way— that he should learn it from you! And it would put me in a horribly disagreeable position—

KROGSTAD. Only disagreeable?

NORA (*impetuously*). Well, do it, then!—and it will be the worse for you. My husband will see for himself what a blackguard you are, and you certainly won't keep your post then.

KROGSTAD. I asked you if it was only a disagreeable scene at home that you were afraid of?

NORA. If my husband does get to know of it, of course he will at once pay you what is still owing, and we shall have nothing more to do with you.

KROGSTAD (*coming a step nearer*). Listen to me, Mrs. Helmer. Either you have a very bad memory or you know very little of business. I shall be obliged to remind you of a few details.

NORA. What do you mean?

KROGSTAD. When your husband was ill, you came to me to borrow two hundred and fifty pounds.

NORA. I didn't know any one else to go to.

KROGSTAD. I promised to get you that amount—

NORA. Yes, and you did so.

KROGSTAD. I promised to get you that amount, on certain conditions. Your mind was so taken up with your husband's illness, and you were so anxious to get the money for your journey, that you seem to have paid no attention to the conditions of our bargain.

Therefore it will not be amiss if I remind you of them. Now, I promised to get the money on the security of a bond which I drew up.

NORA. Yes, and which I signed.

KROGSTAD. Good. But below your signature there were a few lines constituting your father a surety for the money; those lines your father should have signed.

NORA. Should? He did sign them.

KROGSTAD. I had left the date blank; that is to say your father should himself have inserted the date on which he signed the paper. Do you remember that?

NORA. Yes, I think I remember—

KROGSTAD. Then I gave you the bond to send by post to your father. Is that not so?

NORA. Yes.

KROGSTAD. And you naturally did so at once, because five or six days afterwards you brought me the bond with your father's signature. And then I gave you the money.

NORA. Well, haven't I been paying it off regularly?

KROGSTAD. Fairly so, yes. But—to come back to the matter in hand—that must have been a very trying time for you, Mrs. Helmer?

NORA. It was, indeed.

KROGSTAD. Your father was very ill, wasn't he?

NORA. He was very near his end.

KROGSTAD. And died soon afterwards?

NORA. Yes.

KROGSTAD. Tell me, Mrs. Helmer, can you by any chance remember what day your father died?—on what day of the month, I mean.

NORA. Papa died on the 29th of September.

KROGSTAD. That is correct; I have ascertained it for myself. And, as that is so, there is a discrepancy (*taking a paper from his pocket*) which I cannot account for.

NORA. What discrepancy? I don't know—

KROGSTAD. The discrepancy consists, Mrs. Helmer, in the fact that your father signed this bond three days after his death.

NORA. What do you mean? I don't understand—

KROGSTAD. Your father died on the 29th of September. But, look here; your father dated his signature the 2nd of October. It is a discrepancy, isn't it? (*Nora is silent*). Can you explain it to me? (*Nora is still silent*). It is a remarkable thing, too, that the words "2nd of October," as well as the year, are not written in your father's handwriting but in one that I think I know. Well, of course it can be explained; your father may have forgotten to date his signature, and someone else may have dated it haphazard before they knew of his death. There is no harm in that. It all depends on the signature of the name; and *that* is genuine, I suppose, Mrs. Helmer? It was your father himself who signed his name here?

NORA (*after a short pause, throws her head up and looks defiantly at him*). No, it was not. It was I that wrote papa's name.

KROGSTAD. Are you aware that is a dangerous confession?

NORA. In what way? You shall have your money soon.

KROGSTAD. Let me ask you a question; why did you not send the paper to your father?

NORA. It was impossible; papa was so ill. If I had asked him for his signature, I should have had to tell him what the money was to be used for; and when he was so ill himself I couldn't tell him that my husband's life was in danger—it was impossible.

KROGSTAD. It would have been better for you if you had given up your trip abroad.

NORA. No, that was impossible. That trip was to save my husband's life; I couldn't give that up.

KROGSTAD. But did it never occur to you that you were committing a fraud on me?

NORA. I couldn't take that into account; I didn't trouble myself about you at all. I couldn't bear you, because you put so many heartless difficulties in my way, although you knew what a dangerous condition my husband was in.

KROGSTAD. Mrs. Helmer, you evidently do not realise clearly what it is that you have been guilty of. But I can assure you that my one false step, which lost me all my reputation, was nothing more or nothing worse than what you have done.

NORA. You? Do you ask me to believe that you were brave enough to run a risk to save your wife's life.

KROGSTAD. The law cares nothing about motives.

NORA. Then it must be a very foolish law.

KROGSTAD. Foolish or not, it is the law by which you will be judged, if I produce this paper in court.

NORA. I don't believe it. Is a daughter not to be allowed to spare her dying father anxiety and care? Is a wife not to be allowed to save her husband's life? I don't know much about law; but I am certain that there must be laws permitting such things as that. Have you no knowledge of such laws—you who are a lawyer? You must be a very poor lawyer, Mr. Krogstad.

KROGSTAD. Maybe. But matters of business—such business as you and I have had together—do you think I don't understand that? Very well. Do as you please. But let me tell you this—if I lose my position a second time, you shall lose yours with me. (*He bows, and goes out through the hall*).

NORA (*appears buried in thought for a short time, then tosses her head*). Nonsense! Trying to frighten me like that!—I am not so silly as he thinks. (*Begins to busy herself putting the children's things in order*). And yet—? No, it's impossible! I did it for love's sake.

THE CHILDREN (*in the doorway on the left*). Mother, the stranger man has gone out through the gate.

NORA. Yes, dears, I know. But, don't tell anyone about the stranger man. Do you hear? Not even papa.

CHILDREN. No, mother; but will you come and play again?

NORA. No no,—not now.

CHILDREN. But, mother, you promised us.

NORA. Yes, but I can't now. Run away in; I have such a lot to do. Run away in, sweet little darlings. (*She gets them into the room by degrees and shuts the door on them; then sits down on the sofa, takes up a piece of needlework and sews a few stitches, but soon stops*). No! (*Throws down the work, gets up, goes to the hall door and calls out*). Helen, bring the Tree in. (*Goes to the table on the left, opens a drawer, and stops again*). No, no! it is quite impossible!

MAID (*coming in with the Tree*). Where shall I put it, ma'am?

NORA. Here, in the middle of the floor.

MAID. Shall I get you anything else?

NORA. No, thank you. I have all I want.

Exit Maid.

NORA (*begins dressing the tree*). A candle here— and flowers here—. The horrible man! It's all nonsense—there's nothing wrong. The Tree shall be splendid! I will do everything I can think of to please you, Torvald!—I will sing for you, dance for you—(Helmer *comes in with some papers under his arm*). Oh! are you back already?

HELMER. Yes. Has anyone been here?

NORA. Here? No.

HELMER. That is strange. I saw Krogstad going out of the gate.

NORA. Did you? Oh yes, I forgot Krogstad was here for a moment.

HELMER. Nora, I can see from your manner that he has been here begging you to say a good word for him.

NORA. Yes.

HELMER. And you were to appear to do it of your own accord; you were to conceal from me the fact of his having been here; didn't he beg that of you too?

NORA. Yes, Torvald, but—

HELMER. Nora, Nora, and you would be a party to that sort of thing? To have any talk with a man like that, and give him any sort of promise? And to tell me a lie into the bargain?

NORA. A lie—?

HELMER. Didn't you tell me no one had been here? (*Shakes his finger at her*). My little song-bird must never do that again. A song-bird must have a clean beak to chirp with—no false notes! (*Puts his arm round her waist*). That is so, isn't it? Yes, I am sure it is. (*Lets her go*). We will say no more about it. (*Sits down by the stove*). How warm and snug it is here! (*Turns over his papers*).

NORA (*after a short pause, during which she busies herself with the Christmas Tree*). Torvald!

HELMER. Yes.

NORA. I am looking forward tremendously to the fancy dress ball at the Stensborgs' the day after tomorrow.

HELMER. And I am tremendously curious to see what you are going to surprise me with.

NORA. It was very silly of me to want to do that.

HELMER. What do you mean?

NORA. I can't hit upon anything that will do; everything I think of seems so silly and insignificant.

HELMER. Does my little Nora acknowledge that at last?

NORA (*standing behind his chair with her arms on the back of it*). Are you very busy, Torvald?

HELMER. Well—

NORA. What are all those papers?

HELMER. Bank business.

NORA. Already?

HELMER. I have got authority from the retiring manager to undertake the necessary changes in the staff and in the rearrangement of the work; and I must make use of the Christmas week for that, so as to have everything in order for the new year.

NORA. Then that was why this poor Krogstad—

HELMER. Hm!

NORA (*leans against the back of his chair and strokes his hair*). If you hadn't been so busy I should have asked you a tremendously big favour, Torvald.

HELMER. What is that? Tell me.

NORA. There is no one has such good taste as you. And I do so want to look nice at the fancy-dress ball. Torvald, couldn't you take me in hand and decide what I shall go as, and what sort of a dress I shall wear?

HELMER. Aha! so my obstinate little woman is obliged to get someone to come to her rescue?

NORA. Yes, Torvald, I can't get along a bit without your help.

HELMER Very well, I will think it over, we shall manage to hit upon something.

NORA. That is nice of you. (*Goes to the Christmas Tree. A short pause*). How pretty the red flowers look—. But, tell me, was it really something very bad that this Krogstad was guilty of?

HELMER. He forged someone's name. Have you any idea what that means?

NORA. Isn't it possible that he was driven to do it by necessity?

HELMER. Yes; or, as in so many cases, by imprudence. I am not so heartless as to condemn a man altogether because of a single false step of that kind.

NORA. No you wouldn't, would you, Torvald?

HELMER. Many a man has been able to retrieve his character, if he has openly confessed his fault and taken his punishment.

NORA. Punishment—?

HELMER. But Krogstad did nothing of that sort; he got himself out of it by a cunning trick, and that is why he has gone under altogether.

NORA. But do you think it would—?

HELMER. Just think how a guilty man like that has to lie and play the hypocrite with everyone, how he has to wear a mask in the presence of those near and dear to him, even before his own wife and children. And about the children—that is the most terrible part of it all, Nora.

NORA. How?

HELMER. Because such an atmosphere of lies infects and poisons the whole life of a home. Each breath the children take in such a house is full of the germs of evil.

NORA (*coming nearer him*). Are you sure of that?

HELMER. My dear, I have often seen it in the course of my life as a lawyer. Almost everyone who has gone to the bad early in life has had a deceitful mother.

NORA. Why do you only say—mother?

HELMER. It seems most commonly to be the mother's influence, though naturally a bad father's would have the same result. Every lawyer is familiar with the fact. This Krogstad, now, has been persistently poisoning his own children with lies and dissimulation; that is why I say he has lost all moral character. (*Holds out his hands to her*). That is why my sweet little Nora must promise me not to plead his cause. Give me your hand on it. Come, come, what is this? Give me your hand. There now, that's settled. I assure you it would be quite impossible for me to work with him; I literally feel physically ill when I am in the company of such people.

NORA (*takes her hand out of his and goes to the opposite side of the Christmas Tree*). How hot it is in here; and I have such a lot to do.

HELMER (*getting up and putting his papers in order*). Yes, and I must try and read through some of these before dinner; and I must think about your costume, too. And it is just possible I may have

something ready in gold paper to hang up on the Tree. (*Puts his hand on her head*). My precious little singing-bird! (*He goes into his room and shuts the door after him*).

NORA (*after a pause, whispers*). No, no—it isn't true. It's impossible; it must be impossible.

The NURSE *opens the door on the left.*

NURSE. The little ones are begging so hard to be allowed to come in to mamma.

NORA. No, no, no! Don't let them come in to me! You stay with them, Anne.

NURSE. Very well, ma'am. (*Shuts the door*).

NORA (*pale with terror*). Deprave my little children? Poison my home? (*A short pause. Then she tosses her head*). It's not true. It can't possibly be true.

Act 2

The same Scene—The Christmas Tree is in the corner by the piano, stripped of its ornaments and with burnt-down candle-ends on its dishevelled branches. Nora'S cloak and hat are lying on the sofa. She is alone in the room, walking about uneasily. She stops by the sofa and takes up her cloak.

NORA. (*drops the cloak*). Someone is coming now! (*Goes to the door and listens*). No—it is no one. Of course, no one will come today, Christmas Day— nor tomorrow either. But, perhaps—(*opens the door and looks out*). No, nothing in the letter-box; it is quite empty. (*Comes forward*). What rubbish! of course he can't be in earnest about it. Such a thing couldn't happen; it is impossible—I have three little children.

Enter the NURSE *from the room on the left, carrying a big cardboard box.*

NURSE. At last I have found the box with the fancy dress.

NORA. Thanks; put it on the table.

NURSE (*doing so*). But it is very much in want of mending.

NORA. I should like to tear it into a hundred thousand pieces.

NURSE. What an idea! It can easily be put in order— just a little patience.

NORA. Yes, I will go and get Mrs. Linde to come and help me with it.

NURSE. What, out again? In this horrible weather? You will catch cold, ma'am, and make yourself ill.

NORA. Well, worse than that might happen. How are the children?

NURSE. The poor little souls are playing with their Christmas presents, but—

NORA. Do they ask much for me?

NURSE. You see, they are so accustomed to have their mamma with them.

NORA. Yes, but, nurse, I shall not be able to be so much with them now as I was before.

NURSE. Oh well, young children easily get accustomed to anything.

NORA. Do you think so? Do you think they would forget their mother if she went away altogether?

NURSE. Good heavens!—went away altogether?

NORA. Nurse, I want you to tell me something I have often wondered about—how could you have the heart to put your own child out among strangers?

NURSE. I was obliged to, if I wanted to be little Nora's nurse.

NORA. Yes, but how could you be willing to do it?

NURSE. What, when I was going to get such a good place by it? A poor girl who has got into trouble should be glad to. Besides, that wicked man didn't do a single thing for me.

NORA. But I suppose your daughter has quite forgotten you.

NURSE. No, indeed she hasn't. She wrote to me when she was confirmed, and when she was married.

NORA (*putting her arms round her neck*). Dear old Anne, you were a good mother to me when I was little.

NURSE. Little Nora, poor dear, had no other mother but me.

NORA. And if my little ones had no other mother, I am sure you would—What nonsense I am talking! (*Opens the box*). Go in to them. Now I must—. You will see tomorrow how charming I shall look.

NURSE. I am sure there will be no one at the ball so charming as you, ma'am. (*Goes into the room on the left*).

NORA (*begins to unpack the box, but soon pushes it away from her*). If only I dared go out. If only no one would come. If only I could be sure nothing would happen here in the meantime. Stuff and nonsense! No one will come. Only I mustn't think about it. I will brush my muff. What lovely, lovely gloves! Out of my thoughts, out of my thoughts! One, two, three, four, five, six—(*Screams*). Ah! there is someone coming—. (*Makes a movement towards the door, but stands irresolute*).

Enter MRS. LINDE *from the hall, where she has taken off her cloak and hat.*

NORA. Oh, it's you, Christine. There is no one else out there, is there? How good of you to come!

MRS. LINDE. I heard you were up asking for me.

NORA. Yes, I was passing by. As a matter of fact, it is something you could help me with. Let us sit down here on the sofa. Look here. Tomorrow evening there is to be a fancy-dress ball at the Stenborgs', who live above us; and Torvald wants me to go as a Neapolitan fisher-girl, and dance the Tarantella that I learnt at Capri.

MRS. LINDE. I see; you are going to keep up the character.

NORA. Yes, Torvald wants me to. Look, here is the dress; Torvald had it made for me there, but now it is all so torn, and I haven't any idea—

MRS. LINDE. We will easily put that right. It is only some of the trimming come unsewn here and there. Needle and thread? Now then, that's all we want.

NORA. It *is* nice of you.

MRS. LINDE (*sewing*). So you are going to be dressed up tomorrow, Nora. I will tell you what—I shall come in for a moment and see you in your fine feathers. But I have completely forgotten to thank you for a delightful evening yesterday.

NORA (*gets up, and crosses the stage*). Well I don't think yesterday was as pleasant as usual. You ought to have come to town a little earlier, Christine. Certainly Torvald does understand how to make a house dainty and attractive.

MRS. LINDE. And so do you, it seems to me; you are not your father's daughter for nothing. But tell me, is Doctor Rank always as depressed as he was yesterday?

NORA. No; yesterday it was very noticeable. I must tell you that he suffers from a *very* dangerous disease. He has consumption of the spine, poor creature. His father was a horrible man who committed all sorts of excesses; and that is why his son was sickly from childhood, do you understand?

MRS. LINDE (*dropping her sewing*). But, my dearest Nora, how do you know anything about such things?

NORA (*walking about*). Pooh! When you have three children, you get visits now and then from—from married women, who know something of medical matters, and they talk about one thing and another.

MRS. LINDE (*goes on sewing. A short silence*). Does Doctor Rank come here every day?

NORA. Every day regularly. He is Torvald's most intimate friend, and a great friend of mine too. He is just like one of the family.

MRS. LINDE. But tell me this—is he perfectly sincere? I mean, isn't he the kind of a man that is very anxious to make himself agreeable?

NORA. Not in the least. What makes you think that?

MRS. LINDE. When you introduced him to me yesterday, he declared he had often heard my name mentioned in this house; but afterwards I noticed that your husband hadn't the slightest idea who I was. So how could Doctor Rank—?

NORA. That is quite right, Christine. Torvald is so absurdly fond of me that he wants me absolutely to himself, as he says. At first he used to seem almost jealous if I mentioned any of the dear folk at home, so naturally I gave up doing so. But I often talk about such things with Doctor Rank, because he likes hearing about them.

MRS. LINDE. Listen to me, Nora. You are still very like a child in many ways, and I am older than you in many ways and have a little more experience. Let me tell you this—you ought to make an end of it with Doctor Rank.

NORA. What ought I to make an end of?

MRS. LINDE. Of two things, I think. Yesterday you talked some nonsense about a rich admirer who was to leave you money—

NORA. An admirer who doesn't exist, unfortunately! But what then?

MRS. LINDE. Is Doctor Rank a man of means?

NORA. Yes, he is.

MRS. LINDE. And has no one to provide for?

NORA. No, no one; but—

MRS. LINDE. And comes here every day?

NORA. Yes, I told you so.

MRS. LINDE. But how can this well-bred man be so tactless?

NORA. I don't understand you at all.

MRS. LINDE. Don't prevaricate, Nora. Do you suppose I don't guess who lent you the two hundred and fifty pounds.

NORA. Are you out of your senses? How can you think of such a thing! A friend of ours, who comes here every day! Do you realise what a horribly painful position that would be?

MRS. LINDE. Then it really isn't he?

NORA. No, certainly not. It would never have entered into my head for a moment. Besides, he had no money to lend then; he came into his money afterwards.

MRS. LINDE. Well, I think that was lucky for you, my dear Nora.

NORA. No, it would never have come into my head to ask Doctor Rank. Although I am quite sure that if I had asked him—

MRS. LINDE. But of course you won't.

NORA. Of course not. I have no reason to think it could possibly be necessary. But I am quite sure that if I told Doctor Rank—

MRS. LINDE. Behind your husband's back?

NORA. I must make an end of it with the other one, and that will be behind his back too. I *must* make an end of it with him.

MRS. LINDE. Yes, that is what I told you yesterday, but—

NORA (*walking up and down*). A man can put a thing like that straight much easier than a woman—

MRS. LINDE. One's husband, yes.

NORA. Nonsense! (*Standing still*). When you pay off a debt you get your bond back, don't you?

MRS. LINDE. Yes, as a matter of course.

NORA. And can tear it into a hundred thousand pieces, and burn it up—the nasty, dirty paper!

MRS. LINDE (*looks hard at her, lays down her sewing and gets up slowly*). Nora, you are concealing something from me.

NORA. Do I look as if I were?

MRS. LINDE. Something has happened to you since yesterday morning. Nora, what is it?

NORA (*going nearer to her*). Christine! (*Listens*). Hush! there's Torvald come home. Do you mind going in to the children for the present? Torvald can't bear to see dressmaking going on. Let Anne help you.

MRS. LINDE (*gathering some of the things together*). Certainly—but I am not going away from here till we have had it out with one another. (*She goes into the room, on the left, as Helmer comes in from the hall*).

NORA (*going up to* HELMAR). I have wanted you so much, Torvald dear.

HELMER. Was that the dressmaker?

NORA. No, it was Christine; she is helping me to put my dress in order. You will see I shall look quite smart.

HELMER. Wasn't that a happy thought of mine, now?

NORA. Splendid! But don't you think it is nice of me, too, to do as you wish?

HELMER. Nice?—because you do as your husband wishes? Well, well, you little rogue, I am sure you did not mean it in that way. But I am not going to disturb you; you will want to be trying on your dress, I expect.

NORA. I suppose you are going to work.

HELMER. Yes. (*Shows her a bundle of papers*). Look at that. I have just been into the bank. (*Turns to go into his room*).

NORA. Torvald.

HELMER. Yes.

NORA. If your little squirrel were to ask you for something very, very prettily—?

HELMER. What then?

NORA. Would you do it?

HELMER. I should like to hear what it is, first.

NORA. Your squirrel would run about and do all her tricks if you would be nice, and do what she wants.

HELMER. Speak plainly.

NORA. Your skylark would chirp about in every room, with her song rising and falling—

HELMER. Well, my skylark does that anyhow.

NORA. I would play the fairy and dance for you in the moonlight, Torvald.

HELMER. Nora—you surely don't mean that request you made of me this morning?

NORA (*going near him*). Yes, Torvald, I beg you so earnestly—

HELMER. Have you really the courage to open up that question again?

NORA. Yes, dear, you *must* do as I ask; you *must* let Krogstad keep his post in the bank.

HELMER. My dear Nora, it is his post that I have arranged Mrs. Linde shall have.

NORA. Yes, you have been awfully kind about that; but you could just as well dismiss some other clerk instead of Krogstad.

HELMER. This is simply incredible obstinacy! Because you chose to give him a thoughtless promise that you would speak for him, I am expected to—

NORA. That isn't the reason, Torvald. It is for your own sake. This fellow writes in the most scurrilous newspapers; you have told me so yourself. He can do you an unspeakable amount of harm. I am frightened to death of him—

HELMER. Ah, I understand; it is recollections of the past that scare you.

NORA. What do you mean?

HELMER. Naturally you are thinking of your father.

NORA. Yes—yes, of course. Just recall to your mind what these malicious creatures wrote in the papers about papa, and how horribly they slandered him. I believe they would have procured his dismissal if the Department had not sent you over to inquire into it, and if you had not been so kindly disposed and helpful to him.

HELMER. My little Nora, there is an important difference between your father and me. Your father's reputation as a public official was not above suspicion. Mine is, and I hope it will continue to be so, as long as I hold my office.

NORA. You never can tell what mischief these men may contrive. We ought to be so well off, so snug and happy here in our peaceful home, and have no cares—you and I and the children, Torvald! That is why I beg you so earnestly—

HELMER. And it is just by interceding for him that you make it impossible for me to keep him. It is already known at the Bank that I mean to dismiss Krogstad. Is it to get about now that the new manager has changed his mind at his wife's bidding—

NORA. And what if it did?

HELMER. Of course!—if only this obstinate little person can get her way! Do you suppose I am going to make myself ridiculous before my whole staff, to let people think that I am a man to be swayed by all sorts of outside influence? I should very soon feel the consequences of it, I can tell you. And besides, there is one thing that makes it quite impossible for me to have Krogstad in the bank as long as I am manager.

NORA. Whatever is that?

HELMER. His moral failings I might perhaps have overlooked, if necessary—

NORA. Yes, you could—couldn't you?

HELMER. And, I hear he is a good worker, too. But I knew him when we were boys. It was one of those rash friendships that so often prove an incubus in after life. I may as well tell you plainly, we were once on very intimate terms with one another. But this tactless fellow lays no restraint upon himself when other people are present. On the contrary, he thinks it gives him the right to adopt a familiar tone with me, and every minute it is "I say, Helmer, old fellow!" and that sort of thing. I assure you it is extremely painful to me. He would make my position in the bank intolerable.

NORA. Torvald, I don't believe you mean that.

HELMER. Don't you? Why not?

NORA. Because it is such a narrow-minded way of looking at things.

HELMER. What are you saying? Narrow-minded? Do you think I am narrow-minded?

NORA. No, just the opposite, dear—and it is exactly for that reason.

HELMER. It's the same thing. You say my point of view is narrow-minded, so I must be so, too. Narrow-minded! Very well—I must put an end to this. (*Goes to the hall door and calls*). Helen!

NORA. What are you going to do?

HELMER (*looking among his papers*). Settle it. (*Enter* MAID). Look here; take this letter and go downstairs with it at once. Find a messenger and tell him to deliver it, and be quick. The address is on it, and here is the money.

MAID. Very well, sir. (*Exit with the letter*).

HELMER (*putting his papers together*). Now, then, little Miss Obstinate.

NORA (*breathlessly*). Torvald—what was that letter?

HELMER. Krogstad's dismissal.

NORA. Call her back, Torvald! There is still time. Oh Torvald, call her back! Do it for my sake—for your own sake, for the children's sake! Do you hear me, Torvald? Call her back! You don't know what that letter can bring upon us.

HELMER. It's too late.

NORA. Yes, it's too late.

HELMER. My dear Nora, I can forgive the anxiety you are in, although really it is an insult to me. It is, indeed. Isn't it an insult to think that I should be afraid of a starving quill-driver's vengeance? But I forgive you, nevertheless, because it is such eloquent witness to your great love for me. (*Takes her in his arms*). And that is as it should be, my own darling Nora. Come what will, you may be sure I shall have both courage and strength if they be needed. You will see I am man enough to take everything upon myself.

NORA (*in a horror-stricken voice*). What do you mean by that?

HELMER. Everything I say—

NORA (*recovering herself*). You will never have to do that.

HELMER. That's right. Well, we will share it, Nora, as man and wife should. That is how it shall be. (*Caressing her*). Are you content now? There! There!—not these frightened dove's eyes! The whole thing is only the wildest fancy!—Now, you must go and play through the Tarantella and practice with your tambourine. I shall go into the inner office and shut the door, and I shall hear nothing; you can make as much noise as you please. (*Turns back at the door*). And when Rank comes, tell him where he will find me. (*Nods to her, takes his papers and goes into his room, and shuts the door after him*).

NORA (*bewildered with anxiety, stands as if rooted to the spot, and whispers*). He was capable of doing it. He will do it. He will do it in spite of everything.—No, not that! Never, never! Anything rather than that! Oh, for some help, some way out of it. (*The door-bell rings*). Doctor RANK! Anything rather than that—anything, whatever it is! (*She puts her hands over her face, pulls herself together, goes to the door and opens it. RANK is standing without, hanging up his coat. During the following dialogue it begins to grow dark*).

NORA. Good-day, Doctor Rank. I knew your ring. But you mustn't go into Torvald now; I think he is busy with something.

RANK. And you?

NORA (*brings him in and shuts the door after him*). Oh, you know very well I always have time for you.

RANK. Thank you. I shall make use of as much of it as I can.

NORA. What do you mean by that? As much of it as you can.

RANK. Well, does that alarm you?

NORA. It was such a strange way of putting it. Is anything likely to happen?

RANK. Nothing but what I have long been prepared for. But I certainly didn't expect it to happen so soon.

NORA (*gripping him by the arm*). What have you found out? Doctor Rank, you must tell me.

RANK (*sitting down by the stove*). It is all up with me. And it can't be helped.

NORA (*with a sigh of relief*). Is it about yourself?

RANK. Who else? It is no use lying to one's self. I am the most wretched of all my patients, Mrs. Helmer. Lately I have been taking stock of my internal economy. Bankrupt! Probably within a month I shall lie rotting in the church-yard.

NORA. What an ugly thing to say!

RANK. The thing itself is cursedly ugly, and the worst of it is that I shall have to face so much more that is ugly before that. I shall only make one more examination of myself; when I have done that, I shall know pretty certainly when it will be that the horrors of dissolution will begin. There is something I want to tell you. Helmer's refined nature gives him an unconquerable disgust of

everything that is ugly; I won't have him in my sick-room.

NORA. Oh, but, Doctor Rank—

RANK. I won't have him there. Not on any account. I bar my door to him. As soon as I am quite certain that the worst has come, I shall send you my card with a black cross on it, and then you will know that the loathsome end has begun.

NORA. You are quite absurd to-day. And I wanted you so much to be in a really good humour.

RANK. With death stalking beside me?—To have to pay this penalty for another man's sin! Is there any justice in that? And in every single family, in one way or another, some such inexorable retribution is being exacted—

NORA (*putting her hands over her ears*). Rubbish! Do talk of something cheerful.

RANK. Oh, it's a mere laughing matter, the whole thing. My poor innocent spine has to suffer for my father's youthful amusements.

NORA (*sitting at the table on the left*). I suppose you mean that he was too partial to asparagus and pate de foie gras, don't you?

RANK. Yes, and to truffles.

NORA. Truffles, yes. And oysters too, I suppose?

RANK. Oysters, of course, that goes without saying.

NORA. And heaps of port and champagne. It is sad that all these nice things should take their revenge on our bones.

RANK. Especially that they should revenge themselves on the unlucky bones of those who have not had the satisfaction of enjoying them.

NORA. Yes, that's the saddest part of it all.

RANK (*with a searching look at her*). Hm!—

NORA (*after a short pause*). Why did you smile?

RANK. No, it was you that laughed.

NORA. No, it was you that smiled, Doctor Rank!

RANK (*rising*). You are a greater rascal than I thought.

NORA. I am in a silly mood today.

RANK. So it seems.

NORA (*putting her hands on his shoulders*). Dear, dear Doctor Rank, death mustn't take you away from Torvald and me.

RANK. It is a loss you would easily recover from. Those who are gone are soon forgotten.

NORA (*looking at him anxiously*). Do you believe that?

RANK. People form new ties, and then—

NORA. Who will form new ties?

RANK. Both you and Helmer, when I am gone. You yourself are already on the high road to it, I think. What did that Mrs. Linde want here last night?

NORA. Oho!—you don't mean to say you are jealous of poor Christine?

RANK. Yes, I am. She will be my successor in this house. When I am done for, this woman will—

NORA. Hush! don't speak so loud. She is in that room.

RANK. To-day again. There, you see.

NORA. She has only come to sew my dress for me. Bless my soul, how unreasonable you are! (*Sits down on the sofa*). Be nice now, Doctor Rank, and to-morrow you will see how beautifully I shall dance, and you can imagine I am doing it all for you—and for Torvald too, of course. (*Takes various things out of the box*). Doctor Rank, come and sit down here, and I will show you something.

RANK (*sitting down*). What is it?

NORA. Just look at those.

RANK. Silk stockings.

NORA. Flesh-coloured. Aren't they lovely? It is so dark here now, but to-morrow—. No, no, no! you must only look at the feet. Oh, well, you may have leave to look at the legs too.

RANK. Hm!—

NORA. Why are you looking so critical? Don't you think they will fit me?

RANK. I have no means of forming an opinion about that.

NORA (*looks at him for a moment*). For shame! (*Hits him lightly on the ear with the stockings*). That's to punish you. (*Folds them up again*).

RANK. And what other nice things am I to be allowed to see?

NORA. Not a single thing more, for being so naughty. (*She looks among the things, humming to herself*).

RANK (*after a short silence*). When I am sitting here, talking to you as intimately as this, I cannot imagine for a moment what would have become of me if I had never come into this house.

NORA (*smiling*). I believe you do feel thoroughly at home with us.

RANK (*in a lower voice, looking straight in front of him*). And to be obliged to leave it all—

NORA. Nonsense, you are not going to leave it.

RANK (*as before*). And not be able to leave behind one the slightest token of one's gratitude, scarcely even a fleeting regret—nothing but an empty place which the first comer can fill as well as any other.

NORA. And if I asked you now for a—? No!

RANK. For what?

NORA. For a big proof of your friendship—

RANK. Yes, yes.

NORA. I mean a tremendously big favour—

RANK. Would you really make me so happy for once?

NORA. Ah, but you don't know what it is yet.

RANK. No—but tell me.

NORA. I really can't, Doctor Rank. It is something out of all reason; it means advice, and help, and a favour—

RANK. The bigger a thing it is the better. I can't conceive what it is you mean. Do tell me. Haven't I your confidence?

NORA. More than anyone else. I know you are my truest and best friend, and so I will tell you what it is. Well, Doctor Rank, it is something you must help me to prevent. You know how devotedly, how inexpressibly deeply Torvald loves me; he would never for a moment hesitate to give his life for me.

RANK (*leaning toward her*). Nora—do you think he is the only one—?

NORA (*with a slight start*). The only one—?

RANK. The only one who would gladly give his life for your sake.

NORA (*sadly*). Is that it?

RANK. I was determined you should know it before I went away, and there will never be a better opportunity than this. Now you know it, Nora. And now you know, too, that you can trust me as you would trust no one else.

NORA (*rises deliberately and quietly*). Let me pass.

RANK (*makes room for her to pass him, but sits still*). Nora!

NORA (*at the hall door*). Helen, bring in the lamp. (*Goes over to the stove*). Dear Doctor Rank, that was really horrid of you.

RANK. To have loved you as much as anyone else does? Was that horrid?

NORA. No, but to go and tell me so. There was really no need—

RANK. What do you mean? Did you know—? (*Maid enters with lamp, puts it down on the table, and goes out*). Nora—Mrs. Helmer—tell me, had you any idea of this?

NORA. Oh, how do I know whether I had or whether I hadn't. I really can't tell you—To think you could be so clumsy, Doctor Rank! We were getting on so nicely.

RANK. Well, at all events you know now that you can command me, body and soul. So won't you speak out?

NORA (*looking at him*). After what happened?

RANK. I beg you to let me know what it is.

NORA. I can't tell you anything now.

RANK. Yes, yes. You mustn't punish me in that way. Let me have permission to do for you whatever a man may do.

NORA. You can do nothing for me now. Besides, I really don't need any help at all. You will find that the whole thing is merely fancy on my part. It really is so—of course it is! (*Sits down in the rocking-chair, and looks at him with a smile*). You are a nice sort of man, Doctor Rank!—don't you feel ashamed of yourself, now the lamp has come?

RANK. Not a bit. But perhaps I had better go—forever?

NORA. No, indeed, you shall not. Of course you must come here just as before. You know very well Torvald can't do without you.

RANK. Yes, but you?

NORA. Oh, I am always tremendously pleased when you come.

RANK. It is just that, that put me on the wrong track. You are a riddle to me. I have often thought that you would almost as soon be in my company as in Helmer's.

NORA. Yes—you see there are some people one loves best, and others whom one would almost always rather have as companions.

RANK. Yes, there is something in that.

NORA. When I was at home, of course I loved papa best. But I always thought it tremendous fun if I could steal down into the maids' room, because they never moralized at all, and talked to each other about such entertaining things.

RANK. I see—it is their place I have taken.

NORA (jumping-up and going to him). Oh, dear, nice Doctor Rank, I never meant that at all. But surely you can understand that being with Torvald is a little like being with papa—(Enter MAID from the hall).

MAID. If you please, ma'am. (Whispers and hands her a card).

NORA (glancing at the card). Oh! (Puts it in her pocket).

RANK. Is there anything wrong?

NORA. No, no, not in the least. It is only something—It is my new dress—

RANK. What? Your dress is lying there.

NORA. Oh, yes, that one; but this is another. I ordered it. Torvald mustn't know about it—

RANK. Oho! Then that was the great secret.

NORA. Of course. Just go in to him; he is sitting in the inner room. Keep him as long as—

RANK. Make your mind easy; I won't let him escape. (Goes into HELMER'S room).

NORA (to the MAID). And he is standing waiting in the kitchen?

MAID. Yes; he came up the back stairs.

NORA. But didn't you tell him no one was in?

MAID. Yes, but it was no good.

NORA. He won't go away?

MAID. No; he says he won't until he has seen you, ma'am.

NORA. Well, let him come in—but quietly. Helen, you mustn't say anything about it to any one. It is a surprise for my husband.

MAID. Yes, ma'am, I quite understand.

Exit.

NORA. This dreadful thing is going to happen. It will happen in spite of me! No, no, no, it can't happen—it shan't happen! (She bolts the door of HELMER'S room. The MAID opens the hall door for Krogstad and shuts it after him. He is wearing a fur coat, high boots and a fur cap).

NORA (advancing towards him). Speak low—my husband is at home.

KROGSTAD. No matter about that.

NORA. What do you want of me?

KROGSTAD. An explanation of something.

NORA. Make haste then. What is it?

KROGSTAD. You know, I suppose, that I have got my dismissal.

NORA. I couldn't prevent it, Mr. Krogstad. I fought as hard as I could on your side, but it was no good.

KROGSTAD. Does your husband love you so little, then? He knows what I can expose you to, and yet he ventures—

NORA. How can you suppose that he has any knowledge of the sort?

KROGSTAD. I didn't suppose so at all. It would not be the least like our dear Torvald Helmer to show so much courage—

NORA. Mr. Krogstad, a little respect for my husband, please.

KROGSTAD. Certainly—all the respect he deserves. But since you have kept the matter so carefully to yourself, I make bold to suppose that you have a little clearer idea than you had yesterday, of what it actually is that you have done?

NORA. More than you could ever teach me.

KROGSTAD. Yes, such a bad lawyer as I am.

NORA. What is it you want of me?

KROGSTAD. Only to see how you were, Mrs. Helmer. I have been thinking about you all day long. A mere cashier—a quill-driver, a—well, a man like me—even he has a little of what is called feeling, you know.

NORA. Show it, then; think of my little children.

KROGSTAD. Have you and your husband thought of mine? But never mind about that. I only wanted to tell you that you need not take this matter too seriously. In the first place there will be no accusation made on my part.

NORA. No, of course not; I was sure of that.

KROGSTAD. The whole thing can be arranged amicably; there is no reason why anyone should know anything about it. It will remain a secret between us three.

NORA. My husband must never get to know anything about it.

KROGSTAD. How will you be able to prevent it? Am I to understand that you can pay the balance that is owing?

NORA. No, not just at present.

KROGSTAD. Or perhaps that you have some expedient for raising the money soon?

NORA. No expedient that I mean to make use of.

KROGSTAD. Well, in any case, it would have been of no use to you now. If you stood there with ever so much money in your hand, I would never part with your bond.

NORA. Tell me what purpose you mean to put it to.

KROGSTAD. I shall only preserve it—keep it in my possession. No one who is not concerned in the matter shall have the slightest hint of it. So that if the thought of it has driven you to any desperate resolution—

NORA. It has.

KROGSTAD. If you had it in your mind to run away from your home—

NORA. I had.

KROGSTAD. Or even something worse—

NORA. How could you know that?

KROGSTAD. Give up the idea.

NORA. How did you know I had thought of *that*?

KROGSTAD. Most of us think of that at first. I did, too—but I hadn't the courage.

NORA (*faintly*). No more had I.

KROGSTAD (*in a tone of relief*). No, that's it, isn't it—you hadn't the courage either?

NORA. No, I haven't—I haven't.

KROGSTAD. Besides, it would have been a great piece of folly. Once the first storm at home is over—. I have a letter for your husband in my pocket.

NORA. Telling him everything?

KROGSTAD. In as lenient a manner as I possibly could.

NORA (*quickly*). He mustn't get the letter. Tear it up. I will find some means of getting money.

KROGSTAD. Excuse me, Mrs. Helmer, but I think I told you just how—

NORA. I am not speaking of what I owe you. Tell me what sum you are asking my husband for, and I will get the money.

KROGSTAD. I am not asking your husband for a penny.

NORA. What do you want, then?

KROGSTAD. I will tell you. I want to rehabilitate myself, Mrs. Helmer; I want to get on; and in that your husband must help me. For the last year and a half I have not had a hand in anything dishonourable, and all that time I have been struggling in most restricted circumstances. I was content to work my way up step by step. Now I am turned out, and I am not going to be satisfied with merely being taken into favour again. I want to get on, I tell you. I want to get into the Bank again, in a higher position. Your husband must make a place for me—

NORA. That he will never do!

KROGSTAD. He will; I know him; he dare not protest. And as soon as I am in there again with him, then you will see! Within a year I shall be the manager's right hand. It will be Nils Krogstad and not Torvald Helmer who manages the Bank.

NORA. That's a thing you will never see!

KROGSTAD. Do you mean that you will—?

NORA. I have courage enough for it now.

KROGSTAD. Oh, you can't frighten me. A fine, spoilt lady like you—

Nora. You will see, you will see.

Krogstad. Under the ice, perhaps? Down into the cold, coal-black water? And then, in the spring, to float up to the surface, all horrible and unrecognizable, with your hair fallen out—

Nora. You can't frighten me.

Krogstad. Nor you me. People don't do such things, Mrs. Helmer. Besides, what use would it be? I should have him completely in my power all the same.

Nora. Afterwards? When I am no longer—

Krogstad. Have you forgot that it is I who have the keeping of your reputation? (*Nora stands speechlessly looking at him*). Well, now, I have warned you. Do not do anything foolish. When Helmer has had my letter, I shall expect a message from him. And be sure you remember that it is your husband himself who has forced me into such ways as this again. I will never forgive him for that. Good-bye, Mrs. Helmer. (*Exit through the hall*).

Nora (*goes to the hall door, opens it slightly and listens*). He is going. He is not putting the letter in the box. Oh, no, no, that's impossible! (*Opens the door by degrees*). What is that? He is standing outside. He is not going downstairs. Is he hesitating? Can he—? (*A letter drops into the box; then* Krogstad's *footsteps are heard, till they die away as he goes downstairs.* Nora *utters a stifled cry, and runs across the room to the table by the sofa. A short pause*).

Nora. In the letter-box. (*Steals across to the hall-door*). There it lies—Torvald, Torvald, there is no hope for us now!

Mrs. Linde *comes in from the room on the left, carrying the dress.*

Mrs. Linde. There, I can't see anything more to mend now. Would you like to try it on—?

Nora (*in a hoarse whisper*). Christine, come here.

Mrs. Linde (*throwing the dress down on the sofa*). What is the matter with you? You look so agitated!

Nora. Come here. Do you see that letter? There, look—you can see it through the glass in the letter-box.

Mrs. Linde. Yes, I see it.

Nora. That letter is from Krogstad.

Mrs. Linde. Nora—it was Krogstad who lent you the money!

Nora. Yes, and now Torvald will know all about it.

Mrs. Linde. Believe me, Nora, that's the best thing for both of you.

Nora. You don't know all. I forged a name.

Mrs. Linde. Good heavens—!

Nora. I only want to say this to you, Christine—you must be my witness.

Mrs. Linde. Your witness! What do you mean? What am I to—?

Nora. If I should go out of my mind—and it might easily happen—

Mrs. Linde. Nora!

Nora. Or if anything else should happen to me—anything, for instance, that might prevent my being here—

Mrs. Linde. Nora! Nora! you are quite out of your mind.

Nora. And if it should happen that there were someone who wanted to take all the responsibility, all the blame, you understand—

Mrs. Linde. Yes, yes—but how can you suppose—?

Nora. Then you must be my witness, that it is not true, Christine. I am not out of my mind at all; I am in my right senses now, and I tell you no one else has known anything about it; I and I alone, did the whole thing. Remember that.

Mrs. Linde. I will, indeed. But I don't understand all this.

Nora. How should you understand it? A wonderful thing is going to happen.

Mrs. Linde. A wonderful thing?

Nora. Yes, a wonderful thing!—But it is so terrible, Christine; it *mustn't* happen, not for all the world.

Mrs. Linde. I will go at once and see Krogstad.

Nora. Don't go to him; he will do you some harm.

Mrs. Linde. There was a time when he would gladly do anything for my sake.

Nora. He?

Mrs. Linde. Where does he live?

NORA. How should I know—? Yes (*feeling in her pocket*) here is his card. But the letter, the letter—!

HELMER (*calls from his room, knocking at the door*). Nora.

NORA (*cries out anxiously*). Oh, what's that? What do you want?

HELMER. Don't be so frightened. We are not coming in; you have locked the door. Are you trying on your dress?

NORA. Yes, that's it. I look so nice, Torvald.

MRS. LINDE (*who has read the card*). I see he lives at the corner here.

NORA. Yes, but it's no use. It is hopeless. The letter is lying there in the box.

MRS. LINDE. And your husband keeps the key?

NORA. Yes, always.

MRS. LINDE. Krogstad must ask for his letter back unread, he must find some pretence—

NORA. But it is just at this time that Torvald generally—

MRS. LINDE. You must delay him. Go in to him in the meantime. I will come back as soon as I can. (*She goes out hurriedly through the hall door*).

NORA (*goes to* HELMER'S *door, opens it and peeps in*). Torvald!

HELMER (*from the inner room*). Well? May I venture at last to come into my own room again? Come along, Rank, now you will see—(*Halting in the doorway*). But what is this?

NORA. What is what, dear?

HELMER. Rank led me to expect a splendid transformation.

RANK (*in the doorway*). I understood so, but evidently I was mistaken.

NORA. Yes, nobody is to have the chance of admiring me in my dress until to-morrow.

HELMER. But, my dear Nora, you look so worn out. Have you been practising too much?

NORA. No, I have not practised at all.

HELMER. But you will need to—

NORA. Yes, indeed I shall, Torvald. But I can't get on a bit without you to help me; I have absolutely forgotten the whole thing.

HELMER. Oh, we will soon work it up again.

NORA. Yes, help me, Torvald. Promise that you will! I am so nervous about it—all the people—. You must give yourself up to me entirely this evening. Not the tiniest bit of business—you mustn't even take a pen in your hand. Will you promise, Torvald dear?

HELMER. I promise. This evening I will be wholly and absolutely at your service, you helpless little mortal. Ah, by the way, first of all I will just— (*Goes toward the hall-door*).

NORA. What are you going to do there?

HELMER. Only see if any letters have come.

NORA. No, no! don't do that, Torvald!

HELMER. Why not?

NORA. Torvald, please don't. There is nothing there.

HELMER. Well, let me look. (*Turns to go to the letter-box.* NORA, *at the piano, plays the first bars of the Tarantella.* HELMER *stops in the doorway*). Aha!

NORA. I can't dance to-morrow if I don't practise with you.

HELMER (*going up to her*). Are you really so afraid of it, dear?

NORA. Yes, so dreadfully afraid of it. Let me practise at once; there is time now, before we go to dinner. Sit down and play for me, Torvald dear; criticise me, and correct me as you play.

HELMER. With great pleasure, if you wish me to. (*Sits down at the piano*).

NORA (*takes out of the box a tambourine and a long variegated shawl. She hastily drapes the shawl round her. Then she springs to the front of the stage and calls out*). Now play for me! I am going to dance!

HELMER *plays and* NORA *dances.* RANK *stands by the piano behind* HELMER, *and looks on.*

HELMER (*as he plays*). Slower, slower!

NORA. I can't do it any other way.

HELMER. Not so violently, Nora!

NORA. This is the way.

HELMER (*stops playing*). No, no—that is not a bit right.

NORA (*laughing and swinging the tambourine*). Didn't I tell you so?

RANK. Let me play for her.

HELMER (*getting up*). Yes, do. I can correct her better then.

RANK *sits down at the piano and plays. Nora dances more and more wildly.* HELMER *has taken up a position beside the stove, and during her dance gives her frequent instructions. She does not seem to hear him; her hair comes down and falls over her shoulders; she pays no attention to it, but goes on dancing. Enter* MRS. LINDE.

MRS. LINDE (*standing as if spell-bound in the doorway*). Oh!—

NORA (*as she dances*). Such fun, Christine!

HELMER. My dear darling Nora, you are dancing as if your life depended on it.

NORA. So it does.

HELMER. Stop, Rank; this is sheer madness. Stop, I tell you. (RANK *stops playing, and,* NORA *suddenly stands still.* HELMER *goes up to her*). I could never have believed it. You have forgotten everything I taught you.

NORA (*throwing away the tambourine*). There, you see.

HELMER. You will want a lot of coaching.

NORA. Yes, you see how much I need it. You must coach me up to the last minute. Promise me that, Torvald!

HELMER. You can depend on me.

NORA. You must not think of anything but me, either to-day or to-morrow; you mustn't open a single letter—not even open the letter-box—

HELMER. Ah, you are still afraid of that fellow—

NORA. Yes, indeed I am.

HELMER. Nora, I can tell from your looks that there is a letter from him lying there.

NORA. I don't know; I think there is; but you must not read anything of that kind now. Nothing horrid must come between us till this is all over.

RANK (*whispers to* Helmer). You mustn't contradict her.

HELMER (*taking her in his arms*). The child shall have her way. But to-morrow night, after you have danced—

NORA. Then you will be free. (*The* MAID *appears in the doorway to the right*).

MAID. Dinner is served, ma'am.

NORA. We will have champagne, Helen.

MAID. Very good, ma'am.

HELMER. Hullo!—are we going to have a banquet?

Exit.

NORA. Yes, a champagne banquet till the small hours. (*Calls out*). And a few macaroons, Helen—lots, just for once!

HELMER. Come, come, don't be so wild and nervous. Be my own little skylark, as you used.

NORA. Yes, dear, I will. But go in now and you too, Doctor Rank. Christine, you must, help me to do up my hair.

RANK (*whispers to Helmer as they go out*). I suppose there is nothing—she is not expecting anything?

HELMER. Far from it, my dear fellow; it is simply nothing more than this childish nervousness I was telling you of. (*They go into the right-hand room*).

NORA. Well!

MRS. LINDE. Gone out of town.

NORA. I could tell from your face.

MRS. LINDE. He is coming home tomorrow evening. I wrote a note for him.

NORA. You should have let it alone; you must prevent nothing. After all, it is splendid to be waiting for a wonderful thing to happen.

MRS. LINDE. What is it that you are waiting for?

NORA. Oh, you wouldn't understand. Go in to them. I will come in a moment. (Mrs. Linde *goes into the dining-room. Nora stands still for a little while, as if to compose herself. Then she looks at her watch*). Five o'clock. Seven hours till midnight; and then four-and-twenty hours till the next midnight. Then the Tarantella will be over. Twenty-four and seven? Thirty-one hours to live.

HELMER (*from the doorway on the right*). Where's my little skylark?

NORA (*going to him with her arms out-stretched*). Here she is!

Act 3

The same Scene—The table has been placed in the middle of the stage, with chairs around it. A lamp is burning on the table. The door into the hall stands open. Dance music is heard in the room above. Mrs. LINDE is sitting at the table idly turning over the leaves of a book; she tries to read, but does not seem able to collect her thoughts. Every now and then she listens intently for a sound at the outer door.

MRS. LINDE (*looking at her watch*). Not yet—and the time is nearly up. If only he does not—. (*Listens again*). Ah, there he is. (*Goes into the hall and opens the outer door carefully. Light footsteps are heard on the stairs. She whispers*). Come in. There is no one here.

KROGSTAD (*in the doorway*). I found a note from you at home. What does this mean?

MRS. LINDE. It is absolutely necessary that I should have a talk with you.

KROGSTAD. Really? And is it absolutely necessary that it should be here?

MRS. LINDE. It is impossible where I live; there is no private entrance to my rooms. Come in; we are quite alone. The maid is asleep, and the Helmers are at the dance upstairs.

KROGSTAD (*coming into the room*). Are the Helmers really at a dance tonight?

MRS. LINDE. Yes, why not?

KROGSTAD. Certainly—why not?

MRS. LINDE. Now, Nils, let us have a talk.

KROGSTAD. Can we two have anything to talk about?

MRS. LINDE. We have a great deal to talk about.

KROGSTAD. I shouldn't have thought so.

MRS. LINDE. No, you have never properly understood me.

KROGSTAD. Was there anything else to understand except what was obvious to all the world—a heartless woman jilts a man when a more lucrative chance turns up.

MRS. LINDE. Do you believe I am as absolutely heartless as all that? And do you believe that I did it with a light heart?

KROGSTAD. Didn't you?

MRS. LINDE. Nils, did you really think that?

KROGSTAD. If it were as you say, why did you write to me as you did at the time?

MRS. LINDE. I could do nothing else. As I had to break with you, it was my duty also to put an end to all that you felt for me.

KROGSTAD (*wringing his hands*). So that was it. And all this—only for the sake of money.

MRS. LINDE. You must not forget that I had a helpless mother and two little brothers. We couldn't wait for you, Nils; your prospects seemed hopeless then.

KROGSTAD. That may be so, but you had no right to throw me over for any one else's sake.

MRS. LINDE. Indeed I don't know. Many a time did I ask myself if I had a right to do it.

KROGSTAD (*more gently*). When I lost you, it was as if all the solid ground went from under my feet. Look at me now—I am a shipwrecked man clinging to a bit of wreckage.

MRS. LINDE. But help may be near.

KROGSTAD. It *was* near; but then you came and stood in my way.

MRS. LINDE. Unintentionally, Nils. It was only today that I learnt it was your place I was going to take in the bank.

KROGSTAD. I believe you, if you say so. But now that you know it, are you not going to give it up to me?

MRS. LINDE. No, because that would not benefit you in the least.

KROGSTAD. Oh, benefit, benefit—I would have done it whether or no.

MRS. LINDE. I have learnt to act prudently. Life, and hard, bitter necessity have taught me that.

KROGSTAD. And life has taught me not to believe in fine speeches.

MRS. LINDE. Then life has taught you something very reasonable. But deeds you must believe in?

KROGSTAD. What do you mean by that?

MRS. LINDE. You said you were like a shipwrecked man clinging to some wreckage.

KROGSTAD. I had good reason to say so.

MRS. LINDE. Well, I am like a shipwrecked woman clinging to some wreckage—no one to mourn for, no one to care for.

KROGSTAD. It was your own choice.

MRS. LINDE. There was no other choice, then.

KROGSTAD. Well, what now?

MRS. LINDE. Nils, how would it be if we two shipwrecked people could join forces?

KROGSTAD. What are you saying?

MRS. LINDE. Two on the same piece of wreckage would stand a better chance than each on their own.

KROGSTAD. Christine!

MRS. LINDE. What do you suppose brought me to town?

KROGSTAD. Do you mean that you gave me a thought?

MRS. LINDE. I could not endure life without work. All my life, as long as I can remember, I have worked, and it has been my greatest and only pleasure. But now I am quite alone in the world—my life is so dreadfully empty and I feel so forsaken. There is not the least pleasure in working for one's self. Nils, give me someone and something to work for.

KROGSTAD. I don't trust that. It is nothing but a woman's overstrained sense of generosity that prompts you to make such an offer of your self.

MRS. LINDE. Have you ever noticed anything of the sort in me?

KROGSTAD. Could you really do it? Tell me—do you know all about my past life?

MRS. LINDE. Yes.

KROGSTAD. And do you know what they think of me here?

MRS. LINDE. You seemed to me to imply that with me you might have been quite another man.

KROGSTAD. I am certain of it.

MRS. LINDE. Is it too late now?

KROGSTAD. Christine, are you saying this deliberately? Yes, I am sure you are. I see it in your face. Have you really the courage, then—?

MRS. LINDE. I want to be a mother to someone, and your children need a mother. We two need each other. Nils, I have faith in your real character—I can dare anything together with you.

KROGSTAD (grasps her hands). Thanks, thanks, Christine! Now I shall find a way to clear myself in the eyes of the world. Ah, but I forgot—

MRS. LINDE (listening). Hush! The Tarantella! Go, go!

KROGSTAD. Why? What is it?

MRS. LINDE. Do you hear them up there? When that is over, we may expect them back.

KROGSTAD. Yes, yes—I will go. But it is all no use. Of course you are not aware what steps I have taken in the matter of the Helmers.

MRS. LINDE. Yes, I know all about that.

KROGSTAD. And in spite of that have you the courage to—?

MRS. LINDE. I understand very well to what lengths a man like you might be driven by despair.

KROGSTAD. If I could only undo what I have done!

MRS. LINDE. You cannot. Your letter is lying in the letter-box now.

KROGSTAD. Are you sure of that?

MRS. LINDE. Quite sure, but—

KROGSTAD (with a searching look at her). Is that what it all means?—that you want to save your friend at any cost? Tell me frankly. Is that it?

MRS. LINDE. Nils, a woman who has once sold herself for another's sake, doesn't do it a second time.

KROGSTAD. I will ask for my letter back.

MRS. LINDE. No, no.

KROGSTAD. Yes, of course I will. I will wait here till Helmer comes; I will tell him he must give me my letter back—that it only concerns my dismissal—that he is not to read it—

MRS. LINDE. No, Nils, you must not recall your letter.

KROGSTAD. But, tell me, wasn't it for that very purpose that you asked me to meet you here?

MRS. LINDE. In my first moment of fright, it was. But twenty-four hours have elapsed since then, and in that time I have witnessed incredible things in this house. Helmer must know all about it. This unhappy secret must be enclosed; they must have a complete understanding between them, which is impossible with all this concealment and falsehood going on.

KROGSTAD. Very well, if you will take the responsibility. But there is one thing I can do in any case, and I shall do it at once.

MRS. LINDE. (*listening*). You must be quick and go! The dance is over; we are not safe a moment longer.

KROGSTAD. I will wait for you below.

MRS. LINDE Yes, do. You must see me back to my door.

KROGSTAD. I have never had such an amazing piece of good fortune in my life! (*Goes out through the outer door. The door between the room and the hall remains open*).

MRS. LINDE (*tidying up the room and laying her hat and cloak ready*). What a difference! What a difference! Someone to work for and live for—a home to bring comfort into. That I will do, indeed. I wish they would be quick and come. (*Listens*). Ah, there they are now. I must put on my things. (*Takes up her hat and cloak.* HELMER's *and* NORA's *voices are heard outside; a key is turned, and* HELMER *brings* NORA *almost by force into the hall. She is in an Italian costume with a large black shawl round her; he is in evening dress, and a black domino which is flying open*).

NORA (*hanging back in the doorway, and struggling with him*). No, no, no!—don't take me in. I want to go upstairs again; I don't want to leave so early.

HELMER. But, my dearest Nora—

NORA. Please, Torvald dear—please, *please*—only an hour more.

HELMER. Not a single minute, my sweet Nora. You know that was our agreement. Come along into the room; you are catching cold standing there. (*He brings her gently into the room, in spite of her resistance*).

MRS. LINDE. Good evening.

NORA. Christine!

HELMER. You here, so late, Mrs. Linde?

MRS. LINDE. Yes, you must excuse me; I was so anxious to see Nora in her dress.

NORA. Have you been sitting here waiting for me?

MRS. LINDE. Yes, unfortunately I came too late, you had already gone upstairs; and I thought I couldn't go away again without having seen you.

HELMER (*taking off* NORA's *shawl*). Yes, take a good look at her. I think she is worth looking at. Isn't she charming, MRS. LINDE?

MRS. LINDE. Yes, indeed she is.

HELMER. Doesn't she look remarkably pretty? Everyone thought so at the dance. But she is terribly self-willed, this sweet little person. What are we to do with her? You will hardly believe that I had almost to bring her away by force.

NORA. Torvald, you will repent not having let me stay, even if it were only for half an hour.

HELMER. Listen to her, Mrs. Linde! She had danced her Tarantella, and it had been a tremendous success, as it deserved—although possibly the performance was a trifle too realistic—little more so, I mean, than was strictly compatible with the limitations of art. But never mind about that! The chief thing is, she had made a success—she had made a tremendous success. Do you think I was going to let her remain there after that, and spoil the effect? No, indeed! I took my charming little Capri maiden—my capricious little Capri maiden, I should say—on my arm; took one quick turn round the room; a curtsey on either side, and, as they say in novels, the beautiful apparition disappeared. An exit ought always to be effective, Mrs. Linde; but that is what I cannot make Nora understand. Pooh! this room is hot. (*Throws his domino on a chair, and opens the door of his room*). Hullo! it's all dark in here. Oh, of course—excuse me—. (*He goes in, and lights some candles*).

NORA (*in a hurried and breathless whisper*). Well?

MRS. LINDE (*in a low voice*). I have had a talk with him.

NORA. Yes, and—

MRS. LINDE. Nora, you must tell your husband all about it.

NORA (*in an expressionless voice*). I knew it.

MRS. LINDE. You have nothing to be afraid of as far as Krogstad is concerned; but you must tell him.

NORA. I won't tell him.

MRS. LINDE. Then the letter will.

NORA. Thank you, Christine. Now I know what I must do. Hush—!

HELMER (*coming in again*). Well, Mrs. Linde, have you admired her?

MRS. LINDE. Yes, and now I will say good-night.

HELMER. What, already? Is this yours, this knitting?

MRS. LINDE (*taking it*). Yes, thank you, I had very nearly forgotten it.

HELMER. So you knit?

MRS. LINDE. Of course.

HELMER. Do you know, you ought to embroider?

MRS. LINDE. Really? Why?

HELMER. Yes, it's far more becoming. Let me show you. You hold the embroidery thus in your left hand, and use the needle with the right—like this—with a long, easy sweep. Do you see?

MRS. LINDE. Yes, perhaps—

HELMER. But in the case of knitting—that can never be anything but ungraceful; look here—the arms close together, the knitting-needles going up and down—it has a sort of Chinese effect—. That was really excellent champagne they gave us.

MRS. LINDE. Well,—good-night, Nora, and don't be self-willed any more.

HELMER. That's right, Mrs. Linde.

MRS. LINDE. Good-night, Mr. Helmer.

HELMER (*accompanying her to the door*). Good-night, good-night. I hope you will get home all right. I should be very happy to—but you haven't any great distance to go. Good-night, good-night. (*She goes out; he shuts the door after her and comes in again*). Ah!—at last we have got rid of her. She is a frightful bore, that woman.

NORA. Aren't you very tired, Torvald?

HELMER. No, not in the least.

NORA. Nor sleepy?

HELMER. Not a bit. On the contrary, I feel extraordinarily lively. And you?—you really look both tired and sleepy.

NORA. Yes, I am very tired. I want to go to sleep at once.

HELMER. There, you see it was quite right of me not to let you stay there any longer.

NORA. Everything you do is quite right, Torvald.

HELMER (*kissing her on the forehead*). Now my little skylark is speaking reasonably. Did you notice what good spirits Rank was in this evening?

NORA. Really? Was he? I didn't speak to him at all.

HELMER. And I very little, but I have not for a long time seen him in such good form. (*Looks for a while at her and then goes nearer to her*). It is delightful to be at home by ourselves again, to be all alone with you—you fascinating, charming little darling!

NORA. Don't look at me like that, Torvald.

HELMER. Why shouldn't I look at my dearest treasure?—at all the beauty that is mine, all my very own?

NORA (*going to the other side of the table*). You mustn't say things like that to me tonight.

HELMER (*following her*). You have still got the Tarantella in your blood, I see. And it makes you more captivating than ever. Listen—the guests are beginning to go now. (*In a lower voice*). Nora—soon the whole house will be quiet.

NORA. Yes, I hope so.

HELMER. Yes, my own darling Nora. Do you know, when I am out at a party with you like this, why I speak so little to you, keep away from you, and only send a stolen glance in your direction now and then?—do you know why I do that? It is because I make believe to myself that we are secretly in love, and you are my secretly promised bride, and that no one suspects there is anything between us.

NORA. Yes, yes—I know very well your thoughts are with me all the time.

HELMER. And when we are leaving, and I am putting the shawl over your beautiful young shoulders—on your lovely neck—then I imagine that you are my young bride and that we have just come from the wedding, and I am bringing you for the first time into our home—to be alone with you for the first time—quite alone with my shy little darling! All this evening I have longed for nothing but you. When I watched the seductive figures of the Tarantella, my blood was on fire; I could endure it no longer, and that was why I brought you down so early—

NORA. Go away, Torvald! You must let me go. I won't—

HELMER. What's that? You're joking, my little Nora! You won't—you won't? Am I not your husband—? (*A knock is heard at the outer door*).

NORA (*starting*). Did you hear—?

HELMER (*going into the hall*). Who is it?

RANK (*outside*). It is I. May I come in for a moment?

HELMER (*in a fretful whisper*). Oh, what does he want now? (*Aloud*). Wait a minute? (*Unlocks the door*). Come, that's kind of you not to pass by our door.

RANK. I thought I heard your voice, and felt as if I should like to look in. (*With a swift glance round*). Ah, yes!—these dear familiar rooms. You are very happy and cosy in here, you two.

HELMER. It seems to me that you looked after yourself pretty well upstairs too.

RANK. Excellently. Why shouldn't I? Why shouldn't one enjoy everything in this world?—at any rate as much as one can, and as long as one can. The wine was capital—

HELMER. Especially the champagne.

RANK. So you noticed that too? It is almost incredible how much I managed to put away!

NORA. Torvald drank a great deal of champagne tonight, too.

RANK. Did he?

NORA. Yes, and he is always in such good spirits afterwards.

RANK. Well, why should one not enjoy a merry evening after a well-spent day?

HELMER. Well spent? I am afraid I can't take credit for that.

RANK (*clapping him on the back*). But I can, you know!

NORA. Doctor Rank, you must have been occupied with some scientific investigation today.

RANK. Exactly.

HELMER. Just listen!—little Nora talking about scientific investigations!

NORA. And may I congratulate you on the result?

RANK. Indeed you may.

NORA. Was it favourable, then.

RANK. The best possible, for both doctor and patient—certainty.

NORA (*quickly and searchingly*). Certainty?

RANK. Absolute certainty. So wasn't I entitled to make a merry evening of it after that?

NORA. Yes, you certainly were, Doctor Rank.

HELMER. I think so too, so long as you don't have to pay for it in the morning.

RANK. Oh well, one can't have anything in this life without paying for it.

NORA. Doctor Rank—are you fond of fancy-dress balls?

RANK. Yes, if there is a fine lot of pretty costumes.

NORA. Tell me—what shall we two wear at the next?

HELMER. Little featherbrain!—are you thinking of the next already?

RANK. We two? Yes, I can tell you. You shall go as a good fairy—

HELMER. Yes, but what do you suggest as an appropriate costume for that?

RANK. Let your wife go dressed just as she is in every-day life.

HELMER. That was really very prettily turned. But can't you tell us what you will be?

RANK. Yes, my dear friend, I have quite made up my mind about that.

HELMER. Well?

RANK. At the next fancy-dress ball I shall be invisible.

HELMER. That's a good joke!

RANK. There is a big black hat—have you never heard of hats that make you invisible? If you put one on, no one can see you.

HELMER (*suppressing a smile*). Yes, you are quite right.

RANK. But I am clean forgetting what I came for. Helmer, give me a cigar—one of the dark Havanas.

HELMER. With the greatest pleasure. (*Offers him his case*).

RANK (*takes a cigar and cuts off the end*). Thanks.

NORA (*striking a match*). Let me give you a light.

RANK. Thank you. (*She holds the match for him to light his cigar*). And now good-bye!

HELMER. Good-bye, good-bye, dear old man!

NORA. Sleep well, Doctor Rank.

RANK. Thank you for that wish.

NORA. Wish me the same.

RANK. You? Well, if you want me to sleep well! And thanks for the light. (*He nods to them both and goes out*).

HELMER (*in a subdued voice*). He has drunk more than he ought.

NORA (*absently*). Maybe. (HELMER *takes a bunch of keys out of his pocket and goes into the hall*). Torvald! what are you going to do there?

HELMER. Empty the letter-box; it is quite full; there will be no room to put the newspaper in to-morrow morning.

NORA. Are you going to work to-night?

HELMER. You know quite well I'm not. What is this? Some one has been at the lock.

NORA. At the lock?

HELMER. Yes, someone has. What can it mean? I should never have thought the maid—. Here is a broken hairpin. Nora, it is one of yours.

NORA (*quickly*). Then it must have been the children—

HELMER. Then you must get them out of those ways. There, at last I have got it open. (*Takes out the contents of the letter-box, and calls to the kitchen*). Helen!—Helen, put out the light over the front door. (*Goes back into the room and shuts the door into the hall. He holds out his hand full of letters*). Look at that—look what a heap of them there are. (*Turning them over*). What on earth is that?

NORA (*at the window*). The letter—No! Torvald, no!

HELMER. Two cards—of Rank's.

NORA. Of Doctor Rank's?

HELMER (*looking at them*). Doctor Rank. They were on the top. He must have put them in when he went out.

NORA. Is there anything written on them?

HELMER. There is a black cross over the name. Look there—what an uncomfortable idea! It looks as if he were announcing his own death.

NORA. It is just what he is doing.

HELMER. What? Do you know anything about it? Has he said anything to you?

NORA. Yes. He told me that when the cards came it would be his leave-taking from us. He means to shut himself up and die.

HELMER. My poor old friend. Certainly I knew we should not have him very long with us. But so soon! And so he hides himself away like a wounded animal.

NORA. If it has to happen, it is best it should be without a word—don't you think so, Torvald?

HELMER (*walking up and down*). He has so grown into our lives. I can't think of him as having gone out of them. He, with his sufferings and his loneliness, was like a cloudy background to our sunlit happiness. Well, perhaps it is best so. For him, anyway. (*Standing still*). And perhaps for us too, Nora. We two are thrown quite upon each other now. (*Puts his arms around her*). My darling wife, I don't feel as if I could hold you tight enough. Do you know, Nora, I have often wished that you might be threatened by some great danger, so that I might risk my life's blood, and everything, for your sake.

NORA (*disengages herself, and says firmly and decidedly*). Now you must read your letters, Torvald.

HELMER. No, no; not tonight. I want to be with you, my darling wife.

NORA. With the thought of your friend's death—

HELMER. You are right, it has affected us both. Something ugly has come between us—the thought of the horrors of death. We must try and rid our minds of that. Until then—we will each go to our own room.

NORA (*hanging on his neck*). Good-night, Torvald—Good-night!

HELMER (*kissing her on the forehead*). Good-night, my little singing-bird. Sleep sound, Nora. Now I will read my letters through. (*He takes his letters and goes into his room, shutting the door after him*).

NORA (*gropes distractedly about, seizes* HELMER's *domino, throws it round her, while she says in quick, hoarse, spasmodic whispers*). Never to see him again. Never! Never! (*Puts her shawl over her head*). Never to see my children again either—never again. Never! Never!—Ah! the icy, black water—the unfathomable depths—If only it were over! He has got it now—now he is reading it. Good-bye, Torvald and my children! (*She is about to rush out through the hall, when* HELMER *opens his door hurriedly and stands with an open letter in his hand*).

HELMER. Nora!

NORA. Ah!—

HELMER. What is this? Do you know what is in this letter?

NORA. Yes, I know. Let me go! Let me get out!

HELMER (*holding her back*). Where are you going?

NORA (*trying to get free*). You shan't save me, Torvald!

HELMER (*reeling*). True? Is this true, that I read here? Horrible! No, no—it is impossible that it can be true.

NORA. It is true. I have loved you above everything else in the world.

HELMER. Oh, don't let us have any silly excuses.

NORA (*taking a step towards him*). Torvald—!

HELMER. Miserable creature—what have you done?

NORA. Let me go. You shall not suffer for my sake. You shall not take it upon yourself.

HELMER. No tragedy airs, please. (*Locks the hall door*). Here you shall stay and give me an explanation. Do you understand what you have done? Answer me? Do you understand what you have done?

NORA (*looks steadily at him and says with a growing look of coldness in her face*). Yes, now I am beginning to understand thoroughly.

HELMER (*walking about the room*). What a horrible awakening! All these eight years—she who was my joy and pride—a hypocrite, a liar—worse, worse—a criminal! The unutterable ugliness of it all!—For shame! For shame! (NORA *is silent and looks steadily at him. He stops in front of her*). I ought to have suspected that something of the sort would happen. I ought to have foreseen it. All your father's want of principle—be silent!—all your father's want of principle has come out in you. No religion, no morality, no sense of duty— How I am punished for having winked at what he did! I did it for your sake, and this is how you repay me.

NORA. Yes, that's just it.

HELMER. Now you have destroyed all my happiness. You have ruined all my future. It is horrible to think of! I am in the power of an unscrupulous man; he can do what he likes with me, ask anything he likes of me, give me any orders he pleases—I dare not refuse. And I must sink to such miserable depths because of a thoughtless woman!

NORA. When I am out of the way, you will be free.

HELMER. No fine speeches, please. Your father had always plenty of those ready, too. What good would it be to me if you were out of the way, as you say? Not the slightest. He can make the affair known everywhere; and if he does, I may be falsely suspected of having been a party to your criminal action. Very likely people will think I was behind it all—that it was I who prompted you! And I have to thank you for all this—you whom I have cherished during the whole of our married life. Do you understand now what it is you have done for me?

NORA (*coldly and quietly*). Yes.

HELMER. It is so incredible that I can't take it in. But we must come to some understanding. Take off that shawl. Take it off, I tell you. I must try and appease him some way or another. The matter must be hushed up at any cost. And as for you and me, it must appear as if everything between us were as before—but naturally only in the eyes of the world. You will still remain in my house, that is a matter of course. But I shall not allow you to bring up the children; I dare not trust them to you. To think that I should be obliged to say so to one whom I have loved so dearly, and whom I still—. No, that is all over. From this moment happiness is not the question; all that concerns us is to save the remains, the fragments, the appearance—

A ring is heard at the front-door bell.

HELMER (*with a start*). What is that? So late! Can the worst—? Can he—? Hide yourself, Nora. Say you are ill.

NORA *stands motionless.* Helmer *goes and unlocks the hall door.*

MAID (*half-dressed, comes to the door*). A letter for the mistress.

HELMER. Give it to me. (*Takes the letter, and shuts the door*). Yes, it is from him. You shall not have it; I will read it myself.

NORA. Yes, read it.

HELMER (*standing by the lamp*). I scarcely have the courage to do it. It may mean ruin for both of us. No, I must know. (*Tears open the letter, runs his eye over a few lines, looks at a paper enclosed, and gives a shout of joy*). Nora! (*She looks at him, questioningly*). Nora! No, I must read it once again—. Yes, it is true! I am saved! Nora, I am saved!

NORA. And I?

HELMER. You too, of course; we are both saved, both saved, both you and I. Look, he sends you your bond back. He says he regrets and repents—that a happy change in his life—never mind what he says! We are saved, Nora! No one can do anything to you. Oh, Nora, Nora!—no, first I must destroy these hateful things. Let me see—. (*Takes a look at the bond*). No, no, I won't look at it. The whole thing shall be nothing but a bad dream to me. (*Tears up the bond and both letters, throws them all into the stove, and watches them burn*). There—now it doesn't exist any longer. He says that since Christmas Eve you—. These must have been three dreadful days for you, Nora.

NORA. I have fought a hard fight these three days.

HELMER. And suffered agonies, and seen no way out but—. No, we won't call any of the horrors to mind. We will only shout with joy, and keep saying, "It's all over! It's all over!" Listen to me, Nora. You don't seem to realise that it is all over. What is this?—such a cold, set face! My poor little Nora, I quite understand; you don't feel as if you could believe that I have forgiven you. But it is true, Nora, I swear it; I have forgiven you everything. I know that what you did, you did out of love for me.

NORA. That is true.

HELMER. You have loved me as a wife ought to love her husband. Only you had not sufficient knowledge to judge of the means you used. But do you suppose you are any the less dear to me, because you don't understand how to act on your own responsibility? No, no; only lean on me; I will advise you and direct you. I should not be a man if this womanly helplessness did not just give you a double attractiveness in my eyes. You must not think any more about the hard things I said in my first moment of consternation, when I thought everything was going to overwhelm me. I have forgiven you, Nora; I swear to you I have forgiven you.

NORA. Thank you for your forgiveness. (*She goes out through the door to the right*).

HELMER. No, don't go—. (*Looks in*). What are you doing in there?

NORA (*from within*). Taking off my fancy dress.

HELMER (*standing at the open door*). Yes, do. Try and calm yourself, and make your mind easy again, my frightened little singing-bird. Be at rest, and feel secure; I have broad wings to shelter you under. (*Walks up and down by the door*). How warm and cosy our home is, Nora. Here is shelter for you; here I will protect you like a hunted dove that I have saved from a hawk's claws; I will bring peace to your poor beating heart. It will come, little by little, Nora, believe me. To-morrow morning you will look upon it all quite differently; soon everything will be just as it was before. Very soon you won't need me to assure you that I have forgiven you; you will yourself feel the certainty that I have done so. Can you suppose I should ever think of such a thing as repudiating you, or even reproaching you? You have no idea what a true man's heart is like, Nora. There is something so indescribably sweet and satisfying, to a man, in the knowledge that he has forgiven his wife—forgiven her freely, and with all his heart. It seems as if that had made her, as it were, doubly his own; he has given her a new life, so to speak; and she is in a way become both wife and child to him. So you shall be for me after this, my little scared, helpless darling. Have no anxiety about anything, Nora; only be frank and open with me, and I will serve as will and conscience both to you—. What is this? Not gone to bed? Have you changed your things?

NORA (*in everyday dress*). Yes, Torvald, I have changed my things now.

HELMER. But what for?—so late as this.

NORA. I shall not sleep tonight.

HELMER. But, my dear Nora—

NORA (*looking at her watch*). It is not so very late. Sit down here, Torvald. You and I have much to say to one another. (*She sits down at one side of the table*).

HELMER. Nora—what is this?—this cold, set face?

NORA. Sit down. It will take some time; I have a lot to talk over with you.

HELMER (*sits down at the opposite side of the table*). You alarm me, Nora!—and I don't understand you.

NORA. No, that is just it. You don't understand me, and I have never understood you either—before tonight. No, you mustn't interrupt me. You must simply listen to what I say. Torvald, this is a settling of accounts.

HELMER. What do you mean by that?

NORA (*after a short silence*). Isn't there one thing that strikes you as strange in our sitting here like this?

HELMER. What is that?

NORA. We have been married now eight years. Does it not occur to you that this is the first time we two, you and I, husband and wife, have had a serious conversation?

HELMER. What do you mean by serious?

NORA. In all these eight years—longer than that—from the very beginning of our acquaintance, we have never exchanged a word on any serious subject.

HELMER. Was it likely that I would be continually and forever telling you about worries that you could not help me to bear?

NORA. I am not speaking about business matters. I say that we have never sat down in earnest together to try and get at the bottom of anything.

HELMER. But, dearest Nora, would it have been any good to you?

NORA. That is just it; you have never understood me. I have been greatly wronged, Torvald—first by papa and then by you.

HELMER. What! By us two—by us two, who have loved you better than anyone else in the world?

NORA (*shaking her head*). You have never loved me. You have only thought it pleasant to be in love with me.

HELMER. Nora, what do I hear you saying?

NORA. It is perfectly true, Torvald. When I was at home with papa, he told me his opinion about everything, and so I had the same opinions; and if I differed from him I concealed the fact, because he would not have liked it. He called me his doll-child, and he played with me just as I used to play with my dolls. And when I came to live with you—

HELMER. What sort of an expression is that to use about our marriage?

NORA (*undisturbed*). I mean that I was simply transferred from papa's hands into yours. You arranged everything according to your own taste, and so I got the same tastes as you—or else I pretended to, I am really not quite sure which—I think sometimes the one and sometimes the other. When I look back on it, it seems to me as if I had been living here like a poor woman—just from hand to mouth. I have existed merely to perform tricks for you, Torvald. But you would have it so. You and papa have committed a great sin against me. It is your fault that I have made nothing of my life.

HELMER. How unreasonable and how ungrateful you are, Nora! Have you not been happy here?

NORA. No, I have never been happy. I thought I was, but it has never really been so.

HELMER. Not—not happy!

NORA. No, only merry. And you have always been so kind to me. But our home has been nothing but a playroom. I have been your doll-wife, just as at home I was papa's doll-child; and here the children have been my dolls. I thought it great fun when you played with me, just as they thought it great fun when I played with them. That is what our marriage has been, Torvald.

HELMER. There is some truth in what you say—exaggerated and strained as your view of it is. But for the future it shall be different. Playtime shall be over, and lesson-time shall begin.

NORA. Whose lessons? Mine, or the children's?

HELMER. Both yours and the children's, my darling Nora.

NORA. Alas, Torvald, you are not the man to educate me into being a proper wife for you.

HELMER. And you can say that!

NORA. And I—how am I fitted to bring up the children?

HELMER. Nora!

NORA. Didn't you say so yourself a little while ago—that you dare not trust me to bring them up?

HELMER. In a moment of anger! Why do you pay any heed to that?

NORA. Indeed, you were perfectly right. I am not fit for the task. There is another task I must undertake first. I must try and educate myself—you are not the man to help me in that. I must do that for myself. And that is why I am going to leave you now.

HELMER (*springing up*). What do you say?

NORA. I must stand quite alone, if I am to understand myself and everything about me. It is for that reason that I cannot remain with you any longer.

HELMER. Nora, Nora!

Nora. I am going away from here now, at once. I am sure Christine will take me in for the night—

Helmer. You are out of your mind! I won't allow it! I forbid you!

Nora. It is no use forbidding me anything any longer. I will take with me what belongs to myself. I will take nothing from you, either now or later.

Helmer. What sort of madness is this!

Nora. Tomorrow I shall go home—I mean to my old home. It will be easiest for me to find something to do there.

Helmer. You blind, foolish woman!

Nora. I must try and get some sense, Torvald.

Helmer. To desert your home, your husband and your children! And you don't consider what people will say!

Nora. I cannot consider that at all. I only know that it is necessary for me.

Helmer. It's shocking. This is how you would neglect your most sacred duties.

Nora. What do you consider my most sacred duties?

Helmer. Do I need to tell you that? Are they not your duties to your husband and your children?

Nora. I have other duties just as sacred.

Helmer. That you have not. What duties could those be?

Nora. Duties to myself.

Helmer. Before all else, you are a wife and mother.

Nora. I don't believe that any longer. I believe that before all else I am a reasonable human being, just as you are—or, at all events, that I must try and become one. I know quite well, Torvald, that most people would think you right, and that views of that kind are to be found in books; but I can no longer content myself with what most people say, or with what is found in books. I must think over things for myself and get to understand them.

Helmer. Can you not understand your place in your own home? Have you not a reliable guide in such matters as that?—have you no religion?

Nora. I am afraid, Torvald, I do not exactly know what religion is.

Helmer. What are you saying?

Nora. I know nothing but what the clergyman said, when I went to be confirmed. He told us that religion was this, and that, and the other. When I am away from all this, and am alone, I will look into that matter too. I will see if what the clergyman said is true, or at all events if it is true for me.

Helmer. This is unheard of in a girl of your age! But if religion cannot lead you aright, let me try and awaken your conscience. I suppose you have some moral sense? Or—answer me—am I to think you have none?

Nora. I assure you, Torvald, that is not an easy question to answer. I really don't know. The thing perplexes me altogether. I only know that you and I look at it in quite a different light. I am learning, too, that the law is quite another thing from what I supposed; but I find it impossible to convince myself that the law is right. According to it a woman has no right to spare her old dying father, or to save her husband's life. I can't believe that.

Helmer. You talk like a child. You don't understand the conditions of the world in which you live.

Nora. No, I don't. But now I am going to try. I am going to see if I can make out who is right, the world or I.

Helmer. You are ill, Nora; you are delirious; I almost think you are out of your mind.

Nora. I have never felt my mind so clear and certain as to-night.

Helmer. And is it with a clear and certain mind that you forsake your husband and your children?

Nora. Yes, it is.

Helmer. Then there is only one possible explanation.

Nora. What is that?

Helmer. You do not love me any more.

Nora. No, that is just it.

Helmer. Nora!—and you can say that?

Nora. It gives me great pain, Torvald, for you have always been so kind to me, but I cannot help it. I do not love you any more.

Helmer (*regaining his composure*). Is that a clear and certain conviction too?

Nora. Yes, absolutely clear and certain. That is the reason why I will not stay here any longer.

HELMER. And can you tell me what I have done to forfeit your love?

NORA. Yes, indeed I can. It was to-night, when the wonderful thing did not happen; then I saw you were not the man I had thought you.

HELMER. Explain yourself better—I don't understand you.

NORA. I have waited so patiently for eight years; for, goodness knows, I knew very well that wonderful things don't happen every day. Then this horrible misfortune came upon me; and then I felt quite certain that the wonderful thing was going to happen at last. When Krogstad's letter was lying out there, never for a moment did I imagine that you would consent to accept this man's conditions. I was so absolutely certain that you would say to him: Publish the thing to the whole world. And when that was done—

HELMER. Yes, what then?—when I had exposed my wife to shame and disgrace?

NORA. When that was done, I was so absolutely certain, you would come forward and take everything upon yourself, and say: I am the guilty one.

HELMER. Nora—!

NORA. You mean that I would never have accepted such a sacrifice on your part? No, of course not. But what would my assurances have been worth against yours? That was the wonderful thing which I hoped for and feared; and it was to prevent that, that I wanted to kill myself.

HELMER. I would gladly work night and day for you, Nora—bear sorrow and want for your sake. But no man would sacrifice his honour for the one he loves.

NORA. It is a thing hundreds of thousands of women have done.

HELMER. Oh, you think and talk like a heedless child.

NORA. Maybe. But you neither think nor talk like the man I could bind myself to. As soon as your fear was over—and it was not fear for what threatened me, but for what might happen to you—when the whole thing was past, as far as you were concerned it was exactly as if nothing at all had happened. Exactly as before, I was your little skylark, your doll, which you would in future treat with doubly gentle care, because it was so brittle and fragile. (*Getting up*). Torvald—it was then it dawned upon me that for eight years I had been living here with a strange man, and had borne him three children—. Oh! I can't bear to think of it! I could tear myself into little bits!

HELMER (*sadly*). I see, I see. An abyss has opened between us—there is no denying it. But, Nora, would it not be possible to fill it up?

NORA. As I am now, I am no wife for you.

HELMER. I have it in me to become a different man.

NORA. Perhaps—if your doll is taken away from you.

HELMER. But to part!—to part from you! No, no, Nora, I can't understand that idea.

NORA (*going out to the right*). That makes it all the more certain that it must be done. (*She comes back with her cloak and hat and a small bag which she puts on a chair by the table*).

HELMER. Nora, Nora, not now! Wait till tomorrow.

NORA (*putting on her cloak*). I cannot spend the night in a strange man's room.

HELMER. But can't we live here like brother and sister—?

NORA (*putting on her hat*). You know very well that would not last long. (*Puts the shawl round her*). Good-bye, Torvald. I won't see the little ones. I now they are in better hands than mine. As I am now, I can be of no use to them.

HELMER. But some day, Nora—some day?

NORA. How can I tell? I have no idea what is going to become of me.

HELMER. But you are my wife, whatever becomes of you.

NORA. Listen, Torvald. I have heard that when a wife deserts her husband's house, as I am doing now, he is legally freed from all obligations towards her. In any case I set you free from all your obligations. You are not to feel yourself bound in the slightest way, any more than I shall. There must be perfect freedom on both sides. See, here is your ring back. Give me mine.

HELMER. That too?

NORA. That too.

HELMER. Here it is.

NORA. That's right. Now it is all over. I have put the keys here. The maids know all about everything in the house—better than I do. Tomorrow, after I have left her, Christine will come here and pack up my own things that I brought with me from home. I will have them sent after me.

HELMER. All over! All over!—Nora, shall you never think of me again?

NORA. I know I shall often think of you and the children and this house.

HELMER. May I write to you, Nora?

NORA. No—never. You must not do that.

HELMER. But at least let me send you—

NORA. Nothing—nothing—

HELMER. Let me help you if you are in want.

NORA. No. I can receive nothing from a stranger.

HELMER. Nora—can I never be anything more than a stranger to you?

NORA (*taking her bag*). Ah, Torvald, the most wonderful thing of all would have to happen.

HELMER. Tell me what that would be!

NORA. Both you and I would have to be so changed that—. Oh, Torvald, I don't believe any longer in wonderful things happening.

HELMER. But I will believe in it. Tell me? So changed that—?

NORA. That our life together would be a real wedlock. Good-bye. (*She goes out through the hall*).

HELMER (*sinks down on a chair at the door and buries his face in his hands*). Nora! Nora! (*Looks round, and rises*). Empty. She is gone. (*A hope flashes across his mind*). The most wonderful thing of all—?

The sound of a door shutting is heard from below.

The Importance of Being Earnest

Introduction by Rusty Tennant

Oscar Wilde: More Than Just an Icon

Few playwrights (save perhaps Shakespeare and Moliere) have cemented themselves as icons of literature as strongly as Oscar Wilde. Though we will focus mainly on his contributions to the world of theatre, his work outside the theatre was equally as prolific. A playwright (*The Importance of Being Ernest, An Ideal Husband, Lady Windermere's Fan*), poet (*The Ballad of Reading Gaol*), journalist (*The Portrait of Mr. W.H.*), and novelist (*The Picture of Dorian Gray*), perhaps his greatest accomplishments reside in the arena of social change. A champion of aestheticism, Wilde and his fellow members of the movement emphasized aesthetic values over moral or social themes in their art. An offshoot of the French symbolist movement, the demise of aestheticism coincides directly with Wilde's own passing.

In *The Importance of Being Earnest, a Trivial Comedy for Serious People*, Wilde draws from the great comedies of ancient Greece and Rome. The deception in which both Jack and Algernon partake is grounded in the age-old devise of mistaken identity. Whether in the works of Plautus and Shakespeare (*The Twin Menechemii, The Comedy of Errors*), or in the television show *Three's Company*, mistaken identity and the confusion it can create have long delighted audiences. Both Algernon and Ernest engage in deception more as a sport than any real means to an end, and by the end of the play offer little, if any, retribution or remorse for their actions, illustrating aestheticism's tendency to portray the more enjoyable, pleasing qualities of storytelling without delving too far into its moral messages.

Because of Wilde's stance on Greek pederasty and his blatant and candid (for its time) discussion of his love interest Lord Alfred Douglas, Wilde and his plays are often labeled as "gay theatre." Indeed, to even speak the name Oscar Wilde conjures images of flamboyant Victorian garb, elegantly romantic discourse, and bacchanal feasts with scantily dressed young men frolicking about reading the great works of Byron and Keats. However, his work should not be limited to this, and only this, classification. Indeed his work may be a predecessor to the great works of Tony Kushner, Terrence McNally, Paul Rudnick, Moises Kauffman, and Richard Greenburg, but certainly his work avoids the head-to-head conversation on the topic of homosexuality that we have become accustomed to from the more recent authors. Perhaps this is because Wilde, himself, was imprisoned for a crime known as gross indecency. In essence, gross indecency was a charge handed down to people who openly or privately engaged in homosexual activity.

When, during the course of his trial, he was asked to explain his use of the phrase "the love that dare not speak its name," Wilde replied. . .

"The love that dare not speak its name" in this century is such a great affection of an elder for a younger man as there was between David and Jonathan, such as Plato made the very basis of his philosophy, and such as you find in the sonnets of Michelangelo and Shakespeare. It is that deep spiritual affection that is as pure as it is perfect. It dictates and pervades great works of art, like those of Shakespeare and Michelangelo, and those two letters of mine, such as they are. It is in this century misunderstood, so much misunderstood that it may be described as "the love that dare not speak its name," and on that account of it I am placed where I am now. It is beautiful, it is fine, it is the noblest form of affection. There is nothing unnatural about it. It is intellectual, and it repeatedly exists between an older and a younger man, when the older man has intellect,

and the younger man has all the joy, hope and glamour of life before him. That it should be so, the world does not understand. The world mocks at it, and sometimes puts one in the pillory for it.

In his day, Wilde was loved and scorned in the same breath. His plays were enormous successes as literature and well loved by live audiences. It was certain his reputation as the leading playwright of his time would pack the theatre on the opening night of *The Importance of Being Earnest*. This was such a certainty that his arch enemy, The Marquess of Queensberry (the father of his love interest, Lord Alfred Douglas), out of spite for Wilde's pursuit of his son's love, planned to ambush the opening night's curtain call by throwing a bouquet of spoiled vegetables and flowers onto the stage. Wilde caught wind of the plot and had the Marquess banned from entering the building.

The battle with Queensbury had only just begun, however. Soon after, Queensbury left a calling card at one of Wilde's clubs publicly proclaiming Wilde a sodomite. Upon Douglas's urging, Wilde brought charges of libel upon the Marquess. This resulted in a media circus that erupted with information about Wilde's personal life and ultimately led to charges of gross indecency being levied against the playwright. A total of three trials finally resulted in Wilde being found guilty with the maximum punishment of two years hard labor levied against him. His time in prison virtually destroyed the aesthete the world had come to know. While Wilde was in prison he wrote a letter to his former lover, Lord Alfred Douglas. The letter was later published under the name *Das Profundis*. Douglas had visited Wilde while in prison and commented that "when you are not on your pedestal, you are not interesting." Wilde's letter replied to this with a very "un-aesthetic" response: ". . . I wanted to eat of the fruit of all the trees in the garden of the world . . . And so, indeed, I went out, and so I lived. My only mistake was that I confined myself so exclusively to the trees of what seemed to me the sun-lit side of the garden, and shunned the other side for its shadow and its gloom."

Oscar Wilde lived to the fullest extent of life. His passion for the joys of life and the aesthetic lifestyle dominate the image that we are left with. An ironic icon of the Victorian era whose rigid confines he vehemently opposed, Wilde lived beyond the means of his society, pushing the envelope with his literature and his persona. Wilde famously said, "Anyone who lives within their means suffers from a serious lack of imagination." He has been the topic of numerous books, films, and plays. Most recently he was depicted in Tom Stoppard's *The Invention of Love* as the hedonistic aesthete we have all come to stereotype him as. However, in Moises Kaufman's *Gross Indecency: The Three Trials of Oscar Wilde*, we see a much more human Wilde driven by human emotion and complexity. His struggle against authority is one we have all felt at one time or another in our lives. His desire to be himself, good, bad and ugly, against any and all odds survives today as a heroic story in spite of its historical context. Perhaps Lord Darlington of *Lady Windermere's Fan* encapsulates his author and his philosophies best in the line, "We are all in the gutter, but some of us are looking at the stars."

The Importance of Being Earnest

Quite possibly the high point of Wilde's career came with the opening of *The Importance of Being Earnest*. Ironically, because of Queensbury's plot to ruin the opening-night festivities, it nearly became the worst night of his life. Luckily, however, Wilde was able to intervene with Queensbury's plans, and the opening night of Wilde's newest and greatest play was a smash hit on London's West End.

Wilde's tale centers around the homophones *earnest*, meaning "truthful," and *Ernest*, a fairly common Anglo name, which serve as the centerpiece of the confusion that is the true delight of this script; there is notably little of the former and considerably more of the latter in Wilde's script. The play opens in the city of London where two good friends, Algernon and Ernest, are sitting in a Victorian vista discussing Ernest's intended proposal to Algernon's cousin, Gwendolyn. Algernon refuses to allow this unless Ernest explains the inscription on a cigarette case that bears the name "Jack." Ernest is forced to reveal his

secret and informs Algernon of a double life he leads between the city and the country; in the city he goes by Ernest, in the country, Jack. Algernon reveals his own similar deceptions, going by the name of Bunbury, and agrees to the proposal.

Enter Lady Bracknell, perhaps Wilde's most vibrant creation, along with her daughter Gwendolyn. Bracknell is a glorious concoction of the finest of theatrical spirits; part Shakespeare, part Moliere, a bawd of the brashest sort, Bracknell serves as a sturdy root from which Wilde's satire blossoms. Her line, "A handbag?" has been credited as the most widely interpreted line in the entire English canon. It's hard to say when the practice of cross-gender casting became a relevant interpretation of the role, but it is worth noting that actors of both genders have delivered noteworthy performances of Lady Bracknell.

Along with Bracknell comes her daughter, the play's ingénue, Gwendolyn. The ladies invite Algernon to dinner, but Algernon contrives an excuse about having to visit his cousin, Bunbury, in the country. Algernon distracts Bracknell in order to allow Ernest to propose. Gwendolyn accepts his proposal but admits she is truthfully in love with the name Ernest. However, when Bracknell re-enters and question's her daughter's new suitor, she is unhappy with his questionable birth and refuses the proposal. This sets up the almost Shakespearean escape to the country, where young lovers can love freely.

In the country, we meet Cecily, Jack's (Ernest's) ward. Before long, Algernon arrives claiming that he is Ernest, Jack's cousin from the city and Cecily falls in love with him, again, not for the man, but for the name Ernest. What unfolds is a satirical romp that pokes fun at Victorian morals and norms with a wit and relevance that has allowed it to become one of the most loved comedies in all of theatrical history.

Ironically, Wilde's life was far from a comedy. His consistent run-ins with the law, outright homosexual life-style, and verbose critique of the society in which he lived made him an easy target for ridicule, discrimination, and intolerance. It is far from ironic that this play is about concealed identities, false perceptions, and acceptance of one's true identity. These were the very forces at play on the playwright himself. What is ironic is that, out of such intolerance, Wilde cemented his legacy as both a civil rights pioneer and playwright extraordinaire.

Food for Thought

As you read the play, consider the following questions:

1. Which couple—Jack and Gwendolen or Algernon and Cecily—do you think will be most successful?
2. For all the talk of wickedness and badness in this play, do we ever see any examples of truly "wicked" people or actions? For that matter, do we see any examples of true virtue and goodness?
3. Which witty lines from the play still hold up as humorous and effective today? Are there any lines that you don't think have stood the test of time?
4. There are many themes in this play. One is death. How do these characters react to and deal with the idea of death?

Fun Facts

1. Wilde originally subtitled *The Importance of Being Earnest* "A Serious Comedy for Trivial People" before changing it to "A Trivial Comedy for Serious People."
2. Wilde's life has been the subject of hundreds of plays, novels and films.
3. A few great quotes from the master of witty remarks: "A man can be happy with a woman as long as he does not love her." "Life is much too important a thing ever to talk seriously about it." "Women are to be loved, not to be understood." "Men become old, but they never become good."

The Importance of Being Earnest

Characters

John Worthing, J.P.
Algernon Moncrieff
Rev. Canon Chasuble, D.D.
Merriman, Butler
Lane, Manservant

Lady Bracknell
Hon. Gwendolen Fairfax
Cecily Cardew
Miss Prism, Governess

First Act

Scene: Morning-room in Algernon's flat in Half-Moon Street. The room is luxuriously and artistically furnished. The sound of a piano is heard in the adjoining room.

[LANE *is arranging afternoon tea on the table, and after the music has ceased,* ALGERNON *enters.*]

ALGERNON. Did you hear what I was playing, Lane?

LANE. I didn't think it polite to listen, sir.

ALGERNON. I'm sorry for that, for your sake. I don't play accurately—any one can play accurately—but I play with wonderful expression. As far as the piano is concerned, sentiment is my forte. I keep science for Life.

LANE. Yes, sir.

ALGERNON. And, speaking of the science of Life, have you got the cucumber sandwiches cut for Lady Bracknell?

LANE. Yes, sir. [*Hands them on a salver.*]

ALGERNON. [*Inspects them, takes two, and sits down on the sofa.*] Oh! . . . by the way, Lane, I see from your book that on Thursday night, when Lord Shoreman and Mr. Worthing were dining with me, eight bottles of champagne are entered as having been consumed.

LANE. Yes, sir; eight bottles and a pint.

ALGERNON. Why is it that at a bachelor's establishment the servants invariably drink the champagne? I ask merely for information.

LANE. I attribute it to the superior quality of the wine, sir. I have often observed that in married households the champagne is rarely of a first-rate brand.

ALGERNON. Good heavens! Is marriage so demoralising as that?

LANE. I believe it *is* a very pleasant state, sir. I have had very little experience of it myself up to the present. I have only been married once. That was in consequence of a misunderstanding between myself and a young person.

ALGERNON. [*Languidly.*] I don't know that I am much interested in your family life, Lane.

LANE. No, sir; it is not a very interesting subject. I never think of it myself.

ALGERNON. Very natural, I am sure. That will do, Lane, thank you.

LANE. Thank you, sir. [*LANE goes out.*]

ALGERNON. Lane's views on marriage seem somewhat lax. Really, if the lower orders don't set us a good example, what on earth is the use of them? They seem, as a class, to have absolutely no sense of moral responsibility.

[*Enter Lane.*]

LANE. Mr. Ernest Worthing.

[*Enter Jack.*]

[LANE *goes out.*]

ALGERNON. How are you, my dear Ernest? What brings you up to town?

JACK. Oh, pleasure, pleasure! What else should bring one anywhere? Eating as usual, I see, Algy!

ALGERNON. [*Stiffly.*] I believe it is customary in good society to take some slight refreshment at five o'clock. Where have you been since last Thursday?

JACK. [*Sitting down on the sofa.*] In the country.

ALGERNON. What on earth do you do there?

JACK. [*Pulling off his gloves.*] When one is in town one amuses oneself. When one is in the country one amuses other people. It is excessively boring.

ALGERNON. And who are the people you amuse?

JACK. [*Airily.*] Oh, neighbours, neighbours.

ALGERNON. Got nice neighbours in your part of Shropshire?

JACK. Perfectly horrid! Never speak to one of them.

ALGERNON. How immensely you must amuse them! [*Goes over and takes sandwich.*] By the way, Shropshire is your county, is it not?

JACK. Eh? Shropshire? Yes, of course. Hallo! Why all these cups? Why cucumber sandwiches? Why such reckless extravagance in one so young? Who is coming to tea?

ALGERNON. Oh! merely Aunt Augusta and Gwendolen.

JACK. How perfectly delightful!

ALGERNON. Yes, that is all very well; but I am afraid Aunt Augusta won't quite approve of your being here.

JACK. May I ask why?

ALGERNON. My dear fellow, the way you flirt with Gwendolen is perfectly disgraceful. It is almost as bad as the way Gwendolen flirts with you.

JACK. I am in love with Gwendolen. I have come up to town expressly to propose to her.

ALGERNON. I thought you had come up for pleasure? . . . I call that business.

JACK. How utterly unromantic you are!

ALGERNON. I really don't see anything romantic in proposing. It is very romantic to be in love. But there is nothing romantic about a definite proposal. Why, one may be accepted. One usually is, I believe. Then the excitement is all over. The very essence of romance is uncertainty. If ever I get married, I'll certainly try to forget the fact.

JACK. I have no doubt about that, dear Algy. The Divorce Court was specially invented for people whose memories are so curiously constituted.

ALGERNON. Oh! there is no use speculating on that subject. Divorces are made in Heaven—[JACK *puts out his hand to take a sandwich.* ALGERNON *at once interferes.*] Please don't touch the cucumber sandwiches. They are ordered specially for Aunt Augusta. [*Takes one and eats it.*]

JACK. Well, you have been eating them all the time.

ALGERNON. That is quite a different matter. She is my aunt. [*Takes plate from below.*] Have some bread and butter. The bread and butter is for Gwendolen. Gwendolen is devoted to bread and butter.

JACK. [*Advancing to table and helping himself.*] And very good bread and butter it is too.

ALGERNON. Well, my dear fellow, you need not eat as if you were going to eat it all. You behave as if you were married to her already. You are not married to her already, and I don't think you ever will be.

JACK. Why on earth do you say that?

ALGERNON. Well, in the first place girls never marry the men they flirt with. Girls don't think it right.

JACK. Oh, that is nonsense!

ALGERNON. It isn't. It is a great truth. It accounts for the extraordinary number of bachelors that one sees all over the place. In the second place, I don't give my consent.

JACK. Your consent!

ALGERNON. My dear fellow, Gwendolen is my first cousin. And before I allow you to marry her, you will have to clear up the whole question of Cecily. [*Rings bell.*]

JACK. Cecily! What on earth do you mean? What do you mean, Algy, by Cecily! I don't know any one of the name of Cecily.

[*Enter* LANE.]

ALGERNON. Bring me that cigarette case Mr. Worthing left in the smoking-room the last time he dined here.

LANE. Yes, sir. [LANE *goes out.*]

JACK. Do you mean to say you have had my cigarette case all this time? I wish to goodness you had let me know. I have been writing frantic letters to Scotland Yard about it. I was very nearly offering a large reward.

ALGERNON. Well, I wish you would offer one. I happen to be more than usually hard up.

JACK. There is no good offering a large reward now that the thing is found.

[*Enter* LANE *with the cigarette case on a salver.* ALGERNON *takes it at once.* LANE *goes out.*]

ALGERNON. I think that is rather mean of you, Ernest, I must say. [*Opens case and examines it.*] However, it makes no matter, for, now that I look at the

inscription inside, I find that the thing isn't yours after all.

JACK. Of course it's mine. [*Moving to him.*] You have seen me with it a hundred times, and you have no right whatsoever to read what is written inside. It is a very ungentlemanly thing to read a private cigarette case.

ALGERNON. Oh! it is absurd to have a hard and fast rule about what one should read and what one shouldn't. More than half of modern culture depends on what one shouldn't read.

JACK. I am quite aware of the fact, and I don't propose to discuss modern culture. It isn't the sort of thing one should talk of in private. I simply want my cigarette case back.

ALGERNON. Yes; but this isn't your cigarette case. This cigarette case is a present from some one of the name of Cecily, and you said you didn't know any one of that name.

JACK. Well, if you want to know, Cecily happens to be my aunt.

ALGERNON. Your aunt!

JACK. Yes. Charming old lady she is, too. Lives at Tunbridge Wells. Just give it back to me, Algy.

ALGERNON. [*Retreating to back of sofa.*] But why does she call herself little Cecily if she is your aunt and lives at Tunbridge Wells? [*Reading.*] 'From little Cecily with her fondest love.'

JACK. [*Moving to sofa and kneeling upon it.*] My dear fellow, what on earth is there in that? Some aunts are tall, some aunts are not tall. That is a matter that surely an aunt may be allowed to decide for herself. You seem to think that every aunt should be exactly like your aunt! That is absurd! For Heaven's sake give me back my cigarette case. [*Follows* ALGERNON *round the room.*]

ALGERNON. Yes. But why does your aunt call you her uncle? 'From little Cecily, with her fondest love to her dear Uncle Jack.' There is no objection, I admit, to an aunt being a small aunt, but why an aunt, no matter what her size may be, should call her own nephew her uncle, I can't quite make out. Besides, your name isn't Jack at all; it is Ernest.

JACK. It isn't Ernest; it's Jack.

ALGERNON. You have always told me it was Ernest. I have introduced you to every one as Ernest. You answer to the name of Ernest. You look as if your name was Ernest. You are the most earnest-looking person I ever saw in my life. It is perfectly absurd your saying that your name isn't Ernest. It's on your cards. Here is one of them. [*Taking it from case.*] 'Mr. Ernest Worthing, B. 4, The Albany.' I'll keep this as a proof that your name is Ernest if ever you attempt to deny it to me, or to Gwendolen, or to any one else. [*Puts the card in his pocket.*]

JACK. Well, my name is Ernest in town and Jack in the country, and the cigarette case was given to me in the country.

ALGERNON. Yes, but that does not account for the fact that your small Aunt Cecily, who lives at Tunbridge Wells, calls you her dear uncle. Come, old boy, you had much better have the thing out at once.

JACK. My dear Algy, you talk exactly as if you were a dentist. It is very vulgar to talk like a dentist when one isn't a dentist. It produces a false impression.

ALGERNON. Well, that is exactly what dentists always do. Now, go on! Tell me the whole thing. I may mention that I have always suspected you of being a confirmed and secret Bunburyist; and I am quite sure of it now.

JACK. Bunburyist? What on earth do you mean by a Bunburyist?

ALGERNON. I'll reveal to you the meaning of that incomparable expression as soon as you are kind enough to inform me why you are Ernest in town and Jack in the country.

JACK. Well, produce my cigarette case first.

ALGERNON. Here it is. [*Hands cigarette case.*] Now produce your explanation, and pray make it improbable. [*Sits on sofa.*]

JACK. My dear fellow, there is nothing improbable about my explanation at all. In fact it's perfectly ordinary. Old Mr. Thomas Cardew, who adopted me when I was a little boy, made me in his will guardian to his grand-daughter, Miss Cecily Cardew. Cecily, who addresses me as her uncle from motives of respect that you could not possibly appreciate, lives at my place in the country under the charge of her admirable governess, Miss Prism.

ALGERNON. Where is that place in the country, by the way?

JACK. That is nothing to you, dear boy. You are not going to be invited . . . I may tell you candidly that the place is not in Shropshire.

ALGERNON. I suspected that, my dear fellow! I have Bunburyed all over Shropshire on two separate occasions. Now, go on. Why are you Ernest in town and Jack in the country?

JACK. My dear Algy, I don't know whether you will be able to understand my real motives. You are hardly serious enough. When one is placed in the position of guardian, one has to adopt a very high moral tone on all subjects. It's one's duty to do so. And as a high moral tone can hardly be said to conduce very much to either one's health or one's happiness, in order to get up to town I have always pretended to have a younger brother of the name of Ernest, who lives in the Albany, and gets into the most dreadful scrapes. That, my dear Algy, is the whole truth pure and simple.

ALGERNON. The truth is rarely pure and never simple. Modern life would be very tedious if it were either, and modern literature a complete impossibility!

JACK. That wouldn't be at all a bad thing.

ALGERNON. Literary criticism is not your forte, my dear fellow. Don't try it. You should leave that to people who haven't been at a University. They do it so well in the daily papers. What you really are is a Bunburyist. I was quite right in saying you were a Bunburyist. You are one of the most advanced Bunburyists I know.

JACK. What on earth do you mean?

ALGERNON. You have invented a very useful younger brother called Ernest, in order that you may be able to come up to town as often as you like. I have invented an invaluable permanent invalid called Bunbury, in order that I may be able to go down into the country whenever I choose. Bunbury is perfectly invaluable. If it wasn't for Bunbury's extraordinary bad health, for instance, I wouldn't be able to dine with you at Willis's to-night, for I have been really engaged to Aunt Augusta for more than a week.

JACK. I haven't asked you to dine with me anywhere to-night.

ALGERNON. I know. You are absurdly careless about sending out invitations. It is very foolish of you. Nothing annoys people so much as not receiving invitations.

JACK. You had much better dine with your Aunt Augusta.

ALGERNON. I haven't the smallest intention of doing anything of the kind. To begin with, I dined there on Monday, and once a week is quite enough to dine with one's own relations. In the second place, whenever I do dine there I am always treated as a member of the family, and sent down with either no woman at all, or two. In the third place, I know perfectly well whom she will place me next to, to-night. She will place me next Mary Farquhar, who always flirts with her own husband across the dinner-table. That is not very pleasant. Indeed, it is not even decent . . . and that sort of thing is enormously on the increase. The amount of women in London who flirt with their own husbands is perfectly scandalous. It looks so bad. It is simply washing one's clean linen in public. Besides, now that I know you to be a confirmed Bunburyist I naturally want to talk to you about Bunburying. I want to tell you the rules.

JACK. I'm not a Bunburyist at all. If Gwendolen accepts me, I am going to kill my brother, indeed I think I'll kill him in any case. Cecily is a little too much interested in him. It is rather a bore. So I am going to get rid of Ernest. And I strongly advise you to do the same with Mr. . . . with your invalid friend who has the absurd name.

ALGERNON. Nothing will induce me to part with Bunbury, and if you ever get married, which seems to me extremely problematic, you will be very glad to know Bunbury. A man who marries without knowing Bunbury has a very tedious time of it.

JACK. That is nonsense. If I marry a charming girl like Gwendolen, and she is the only girl I ever saw in my life that I would marry, I certainly won't want to know Bunbury.

ALGERNON. Then your wife will. You don't seem to realise, that in married life three is company and two is none.

JACK. [Sententiously.] That, my dear young friend, is the theory that the corrupt French Drama has been propounding for the last fifty years.

ALGERNON. Yes; and that the happy English home has proved in half the time.

JACK. For heaven's sake, don't try to be cynical. It's perfectly easy to be cynical.

ALGERNON. My dear fellow, it isn't easy to be anything nowadays. There's such a lot of beastly competition about. [The sound of an electric bell is heard.] Ah! that must be Aunt Augusta. Only relatives, or creditors, ever ring in that Wagnerian manner. Now, if I get her out of the way for ten minutes, so that you can

have an opportunity for proposing to Gwendolen, may I dine with you to-night at Willis's?

JACK. I suppose so, if you want to.

ALGERNON. Yes, but you must be serious about it. I hate people who are not serious about meals. It is so shallow of them.

[*Enter* LANE.]

LANE. Lady Bracknell and Miss Fairfax.

[ALGERNON *goes forward to meet them. Enter* LADY BRACKNELL *and* GWENDOLEN.]

LADY BRACKNELL. Good afternoon, dear Algernon, I hope you are behaving very well.

ALGERNON. I'm feeling very well, Aunt Augusta.

LADY BRACKNELL. That's not quite the same thing. In fact the two things rarely go together. [*Sees* JACK *and bows to him with icy coldness.*]

ALGERNON. [*To* GWENDOLEN.] Dear me, you are smart!

GWENDOLEN. I am always smart! Am I not, Mr. Worthing?

JACK. You're quite perfect, Miss Fairfax.

GWENDOLEN. Oh! I hope I am not that. It would leave no room for developments, and I intend to develop in many directions. [GWENDOLEN *and* JACK *sit down together in the corner.*]

LADY BRACKNELL. I'm sorry if we are a little late, Algernon, but I was obliged to call on dear Lady Harbury. I hadn't been there since her poor husband's death. I never saw a woman so altered; she looks quite twenty years younger. And now I'll have a cup of tea, and one of those nice cucumber sandwiches you promised me.

ALGERNON. Certainly, Aunt Augusta. [*Goes over to tea-table.*]

LADY BRACKNELL. Won't you come and sit here, Gwendolen?

GWENDOLEN. Thanks, mamma, I'm quite comfortable where I am.

ALGERNON. [*Picking up empty plate in horror.*] Good heavens! Lane! Why are there no cucumber sandwiches? I ordered them specially.

LANE. [*Gravely.*] There were no cucumbers in the market this morning, sir. I went down twice.

ALGERNON. No cucumbers!

LANE. No, sir. Not even for ready money.

ALGERNON. That will do, Lane, thank you.

LANE. Thank you, sir. [*Goes out.*]

ALGERNON. I am greatly distressed, Aunt Augusta, about there being no cucumbers, not even for ready money.

LADY BRACKNELL. It really makes no matter, Algernon. I had some crumpets with Lady Harbury, who seems to me to be living entirely for pleasure now.

ALGERNON. I hear her hair has turned quite gold from grief.

LADY BRACKNELL. It certainly has changed its colour. From what cause I, of course, cannot say. [ALGERNON *crosses and hands tea.*] Thank you. I've quite a treat for you to-night, Algernon. I am going to send you down with Mary Farquhar. She is such a nice woman, and so attentive to her husband. It's delightful to watch them.

ALGERNON. I am afraid, Aunt Augusta, I shall have to give up the pleasure of dining with you to-night after all.

LADY BRACKNELL. [*Frowning.*] I hope not, Algernon. It would put my table completely out. Your uncle would have to dine upstairs. Fortunately he is accustomed to that.

ALGERNON. It is a great bore, and, I need hardly say, a terrible disappointment to me, but the fact is I have just had a telegram to say that my poor friend Bunbury is very ill again. [*Exchanges glances with* JACK.] They seem to think I should be with him.

LADY BRACKNELL. It is very strange. This Mr. Bunbury seems to suffer from curiously bad health.

ALGERNON. Yes; poor Bunbury is a dreadful invalid.

LADY BRACKNELL. Well, I must say, Algernon, that I think it is high time that Mr. Bunbury made up his mind whether he was going to live or to die. This shilly-shallying with the question is absurd. Nor do I in any way approve of the modern sympathy with invalids. I consider it morbid. Illness of any kind is hardly a thing to be encouraged in others. Health is the primary duty of life. I am always telling that to your poor uncle, but he never seems to take much notice . . . as far as any improvement in his ailment goes. I should be much obliged if you would ask Mr. Bunbury, from me, to be kind enough not to have a relapse on Saturday,

for I rely on you to arrange my music for me. It is my last reception, and one wants something that will encourage conversation, particularly at the end of the season when every one has practically said whatever they had to say, which, in most cases, was probably not much.

ALGERNON. I'll speak to Bunbury, Aunt Augusta, if he is still conscious, and I think I can promise you he'll be all right by Saturday. Of course the music is a great difficulty. You see, if one plays good music, people don't listen, and if one plays bad music people don't talk. But I'll run over the programme I've drawn out, if you will kindly come into the next room for a moment.

LADY BRACKNELL. Thank you, Algernon. It is very thoughtful of you. [*Rising, and following* ALGERNON.] I'm sure the programme will be delightful, after a few expurgations. French songs I cannot possibly allow. People always seem to think that they are improper, and either look shocked, which is vulgar, or laugh, which is worse. But German sounds a thoroughly respectable language, and indeed, I believe is so. Gwendolen, you will accompany me.

GWENDOLEN. Certainly, mamma.

[*LADY BRACKNELL and* ALGERNON *go into the music-room,* GWENDOLEN *remains behind.*]

JACK. Charming day it has been, Miss Fairfax.

GWENDOLEN. Pray don't talk to me about the weather, Mr. Worthing. Whenever people talk to me about the weather, I always feel quite certain that they mean something else. And that makes me so nervous.

JACK. I do mean something else.

GWENDOLEN. I thought so. In fact, I am never wrong.

JACK. And I would like to be allowed to take advantage of Lady Bracknell's temporary absence . . .

GWENDOLEN. I would certainly advise you to do so. Mamma has a way of coming back suddenly into a room that I have often had to speak to her about.

JACK. [*Nervously.*] Miss Fairfax, ever since I met you I have admired you more than any girl . . . I have ever met since . . . I met you.

GWENDOLEN. Yes, I am quite well aware of the fact. And I often wish that in public, at any rate, you had been more demonstrative. For me you have always had an irresistible fascination. Even before I met

you I was far from indifferent to you. [JACK *looks at her in amazement.*] We live, as I hope you know, Mr. Worthing, in an age of ideals. The fact is constantly mentioned in the more expensive monthly magazines, and has reached the provincial pulpits, I am told; and my ideal has always been to love some one of the name of Ernest. There is something in that name that inspires absolute confidence. The moment Algernon first mentioned to me that he had a friend called Ernest, I knew I was destined to love you.

JACK. You really love me, Gwendolen?

GWENDOLEN. Passionately!

JACK. Darling! You don't know how happy you've made me.

GWENDOLEN. My own Ernest!

JACK. But you don't really mean to say that you couldn't love me if my name wasn't Ernest?

GWENDOLEN. But your name is Ernest.

JACK. Yes, I know it is. But supposing it was something else? Do you mean to say you couldn't love me then?

GWENDOLEN. [*Glibly.*] Ah! that is clearly a metaphysical speculation, and like most metaphysical speculations has very little reference at all to the actual facts of real life, as we know them.

JACK. Personally, darling, to speak quite candidly, I don't much care about the name of Ernest . . . I don't think the name suits me at all.

GWENDOLEN. It suits you perfectly. It is a divine name. It has a music of its own. It produces vibrations.

JACK. Well, really, Gwendolen, I must say that I think there are lots of other much nicer names. I think Jack, for instance, a charming name.

GWENDOLEN. Jack? . . . No, there is very little music in the name Jack, if any at all, indeed. It does not thrill. It produces absolutely no vibrations . . . I have known several Jacks, and they all, without exception, were more than usually plain. Besides, Jack is a notorious domesticity for John! And I pity any woman who is married to a man called John. She would probably never be allowed to know the entrancing pleasure of a single moment's solitude. The only really safe name is Ernest.

JACK. Gwendolen, I must get christened at once—I mean we must get married at once. There is no time to be lost.

GWENDOLEN. Married, Mr. Worthing?

JACK. [*Astounded.*] Well . . . surely. You know that I love you, and you led me to believe, Miss Fairfax, that you were not absolutely indifferent to me.

GWENDOLEN. I adore you. But you haven't proposed to me yet. Nothing has been said at all about marriage. The subject has not even been touched on.

JACK. Well . . . may I propose to you now?

GWENDOLEN. I think it would be an admirable opportunity. And to spare you any possible disappointment, Mr. Worthing, I think it only fair to tell you quite frankly before-hand that I am fully determined to accept you.

JACK. Gwendolen!

GWENDOLEN. Yes, Mr. Worthing, what have you got to say to me?

JACK. You know what I have got to say to you.

GWENDOLEN. Yes, but you don't say it.

JACK. Gwendolen, will you marry me? [*Goes on his knees.*]

GWENDOLEN. Of course I will, darling. How long you have been about it! I am afraid you have had very little experience in how to propose.

JACK. My own one, I have never loved any one in the world but you.

GWENDOLEN. Yes, but men often propose for practice. I know my brother Gerald does. All my girl-friends tell me so. What wonderfully blue eyes you have, Ernest! They are quite, quite, blue. I hope you will always look at me just like that, especially when there are other people present. [*Enter LADY BRACKNELL.*]

LADY BRACKNELL. Mr. Worthing! Rise, sir, from this semi-recumbent posture. It is most indecorous.

GWENDOLEN. Mamma! [*He tries to rise; she restrains him.*] I must beg you to retire. This is no place for you. Besides, Mr. Worthing has not quite finished yet.

LADY BRACKNELL. Finished what, may I ask?

GWENDOLEN. I am engaged to Mr. Worthing, mamma. [*They rise together.*]

LADY BRACKNELL. Pardon me, you are not engaged to any one. When you do become engaged to some one, I, or your father, should his health permit him, will inform you of the fact. An engagement should come on a young girl as a surprise, pleasant or unpleasant, as the case may be. It is hardly a matter that she could be allowed to arrange for herself . . . And now I have a few questions to put to you, Mr. Worthing. While I am making these inquiries, you, Gwendolen, will wait for me below in the carriage.

GWENDOLEN. [*Reproachfully.*] Mamma!

LADY BRACKNELL. In the carriage, Gwendolen! [*GWENDOLEN goes to the door. She and JACK blow kisses to each other behind LADY BRACKNELL's back. LADY BRACKNELL looks vaguely about as if she could not understand what the noise was. Finally turns round.*] Gwendolen, the carriage!

GWENDOLEN. Yes, mamma. [*Goes out, looking back at JACK.*]

LADY BRACKNELL. [*Sitting down.*] You can take a seat, Mr. Worthing.

[*Looks in her pocket for note-book and pencil.*]

JACK. Thank you, Lady Bracknell, I prefer standing.

LADY BRACKNELL. [*Pencil and note-book in hand.*] I feel bound to tell you that you are not down on my list of eligible young men, although I have the same list as the dear Duchess of Bolton has. We work together, in fact. However, I am quite ready to enter your name, should your answers be what a really affectionate mother requires. Do you smoke?

JACK. Well, yes, I must admit I smoke.

LADY BRACKNELL. I am glad to hear it. A man should always have an occupation of some kind. There are far too many idle men in London as it is. How old are you?

JACK. Twenty-nine.

LADY BRACKNELL. A very good age to be married at. I have always been of opinion that a man who desires to get married should know either everything or nothing. Which do you know?

JACK. [*After some hesitation.*] I know nothing, Lady Bracknell.

LADY BRACKNELL. I am pleased to hear it. I do not approve of anything that tampers with natural ignorance. Ignorance is like a delicate exotic fruit;

touch it and the bloom is gone. The whole theory of modern education is radically unsound. Fortunately in England, at any rate, education produces no effect whatsoever. If it did, it would prove a serious danger to the upper classes, and probably lead to acts of violence in Grosvenor Square. What is your income?

JACK. Between seven and eight thousand a year.

LADY BRACKNELL. [*Makes a note in her book.*] In land, or in investments?

JACK. In investments, chiefly.

LADY BRACKNELL. That is satisfactory. What between the duties expected of one during one's lifetime, and the duties exacted from one after one's death, land has ceased to be either a profit or a pleasure. It gives one position, and prevents one from keeping it up. That's all that can be said about land.

JACK. I have a country house with some land, of course, attached to it, about fifteen hundred acres, I believe; but I don't depend on that for my real income. In fact, as far as I can make out, the poachers are the only people who make anything out of it.

LADY BRACKNELL. A country house! How many bedrooms? Well, that point can be cleared up afterwards. You have a town house, I hope? A girl with a simple, unspoiled nature, like Gwendolen, could hardly be expected to reside in the country.

JACK. Well, I own a house in Belgrave Square, but it is let by the year to Lady Bloxham. Of course, I can get it back whenever I like, at six months' notice.

LADY BRACKNELL. Lady Bloxham? I don't know her.

JACK. Oh, she goes about very little. She is a lady considerably advanced in years.

LADY BRACKNELL. Ah, nowadays that is no guarantee of respectability of character. What number in Belgrave Square?

JACK. 149.

LADY BRACKNELL. [*Shaking her head.*] The unfashionable side. I thought there was something. However, that could easily be altered.

JACK. Do you mean the fashion, or the side?

LADY BRACKNELL. [*Sternly.*] Both, if necessary, I presume. What are your politics?

JACK. Well, I am afraid I really have none. I am a Liberal Unionist.

LADY BRACKNELL. Oh, they count as Tories. They dine with us. Or come in the evening, at any rate. Now to minor matters. Are your parents living?

JACK. I have lost both my parents.

LADY BRACKNELL. To lose one parent, Mr. Worthing, may be regarded as a misfortune; to lose both looks like carelessness. Who was your father? He was evidently a man of some wealth. Was he born in what the Radical papers call the purple of commerce, or did he rise from the ranks of the aristocracy?

JACK. I am afraid I really don't know. The fact is, Lady Bracknell, I said I had lost my parents. It would be nearer the truth to say that my parents seem to have lost me . . . I don't actually know who I am by birth. I was . . . well, I was found.

LADY BRACKNELL. Found!

JACK. The late Mr. Thomas Cardew, an old gentleman of a very charitable and kindly disposition, found me, and gave me the name of Worthing, because he happened to have a first-class ticket for Worthing in his pocket at the time. Worthing is a place in Sussex. It is a seaside resort.

LADY BRACKNELL. Where did the charitable gentleman who had a first-class ticket for this seaside resort find you?

JACK. [*Gravely.*] In a hand-bag.

LADY BRACKNELL. A hand-bag?

JACK. [*Very seriously.*] Yes, Lady Bracknell. I was in a hand-bag—a somewhat large, black leather hand-bag, with handles to it—an ordinary hand-bag in fact.

LADY BRACKNELL. In what locality did this Mr. James, or Thomas, Cardew come across this ordinary hand-bag?

JACK. In the cloak-room at Victoria Station. It was given to him in mistake for his own.

LADY BRACKNELL. The cloak-room at Victoria Station?

JACK. Yes. The Brighton line.

LADY BRACKNELL. The line is immaterial. Mr. Worthing, I confess I feel somewhat bewildered by what you have just told me. To be born, or at any rate bred, in a hand-bag, whether it had handles or not, seems to me to display a contempt for the ordinary decencies of family life that reminds one of the worst excesses of the French Revolution. And I presume you know what that unfortunate

movement led to? As for the particular locality in which the hand-bag was found, a cloak-room at a railway station might serve to conceal a social indiscretion—has probably, indeed, been used for that purpose before now—but it could hardly be regarded as an assured basis for a recognised position in good society.

JACK. May I ask you then what you would advise me to do? I need hardly say I would do anything in the world to ensure Gwendolen's happiness.

LADY BRACKNELL. I would strongly advise you, Mr. Worthing, to try and acquire some relations as soon as possible, and to make a definite effort to produce at any rate one parent, of either sex, before the season is quite over.

JACK. Well, I don't see how I could possibly manage to do that. I can produce the hand-bag at any moment. It is in my dressing-room at home. I really think that should satisfy you, Lady Bracknell.

LADY BRACKNELL. Me, sir! What has it to do with me? You can hardly imagine that I and Lord Bracknell would dream of allowing our only daughter—a girl brought up with the utmost care—to marry into a cloak-room, and form an alliance with a parcel? Good morning, Mr. Worthing!

[LADY BRACKNELL *sweeps out in majestic indignation.*]

JACK. Good morning! [ALGERNON, *from the other room, strikes up the Wedding March.* JACK *looks perfectly furious, and goes to the door.*] For goodness' sake don't play that ghastly tune, Algy. How idiotic you are!

[*The music stops and* ALGERNON *enters cheerily.*]

ALGERNON. Didn't it go off all right, old boy? You don't mean to say Gwendolen refused you? I know it is a way she has. She is always refusing people. I think it is most ill-natured of her.

JACK. Oh, Gwendolen is as right as a trivet. As far as she is concerned, we are engaged. Her mother is perfectly unbearable. Never met such a Gorgon . . . I don't really know what a Gorgon is like, but I am quite sure that Lady Bracknell is one. In any case, she is a monster, without being a myth, which is rather unfair . . . I beg your pardon, Algy, I suppose I shouldn't talk about your own aunt in that way before you.

ALGERNON. My dear boy, I love hearing my relations abused. It is the only thing that makes me put up

with them at all. Relations are simply a tedious pack of people, who haven't got the remotest knowledge of how to live, nor the smallest instinct about when to die.

JACK. Oh, that is nonsense!

ALGERNON. It isn't!

JACK. Well, I won't argue about the matter. You always want to argue about things.

ALGERNON. That is exactly what things were originally made for.

JACK. Upon my word, if I thought that, I'd shoot myself . . . [*A pause.*] You don't think there is any chance of Gwendolen becoming like her mother in about a hundred and fifty years, do you, Algy?

ALGERNON. All women become like their mothers. That is their tragedy. No man does. That's his.

JACK. Is that clever?

ALGERNON. It is perfectly phrased! and quite as true as any observation in civilised life should be.

JACK. I am sick to death of cleverness. Everybody is clever nowadays. You can't go anywhere without meeting clever people. The thing has become an absolute public nuisance. I wish to goodness we had a few fools left.

ALGERNON. We have.

JACK. I should extremely like to meet them. What do they talk about?

ALGERNON. The fools? Oh! about the clever people, of course.

JACK. What fools!

ALGERNON. By the way, did you tell Gwendolen the truth about your being Ernest in town, and Jack in the country?

JACK. [*In a very patronising manner.*] My dear fellow, the truth isn't quite the sort of thing one tells to a nice, sweet, refined girl. What extraordinary ideas you have about the way to behave to a woman!

ALGERNON. The only way to behave to a woman is to make love to her, if she is pretty, and to some one else, if she is plain.

JACK. Oh, that is nonsense.

ALGERNON. What about your brother? What about the profligate Ernest?

JACK. Oh, before the end of the week I shall have got rid of him. I'll say he died in Paris of apoplexy. Lots of people die of apoplexy, quite suddenly, don't they?

ALGERNON. Yes, but it's hereditary, my dear fellow. It's a sort of thing that runs in families. You had much better say a severe chill.

JACK. You are sure a severe chill isn't hereditary, or anything of that kind?

ALGERNON. Of course it isn't!

JACK. Very well, then. My poor brother Ernest to carried off suddenly, in Paris, by a severe chill. That gets rid of him.

ALGERNON. But I thought you said that . . . Miss Cardew was a little too much interested in your poor brother Ernest? Won't she feel his loss a good deal?

JACK. Oh, that is all right. Cecily is not a silly romantic girl, I am glad to say. She has got a capital appetite, goes long walks, and pays no attention at all to her lessons.

ALGERNON. I would rather like to see Cecily.

JACK. I will take very good care you never do. She is excessively pretty, and she is only just eighteen.

ALGERNON. Have you told Gwendolen yet that you have an excessively pretty ward who is only just eighteen?

JACK. Oh! one doesn't blurt these things out to people. Cecily and Gwendolen are perfectly certain to be extremely great friends. I'll bet you anything you like that half an hour after they have met, they will be calling each other sister.

ALGERNON. Women only do that when they have called each other a lot of other things first. Now, my dear boy, if we want to get a good table at Willis's, we really must go and dress. Do you know it is nearly seven?

JACK. [Irritably.] Oh! It always is nearly seven.

ALGERNON. Well, I'm hungry.

JACK. I never knew you when you weren't . . .

ALGERNON. What shall we do after dinner? Go to a theatre?

JACK. Oh no! I loathe listening.

ALGERNON. Well, let us go to the Club?

JACK. Oh, no! I hate talking.

ALGERNON. Well, we might trot round to the Empire at ten?

JACK. Oh, no! I can't bear looking at things. It is so silly.

ALGERNON. Well, what shall we do?

JACK. Nothing!

ALGERNON. It is awfully hard work doing nothing. However, I don't mind hard work where there is no definite object of any kind.

[Enter LANE.]

LANE. Miss Fairfax.

[Enter GWENDOLEN. LANE goes out.]

ALGERNON. Gwendolen, upon my word!

GWENDOLEN. Algy, kindly turn your back. I have something very particular to say to Mr. Worthing.

ALGERNON. Really, Gwendolen, I don't think I can allow this at all.

GWENDOLEN. Algy, you always adopt a strictly immoral attitude towards life. You are not quite old enough to do that. [ALGERNON retires to the fireplace.]

JACK. My own darling!

GWENDOLEN. Ernest, we may never be married. From the expression on mamma's face I fear we never shall. Few parents nowadays pay any regard to what their children say to them. The old-fashioned respect for the young is fast dying out. Whatever influence I ever had over mamma, I lost at the age of three. But although she may prevent us from becoming man and wife, and I may marry some one else, and marry often, nothing that she can possibly do can alter my eternal devotion to you.

JACK. Dear Gwendolen!

GWENDOLEN. The story of your romantic origin, as related to me by mamma, with unpleasing comments, has naturally stirred the deeper fibres of my nature. Your Christian name has an irresistible fascination. The simplicity of your character makes you exquisitely incomprehensible to me. Your town address at the Albany I have. What is your address in the country?

JACK. The Manor House, Woolton, Hertfordshire.

[ALGERNON, who has been carefully listening, smiles to himself, and writes the address on his shirt-cuff. Then picks up the Railway Guide.]

GWENDOLEN. There is a good postal service, I suppose? It may be necessary to do something desperate. That of course will require serious consideration. I will communicate with you daily.

JACK. My own one!

GWENDOLEN. How long do you remain in town?

JACK. Till Monday.

GWENDOLEN. Good! Algy, you may turn round now.

ALGERNON. Thanks, I've turned round already.

GWENDOLEN. You may also ring the bell.

JACK. You will let me see you to your carriage, my own darling?

GWENDOLEN. Certainly.

JACK. [*To* LANE, *who now enters.*] I will see Miss Fairfax out.

LANE. Yes, sir. [JACK *and* GWENDOLEN *go off.*]

[LANE *presents several letters on a salver to* ALGERNON. *It is to be surmised that they are bills, as* ALGERNON, *after looking at the envelopes, tears them up.*]

ALGERNON. A glass of sherry, Lane.

LANE. Yes, sir.

ALGERNON. To-morrow, Lane, I'm going Bunburying.

LANE. Yes, sir.

ALGERNON. I shall probably not be back till Monday. You can put up my dress clothes, my smoking jacket, and all the Bunbury suits . . .

LANE. Yes, sir. [*Handing sherry.*]

ALGERNON. I hope to-morrow will be a fine day, Lane.

LANE. It never is, sir.

ALGERNON. Lane, you're a perfect pessimist.

LANE. I do my best to give satisfaction, sir.

[Enter JACK. LANE *goes off.*]

JACK. There's a sensible, intellectual girl! the only girl I ever cared for in my life. [ALGERNON *is laughing immoderately.*] What on earth are you so amused at?

ALGERNON. Oh, I'm a little anxious about poor Bunbury, that is all.

JACK. If you don't take care, your friend Bunbury will get you into a serious scrape some day.

ALGERNON. I love scrapes. They are the only things that are never serious.

JACK. Oh, that's nonsense, Algy. You never talk anything but nonsense.

ALGERNON. Nobody ever does.

[JACK *looks indignantly at him, and leaves the room.* ALGERNON *lights a cigarette, reads his shirt-cuff, and smiles.*]

ACT DROP

Second Act
Scene

Garden at the Manor House. A flight of grey stone steps leads up to the house. The garden, an old-fashioned one, full of roses. Time of year, July. Basket chairs, and a table covered with books, are set under a large yew-tree.

[MISS PRISM *discovered seated at the table.* CECILY *is at the back watering flowers.*]

MISS PRISM. [*Calling.*] Cecily, Cecily! Surely such a utilitarian occupation as the watering of flowers is rather Moulton's duty than yours? Especially at a moment when intellectual pleasures await you. Your German grammar is on the table. Pray open it at page fifteen. We will repeat yesterday's lesson.

CECILY. [*Coming over very slowly.*] But I don't like German. It isn't at all a becoming language. I know perfectly well that I look quite plain after my German lesson.

MISS PRISM. Child, you know how anxious your guardian is that you should improve yourself in every way. He laid particular stress on your German, as he was leaving for town yesterday. Indeed, he always lays stress on your German when he is leaving for town.

CECILY. Dear Uncle Jack is so very serious! Sometimes he is so serious that I think he cannot be quite well.

MISS PRISM. [*Drawing herself up.*] Your guardian enjoys the best of health, and his gravity of demeanour is especially to be commended in one so comparatively young as he is. I know no one who has a higher sense of duty and responsibility.

CECILY. I suppose that is why he often looks a little bored when we three are together.

MISS PRISM. Cecily! I am surprised at you. Mr. Worthing has many troubles in his life. Idle merriment and triviality would be out of place in his conversation. You must remember his constant anxiety about that unfortunate young man his brother.

CECILY. I wish Uncle Jack would allow that unfortunate young man, his brother, to come down here sometimes. We might have a good influence over him, Miss Prism. I am sure you certainly would. You know German, and geology, and things of that kind influence a man very much. [CECILY *begins to write in her diary.*]

MISS PRISM. [*Shaking her head.*] I do not think that even I could produce any effect on a character that according to his own brother's admission is irretrievably weak and vacillating. Indeed I am not sure that I would desire to reclaim him. I am not in favour of this modern mania for turning bad people into good people at a moment's notice. As a man sows so let him reap. You must put away your diary, Cecily. I really don't see why you should keep a diary at all.

CECILY. I keep a diary in order to enter the wonderful secrets of my life. If I didn't write them down, I should probably forget all about them.

MISS PRISM. Memory, my dear Cecily, is the diary that we all carry about with us.

CECILY. Yes, but it usually chronicles the things that have never happened, and couldn't possibly have happened. I believe that Memory is responsible for nearly all the three-volume novels that Mudie sends us.

MISS PRISM. Do not speak slightingly of the three-volume novel, Cecily. I wrote one myself in earlier days.

CECILY. Did you really, Miss Prism? How wonderfully clever you are! I hope it did not end happily? I don't like novels that end happily. They depress me so much.

MISS PRISM. The good ended happily, and the bad unhappily. That is what Fiction means.

CECILY. I suppose so. But it seems very unfair. And was your novel ever published?

MISS PRISM. Alas! no. The manuscript unfortunately was abandoned. [CECILY *starts.*] I use the word in the sense of lost or mislaid. To your work, child, these speculations are profitless.

CECILY. [*Smiling.*] But I see dear Dr. Chasuble coming up through the garden.

MISS PRISM. [*Rising and advancing.*] Dr. Chasuble! This is indeed a pleasure.

[*Enter* CANON CHASUBLE.]

CHASUBLE. And how are we this morning? Miss Prism, you are, I trust, well?

CECILY. Miss Prism has just been complaining of a slight headache. I think it would do her so much good to have a short stroll with you in the Park, Dr. Chasuble.

MISS PRISM. Cecily, I have not mentioned anything about a headache.

CECILY. No, dear Miss Prism, I know that, but I felt instinctively that you had a headache. Indeed I was thinking about that, and not about my German lesson, when the Rector came in.

CHASUBLE. I hope, Cecily, you are not inattentive.

CECILY. Oh, I am afraid I am.

CHASUBLE. That is strange. Were I fortunate enough to be Miss Prism's pupil, I would hang upon her lips. [MISS PRISM *glares.*] I spoke metaphorically.—My metaphor was drawn from bees. Ahem! Mr. Worthing, I suppose, has not returned from town yet?

MISS PRISM. We do not expect him till Monday afternoon.

CHASUBLE. Ah yes, he usually likes to spend his Sunday in London. He is not one of those whose sole aim is enjoyment, as, by all accounts, that unfortunate young man his brother seems to be. But I must not disturb Egeria and her pupil any longer.

MISS PRISM. Egeria? My name is Lætitia, Doctor.

CHASUBLE. [*Bowing.*] A classical allusion merely, drawn from the Pagan authors. I shall see you both no doubt at Evensong?

MISS PRISM. I think, dear Doctor, I will have a stroll with you. I find I have a headache after all, and a walk might do it good.

CHASUBLE. With pleasure, Miss Prism, with pleasure. We might go as far as the schools and back.

MISS PRISM. That would be delightful. Cecily, you will read your Political Economy in my absence. The chapter on the Fall of the Rupee you may omit. It is somewhat too sensational. Even these metallic problems have their melodramatic side.

[*Goes down the garden with* DR. CHASUBLE.]

CECILY. [*Picks up books and throws them back on table.*] Horrid Political Economy! Horrid Geography! Horrid, horrid German!

[*Enter* MERRIMAN *with a card on a salver.*]

MERRIMAN. Mr. Ernest Worthing has just driven over from the station. He has brought his luggage with him.

CECILY. [*Takes the card and reads it.*] 'Mr. Ernest Worthing, B. 4, The Albany, W.' Uncle Jack's brother! Did you tell him Mr. Worthing was in town?

MERRIMAN. Yes, Miss. He seemed very much disappointed. I mentioned that you and Miss Prism were in the garden. He said he was anxious to speak to you privately for a moment.

CECILY. Ask Mr. Ernest Worthing to come here. I suppose you had better talk to the housekeeper about a room for him.

MERRIMAN. Yes, Miss.

[MERRIMAN *goes off.*]

CECILY. I have never met any really wicked person before. I feel rather frightened. I am so afraid he will look just like every one else.

[*Enter* ALGERNON, *very gay and debonnair.*] He does!

ALGERNON. [*Raising his hat.*] You are my little cousin Cecily, I'm sure.

CECILY. You are under some strange mistake. I am not little. In fact, I believe I am more than usually tall for my age. [ALGERNON *is rather taken aback.*] But I am your cousin Cecily. You, I see from your card, are Uncle Jack's brother, my cousin Ernest, my wicked cousin Ernest.

ALGERNON. Oh! I am not really wicked at all, cousin Cecily. You mustn't think that I am wicked.

CECILY. If you are not, then you have certainly been deceiving us all in a very inexcusable manner. I hope you have not been leading a double life, pretending to be wicked and being really good all the time. That would be hypocrisy.

ALGERNON. [*Looks at her in amazement.*] Oh! Of course I have been rather reckless.

CECILY. I am glad to hear it.

ALGERNON. In fact, now you mention the subject, I have been very bad in my own small way.

CECILY. I don't think you should be so proud of that, though I am sure it must have been very pleasant.

ALGERNON. It is much pleasanter being here with you.

CECILY. I can't understand how you are here at all. Uncle Jack won't be back till Monday afternoon.

ALGERNON. That is a great disappointment. I am obliged to go up by the first train on Monday morning. I have a business appointment that I am anxious . . . to miss?

CECILY. Couldn't you miss it anywhere but in London?

ALGERNON. No: the appointment is in London.

CECILY. Well, I know, of course, how important it is not to keep a business engagement, if one wants to retain any sense of the beauty of life, but still I think you had better wait till Uncle Jack arrives. I know he wants to speak to you about your emigrating.

ALGERNON. About my what?

CECILY. Your emigrating. He has gone up to buy your outfit.

ALGERNON. I certainly wouldn't let Jack buy my outfit. He has no taste in neckties at all.

CECILY. I don't think you will require neckties. Uncle Jack is sending you to Australia.

ALGERNON. Australia! I'd sooner die.

CECILY. Well, he said at dinner on Wednesday night, that you would have to choose between this world, the next world, and Australia.

ALGERNON. Oh, well! The accounts I have received of Australia and the next world, are not particularly encouraging. This world is good enough for me, cousin Cecily.

CECILY. Yes, but are you good enough for it?

ALGERNON. I'm afraid I'm not that. That is why I want you to reform me. You might make that your mission, if you don't mind, cousin Cecily.

CECILY. I'm afraid I've no time, this afternoon.

ALGERNON. Well, would you mind my reforming myself this afternoon?

CECILY. It is rather Quixotic of you. But I think you should try.

ALGERNON. I will. I feel better already.

CECILY. You are looking a little worse.

ALGERNON. That is because I am hungry.

CECILY. How thoughtless of me. I should have remembered that when one is going to lead an entirely new life, one requires regular and wholesome meals. Won't you come in?

ALGERNON. Thank you. Might I have a buttonhole first? I never have any appetite unless I have a buttonhole first.

CECILY. A Marechal Niel? [*Picks up scissors.*]

ALGERNON. No, I'd sooner have a pink rose.

CECILY. Why? [*Cuts a flower.*]

ALGERNON. Because you are like a pink rose, Cousin Cecily.

CECILY. I don't think it can be right for you to talk to me like that. Miss Prism never says such things to me.

ALGERNON. Then Miss Prism is a short-sighted old lady. [*CECILY puts the rose in his buttonhole.*] You are the prettiest girl I ever saw.

CECILY. Miss Prism says that all good looks are a snare.

ALGERNON. They are a snare that every sensible man would like to be caught in.

CECILY. Oh, I don't think I would care to catch a sensible man. I shouldn't know what to talk to him about.

[*They pass into the house. MISS PRISM and DR. CHASUBLE return.*]

MISS PRISM. You are too much alone, dear Dr. Chasuble. You should get married. A misanthrope I can understand—a womanthrope, never!

CHASUBLE. [*With a scholar's shudder.*] Believe me, I do not deserve so neologistic a phrase. The precept as well as the practice of the Primitive Church was distinctly against matrimony.

MISS PRISM. [*Sententiously.*] That is obviously the reason why the Primitive Church has not lasted up to the present day. And you do not seem to realise, dear Doctor, that by persistently remaining single, a man converts himself into a permanent public temptation. Men should be more careful; this very celibacy leads weaker vessels astray.

CHASUBLE. But is a man not equally attractive when married?

MISS PRISM. No married man is ever attractive except to his wife.

CHASUBLE. And often, I've been told, not even to her.

MISS PRISM. That depends on the intellectual sympathies of the woman. Maturity can always be depended on. Ripeness can be trusted. Young women are green. [*DR. CHASUBLE starts.*] I spoke horticulturally. My metaphor was drawn from fruits. But where is Cecily?

CHASUBLE. Perhaps she followed us to the schools.

[*Enter JACK slowly from the back of the garden. He is dressed in the deepest mourning, with crape hatband and black gloves.*]

MISS PRISM. Mr. Worthing!

CHASUBLE. Mr. Worthing?

MISS PRISM. This is indeed a surprise. We did not look for you till Monday afternoon.

JACK. [*Shakes MISS PRISM's hand in a tragic manner.*] I have returned sooner than I expected. Dr. Chasuble, I hope you are well?

CHASUBLE. Dear Mr. Worthing, I trust this garb of woe does not betoken some terrible calamity?

JACK. My brother.

MISS PRISM. More shameful debts and extravagance?

CHASUBLE. Still leading his life of pleasure?

JACK. [*Shaking his head.*] Dead!

CHASUBLE. Your brother Ernest dead?

JACK. Quite dead.

MISS PRISM. What a lesson for him! I trust he will profit by it.

CHASUBLE. Mr. Worthing, I offer you my sincere condolence. You have at least the consolation of knowing that you were always the most generous and forgiving of brothers.

JACK. Poor Ernest! He had many faults, but it is a sad, sad blow.

CHASUBLE. Very sad indeed. Were you with him at the end?

JACK. No. He died abroad; in Paris, in fact. I had a telegram last night from the manager of the Grand Hotel.

CHASUBLE. Was the cause of death mentioned?

JACK. A severe chill, it seems.

MISS PRISM. As a man sows, so shall he reap.

CHASUBLE. [*Raising his hand.*] Charity, dear Miss Prism, charity! None of us are perfect. I myself am peculiarly susceptible to draughts. Will the interment take place here?

JACK. No. He seems to have expressed a desire to be buried in Paris.

CHASUBLE. In Paris! [*Shakes his head.*] I fear that hardly points to any very serious state of mind at the last. You would no doubt wish me to make some slight allusion to this tragic domestic affliction next Sunday. [*JACK presses his hand convulsively.*] My sermon on the meaning of the manna in the wilderness can be adapted to almost any occasion, joyful, or, as in the present case, distressing. [*All sigh.*] I have preached it at harvest celebrations, christenings, confirmations, on days of humiliation and festal days. The last time I delivered it was in the Cathedral, as a charity sermon on behalf of the Society for the Prevention of Discontent among the Upper Orders. The Bishop, who was present, was much struck by some of the analogies I drew.

JACK. Ah! that reminds me, you mentioned christenings I think, Dr. Chasuble? I suppose you know how to christen all right? [*DR. CHASUBLE looks astounded.*] I mean, of course, you are continually christening, aren't you?

MISS PRISM. It is, I regret to say, one of the Rector's most constant duties in this parish. I have often spoken to the poorer classes on the subject. But they don't seem to know what thrift is.

CHASUBLE. But is there any particular infant in whom you are interested, Mr. Worthing? Your brother was, I believe, unmarried, was he not?

JACK. Oh yes.

MISS PRISM. [*Bitterly.*] People who live entirely for pleasure usually are.

JACK. But it is not for any child, dear Doctor. I am very fond of children. No! the fact is, I would like to be christened myself, this afternoon, if you have nothing better to do.

CHASUBLE. But surely, Mr. Worthing, you have been christened already?

JACK. I don't remember anything about it.

CHASUBLE. But have you any grave doubts on the subject?

JACK. I certainly intend to have. Of course I don't know if the thing would bother you in any way, or if you think I am a little too old now.

CHASUBLE. Not at all. The sprinkling, and, indeed, the immersion of adults is a perfectly canonical practice.

JACK. Immersion!

CHASUBLE. You need have no apprehensions. Sprinkling is all that is necessary, or indeed I think advisable. Our weather is so changeable. At what hour would you wish the ceremony performed?

JACK. Oh, I might trot round about five if that would suit you.

CHASUBLE. Perfectly, perfectly! In fact I have two similar ceremonies to perform at that time. A case of twins that occurred recently in one of the outlying cottages on your own estate. Poor Jenkins the carter, a most hard-working man.

JACK. Oh! I don't see much fun in being christened along with other babies. It would be childish. Would half-past five do?

CHASUBLE. Admirably! Admirably! [*Takes out watch.*] And now, dear Mr. Worthing, I will not intrude any longer into a house of sorrow. I would merely beg you not to be too much bowed down by grief. What seem to us bitter trials are often blessings in disguise.

MISS PRISM. This seems to me a blessing of an extremely obvious kind.

[*Enter CECILY from the house.*]

CECILY. Uncle Jack! Oh, I am pleased to see you back. But what horrid clothes you have got on! Do go and change them.

MISS PRISM. Cecily!

CHASUBLE. My child! my child! [*CECILY goes towards JACK; he kisses her brow in a melancholy manner.*]

CECILY. What is the matter, Uncle Jack? Do look happy! You look as if you had toothache, and I have got such a surprise for you. Who do you think is in the dining-room? Your brother!

JACK. Who?

CECILY. Your brother Ernest. He arrived about half an hour ago.

JACK. What nonsense! I haven't got a brother.

CECILY. Oh, don't say that. However badly he may have behaved to you in the past he is still your brother. You couldn't be so heartless as to disown him. I'll tell him to come out. And you will shake hands with him, won't you, Uncle Jack? [*Runs back into the house.*]

CHASUBLE. These are very joyful tidings.

MISS PRISM. After we had all been resigned to his loss, his sudden return seems to me peculiarly distressing.

JACK. My brother is in the dining-room? I don't know what it all means. I think it is perfectly absurd.

[*Enter ALGERNON and CECILY hand in hand. They come slowly up to JACK.*]

JACK. Good heavens! [*Motions ALGERNON away.*]

ALGERNON. Brother John, I have come down from town to tell you that I am very sorry for all the trouble I have given you, and that I intend to lead a better life in the future. [*JACK glares at him and does not take his hand.*]

CECILY. Uncle Jack, you are not going to refuse your own brother's hand?

JACK. Nothing will induce me to take his hand. I think his coming down here disgraceful. He knows perfectly well why.

CECILY. Uncle Jack, do be nice. There is some good in every one. Ernest has just been telling me about his poor invalid friend Mr. Bunbury whom he goes to visit so often. And surely there must be much good in one who is kind to an invalid, and leaves the pleasures of London to sit by a bed of pain.

JACK. Oh! he has been talking about Bunbury, has he?

CECILY. Yes, he has told me all about poor Mr. Bunbury, and his terrible state of health.

JACK. Bunbury! Well, I won't have him talk to you about Bunbury or about anything else. It is enough to drive one perfectly frantic.

ALGERNON. Of course I admit that the faults were all on my side. But I must say that I think that Brother John's coldness to me is peculiarly painful. I expected a more enthusiastic welcome, especially considering it is the first time I have come here.

CECILY. Uncle Jack, if you don't shake hands with Ernest I will never forgive you.

JACK. Never forgive me?

CECILY. Never, never, never!

JACK. Well, this is the last time I shall ever do it. [*Shakes with ALGERNON and glares.*]

CHASUBLE. It's pleasant, is it not, to see so perfect a reconciliation? I think we might leave the two brothers together.

MISS PRISM. Cecily, you will come with us.

CECILY. Certainly, Miss Prism. My little task of reconciliation is over.

CHASUBLE. You have done a beautiful action to-day, dear child.

MISS PRISM. We must not be premature in our judgments.

CECILY. I feel very happy. [*They all go off except JACK and ALGERNON.*]

JACK. You young scoundrel, Algy, you must get out of this place as soon as possible. I don't allow any Bunburying here.

[*Enter MERRIMAN.*]

MERRIMAN. I have put Mr. Ernest's things in the room next to yours, sir. I suppose that is all right?

JACK. What?

MERRIMAN. Mr. Ernest's luggage, sir. I have unpacked it and put it in the room next to your own.

JACK. His luggage?

MERRIMAN. Yes, sir. Three portmanteaus, a dressing-case, two hat-boxes, and a large luncheon-basket.

ALGERNON. I am afraid I can't stay more than a week this time.

JACK. Merriman, order the dog-cart at once. Mr. Ernest has been suddenly called back to town.

MERRIMAN. Yes, sir. [*Goes back into the house.*]

ALGERNON. What a fearful liar you are, Jack. I have not been called back to town at all.

JACK. Yes, you have.

ALGERNON. I haven't heard any one call me.

JACK. Your duty as a gentleman calls you back.

ALGERNON. My duty as a gentleman has never interfered with my pleasures in the smallest degree.

JACK. I can quite understand that.

ALGERNON. Well, Cecily is a darling.

JACK. You are not to talk of Miss Cardew like that. don't like it.

ALGERNON. Well, I don't like your clothes. You look perfectly ridiculous in them. Why on earth don't you go up and change? It is perfectly childish to be in deep mourning for a man who is actually staying for a whole week with you in your house as a guest. I call it grotesque.

JACK. You are certainly not staying with me for a whole week as a guest or anything else. You have got to leave . . . by the four-five train.

ALGERNON. I certainly won't leave you so long as you are in mourning. It would be most unfriendly. If I were in mourning you would stay with me, I suppose. I should think it very unkind if you didn't.

JACK. Well, will you go if I change my clothes?

ALGERNON. Yes, if you are not too long. I never saw anybody take so long to dress, and with such little result.

JACK. Well, at any rate, that is better than being always over-dressed as you are.

ALGERNON. If I am occasionally a little over-dressed, I make up for it by being always immensely over-educated.

JACK. Your vanity is ridiculous, your conduct an outrage, and your presence in my garden utterly absurd. However, you have got to catch the four-five, and I hope you will have a pleasant journey back to town. This Bunburying, as you call it, has not been a great success for you.

[*Goes into the house.*]

ALGERNON. I think it has been a great success. I'm in love with Cecily, and that is everything.

[*Enter CECILY at the back of the garden. She picks up the can and begins to water the flowers.*] But I must see her before I go, and make arrangements for another Bunbury. Ah, there she is.

CECILY. Oh, I merely came back to water the roses. I thought you were with Uncle Jack.

ALGERNON. He's gone to order the dog-cart for me.

CECILY. Oh, is he going to take you for a nice drive?

ALGERNON. He's going to send me away.

CECILY. Then have we got to part?

ALGERNON. I am afraid so. It's a very painful parting.

CECILY. It is always painful to part from people whom one has known for a very brief space of time. The absence of old friends one can endure with equanimity. But even a momentary separation from anyone to whom one has just been introduced is almost unbearable.

ALGERNON. Thank you.

[*Enter MERRIMAN.*]

MERRIMAN . The dog-cart is at the door, sir. [*ALGERNON looks appealingly at CECILY.*]

CECILY. It can wait, Merriman for . . . five minutes.

MERRIMAN. Yes, Miss. [*Exit MERRIMAN.*]

ALGERNON. I hope, Cecily, I shall not offend you if I state quite frankly and openly that you seem to me to be in every way the visible personification of absolute perfection.

CECILY. I think your frankness does you great credit, Ernest. If you will allow me, I will copy your remarks into my diary. [*Goes over to table and begins writing in diary.*]

ALGERNON. Do you really keep a diary? I'd give anything to look at it. May I?

CECILY. Oh no. [*Puts her hand over it.*] You see, it is simply a very young girl's record of her own thoughts and impressions, and consequently meant for publication. When it appears in volume form I hope you will order a copy. But pray, Ernest, don't stop. I delight in taking down from dictation. I have reached 'absolute perfection'. You can go on. I am quite ready for more.

ALGERNON. [*Somewhat taken aback.*] Ahem! Ahem!

CECILY. Oh, don't cough, Ernest. When one is dictating one should speak fluently and not cough. Besides, I don't know how to spell a cough. [*Writes as ALGERNON speaks.*]

ALGERNON. [*Speaking very rapidly.*] Cecily, ever since I first looked upon your wonderful and incomparable beauty, I have dared to love you wildly, passionately, devotedly, hopelessly.

CECILY. I don't think that you should tell me that you love me wildly, passionately, devotedly, hopelessly. Hopelessly doesn't seem to make much sense, does it?

ALGERNON. Cecily!

[*Enter* MERRIMAN.]

MERRIMAN. The dog-cart is waiting, sir.

ALGERNON. Tell it to come round next week, at the same hour.

MERRIMAN. [*Looks at* CECILY, *who makes no sign.*] Yes, sir.

[MERRIMAN *retires.*]

CECILY. Uncle Jack would be very much annoyed if he knew you were staying on till next week, at the same hour.

ALGERNON. Oh, I don't care about Jack. I don't care for anybody in the whole world but you. I love you, Cecily. You will marry me, won't you?

CECILY. You silly boy! Of course. Why, we have been engaged for the last three months.

ALGERNON. For the last three months?

CECILY. Yes, it will be exactly three months on Thursday.

ALGERNON. But how did we become engaged?

CECILY. Well, ever since dear Uncle Jack first confessed to us that he had a younger brother who was very wicked and bad, you of course have formed the chief topic of conversation between myself and Miss Prism. And of course a man who is much talked about is always very attractive. One feels there must be something in him, after all. I daresay it was foolish of me, but I fell in love with you, Ernest.

ALGERNON. Darling! And when was the engagement actually settled?

CECILY. On the 14th of February last. Worn out by your entire ignorance of my existence, I determined to end the matter one way or the other, and after a long struggle with myself I accepted you under this dear old tree here. The next day I bought this little ring in your name, and this is the little bangle with the true lover's knot I promised you always to wear.

ALGERNON. Did I give you this? It's very pretty, isn't it?

CECILY. Yes, you've wonderfully good taste, Ernest. It's the excuse I've always given for your leading such a bad life. And this is the box in which I keep all your dear letters. [*Kneels at table, opens box, and produces letters tied up with blue ribbon.*]

ALGERNON. My letters! But, my own sweet Cecily, I have never written you any letters.

CECILY. You need hardly remind me of that, Ernest. I remember only too well that I was forced to write your letters for you. I wrote always three times a week, and sometimes oftener.

ALGERNON. Oh, do let me read them, Cecily?

CECILY. Oh, I couldn't possibly. They would make you far too conceited. [*Replaces box.*] The three you wrote me after I had broken off the engagement are so beautiful, and so badly spelled, that even now I can hardly read them without crying a little.

ALGERNON. But was our engagement ever broken off?

CECILY. Of course it was. On the 22nd of last March. You can see the entry if you like. [*Shows diary.*] 'To-day I broke off my engagement with Ernest. I feel it is better to do so. The weather still continues charming.'

ALGERNON. But why on earth did you break it off? What had I done? I had done nothing at all. Cecily, I am very much hurt indeed to hear you broke it off. Particularly when the weather was so charming.

CECILY. It would hardly have been a really serious engagement if it hadn't been broken off at least once. But I forgave you before the week was out.

ALGERNON. [*Crossing to her, and kneeling.*] What a perfect angel you are, Cecily.

CECILY. You dear romantic boy. [*He kisses her, she puts her fingers through his hair.*] I hope your hair curls naturally, does it?

ALGERNON. Yes, darling, with a little help from others.

CECILY. I am so glad.

ALGERNON. You'll never break off our engagement again, Cecily?

CECILY. I don't think I could break it off now that I have actually met you. Besides, of course, there is the question of your name.

ALGERNON. Yes, of course. [*Nervously.*]

CECILY. You must not laugh at me, darling, but it had always been a girlish dream of mine to love some one whose name was Ernest. [ALGERNON *rises,* CECILY *also.*] There is something in that name that seems to inspire absolute confidence. I pity any poor married woman whose husband is not called Ernest.

ALGERNON. But, my dear child, do you mean to say you could not love me if I had some other name?

CECILY. But what name?

ALGERNON. Oh, any name you like—Algernon—for instance . . .

CECILY. But I don't like the name of Algernon.

ALGERNON. Well, my own dear, sweet, loving little darling, I really can't see why you should object to the name of Algernon. It is not at all a bad name. In fact, it is rather an aristocratic name. Half of the chaps who get into the Bankruptcy Court are called Algernon. But seriously, Cecily . . . [*Moving to her*] . . . if my name was Algy, couldn't you love me?

CECILY. [*Rising.*] I might respect you, Ernest, I might admire your character, but I fear that I should not be able to give you my undivided attention.

ALGERNON. Ahem! Cecily! [*Picking up hat.*] Your Rector here is, I suppose, thoroughly experienced in the practice of all the rites and ceremonials of the Church?

CECILY. Oh, yes. Dr. Chasuble is a most learned man. He has never written a single book, so you can imagine how much he knows.

ALGERNON. I must see him at once on a most important christening—I mean on most important business.

CECILY . Oh!

ALGERNON. I shan't be away more than half an hour.

CECILY. Considering that we have been engaged since February the 14th, and that I only met you to-day for the first time, I think it is rather hard that you should leave me for so long a period as half an hour. Couldn't you make it twenty minutes?

ALGERNON. I'll be back in no time.

[*Kisses her and rushes down the garden.*]

CECILY. What an impetuous boy he is! I like his hair so much. I must enter his proposal in my diary.

[*Enter MERRIMAN.*]

MERRIMAN. A Miss Fairfax has just called to see Mr. Worthing. On very important business, Miss Fairfax states.

CECILY. Isn't Mr. Worthing in his library?

MERRIMAN. Mr. Worthing went over in the direction of the Rectory some time ago.

CECILY. Pray ask the lady to come out here; Mr. Worthing is sure to be back soon. And you can bring tea.

MERRIMAN. Yes, Miss. [*Goes out.*]

CECILY. Miss Fairfax! I suppose one of the many good elderly women who are associated with Uncle Jack in some of his philanthropic work in London. I don't quite like women who are interested in philanthropic work. I think it is so forward of them.

[*Enter MERRIMAN.*]

MERRIMAN. Miss Fairfax.

[*Enter GWENDOLEN.*]

[*Exit MERRIMAN.*]

CECILY. [*Advancing to meet her.*] Pray let me introduce myself to you. My name is Cecily Cardew.

GWENDOLEN. Cecily Cardew? [*Moving to her and shaking hands.*] What a very sweet name! Something tells me that we are going to be great friends. I like you already more than I can say. My first impressions of people are never wrong.

CECILY. How nice of you to like me so much after we have known each other such a comparatively short time. Pray sit down.

GWENDOLEN. [*Still standing up.*] I may call you Cecily, may I not?

CECILY. With pleasure!

GWENDOLEN. And you will always call me Gwendolen, won't you?

CECILY. If you wish.

GWENDOLEN. Then that is all quite settled, is it not?

CECILY. I hope so. [*A pause. They both sit down together.*]

GWENDOLEN. Perhaps this might be a favourable opportunity for my mentioning who I am. My father is Lord Bracknell. You have never heard of papa, I suppose?

CECILY. I don't think so.

GWENDOLEN. Outside the family circle, papa, I am glad to say, is entirely unknown. I think that is quite as it should be. The home seems to me to be the proper sphere for the man. And certainly once a man begins to neglect his domestic duties he becomes painfully effeminate, does he not? And I don't like that. It makes men so very attractive.

Cecily, mamma, whose views on education are remarkably strict, has brought me up to be extremely short-sighted; it is part of her system; so do you mind my looking at you through my glasses?

CECILY. Oh! not at all, Gwendolen. I am very fond of being looked at.

GWENDOLEN. [*After examining* CECILY *carefully through a lorgnette*.] You are here on a short visit, I suppose.

CECILY. Oh no! I live here.

GWENDOLEN. [*Severely*.] Really? Your mother, no doubt, or some female relative of advanced years, resides here also?

CECILY. Oh no! I have no mother, nor, in fact, any relations.

GWENDOLEN. Indeed?

CECILY. My dear guardian, with the assistance of Miss Prism, has the arduous task of looking after me.

GWENDOLEN. Your guardian?

CECILY. Yes, I am Mr. Worthing's ward.

GWENDOLEN. Oh! It is strange he never mentioned to me that he had a ward. How secretive of him! He grows more interesting hourly. I am not sure, however, that the news inspires me with feelings of unmixed delight. [*Rising and going to her.*] I am very fond of you, Cecily; I have liked you ever since I met you! But I am bound to state that now that I know that you are Mr. Worthing's ward, I cannot help expressing a wish you were—well, just a little older than you seem to be—and not quite so very alluring in appearance. In fact, if I may speak candidly—

CECILY. Pray do! I think that whenever one has anything unpleasant to say, one should always be quite candid.

GWENDOLEN. Well, to speak with perfect candour, Cecily, I wish that you were fully forty-two, and more than usually plain for your age. Ernest has a strong upright nature. He is the very soul of truth and honour. Disloyalty would be as impossible to him as deception. But even men of the noblest possible moral character are extremely susceptible to the influence of the physical charms of others. Modern, no less than Ancient History, supplies us with many most painful examples of what I refer to. If it were not so, indeed, History would be quite unreadable.

CECILY. I beg your pardon, Gwendolen, did you say Ernest?

GWENDOLEN. Yes.

CECILY. Oh, but it is not Mr. Ernest Worthing who is my guardian. It is his brother—his elder brother.

GWENDOLEN. [*Sitting down again.*] Ernest never mentioned to me that he had a brother.

CECILY. I am sorry to say they have not been on good terms for a long time.

GWENDOLEN. Ah! that accounts for it. And now that I think of it I have never heard any man mention his brother. The subject seems distasteful to most men. Cecily, you have lifted a load from my mind. I was growing almost anxious. It would have been terrible if any cloud had come across a friendship like ours, would it not? Of course you are quite, quite sure that it is not Mr. Ernest Worthing who is your guardian?

CECILY. Quite sure. [*A pause.*] In fact, I am going to be his.

GWENDOLEN. [*Inquiringly.*] I beg your pardon?

CECILY. [*Rather shy and confidingly.*] Dearest Gwendolen, there is no reason why I should make a secret of it to you. Our little county newspaper is sure to chronicle the fact next week. Mr. Ernest Worthing and I are engaged to be married.

GWENDOLEN. [*Quite politely, rising.*] My darling Cecily, I think there must be some slight error. Mr. Ernest Worthing is engaged to me. The announcement will appear in the *Morning Post* on Saturday at the latest.

CECILY. [*Very politely, rising.*] I am afraid you must be under some misconception. Ernest proposed to me exactly ten minutes ago. [*Shows diary.*]

GWENDOLEN. [*Examines diary through her lorgnette carefully.*] It is certainly very curious, for he asked me to be his wife yesterday afternoon at 5.30. If you would care to verify the incident, pray do so. [*Produces diary of her own.*] I never travel without my diary. One should always have something sensational to read in the train. I am so sorry, dear Cecily, if it is any disappointment to you, but I am afraid I have the prior claim.

CECILY. It would distress me more than I can tell you, dear Gwendolen, if it caused you any mental or physical anguish, but I feel bound to point out

that since Ernest proposed to you he clearly has changed his mind.

GWENDOLEN. [*Meditatively.*] If the poor fellow has been entrapped into any foolish promise I shall consider it my duty to rescue him at once, and with a firm hand.

CECILY. [*Thoughtfully and sadly.*] Whatever unfortunate entanglement my dear boy may have got into, I will never reproach him with it after we are married.

GWENDOLEN. Do you allude to me, Miss Cardew, as an entanglement? You are presumptuous. On an occasion of this kind it becomes more than a moral duty to speak one's mind. It becomes a pleasure.

CECILY. Do you suggest, Miss Fairfax, that I entrapped Ernest into an engagement? How dare you? This is no time for wearing the shallow mask of manners. When I see a spade I call it a spade.

GWENDOLEN. [*Satirically.*] I am glad to say that I have never seen a spade. It is obvious that our social spheres have been widely different.

[*Enter* MERRIMAN, *followed by the footman. He carries a salver, table cloth, and plate stand.* CECILY *is about to retort. The presence of the servants exercises a restraining influence, under which both girls chafe.*]

MERRIMAN. Shall I lay tea here as usual, Miss?

CECILY. [*Sternly, in a calm voice.*] Yes, as usual. [MERRIMAN *begins to clear table and lay cloth. A long pause.* CECILY *and* GWENDOLEN *glare at each other.*]

GWENDOLEN. Are there many interesting walks in the vicinity, Miss Cardew?

CECILY. Oh! yes! a great many. From the top of one of the hills quite close one can see five counties.

GWENDOLEN. Five counties! I don't think I should like that; I hate crowds.

CECILY. [*Sweetly.*] I suppose that is why you live in town? [GWENDOLEN *bites her lip, and beats her foot nervously with her parasol.*]

GWENDOLEN. [*Looking round.*] Quite a well-kept garden this is, Miss Cardew.

CECILY. So glad you like it, Miss Fairfax.

GWENDOLEN . I had no idea there were any flowers in the country.

CECILY. Oh, flowers are as common here, Miss Fairfax, as people are in London.

GWENDOLEN. Personally I cannot understand how anybody manages to exist in the country, if anybody who is anybody does. The country always bores me to death.

CECILY. Ah! This is what the newspapers call agricultural depression, is it not? I believe the aristocracy are suffering very much from it just at present. It is almost an epidemic amongst them, I have been told. May I offer you some tea, Miss Fairfax?

GWENDOLEN. [*With elaborate politeness.*] Thank you. [*Aside.*] Detestable girl! But I require tea!

CECILY. [*Sweetly.*] Sugar?

GWENDOLEN . [*Superciliously.*] No, thank you. Sugar is not fashionable any more. [CECILY *looks angrily at her, takes up the tongs and puts four lumps of sugar into the cup.*]

CECILY. [*Severely.*] Cake or bread and butter?

GWENDOLEN. [*In a bored manner.*] Bread and butter, please. Cake is rarely seen at the best houses nowadays.

CECILY. [*Cuts a very large slice of cake, and puts it on the tray.*] Hand that to Miss Fairfax.

[MERRIMAN *does so, and goes out with footman.* GWENDOLEN *drinks the tea and makes a grimace. Puts down cup at once, reaches out her hand to the bread and butter, looks at it, and finds it is cake. Rises in indignation.*]

GWENDOLEN. You have filled my tea with lumps of sugar, and though I asked most distinctly for bread and butter, you have given me cake. I am known for the gentleness of my disposition, and the extraordinary sweetness of my nature, but I warn you, Miss Cardew, you may go too far.

CECILY. [*Rising.*] To save my poor, innocent, trusting boy from the machinations of any other girl there are no lengths to which I would not go.

GWENDOLEN. From the moment I saw you I distrusted you. I felt that you were false and deceitful. I am never deceived in such matters. My first impressions of people are invariably right.

CECILY. It seems to me, Miss Fairfax, that I am trespassing on your valuable time. No doubt you have many other calls of a similar character to make in the neighbourhood.

[*Enter* JACK.]

GWENDOLEN. [*Catching sight of him.*] Ernest! My own Ernest!

JACK. Gwendolen! Darling! [*Offers to kiss her.*]

GWENDOLEN. [*Draws back.*] A moment! May I ask if you are engaged to be married to this young lady? [*Points to* CECILY.]

JACK. [*Laughing.*] To dear little Cecily! Of course not! What could have put such an idea into your pretty little head?

GWENDOLEN. Thank you. You may! [*Offers her cheek.*]

CECILY. [*Very sweetly.*] I knew there must be some misunderstanding, Miss Fairfax. The gentleman whose arm is at present round your waist is my guardian, Mr. John Worthing.

GWENDOLEN. I beg your pardon?

CECILY. This is Uncle Jack.

GWENDOLEN. [*Receding.*] Jack! Oh!

[*Enter* ALGERNON.]

CECILY. Here is Ernest.

ALGERNON. [*Goes straight over to* CECILY *without noticing any one else.*] My own love! [*Offers to kiss her.*]

CECILY. [*Drawing back.*] A moment, Ernest! May I ask you—are you engaged to be married to this young lady?

ALGERNON. [*Looking round.*] To what young lady? Good heavens! Gwendolen!

CECILY. Yes! to good heavens, Gwendolen, I mean to Gwendolen.

ALGERNON. [*Laughing.*] Of course not! What could have put such an idea into your pretty little head?

CECILY. Thank you. [*Presenting her cheek to be kissed.*] You may. [ALGERNON *kisses her.*]

GWENDOLEN. I felt there was some slight error, Miss Cardew. The gentleman who is now embracing you is my cousin, Mr. Algernon Moncrieff.

CECILY. [*Breaking away from* ALGERNON.] Algernon Moncrieff! Oh! [*The two girls move towards each other and put their arms round each other's waists as if for protection.*]

CECILY. Are you called Algernon?

ALGERNON. I cannot deny it.

CECILY. Oh!

GWENDOLEN. Is your name really John?

JACK. [*Standing rather proudly.*] I could deny it if I liked. I could deny anything if I liked. But my name certainly is John. It has been John for years.

CECILY. [*To* GWENDOLEN.] A gross deception has been practised on both of us.

GWENDOLEN. My poor wounded Cecily!

CECILY. My sweet wronged Gwendolen!

GWENDOLEN. [*Slowly and seriously.*] You will call me sister, will you not? [*They embrace.* JACK *and* ALGERNON *groan and walk up and down.*]

CECILY. [*Rather brightly.*] There is just one question I would like to be allowed to ask my guardian.

GWENDOLEN. An admirable idea! Mr. Worthing, there is just one question I would like to be permitted to put to you. Where is your brother Ernest? We are both engaged to be married to your brother Ernest, so it is a matter of some importance to us to know where your brother Ernest is at present.

JACK. [*Slowly and hesitatingly.*] Gwendolen—Cecily—it is very painful for me to be forced to speak the truth. It is the first time in my life that I have ever been reduced to such a painful position, and I am really quite inexperienced in doing anything of the kind. However, I will tell you quite frankly that I have no brother Ernest. I have no brother at all. I never had a brother in my life, and I certainly have not the smallest intention of ever having one in the future.

CECILY. [*Surprised.*] No brother at all?

JACK. [*Cheerily.*] None!

GWENDOLEN. [*Severely.*] Had you never a brother of any kind?

JACK. [*Pleasantly.*] Never. Not even of an kind.

GWENDOLEN. I am afraid it is quite clear, Cecily, that neither of us is engaged to be married to any one.

CECILY. It is not a very pleasant position for a young girl suddenly to find herself in. Is it?

GWENDOLEN. Let us go into the house. They will hardly venture to come after us there.

CECILY. No, men are so cowardly, aren't they?

[*They retire into the house with scornful looks.*]

JACK. This ghastly state of things is what you call Bunburying, I suppose?

ALGERNON. Yes, and a perfectly wonderful Bunbury it is. The most wonderful Bunbury I have ever had in my life.

JACK. Well, you've no right whatsoever to Bunbury here.

ALGERNON. That is absurd. One has a right to Bunbury anywhere one chooses. Every serious Bunburyist knows that.

JACK. Serious Bunburyist! Good heavens!

ALGERNON. Well, one must be serious about something, if one wants to have any amusement in life. I happen to be serious about Bunburying. What on earth you are serious about I haven't got the remotest idea. About everything, I should fancy. You have such an absolutely trivial nature.

JACK. Well, the only small satisfaction I have in the whole of this wretched business is that your friend Bunbury is quite exploded. You won't be able to run down to the country quite so often as you used to do, dear Algy. And a very good thing too.

ALGERNON. Your brother is a little off colour, isn't he, dear Jack? You won't be able to disappear to London quite so frequently as your wicked custom was. And not a bad thing either.

JACK. As for your conduct towards Miss Cardew, I must say that your taking in a sweet, simple, innocent girl like that is quite inexcusable. To say nothing of the fact that she is my ward.

ALGERNON. I can see no possible defence at all for your deceiving a brilliant, clever, thoroughly experienced young lady like Miss Fairfax. To say nothing of the fact that she is my cousin.

JACK. I wanted to be engaged to Gwendolen, that is all. I love her.

ALGERNON. Well, I simply wanted to be engaged to Cecily. I adore her.

JACK. There is certainly no chance of your marrying Miss Cardew.

ALGERNON. I don't think there is much likelihood, Jack, of you and Miss Fairfax being united.

JACK. Well, that is no business of yours.

ALGERNON. If it was my business, I wouldn't talk about it. [Begins to eat muffins.] It is very vulgar to talk about one's business. Only people like stock-brokers do that, and then merely at dinner parties.

JACK. How can you sit there, calmly eating muffins when we are in this horrible trouble, I can't make out. You seem to me to be perfectly heartless.

ALGERNON. Well, I can't eat muffins in an agitated manner. The butter would probably get on my cuffs. One should always eat muffins quite calmly. It is the only way to eat them.

JACK. I say it's perfectly heartless your eating muffins at all, under the circumstances.

ALGERNON. When I am in trouble, eating is the only thing that consoles me. Indeed, when I am in really great trouble, as any one who knows me intimately will tell you, I refuse everything except food and drink. At the present moment I am eating muffins because I am unhappy. Besides, I am particularly fond of muffins. [Rising.]

JACK. [Rising.] Well, that is no reason why you should eat them all in that greedy way. [Takes muffins from ALGERNON.]

ALGERNON. [Offering tea-cake.] I wish you would have tea-cake instead. I don't like tea-cake.

JACK. Good heavens! I suppose a man may eat his own muffins in his own garden.

ALGERNON. But you have just said it was perfectly heartless to eat muffins.

JACK. I said it was perfectly heartless of you, under the circumstances. That is a very different thing.

ALGERNON. That may be. But the muffins are the same. [He seizes the muffin-dish from JACK.]

JACK. Algy, I wish to goodness you would go.

ALGERNON. You can't possibly ask me to go without having some dinner. It's absurd. I never go without my dinner. No one ever does, except vegetarians and people like that. Besides I have just made arrangements with Dr. Chasuble to be christened at a quarter to six under the name of Ernest.

JACK. My dear fellow, the sooner you give up that nonsense the better. I made arrangements this morning with Dr. Chasuble to be christened myself at 5.30, and I naturally will take the name of Ernest. Gwendolen would wish it. We can't both be christened Ernest. It's absurd. Besides, I have a perfect right to be christened if I like. There

is no evidence at all that I have ever been christened by anybody. I should think it extremely probable I never was, and so does Dr. Chasuble. It is entirely different in your case. You have been christened already.

ALGERNON. Yes, but I have not been christened for years.

JACK. Yes, but you have been christened. That is the important thing.

ALGERNON. Quite so. So I know my constitution can stand it. If you are not quite sure about your ever having been christened, I must say I think it rather dangerous your venturing on it now. It might make you very unwell. You can hardly have forgotten that some one very closely connected with you was very nearly carried off this week in Paris by a severe chill.

JACK. Yes, but you said yourself that a severe chill was not hereditary.

ALGERNON. It usen't to be, I know—but I daresay it is now. Science is always making wonderful improvements in things.

JACK. [*Picking up the muffin-dish.*] Oh, that is nonsense; you are always talking nonsense.

ALGERNON. Jack, you are at the muffins again! I wish you wouldn't. There are only two left. [*Takes them.*] I told you I was particularly fond of muffins.

JACK. But I hate tea-cake.

ALGERNON. Why on earth then do you allow tea-cake to be served up for your guests? What ideas you have of hospitality!

JACK. Algernon! I have already told you to go. I don't want you here. Why don't you go!

ALGERNON. I haven't quite finished my tea yet! and there is still one muffin left. [*JACK groans, and sinks into a chair. ALGERNON still continues eating.*]

ACT DROP

Third Act
Scene

Morning-room at the Manor House.

[*GWENDOLEN and CECILY are at the window, looking out into the garden.*]

GWENDOLEN. The fact that they did not follow us at once into the house, as any one else would have done, seems to me to show that they have some sense of shame left.

CECILY. They have been eating muffins. That looks like repentance.

GWENDOLEN. [*After a pause.*] They don't seem to notice us at all. Couldn't you cough?

CECILY. But I haven't got a cough.

GWENDOLEN. They're looking at us. What effrontery!

CECILY. They're approaching. That's very forward of them.

GWENDOLEN. Let us preserve a dignified silence.

CECILY. Certainly. It's the only thing to do now. [*Enter JACK followed by ALGERNON. They whistle some dreadful popular air from a British Opera.*]

GWENDOLEN. This dignified silence seems to produce an unpleasant effect.

CECILY. A most distasteful one.

GWENDOLEN. But we will not be the first to speak.

CECILY. Certainly not.

GWENDOLEN. Mr. Worthing, I have something very particular to ask you. Much depends on your reply.

CECILY. Gwendolen, your common sense is invaluable. Mr. Moncrieff, kindly answer me the following question. Why did you pretend to be my guardian's brother?

ALGERNON. In order that I might have an opportunity of meeting you.

CECILY. [*To GWENDOLEN.*] That certainly seems a satisfactory explanation, does it not?

GWENDOLEN. Yes, dear, if you can believe him.

CECILY. I don't. But that does not affect the wonderful beauty of his answer.

GWENDOLEN. True. In matters of grave importance, style, not sincerity is the vital thing. Mr. Worthing, what explanation can you offer to me for pretending to have a brother? Was it in order that you might have an opportunity of coming up to town to see me as often as possible?

JACK. Can you doubt it, Miss Fairfax?

GWENDOLEN. I have the gravest doubts upon the subject. But I intend to crush them. This is not the

moment for German scepticism. [*Moving to CECILY.*] Their explanations appear to be quite satisfactory, especially Mr. Worthing's. That seems to me to have the stamp of truth upon it.

CECILY. I am more than content with what Mr. Moncrieff said. His voice alone inspires one with absolute credulity.

GWENDOLEN. Then you think we should forgive them?

CECILY. Yes. I mean no.

GWENDOLEN. True! I had forgotten. There are principles at stake that one cannot surrender. Which of us should tell them? The task is not a pleasant one.

CECILY. Could we not both speak at the same time?

GWENDOLEN. An excellent idea! I nearly always speak at the same time as other people. Will you take the time from me?

CECILY. Certainly. [*GWENDOLEN beats time with uplifted finger.*]

GWENDOLEN. and **Cecily** [*Speaking together.*] Your Christian names are still an insuperable barrier. That is all!

JACK. and **Algernon** [*Speaking together.*] Our Christian names! Is that all? But we are going to be christened this afternoon.

GWENDOLEN. [*To JACK.*] For my sake you are prepared to do this terrible thing?

JACK. I am.

CECILY. [*To ALGERNON.*] To please me you are ready to face this fearful ordeal?

ALGERNON. I am!

GWENDOLEN. How absurd to talk of the equality of the sexes! Where questions of self-sacrifice are concerned, men are infinitely beyond us.

JACK. We are. [*Clasps hands with ALGERNON.*]

CECILY. They have moments of physical courage of which we women know absolutely nothing.

GWENDOLEN. [*To JACK.*] Darling!

ALGERNON. [*To CECILY.*] Darling! [*They fall into each other's arms.*]

[*Enter MERRIMAN. When he enters he coughs loudly, seeing the situation.*]

MERRIMAN. Ahem! Ahem! Lady Bracknell!

JACK. Good heavens!

[*Enter LADY BRACKNELL. The couples separate in alarm. Exit MERRIMAN.*]

LADY BRACKNELL. Gwendolen! What does this mean?

GWENDOLEN. Merely that I am engaged to be married to Mr. Worthing, mamma.

LADY BRACKNELL. Come here. Sit down. Sit down immediately. Hesitation of any kind is a sign of mental decay in the young, of physical weakness in the old. [*Turns to JACK.*] Apprised, sir, of my daughter's sudden flight by her trusty maid, whose confidence I purchased by means of a small coin, I followed her at once by a luggage train. Her unhappy father is, I am glad to say, under the impression that she is attending a more than usually lengthy lecture by the University Extension Scheme on the Influence of a permanent income on Thought. I do not propose to undeceive him. Indeed I have never undeceived him on any question. I would consider it wrong. But of course, you will clearly understand that all communication between yourself and my daughter must cease immediately from this moment. On this point, as indeed on all points, I am firm.

JACK. I am engaged to be married to Gwendolen Lady Bracknell!

LADY BRACKNELL. You are nothing of the kind, sir. And now, as regards Algernon! . . . Algernon!

ALGERNON. Yes, Aunt Augusta.

LADY BRACKNELL. May I ask if it is in this house that your invalid friend Mr. Bunbury resides?

ALGERNON. [*Stammering.*] Oh! No! Bunbury doesn't live here. Bunbury is somewhere else at present. In fact, Bunbury is dead.

LADY BRACKNELL. Dead! When did Mr. Bunbury die? His death must have been extremely sudden.

ALGERNON. [*Airily.*] Oh! I killed Bunbury this afternoon. I mean poor Bunbury died this afternoon.

LADY BRACKNELL. What did he die of?

ALGERNON. Bunbury? Oh, he was quite exploded.

LADY BRACKNELL. Exploded! Was he the victim of a revolutionary outrage? I was not aware that Mr. Bunbury was interested in social legislation. If so, he is well punished for his morbidity.

ALGERNON. My dear Aunt Augusta, I mean he was found out! The doctors found out that Bunbury could not live, that is what I mean—so Bunbury died.

LADY BRACKNELL. He seems to have had great confidence in the opinion of his physicians. I am glad, however, that he made up his mind at the last to some definite course of action, and acted under proper medical advice. And now that we have finally got rid of this Mr. Bunbury, may I ask, Mr. Worthing, who is that young person whose hand my nephew Algernon is now holding in what seems to me a peculiarly unnecessary manner?

JACK. That lady is Miss *Cecily Cardew, my ward.* [LADY BRACKNELL *bows coldly to* CECILY.]

ALGERNON. I am engaged to be married to Cecily, Aunt Augusta.

LADY BRACKNELLL. I beg your pardon?

CECILY. Mr. Moncrieff and I are engaged to be married, Lady Bracknell.

LADY BRACKNELL. [*With a shiver, crossing to the sofa and sitting down.*] I do not know whether there is anything peculiarly exciting in the air of this particular part of Hertfordshire, but the number of engagements that go on seems to me considerably above the proper average that statistics have laid down for our guidance. I think some preliminary inquiry on my part would not be out of place. Mr. Worthing, is Miss Cardew at all connected with any of the larger railway stations in London? I merely desire information. Until yesterday I had no idea that there were any families or persons whose origin was a Terminus. [JACK *looks perfectly furious, but restrains himself.*]

JACK. [*In a clear, cold voice.*] Miss Cardew is the grand-daughter of the late Mr. Thomas Cardew of 149 Belgrave Square, S.W.; Gervase Park, Dorking, Surrey; and the Sporran, Fifeshire, N.B.

LADY BRACKNELL. That sounds not unsatisfactory. Three addresses always inspire confidence, even in tradesmen. But what proof have I of their authenticity?

JACK. I have carefully preserved the Court Guides of the period. They are open to your inspection, Lady Bracknell.

LADY BRACKNELL. [*Grimly.*] I have known strange errors in that publication.

JACK. Miss Cardew's family solicitors are Messrs. Markby, Markby, and Markby.

LADY BRACKNELL. Markby, Markby, and Markby? A firm of the very highest position in their profession. Indeed I am told that one of the Mr. Markby's is occasionally to be seen at dinner parties. So far I am satisfied.

JACK. [*Very irritably.*] How extremely kind of you, Lady Bracknell! I have also in my possession, you will be pleased to hear, certificates of Miss Cardew's birth, baptism, whooping cough, registration, vaccination, confirmation, and the measles; both the German and the English variety.

LADY BRACKNELL. Ah! A life crowded with incident, I see; though perhaps somewhat too exciting for a young girl. I am not myself in favour of premature experiences. [*Rises, looks at her watch.*] Gwendolen! the time approaches for our departure. We have not a moment to lose. As a matter of form, Mr. Worthing, I had better ask you if Miss Cardew has any little fortune?

JACK. Oh! about a hundred and thirty thousand pounds in the Funds. That is all. Goodbye, Lady Bracknell. So pleased to have seen you.

LADY BRACKNELL. [*Sitting down again.*] A moment, Mr. Worthing. A hundred and thirty thousand pounds! And in the Funds! Miss Cardew seems to me a most attractive young lady, now that I look at her. Few girls of the present day have any really solid qualities, any of the qualities that last, and improve with time. We live, I regret to say, in an age of surfaces. [*To* CECILY.] Come over here, dear. [CECILY *goes across.*] Pretty child! your dress is sadly simple, and your hair seems almost as Nature might have left it. But we can soon alter all that. A thoroughly experienced French maid produces a really marvellous result in a very brief space of time. I remember recommending one to young Lady Lancing, and after three months her own husband did not know her.

JACK. And after six months nobody knew her.

LADY BRACKNELL. [*Glares at* JACK *for a few moments. Then bends, with a practised smile, to* CECILY.] Kindly turn round, sweet child. [CECILY *turns completely round.*] No, the side view is what I want. [CECILY *presents her profile.*] Yes, quite as I expected. There are distinct social possibilities in your profile. The two weak points in our age are its want of principle

and its want of profile. The chin a little higher, dear. Style largely depends on the way the chin is worn. They are worn very high, just at present. Algernon!

ALGERNON. Yes, Aunt Augusta!

LADY BRACKNELL. There are distinct social possibilities in Miss Cardew's profile.

ALGERNON. Cecily is the sweetest, dearest, prettiest girl in the whole world. And I don't care twopence about social possibilities.

LADY BRACKNELL. Never speak disrespectfully of Society, Algernon. Only people who can't get into it do that. [*To* CECILY.] Dear child, of course you know that Algernon has nothing but his debts to depend upon. But I do not approve of mercenary marriages. When I married Lord Bracknell I had no fortune of any kind. But I never dreamed for a moment of allowing that to stand in my way. Well, I suppose I must give my consent.

ALGERNON. Thank you, Aunt Augusta.

LADY BRACKNELL. Cecily, you may kiss me!

CECILY. [*Kisses her.*] Thank you, Lady Bracknell.

LADY BRACKNELL. You may also address me as Aunt Augusta for the future.

CECILY. Thank you, Aunt Augusta.

LADY BRACKNELL. The marriage, I think, had better take place quite soon.

ALGERNON. Thank you, Aunt Augusta.

CECILY. Thank you, Aunt Augusta.

LADY BRACKNELL. To speak frankly, I am not in favour of long engagements. They give people the opportunity of finding out each other's character before marriage, which I think is never advisable.

JACK. I beg your pardon for interrupting you, Lady Bracknell, but this engagement is quite out of the question. I am Miss Cardew's guardian, and she cannot marry without my consent until she comes of age. That consent I absolutely decline to give.

LADY BRACKNELL. Upon what grounds may I ask? Algernon is an extremely, I may almost say an ostentatiously, eligible young man. He has nothing, but he looks everything. What more can one desire?

JACK. It pains me very much to have to speak frankly to you, Lady Bracknell, about your nephew, but the fact is that I do not approve at all of his moral character. I suspect him of being untruthful. [ALGERNON *and* CECILY *look at him in indignant amazement.*]

LADY BRACKNELL. Untruthful! My nephew Algernon? Impossible! He is an Oxonian.

JACK. I fear there can be no possible doubt about the matter. This afternoon during my temporary absence in London on an important question of romance, he obtained admission to my house by means of the false pretence of being my brother. Under an assumed name he drank, I've just been informed by my butler, an entire pint bottle of my Perrier-Jouet, Brut, '89; wine I was specially reserving for myself. Continuing his disgraceful deception, he succeeded in the course of the afternoon in alienating the affections of my only ward. He subsequently stayed to tea, and devoured every single muffin. And what makes his conduct all the more heartless is, that he was perfectly well aware from the first that I have no brother, that I never had a brother, and that I don't intend to have a brother, not even of any kind. I distinctly told him so myself yesterday afternoon.

LADY BRACKNELL. Ahem! Mr. Worthing, after careful consideration I have decided entirely to overlook my nephew's conduct to you.

JACK. That is very generous of you, Lady Bracknell. My own decision, however, is unalterable. I decline to give my consent.

LADY BRACKNELL. [*To* CECILY.] Come here, sweet child. [CECILY *goes over.*] How old are you, dear?

CECILY. Well, I am really only eighteen, but I always admit to twenty when I go to evening parties.

LADY BRACKNELL. You are perfectly right in making some slight alteration. Indeed, no woman should ever be quite accurate about her age. It looks so calculating . . . [*In a meditative manner.*] Eighteen, but admitting to twenty at evening parties. Well, it will not be very long before you are of age and free from the restraints of tutelage. So I don't think your guardian's consent is, after all, a matter of any importance.

JACK. Pray excuse me, Lady Bracknell, for interrupting you again, but it is only fair to tell you that according to the terms of her grandfather's will Miss Cardew does not come legally of age till she is thirty-five.

LADY BRACKNELL. That does not seem to me to be a grave objection. Thirty-five is a very attractive age. London society is full of women of the very highest birth who have, of their own free choice, remained thirty-five for years. Lady Dumbleton is an instance in point. To my own knowledge she has been thirty-five ever since she arrived at the age of forty, which was many years ago now. I see no reason why our dear Cecily should not be even still more attractive at the age you mention than she is at present. There will be a large accumulation of property.

CECILY. Algy, could you wait for me till I was thirty-five?

ALGERNON. Of course I could, Cecily. You know I could.

CECILY. Yes, I felt it instinctively, but I couldn't wait all that time. I hate waiting even five minutes for anybody. It always makes me rather cross. I am not punctual myself, I know, but I do like punctuality in others, and waiting, even to be married, is quite out of the question.

ALGERNON. Then what is to be done, Cecily?

CECILY. I don't know, Mr. Moncrieff.

LADY BRACKNELL. My dear Mr. Worthing, as Miss Cardew states positively that she cannot wait till she is thirty-five—a remark which I am bound to say seems to me to show a somewhat impatient nature—I would beg of you to reconsider your decision.

JACK. But my dear Lady Bracknell, the matter is entirely in your own hands. The moment you consent to my marriage with Gwendolen, I will most gladly allow your nephew to form an alliance with my ward.

LADY BRACKNELL. [Rising and drawing herself up.] You must be quite aware that what you propose is out of the question.

JACK. Then a passionate celibacy is all that any of us can look forward to.

LADY BRACKNELL. That is not the destiny I propose for Gwendolen. Algernon, of course, can choose for himself. [Pulls out her watch.] Come, dear, [GWENDOLEN rises] we have already missed five, if not six, trains. To miss any more might expose us to comment on the platform.

[Enter DR. CHASUBLE.]

CHASUBLE. Everything is quite ready for the christenings.

LADY BRACKNELL. The christenings, sir! Is not that somewhat premature?

CHASUBLE. [Looking rather puzzled, and pointing to JACK and ALGERNON.] Both these gentlemen have expressed a desire for immediate baptism.

LADY BRACKNELL. At their age? The idea is grotesque and irreligious! Algernon, I forbid you to be baptized. I will not hear of such excesses. Lord Bracknell would be highly displeased if he learned that that was the way in which you wasted your time and money.

CHASUBLE. Am I to understand then that there are to be no christenings at all this afternoon?

JACK. I don't think that, as things are now, it would be of much practical value to either of us, Dr. Chasuble.

CHASUBLE. I am grieved to hear such sentiments from you, Mr. Worthing. They savour of the heretical views of the Anabaptists, views that I have completely refuted in four of my unpublished sermons. However, as your present mood seems to be one peculiarly secular, I will return to the church at once. Indeed, I have just been informed by the pew-opener that for the last hour and a half Miss Prism has been waiting for me in the vestry.

LADY BRACKNELL. [Starting.] Miss Prism! Did I hear you mention a Miss Prism?

CHASUBLE. Yes, Lady Bracknell. I am on my way to join her.

LADY BRACKNELL. Pray allow me to detain you for a moment. This matter may prove to be one of vital importance to Lord Bracknell and myself. Is this Miss Prism a female of repellent aspect, remotely connected with education?

CHASUBLE. [Somewhat indignantly.] She is the most cultivated of ladies, and the very picture of respectability.

LADY BRACKNELL. It is obviously the same person. May I ask what position she holds in your household?

CHASUBLE. [Severely.] I am a celibate, madam.

JACK. [Interposing.] Miss Prism, Lady Bracknell, has been for the last three years Miss Cardew's esteemed governess and valued companion.

LADY BRACKNELL. In spite of what I hear of her, I must see her at once. Let her be sent for.

CHASUBLE. [*Looking off.*] She approaches; she is nigh.

[*Enter MISS PRISM hurriedly.*]

MISS PRISM. I was told you expected me in the vestry, dear Canon. I have been waiting for you there for an hour and three-quarters. [*Catches sight of LADY BRACKNELL, who has fixed her with a stony glare. MISS PRISM grows pale and quails. She looks anxiously round as if desirous to escape.*]

LADY BRACKNELL. [*In a severe, judicial voice.*] Prism! [*MISS PRISM bows her head in shame.*] Come here, Prism! [*MISS PRISM approaches in a humble manner.*] Prism! Where is that baby? [*General consternation. The CANON starts back in horror. ALGERNON and JACK pretend to be anxious to shield CECILY and GWENDOLEN from hearing the details of a terrible public scandal.*] Twenty-eight years ago, Prism, you left Lord Bracknell's house, Number 104, Upper Grosvenor Street, in charge of a perambulator that contained a baby of the male sex. You never returned. A few weeks later, through the elaborate investigations of the Metropolitan police, the perambulator was discovered at midnight, standing by itself in a remote corner of Bayswater. It contained the manuscript of a three-volume novel of more than usually revolting sentimentality. [*MISS PRISM starts in involuntary indignation.*] But the baby was not there! [*Every one looks at MISS PRISM.*] Prism! Where is that baby? [*A pause.*]

MISS PRISM. Lady Bracknell, I admit with shame that I do not know. I only wish I did. The plain facts of the case are these. On the morning of the day you mention, a day that is for ever branded on my memory, I prepared as usual to take the baby out in its perambulator. I had also with me a somewhat old, but capacious hand-bag in which I had intended to place the manuscript of a work of fiction that I had written during my few unoccupied hours. In a moment of mental abstraction, for which I never can forgive myself, I deposited the manuscript in the basinette, and placed the baby in the hand-bag.

JACK. [*Who has been listening attentively.*] But where did you deposit the hand-bag?

MISS PRISM. Do not ask me, Mr. Worthing.

JACK. Miss Prism, this is a matter of no small importance to me. I insist on knowing where you deposited the hand-bag that contained that infant.

MISS PRISM. I left it in the cloak-room of one of the larger railway stations in London.

JACK. What railway station?

MISS PRISM. [*Quite crushed.*] Victoria. The Brighton line. [*Sinks into a chair.*]

JACK. I must retire to my room for a moment. Gwendolen, wait here for me.

GWENDOLEN. If you are not too long, I will wait here for you all my life. [*Exit JACK in great excitement.*]

CHASUBLE. What do you think this means, Lady Bracknell?

LADY BRACKNELL. I dare not even suspect, Dr. Chasuble. I need hardly tell you that in families of high position strange coincidences are not supposed to occur. They are hardly considered the thing.

[*Noises heard overhead as if some one was throwing trunks about. Every one looks up.*]

CECILY. Uncle Jack seems strangely agitated.

CHASUBLE. Your guardian has a very emotional nature.

LADY BRACKNELL. This noise is extremely unpleasant. It sounds as if he was having an argument. I dislike arguments of any kind. They are always vulgar, and often convincing.

CHASUBLE. [*Looking up.*] It has stopped now. [*The noise is redoubled.*]

LADY BRACKNELL. I wish he would arrive at some conclusion.

GWENDOLEN. This suspense is terrible. I hope it will last. [*Enter JACK with a hand-bag of black leather in his hand.*]

JACK. [*Rushing over to MISS PRISM.*] Is this the hand-bag, Miss Prism? Examine it carefully before you speak. The happiness of more than one life depends on your answer.

MISS PRISM. [*Calmly.*] It seems to be mine. Yes, here is the injury it received through the upsetting of a Gower Street omnibus in younger and happier days. Here is the stain on the lining caused by the explosion of a temperance beverage, an incident that occurred at Leamington. And here, on the lock, are my initials. I had forgotten that in an extravagant mood I had had them placed there. The bag is undoubtedly mine. I am delighted to have it so unexpectedly restored to me. It has been a great inconvenience being without it all these years.

JACK. [*In a pathetic voice.*] Miss Prism, more is restored to you than this hand-bag. I was the baby you placed in it.

MISS PRISM. [*Amazed.*] You?

JACK. [*Embracing her.*] Yes . . . mother!

MISS PRISM. [*Recoiling in indignant astonishment.*] Mr. Worthing! I am unmarried!

JACK. Unmarried! I do not deny that is a serious blow. But after all, who has the right to cast a stone against one who has suffered? Cannot repentance wipe out an act of folly? Why should there be one law for men, and another for women? Mother, I forgive you. [*Tries to embrace her again.*]

MISS PRISM. [*Still more indignant.*] Mr. Worthing, there is some error. [*Pointing to* LADY BRACKNELL.] There is the lady who can tell you who you really are.

JACK. [*After a pause.*] Lady Bracknell, I hate to seem inquisitive, but would you kindly inform me who I am?

LADY BRACKNELL. I am afraid that the news I have to give you will not altogether please you. You are the son of my poor sister, Mrs. Moncrieff, and consequently Algernon's elder brother.

JACK. Algy's elder brother! Then I have a brother after all. I knew I had a brother! I always said I had a brother! Cecily,—how could you have ever doubted that I had a brother? [*Seizes hold of* ALGERNON.] Dr. Chasuble, my unfortunate brother. Miss Prism, my unfortunate brother. Gwendolen, my unfortunate brother. Algy, you young scoundrel, you will have to treat me with more respect in the future. You have never behaved to me like a brother in all your life.

ALGERNON. Well, not till to-day, old boy, I admit. I did my best, however, though I was out of practice.

[*Shakes hands.*]

GWENDOLEN. [*To* JACK.] My own! But what own are you? What is your Christian name, now that you have become some one else?

JACK. Good heavens! . . . I had quite forgotten that point. Your decision on the subject of my name is irrevocable, I suppose?

GWENDOLEN. I never change, except in my affections.

CECILY. What a noble nature you have, Gwendolen!

JACK. Then the question had better be cleared up at once. Aunt Augusta, a moment. At the time when Miss Prism left me in the hand-bag, had I been christened already?

LADY BRACKNELL. Every luxury that money could buy, including christening, had been lavished on you by your fond and doting parents.

JACK. Then I was christened! That is settled. Now, what name was I given? Let me know the worst.

LADY BRACKNELL. Being the eldest son you were naturally christened after your father.

JACK. [*Irritably.*] Yes, but what was my father's Christian name?

LADY BRACKNELL. [*Meditatively.*] I cannot at the present moment recall what the General's Christian name was. But I have no doubt he had one. He was eccentric, I admit. But only in later years. And that was the result of the Indian climate, and marriage, and indigestion, and other things of that kind.

JACK. Algy! Can't you recollect what our father's Christian name was?

ALGERNON. My dear boy, we were never even on speaking terms. He died before I was a year old.

JACK. His name would appear in the Army Lists of the period, I suppose, Aunt Augusta?

LADY BRACKNELL. The General was essentially a man of peace, except in his domestic life. But I have no doubt his name would appear in any military directory.

JACK. The Army Lists of the last forty years are here. These delightful records should have been my constant study. [*Rushes to bookcase and tears the books out.*] M. Generals . . . Mallam, Maxbohm, Magley, what ghastly names they have—Markby, Migsby, Mobbs, Moncrieff! Lieutenant 1840, Captain, Lieutenant-Colonel, Colonel, General 1869, Christian names, Ernest John. [*Puts book very quietly down and speaks quite calmly.*] I always told you, Gwendolen, my name was Ernest, didn't I? Well, it is Ernest after all. I mean it naturally is Ernest.

LADY BRACKNELL. Yes, I remember now that the General was called Ernest, I knew I had some particular reason for disliking the name.

GWENDOLEN. Ernest! My own Ernest! I felt from the first that you could have no other name!

JACK. Gwendolen, it is a terrible thing for a man to find out suddenly that all his life he has been speaking nothing but the truth. Can you forgive me?

GWENDOLEN. I can. For I feel that you are sure to change.

JACK. My own one!

CHASUBLE. [*To Miss Prism.*] Lætitia! [*Embraces her*]

MISS PRISM. [*Enthusiastically.*] Frederick! At last!

ALGERNON. Cecily! [*Embraces her.*] At last!

JACK. Gwendolen! [*Embraces her.*] At last!

LADY BRACKNELL. My nephew, you seem to be displaying signs of triviality.

JACK. On the contrary, Aunt Augusta, I've now realised for the first time in my life the vital Importance of Being Earnest.

Cat on a Hot Tin Roof

Tennessee Williams: Poetry in Motion

Until the arrival of Eugene O'Neill, American drama was virtually ignored by the rest of the world. By the middle of the twentieth century, however, the United States was actually turning out some of the finest playwrights on the planet. This is largely thanks to the plays of three men: the above-mentioned O'Neill, Arthur Miller, and Tennessee Williams.

All three of these writers melded the realistic drama of Ibsen with some expressionist concepts. The net result is an interesting form of realism where environs and characters are skewed based on the psychology of those perceiving the action. Miller's masterpiece, *Death of a Salesman* was originally titled *The Inside of His Head* because it bounces through time and reality as Willy Loman progressively loses his grip on reality. While the atmosphere of these plays may be dreamlike and psychologically skewed, the characters who populate them are often very real, working-class people who are dealing with very real and tangible domestic and societal issues. Some academics have labeled this style of theatre as psychological realism.

While O'Neill and Miller enjoyed smashing success writing in this genre, Williams seemed the most comfortable with psychological realism and truly embraced the theatrical possibilities it allowed. He often called his plays memory plays, and he explored the world through his protagonist's eyes rather than from an omniscient perspective. This method served him quite well, and Williams is considered one of America's greatest playwrights. His works are produced all over the world every year in staggering numbers.

Born Thomas Lanier Williams in Columbus, Mississippi, he grew up a sickly child who was often bullied at school. While physically challenged, Williams's intellectual talents were vast. He published his first story when he was only sixteen. In 1940, Williams had his first commercial play, *Battle of Angels*, produced in Boston. The play received horrible reviews and was a flop. The young playwright refused to be deterred, and in 1945 his play *The Glass Menagerie* was a smash hit on Broadway. Williams went on to write a string of successes including *A Streetcar Named Desire*, *Cat on a Hot Tin Roof*, and *Night of the Iguana*. Several of his major plays were turned into Hollywood films, most notably *A Streetcar Named Desire* and *Cat on a Hot Tin Roof*.

Plays are merely blueprints for productions, and as great as they are, Williams's major plays owe much of their success to the production team of Elia Kazan and Jo Mielziner. Kazan, a former member of The Group Theatre, directed the Broadway productions of *A Streetcar Named Desire* and *Cat on a Hot Tin Roof*. Mielziner designed the sets for both of these productions. Mielziner's innovative sets and Kazan's ability to cast and direct amazing young talent gave these plays a live power that resonated with audiences and critics.

Over the course of his career, Williams won two Pulitzer Prizes, four New York Drama Critics Awards, a Tony Award, and an honorary doctorate from Harvard University. His plays and films brought us characters and quotes that remain ingrained in American culture. The list of actors involved in Williams's plays and films reads like a who's who of American performers in the twentieth century. Among those who brought some of Williams's remarkable characters to life are Marlon Brando, Elizabeth Taylor, Paul Newman, Katherine Hepburn, James Earl Jones, Bette Davis, Eli Wallach, Jessica Tandy, Geraldine Page, Burl Ives, Montgomery Clift, Tallulah Bankhead, Terrence Howard, and Maureen Stapleton.

Williams died in 1983, leaving behind a legacy of thirty full-length plays; numerous one-act plays; and several collections of poetry, essays, and short stories. Pulitzer Prize–winning playwright David Mamet called Williams's writing "the greatest dramatic poetry in the American language." Few would argue.

Cat on a Hot Tin Roof

Cat on a Hot Tin Roof takes place on a spacious plantation home in the Mississippi delta. Several generations of a family have gathered to celebrate the birthday of their patriarch, Big Daddy. All is not well in this family, despite Big Daddy's wealth and what should be a happy occasion. Much of the drama focuses on Big Daddy's son, Brick, and his beautiful wife, Margaret. Margaret carries the nickname Maggie the Cat because of her beauty and sensuality. Unfortunately for her, Brick isn't very interested in her. Brick is caught up in a secret that is tearing him apart. He hides in his room, drinking and trying to escape from his reality.

Brick isn't the only one with a secret, though. The entire family is keeping a huge secret from Big Daddy: his impending death. With the death of their patriarch looming large, the family seems to be scrambling for his affections, in the hopes of getting the biggest piece of the inheritance pie. Although Brick and Maggie seem to be favorites of the old man, their inability to produce a child is a major concern. Maggie must struggle to save her husband from self-destruction and secure a sound future for herself. As the tension rises, and lies can no longer remain hidden, a searing family conflict ignites the stage. Williams's emotional and poetic writing captures all the secrets, lies, infighting, love, sensuality, confusion, loyalty, and greed that surround this all-too-American family.

Williams wrote in his memoirs that *Cat on a Hot Tin Roof* was his favorite of his plays. Although Brick and Maggie are the focus of much of the play, Williams was quite proud of the character he had created in Big Daddy. The show was and remains a Williams favorite among audiences. Some scholars feel that part of the appeal of this play is due to the fact that Williams follows the neoclassical rules regarding the three unities of time, place, and action. While this may seem an awfully academic reason for a play's popularity, there is something to be said for a show that confines its drama to one location in a twenty-four-hour period and remains focused on a single plot line. It is a formula that has remained with us since the days of ancient Greek theatre, and many of the theatre's most enduring pieces seem to follow these basic tenets.

Oddly enough, the Broadway premiere of *Cat on a Hot Tin Roof* involved some pretty dramatic circumstances for a playwright of Williams's caliber. The production was directed by Elia Kazan, the famous director who brought Williams's *A Streetcar Named Desire* and Arthur Miller's *Death of a Salesman* to the Broadway stage. The original play ended on a much darker note than the one that hit the Broadway stage. Kazan argued with the playwright and insisted that several things be altered in the third act. Kazan also insisted that the play end on a more positive note. Finally, Williams relented and revised the play's concluding act. The version in this text is the one Williams rewrote for the Broadway premiere. Although he preferred his original ending, Williams later revealed that Kazan's version was the better of the two. Still, Williams insisted that later versions of the play were published with both endings so that directors and theatre companies could choose which version they wanted to stage.

The original Broadway production was a huge success and sparked a major Hollywood film with an all-star cast, featuring Paul Newman and Elizabeth Taylor. Oddly enough, Hollywood felt that the play's homosexual issues were too much to put on the silver screen, and the movie version of this play completely eliminates the issue of homosexuality. This leads us to the major debate that continues to surround this play. Critics are divided over the issue of Brick's homosexuality. Some feel it is essential to the play and is one of Williams's most compelling looks at what it is to be a homosexual man in a heterosexual world. Others feel that Williams's handling of the issue in this play is so subtle that it is actually a muddy and underdeveloped theme. As you read the play, see which side of this debate you fall on. Either way, the play remains enormously popular and is considered one of the three greatest plays by one of the most important playwrights of the twentieth century.

Food for Thought

As you read the play, consider the following questions:

1. Many of Williams's plays deal with the gentility of the old South coming to terms with the new, industrialized world of the twentieth century. Does *Cat on a Hot Tin Roof* deal with this theme? How so? What does Williams seem to be saying about this conflict in *Cat on a Hot Tin Roof*?
2. Like most great plays, *Cat on a Hot Tin Roof* explores a number of themes. If you were going to direct this play, which theme would your production focus on? Try to boil your major theme for this play down to a single sentence. Why do you think your choice is an important theme to explore?
3. Fast-forward to three years after this play ends. What do you think has become of Brick and Maggie? Why?
4. In spite of Brick's obvious problems, why do you suppose Big Daddy seems to favor Brick and Maggie much more than Gooper and Mae?
5. Why do you think Maggie chooses to stay with Brick? She's a beautiful, desired woman, and Brick seems to be a source of constant disappointment. What does Maggie want?

Fun Facts

1. In 1947, Williams became the first playwright to win the Pulitzer Prize, the Donaldson Award, and the New York Drama Critics Circle Award in the same year.
2. The title *Cat on a Hot Tin Roof* came from a remark Williams's father made about how nervous his wife made him.
3. Williams said the ideal person to play the role of Big Daddy would have been his own father, Cornelius Williams.
4. In 2008, Debbie Allen directed a Broadway revival of *Cat on a Hot Tin Roof* featuring an all African American cast. The all-star cast included James Earl Jones, Phylicia Rashad, Terrence Howard, and Anika Noni Rose.

Cat on a Hot Tin Roof

Tennessee Williams

Act One

At the rise of the curtain someone is taking a shower in the bathroom, the door of which is half open. A pretty young woman, with anxious lines in her face, enters the bedroom and crosses to the bathroom door.

MARGARET (*shouting above roar of water*). One of those no-neck monsters hit me with a hot buttered biscuit so I have t' change!

MARGARET'S *voice is both rapid and drawling. In her long speeches she has the vocal tricks of a priest delivering a liturgical chant, the lines are almost sung, always continuing a little beyond her breath so she has to gasp for another. Sometimes she intersperses the lines with a little wordless singing, such as "Da-da-daaaa!"*

Water turns off and BRICK *calls out to her, but is still unseen. A tone of politely feigned interest, masking indifference, or worse, is characteristic of his speech with Margaret.*

BRICK. Wha'd you say, Maggie? Water was on s' loud I couldn't hearya. . . .

MARGARET. Well, I!—just remarked that!—one of th' no-neck monsters messed up m' lovely lace dress so I got t'—cha-a-ange. . . .

She opens and kicks shut drawers of the dresser.

BRICK. Why d'ya call Gooper's kiddies no-neck monsters?

MARGARET. Because they've got no necks! Isn't that a good enough reason?

BRICK. Don't they have any necks?

MARGARET. None visible. Their fat little heads are set on their fat little bodies without a bit of connection.

BRICK. That's too bad.

MARGARET. Yes, it's too bad because you can't wring their necks if they've got no necks to wring! Isn't that right, honey?

She steps out of her dress, stands in a slip of ivory satin and lace.

Yep, they're no-neck monsters, all no-neck people are monsters . . .

Children shriek downstairs.

Hear them? Hear them screaming? I don't know where their voice boxes are located since they don't have necks. I tell you I got so nervous at that table tonight I thought I would throw back my head and utter a scream you could hear across the Arkansas border an' parts of Louisiana an' Tennessee. I said to your charming sister-in-law, Mae, honey, couldn't you feed those precious little things at a separate table with an oilcloth cover? They make such a mess an' the lace cloth looks *so* pretty! She made enormous eyes at me and said, "Ohhh, noooooo! On Big Daddy's birthday? Why, he would never forgive me!" Well, I want you to know, Big Daddy hadn't been at the table two minutes with those five no-neck monsters slobbering and drooling over their food before he' threw down his fork an' shouted, "Fo' God's sake, Gooper, why don't you put them pigs at a trough in th' kitchen?"—Well, I swear, I simply could have di-ieed!

Think of it, Brick, they've got five of them and number six is coming. They've brought the whole bunch down here like animals to display at a county fair. Why, they have those children doin' tricks all the time! "Junior, show Big Daddy how you do this, show Big Daddy how you do that, say your little piece fo' Big Daddy, Sister. Show your dimples, Sugar. Brother, show Big Daddy how you stand on your head!"—It goes on all the time, along with constant little remarks and innuendos about the fact that you and I have not produced any children, are totally childless and therefore totally useless!—Of course it's comical but it's also disgusting since it's so obvious what they're up to!

BRICK (*without interest*). What are they up to, Maggie?

MARGARET. Why, you know what they're up to!

BRICK (*appearing*). No, I don't know what they're up to.

He stands there in the bathroom doorway drying his hair with a towel and hanging onto the towel rack because one ankle is broken, plastered and bound. He is still slim and firm as a boy. His liquor hasn't started tearing him down outside. He has the additional charm of that cool air of detachment that people have who have given up the struggle. But now and then, when disturbed, something flashes behind it, like lightning in a fair sky, which shows that at some deeper level he is far from peaceful. Perhaps in a stronger light he would show some signs of deliquescence, but the fading, still warm, light from the gallery treats him gently.

MARGARET. I'll tell you what they're up to, boy of mine!—They're up to cutting you out of your father's estate, and—

She freezes momentarily before her next remark. Her voice drops as if it were somehow a personally embarrassing admission.

—Now we know that Big Daddy's dyin' of—*cancer.* . . .

There are voices on the lawn below: long-drawn calls across distance. Margaret raises her lovely bare arms and powders her armpits with a light sigh.

She adjusts the angle of a magnifying mirror to straighten an eyelash, then rises fretfully saying:

There's so much light in the room it—

BRICK (*softly but sharply*). Do we?

MARGARET. Do we what?

BRICK. Know Big Daddy's dyin' of cancer?

MARGARET. Got the report today.

BRICK. Oh . . .

MARGARET (*letting down bamboo blinds which cast long, gold-fretted shadows over the room*). Yep, got th' report just now . . . it didn't surprise me, Baby. . . .

Her voice has range, and music; sometimes it drops low as a boy's and you have a sudden image of her playing boy's games as a child.

I recognized the symptoms soon's we got here last spring and I'm willin' to bet you that Brother Man

and his wife were pretty sure of it, too. That more than likely explains why their usual summer migration to the coolness of the Great Smokies was passed up this summer in favor of—hustlin' down here ev'ry whipstitch with their whole screamin' tribe! And why so many allusions have been made to Rainbow Hill lately. You know what Rainbow Hill is? Place that's famous for treatin' alcoholics an dope fiends in the movies!

BRICK. I'm not in the movies.

MARGARET. No, and you don't take dope. Otherwise you're a perfect candidate for Rainbow Hill, Baby, and that's where they aim to ship you—over my dead body! Yep, over my dead body they'll ship you there, but nothing would please them better. Then Brother Man could get a-hold of the purse strings and dole out remittances to us, maybe get power of attorney and sign checks for us and cut off our credit wherever, whenever he wanted! Son-of-a-bitch!—How'd you like that, Baby?—Well, you've been doin' just about ev'rything in your power to bring it about, you've just been doin' ev'rything you can think of to aid and abet them in this scheme of theirs! Quittin' work, devoting yourself to the occupation of drinkin'!—Breakin' your ankle last night on the high school athletic field: doin' what? Jumpin' hurdles? At two or three in the morning? Just fantastic! Got in the paper. *Clarksdale Register* carried a nice little item about it, human interest story about a well-known former athlete stagin' a one-man track meet on the Glorious Hill High School athletic field last night, but was slightly out of condition and didn't clear the first hurdle! Brother Man Gooper claims he exercised his influence t' keep it from goin' out over AP or UP or every goddam "P."

But, Brick? You still have one big advantage!

During the above swift flood of words, BRICK *has reclined with contrapuntal leisure on the snowy surface of the bed and has rolled over carefully on his side or belly.*

BRICK (*wryly*). Did you *say* something, Maggie?

MARGARET. Big Daddy dotes on you, honey. And he can't stand Brother Man and Brother Man's wife, that monster of fertility, Mae. Know how I know? By little expressions that flicker over his face when that woman is holding fo'th on one of her choice topics such as—how she refused twilight sleep!—when the twins were delivered! Because she feels motherhood's an experience

that a woman ought to experience fully!—in order to fully appreciate the wonder and beauty of it! HAH!—and how she made Brother Man come in an' stand beside her in the delivery room so he would not miss out on the "wonder and beauty" of it either!—producin' those no-neck monsters. . . .

A speech of this kind would be antipathetic from almost anybody but MARGARET; *she makes it oddly funny, because her eyes constantly twinkle and her voice shakes with laughter which is basically indulgent.*

—Big Daddy shares my attitude toward those two! As for me, well—I give him a laugh now and then and he tolerates me. In fact!—I sometimes suspect that Big Daddy harbors a little unconscious "lech" fo' me. . . .

BRICK. What makes you think that Big Daddy has a lech for you, Maggie?

MARGARET. Way he always drops his eyes down my body when I'm talkin' to him, drops his eyes to my boobs an' licks his old chops! Ha ha!

BRICK. That kind of talk is disgusting.

MARGARET. Did anyone ever tell you that you're an ass-aching Puritan, Brick?
I think it's mighty fine that that ole fellow, on the doorstep of death, still takes in my shape with what I think is deserved appreciation!
And you wanta know something else? Big Daddy didn't know how many little Maes and Goopers had been produced! "How many kids have you got?" he asked at the table, just like Brother Man and his wife were new acquaintances to him! Big Mama said he was jokin', but that ole boy wasn't jokin', Lord, no!
And when they infawmed him that they had five already and were turning out number six!—the news seemed to come as a sort of unpleasant surprise . . .

Children yell below.

Scream, monsters!

Turns to BRICK *with a sudden, gay, charming smile which fades as she notices that be is not looking at her but into fading gold space with a troubled expression.*

It is constant rejection that makes her bumor "bitchy."

Yes, you should have been at that supper-table, Baby.

Whenever she calls him "baby" the word is a soft caress.

Y'know, Big Daddy, bless his ole sweet soul, he's the dearest ole thing in the world, but he does hunch over his food as if he preferred not to notice anything else. Well, Mae an' Gooper were side by side at the table, direckly across from Big Daddy, watchin' his face like hawks while they jawed an' jabbered about the cuteness an' brillance of th' no-neck monsters!

She giggles with a hand fluttering at her throat and her breast and her long throat arched.

She comes downstage and recreates the scene with voice and gesture.

And the no-neck monsters were ranged around the table, some in high chairs and some on th' *Books of Knowledge*, all in fancy little paper caps in honor of Big Daddy's birthday, and all through dinner, well, I want you to know that Brother Man an' his partner never once, for one moment, stopped exchanging pokes an' pinches an' kicks an' signs an' signals!—Why, they were like a couple of cardsharps fleecing a sucker.—Even Big Mama, bless her ole sweet soul, she isn't th' quickest an' brightest thing in the world, she finally noticed, at last, an' said to Gooper, "Gooper, what are you an' Mae makin' all these signs at each other about?"—I swear t' goodness, I nearly choked on my chicken!

MARGARET, *back at the dressing table, still doesn't see* BRICK. *He is watching her with a look that is not quite definable—Amused? shocked? contemptuous?—part of those and part of something else.*

Y'know—your brother Gooper still cherishes the illusion he took a giant step up on the social ladder when he married Miss Mae Flynn of the Memphis Flynns.
But I have a piece of Spanish news for Gooper. The Flynns never had a thing in this world but money and they lost that, they were nothing at all but fairly successful climbers. Of course, Mae Flynn came out in Memphis eight years before I made my debut in Nashville, but I had friends at Ward-Belmont who came from Memphis and they used to come to see me and I used to go to see them for Christmas and spring vacations, and so I know who rates an' who doesn't rate in Memphis society. Why, y'know ole Papa Flynn, he barely escaped doing time in the Federal pen for shady manipulations on th' stock market when his chain stores crashed, and as for Mae having

been a cotton carnival queen, as they remind us so often, lest we forget, well, that's one honor that I don't envy her for!—Sit on a brass throne on a tacky float an' ride down Main Street, smilin', bowin', and blowin' kisses to all the trash on the street—

She picks out a pair of jeweled sandals and rushes to the dressing table.

Why, year before last, when Susan McPheeters was singled out fo' that honor, y' know what happened to her? Y'know what happened to poor little Susie McPheeters?

BRICK [*absently*]. No. What happened to little Susie McPheeters?

MARGARET. Somebody spit tobacco juice in her face.

BRICK (*dreamily*). Somebody spit tobacco juice in her face?

MARGARET. That's right, some old drunk leaned out of a window in the Hotel Gayoso and yelled, "Hey, Queen, hey, hey, there, Queenie!" Poor Susie looked up and flashed him a radiant smile and he shot out a squirt of tobacco juice right in poor Susie's face.

BRICK. Well, what d'you know about that.

MARGARET (*gaily*). What do I know about it? I was there, I saw it!

BRICK (*absently*). Must have been kind of funny.

MARGARET. Susie didn't think so. Had hysterics. Screamed like a banshee. They had to stop th' parade an' remove her from her throne an' go on with—

She catches sight of him in the mirror, gasps slightly, wheels about to face him. Count ten.

—Why are you looking at me like that?

BRICK (*whistling softly, now*). Like what, Maggie?

MARGARET (*intensely, fearfully*). The way y' were lookin' at me just now, befo' I caught your eye in the mirror and you started t' whistle! I don't know how t' d escribe it but it froze my blood!—I've caught you lookin' at me like that so often lately. What are you thinkin' of when you look at me like that?

BRICK. I wasn't conscious of lookin' at you, Maggie.

MARGARET. Well, I was conscious of it! What were you thinkin'?

BRICK. I don't remember thinking of anything, Maggie.

MARGARET. Don't you think I know that—? Don't you—?—Think I know that—?

BRICK (*coolly*). Know *what*, Maggie?

MARGARET (*struggling for expression*). That I've gone through this—*hideous!*—transformation, become—hard! Frantic!

Then she adds, almost tenderly.

—*cruel!!*
That's what you've been observing in me lately. How could y' help but observe it? That's all right. I'm not—thin-skinned any more, can't afford t' be thin-skinned any more.

She is now recovering her power.

—But Brick? Brick?

BRICK. Did you say something?

MARGARET. I was *goin'* t' say something: that I get—lonely. Very!

BRICK. Ev'rybody gets that . . .

MARGARET. Living with someone you love can be lonelier—than living entirely *alone!*—if the one that y' love doesn't love you. . . .

There is a pause. BRICK *bobbles downstage and asks, without looking at her.*

BRICK. Would you like to live alone, Maggie?

Another pause: then—after she has caught a quick, hurt breath:

MARGARET. *No!—God!—I wouldn't!*

Another gasping breath. She forcibly controls what must have been an impulse to cry out. We see her deliberately, very forcibly, going all the way back to the world in which you can talk about ordinary matters.

Did you have a nice shower?

BRICK. Uh-huh.

MARGARET. Was the water cool?

BRICK. No.

MARGARET. But it made y' feel fresh, huh?

BRICK. Fresher. . . .

MARGARET. I know something would make y' feel *much* fresher!

BRICK. What?

MARGARET. An alcohol rub. Or cologne, a rub with cologne!

BRICK. That's good after a workout but I haven't been workin' out, Maggie.

MARGARET. You've kept in good shape, though.

BRICK (*indifferently*). You think so, Maggie?

MARGARET. I always thought drinkin' men lost their looks, but I was plainly mistaken.

BRICK (*wryly*). Why; thanks, Maggie.

MARGARET. You're the only drinkin' man I know that it never seems t' put fat on.

BRICK. I'm gettin' softer, Maggie.

MARGARET. Well, sooner or later it's bound to soften you up. It was just beginning to soften up Skipper when—

She stops short.

I'm sorry. I never could keep my fingers off a sore— I wish you *would* lose your looks. If you did it would make the martyrdom of Saint Maggie a little more bearable. But no such goddam luck. I actually believe you've gotten better looking since you've gone on the bottle. Yeah, a person who didn't know you would think you'd never had a tense nerve in your body or a strained muscle.

There are sounds of croquet on the lawn below: the click of mallets, light voices, near and distant.

Of course, you always had that detached quality as if you were playing a game without much concern over whether you won or lost, and now that you've lost the game, not lost but just quit playing, you have that rare sort of charm that usually only happens in very old or hopelessly sick people, the charm of the defeated.— You look so cool, so cool, so enviably cool.

REVEREND TOOKER (*off stage right*). Now looka here, boy, lemme show you how to get outa that!

MARGARET. They're playing croquet. The moon has appeared and it's white, just beginning to turn a little bit yellow. . . .

You were a wonderful lover. . . .
Such a wonderful person to go to bed with, and I think mostly because you were really indifferent to it. Isn't that right? Never had any anxiety about it, did it naturally, easily, slowly, with absolute confidence and perfect calm, more like opening a door for a lady or seating her at a table than giving expression to any longing for her. Your indifference made you wonderful at lovemaking—*strange?*—but true. . . .

REVEREND TOOKER. Oh! That's a beauty.

DOCTOR BAUGH. Yeah. I got you boxed.

MARGARET. You know, if I thought you would never, never, *never* make love to me again—I would go downstairs to the kitchen and pick out the longest and sharpest knife I could find and stick it straight into my heart, I swear that I would!

REVEREND TOOKER. Watch out, you're gonna miss it.

DOCTOR BAUGH. You just don't know me, boy!

MARGARET. But one thing I don't have is the charm of the defeated, my hat is still in the ring, and I am determined to win!

There is the sound of croquet mallets hitting croquet balls.

REVEREND TOOKER. Mmm—You're too slippery for me.

MARGARET. —What is the victory of a cat on a hot tin roof?—I wish I knew. . . .
Just staying on it, I guess, as long as she can. . . .

DOCTOR BAUGH. Jus' like an eel, boy, jus' like an eel!

More croquet sounds.

MARGARET. Later tonight I'm going to tell you I love you an' maybe by that time you'll be drunk enough to believe me. Yes, they're playing croquet. . . .
Big Daddy is dying of cancer. . . .
What were you thinking of when I caught you looking at me like that? Were you thinking of Skipper?

BRICK takes up his crutch, rises.

Oh, excuse me, forgive me, but laws of silence don't work! No, laws of silence don't work. . . .

BRICK crosses to the bar, takes a quick drink, and rubs his head with a towel.

Laws of silence don't work. . . .
When something is festering in your memory or your imagination, laws of silence don't work, it's just like shutting a door and locking it on a house on fire in hope of forgetting that the house is burning. But not facing a fire doesn't put it out. Silence about a thing just magnifies it. It grows and festers in silence, becomes malignant. . . .

He drops his crutch.

BRICK. Give me my crutch.

He has stopped rubbing his hair dry but still stands hanging onto the towel rack in a white towel-cloth robe.

MARGARET. Lean on me.

BRICK. No, just give me my crutch.

MARGARET. Lean on my shoulder.

BRICK. *I don't want to lean on your shoulder, I want my crutch!*

This is spoken like sudden lightning.

Are you going to give me my crutch or do I have to get down on my knees on the floor and—

MARGARET. *Here, here, take it, take it!*

She has thrust the crutch at him.

BRICK *(bobbling out).* Thanks . . .

MARGARET. We mustn't scream at each other, the walls in this house have ears. . . .

He bobbles directly to liquor cabinet to get a new drink.

—but that's the first time I've heard you raise your voice in a long time, Brick. A crack in the wall?— Of composure?
—I think that's a good sign. . . .
A sign of nerves in a player on the defensive!

Brick turns and smiles at her coolly over his fresh drink.

BRICK. It just hasn't happened yet, Maggie.

MARGARET. What?

BRICK. The click I get in my head when I've had enough of this stuff to make me peaceful. . . .
Will you do me a favor?

MARGARET. Maybe I will. What favor?

BRICK. Just, just keep your voice down!

MARGARET *(in a boarse whisper).* I'll do you that favor, I'll speak in a whisper, if not shut up completely, if *you* will do *me* a favor and make that drink your last one till after the party.

BRICK. What party?

MARGARET. Big Daddy's birthday party.

BRICK. Is this Big Daddy's birthday?

MARGARET. You know this is Big Daddy's birthday!

BRICK. No, I don't, I forgot it.

MARGARET. Well, I remembered it for you. . . .

They are both speaking as breathlessly as a pair of kids after a fight, drawing deep exhausted breaths and looking at each other with faraway eyes, shaking and panting together as if they had broken apart from a violent struggle.

BRICK. Good for you, Maggie.

MARGARET. You just have to scribble a few lines on this card.

BRICK. You scribble something, Maggie.

MARGARET. It's got to be your handwriting; it's your present, I've given him my present; it's got to be your handwriting!

The tension between them is building again, the voices becoming shrill once more.

BRICK. I didn't get him a present.

MARGARET. I got one for you.

BRICK. All right. You write the card, then.

MARGARET. And have him know you didn't remember his birthday?

BRICK. I didn't remember his birthday.

MARGARET. You don't have to prove you didn't!

BRICK. I don't want to fool him about it.

MARGARET. Just write "Love, Brick!" for God's—

BRICK. No.

MARGARET. You've *got* to!

BRICK. I don't have to do anything I don't want to do. You keep forgetting the conditions on which I agreed to stay on living with you.

MARGARET *(out before she knows it).* I'm not living with you. We occupy the same cage.

BRICK. You've got to remember the conditions agreed on.

SONNY (*off stage*). Mommy, give it to me. I had it first.

MAE. Hush.

MARGARET. They're impossible conditions!

BRICK. Then why don't you—?

SONNY. I want it, I want it!

MAE. Get away!

MARGARET. HUSH! Who is out there? Is somebody at the door?

There are footsteps in hall.

MAE (*outside*). May I enter a moment?

MARGARET. Oh, *you!* Sure. Come in, Mae.

MAE *enters bearing aloft the bow of a young lady's archery set.*

MAE. Brick, is this thing yours?

MARGARET. Why, Sister Woman—that's my Diana Trophy. Won it at the intercollegiate archery contest on the Ole Miss campus.

MAE. It's a mighty dangerous thing to leave exposed round a house full of nawmal rid-blooded children attracted t'weapons.

MARGARET. "Nawmal rid-blooded children attracted t'weapons" ought t'be taught to keep their hands off things that don't belong to them.

MAE. Maggie, honey, if you had children of your own you'd know how funny that is. Will you please lock this up and put the key out of reach?

MARGARET. Sister Woman, nobody is plotting the destruction of your kiddies. —Brick and I still have our special archers' license. We're goin' deer-huntin' on Moon Lake as soon as the season starts. I love to run with dogs through chilly woods, run, run leap over obstructions—

She goes into the closet carrying the bow.

MAE. How's the injured ankle, Brick?

BRICK. Doesn't hurt. Just itches.

MAE. Oh, my! Brick—Brick, you should've been downstairs after supper! Kiddies put on a show. Polly played the piano, Buster an' Sonny drums, an' then they turned out the lights an' Dixie an'

Trixie puhfawmed a toe dance in fairy costume with *spahkluhs!* Big Daddy just beamed! He just beamed!

MARGARET (*from the closet with a sharp laugh*). Oh, I bet. It breaks my heart that we missed it!

She reenters.

But Mae? Why did y' give dawgs' names to all your kiddies?

MAE. *Dogs'* names?

MARGARET (*sweetly*). Dixie, Trixie, Buster, Sonny, Polly!— Sounds like four dogs and a parrot . . .

MAE. Maggie?

MARGARET *turns with a smile.*

Why are you so catty?

MARGARET. Cause I'm a cat! But why can't *you* take a joke, Sister Woman?

MAE. Nothin' pleases me more than a joke that's funny. You know the real names of our kiddies. Buster's real name is Robert. Sonny's real name is Saunders. Trixie's real name is Marlene and Dixie's—

GOOPER *downstairs calls for her.* "Hey, Mae! Sister Woman, intermission is over!"—*She rushes to door, saying:*

Intermission is over! See ya later!

MARGARET. I wonder what Dixie's real name is?

BRICK. Maggie, being catty doesn't help things any . . .

MARGARET. I know! WHY!—Am I so catty?—Cause I'm consumed with envy an' eaten up with longing?—Brick, I'm going to lay out your beautiful Shantung silk suit from Rome and one of your monogrammed silk shirts. I'll put your cuff links in it, those lovely star sapphires I get you to wear so rarely. . . .

BRICK. I can't get trousers on over this plaster cast.

MARGARET. Yes, you can, I'll help you.

BRICK. I'm not going to get dressed, Maggie.

MARGARET. Will you just put on a pair of white silk pajamas?

BRICK. Yes, I'll do that, Maggie.

MARGARET. *Thank* you, thank you so *much!*

BRICK. Don't mention it.

MARGARET. *Oh, Brick!* How long does it have t' go on? This punishment? Haven't I done time enough, haven't I served my term, can't I apply for a—pardon?

BRICK. Maggie, you're spoiling my liquor. Lately your voice always sounds like you'd been running upstairs to warn somebody that the house was on fire!

MARGARET. Well, no wonder, no wonder. Y'know what I feel like, Brick?

I feel all the time like a cat on a hot tin roof!

BRICK. Then jump off the roof, jump off it, cats can jump off roofs and land on their four feet uninjured!

MARGARET. Oh, yes!

BRICK. Do it!—fo' God's sake, do it . . .

MARGARET. Do what?

BRICK. Take a lover!

MARGARET. I can't see a man but you! Even with my eyes closed, I just see you! Why don't you get ugly, Brick, why don't you please get fat or ugly or something so I could stand it?

She rushes to hall door, opens it, listens.

The concert is still going on! Bravo, no-necks, bravo!

She slams and locks door fiercely.

BRICK. What did you lock the door for?

MARGARET. To give us a little privacy for a while.

BRICK. You know better, Maggie.

MARGARET. No, I don't know better. . . .

She rushes to gallery doors, draws the rose-silk drapes across them.

BRICK. Don't make a fool of yourself.

MARGARET. I don't mind makin' a fool of myself over you!

BRICK. I mind, Maggie. I feel embarrassed for you.

MARGARET. Feel embarrassed! But don't continue my torture. I can't live on and on under these circumstances.

BRICK. You agreed to—

MARGARET. I know but—

BRICK. —Accept that condition!

MARGARET. *I CAN'T! CAN'T! CAN'T!*

She seizes his shoulder.

BRICK. Let go!

He breaks away from her and seizes the small boudoir chair and raises it like a lion-tamer facing a big circus cat.

Count five. She stares at him with her fist pressed to her mouth, then bursts into shrill, almost hysterical laughter. He remains grave for a moment, then grins and puts the chair down.

BIG MAMA calls through closed door.

BIG MAMA. Son? Son? Son?

BRICK. What is it, Big Mama?

BIG MAMA (*outside*). Oh, son! We got the most wonderful news about Big Daddy. I just had t' run up an' tell you right this—

She rattles the knob.

—What's this door doin', locked, faw? You all think there's robbers in the house?

MARGARET. Big Mama, Brick is dressin', he's not dressed yet.

BIG MAMA. That's all right, it won't be the first time I've seen Brick not dressed. Come on, open this door!

MARGARET, *with a grimace, goes to unlock and open the hall door, as* BRICK *hobbles rapidly to the bathroom and kicks the door shut.* BIG MAMA *has disappeared from the hall.*

MARGARET. Big Mama?

BIG MAMA *appears through the opposite gallery doors behind* MARGARET, *huffing and puffing like an old bulldog. She is a short, stout woman; her sixty years and 170 pounds have left her somewhat breathless most of the time; she's always tensed like a boxer, or rather, a Japanese wrestler. Her "family" was maybe a little superior to* BIG DADDY'S, *but not much. She wears a black or silver lace dress and at least half a million in flashy gems. She is very sincere.*

BIG MAMA (*loudly, startling Margaret*). Here—I come through Gooper's and Mae's gall'ry door. Where's Brick? *Brick*—Hurry on out of there, son, I just have a second and want to give you the news about Big Daddy.—I hate locked doors in a house. . . .

MARGARET (*with affected lightness*). I've noticed you do, Big Mama, but people have got to have *some* moments of privacy, don't they?

BIG MAMA. No, ma'ma, not in *my* house. (*without pause*) Whacha took off you' dress faw? I thought that little lace dress was so sweet on yuh, honey.

MARGARET. I thought it looked sweet on me, too, but one of m' cute little table-partners used it for a napkin so—!

BIG MAMA (*picking up stockings on floor*). What?

MARGARET. You know, Big Mama, Mae and Gooper's so touchy about those children—thanks, Big Mama . . .

BIG MAMA *has thrust the picked-up stockings in* MARGARET'S *hand with a grunt.*

—that you just don't dare to suggest there's any room for improvement in their—

BIG MAMA. Brick, hurry out!—Shoot, Maggie, you just don't like children.

MARGARET. I do SO like children! Adore them!—well brought up!

BIG MAMA (*gentle—loving*). Well, why don't you have some and bring them up well, then, instead of all the time pickin' on Gooper's an' Mae's?

GOOPER (*shouting up the stairs*). Hey, hey, Big Mama, Betsy an' Hugh got to go, waitin' t' tell yuh g'by!

BIG MAMA. Tell 'em to hold their hawses, I'll be right down in a jiffy!

GOOPER. Yes ma'am!

She turns to the bathroom door and calls out.

BIG MAMA. Son? Can you hear me in there?

There is a muffled answer.

We just got the full report from the laboratory at the Ochsner Clinic, completely negative, son, ev'rything negative, right on down the line! Nothin' a-tall's wrong with him but some little functional thing called a spastic colon. Can you hear me, son?

MARGARET. He can hear you, Big Mama.

BIG MAMA. Then why don't he say something? God Almighty, a piece of news like that should make him shout. It made *me* shout, I can tell you. I shouted and sobbed and fell right down on my knees!—Look!

She pulls up her skirt.

See the bruises where I hit my kneecaps? Took both doctors to haul me back on my feet!

She laughs—she always laughs like hell at herself.

Big Daddy was furious with me! But ain't that wonderful news?

Facing bathroom again, she continues:

After all the anxiety we been through to git a report like that on Big Daddy's birthday? Big Daddy tried to hide how much of a load that news took off his mind, but didn't fool *me*. He was mighty close to crying about it *himself!*

Goodbyes are shouted downstairs, and she rushes to door.

GOOPER. Big Mama!

BIG MAMA. *Hold those people down there, don't let them go!*—Now, git dressed, we're all comin' up to this room fo' Big Daddy's birthday party because of your ankle.—How's his ankle, Maggie?

MARGARET. Well, he broke it, Big Mama.

BIG MAMA. I know he broke it.

A phone is ringing in hall. A Negro voice answers: "Mistuh Polly's res'dence."

I mean does it hurt him much still.

MARGARET. I'm afraid I can't give you that information, Big Mama. You'll have to ask Brick if it hurts much still or not.

SOOKEY (*in the hall*). It's Memphis, Mizz Polly, it's Miss Sally in Memphis.

BIG MAMA. Awright, Sookey.

BIG MAMA *rushes into the hall and is heard shouting on the phone:*

Hello, Miss Sally. How are you, Miss Sally?—Yes, well, I was just gonna call you about it. Shoot!—

MARGARET. Brick, don't!

Big Mama raises her voice to a bellow.

BIG MAMA. *Miss Sally? Don't ever call me from the Gayoso Lobby, too much talk goes on in that hotel lobby, no wonder you can't hear me! Now listen, Miss Sally. They's nothin' serious wrong with Big Daddy. We got the report just now, they's nothin' wrong but a thing called a—spastic! SPASTIC!—colon . . .*

She appears at the hall door and calls to Margaret.

—Maggie, come out here and talk to that fool on the phone. I'm shouted breathless!

MARGARET (*goes out and is heard sweetly at phone*). Miss Sally? This is Brick's wife, Maggie. So nice to hear your voice. Can you hear *mine?* Well, *good!*—Big Mama just wanted you to know that they've got the report from the Ochsner Clinic and what Big Daddy has is a spastic colon. Yes. Spastic colon, Miss Sally. That's right, spastic colon. *G'bye, Miss Sally, hope I'll see you real soon!*

Hangs up a little before MISS SALLY *was probably ready to terminate the talk. She returns through the hall door.*

She heard me perfectly. I've discovered with deaf people the thing to do is not shout at them but just enunciate clearly. My rich old Aunt Cornelia was deaf as the dead but I could make her hear me just by sayin' each word slowly, distinctly, close to her ear. I read her the *Commercial Appeal* ev'ry night, read her the classified ads in it, even, she never missed a word of it. But was she a mean ole thing! Know what I got when she died? Her unexpired subscriptions to five magazines and the Book-of-the-Month Club and a LIBRARY full of ev'ry dull book ever written! All else went to her hellcat of a sister . . . meaner than she was, even!

BIG MAMA *has been straightening things up in the room during this speech.*

BIG MAMA (*closing closet door on discarded clothes*). Miss Sally sure is a case! Big Daddy says she's always got her hand out fo' something. He's not mistaken. That poor ole thing always has her hand out fo' somethin'. I don't think Big Daddy gives her as much as he should.

GOOPER. Big Mama! Come on now! Betsy and Hugh can't wait no longer!

BIG MAMA (*shouting*). I'm comin'!

She starts out. At the hall door, turns and jerks a fore-finger, first toward the bathroom door, then toward the liquor cabinet, meaning: "Has BRICK *been drinking?"* MARGARET *pretends not to understand, cocks her head and raises her brows as if the pantomimic performance was completely mystifying to her.*

BIG MAMA *rushes back to* MARGARET:

Shoot! Stop playin' so dumb!—I mean has he been drinkin' that stuff much yet?

MARGARET [*with a little laugh*]. Oh! I think he had a highball after supper.

BIG MAMA. Don't laugh about it!—Some single men stop drinkin' when they git married and others start! Brick never touched liquor before he—!

MARGARET (*crying out*). THAT'S NOT FAIR!

BIG MAMA. Fair or not fair I want to ask you a question, one question: D'you make Brick happy in bed?

MARGARET. Why don't you ask if he makes *me* happy in bed?

BIG MAMA. Because I know that—

MARGARET. *It works both ways!*

BIG MAMA. Something's not right! You're childless and my son drinks!

GOOPER. Come on, Big Mama!

GOOPER *has called her downstairs and she has rushed to the door on the line above. She turns at the door and points at the bed.*

—When a marriage goes on the rocks, the rocks are *there*, right *there!*

MARGARET. *That's*—

BIG MAMA *has swept out of the room and slammed the door.*

—not—*fair* . . .

MARGARET *is alone, completely alone, and she feels it. She draws in, hunches her shoulders, raises her arms with fists clenched, shuts her eyes tight as a child about to be stabbed with a vaccination needle. When she opens her eyes again, what she sees is the long oval mirror and she rushes straight to it, stares into it with a grimace and says: "Who are you?"—Then she crouches a little and answers herself in a different voice which is high, thin, mocking: "I am Maggie the Cat!"—Straightens quickly as bathroom door opens a little and Bricks calls out to her.*

BRICK. Has Big Mama gone?

MARGARET. She's gone.

He opens the bathroom door and hobbles out, with his liquor glass now empty, straight to the liquor cabinet. He is whistling softly. MARGARET'S *head pivots on her long, slender throat to watch him.*

She raises a hand uncertainly to the base of her throat, as if it was difficult for her to swallow, before she speaks.

You know, our sex life didn't just peter out in the usual way, it was cut off short, long before the natural time for it to, and it's going to revive again, just as sudden as that. I'm confident of it. That's what I'm keeping myself attractive for. For the time when you'll see me again like other men see me. Yes, like other men see me. They still see me, Brick, and they like what they see. Uh-huh. Some of them would give their—
Look, Brick!

She stands before the long oval mirror, touches her breast and then her hips with her two hands.

How high my body stays on me!—Nothing has fallen on me—not a fraction. . . .

Her voice is soft and trembling: a pleading child's. At this moment as he turns to glance at her—a look which is like a player passing a ball to another player, third down and goal to go—she has to capture the audience in a grip so tight that she can hold it till the first intermission without any lapse of attention.

Other men still want me. My face looks strained, sometimes, but I've kept my figure as well as you've kept yours, and men admire it. I still turn heads on the street. Why, last week in Memphis everywhere that I went men's eyes burned holes in my clothes, at the country club and in restaurants and department stores, there wasn't a man I met or walked by that didn't just eat me up with his eyes and turn around when I passed him and look back at me. Why, at Alice's party for her New York cousins, the best-lookin' man in the crowd—followed me upstairs and tried to force his way in the powder room with me, followed me to the door and tried to force his way in!

BRICK. Why didn't you let him, Maggie?

MARGARET. Because I'm not that common, for one thing. Not that I wasn't almost tempted to. You like to know who it was? It was Sonny Boy Maxwell, that's who!

BRICK. Oh, yeah, Sonny Boy Maxwell, he was a good end-runner but had a little injury to his back and had to quit.

MARGARET. He has no injury now and has no wife and still has a lech for me!

BRICK. I see no reason to lock him out of a powder room in that case.

MARGARET. And have someone catch me at it? I'm not that stupid. Oh, I might sometime cheat on you with someone, since you're so insultingly eager to have me do it!—But if I do, you can be damned sure it will be in a place and a time where no one but me and the man could possibly know. Because I'm not going to give you any excuse to divorce me for being unfaithful or anything else. . . .

BRICK. Maggie, I wouldn't divorce you for being unfaithful or anything else. Don't you know that? Hell. I'd be relieved to know that you'd found yourself a lover.

MARGARET. Well, I'm taking no chances. No, I'd rather stay on this hot tin roof.

BRICK. A hot tin roof's 'n uncomfo'table place t' stay on. . . .

He starts to whistle softly.

MARGARET (*through his whistle*). Yeah, but I can stay on it just as long as I have to.

BRICK. You could leave me, Maggie.

He resumes whistle. She wheels about to glare at him.

MARGARET. *Don't want to and will not!* Besides if I did, you don't have a cent to pay for it but what you get from Big Daddy and he's dying of cancer!

For the first time a realization of BIG DADDY's doom seems to penetrate to BRICK's consciousness, visibly, and he looks at MARGARET.

BRICK. Big Mama just said he *wasn't*, that the report was okay.

MARGARET. That's what she thinks because she got the same story that they gave Big Daddy. And was just as taken in by it as he was, poor ole things. . . . But tonight they're going to tell her the truth about it. When Big Daddy goes to bed, they're going to tell her that he is dying of cancer.

She slams the dresser drawer.

—It's malignant and it's terminal.

BRICK. Does Big Daddy know it?

MARGARET. Hell, do they *ever* know it? Nobody says, "You're dying." You have to fool them. They have to fool *themselves*.

BRICK. Why?

MARGARET. *Why?* Because human beings dream of life everlasting, that's the reason! But most of them want it on earth and not in heaven.

He gives a short, hard laugh at her touch of humor.

Well. . . . (*She touches up her mascara*). That's how it is, anyhow. . . . (*She looks about*). Where did I put down my cigarette? Don't want to burn up the home-place, at least not with Mae and Gooper and their five monsters in it!

She has found it and sucks at it greedily. Blows out smoke and continues:

So this is Big Daddy's last birthday. And Mae and Gooper, they know it, oh, *they* know it, all right. They got the first information from the Ochsner Clinic. That's why they rushed down here with their no-neck monsters. Because. Do you know something? Big Daddy's made no will? Big Daddy's never made out any will in his life, and so this campaign's afoot to impress him, forcibly as possible, with the fact that you drink and I've borne no children!

He continues to stare at her a moment, then mutters something sharp but not audible and hobbles rather rapidly out onto the long gallery in the fading, much faded, gold light.

MARGARET (*continuing her liturgical chant*). Y'know, I'm *fond* of Big Daddy, I am genuinely fond of that old man, I really *am*, you know. . . .

BRICK (*faintly, vaguely*). Yes, I know you are. . . .

MARGARET. I've always sort of admired him in spite of his coarseness, his four-letter words and so forth. Because Big Daddy *is* what he *is*, and he makes no bones about it. He hasn't turned gentleman farmer, he's still a Mississippi redneck, as much of a redneck as he must have been when he was just overseer here on the old Jack Straw and Peter Ochello place. But he got hold of it an' built it into th' biggest an' finest plantation in the Delta. —I've always *liked* Big Daddy. . . .

She crosses to the proscenium.

Well, this is Big Daddy's last birthday. I'm sorry about it. But I'm facing the facts. It takes money to take care of a drinker and that's the office that I've been elected to lately.

BRICK. You don't have to take care of me.

MARGARET. Yes, I do. Two people in the same boat have got to take care of each other. At least you want money to buy more Echo Spring when this supply is exhausted, or will you be satisfied with a ten-cent beer?
Mae an' Gooper are plannin' to freeze us out of Big Daddy's estate because you drink and I'm childless. But we can defeat that plan. We're *going* to defeat that plan!
Brick, y'know, I've been so God damn disgustingly poor all my life!—That's the *truth*, Brick!

BRICK. I'm not sayin' it isn't.

MARGARET. Always had to suck up to people I couldn't stand because they had money and I was poor as Job's turkey. You don't know what that's like. Well, I'll tell you, it's like you would feel a thousand miles away from Echo Spring!—And had to get back to it on that broken ankle . . . without a crutch!
That's how it feels to be as poor as Job's turkey and have to suck up to relatives that you hated because they had money and all you had was a bunch of hand-me-down clothes and a few old moldly three-per-cent government bonds. My daddy loved his liquor, he fell in love with his liquor the way you've fallen in love with Echo Spring!—And my poor Mama, having to maintain some semblance of social position, to keep appearances up, on an income of one hundred and fifty dollars a month on those old government bonds!
When I came out, the year that I made my debut, I had just two evening dresses! One Mother made me from a pattern in *Vogue*, the other a hand-me-down from a snotty rich cousin I hated!
—The dress that I married you in was my grand-mother's weddin' gown. . . .
So that's why I'm like a cat on a hot tin roof!

Brick is still on the gallery. Someone below calls up to him in a warm Negro voice, "Hiya, Mistuh BRICK, how yuh feelin'?" BRICK raises his liquor glass as if that answered the question.

MARGARET. You can be young without money, but you can't be old without it. You've got to be old *with* money because to be old without it is just too awful, you've got to be one or the other, either *young* or *with money*, you can't be old and *without* it.—That's the *truth*, Brick. . . .

BRICK whistles softly, vaguely.

Well, now I'm dressed, I'm all dressed, there's nothing else for me to do.

Forlornly, almost fearfully.

I'm dressed, all dressed, nothing else for me to do. . . .

She moves about restlessly, aimlessly, and speaks, as if to herself.

What am I—? Oh!—my bracelets. . . .

She starts working a collection of bracelets over her hands onto her wrists, about six on each, as she talks.

I've thought a whole lot about it and now I know when I made my mistake. Yes, I made my mistake when I told you the truth about that thing with Skipper. Never should have confessed it, a fatal error, tellin' you about that thing with Skipper.

BRICK. Maggie, shut up about Skipper. I mean it, Maggie; you got to shut up about Skipper.

MARGARET. You ought to understand that Skipper and I—

BRICK. You don't think I'm serious, Maggie? You're fooled by the fact that I am saying this quiet? Look, Maggie. What you're doing is a dangerous thing to do. You're—you're—you're—foolin' with something that-nobody ought to fool with.

MARGARET. This time I'm going to finish what I have to say to you. Skipper and I made love, if love you could call it, because it made both of us feel a little bit closer to you. You see, you son of a bitch, you asked too much of people, of me, of him, of all the unlucky poor damned sons of bitches that happen to love you, and there was a whole pack of them, yes, there was a pack of them besides me and Skipper, you asked too goddam much of people that loved you, you—superior creature!—you godlike being!—And so we made love to each other to dream it was you, both of us! Yes, yes, yes! Truth, truth! What's so awful about it? I like it, I think the truth is—yeah! I shouldn't have told you. . . .

BRICK (*holding his head unnaturally still and uptilted a bit*). It was Skipper that told me about it. Not you, Maggie.

MARGARET. I told you!

BRICK. After he told me!

MARGARET. What does it matter who—?

DIXIE. I got your mallet, I got your mallet.

TRIXIE. Give it to me, give it to me. IT's mine.

BRICK turns suddenly out upon the gallery and calls:

BRICK. Little girl! Hey, little girl!

LITTLE GIRL (*at a distance*). What, Uncle Brick?

BRICK. Tell the folks to come up!—Bring everybody upstairs!

TRIXIE. It's mine, it's mine.

MARGARET. I can't stop myself! I'd go on telling you this in front of them all, if I had to!

BRICK. Little girl! Go on, go on, will you? Do what I told you, call them!

DIXIE. Okay.

MARGARET. Because it's got to be told and you, you!—you never let me!

She sobs, then controls herself, and continues almost calmly.

It was one of those beautiful, ideal things they tell about in the Greek legends, it couldn't be anything else, you being you, and that's what made it so sad, that's what made it so awful, because it was love that never could be carried through to anything satisfying or even talked about plainly.

BRICK. Maggie, you gotta stop this.

MARGARET. Brick, I tell you, you got to believe me, Brick, I *do* understand all about it! I—I think it was—*noble!* Can't you tell I'm sincere when I say I respect it? My only point, the only point that I'm making, is life has got to be allowed to continue even after the *dream* of life is—all—over. . . .

BRICK is without his crutch. Leaning on furniture, he crosses to pick it up as she continues as if possessed by a will outside herself.

Why I remember when we double-dated at college, Gladys Fitzgerald and I and you and Skipper, it was more like a date between you and Skipper. Gladys and I were just sort of tagging along as if it was necessary to chaperone you!—to make a good public impression—

BRICK (*turns to face her, half lifting his crutch*). Maggie, you want me to hit you with this crutch? Don't you know I could kill you with this crutch?

MARGARET. Good Lord, man, d' you think I'd care if you did?

BRICK. One man has one great good true thing in his life. One great good thing which is true!—I had friendship with Skipper.—You are naming it dirty!

MARGARET. I'm not naming it dirty! I am naming it clean.

BRICK. Not love with you, Maggie, but friendship with Skipper was that one great true thing, and you are naming it dirty!

MARGARET. Then you haven't been listenin', not understood what I'm saying! I'm naming it so damn clean that it killed poor Skipper!—You two had something that had to be kept on ice, yes, incorruptible, yes!—and death was the only icebox where you could keep it. . . .

BRICK. I married you, Maggie. Why would I marry you, Maggie, if I was—?

MARGARET. Brick, let me finish!—I know, believe me I know, that it was only Skipper that harbored even any *unconscious* desire for anything not perfectly pure between you two!—Now let me skip a little. You married me early that summer we graduated out of Ole Miss, and we were happy, weren't we, we were blissful, yes, hit heaven together ev'ry time that we loved! But that fall you an' Skipper turned down wonderful offers of jobs in order to keep on bein' football heroes—pro-football heroes. You organized the Dixie Stars that fall, so you could keep on bein' teammates forever! But somethin' was not right with it!—*Me included!*—between you. Skipper began hittin' the bottle . . . you got a spinal injury—couldn't play the Thanks-givin' game in Chicago, watched it on TV from a traction bed in Toledo. I joined Skipper. The Dixie Stars lost because poor Skipper was drunk. We drank together that night all night in the bar of the Blackstone and when cold day was comin' up over the Lake an' we were comin' out drunk to take a dizzy look at it, I said, "SKIPPER! STOP LOVIN' MY HUSBAND OR TELL HIM HE'S GOT TO LET YOU ADMIT IT TO HIM!"—one way or another!
HE SLAPPED ME HARD ON THE MOUTH!—then turned and ran without stopping once, I am sure, all the way back into his room at the Blackstone. . . .
—When I came to his room that night, with a little scratch like a shy little mouse at his door, he made that pitiful, ineffectual little attempt to prove that what I had said wasn't true. . . .

BRICK strikes at her with crutch, a blow that shatters the gemlike lamp on the table.

—In this way, I destroyed him, by telling him truth that he and his world which he was born and raised in, your and his world, had told him could not be told?
—From then on Skipper was nothing at all but a receptacle for liquor and drugs. . . .
—Who shot cock robin? I with my—

She throws back her head with tight shut eyes.

—merciful arrow!

BRICK strikes at her; misses.

Missed me!—Sorry,—I'm not tryin' to whitewash my behavior, Christ, no! Brick, I'm not good. I don't know why people have to pretend to be good, nobody's good. The rich or the well-to-do can afford to respect moral patterns, conventional moral patterns, but I could never afford to, yeah, but—I'm honest! Give me credit for just that, will you *please*?—Born poor, raised poor, expect to die poor unless I manage to get us something out of what Big Daddy leaves when he dies of cancer! But Brick?!—*Skipper is dead! I'm alive!* Maggie the cat is—

BRICK hops awkwardly forward and strikes at her again with his crutch.

—alive! I am alive, alive! I am . . .

He hurls the crutch at her, across the bed she took refuge behind, and pitches forward on the floor as she completes her speech.

—alive!

A little girl, Dixie, bursts into the room, wearing an Indian war bonnet and firing a cap pistol at Margaret and shouting: "Bang, bang, bang!"

Laughter downstairs floats through the open hall door. MARGARET had crouched gasping to bed at child's entrance. She now rises and says with cool fury:

Little girl, your mother or someone should teach you—(*gasping*)—to knock at a door before you come into a room. Otherwise people might think that you—lack—good breeding. . . .

DIXIE. Yanh, yanh, yanh, what is Uncle Brick doin' on th' floor?

BRICK. I tried to kill your Aunt Maggie, but I failed—and I fell. Little girl, give me my crutch so I can get up off th' floor.

MARGARET. Yes, give your uncle his crutch, he's a cripple, honey, he broke his ankle last night jumping hurdles on the high school athletic field!

DIXIE. What were you jumping hurdles for, Uncle Brick?

BRICK. Because I used to jump them, and people like to do what they used to do, even after they've stopped being able to do it. . . .

MARGARET. *That's right, that's your answer, now go away, little girl.*

Dixie fires cap pistol at MARGARET *three times.*

Stop, you stop that, monster! You little no-neck monster!

She seizes the cap pistol and hurls it through gallery doors.

DIXIE (*with a precocious instinct for the cruelest thing*). You're *jealous!*—You're just jealous because you can't have babies!

She sticks out her tongue at MARGARET *as she sashays past her with her stomach stuck out, to the gallery.* MARGARET *slams the gallery doors and leans panting against them. There is a pause. Brick has replaced his spilt drink and sits, faraway, on the great four-poster bed.*

MARGARET. You see?—they gloat over us being childless, even in front of their five little no-neck monsters!

Pause. Voices approach on the stairs.

Brick?—I've been to a doctor in Memphis, a—a gynecologist. . . .

I've been completely examined, and there is no reason why we can't have a child whenever we want one. And this is my time by the calendar to conceive. Are you listening to me? Are you? Are you LISTENING TO ME!

BRICK. Yes. I hear you, Maggie.

His attention returns to her inflamed face.

—But how in hell on earth do you imagine—that you're going to have a child by a man that can't stand you?

MARGARET. That's a problem that I will have to work out.

She wheels about to face the hall door.

MAE (*off stage left*). Come on, Big Daddy. We're all goin' up to Brick's room.

From off stage left, voices: REVEREND TOOKER, DOCTOR BAUGH, MAE.

MARGARET. *Here they come!*

The lights dim.

CURTAIN.

Act Two

There is no lapse of time. Margaret and Brick are in the same positions they held at the end of Act I.

MARGARET (*at door*). *Here they come!*

BIG DADDY *appears first, a tall man with a fierce, anxious look, moving carefully not to betray his weakness even, or especially, to himself.*

GOOPER. I read in the *Register* that you're getting a new memorial window.

Some of the people are approaching through the hall, others along the gallery: voices from both directions. Gooper and Reverend Tooker become visible outside gallery doors, and their voices come in clearly.

They pause outside as GOOPER *lights a cigar.*

REVEREND TOOKER (*vivaciously*). Oh, but St. Paul's in Grenada has three memorial windows, and the latest one is a Tiffany stained-glass window that cost twenty-five hundred dollars, a picture of Christ the Good Shepherd with a Lamb in His arms.

MARGARET. Big Daddy.

BIG DADDY. Well, Brick.

BRICK. Hello Big Daddy.—Congratulations!

BIG DADDY. —Crap. . . .

GOOPER. Who give that window, Preach?

REVEREND TOOKER. Clyde Fletcher's widow. Also presented St. Paul's with a baptismal font.

GOOPER. Y'know what somebody ought t' give your church is a *coolin'* system, Preach.

MAE (*almost religiously*). —Let's see now, they've had their *tyyy*-phoid shots, and their tetanus shots, their diphtheria shots and their hepatitis shots

and their polio shots, they got *those* shots every month from May through September, and—Gooper? Hey! Gooper!—What all have the kiddies been shot faw?

REVEREND TOOKER. Yes, siree, Bob! And y'know what Gus Hamma's family gave in his memory to the church at Two Rivers? A complete new stone parish-house with a basketball court in the basement and a—

BIG DADDY (*uttering a loud barking laugh which is far from truly mirthful*). Hey, Preach! What's all this talk about memorials, Preach? Y 'think somebody's about t' kick off around here? 'S that it?

Startled by this interjection, REVEREND TOOKER decides to laugh at the question almost as loud as he can.

How he would answer the question we'll never know, as he's spared that embarrassment by the voice of GOOPER'S wife, MAE, rising high and clear as she appears with "Doc" Baugh, the family doctor, through the hall door.

MARGARET (*overlapping a bit*). Turn on the hi-fi, Brick! Let's have some music t' start off th' party with!

BRICK. You turn it on, Maggie.

The talk becomes so general that the room sounds like a great aviary of chattering birds. Only BRICK remains unengaged, leaning upon the liquor cabinet with his faraway smile, an ice cube in a paper napkin with which he now and then rubs his forehead. He doesn't respond to MARGARET'S command. She bounds forward and stoops over the instrument panel of the console.

GOOPER. We gave 'em that thing for a third anniversary present, got three speakers in it.

The room is suddenly blasted by the climax of a Wagnerian opera or a Beethoven symphony.

BIG DADDY. *Turn that dam thing off!*

Almost instant silence, almost instantly broken by the shouting charge of BIG MAMA, entering through hall door like a charging rhino.

BIG MAMA. *Wha's my Brick, wha's mah precious baby!!*

BIG DADDY. *Sorry! Turn it back on!*

Everyone laughs very loud. BIG DADDY is famous for his jokes at BIG MAMA'S expense, and nobody laughs louder at these jokes than Big Mama herself, though sometimes they're pretty cruel and BIG MAMA has to pick up or fuss with something to cover the hurt that the loud laugh doesn't quite cover.

On this occasion, a happy occasion because the dread in her heart has also been lifted by the false report on Big Daddy's condition, she giggles, grotesquely, coyly, in BIG DADDY'S direction and bears down upon BRICK, all very quick and alive.

BIG MAMA. Here he is, here's my precious baby! What's that you've got in your hand? You put that liquor down, son, your hand was made fo' holdin' somethin' better than that!

GOOPER. Look at Brick put it down!

BRICK has obeyed BIG MAMA by draining the glass and handing it to her. Again everyone laughs, some high, some low.

BIG MAMA. Oh, you bad boy, you, you're my bad little boy. Give Big Mama a kiss, you bad boy, you!—Look at him shy away, will you? Brick never liked bein' kissed or made a fuss over, I guess because he's always had too much of it!
Son, you turn that thing off!

BRICK has switched on the TV set.

I can't stand TV, radio was bad enough but TV has gone it one better, I mean—(*plops wheezing in chair*)—one worse, ha ha! Now what'm I sittin' down here faw? I want t' sit next to my sweetheart on the sofa, hold hands with him and love him up a little!

BIG MAMA has on a black and white figured chiffon. The large irregular patterns, like the markings of some massive animal, the luster of her great diamonds and many pearls, the brilliants set in the silver frames of her glasses, her riotous voice, booming laugh, have dominated the room since she entered. BIG DADDY has been regarding her with a steady grimace of chronic annoyance.

BIG MAMA (*still louder*). Preacher, Preacher, hey, Preach! Give me you' hand an' help me up from this chair!

REVEREND TOOKER. None of your tricks, Big Mama!

BIG MAMA. What tricks? You give me you' hand so I can get up an'—

REVEREND TOOKER extends her his hand. She grabs it and pulls him into her lap with a shrill laugh that spans an octave in two notes.

Ever seen a preacher in a fat lady's lap? Hey, hey, folks! Ever seen a preacher in a fat lady's lap?

BIG MAMA is notorious throughout the Delta for this sort of inelegant horseplay. MARGARET looks on with



indulgent humor, sipping Dubonnet "on the rocks" and watching Brick, but MAE *and* GOOPER *exchange signs of humorless anxiety over these antics, the sort of behavior which* MAE *thinks may account for their failure to quite get in with the smartest young married set in Memphis, despite all. One of the Negroes,* LACY *or* SOOKEY, *peeks in, cackling. They are waiting for a sign to bring in the cake and champagne. But* BIG DADDY'S *not amused. He doesn't understand why, in spite of the infinite mental relief he's received from the doctor's report, he still has these same old fox teeth in his guts. "This spastic condition is something else," he says to himself, but aloud he roars at* BIG MAMA.

BIG DADDY. *BIG MAMA, WILL YOU QUIT HORSIN'?*—You're too old an' too fat fo' that sort of crazy kid stuff an' besides a woman with your blood pressure—she had two hundred last spring!—is riskin' a stroke when you mess around like that. . . .

MAE *blows on a pitch pipe.*

BIG MAMA. *Here comes Big Daddy's birthday!*

Negroes in white jackets enter with an enormous birthday cake ablaze with candles and carrying buckets of champagne with satin ribbons about the bottle necks.

MAE *and* GOOPER *strike up song, and everybody, including the Negroes and Children, joins in. Only* BRICK *remains aloof.*

EVERYONE. Happy birthday to you.
Happy birthday to you.
Happy birthday, Big Daddy—

Some sing: "Dear, Big Daddy!"

Happy birthday to you.

Some sing: "How old are you?"

MAE *has come down center and is organizing her children like a chorus. She gives them a barely audible: "One, two, three!" and they are off in the new tune.*

CHILDREN. Skinamarinka—dinka—dink
Skinamarinka—do
We love you.
Skinamarinka—dinka—dink
Skinamarinka—do.

All together, they turn to BIG DADDY.

Big Daddy, you!

They turn back front, like a musical comedy chorus.

We love you in the morning;
We love you in the night.
We love you when we're with you,
And we love you out of sight.
Skinamarinka—dinka—dink
Skinamarinka—do.

MAE *turns to* BIG MAMA.

Big Mama, too!

BIG MAMA *bursts into tears. The Negroes leave.*

BIG DADDY. Now Ida, what the hell is the matter with you?

MAE. She's just so happy.

BIG MAMA. I'm just so happy, Big Daddy, I have to cry or something.

Sudden and loud in the hush:

Brick, do you know the wonderful news that Doc Baugh got from the clinic about Big Daddy? Big Daddy's one hundred per cent!

MARGARET. Isn't that wonderful?

BIG MAMA. He's just one hundred per cent. Passed the examination with flying colors. Now that we know there's nothing wrong with Big Daddy but a spastic colon, I can tell you something. I was worried sick, half out of my mind, for fear that Big Daddy might have a thing like—

MARGARET *cuts through this speech, jumping up and exclaiming shrilly.*

MARGARET. Brick, honey, aren't you going to give Big Daddy his birthday present?

Passing by him, she snatches his liquor glass from him.

She picks up a fancily wrapped package.

Here it is, Big Daddy, this is from Brick!

BIG MAMA. This is the biggest birthday Big Daddy's ever had, a hundred presents and bushels of telegrams from—

MAE *(at same time).* What is it, Brick?

GOOPER. I bet 500 to 50 that Brick don't *know* what it is.

BIG MAMA. The fun of presents is not knowing what they are till you open the package. Open your present, Big Daddy.

BIG DADDY. Open it you'self. I want to ask Brick something! Come here, Brick.

MARGARET. Big Daddy's callin' you, Brick.

She is opening the package.

BRICK. Tell Big Daddy I'm crippled.

BIG DADDY. I see you're crippled. I want to know how you got crippled.

MARGARET (*making diversionary tactics*). Oh, look, oh, look, why, it's a cashmere robe!

She holds the robe up for all to see.

MAE. You sound surprised, Maggie.

MARGARET. I never saw one before.

MAE. That's funny.—*Hah!*

MARGARET (*turning on her fiercely, with a brilliant smile*). Why is it funny? All my family ever had was family—and luxuries such as cashmere robes still surprise me!

BIG DADDY (*ominously*). Quiet!

MAE (*heedless in her fury*). I don't see how you could be so surprised when you bought it yourself at Loewenstein's in Memphis last Saturday. You know how I know?

BIG DADDY. I said, Quiet!

MAE. —I know because the salesgirl that sold it to you waited on me and said, Oh, Mrs. Pollitt, your sister-in-law just bought a cashmere robe for your husband's father!

MARGARET. Sister Woman! Your talents are wasted as a housewife and mother, you really ought to be with the FBI or—

BIG DADDY. QUIET!

REVEREND TOOKER'S *reflexes are slower than the others'. He finishes a sentence after the bellow.*

REVEREND TOOKER (*To Doc Baugh*). —the Stork and the Reaper are running neck and neck!

He starts to laugh gaily when he notices the silence and BIG DADDY'S *glare. His laugh dies falsely.*

BIG DADDY. Preacher, I hope I'm not butting in on more talk about memorial stained-glass windows, am I, Preacher?

REVEREND TOOKER *laughs feebly, then coughs dryly in the embarrassed silence.*

Preacher?

BIG MAMA. Now, Big Daddy, don't you pick on Preacher!

BIG DADDY (*raising his voice*). You ever hear that expression all hawk and no spit? You bring that expression to mind with that little dry cough of yours, all hawk an' no spit. . . .

The pause is broken only by a short startled laugh from MARGARET, *the only one there who is conscious of and amused by the grotesque.*

MAE (*raising her arms and jangling her bracelets*). I wonder if the mosquitoes are active tonight?

BIG DADDY. What's that, Little Mama? Did you make some remark?

MAE. Yes, I said I wondered if the mosquitoes would eat us alive if we went out on the gallery for a while.

BIG DADDY. Well, if they do, I'll have your bones pulverized for fertilizer!

BIG MAMA (*quickly*). Last week we had an airplane spraying the place and I think it done some good, at least I haven't had a—

BIG DADDY (*cutting her speech*). Brick, they tell me, if what they tell me is true, that you done some jumping last night on the high school athletic field?

BIG MAMA. Brick, Big Daddy is talking to you, son.

BRICK (*smiling vaguely over his drink*). What was that, Big Daddy?

BIG DADDY. They said you done some jumping on the high school track field last night.

BRICK. That's what they told me, too.

BIG DADDY. Was it jumping or humping that you were doing out there? What were doing out there at three A.M., layin' a woman on that cinder track?

BIG MAMA. Big Daddy, you are off the sick-list, now, and I'm not going to excuse you for talkin' so—

BIG DADDY. Quiet!

BIG MAMA. —*nasty* in front of Preacher and—

BIG DADDY. QUIET!—I ast you, Brick, if you was cuttin' you'self a piece o' poon-tang last night on that

cinder track? I thought maybe you were chasin' poon-tang on that track an' tripped over something in the heat of the chase—'sthat it?

GOOPER *laughs, loud and false, others nervously following suit.* BIG MAMA *stamps her foot, and purses her lips, crossing to* MAE *and whispering something to her as* BRICK *meets his father's hard, intent, grinning stare with a slow, vague smile that he offers all situations from behind the screen of his liquor.*

BRICK. No, sir, I don't think so. . . .

MAE (*at the same time, sweetly*). Reverend Tooker, let's you and I take a stroll on the widow's walk.

She and the preacher go out on the gallery as BIG DADDY *says:*

BIG DADDY. Then what the hell were you doing out there at three o'clock in the morning?

BRICK. Jumping the hurdles, Big Daddy, runnin' and jumpin' the hurdles, but those high hurdles have gotten too high for me, now.

BIG DADDY. Cause you was drunk?

BRICK (*his vague smile fading a little*). Sober I wouldn't have tried to jump the *low* ones. . . .

BIG MAMA (*quickly*). Big Daddy, blow out the candles on your birthday cake!

MARGARET (*at the same time*). I want to propose a toast to Big Daddy Pollitt on his sixty-fifth birthday, the biggest cotton planter in—

BIG DADDY (*bellowing with fury and disgust*). I told you to stop it, now stop it, quit this—!

BIG MAMA (*coming in front of Big Daddy with the cake*). Big Daddy, I will not allow you to talk that way, not even on your birthday, I—

BIG DADDY. I'll talk like I want to on my birthday, Ida, or any other goddam day of the year and anybody here that don't like it knows what they can do!

BIG MAMA. You don't mean that!

BIG DADDY. What makes you think I don't mean it?

Meanwhile various discreet signals have been exchanged and GOOPER *has also gone out on the gallery.*

BIG MAMA. I just know you don't mean it.

BIG DADDY. You don't know a goddam thing and you never did!

BIG MAMA. Big Daddy, you don't mean that.

BIG DADDY. Oh, yes, I do, oh, yes, I do, I mean it! I put up with a whole lot of crap around here because I thought I was dying. And you thought I was dying and you started taking over, well, you can stop taking over now, Ida, because I'm not gonna die, you can just stop now this business of taking over because you're not taking over because I'm not dying, I went through the laboratory and the goddam exploratory operation and there's nothing wrong with me but a spastic colon. And I'm not dying of cancer which you thought I was dying of. Ain't that so? Didn't you think that I was dying of cancer, Ida?

Almost everybody is out on the gallery but the two old people glaring at each other across the blazing cake.

BIG MAMA'S *chest heaves and she presses a fat fist to her mouth.*

BIG DADDY *continues, hoarsely:*

Ain't that so, Ida? Didn't you have an idea I was dying of cancer and now you could take control of this place and everything on it? I got that impression, I seemed to get that impression. Your loud voice everywhere, your fat old body butting in here and there!

BIG MAMA. Hush! The Preacher!

BIG DADDY. Fuck the goddam preacher!

BIG MAMA *gasps loudly and sits down on the sofa which is almost too small for her.*

Did you hear what I said? I said fuck the goddam preacher!

Somebody closes the gallery doors from outside just as there is a burst of fireworks and excited cries from the children.

BIG MAMA. I never seen you act like this before and I can't think what's got in you!

BIG DADDY. I went through all that laboratory and operation and all just so I would know if you or me was boss here! Well, now it turns out that I am and you ain't—and that's my birthday present—and my cake and champagne!—because for three years now you been gradually taking over. Bossing. Talking. Sashaying your fat old body around the place I made! I made this place! I was overseer on it! I was the overseer on the old Straw and Ochello plantation. I quit school at ten! I quit school at ten years old and went

to work like a nigger in the fields. And I rose to be overseer of the Straw and Ochello plantation. And old Straw died and I was Ochello's partner and the place got bigger and bigger and bigger and bigger and bigger! I did all that myself with no goddam help from you, and now you think you're just about to take over. Well, I am just about to tell you that you are not just about to take over, you are not just about to take over a God damn thing. Is that clear to you, Ida? Is that very plain to you, now? Is that understood completely? I been through the laboratory from A to Z. I've had the goddam exploratory operation, and nothing is wrong with me but a spastic colon—made spastic, I guess, by *disgust!* By all the goddam lies and liars that I have had to put up with, and all the goddam hypocrisy that I lived with all these forty years that we been livin' together! Hey! Ida!! Blow out the candles on the birthday cake! Purse up your lips and draw a deep breath and blow out the goddam candles on the cake!

BIG MAMA. Oh, Big Daddy, oh, oh, oh, Big Daddy!

BIG DADDY. What's the matter with you?

BIG MAMA. *In all these years you never believed that I loved You??*

BIG DADDY. Huh?

BIG MAMA. *And I did, I did so much, I did love you!—I even loved your hate and your hardness, Big Daddy!*

She sobs and rushes awkwardly out onto the gallery.

BIG DADDY (*to himself*). *Wouldn't it be funny if that was true. . . .*

A pause is followed by a burst of light in the sky from the fireworks.

BRICK! HEY, BRICK!

He stands over his blazing birthday cake.

After some moments, BRICK *hobbles in on his crutch, holding his glass.*

MARGARET *follows him with a bright, anxious smile.*

I didn't call you, Maggie. I called Brick.

MARGARET. I'm just delivering him to you.

She kisses BRICK *on the mouth which he immediately wipes with the back of his hand. She flies girlishly back out.* BRICK *and his father are alone.*

BIG DADDY. Why did you do that?

BRICK. Do what, Big Daddy?

BIG DADDY. Wipe her kiss off your mouth like she'd spit on you.

BRICK. I don't know. I wasn't conscious of it.

BIG DADDY. That woman of yours has a better shape on her than Gooper's but somehow or other they got the same look about them.

BRICK. What sort of look is that, Big Daddy?

BIG DADDY. I don't know how to describe it but it's the same look.

BRICK. They don't look peaceful, do they?

BIG DADDY. No, they sure in hell don't.

BRICK. They look nervous as cats?

BIG DADDY. That's right, they look nervous as cats.

BRICK. Nervous as a couple of cats on a hot tin roof?

BIG DADDY. That's right, boy, they look like a couple of cats on a hot tin roof. It's funny that you and Gooper being so different would pick out the same type of woman.

BRICK. Both of us married into society, Big Daddy.

BIG DADDY. Crap . . . I wonder what gives them both that look?

BRICK. Well. They're sittin' in the middle of a big piece of land, Big Daddy, twenty-eight thousand acres is a pretty big piece of land and so they're squaring off on it, each determined to knock off a bigger piece of it than the other whenever you let it go.

BIG DADDY. I got a surprise for those women. I'm not gonna let it go for a long time yet if that's what they're waiting for.

BRICK. That's right, Big Daddy. You just sit tight and let them scratch each other's eyes out. . . .

BIG DADDY. You bet your life I'm going to sit tight on it and let those sons of bitches scratch their eyes out, ha ha ha. . . .
But Gooper's wife's a good breeder, you got to admit she's fertile. Hell, at supper tonight she had them all at the table and they had to put a couple of extra leafs in the table to make room for them, she's got five head of them, now, and another one's comin'.

BRICK. Yep, number six is comin'. . . .

BIG DADDY. Six hell, she'll probably drop a litter next time. Brick, you know, I swear to God, I don't know the way it happens?

BRICK. The way what happens, Big Daddy?

BIG DADDY. You git you a piece of land, by hook or crook, an' things start growin' on it, things accumulate on it, and the first thing you know it's completely out of hand, completely out of hand!

BRICK. Well, they say nature hates a vacuum, Big Daddy.

BIG DADDY. That's what they say, but sometimes I think that a vacuum is a hell of a lot better than some of the stuff that nature replaces it with.
Is someone out there by that door?

GOOPER. Hey Mae.

BRICK. Yep.

BIG DADDY. Who?

He has lowered his voice.

BRICK. Someone int'rested in what we say to each other.

BIG DADDY. Gooper?——GOOPER!

After a discreet pause, MAE *appears in the gallery door.*

MAE. Did you call Gooper, Big Daddy?

BIG DADDY. Aw, it was you.

MAE. Do you want Gooper, Big Daddy?

BIG DADDY. No, and I don't want you. I want some privacy here, while I'm having a confidential talk with my son Brick. Now it's too hot in here to close them doors, but if I have to close those fuckin' doors in order to have a private talk with my son Brick, just let me know and I'll close 'em. Because I hate eavesdroppers, I don't like any kind of sneakin' an' spyin'.

MAE. Why, Big Daddy—

BIG DADDY. You stood on the wrong side of the moon, it threw your shadow!

MAE. I was just—

BIG DADDY. You was just nothing but *spyin'* an' you *know* it!

MAE (*begins to sniff and sob*). Oh, Big Daddy, you're so unkind for some reason to those that really love you!

BIG DADDY. Shut up, shut up, shut up! I'm going to move you and Gooper out of that room next to this! It's none of your goddam business what goes on in here at night between Brick an' Maggie. You listen at night like a couple of rutten peekhole spies and go and give a report on what you hear to Big Mama an' she comes to me and says they say such and such and so and so about what they heard goin' on between Brick an' Maggie, and Jesus, it makes me sick. I'm goin' to move you an' Gooper out of that room, I can't stand sneakin' an' spyin', it makes me puke. . . .

MAE throws back her head and rolls her eyes heavenward and extends her arms as if invoking God's pity for this unjust martyrdom; then she presses a handkerchief to her nose and flies from the room with a loud swish of skirts.

BRICK (*now at the liquor cabinet*). They listen, do they?

BIG DADDY. Yeah. They listen and give reports to Big Mama on what goes on in here between you and Maggie. They say that—

He stops as if embarrassed.

—You won't sleep with her, that you sleep on the sofa. Is that true or not true? If you don't like Maggie, get rid of Maggie!—What are you doin' there now?

BRICK. Fresh'nin' up my drink.

BIG DADDY. Son, you know you got a real liquor problem?

BRICK. Yes, sir, yes, I know.

BIG DADDY. Is that why you quit sports-announcing, because of this liquor problem?

BRICK. Yes, sir, yes, sir, I guess so.

He smiles vaguely and amiably at his father across his replenished drink.

BIG DADDY. Son, don't guess about it, it's too important.

BRICK (*vaguely*). Yes, sir.

BIG DADDY. And listen to me, don't look at the damn chandelier. . . .

Pause. BIG DADDY's *voice is husky.*

—Somethin' else we picked up at th' big fire sale in Europe.

Another pause.

Life is important. There's nothing else to hold onto. A man that drinks is throwing his life away. Don't do it, hold onto your life. There's nothing else to hold onto. . . .
Sit down over here so we don't have to raise our voices, the walls have ears in this place.

BRICK (*hobbling over to sit on the sofa beside him*). All right, Big Daddy.

BIG DADDY. Quit!—how'd that come about? Some disappointment?

BRICK. I don't know. Do you?

BIG DADDY. I'm askin' you, God damn it! How in hell would I know if you don't?

BRICK. I just got out there and found that I had a mouth full of cotton. I was always two or three beats behind what was goin' on on the field and so I—

BIG DADDY. Quit!

BRICK (*amiably*). Yes, quit.

BIG DADDY. Son?

BRICK. Huh?

BIG DADDY (*inhales loudly and deeply from his cigar; then bends suddenly a little forward, exhaling loudly and raising a hand to his forehead*). —Whew!—ha ha!— I took in too much smoke, it made me a little lightheaded. . . .

The mantel clock chimes.

Why is it so damn hard for people to talk?

BRICK. Yeah. . . .

The clock goes on sweetly chiming till it has completed the stroke of ten.

—Nice peaceful-soundin' clock, I like to hear it all night. . . .

He slides low and comfortable on the sofa; BIG DADDY sits up straight and rigid with some unspoken anxiety. All his gestures are tense and jerky as he talks. He wheezes and pants and sniffs through his nervous speech, glancing quickly, shyly, from time to time, at his son.

BIG DADDY. We got that clock the summer we wint to Europe, me an' Big Mama on that damn Cook's Tour, never had such an awful time in my life, I'm tellin' you, son, those gooks over there, they gouge your eyeballs out in their grand hotels. And Big Mama bought more stuff than you could haul in a couple of boxcars, that's no crap. Everywhere she wint on this whirlwind tour, she bought, bought, bought. Why, half that stuff she bought is still crated up in the cellar, under water last spring!

He laughs.

That Europe is nothin' on earth but a great big auction, that's all it is, that bunch of old worn-out places, it's just a big fire-sale, the whole fuckin' thing, an' Big Mama wint wild in it, why, you couldn't hold that woman with a mule's harness! Bought, bought, bought!—lucky I'm a rich man, yes siree, Bob, an' half that stuff is mildewin' in th' basement. It's lucky I'm a rich man, it sure is lucky, well, I'm a rich man, Brick, yep, I'm a mighty rich man.

His eyes light up for a moment.

Y'know how much I'm worth? Guess, Brick! Guess how much I'm worth!

BRICK *smiles vaguely over his drink.*

Close on ten million in cash an' blue-chip stocks, outside, mind you, of twenty-eight thousand acres of the richest land this side of the valley Nile!
But a man can't buy his life with it, he can't buy back his life with it when his life has been spent, that's one thing not offered in the Europe fire-sale or in the American markets or any markets on earth, a man can't buy his life with it, he can't buy back his life when his life is finished. . . .
That's a sobering thought, a very sobering thought, and that's a thought that I was turning over in my head, over and over and over—until today. . . .
I'm wiser and sadder, Brick, for this experience which I just gone through. They's one thing else that I remember in Europe.

BRICK. What is that, Big Daddy?

BIG DADDY. The hills around Barcelona in the country of Spain and the children running over those bare hills in their bare skins beggin' like starvin' dogs with howls and screeches, and how fat the priests are on the streets of Barcelona, so many of them and so fat and so pleasant, ha ha!—Y'know I could feed that country? I got money enough to feed that goddam country, but the human animal is a selfish beast and I don't reckon the money I passed out there to those howling children in the hills around Barcelona would more than upholster the chairs in this room, I mean pay to put a new cover on this chair!
Hell, I threw them money like you'd scatter feed corn for chickens, I threw money at them just to get rid of them long enough to climb back into th' car and—drive away. . . .

And then in Morocco, them Arabs, why, I remember one day in Marrakech, that old walled Arab city, I set on a broken-down wall to have a cigar, it was fearful hot there and this Arab woman stood in the road and looked at me till I was embarrassed, she stood stock still in the dusty hot road and looked at me till I was embarrassed. But listen to this. She had a naked child with her, a little naked girl with her, barely able to toddle, and after a while she set this child on the ground and give her a push and whispered something to her.

This child come toward me, barely able t' walk, come toddling up to me and—

Jesus, it makes you sick t' remember a thing like this! It stuck out its hand and tried to unbutton my trousers!

That child was not yet five! Can you believe me? Or do you think that I am making this up? I wint back to the hotel and said to Big Mama, Git packed! We're clearing out of this country. . . .

BRICK. Big Daddy, you're on a talkin' jag tonight.

BIG DADDY (*ignoring this remark*). Yes, sir, that's how it is, the human animal is a beast that dies but the fact that he's dying don't give him pity for others, no, sir, it—

—Did you say something?

BRICK. Yes.

BIG DADDY. What?

BRICK. Hand me over that crutch so I can get up.

BIG DADDY. Where you goin'?

BRICK. I'm takin' a little short trip to Echo Spring.

BIG DADDY. To where?

BRICK. Liquor cabinet. . . .

BIG DADDY. Yes, sir, boy—

He hands BRICK *the crutch.*

—the human animal is a beast that dies and if he's got money he buys and buys and buys I think the reason he buys everything he can buy is that in the back of his mind he has the crazy hope that one of his purchases will be life everlasting!—Which it never can be. . . . The human animal is a beast that—

BRICK (*at the liquor cabinet*). Big Daddy, you sure are shootin' th' breeze here tonight.

There is a pause and voices are heard outside.

BIG DADDY. I been quiet here lately, spoke not a word, just sat and stared into space. I had something heavy weighing on my mind but tonight that load was took off me. That's why I'm talking.—The sky looks diff'rent to me. . . .

BRICK. You know what I like to hear most?

BIG DADDY. What?

BRICK. Solid quiet. Perfect unbroken quiet.

BIG DADDY. Why?

BRICK. Because it's more peaceful.

BIG DADDY. Man, you'll hear a lot of that in the grave.

He chuckles agreeably.

BRICK. Are you through talkin' to me?

BIG DADDY. Why are you so anxious to shut me up?

BRICK. Well, sir, ever so often you say to me, Brick, I want to have a talk with you, but when we talk, it never materializes. Nothing is said. You sit in a chair and gas about this and that and I look like I listen. I try to look like I listen, but I don't listen, not much. Communication is—awful hard between people an'—somehow between you and me, it just don't—happen.

BIG DADDY. Have you ever been scared? I mean have you ever felt downright terror of something?

He gets up.

Just one moment.

He looks off as if he were going to tell an important secret.

BIG DADDY. Brick?

BRICK. What?

BIG DADDY. Son, I thought I had it!

BRICK. Had what? Had what, Big Daddy?

BIG DADDY. Cancer!

BRICK. Oh . . .

BIG DADDY. I thought the old man made out of bones had laid his cold and heavy hand on my shoulder!

BRICK. Well, Big Daddy, you kept a tight mouth about it.

BIG DADDY. A pig squeals. A man keeps a tight mouth about it, in spite of a man not having a pig's advantage.

BRICK. What advantage is that?

BIG DADDY. Ignorance—of mortality—is a comfort. A man don't have that comfort, he's the only living thing that conceives of death, that knows what it is. The others go without knowing which is the way that anything living should go, go without knowing, without any knowledge of it, and yet a pig squeals, but a man sometimes, he can keep a tight mouth about it. Sometimes he—

There is a deep, smoldering ferocity in the old man.

—can keep a tight mouth about it. I wonder if—

BRICK. What, Big Daddy?

BIG DADDY. A whiskey highball would injure this spastic condition?

BRICK. No, sir, it might do it good.

BIG DADDY (*grins suddenly, wolfishly*). *Jesus, I can't tell you! The sky is open! Christ, it's open again! It's open, boy, it's open!*

BRICK looks down at his drink.

BRICK. You feel better, Big Daddy?

BIG DADDY. Better? Hell! I can breathe!—All of my life I been like a doubled up fist. . . .

He pours a drink.

—Poundin', smashin', drivin'!—now I'm going to loosen these doubled-up hands and touch things *easy* with them. . . .

He spreads his hands as if caressing the air.

You know what I'm contemplating?

BRICK (*vaguely*). No, sir. What are you contemplating?

BIG DADDY. Ha ha!—*Pleasure!*—pleasure with *women!*

BRICK'S smile fades a little but lingers.

—Yes, boy. I'll tell you something that you might not guess. I still have desire for women and this is my sixty-fifth birthday.

BRICK. I think that's mighty remarkable, Big Daddy.

BIG DADDY. Remarkable?

BRICK. *Admirable*, Big Daddy.

BIG DADDY. You're damn right it is, remarkable and admirable both. I realize now that I never had me enough. I let many chances slip by because of scruples about it, scruples, convention—crap. . . .

All that stuff is bull, bull, bull!—It took the shadow of death to make me see it. Now that shadow's lifted, I'm going to cut loose and have, what is it they call it, have me a—ball!

BRICK. A ball, huh?

BIG DADDY. That's right, a ball, a ball! Hell!—I slept with Big Mama till, let's see, five years ago, till I was sixty and she was fifty-eight, and never even liked her, never did!

The phone has been ringing down the hall. BIG MAMA enters, exclaiming:

BIG MAMA. Don't you men hear that phone ring? I heard it way out on the gall'ry.

BIG DADDY. There's five rooms off this front gall'ry that you could go through. Why do you go through this one?

BIG MAMA makes a playful face as she bustles out the hall door.

Hunh!—Why, when Big Mama goes out of a room, I can't remember what that woman looks like—

BIG MAMA. Hello.

BIG DADDY. —But when Big Mama comes back into the room, boy, then I see what she looks like, and I wish I didn't!

Bends over laughing at this joke till it hurts his guts and he straightens with a grimace. The laugh subsides to a chuckle as he puts the liquor glass a little distrustfully down the table.

BIG MAMA. Hello, Miss Sally.

BRICK has risen and hobbled to the gallery doors.

BIG DADDY. Hey! Where you goin'?

BRICK. Out for a breather.

BIG DADDY. Not yet you ain't. Stay here till this talk is finished, young fellow.

BRICK. I thought it was finished, Big Daddy.

BIG DADDY. It ain't even begun.

BRICK. My mistake. Excuse me. I just wanted to feel that river breeze.

BIG DADDY. Set back down in that chair.

BIG MAMA'S voice rises, carrying down the hall.

BIG MAMA. Miss Sally, you're a case! You're a caution, Miss Sally.

BIG DADDY. Jesus, she's talking to my old maid sister again.

BIG MAMA. Why didn't you give me a chance to explain it to you?

BIG DADDY. Brick, this stuff burns me.

BIG MAMA. Well, goodbye, now, Miss Sally. You come down real soon. Big Daddy's dying to see you.

BIG DADDY. Crap!

BIG MAMA. Yaiss, goodbye, Miss Sally. . . .

She hangs up and bellows with mirth. BIG DADDY *groans and covers his ears as she approaches.*

Bursting in.

Big Daddy, that was Miss Sally callin' from Memphis again! You know what she done, Big Daddy? She called her doctor in Memphis to git him to tell her what that spastic thing is! Ha-*HAAAA!*—And called back to tell me how relieved she was that—Hey! Let me in!

BIG DADDY *has been holding the door half closed against her.*

BIG DADDY. Naw I ain't. I told you not to come and go through this room. You just back out and go through those five other rooms.

BIG MAMA. Big Daddy? Big Daddy? Oh, big Daddy!—You didn't mean those things you said to me, did you?

He shuts door firmly against her but she still calls.

Sweetheart? Sweetheart? Big Daddy? You didn't mean those awful things you said to me?—I know you didn't. I know you didn't mean those things in your heart. . . .

The childlike voice fades with a sob and her heavy footsteps retreat down the hall. BRICK *has risen once more on his crutches and starts for the gallery again.*

BIG DADDY. All I ask of that woman is that she leave me alone. But she can't admit to herself that she makes me sick. That comes of having slept with her too many years. Should of quit much sooner but that old woman she never got enough of it—and I was good in bed . . . I never should of wasted so much of it on her. . . .They say you got just so many and each one is numbered. Well, I got a few left in me, a few, and I'm going to pick me a good one to spend 'em on! I'm going to pick me a choice one, I don't care how much she costs,

I'll smother her in—minks! Ha ha! I'll strip her naked and smother her in minks and choke her with diamonds! Ha ha! I'll strip her naked and choke her with diamonds and smother her with minks and hump her from hell to breakfast. *Ha aha ha ha ha!*

MAE (*gaily at door*). Who's that laughin' in there?

GOOPER. Is Big Daddy laughin' in there?

BIG DADDY. Crap!—them two—*drips.* . . .

He goes over and touches BRICK's *shoulder.*

Yes, son. Brick, boy.—I'm—*happy!* I'm happy, son, I'm happy!

He chokes a little and bites his under lip, pressing his head quickly, shyly against his son's head and then, coughing with embarrassment, goes uncertainly back to the table where he set down the glass. He drinks and makes a grimace as it burns his guts. BRICK *sighs and rises with effort.*

What makes you so restless? Have you got ants in your britches?

BRICK. Yes, sir . . .

BIG DADDY. Why?

BRICK. —Something—hasn't—happened. . . .

BIG DADDY. Yeah? What is that!

BRICK (*sadly*). —the click. . . .

BIG DADDY. Did you say click?

BRICK. Yes, click.

BIG DADDY. What click?

BRICK. A click that I get in my head that makes me peaceful.

BIG DADDY. I sure in hell don't know what you're talking about, but it disturbs me.

BRICK. It's just a mechanical thing.

BIG DADDY. What is a mechanical thing?

BRICK. This click that I get in my head that makes me peaceful. I got to drink till I get it. It's just a mechanical thing, something like a—like a—like a—

BIG DADDY. Like a—

BRICK. Switch clicking off in my head, turning the hot light off and the cool night on and—

He looks up, smiling sadly.

—all of a sudden there's—peace!

BIG DADDY (*whistles long and soft with astonishment; he goes back to Brick and clasps his son's two shoulders*). Jesus! I didn't know it had gotten that bad with you. Why, boy, you're—*alcoholic!*

BRICK. That's the truth, Big Daddy. I'm alcoholic.

BIG DADDY. This shows how I—let things go!

BRICK. I have to hear that little click in my head that makes me peaceful. Usually I hear it sooner than this, sometimes as early as—noon, but—
—Today it's—dilatory. . . .
—I just haven't got the right level of alcohol in my bloodstream yet!

This last statement is made with energy as he freshens his drink.

BIG DADDY. Uh—huh. Expecting death made me blind. I didn't have no idea that a son of mine was turning into a drunkard under my nose.

BRICK (*gently*). Well, now you do, Big Daddy, the news has penetrated.

BIG DADDY. UH-huh, yes, now I do, the news has—penetrated. . . .

BRICK. And so if you'll excuse me—

BIG DADDY. No, I won't excuse you.

BRICK. —I'd better sit by myself till I hear that click in my head, it's just a mechanical thing but it don't happen except when I'm alone or talking to no one. . . .

BIG DADDY. You got a long, long time to sit still, boy, and talk to no one, but now you're talkin' to me. At least I'm talking to you. And you set there and listen until I tell you the conversation is over!

BRICK. But this talk is like all the others we've ever had together in our lives! It's nowhere, nowhere!—it's—it's *painful*, Big Daddy. . . .

BIG DADDY. All right, then let it be painful, but don't you move from that chair!—I'm going to remove that crutch. . . .

He seizes the crutch and tosses it across room.

BRICK. I can hop on one foot, and if I fall, I can crawl!

BIG DADDY. If you ain't careful you're gonna crawl off this plantation and then, by Jesus, you'll have to hustle your drinks along Skid Row!

BRICK. That'll come, Big Daddy.

BIG DADDY. Naw, it won't. You're my son and I'm going to straighten you out; now that *I'm* straightened out, I'm going to straighten out you!

BRICK. Yeah?

BIG DADDY. Today the report come in from Ochsner Clinic. Y'know what they told me?

His face glows with triumph.

The only thing that they could detect with all the instruments of science in that great hospital is a little spastic condition of the colon! And nerves torn to pieces by all that worry about it.

A little girl bursts into room with a sparkler clutched in each fist, hops and shrieks like a monkey gone mad and rushes back out again as BIG DADDY *strikes at her.*

Silence. The two men stare at each other. A woman laughs gaily outside.

I want you to know I breathed a sigh of relief almost as powerful as the Vicksburg tornado!

There is laughter outside, running footsteps, the soft, plushy sound and light of exploding rockets.

BRICK *stares at him soberly for a long moment; then makes a sort of startled sound in his nostrils and springs up on one foot and hops across the room to grab his crutch, swinging on the furniture for support. He gets the crutch and flees as if in horror for the gallery. His father seizes him by the sleeve of his white silk pajamas.*

Stay here, you son of a bitch!—till I say go!

BRICK. I can't.

BIG DADDY. You sure in hell will, God damn it.

BRICK. No, I can't. We talk, you talk, in—circles! We get no where, no where! It's always the same, you say you want to talk to me and don't have a fuckin' thing to say to me!

BIG DADDY. Nothin' to say when I'm tellin' you I'm going to live when I thought I was dying?!

BRICK. Oh—*that!*—Is that what you have to say to me?

BIG DADDY. Why, you son of a bitch! Ain't that, ain't that—*important?!*

BRICK. Well, you said that, that's said, and now I—

BIG DADDY. Now you set back down.

BRICK. You're all balled up, you—

BIG DADDY. I ain't balled up!

BRICK. You are, you're all balled up!

BIG DADDY. Don't tell me what I am, you drunken whelp! I'm going to tear this coat sleeve off if you don't set down!

BRICK. Big Daddy—

BIG DADDY. Do what I tell you! I'm the boss here, now! I want you to know I'm back in the driver's seat now!

BIG MAMA *rushes in, clutching her great heaving bosom.*

BIG MAMA. Big Daddy!

BIG DADDY. What in hell do you want in here, Big Mama?

BIG MAMA. Oh, Big Daddy! Why are you shouting like that? I just cain't *stainnnnnnnd*—it. . . .

BIG DADDY (*raising the back of his hand above his head*). GIT!—outa here.

She rushes back out, sobbing.

BRICK (*softly, sadly*). Christ. . . .

BIG DADDY (*fiercely*). Yeah! Christ!—is right . . .

BRICK *breaks loose and hobbles toward the gallery.*

BIG DADDY *jerks his crutch from under* BRICK *so he steps with the injured ankle. He utters a hissing cry of anguish, clutches a chair and pulls it over on top of him on the floor.*

Son of a—tub of—hog fat. . . .

BRICK. Big Daddy! Give me my crutch.

BIG DADDY *throws the crutch out of reach.*

Give me that crutch, Big Daddy.

BIG DADDY. Why do you drink?

BRICK. Don't know, give me my crutch!

BIG DADDY. You better think why you drink or give up drinking!

BRICK. Will you please give me my crutch so I can get up off this floor?

BIG DADDY. First you answer my question. Why do you drink? Why are you throwing your life away, boy, like somethin' disgusting you picked up on the street?

BRICK (*getting onto his knees*). Big Daddy, I'm in pain, I stepped on that foot.

BIG DADDY. Good! I'm glad you're not too numb with the liquor in you to feel some pain!

BRICK. You—spilled my—drink . . .

BIG DADDY. I'll make a bargain with you. You tell me why you drink and I'll hand you one. I'll pour you the liquor myself and hand it to you.

BRICK. Why do I drink?

BIG DADDY. Yea! Why?

BRICK. Give me a drink and I'll tell you.

BIG DADDY. Tell me first!

BRICK. I'll tell you in one word.

BIG DADDY. What word?

BRICK. DISGUST!

The clock chimes softly, sweetly. BIG DADDY *gives it a short, outraged glance.*

Now how about that drink?

BIG DADDY. What are you disgusted with? You got to tell me that, first. Otherwise being disgusted don't make no sense!

BRICK. Give me my crutch.

BIG DADDY. You heard me, you got to tell me what I asked you first.

BRICK. I told you, I said to kill my disgust!

BIG DADDY. DISGUST WITH WHAT!

BRICK. You strike a hard bargain.

BIG DADDY. What are you disgusted with?—an' I'll pass you the liquor.

BRICK. I can hop on one foot, and if I fall, I can crawl.

BIG DADDY. You want liquor that bad?

BRICK (*dragging himself up, clinging to bedstead*). Yeah, I want it that bad.

BIG DADDY. If I give you a drink, will you tell me what it is you're disgusted with, Brick?

BRICK. Yes, sir, I will try to.

The old man pours him a drink and solemnly passes it to him.

There is silence as BRICK *drinks.*

Have you ever heard the word "mendacity"?

BIG DADDY. Sure. Mendacity is one of them five dollar words that cheap politicians throw back and forth at each other.

BRICK. You know what it means?

BIG DADDY. Don't it mean lying and liars?

BRICK. Yes, sir, lying and liars.

BIG DADDY. Has someone been lying to you?

CHILDREN (*chanting in chorus offstage*). We want Big Dad-dee! We want Big Dad-dee!

GOOPER *appears in the gallery door.*

GOOPER. Big Daddy, the kiddies are shouting for you out there.

BIG DADDY (*fiercely*). Keep out, Gooper!

GOOPER. 'Scuse *me!*

BIG DADDY *slams the doors after* GOOPER.

BIG DADDY. Who's been lying to you, has Margaret been lying to you, has your wife been lying to you about something, Brick?

BRICK. Not her. That wouldn't matter.

BIG DADDY. Then who's been lying to you, and what about?

BRICK. No one single person and no one lie. . . .

BIG DADDY. Then what, what then, for Christ's sake?

BRICK. —The whole, the whole—thing. . . .

BIG DADDY. Why are you rubbing your head? You got a headache?

BRICK. No, I'm tryin' to—

BIG DADDY. —Concentrate, but you can't because your brain's all soaked with liquor, is that the trouble? Wet brain!

He snatches the glass from BRICK'S *hand.*

What do you know about this mendacity thing? Hell! I could write a book on it! Don't you know that? I could write a book on it and still not cover the subject? Well, I could, I could write a goddam book on it and still not cover the subject anywhere near enough!!—Think of all the lies I got to put up with!—Pretenses! Ain't that mendacity? Having to pretend stuff you don't think or feel or have any idea of? Having for instance to act like I care for Big Mama!—I haven't been able to stand the sight, sound, or smell of that woman for forty years now!—even when I *laid* her!—regular as a piston. . . . Pretend to love that son of a bitch of a Gooper and his wife Mae and those five same screechers out there like parrots in a jungle? Jesus! Can't stand to look at 'em!
Church!—it bores the bejesus out of me but I go!—I go an' sit there and listen to the fool preacher! Clubs!—Elks! Masons! Rotary!—*crap!*

A spasm of pain makes him clutch his belly. He sinks into a chair and his voice is softer and hoarser.

You I *do* like for some reason, did always have some kind of real feeling for—affection—respect—yes, always. . . .
You and being a success as a planter is all I ever had any devotion to in my whole life!—and that's the truth. . . .
I don't know why, but it is!
I've lived with mendacity!—Why can't *you* live with it? Hell, you *got* to live with it, there's nothing *else* to *live* with except mendacity, is there?

BRICK. Yes, sir. Yes, sir there is something else that you can live with!

BIG DADDY. What?

BRICK (*lifting his glass*). This!—Liquor. . . .

BIG DADDY. That's not living, that's dodging away from life.

BRICK. I want to dodge away from it.

BIG DADDY. Then why don't you kill yourself, man?

BRICK. I like to drink. . . .

BIG DADDY. Oh, God, I can't talk to you. . . .

BRICK. I'm sorry, Big Daddy.

BIG DADDY. Not as sorry as I am. I'll tell you something. A little while back when I thought my number was up—

This speech should have torrential pace and fury.

—before I found out it was just this—spastic—colon. I thought about you. Should I or should I not, if the jig was up, give you this place when I go—since I hate Gooper an' Mae an' know that they hate me, and since all five same monkeys are little Maes an' Goopers.—And I thought,

No!—Then I thought, Yes!—I couldn't make up my mind. I hate Gooper and his five same monkeys and that bitch Mae! Why should I turn over twenty-eight thousand acres of the richest land this side of the valley Nile to not my kind?—But why in hell, on the other hand, Brick—should I subsidize a goddam fool on the bottle?—Liked or not liked, well, maybe even—*loved!*—Why should I do that?—Subsidize worthless behavior? Rot? Corruption?

BRICK *(smiling)*. I understand.

BIG DADDY. Well, if you do, you're smarter than I am, God damn it, because I don't understand. And this I will tell you frankly. I didn't make up my mind at all on that question and still to this day I ain't made out no will!—Well, now I don't *have* to. The pressure is gone. I can just wait and see if you pull yourself together or if you don't.

BRICK. That's right, Big Daddy.

BIG DADDY. You sound like you thought I was kidding.

BRICK *(rising)*. No, sir, I know you're not kidding.

BIG DADDY. But you don't care—?

BRICK *(hobbling toward the gallery door)*. No, sir, I don't care. . . .

He stands in the gallery doorway as the night sky turns pink and green and gold with successive flashes of light.

BIG DADDY. WAIT!—Brick. . . .

His voice drops. Suddenly there is something shy, almost tender, in his restraining gesture.

Don't let's—leave it like this, like them other talks we've had, we've always—talked around things, we've—just talked around things for some fuckin' reason, I don't know what, it's always like something was left not spoken, something avoided because neither of us was honest enough with the—other. . . .

BRICK. I never lied to you, Big Daddy.

BIG DADDY. Did I ever to *you?*

BRICK. No, sir. . . .

BIG DADDY. Then there is at least two people that never lied to each other.

BRICK. But we've never *talked* to each other.

BIG DADDY. We can *now.*

BRICK. Big Daddy, there don't seem to be anything much to say.

BIG DADDY. You say that you drink to kill your disgust with lying.

BRICK. You said to give you a reason.

BIG DADDY. Is liquor the only thing that'll kill this disgust?

BRICK. Now. Yes.

BIG DADDY. But not once, huh?

BRICK. Not when I was still young an' believing. A drinking man's someone who wants to forget he isn't still young an' believing.

BIG DADDY. Believing what?

BRICK. Believing. . . .

BIG DADDY. Believing *what?*

BRICK *(stubbornly evasive)*. Believing. . . .

BIG DADDY. I don't know what the hell you mean by believing and I don't think you know what you mean by believing, but if you still got sports in your blood, go back to sports announcing and—

BRICK. Sit in a glass box watching games I can't play? Describing what I can't do while players do it? Sweating out their disgust and confusion in contests I'm not fit for? Drinkin' a coke, half bourbon, so I can stand it? That's no goddam good any more, no help—time just outran me, Big Daddy—got there first . . .

BIG DADDY. I think you're passing the buck.

BRICK. You know many drinkin' men?

BIG DADDY *(with a slight, charming smile)*. I have known a fair number of that species.

BRICK. Could any of them tell you why he drank?

BIG DADDY. Yep, you're passin' the buck to things like time and disgust with "mendacity" and—crap!—if you got to use that kind of language about a thing, it's ninety-proof bull, and I'm not buying any.

BRICK. I had to give you a reason to get a drink!

BIG DADDY. You started drinkin' when your friend Skipper died.

Silence for five beats. Then BRICK makes a startled movement, reaching for his crutch.

BRICK. What are you suggesting?

BIG DADDY. I'm suggesting nothing.

The shuffle and clop of BRICK'S rapid hobble away from his father's steady, grave attention.

—But Gooper an' Mae suggested that there was something not right exactly in your—

BRICK (*stopping short downstage as if backed to a wall*). "Not right"?

BIG DADDY. Not, well, exactly *normal* in your friend-ship with—

BRICK. They suggested that, too? I thought that was Maggie's suggestion.

BRICK'S detachment is at last broken through. His heart is accelerated; his forehead sweat-beaded; his breath be-comes more rapid and his voice hoarse. The thing they're discussing, timidly and painfully on the side of BIG DADDY, fiercely, violently on BRICK'S side, is the inadmissible thing that Skipper died to disavow between them. The fact that if it existed it had to be disavowed to "keep face" in the world they lived in, may be at the heart of the "mendacity" that Brick drinks to kill his disgust with. It may be the root of his collapse. Or maybe it is only a single manifestation of it, not even the most important. The bird that I hope to catch in the net of this play is not the solution of one man's psychological problem. I'm trying to catch the true quality of experience in a group of people, that cloudy, flickering, evanescent—fiercely charged!—interplay of live human beings in the thundercloud of a common crisis. Some mys-tery should be left in the revelation of character in a play, just as a great deal of mystery is always left in the revelation of character in life, even in one's own character to himself. This does not absolve the playwright of his duty to observe and probe as clearly and deeply as he legitimately can: but it should steer him away from "pat" conclusions, facile defi-nitions which make a play just a play, not a snare for the truth of human experience.

The following scene should be played with great concen-tration, with most of the power leashed but palpable in what is left unspoken.

Who else's suggestion is it, is it *yours?* How many others thought that Skipper and I were—

BIG DADDY (*gently*). Now, hold on, hold on a minute, son.—I knocked around in my time.

BRICK. What's that got to do with—

BIG DADDY. I said "Hold on!"—I bummed, I bummed this country till I was—

BRICK. Whose suggestion, who else's suggestion is it?

BIG DADDY. Slept in hobo jungles and railroad Y's and flophouses in all cities before I—

BRICK. Oh, *you* think so, too, you call me your son and a queer. Oh! Maybe that's why you put Maggie and me in this room that was Jack Straw's and Peter Ochello's, in which that pair of old sisters slept in a double bed where both of 'em died!

BIG DADDY. *Now just don't go throwing rocks at—*

Suddenly REVEREND TOOKER appears in the gallery doors, his head slightly, playfully, fatuously cocked, with a practised clergyman's smile, sincere as a bird call blown on a hunter's whistle, the living embodiment of the pious, conventional lie.

BIG DADDY gasps a little at this perfectly timed, but in-congruous, apparition.

—What're you lookin' for, Preacher?

REVEREND TOOKER. The gentleman's lavatory, ha ha!—heh, heh . . .

BIG DADDY (*with strained courtesy*). —Go back out and walk down to the other end of the gallery, Rever-end Tooker, and use the bathroom connected with my bedroom, and if you can't find it, ask them where it is!

REVEREND TOOKER. Ah, thanks.

He goes out with a deprecatory chuckle.

BIG DADDY. It's hard to talk in this place . . .

BRICK. Son of a—!

BIG DADDY (*leaving a lot unspoken*). —I seen all things and understood a lot of them, till 1910. Christ, the year that—I had worn my shoes through, hocked my—I hopped off a yellow dog freight car half a mile down the road, slept in a wagon of cotton out-side the gin—Jack Straw an' Peter Ochello took me in. Hired me to manage this place which grew into this one.—When Jack Straw died—why, old Peter Ochello quit eatin' like a dog does when its master's dead, and died, too!

BRICK. Christ!

BIG DADDY. I'm just saying I understand such—

BRICK (*violently*). Skipper is dead. I have not quit eating!

BIG DADDY. No, but you started drinking.

BRICK wheels on his crutch and hurls his glass across the room shouting.

BRICK. YOU THINK SO, TOO?

Footsteps run on the gallery. There are women's calls.

BIG DADDY goes toward the door.

BRICK is transformed, as if a quiet mountain blew suddenly up in volcanic flame.

BRICK. You think so, too? You think so, too? You think me an' Skipper did, did, did!—*sodomy!*—together?

BIG DADDY. Hold—!

BRICK. That what you—

BIG DADDY. —ON—a minute!

BRICK. You think we did dirty things between us, Skipper an'—

BIG DADDY. Why are you shouting like that? Why are you—

BRICK. —Me, is that what you think of Skipper, is that—

BIG DADDY. —so excited? I don't think nothing. I don't know nothing. I'm simply telling you what—

BRICK. You think that Skipper and me were a pair of dirty old men?

BIG DADDY. Now that's—

BRICK. Straw? Ochello? A couple of—

BIG DADDY. Now just—

BRICK. —fucking sissies? Queers? Is that what you—

BIG DADDY. Shhh.

BRICK. —think?

He loses his balance and pitches to his knees without noticing the pain. He grabs the bed and drags himself up.

BIG DADDY. Jesus!—Whew. . . .Grab my hand!

BRICK. Naw, I don't want your hand. . . .

BIG DADDY. Well, I want yours. Git up!

He draws him up, keeps an arm about him with concern and affection.

You broken out in a sweat! You're panting like you'd run a race with—

BRICK *(freeing himself from his father's hold).* Big Daddy, you shock me, Big Daddy, you, you—*shock* me! Talkin' so—

He turns away from his father.

—casually!—about a—thing like that . . .
—Don't you know how people *feel* about things like that? How, how *disgusted* they are by things like that? Why, at Ole Miss when it was discovered a pledge to our fraternity, Skipper's and mine, did a, *attempted* to do a, unnatural thing with—
We not only dropped him like a hot rock!—We told him to git off the campus, and he did, he got!—All the way to—

He halts, breathless.

BIG DADDY. —Where?

BRICK. —North Africa, last I heard!

BIG DADDY. Well, I have come back from further away than that, I have just now returned from the other side of the moon, death's country, son, and I'm not easy to shock by anything here.

He comes downstage and faces out.

Always, anyhow, lived with too much space around me to be infected by ideas of other people. One thing you can grow on a big place more important than cotton!—is *tolerance!*—I grown it.

He returns toward BRICK.

BRICK. Why can't exceptional friendship, *real, real, deep, deep friendship!* between two men be respected as something clean and decent without being thought of as—

BIG DADDY. It can, it is, for God's sake.

BRICK. —*Fairies.* . . .

In his utterance of this word, we gauge the wide and profound reach of the conventional mores he got from the world that crowned him with early laurel.

BIG DADDY. I told Mae an' Gooper—

BRICK. Frig Mae and Gooper, frig all dirty lies and liars!—Skipper and me had a clean, true thing between us!—had a clean friendship, practically all our lives, till Maggie got the idea you're talking about. Normal? No!—It was too rare to be normal, any true thing between two people is too rare to be normal. Oh, once in a while he put his hand

on my shoulder or I'd put mine on his, oh, maybe even, when we were touring the country in pro-football an' shared hotel-rooms we'd reach across the space between the two beds and shake hands to say goodnight, yeah, one or two times we—

BIG DADDY. Brick, nobody thinks that that's not normal!

BRICK. Well, they're mistaken, it was! It was a pure an' true thing an' that's not normal.

MAE (*off stage*). Big Daddy, they're startin' the fireworks.

They both stare straight at each other for a long moment. The tension breaks and both turn away as if tired.

BIG DADDY. Yeah, it's—hard t'—talk. . . .

BRICK. All right, then, let's—let it go. . . .

BIG DADDY. Why did Skipper crack up? Why have you?

BRICK looks back at his father again. He has already decided, without knowing that he has made this decision, that he is going to tell his father that he is dying of cancer. Only this could even the score between them: one inadmissible thing in return for another.

BRICK (*ominously*). All right. You're asking for it, Big Daddy. We're finally going to have that real true talk you wanted. It's too late to stop it, now, we got to carry it through and cover every subject.

He hobbles back to the liquor cabinet.

Uh-huh.

He opens the ice bucket and picks up the silver tongs with slow admiration of their frosty brightness.

Maggie declares that Skipper and I went into pro-football after we left "Ole Miss" because we were scared to grow up . . .

He moves downstage with the shuffle and clop of a cripple on a crutch. As MARGARET did when her speech became "recitative," he looks out into the house, commanding its attention by his direct, concentrated gaze—a broken, "tragically elegant" figure telling simply as much as he knows of "the Truth":

—Wanted to—keep on tossing—those long, long!—high, high!—passes that—couldn't be intercepted except by time, the aerial attack that made us famous! And so we did, we did, we kept it up for one season, that aerial attack, we held it high!— Yeah, but—
—that summer, Maggie, she laid the law down to me, said, Now or never, and so I married Maggie. . . .

BIG DADDY. How was Maggie in bed?

BRICK (*wryly*). Great! the greatest!

BIG DADDY nods as if he thought so.

She went on the road that fall with the Dixie Stars. Oh, she made a great show of being the world's best sport. She wore a—wore a—tall bearskin cap! A shako, they call it, a dyed moleskin coat, a moleskin coat dyed red!—Cut up crazy! Rented hotel ballrooms for victory celebrations, wouldn't cancel them when it—turned out—defeat. . . .

MAGGIE THE CAT! Ha ha!

BIG DADDY nods.

—But Skipper, he had some fever which came back on him which doctors couldn't explain and I got that injury—turned out to be just a shadow on the X-ray plate—and a touch of bursitis. . . .
I lay in a hospital bed, watched our games on TV, saw Maggie on the bench next to Skipper when he was hauled out of a game for stumbles, fumbles!— Burned me up the way she hung on his arm!— Y'know, I think that Maggie had always felt sort of left out because she and me never got any closer together than two people just get in bed, which is not much closer than two cats on a—fence humping. . . .
So! She took this time to work on poor dumb Skipper. He was a less than average student at Ole Miss, you know that, don't you?!—Poured in his mind the dirty, false idea that what we were, him and me, was a frustrated case of that ole pair of sisters that lived in this room, Jack Straw and Peter Ochello!—He, poor Skipper, went to bed with Maggie to prove it wasn't true, and when it didn't work out, he thought it *was* true!—Skipper broke in two like a rotten stick—nobody ever turned so fast to a lush—or died of it so quick. . . .
—Now are you satisfied?

BIG DADDY has listened to this story, dividing the grain from the chaff. Now he looks at his son.

BIG DADDY. Are *you* satisfied?

BRICK. With what?

BIG DADDY. That half-ass story!

BRICK. What's half-ass about it?

BIG DADDY. Something's left out of that story. What did you leave out?

The phone has started ringing in the hall.

GOOPER (*off stage*). Hello.

As if it reminded him of something, BRICK *glances suddenly toward the sound and says:*

BRICK. Yes!—I left out a long-distance call which I had from Skipper—

GOOPER. Speaking, go ahead.

BRICK. —In which he made a drunken confession to me and on which I hung up!

GOOPER. No.

BRICK. —Last time we spoke to each other in our lives . . .

GOOPER. No, sir.

BIG DADDY. You musta said something to him before you hung up.

BRICK. What could I say to him?

BIG DADDY. Anything. Something.

BRICK. Nothing.

BIG DADDY. Just hung up?

BRICK. Just hung up.

BIG DADDY. Uh-huh. Anyhow now!—we have tracked down the lie with which you're disgusted and which you are drinking to kill your disgust with, Brick. You been passing the buck. This disgust with mendacity is disgust with yourself. *You!*—dug the grave of your friend and kicked him in it!—before you'd face truth with him!

BRICK. *His* truth, not *mine!*

BIG DADDY. His truth, okay! But you wouldn't face it with him!

BRICK. Who *can* face truth? Can *you?*

BIG DADDY. Now don't start passin' the rotten buck again, boy!

BRICK. How about these birthday congratulations, these many, many happy returns of the day, when ev'rybody knows there won't be any except you!

GOOPER, *who has answered the hall phone, lets out a high, shrill laugh; the voice becomes audible saying:* "No, no, you got it all wrong! Upside down! Are you crazy?"

BRICK *suddenly catches his breath as he realized that he has made a shocking disclosure. He hobbles a few paces, then freezes, and without looking at his father's shocked face, says:*

Let's, let's—go out, now, and—watch the fireworks. Come on, Big Daddy.

BIG DADDY *moves suddenly forward and grabs hold of the boy's crutch like it was a weapon for which they were fighting for possession.*

BIG DADDY. Oh, no, no! No one's going out! What did you start to say?

BRICK. I don't remember.

BIG DADDY. "Many happy returns when they know there won't be any"?

BRICK. Aw, hell, Big Daddy, forget it. Come on out on the gallery and look at the fireworks they're shooting off for your birthday. . . .

BIG DADDY. First you finish that remark you were makin' before you cut off. "Many happy returns when they know there won't be any"?—Ain't that what you just said?

BRICK. Look, now. I can get around without that crutch if I have to but it would be a lot easier on the furniture an' glassware if I didn' have to go swinging along like Tarzan of th'—

BIG DADDY. FINISH! WHAT YOU WAS SAYIN'!

An eerie green glow shows in sky behind him.

BRICK (*sucking the ice in his glass, speech becoming thick*). Leave th' place to Gooper and Mae an' their five little same little monkeys. All I want is—

BIG DADDY. "LEAVE TH' PLACE," did you say?

BRICK (*vaguely*). All twenty-eight thousand acres of the richest land this side of the valley Nile.

BIG DADDY. Who said I was "leaving the place" to Gooper or anybody? This is my sixty-fifth birthday! I got fifteen years or twenty years left in me! I'll outlive *you!* I'll bury you an' have to pay for your coffin!

BRICK. Sure. Many happy returns. Now let's go watch the fireworks, come on, let's—

BIG DADDY. Lying, have they been lying? About the report from th'—clinic? Did they, did they—find something?—*Cancer.* Maybe?

BRICK. Mendacity is a system that we live in. Liquor is one way out an' death's the other. . . .

He takes the crutch from Big Daddy's *loose grip and swings out on the gallery leaving the doors open.*

A song, "Pick a Bale of Cotton," is heard.

Mae (*appearing in door*). Oh, Big Daddy, the field hands are singin' fo' you!

Brick. I'm sorry, Big Daddy. My head don't work any more and it's hard for me to understand how anybody could care if he lived or died or was dying or cared about anything but whether or not there was liquor left in the bottle and so I said what I said without thinking. In some ways I'm no better than the others, in some ways worse because I'm less alive. Maybe it's being alive that makes them lie, and being almost *not* alive makes me sort of accidentally truthful—I don't know but—anyway—we've been friends . . .

—And being friends is telling each other the truth. . . .

There is a pause.

You told *me*! I told *you*!

Big Daddy (*slowly and passionately*). CHRIST—DAMN—

Gooper (*offstage*). Let her go!

Fireworks off stage right.

Big Daddy. —ALL—LYING SONS OF—LYING BITCHES!

He straightens at last and crosses to the inside door. At the door he turns and looks back as if he had some desperate question he couldn't put into words. Then he nods reflectively and says in a hoarse voice:

Yes, all liars, all liars, all lying dying liars!

This is said slowly, slowly, with a fierce revulsion. He goes on out.

—Lying! Dying! Liars!

Brick *remains motionless as the lights dim out and the curtain falls.*

CURTAIN.

Act Three

There is No Lapse of Time. Big Daddy is Seen Leaving as at the End of Act II.

Big Daddy. ALL LYIN'—DYIN'!—LIARS! LIARS!—LIARS!

Margaret *enters.*

Margaret. Brick, what in the name of God was goin' on in this room?

Dixie *and* Trixie *enter through the doors and circle around* Margaret *shouting.* Mae *enters from the lower gallery window.*

Mae. Dixie, Trixie, you quit that!

Gooper *enters through the doors.*

Gooper, will y' please get these kiddies to bed right now!

Gooper. Mae, you seen Big Mama?

Mae. Not yet.

Gooper *and kids exit through the doors.*

Reverend Tooker *enters through the windows.*

Reverend Tooker. Those kiddies are so full of vitality. I think I'll have to be starting back to town.

Mae. Not yet, Preacher. You know we regard you as a member of this family, one of our closest an' dearest, so you just got t' be with us when Doc Baugh gives Big Mama th' actual truth about th' report from the clinic.

Margaret. Where do you think you're going?

Brick. Out for some air.

Margaret. Why'd Big Daddy shout "Liars"?

Mae. Has Big Daddy gone to bed, Brick?

Gooper [*entering*]. Now where is that old lady?

Reverend Tooker. I'll look for her.

He exits to the gallery.

Mae. Cain'tcha find her, Gooper?

Gooper. She's avoidin' this talk.

Mae. I think she senses somethin'.

Margaret (*going out on the gallery to* Brick). Brick, they're goin' to tell Big Mama the truth about Big Daddy and she's goin' to need you.

Doctor Baugh. This is going to be painful.

Mae. Painful things caint always be avoided.

REVEREND TOOKER. I see Big Mama.

GOOPER. Hey, Big Mama, come here.

MAE. Hush, Gooper, don't holler.

BIG MAMA (*entering*). Too much smell of burnt fireworks makes me feel a little bit sick at my stomach.—Where is Big Daddy?

MAE. That's what I want to know, where has Big Daddy gone?

BIG MAMA. He must have turned in, I reckon he went to baid . . .

GOOPER. Well, then, now we can talk.

BIG MAMA. What *is* this talk, *what* talk?

MARGARET *appears on the gallery, talking to Doctor Baugh.*

MARGARET (*musically*). My family freed their slaves ten years before abolition. My great-great-grandfather gave his slaves their freedom five years before the War between the States started!

MAE. Oh, for God's sake! Maggie's climbed back up in her family tree!

MARGARET (*sweetly*). What, Mae?

The pace must be very quick: great Southern animation.

BIG MAMA (*Addressing them all*). I think Big Daddy was just worn out. He loves his family, he loves to have them around him, but it's a strain on his nerves. He wasn't himself tonight, Big Daddy wasn't himself, I could tell he was all worked up.

REVEREND TOOKER. I think he's remarkable.

BIG MAMA. Yaisss! Just remarkable. Did you all notice the food he ate at that table? Did you all notice the supper he put away? Why he ate like a hawss!

GOOPER. I hope he doesn't regret it.

BIG MAMA. What? Why that man—ate a huge piece of cawn bread with molasses on it! Helped himself twice to hoppin' John.

MARGARET. Big Daddy loves hoppin' John.—We had a real country dinner.

BIG MAMA (*overlapping* MARGARET). Yaiss, he simply adores it! an' candied yams? Son? That man put away enough food at that table to stuff a *field* hand!

GOOPER (*with grim relish*). I hope he don't have to pay for it later on . . .

BIG MAMA (*fiercely*). What's *that*, Gooper?

MAE. Gooper says he hopes Big Daddy doesn't suffer tonight.

BIG MAMA. Oh, shoot, Gooper says, Gooper says! Why should Big Daddy suffer for satisfying a normal appetite? There's nothin' wrong with that man but nerves, he's sound as a dollar! And now he knows he is an' that's why he ate such a supper. He had a big load off his mind, knowin' he wasn't doomed t'—what he thought he was doomed to . . .

MARGARET (*sadly and sweetly*). Bless his old sweet soul . . .

BIG MAMA (*vaguely*). Yais, bless his heart, where's Brick?

MAE. Outside.

GOOPER. —Drinkin' . . .

BIG MAMA. I know he's drinkin'. Cain't I see he's drinkin' without you continually tellin' me that boy's drinkin'?

MARGARET. Good for you, Big Mama!

She applauds.

BIG MAMA. Other people *drink* and *have* drunk an' will *drink*, as long as they make that stuff an' put it in bottles.

MARGARET. That's the truth. I never trusted a man that didn't drink.

BIG MAMA. *Brick? Brick!*

MARGARET. He's still on the gall'ry. I'll go bring him in so we can talk.

BIG MAMA (*worriedly*). I don't know what this mysterious family conference is about.

Awkward silence. BIG MAMA *looks from face to face, then belches slightly and mutters, "Excuse me . . ." She opens an ornamental fan suspended about her throat. A black lace fan to go with her black lace gown, and fans her wilting corsage, sniffing nervously and looking from face to face in the uncomfortable silence as* MARGARET *calls "Brick?" and* BRICK *sings to the moon on ⸻allery.*

MARGARET. Brick, they're gonna tell ⸻ truth an' she's gonna need you.

BIG MAMA. I don't know what's wrong here, you all have such long faces! Open that door on the hall and let some air circulate through here, will you please, Gooper?

MAE. I think we'd better leave that door closed, Big Mama, till after the talk.

MARGARET. Brick!

BIG MAMA. Reveren' Tooker, will *you* please open that door?

REVEREND TOOKER. I sure will, Big Mama.

MAE. I just didn't think we ought t' take any chance of Big Daddy hearin' a word of this discussion.

BIG MAMA. *I swan!* Nothing's going to be said in Big Daddy's house that he caint hear if he want to!

GOOPER. Well, Big Mama, it's—

MAE gives him a quick, hard poke to shut him up. He glares at her fiercely as she circles before him like a burlesque ballerina, raising her skinny bare arms over her head, jangling her bracelets, exclaiming:

MAE. *A breeze! A breeze!*

REVEREND TOOKER. I think this house is the coolest house in the Delta.—Did you all know that Halsey Banks's widow put air-conditioning units in the church and rectory at Friar's Point in memory of Halsey?

General conversation has resumed; everybody is chatting so that the stage sounds like a bird cage.

GOOPER. Too bad nobody cools your church off for you. I bet you sweat in that pulpit these hot Sundays, Reverend Tooker.

REVEREND TOOKER. Yes, my vestments are drenched. Last Sunday the gold in my chasuble faded into the purple.

GOOPER. Reveren', you musta been preachin' hell's fire last Sunday.

MAE [*at the same time to Doctor Baugh*]. You reckon those vitamin B12 injections are what they're cracked up t' be, Doc Baugh?

DOCTOR BAUGH. Well, if you want to be stuck with something I guess they're as good to be stuck with as anything else.

MA [*at the gallery door*]. *Maggie, Maggie, aren't* *___min' with Brick?*

MAE (*suddenly and loudly, creating a silence*). *I have a strange feeling, I have a peculiar feeling!*

BIG MAMA (*turning from the gallery*). What feeling?

MAE. That Brick said somethin' he shouldn't of said t' Big Daddy.

BIG MAMA. Now what on earth could Brick of said t' Big Daddy that he shouldn't say?

GOOPER. Big Mama, there's somethin'—

MAE. NOW, WAIT!

She rushes up to BIG MAMA and gives her a quick hug and kiss. BIG MAMA pushes her impatiently off.

DOCTOR BAUGH. In my day they had what they call the Keeley cure for heavy drinkers.

BIG MAMA. Shoot!

DOCTOR BAUGH. But now I understand they just take some kind of tablets.

GOOPER. They call them "Annie Bust" tablets.

BIG MAMA. *Brick* don't need to take *nothin'.*

BRICK and MARGARET appear in gallery doors, BIG MAMA unaware of his presence behind her.

That boy is just broken up over Skipper's death. You know how poor Skipper died. They gave him a big, big dose of that sodium amytal stuff at his home and then they called the ambulance and give him another big, big dose of it at the hospital and that and all of the alcohol in his system fo' months an' months just proved too much for his heart . . . I'm scared of needles! I'm more scared of a needle than the knife . . . I think more people have been needled out of this world than—

She stops short and wheels about.

Oh—here's Brick! My precious baby—

She turns upon BRICK with short, fat arms extended, at the same time uttering a loud, short sob, which is both comic and touching. BRICK smiles and bows slightly, making a burlesque gesture of gallantry for MARGARET to pass before him into the room. Then he hobbles on his crutch directly to the liquor cabinet and there is absolute silence, with everybody looking at BRICK as everybody has always looked at BRICK when he spoke or moved or appeared. One by one he drops ice cubes in his glass, then suddenly, but not quickly, looks back over his shoulder with a wry, charming smile, and says:

BRICK. I'm sorry! Anyone else?

BIG MAMA (*sadly*). No, son. I *wish* you wouldn't!

BRICK. I wish I didn't have to, Big Mama, but I'm still waiting for that click in my head which makes it all smooth out!

BIG MAMA. Ow, Brick, you—BREAK MY HEART!

MARGARET (*at same time*). *Brick, go sit with Big Mama!*

BIG MAMA. I just cain't staiiiiii-nnnnnnnd-it . . .

She sobs.

MAE. Now that we're all assembled—

GOOPER. We kin talk . . .

BIG MAMA. Breaks my heart . . .

MARGARET. Sit with Big Mama, Brick, and hold her hand.

BIG MAMA sniffs very loudly three times, almost like three drumbeats in the pocket of silence.

BRICK. You do that, Maggie. I'm a restless cripple. I got to stay on my crutch.

BRICK hobbles to the gallery door; leans there as if waiting.

MAE sits beside BIG MAMA, while GOOPER moves in front and sits on the end of the couch, facing her. REVEREND TOOKER moves nervously into the space between them; on the other side, DOCTOR BAUGH stands looking at nothing in particular and lights a cigar. MARGARET turns away.

BIG MAMA. Why're you all *surroundin'* me—like this? Why're you all starin' at me like this an' makin' signs at each other?

REVEREND TOOKER steps back startled.

MAE. Calm yourself, Big Mama.

BIG MAMA. Calm you'self, *you'self*, Sister Woman. How could I calm myself with everyone starin' at me as if big drops of blood had broken out on m'face? What's this all about, annh! What?

GOOPER coughs and takes a center position.

GOOPER. Now, Doc Baugh.

MAE. Doc Baugh?

GOOPER. Big Mama wants to know the complete truth about the report we got from the Ochsner Clinic.

MAE (*eagerly*). —on Big Daddy's condition!

GOOPER. Yais, on Big Daddy's condition, we got to face it.

DOCTOR BAUGH. Well . . .

BIG MAMA (*terrified, rising*). Is there? Something? Something that I? Don't—know?

In these few words, this startled, very soft, question, BIG MAMA reviews the history of her forty-five years with BIG DADDY, her great, almost embarrassingly true-hearted and simple-minded devotion to BIG DADDY, who must have had something BRICK has, who made himself loved so much by the "simple expedient" of not loving enough to disturb his charming detachment, also once coupled, like Brick, with virile beauty.

BIG MAMA has a dignity at this moment; she almost stops being fat.

DOCTOR BAUGH (*after a pause, uncomfortably*). Yes?—Well—

BIG MAMA. I!!!—want to—*knowwwwww* . . .

Immediately she thrusts her fist to her mouth as if to deny that statement. Then for some curious reason, she snatches the withered corsage from her breast and hurls it on the floor and steps on it with her short, fat feet.

Somebody must be lyin'!—I want to know!

MAE. Sit down, Big Mama, sit down on this sofa.

MARGARET. Brick, go sit with Big Mama.

BIG MAMA. *What is it, what is it?*

DOCTOR BAUGH. I never have seen a more thorough examination than Big Daddy Pollitt was given in all my experience with the Ochsner Clinic.

GOOPER. It's one of the best in the country.

MAE. It's THE best in the country—bar *none!*

For some reason she gives GOOPER a violent poke as she goes past him. He slaps at her hand without removing his eyes from his mother's face.

DOCTOR BAUGH. Of course they were ninety-nine and nine-tenths per cent sure before they even started.

BIG MAMA. Sure of what, sure of what, sure of—what?—what?

She catches her breath in a startled sob. Mae kisses her quickly. She thrusts Mae fiercely away from her, staring at the DOCTOR.

MAE. Mommy, be a brave girl!

BRICK (*in the doorway, softly*). "By the light, by the light, Of the sil-ve-ry mo-oo-n . . ."

GOOPER. Shut up!—Brick.

BRICK. Sorry . . .

He wanders out on the gallery.

DOCTOR BAUGH. But now, you see, Big Mama, they cut a piece off this growth, a specimen of the tissue and—

BIG MAMA. Growth? You told Big Daddy—

DOCTOR BAUGH. Now wait.

BIG MAMA (*fiercely*). You told me and Big Daddy there wasn't a thing wrong with him but—

MAE. Big Mama, they always—

GOOPER. Let Doc Baugh talk, will yuh?

BIG MAMA. —little spastic condition of—

Her breath gives out in a sob.

DOCTOR BAUGH. Yes, that's what we told Big Daddy. But we had this bit of tissue run through the laboratory and I'm sorry to say the test was positive on it. It's—well—malignant . . .

Pause.

BIG MAMA. —Cancer?! Cancer?!

DOCTOR BAUGH *nods gravely.* BIG MAMA *gives a long gasping cry.*

MAE AND GOOPER. Now, now, now, Big Mama, you had to know . . .

BIG MAMA. WHY DIDN'T THEY CUT IT OUT OF HIM? HANH? HANH?

DOCTOR BAUGH. Involved too much, Big Mama, too many organs affected.

MAE. Big Mama, the liver's affected and so's the kidneys, both! It's gone way past what they call a—

GOOPER. A surgical risk.

MAE. —Uh-huh . . .

BIG MAMA *draws a breath like a dying gasp.*

REVEREND TOOKER. Tch, tch, tch, tch, tch!

DOCTOR BAUGH. Yes it's gone past the knife.

MAE. *That's why he's turned yellow, Mommy!*

BIG MAMA. *Git away from me, git away from me, Mae!*

She rises abruptly.

I want Brick! Where's Brick? Where is my only son?

MAE. Mama! Did she say "*only* son"?

GOOPER. What does that make *me*?

MAE. A sober responsible man with five precious children!—*Six*!

BIG MAMA. I want Brick to tell me! Brick! Brick!

MARGARET (*rising from her reflections in a corner*). Brick was so upset he went back out.

BIG MAMA. *Brick!*

MARGARET. Mama, let *me* tell you!

BIG MAMA. No, no, leave me alone, you're not my blood!

GOOPER. *Mama, I'm your son!* Listen to *me*!

MAE. Gooper's your son, he's your first-born!

BIG MAMA. Gooper never liked Daddy.

MAE (*as if terribly shocked*). *That's not TRUE!*

There is a pause. The minister coughs and rises.

REVEREND TOOKER (*to Mae*). I think I'd better slip away at this point.

Discreetly.

Good night, good night, everybody, and God bless you all . . . on this place . . .

He slips out.

MAE *coughs and points at* BIG MAMA.

GOOPER. Well, Big Mama . . .

He sighs.

BIG MAMA. It's all a mistake, I know it's just a bad dream.

DOCTOR BAUGH. We're gonna keep Big Daddy as comfortable as we can.

BIG MAMA. Yes, it's just a bad dream, that's all it is, it's just an awful dream.

GOOPER. In my opinion Big Daddy is having some pain but won't admit that he has it.

BIG MAMA. Just a dream, a bad dream.

DOCTOR BAUGH. That's what lots of them do, they think if they don't admit they're having the pain they can sort of escape the fact of it.

GOOPER (*with relish*). Yes, they get sly about it, they get real sly about it.

MAE. Gooper and I think—

GOOPER. Shut up, Mae! Big Mama, I think—Big Daddy ought to be started on morphine.

BIG MAMA. Nobody's going to give Big Daddy morphine.

DOCTOR BAUGH. Now, Big Mama, when that pain strikes it's going to strike mighty hard and Big Daddy's going to need the needle to bear it.

BIG MAMA. I tell you, nobody's going to give him morphine.

MAE. Big Mama, you don't want to see Big Daddy suffer, you know you—

GOOPER, *standing beside her, gives her a savage poke.*

DOCTOR BAUGH (*placing a package on the table*). I'm leaving this stuff here, so if there's a sudden attack you all won't have to send out for it.

MAE. I know how to give a hypo.

BIG MAMA. Nobody's gonna give Big Daddy morphine.

GOOPER. Mae took a course in nursing during the war.

MARGARET. Somehow I don't think Big Daddy would want Mae to give him a hypo.

MAE. You think he'd want *you* to do it?

DOCTOR BAUGH. Well . . .

DOCTOR BAUGH rises.

GOOPER. Doctor Baugh is goin'.

DOCTOR BAUGH. Yes, I got to be goin'. Well, keep your chin up, Big Mama.

GOOPER (*with jocularity*). She's gonna keep *both* chins up, aren't you, Big Mama?

BIG MAMA sobs.

Now stop that, Big Mama.

GOOPER [*at the door with Doctor Baugh*]. Well, Doc, we sure do appreciate all you done. I'm telling you, we're surely obligated to you for—

DOCTOR BAUGH has gone out without a glance at him.

—I guess that doctor has got a lot on his mind but it wouldn't hurt him to act a little more human . . .

BIG MAMA sobs.

Now be a brave girl, Mommy.

BIG MAMA. It's not true, I know that it's just not true!

GOOPER. Mama, those tests are infallible!

BIG MAMA. Why are you so determined to see your father daid?

MAE. Big Mama!

MARGARET (*gently*). I know what Big Mama means.

MAE (*fiercely*). Oh, do you?

MARGARET (*quietly and very sadly*). Yes, I think I do.

MAE. For a newcomer in the family you sure do show a lot of understanding.

MARGARET. Understanding is needed on this place.

MAE. I guess you must have needed a lot of it in your family, Maggie, with your father's liquor problem and now you've got Brick with his!

MARGARET. Brick does not have a liquor problem at all. Brick is devoted to Big Daddy. This thing is a terrible strain on him.

BIG MAMA. Brick is Big Daddy's boy, but he drinks too much and it worries me and Big Daddy, and, Margaret, you've got to cooperate with us, you've got to co-operate with Big Daddy and me in getting Brick straightened out. Because it will break Big Daddy's heart if Brick don't pull himself together and take hold of things.

MAE. Take hold of *what* things, Big Mama?

BIG MAMA. The place.

There is a quick violent look between MAE and GOOPER.

GOOPER. Big Mama, you've had a shock.

MAE. Yais, we've all had a shock, but . . .

GOOPER. Let's be realistic—

MAE. —Big Daddy would never, would *never*, be foolish enough to—

GOOPER. —put this place in irresponsible hands!

BIG MAMA. Big Daddy ain't going to leave the place in anybody's hands; Big Daddy is *not* going to die. I want you to get that in your heads, all of you!

MAE. Mommy, Mommy, Big Mama, we're just as hopeful an' optimistic as you are about Big Daddy's prospects, we have faith in *prayer*— but nevertheless there are certain matters that have to be discussed an' dealt with, because otherwise—

GOOPER. Eventualities have to be considered and now's the time . . . Mae, will you please get my brief case out of our room?

MAE. Yes, honey.

She rises and goes out through the hall door.

GOOPER (*standing over* BIG MAMA). Now, Big Mom. What you said just now was not at all true and you know it. I've always loved Big Daddy in my own quiet way. I never made a show of it, and I know that Big Daddy has always been fond of me in a quiet way, too, and he never made a show of it neither.

MAE returns with GOOPER'S *brief case.*

MAE. Here's your brief case, Gooper, honey.

GOOPER (*handing the brief case back to her*). Thank you . . . Of cou'se, my relationship with Big Daddy is different from Brick's.

MAE. You're eight years older'n Brick an' always had t' carry a bigger load of th' responsibilities than Brick ever had t' carry. He never carried a thing in his life but a football or a highball.

GOOPER. Mae, will y' let me talk, please?

MAE. Yes, honey.

GOOPER. Now, a twenty-eight-thousand-acre plantation's a mighty big thing t' run.

MAE. Almost singlehanded.

Margaret has gone out onto the gallery and can be HEARD calling softly to BRICK.

BIG MAMA. You never had to run this place! What are you talking about? As if Big Daddy was dead and in his grave, you had to run it? Why, you just helped him out with a few business details and had your law practice at the same time in Memphis!

MAE. Oh, Mommy, Mommy, Big Mommy! Let's be fair!

MARGARET. Brick!

MAE. Why, Gooper has given himself body and soul to keeping this place up for the past five years since Big Daddy's health started failing.

MARGARET. Brick!

MAE. Gooper won't say it, Gooper never thought of it as a duty, he just did it. And what did Brick do? Brick kept living in his past glory at college! Still a football player at twenty-seven!

MARGARET [*returning alone*]. Who are you talking about now? Brick? A football player? He isn't a football player and you know it. Brick is a sports announcer on T.V. and one of the best-known ones in the country!

MAE. I'm talking about what he was.

MARGARET. Well, I wish you would just stop talking about my husband.

GOOPER. I've got a right to discuss my brother with other members of MY OWN family, which don't include *you*. Why don't you go out there and drink with Brick?

MARGARET. I've never seen such malice toward a brother.

GOOPER. How about his for me? Why, he can't stand to be in the same room with me!

MARGARET. This is a deliberate campaign of vilification for the most disgusting and sordid reason on earth, and I know what it is! It's *avarice, avarice, greed, greed!*

BIG MAMA. *Oh, I'll scream! I will scream in a moment unless this stops!*

GOOPER *has stalked up to* MARGARET *with clenched fists at his sides as if he would strike her.* MAE *distorts her face again into a hideous grimace behind* MARGARET'S *back.*

BIG MAMA (*sobs*). Margaret. Child. Come here. Sit next to Big Mama.

MARGARET. Precious Mommy. I'm sorry, I'm sorry, I—!

She bends her long graceful neck to press her forehead to BIG MAMA'S *bulging shoulder under its black chiffon.*

MAE. How beautiful, how touching, this display of devotion! Do you know why she's childless? She's childless because that big beautiful athlete husband of hers won't go to bed with her!

GOOPER. You jest won't let me do this in a nice way, will yah? Aw right—I don't give a goddam if Big Daddy likes me or don't like me or did or never did or will or will never! I'm just appealing to a sense of common decency and fair play. I'll tell you the truth. I've resented Big Daddy's partiality to Brick ever since Brick was born, and the way I've been treated like I was just barely good enough to spit on and sometimes not even good enough for that. Big Daddy is dying of cancer, and it's spread all through him and it's attacked all his vital organs including the kidneys and right now he is sinking into uremia, and you all know what uremia is, it's

poisoning of the whole system due to the failure of the body to eliminate its poisons.

MARGARET (*to herself, downstage, hissingly*). *Poisons, poisons! Venomous thoughts and words! In hearts and minds!—That's poisons!*

GOOPER (*overlapping her*). I am asking for a square deal, and, by God, I expect to get one. But if I don't get one, if there's any peculiar shenanigans going on around here behind my back, well, I'm not a corporation lawyer for nothing, I know how to protect my own interests.

BRICK *enters from the gallery with a tranquil, blurred smile, carrying an empty glass with him.*

BRICK. Storm coming up.

GOOPER. Oh! A late arrival!

MAE. Behold the conquering hero comes!

GOOPER. The fabulous Brick Pollitt! Remember him?—Who could forget him!

MAE. He looks like he's been injured in a game!

GOOPER. Yep, I'm afraid you'll have to warm the bench at the Sugar Bowl this year, Brick!

MAE *laughs shrilly.*

Or was it the Rose Bowl that he made that famous run in?—

Thunder.

MAE. The punch bowl, honey. It was in the punch bowl, the cut-glass punch bowl!

GOOPER. Oh, that's right, I'm getting the bowls mixed up!

MARGARET. Why don't you stop venting your malice and envy on a sick boy?

BIG MAMA. *Now you two hush, I mean it, hush, all of you, hush!*

DAISY, SOOKEY. Storm! Storm comin'! Storm! Storm!

LACEY. Brightie, close them shutters.

GOOPER. Lacey, put the top up on my Cadillac, will yuh?

LACEY. Yes, suh, Mistah Pollitt!

GOOPER (*at the same time*). Big Mama, you know it's necessary for me t' go back to Memphis in th' mornin' t' represent the Parker estate in a lawsuit.

MAE *sits on the bed and arranges papers she has taken from the brief case.*

BIG MAMA. Is it, Gooper?

MAE. Yaiss.

GOOPER. That's why I'm forced to—to bring up a problem that—

MAE. Somethin' that's too important t' be put off!

GOOPER. If Brick was sober, he ought to be in on this.

MARGARET. Brick is present; we're present.

GOOPER. Well, good. I will now give you this outline my partner, Tom Bullitt, an' me have drawn up—a sort of dummy—trusteeship.

MARGARET. Oh, that's it! You'll be in charge an' dole out remittances, will you?

GOOPER. This we did as soon as we got the report on Big Daddy from th' Ochsner Laboratories. We did this thing, I mean we drew up this dummy outline with the advice and assistance of the Chairman of the Boa'd of Directors of th' Southern Plantahs Bank and Trust Company in Memphis, C. C. Bellowes, a man who handles estates for all th' prominent fam'lies in West Tennessee and th' Delta.

BIG MAMA. Gooper?

GOOPER (*crouching in front of Big Mama*). Now this is not—not final, or anything like it. This is just a preliminary outline. But it does provide a basis—a design—a—possible, feasible—*plan!*

MARGARET. Yes, I'll bet it's a plan.

Thunder.

MAE. It's a plan to protect the biggest estate in the Delta from irresponsibility an'—

BIG MAMA. Now you listen to me, all of you, you listen here! They's not goin' to be any more catty talk in my house! And Gooper, you put that away before I grab it out of your hand and tear it right up! I don't know what the hell's in it, and I don't want to know what the hell's in it. I'm talkin' in Big Daddy's language now; I'm his *wife*, not his *widow*, I'm still his *wife!* And I'm talkin' to you in his language an'—

GOOPER. Big Mama, what I have here is—

MAE (*at the same time*). Gooper explained that it's just a plan . . .

BIG MAMA. I don't care what you got there. Just put it back where it came from, an' don't let me see it again, not even the outside of the envelope of it! Is that understood? Basis! Plan! Preliminary! Design! I say—what is it Big Daddy always says when he's disgusted?

BRICK (from the bar). Big Daddy says "crap" when he's disgusted.

BIG MAMA (rising). That's right—CRAP! I say CRAP too, like Big Daddy!

Thunder.

MAE. Coarse language doesn't seem called for in this—

GOOPER. Somethin' in me is deeply outraged by hearin' you talk like this.

BIG MAMA. Nobody's goin' to take nothin'!—till Big Daddy lets go of it—maybe, just possibly, not—not even then! No, not even then!

Thunder.

MAE. Sookey, hurry up an' git that po'ch furniture covahed; want th' paint to come off?

GOOPER. Lacey, put mah car away!

LACEY. Caint, Mistah Pollitt, you got the keys!

GOOPER. Naw, you got 'em, man. Where th' keys to th' car, honey?

MAE. You got 'em in your pocket!

BRICK. "You can always hear me singin' this song, Show me the way to go home."

Thunder distantly.

BIG MAMA. Brick! Come here, Brick, I need you. Tonight Brick looks like he used to look when he was a little boy, just like he did when he played wild games and used to come home when I hollered myself hoarse for him, all sweaty and pink cheeked and sleepy, with his—red curls shining . . .

BRICK draws aside as he does from all physical contact and continues the song in a whisper, opening the ice bucket and dropping in the ice cubes one by one as if he were mixing some important chemical formula.

Distant thunder.

Time goes by so fast. Nothin' can outrun it. Death commences too early—almost before you're half acquainted with life—you meet the other . . . Oh, you know we just got to love each other an' stay together,

all of us, just as close as we can, especially now that such a black thing has come and moved into this place without invitation.

Awkwardly embracing BRICK, she presses her head to his shoulder.

A dog howls off stage.

Oh, Brick, son of Big Daddy, Big Daddy does so love you. Y'know what would be his fondest dream come true? If before he passed on, if Big Daddy has to pass on . . .

A dog howls.

. . . you give him a child of yours, a grandson as much like his son as his son is like Big Daddy . . .

MARGARET. I know that's Big Daddy's dream.

BIG MAMA. That's his dream.

MAE. Such a pity that Maggie and Brick can't oblige.

BIG DADDY (off down stage right on the gallery). Looks like the wind was takin' liberties with this place.

SERVANT (off stage). Yes, sir, Mr. Pollitt.

MARGARET (crossing to the right door). Big Daddy's on the gall'ry.

BIG MAMA has turned toward the hall door at the sound of BIG DADDY's voice on the gallery.

BIG MAMA. I can't stay here. He'll see somethin' in my eyes.

Big Daddy enters the room from up stage right.

BIG DADDY. Can I come in?

He puts his cigar in an ash tray.

MARGARET. Did the storm wake you up, Big Daddy?

BIG DADDY. Which stawm are you talkin' about—th' one outside or th' hullballoo in here?

GOOPER squeezes past BIG DADDY.

GOOPER. 'Scuse me.

MAE tries to squeeze past BIG DADDY to join Gooper, but BIG DADDY puts his arm firmly around her.

BIG DADDY. I heard some mighty loud talk. Sounded like somethin' important was bein' discussed. What was the powwow about?

MAE (flustered). Why—nothin', Big Daddy . . .

BIG DADDY (*crossing to extreme left center, taking Mae with him*). What is that pregnant-lookin' envelope you're puttin' back in your brief case, Gooper?

GOOPER (*at the foot of the bed, caught, as he stuffs papers into envelope*). That? Nothin,' suh—nothin' much of anythin' at all . . .

BIG DADDY. Nothin'? It looks like a whole lot of nothin'!

He turns up stage to the group.

You all know th' story about th' young married couple—

GOOPER. Yes, sir!

BIG DADDY. Hello, Brick—

BRICK. Hello, Big Daddy.

The group is arranged in a semicircle above BIG DADDY, MARGARET *at the extreme right, then* MAE *and* GOOPER, *then* BIG MAMA, *with* BRICK *at the left.*

BIG DADDY. Young married couple took Junior out to th' zoo one Sunday, inspected all of God's creatures in their cages, with satisfaction.

GOOPER. Satisfaction.

BIG DADDY (*crossing to up stage center, facing front*). This afternoon was a warm afternoon in spring an' that ole elephant had somethin' else on his mind which was bigger'n peanuts. You know this story, Brick?

Gooper nods.

BRICK. No, sir, I don't know it.

BIG DADDY. Y'see, in th' cage adjoinin' they was a young female elephant in heat!

BIG MAMA (*at Big Daddy's shoulder*). Oh, Big Daddy!

BIG DADDY. What's the matter, preacher's gone, ain't he? All right. That female elephant in the next cage was permeatin' the atmosphere about her with a powerful and excitin' odor of female fertility! Huh! Ain't that a nice way to put it, Brick?

BRICK. Yes, sir, nothin' wrong with it.

BIG DADDY. Brick says th's nothin' wrong with it!

BIG MAMA. Oh, Big Daddy!

BIG DADDY (*crossing to down stage center*). So this ole bull elephant still had a couple of fornications left in him. He reared back his trunk an' got a whiff of that elephant lady next door!—began to paw at

the dirt in his cage an' butt his head against the separatin' partition and, first thing y'know, there was a conspicuous change in his *profile*—very *conspicuous*! Ain't I tellin' this story in decent language, Brick?

BRICK. Yes, sir, too fuckin' decent!

BIG DADDY. So, the little boy pointed at it and said, "What's that?" His mama said, "Oh, that's—nothin'!"—His papa said, "She's spoiled!"

BIG DADDY crosses to Brick at left.

You didn't laugh at that story, Brick.

BIG MAMA crosses to down stage right crying. MARGARET *goes to her.* MAE *and* GOOPER *hold up stage right center.*

BRICK. No, sir, I didn't laugh at that story.

BIG DADDY. What is the smell in this room? Don't you notice it, Brick? Don't you notice a powerful and obnoxious odor of mendacity in this room?

BRICK. Yes, sir, I think I do, sir.

GOOPER. Mae, Mae . . .

BIG DADDY. There is nothing more powerful. Is there, Brick?

BRICK. No, sir. No, sir, there isn't, an' nothin' more obnoxious.

BIG DADDY. Brick agrees with me. The odor of mendacity is a powerful and obnoxious odor an' the stawm hasn't blown it away from this room yet. You notice it, Gooper?

GOOPER. What, sir?

BIG DADDY. How about you, Sister Woman? You notice the unpleasant odor of mendacity in this room?

MAE. Why, Big Daddy, I don't even know what that is.

BIG DADDY. You can smell it. Hell it smells like death!

BIG MAMA sobs. BIG DADDY *looks toward her.*

What's wrong with that fat woman over there, loaded with diamonds? Hey, what's-you-name, what's the matter with you?

MARGARET (*crossing toward Big Daddy*).

She had a slight dizzy spell, Big Daddy.

BIG DADDY. You better watch that, Big Mama. A stroke is a bad way to go.

MARGARET [*crossing to Big Daddy at center*]. Oh, Brick, Big Daddy has on your birthday present to him, Brick, he has on your cashmere robe, the softest material I have ever felt.

BIG DADDY. Yeah, this is my soft birthday, Maggie . . . Not my gold or my silver birthday, but my soft birthday, everything's got to be soft for Big Daddy on this soft birthday.

MAGGIE kneels before BIG DADDY at center.

MARGARET. Big Daddy's got on his Chinese slippers that I gave him, Brick. Big Daddy, I haven't given you my big present yet, but now I will, now's the time for me to present it to you! I have an announcement to make!

MAE. What? What kind of announcement?

GOOPER. A sports announcement, Maggie?

MARGARET. Announcement of life beginning! A child is coming, sired by Brick, and out of Maggie the Cat! I have Brick's child in my body, an' that's my birthday present to Big Daddy on this birthday!

BIG DADDY looks at BRICK who crosses behind BIG DADDY to down stage portal, left.

BIG DADDY. Get up, girl, get up off your knees, girl.

BIG DADDY helps Margaret to rise. He crosses above her, to her right, bites off the end of a fresh cigar, taken from his bathrobe pocket, as he studies MARGARET.

Uh-huh, this girl has life in her body, that's no lie!

BIG MAMA. BIG DADDY'S DREAM COME TRUE!

BRICK. JESUS!

BIG DADDY (*crossing right below wicker stand*). Gooper, I want my lawyer in the mornin'.

BRICK. Where are you goin', Big Daddy?

BIG DADDY. Son, I'm goin' up on the roof, to the belvedere on th' roof to look over my kingdom before I give up my kingdom—twenty-eight thousand acres of th' richest land this side of the valley Nile!

He exits through right doors, and down right on the gallery.

BIG MAMA (*following*). Sweetheart, sweetheart, sweetheart—can I come with you?

She exits down stage right.

MARGARET is down stage center in the mirror area. Mae has joined GOOPER and she gives him a fierce poke, making a low hissing sound and a grimace of fury.

GOOPER (*pushing her aside*). Brick, could you possibly spare me one small shot of that liquor?

BRICK. Why, help yourself, Gooper boy.

GOOPER. I will.

MAE (*shrilly*). Of course we know that this is—a lie.

GOOPER. *Be still, Mae.*

MAE. I won't be still! I know she's made this up!

GOOPER. Goddam it, I said shut up!

MARGARET. Gracious! I didn't know that my little announcement was going to provoke such a storm!

MAE. *That* woman isn't *pregnant!*

GOOPER. Who said she was?

MAE. *She* did.

GOOPER. The doctor didn't. Doc Baugh didn't.

MARGARET. I haven't gone to Doc Baugh.

GOOPER. Then who'd you go to, Maggie?

MARGARET. One of the best gynecologists in the South.

GOOPER. Uh huh, uh huh!—I see . . .

He takes out a pencil and notebook.

—May we have his name, please?

MARGARET. No, you may not, Mister Prosecuting Attorney!

MAE. He doesn't have any name, he doesn't exist!

MARGARET. Oh, he exists all right, and so does my child, Brick's baby!

MAE. You can't conceive a child by a man that won't sleep with you unless you think you're—

BRICK has turned on the phonograph. A scat song cuts MAE'S speech.

GOOPER. *Turn that off!*

MAE. We know it's a lie because we hear you in here; he won't sleep with you, we hear you! So don't imagine you're going to put a trick over on us, to fool a dying man with a—

A long drawn cry of agony and rage fills the house. MARGARET turns the phonograph down to a whisper. The cry is repeated.

MAE. Did you hear that, Gooper, did you hear that?

GOOPER. Sounds like the pain has struck.

GOOPER. Come along and leave these lovebirds together in their nest!

He goes out first. MAE *follows but turns at the door, contorting her face and hissing at* MARGARET.

MAE. *Liar!*

She slams the door.

MARGARET *exhales with relief and moves a little unsteadily to catch hold of* BRICK'S *arm.*

MARGARET. Thank you for—keeping still . . .

BRICK. O.K., Maggie.

MARGARET. It was gallant of you to save my face!

He now pours down three shots in quick succession and stands waiting, silent. All at once he turns with a smile and says:

BRICK. *There!*

MARGARET. What?

BRICK. The *click* . . .

His gratitude seems almost infinite as he hobbles out on the gallery with a drink. We hear his crutch as he swings out of sight. Then, at some distance, he begins singing to himself a peaceful song. MARGARET *holds the big pillow forlornly as if it were her only companion, for a few moments, then throws it on the bed. She rushes to the liquor cabinet, gathers all the bottles in her arms, turns about undecidedly, then runs out of the room with them, leaving the door ajar on the dim yellow hall.* BRICK *is heard hobbling back along the gallery, singing his peaceful song. He comes back in, sees the pillow on the bed, laughs lightly, sadly, picks it up. He has it under his arm as Margaret returns to the room.* MARGARET *softly shuts the door and leans against it, smiling softly at* BRICK.

MARGARET. Brick, I used to think that you were stronger than me and I didn't want to be overpowered by you. But now, since you've taken to liquor—you know what?—I guess it's bad, but now I'm stronger than

you and I can love you more truly! Don't move that pillow. I'll move it right back if you do!—Brick?

She turns out all the lamps but a single rose-silk-shaded one by the bed.

I really have been to a doctor and I know what to do and—Brick?—this is my time by the calendar to conceive?

BRICK. Yes, I understand, Maggie. But how are you going to conceive a child by a man in love with his liquor?

MARGARET. By locking his liquor up and making him satisfy my desire before I unlock it!

BRICK. Is that what you've done, Maggie?

MARGARET. Look and see. That cabinet's mighty empty compared to before!

BRICK. Well, I'll be a son of a—

He reaches for his crutch but she beats him to it and rushes out on the gallery, hurls the crutch over the rail and comes back in, panting.

MARGARET. And so tonight we're going to make the lie true, and when that's done, I'll bring the liquor back here and we'll get drunk together, here, tonight, in this place that death has come into . . .—What do you say?

BRICK. I don't say anything. I guess there's nothing to say.

MARGARET. Oh, you weak people, you weak, beautiful people!—who give up with such grace. What you want is someone to—

She turns out the rose silk lamp.

—take hold of you.—Gently, gently with love hand your life back to you, like somethin' gold you let go of. I *do* love you, Brick, I *do!*

BRICK (*smiling with charming sadnesS*). Wouldn't it be funny if that was true?

THE END.

The Bald Soprano

Eugene Ionesco: an Absurd Approach to Theatre

Eugene Ionesco is one of a handful of European playwrights credited with pioneering one of the theatre's most bizarre and influential movements. If realism changed everything theatrically that came after it, no other movement in modern drama can make the same claim save for the Theatre of the Absurd. Absurdist drama rose out of existentialist thought, which dominated Europe following the World War II. The Europeans had suffered through two world wars in a span of thirty years, and many nations were war-torn and rebuilding. The dramatic forms that arose out of this chaos were much darker than many of the forms dominating the American stage.

Jean-Paul Sartre is perhaps the best known existentialist philosopher. Sartre denied the existence of God and argued that there were no such things as moral codes. He and the other existentialists argued that one should not conform to the views of others without first questioning those views. This was obviously a direct response to the Nazis' claims they were only following orders when they murdered millions of European Jews. This was a rally to question authority and defy the powers, which paved the way for the use of civil disobedience during subsequent war protests and mass movements, such as the civil rights movement in America.

Albert Camus, another existentialist, described the human condition as absurd because we long for clarity and certainty in a completely random and chaotic universe. Camus's theories and his groundbreaking work, *The Myth of Sisyphus*, inspired a group of dramatists who would defy all theatrical conventions that came before them. Both Sartre and Camus wrote plays. The most famous of these is probably Sartre's *No Exit*, which revolves around three people trapped in a room together. Over the course of the play, each of the people in the room comes to hate the other two. By the play's conclusion, they have realized that, for each of them, this is their own private hell in which they will be trapped for all eternity.

Actual absurdist drama came onto the scene in France around 1950. To the absurdists, truth equaled chaos and lack of order. Their plays reflect this type of thinking. Old theatrical conventions were tossed away. Linear plot structure was replaced with plays that were cyclical in structure, with characters speaking and acting in a desperate manner only to achieve absolutely nothing by the play's conclusion. Cause and effect were abandoned in favor of illogic and chance. Much of the language in absurd plays is senseless; dislocated; and full of clichés, puns, and non sequiturs. The same things are often repeated over and over again to no avail. Realistic or recognizable locations were often removed, and the drama of the absurd often unfolded seemingly in the middle of nowhere.

Nothing is entirely new, however. The absurd playwrights drew from a number of inspirations, including vaudeville, commedia dell'arte, mime, and acrobatics. Previous artistic movements, such as surrealism and expressionism, also influenced their work. Absurd plays were considered quite shocking when they first came on the scene. Such outward flouting of theatrical convention caused intense debate among theatre people, audiences, scholars, and critics. Beneath their exterior of defiance, these plays spoke volumes about the preoccupations of the mid-twentieth century, and these bold insights completely changed how dramatists wrote for the stage. Although absurdist drama peaked quickly and had pretty much fizzled out by the mid-1960s, practically all dramatic work written after the arrival of the absurd has been influenced by it.

The three most famous absurdist playwrights are probably Samuel Beckett, Eugene Ionesco, and Jean Genet. The most enduring of these is undoubtedly Beckett, whose

Waiting for Godot is considered the definitive absurdist play. Beckett's influence of dramatic writing was so great that his emergence directly coincided with a marked decrease in the popularity of stalwarts of the American stage such as Arthur Miller and Tennessee Williams.

Although his contributions are overshadowed by Beckett, Ionesco's plays remain quite popular and were no less influential. Born in Romania in 1909, Ionesco didn't write his first play until 1948. That play was *The Bald Soprano*. His earliest and most innovative plays were one-acts, which he often referred to as anti-plays. These early pieces poke fun at the ridiculousness of everyday life. His characters tend to behave more like automated puppets than human beings, and their conversations are often senseless to the point where the words take on a meaning of their own and eventually overwhelm the people speaking them. Ionesco's early plays are intensely funny and biting in their indictment of mundane, twentieth-century existence. However, beneath all the laughter and ridicule is a serious message about how isolated modern people have become. Some of his major early works include *The Lesson*, in which an insane professor kills his young students, and *The Chairs*, where two old people spend the entire play holding conversations with nonexistent guests.

Ionesco moved on to the full-length play later in his career. His later plays lack the intensity and bite of his short pieces, with one exception; *Rhinoceros*. In *Rhinoceros*, Ionesco tackles the conformist nature of our society in a very innovative manner. The play tells the tale of a man who slowly watches as everyone in his town becomes a rhinoceros. Many felt this was clearly a statement about all those who jumped on the Nazi bandwagon in Europe.

In his later years, Ionesco abandoned playwriting in favor of painting. While his work was never commercially popular, he was elected to the French Academy in 1970. Ionesco's influence can be clearly seen in the works of major late-twentieth-century playwrights such as Tom Stoppard, Harold Pinter, Sam Shepard, and David Mamet.

The Bald Soprano

Ionesco's first play is a classic example of the Theatre of the Absurd. The play actually came about as a result of Ionesco's attempts to learn English from a book. The textbook introduced named characters who would recite inane facts about themselves to one another. Ionesco saw this as a perfect example of a world in which people related to one another on a purely superficial level.

Because it is an absurd play, there is little we can do to prep you for what you are about to read. A plot outline would be impossible, but we'll do our best. The play gives us an evening in the lives of the "very British" Mr. and Mrs. Smith, who have invited Mr. and Mrs. Martin over for a visit. The couples make small talk, a clock chimes ridiculous hours, a fire chief arrives, and madness ensues. The play appears to end where it began, with only a minor variation. Some theorize it was meant to be performed as a continuous, ongoing loop.

The Bald Soprano premiered on May 11, 1950, at the Théâtre des Noctambules. It was directed by Nicolas Bataille. While the play wasn't commercially successful, it was hailed as a breakthrough in dramatic literature by established writers and critics. It has gone on to become one of the most performed plays in France and a benchmark of twentieth-century drama.

Food for Thought

As you read the play, consider the following questions:

1. If you could possibly come up with a theme for this play, what would it be?
2. Are there any discernible differences between the Smiths and the Martins? If so, what are they?

3. What purpose does the character of the fire chief serve? How does his appearance alter the dramatic action of the play?
4. Why does the fire chief's mention of "the bald soprano" seem to have an unsettling effect on the other characters?

Fun Facts

1. Ionesco originally titled the play *English without Pain,* until an actor in the premiere production messed up his lines in rehearsal and ad-libbed the line about the bald soprano. Ionesco loved it and changed the title.
2. Since 1957, *The Bald Soprano* has been in permanent showing at the Théâtre de la Huchette in France.
3. In 1998, the Brat Theatre Company performed *The Bald Soprano* with a six-member ensemble for twenty-four hours straight. Now that's absurd!

The Bald Soprano

Eugene Ionesco

Characters

Mr. Smith
Mrs. Smith
Mr. Martin
Mrs. Martin
Mary, the maid
The Fire Chief

(Scene.—A middle-class English interior, with English armchairs. An English evening. MR. SMITH, an Englishman, seated in his English armchair and wearing English slippers, is smoking his English pipe and reading an English newspaper, near an English fire. He is wearing English spectacles and a small gray English mustache. Beside him, in another English armchair, MRS. SMITH, an Englishwoman, is darning some English socks. A long moment of English silence. The English clock strikes 17 English strokes).

MRS. SMITH. There, it's nine o'clock. We've drunk the soup, and eaten the fish and chips, and the English salad. The children have drunk English water. We've eaten well this evening. That's because we live in the suburbs of London and because our name is Smith.

MR. SMITH (continues to read, clicks his tongue).

MRS. SMITH. Potatoes are very good fried in fat; the salad oil was not rancid. The oil from the grocer at the corner is better quality than the oil from the grocer across the street. It is even better than the oil from the grocer at the bottom of the street. However, I prefer not to tell them that their oil is bad.

MR. SMITH (continues to read, clicks his tongue).

MRS. SMITH. However, the oil from the grocer at the corner is still the best.

MR. SMITH (continues to read, clicks his tongue).

MRS. SMITH. Mary did the potatoes very well, this evening. The last time she did not do them well. I do not like them when they are well done.

MR. SMITH (continues to read, clicks his tongue).

MRS. SMITH. The fish was fresh. It made my mouth water. I had two helpings. No, three helpings. That made me go to the w.c. You also had three helpings. However, the third time you took less than the first two times, while as for me, I took a great deal more. I eat better than you this evening. Why is that? Usually, it is you who eats more. It is not appetite you lack.

MR. SMITH (clicks his tongue).

MRS. SMITH. But still, the soup was perhaps a little too salt. It was saltier than you. Ha, ha, ha. It also had too many leeks and not enough onions. I regret I didn't advise Mary to add some aniseed stars. The next time I'll know better.

MR. SMITH (continues to read, clicks his tongue).

MRS. SMITH. Our little boy wanted to drink some beer; he's going to love getting tiddly. He's like you. At table did you notice how he stared at the bottle? But I poured some water from the jug into his glass. He was thirsty and he drank it. Helen is like me: she's a good manager, thrifty, plays the piano. She never asks to drink English beer. She's like our little daughter who drinks only milk and eats only porridge. It's obvious that she's only two. She's named Peggy. The quince and bean pie was marvelous. It would have been nice, perhaps, to have had a small glass of Australian Burgundy with the sweet, but I did not bring the bottle to the table because I did not wish to set the children a bad example of gluttony. They must learn to be sober and temperate.

MR. SMITH (continues to read, clicks his tongue).

MRS. SMITH. Mrs. Parker knows a Rumanian grocer by the name of Popesco Rosenfeld, who has just come from Constantinople. He is a great specialist in yogurt. He has a diploma from the school of yogurt-making in Adrianople. Tomorrow I shall buy a large pot of native Rumanian yogurt from him. One doesn't often find such things here in the suburbs of London.

MR. SMITH (*continues to read, clicks his tongue*).

MRS. SMITH. Yogurt is excellent for the stomach, the kidneys, the appendicitis, and apotheosis. It was Doctor Mackenzie-King who told me that, he's the one who takes care of the children of our neighbors, the Johns. He's a good doctor. One can trust him. He never prescribes any medicine that he's not tried out on himself first. Before operating on Parker, he had his own liver operated on first, although he was not the least bit ill.

MR. SMITH. But how does it happen that the doctor pulled through while Parker died?

MRS. SMITH. Because the operation was successful in the doctor's case and it was not in Parker's.

MR. SMITH. Then Mackenzie is not a good doctor. The operation should have succeeded with both of them or else both should have died.

MRS. SMITH. Why?

MR. SMITH. A conscientious doctor must die with his patient if they can't get well together. The captain of a ship goes down with his ship into the briny deep, he does not survive alone.

MRS. SMITH. One cannot compare a patient with a ship.

MR. SMITH. Why not? A ship has its diseases too; moreover, your doctor is as hale as a ship; that's why he should have perished at the same time as his patient, like the captain and his ship.

MRS. SMITH. Ah! I hadn't thought of that . . . Perhaps it is true . . . And then, what conclusion do you draw from this?

MR. SMITH. All doctors are quacks. And all patients too. Only the Royal Navy is honest in England.

MRS. SMITH. But not sailors.

MR. SMITH. Naturally (*A pause. Still reading his paper*). Here's a thing I don't understand. In the newspaper they always give the age of deceased persons but never the age of the newly born. That doesn't make sense.

MRS. SMITH. I never thought of that!

Another moment of silence. The clock strikes seven times. Silence. The clock strikes three times. Silence. The clock doesn't strike.

MR. SMITH (*still reading his paper*). Tsk, it says here that Bobby Watson died.

MRS. SMITH. My God, the poor man! When did he die?

MR. SMITH. Why do you pretend to be astonished? You know very well that he's been dead these past two years. Surely you remember that we attended his funeral a year and a half ago.

MRS. SMITH. Oh yes, of course I do remember. I remembered it right away, but I don't understand why you yourself were so surprised to see it in the paper.

MR. SMITH. It wasn't in the paper. It's been three years since his death was announced. I remembered it through an association of ideas.

MRS. SMITH. What a pity! He was so well preserved.

MR. SMITH. He was the handsomest corpse in Great Britain. He didn't look his age. Poor Bobby, he'd been dead for four years and he was still warm. A veritable living corpse. And how cheerful he was!

MRS. SMITH. Poor Bobby.

MR. SMITH. Which poor Bobby do you mean?

MRS. SMITH. It is his wife that I mean. She is called Bobby too, Bobby Watson. Since they both had the same name, you could never tell one from the other when you saw them together. It was only after his death that you could really tell which was which. And there are still people today who confuse her with the deceased and offer their condolences to him. Do you know her?

MR. SMITH. I only met her once, by chance, at Bobby's burial.

MRS. SMITH. I've never seen her. Is she pretty?

MR. SMITH. She has regular features and yet one cannot say that she is pretty. She is too big and stout. Her features are not regular but still one can say that she is very pretty. She is a little too small and too thin. She's a voice teacher.

The clock strikes five times. A long silence.

MRS. SMITH. And when do they plan to be married, those two?

MR. SMITH. Next spring, at the latest.

MRS. SMITH. We shall have to go to their wedding, I suppose.

MR. SMITH. We shall have to give them a wedding present. I wonder what?

MRS. SMITH. Why don't we give them one of the seven silver salvers that were given us for our wedding and which have never been of any use to us? *(Silence).*

MRS. SMITH. How sad for her to be left a widow so young.

MR. SMITH. Fortunately, they had no children.

MRS. SMITH. That was all they needed! Children! Poor woman, how could she have managed!

MR. SMITH. She's still young. She might very well remarry. She looks so well in mourning.

MRS. SMITH. But who would take care of the children? You know very well that they have a boy and a girl. What are their names?

MR. SMITH. Bobby and Bobby like their parents. Bobby Watson's uncle, old Bobby Watson, is a rich man and very fond of the boy. He might very well pay for Bobby's education.

MRS. SMITH. That would be proper. And Bobby Watson's aunt, old Bobby Watson, might very well, in her turn, pay for the education of Bobby Watson, Bobby Watson's daughter. That way Bobby, Bobby Watson's mother, could remarry. Has she anyone in mind?

MR. SMITH. Yes, a cousin of Bobby Watson's.

MRS. SMITH. Who? Bobby Watson?

MR. SMITH. Which Bobby Watson do you mean?

MRS. SMITH. Why, Bobby Watson, the son of old Bobby Watson, the late Bobby Watson's other uncle.

MR. SMITH. No, it's not that one, it's someone else. It's Bobby Watson, the son of old Bobby Watson, the late Bobby Watson's aunt.

MRS. SMITH. Are you referring to Bobby Watson the commercial traveler?

MR. SMITH. All the Bobby Watsons are commercial travelers.

MRS. SMITH. What a difficult trade! However, they do well at it.

MR. SMITH. Yes, when there's no competition.

MRS. SMITH. And when is there no competition?

MR. SMITH. On Tuesdays, Thursdays, and Tuesdays.

MRS. SMITH. Ah! Three days a week? And what does Bobby Watson do on those days?

MR. SMITH. He rests, he sleeps.

MRS. SMITH. But why doesn't he work those three days if there's no competition?

MR. SMITH. I don't know everything. I can't answer all your idiotic questions!

MRS. SMITH *(offended)*. Oh! Are you trying to humiliate me?

MR. SMITH *(all smiles)*. You know very well that I'm not.

MRS. SMITH. Men are all alike! You sit there all day long, a cigarette in your mouth, or you powder your nose and rouge your lips, fifty times a day, or else you drink like a fish.

MR. SMITH. But what would you say if you saw men acting like women do, smoking all day long, powdering, rouging their lips, drinking whisky?

MRS. SMITH. It's nothing to me! But if you're only saying that to annoy me . . . I don't care for that kind of joking, you know that very well!

She hurls the socks across the stage and shows her teeth. She gets up.[1]

MR. SMITH *(also getting up and going towards his wife, tenderly)*. Oh, my little ducky daddles, what a little spitfire you are! You know that I only said it as a joke! *(He takes her by the waist and kisses her).* What a ridiculous pair of old lovers we are! Come, let's put out the lights and go bye-byes.

MARY *(entering)*. I'm the maid. I have spent a very pleasant afternoon. I've been to the cinema with a man and I've seen a film with some women. After the cinema, we went to drink some brandy and milk and then read the newspaper.

[1] In Nicolas Bataille's production, Mrs. Smith did not show her teeth, nor did she throw the socks very far.

MRS. SMITH. I hope that you've spent a pleasant afternoon, that you went to the cinema with a man and that you drank some brandy and milk.

MR. SMITH. And the newspaper.

MARY. Mr. and Mrs. Martin, your guests, are at the door. They were waiting for me. They didn't dare come in by themselves. They were supposed to have dinner with you this evening.

MRS. SMITH. Oh, yes. We were expecting them. And we were hungry. Since they didn't put in an appearance, we were going to start dinner without them. We've had nothing to eat all day. You should not have gone out!

MARY. But it was you who gave me permission.

MR. SMITH. We didn't do it on purpose.

MARY (bursts into laughter, then she bursts into tears. Then she smiles). I bought me a chamber pot.

MRS. SMITH. My dear Mary, please open the door and ask Mr. and Mrs. Martin to step in. We will change quickly.

Mr. and Mrs. SMITH exit right. MARY opens the door at the left by which Mr. and Mrs. MARTIN enter.

MARY. Why have you come so late! You are not very polite. People should be punctual. Do you understand? But sit down there, anyway, and wait now that you're here.

She exits. MR. and MRS. MARTIN sit facing each other, without speaking. They smile timidly at each other. The dialogue which follows must be spoken in voices that are drawling, monotonous, a little singsong, without nuances.[2]

MR. MARTIN. Excuse me, madam, but it seems to me, unless I'm mistaken, that I've met you somewhere before.

MRS. MARTIN. I, too, sir. It seems to me that I've met you somewhere before.

MR. MARTIN. Was it, by any chance, at Manchester that I caught a glimpse of you, madam?

MRS. MARTIN. That is very possible. I am originally from the city of Manchester. But I do not have a good memory, sir. I cannot say whether it was there that I caught a glimpse of you or not!

MR. MARTIN. Good God, that's curious! I, too, am originally from the city of Manchester, madam!

MRS. MARTIN. That is curious!

MR. MARTIN. Isn't that curious! Only, I, madam, I left the city of Manchester about five weeks ago.

MRS. MARTIN. That is curious! What a bizarre coincidence! I, too, sir, I left the city of Manchester about five weeks ago.

MR. MARTIN. Madam, I took the 8:30 morning train which arrives in London at 4:45.

MRS. MARTIN. That is curious! How very bizarre! And what a coincidence! I took the same train, sir, I too.

MR. MARTIN. Good Lord, how curious! Perhaps then, madam, it was on the train that I saw you?

MRS. MARTIN. It is indeed possible; that is, not unlikely. It is plausible and, after all, why not!—But I don't recall it, sir!

MR. MARTIN. I traveled second class, madam. There is no second class in England, but I always travel second class.

MRS. MARTIN. That is curious! How very bizarre! And what a coincidence! I, too, sir, I traveled second class.

MR. MARTIN. How curious that is! Perhaps we did meet in second class, my dear lady!

MRS. MARTIN. That is certainly possible, and it is not at all unlikely. But I do not remember very well, my dear sir!

MR. MARTIN. My seat was in coach No. 8, compartment 6, my dear lady.

MRS. MARTIN. How curious that is! My seat was also in coach No. 8, compartment 6, my dear sir!

MR. MARTIN. How curious that is and what a bizarre coincidence! Perhaps we met in compartment 6, my dear lady?

MRS. MARTIN. It is indeed possible, after all! But I do not recall it, my dear sir!

MR. MARTIN. To tell the truth, my dear lady, I do not remember it either, but it is possible that we caught a glimpse of each other there, and as I think of it, it seems to me even very likely.

[2] In Nicolas Bataille's production, this dialogue was spoken in a tone and played in a style sincerely tragic.

MRS. MARTIN. Oh! truly, of course, truly, sir!

MR. MARTIN. How curious it is! I had seat No. 3, next to the window, my dear lady.

MRS. MARTIN. Oh, good Lord, how curious and bizarre! I had seat No. 6, next to the window, across from you, my dear sir.

MR. MARTIN. Good God, how curious that is and what a coincidence! We were then seated facing each other, my dear lady! It is there that we must have seen each other!

MRS. MARTIN. How curious it is! It is possible, but I do not recall it, sir!

MR. MARTIN. To tell the truth, my dear lady, I do not remember it either. However, it is very possible that we saw each other on that occasion.

MRS. MARTIN. It is true, but I am not at all sure of it, sir.

MR. MARTIN. Dear madam, were you not the lady who asked me to place her suitcase in the luggage rack and who thanked me and gave me permission to smoke?

MRS. MARTIN. But of course, that must have been I, sir. How curious it is, how curious it is, and what a coincidence!

MR. MARTIN. How curious it is, how bizarre, what a coincidence! And well, well, it was perhaps at that moment that we came to know each other, madam?

MRS. MARTIN. How curious it is and what a coincidence! It is indeed possible, my dear sir! However, I do not believe that I recall it.

MR. MARTIN. Nor do I, madam. (*A moment of silence. The clock strikes twice, then once*). Since coming to London, I have resided in Bromfield Street, my dear lady.

MRS. MARTIN. How curious that is, how bizarre! I, too, since coming to London, I have resided in Bromfield Street, my dear sir.

MR. MARTIN. How curious that is, well then, well then, perhaps we have seen each other in Bromfield Street, my dear lady.

MRS. MARTIN. How curious that is, how bizarre! It is indeed possible, after all! But I do not recall it, my dear sir.

MR. MARTIN. I reside at No. 19, my dear lady.

MRS. MARTIN. How curious that is. I also reside at No. 19, my dear sir.

MR. MARTIN. Well then, well then, well then, well then, perhaps we have seen each other in that house, dear lady?

MRS. MARTIN. It is indeed possible but I do not recall it, dear sir.

MR. MARTIN. My flat is on the fifth floor, No. 8, my dear lady.

MRS. MARTIN. How curious it is, good Lord, how bizarre! And what a coincidence! I too reside on the fifth floor, in flat No. 8, dear sir!

MR. MARTIN (*musing*). How curious it is, how curious it is, how curious it is, and what a coincidence! You know, in my bedroom there is a bed, and it is covered with a green eiderdown. This room, with the bed and the green eiderdown, is at the end of the corridor between the w.c. and the bookcase, dear lady!

MRS. MARTIN. What a coincidence, good Lord, what a coincidence! My bedroom, too, has a bed with a green eiderdown and is at the end of the corridor, between the w.c., dear sir, and the bookcase!

MR. MARTIN. How bizarre, curious, strange! Then, madam, we live in the same room and we sleep in the same bed, dear lady. It is perhaps there that we have met!

MRS. MARTIN. How curious it is and what a coincidence! It is indeed possible that we have met there, and perhaps even last night. But I do not recall it, dear sir!

MR. MARTIN. I have a little girl, my little daughter, she lives with me, dear lady. She is two years old, she's blonde, she has a white eye and a red eye, she is very pretty, her name is Alice, dear lady.

MRS. MARTIN. What a bizarre coincidence! I, too, have a little girl. She is two years old, has a white eye and a red eye, she is very pretty, and her name is Alice too, dear sir!

MR. MARTIN (*in the same drawling monotonous voice*). How curious it is and what a coincidence! And bizarre! Perhaps they are the same, dear lady!

MRS. MARTIN. How curious it is! It is indeed possible, dear sir. (*A rather long moment of silence. The clock strikes 29 times*).

MR. MARTIN (*after having reflected at length, gets up slowly and, unhurriedly, moves toward Mrs. Martin, who, surprised by his solemn air, has also gotten up very quietly. Mr. Martin, in the same flat, monotonous voice, slightly singsong*). Then, dear lady, I believe that there can be no doubt about it, we have seen each other before and you are my own wife . . . Elizabeth, I have found you again!

MRS. MARTIN *approaches* MR. MARTIN *without haste. They embrace without expression. The clock strikes once, very loud. This striking of the clock must be so loud that it makes the audience jump. The Martins do not hear it.*

MRS. MARTIN. Donald, it's you, darling!

They sit together in the same armchair, their arms around each other, and fall asleep. The clock strikes several more times. MARY, *on tiptoe, a finger to her lips, enters quietly and addresses the audience.*

MARY. Elizabeth and Donald are now too happy to be able to hear me. I can therefore let you in on a secret. Elizabeth is not Elizabeth, Donald is not Donald. And here is the proof: the child that Donald spoke of is not Elizabeth's daughter, they are not the same person. Donald's daughter has one white eye and one red eye like Elizabeth's daughter. Whereas Donald's child has a white right eye and a red left eye, Elizabeth's child has a red right eye and a white left eye! Thus all of Donald's system of deduction collapses when it comes up against this last obstacle which destroys his whole theory. In spite of the extraordinary coincidences which seem to be definitive proofs, Donald and Elizabeth, not being the parents of the same child, are not Donald and Elizabeth. It is in vain that he thinks he is Donald, it is in vain that she thinks she is Elizabeth. He believes in vain that she is Elizabeth. She believes in vain that he is Donald—they are sadly deceived. But who is the true Donald? Who is the true Elizabeth? Who has any interest in prolonging this confusion? I don't know. Let's not try to know. Let's leave things as they are. (*She takes several steps toward the door, then returns and says to the audience:*) My real name is Sherlock Holmes. (*She exits*).

The clock strikes as much as it likes. After several seconds, MR. *and* MRS. MARTIN *separate and take the chairs they had at the beginning.*

MR. MARTIN. Darling, let's forget all that has not passed between us, and, now that we have found each other again, let's try not to lose each other any more, and live as before.

MRS. MARTIN. Yes, darling.

MR. *and* MRS. SMITH *enter from the right, wearing the same clothes.*

MRS. SMITH. Good evening, dear friends! Please forgive us for having made you wait so long. We thought that we should extend you the courtesy to which you are entitled and as soon as we learned that you had been kind enough to give us the pleasure of coming to see us without prior notice we hurried to dress for the occasion.

MR. SMITH (*furious*). We've had nothing to eat all day. And we've been waiting four whole hours for you. Why have you come so late?

MR. *and* MRS. SMITH *sit facing their guests. The striking of the clock underlines the speeches, more or less strongly, according to the case. The Martins, particularly* MRS. MARTIN, *seem embarrassed and timid. For this reason the conversation begins with difficulty and the words are uttered, at the beginning, awkwardly. A long embarrassed silence at first, then other silences and hesitations follow.*

MR. SMITH. Hm. (*Silence*).

MRS. SMITH. Hm, hm. (*Silence*).

MRS. MARTIN. Hm, hm, hm. (*Silence*).

MR. MARTIN. Hm, hm, hm, hm. (*Silence*).

MRS. MARTIN. Oh, but definitely. (*Silence*).

MR. MARTIN. We all have colds. (*Silence*).

MR. SMITH. Nevertheless, it's not chilly. (*Silence*).

MRS. SMITH. There's no draft. (*Silence*).

MR. MARTIN. Oh no, fortunately. (*Silence*).

MR. SMITH. Oh dear, oh dear, oh dear. (*Silence*).

MR. MARTIN. Don't you feel well? (*Silence*).

MRS. SMITH. No, he's wet his pants. (*Silence*).

MRS. MARTIN. Oh, sir, at your age, you shouldn't. (*Silence*).

MR. SMITH. The heart is ageless. (*Silence*).

MR. MARTIN. That's true. (*Silence*).

MRS. SMITH. So they say. *(Silence)*.

MRS. MARTIN. They also say the opposite. *(Silence)*.

MR. SMITH. The truth lies somewhere between the two. *(Silence)*.

MR. MARTIN. That's true. *(Silence)*.

MRS. SMITH *(to the Martins)*. Since you travel so much, you must have many interesting things to tell us.

MR. MARTIN *(to his wife)*. My dear, tell us what you've seen today.

MRS. MARTIN. It's scarcely worth the trouble, for no one would believe me.

MR. SMITH. We're not going to question your sincerity!

MRS. SMITH. You will offend us if you think that.

MR. MARTIN *(to his wife)*. You will offend them, my dear, if you think that . . .

MRS. MARTIN *(graciously)*. Oh well, today I witnessed something extraordinary. Something really incredible.

MR. MARTIN. Tell us quickly, my dear.

MR. SMITH. Oh, this is going to be amusing.

MRS. SMITH. At last.

MRS. MARTIN. Well, today, when I went shopping to buy some vegetables, which are getting to be dearer and dearer . . .

MRS. SMITH. Where is it all going to end!

MR. SMITH. You shouldn't interrupt, my dear, it's very rude.

MRS. MARTIN. In the street, near a café, I saw a man, properly dressed, about fifty years old, or not even that, who . . .

MR. SMITH. Who, what?

MRS. SMITH. Who, what?

MR. SMITH *(to his wife)*. Don't interrupt, my dear, you're disgusting.

MRS. SMITH. My dear, it is you who interrupted first, you boor.

MR. SMITH *(to his wife)*. Hush. *(To Mrs. Martin)*. What was this man doing?

MRS. MARTIN. Well, I'm sure you'll say that I'm making it up—he was down on one knee and he was bent over.

MR. MARTIN, MR. SMITH, MR. SMITH. Oh!

MRS. MARTIN. Yes, bent over.

MR. SMITH. Not possible.

MRS. MARTIN. Yes, bent over. I went near him to see what he was doing . . .

MR. SMITH. And?

MRS. MARTIN. He was tying his shoe lace which had come undone.

MR. MARTIN, MR. SMITH, MRS. SMITH. **Fantastic!**

MR. SMITH. If someone else had told me this, I'd not believe it.

MR. MARTIN. Why not? One sees things even more extraordinary every day, when one walks around. For instance, today in the Underground I myself saw a man, quietly sitting on a seat, reading his newspaper.

MRS. SMITH. What a character!

MR. SMITH. Perhaps it was the same man! *(The doorbell rings)*.

MR. SMITH. Goodness, someone is ringing.

MRS. SMITH. There must be somebody there. I'll go and see. *(She goes to see, she opens the door and closes it, and comes back)*. Nobody. *(She sits down again)*.

MR. MARTIN. I'm going to give you another example . . .

Doorbell rings again.

MR. SMITH. Goodness, someone is ringing.

MRS. SMITH. There must be somebody there. I'll go and see. *(She goes to see, opens the door, and comes back)*. No one. *(She sits down again)*.

MR. MARTIN *(who has forgotten where he was)*. Uh . . .

MRS. MARTIN. You were saying that you were going to give us another example.

MR. MARTIN. Oh, yes . . .

Doorbell rings again.

MR. SMITH. Goodness, someone is ringing.

MRS. SMITH. I'm not going to open the door again.

MR. SMITH. Yes, but there must be someone there!

MRS. SMITH. The first time there was no one. The second time, no one. Why do you think that there is someone there now?

MR. SMITH. Because someone has rung!

MRS. MARTIN. That's no reason.

MR. MARTIN. What? When one hears the doorbell ring, that means someone is at the door ringing to have the door opened.

MRS. MARTIN. Not always. You've just seen otherwise!

MR. MARTIN. In most cases, yes.

MR. SMITH. As for me, when I go to visit someone, I ring in order to be admitted. I think that everyone does the same thing and that each time there is a ring there must be someone there.

MRS. SMITH. That is true in theory. But in reality things happen differently. You have just seen otherwise.

MRS. MARTIN. Your wife is right.

MR. MARTIN. Oh! You women! You always stand up for each other.

MRS. SMITH. Well, I'll go and see. You can't say that I am obstinate, but you will see that there's no one there! (She goes to look, opens the door and closes it). You see, there's no one there. (She returns to her seat).

MRS. SMITH. Oh, these men who always think they're right and who're always wrong!

The doorbell rings again.

MR. SMITH. Goodness, someone is ringing. There must be someone there.

MRS. SMITH (in a fit of anger). Don't send me to open the door again. You've seen that it was useless. Experience teaches us that when one hears the doorbell ring it is because there is never anyone there.

MRS. MARTIN. Never.

MR. MARTIN. That's not entirely accurate.

MR. SMITH. In fact it's false. When one hears the doorbell ring it is because there is someone there.

MRS. SMITH. He won't admit he's wrong.

MRS. MARTIN. My husband is very obstinate, too.

MR. SMITH. There's someone there.

MR. MARTIN. That's not impossible.

MRS. SMITH (to her husband). No.

MR. SMITH. Yes.

MRS. SMITH. I tell you *no*. In any case you are not going to disturb me again for nothing. If you wish to know, go and look yourself!

MR. SMITH. I'll go.

MRS. SMITH shrugs her shoulders. MRS. MARTIN tosses her head.

MR. SMITH (opening the door). Oh! how do you do. (He glances at Mrs. Smith and the Martins, who are all surprise). It's the Fire Chief!

FIRE CHIEF (he is of course in uniform and is wearing an enormous shining helmet). Good evening, ladies and gentlemen. (The Smiths and the Martins are still slightly astonished. Mrs. Smith turns her head away, in a temper, and does not reply to his greeting). Good evening, Mrs. Smith. You appear to be angry.

MRS. SMITH. Oh!

MR. SMITH. You see it's because my wife is a little chagrined at having been proved wrong.

MR. MARTIN. There's been an argument between Mr. and Mrs. Smith, Mr. Fire Chief.

MRS. SMITH (to MR. MARTIN). This is no business of yours! (To MR. SMITH). I beg you not to involve outsiders in our family arguments.

MR. SMITH. Oh, my dear, this is not so serious. The Fire Chief is an old friend of the family. His mother courted me, and I knew his father. He asked me to give him my daughter in marriage if ever I had one. And he died waiting.

MR. MARTIN. That's neither his fault, nor yours.

FIRE CHIEF. Well, what is it all about?

MRS. SMITH. My husband was claiming . . .

MR. SMITH. No, it was you who was claiming.

MR. MARTIN. Yes, it was she.

MRS. MARTIN. No, it was he.

FIRE CHIEF. Don't get excited. You tell me, Mrs. Smith.

MRS. SMITH. Well, this is how it was. It is difficult for me to speak openly to you, but a fireman is also a confessor.

FIRE CHIEF. Well then?

MRS. SMITH. We were arguing because my husband said that each time the doorbell rings there is always someone there.

MR. MARTIN. It is plausible.

MRS. SMITH. And I was saying that each time the doorbell rings there is never anyone there.

MRS. MARTIN. It might seem strange.

MRS. SMITH. But it has been proved, not by theoretical demonstrations, but by facts.

MR. SMITH. That's false, since the Fire Chief is here. He rang the bell, I opened the door, and there he was.

MRS. MARTIN. When?

MR. MARTIN. But just now.

MRS. SMITH. Yes, but it was only when you heard the doorbell ring the fourth time that there was someone there. And the fourth time does not count.

MRS. MARTIN. Never. It is only the first three times that count.

MR. SMITH. Mr. Fire Chief, permit me in my turn to ask you several questions.

FIRE CHIEF. Go right ahead.

MR. SMITH. When I opened the door and saw you, it was really you who had rung the bell?

FIRE CHIEF. Yes, it was I.

MR. MARTIN. You were at the door? And you rang in order to be admitted?

FIRE CHIEF. I do not deny it.

MR. SMITH (*to his wife, triumphantly*). You see? I was right. When you hear the doorbell ring, that means someone rang it. You certainly cannot say that the Fire Chief is not someone.

MRS. SMITH. Certainly not. I repeat to you that I was speaking of only the first three times, since the fourth time does not count.

MRS. MARTIN. And when the doorbell rang the first time, was it you?

FIRE CHIEF. No, it was not I.

MRS. MARTIN. You see? The doorbell rang and there was no one there.

MR. MARTIN. Perhaps it was someone else?

MR. SMITH. Were you standing at the door for a long time?

FIRE CHIEF. Three-quarters of an hour.

MR. SMITH. And you saw no one?

FIRE CHIEF. No one. I am sure of that.

MRS. MARTIN. And did you hear the bell when it rang the second time?

FIRE CHIEF. Yes, and that wasn't I either. And there was still no one there.

MRS. SMITH. Victory! I was right.

MR. SMITH (*to his wife*). Not so fast. (*To the* FIRE CHIEF). And what were you doing at the door?

FIRE CHIEF. Nothing. I was just standing there. I was thinking of many things.

MR. MARTIN (*to the* FIRE CHIEF). But the third time—it was not you who rang?

FIRE CHIEF. Yes, it was I.

MR. SMITH. But when the door was opened nobody was in sight.

FIRE CHIEF. That was because I had hidden myself—as a joke.

MRS. SMITH. Don't make jokes, Mr. Fire Chief. This business is too sad.

MR. MARTIN. In short, we still do not know whether, when the doorbell rings, there is someone there or not!

MRS. SMITH. Never anyone.

MR. SMITH. Always someone.

FIRE CHIEF. I am going to reconcile you. You both are partly right. When the doorbell rings, sometimes there is someone, other times there is no one.

MR. MARTIN. This seems logical to me.

MRS. MARTIN. I think so too.

FIRE CHIEF. Life is very simple, really. (*To the* SMITHS). Go on and kiss each other.

MRS. SMITH. We just kissed each other a little while ago.

MR. MARTIN. They'll kiss each other tomorrow. They have plenty of time.

MRS. SMITH. Mr. Fire Chief, since you have helped us settle this, please make yourself comfortable, take off your helmet and sit down for a moment.

FIRE CHIEF. Excuse me, but I can't stay long. I should like to remove my helmet, but I haven't time to sit down. (*He sits down, without removing his helmet*). I must admit that I have come to see you for another reason. I am on official business.

MRS. SMITH. And what can we do for you, Mr. Fire Chief?

FIRE CHIEF. I must beg you to excuse my indiscretion (*terribly embarrassed*) . . . uhm (*He points a finger at the* MARTINS) . . . you don't mind . . . in front of them . . .

MRS. MARTIN. Say whatever you like.

MR. MARTIN. We're old friends. They tell us everything.

MR. SMITH. Speak.

FIRE CHIEF. Eh, well—is there a fire here?

MRS. SMITH. Why do you ask us that?

FIRE CHIEF. It's because—pardon me—I have orders to extinguish all the fires in the city.

MRS. MARTIN. All?

FIRE CHIEF. Yes, all.

MRS. SMITH (*confused*). I don't know . . . I don't think so. Do you want me to go and look?

MR. SMITH (*sniffing*). There can't be one here. There's no smell of anything burning.[3]

FIRE CHIEF (*aggrieved*). None at all? You don't have a little fire in the chimney, something burning in the attic or in the cellar? A little fire just starting, at least?

MRS. SMITH. I am sorry to disappoint you but I do not believe there's anything here at the moment. I promise that I will notify you when we do have something.

FIRE CHIEF. Please don't forget, it would be a great help.

MRS. SMITH. That's a promise.

FIRE CHIEF (*to the* MARTINS). And there's nothing burning at your house either?

MRS. MARTIN. No, unfortunately.

MR. MARTIN (*to the* FIRE CHIEF). Things aren't going so well just now.

FIRE CHIEF. Very poorly. There's been almost nothing, a few trifles—a chimney, a barn. Nothing important. It doesn't bring in much. And since there are no returns, the profits on output are very meager.

MR. SMITH. Times are bad. That's true all over. It's the same this year with business and agriculture as it is with fires, nothing is prospering.

MR. MARTIN. No wheat, no fires.

FIRE CHIEF. No floods either.

MRS. SMITH. But there is some sugar.

MRS. SMITH. That's because it is imported.

MRS. MARTIN. It's harder in the case of fires. The tariffs are too high!

FIRE CHIEF. All the same, there's an occasional asphyxiation by gas, but that's unusual too. For instance, a young woman asphyxiated herself last week—she had left the gas on.

MRS. MARTIN. Had she forgotten it?

FIRE CHIEF. No, but she thought it was her comb.

MRS. SMITH. These confusions are always dangerous!

MRS. SMITH. Did you go to see the match dealer?

FIRE CHIEF. There's nothing doing there. He is insured against fires.

MR. MARTIN. Why don't you go see the Vicar of Wakefield, and use my name?

FIRE CHIEF. I don't have the right to extinguish clergymen's fires. The Bishop would get angry. Besides they extinguish their fires themselves, or else they have them put out by vestal virgins.

MR. SMITH. Go see the Durands.

FIRE CHIEF. I can't do that either. He's not English. He's only been naturalized. And naturalized citizens have the right to have houses, but not the right to have them put out if they're burning.

MRS. SMITH. Nevertheless, when they set fire to it last year, it was put out just the same.

FIRE CHIEF. He did that all by himself. Clandestinely. But it's not I who would report him.

MR. SMITH. Neither would I.

MRS. SMITH. Mr. Fire Chief, since you are not too pressed, stay a little while longer. You would be doing us a favor.

FIRE CHIEF. Shall I tell you some stories?

MRS. SMITH. Oh, by all means, how charming of you. (*She kisses him*).

[3] In Nicolas Bataille's production Mr. and Mrs. Martin sniffed too.

MR. SMITH, MRS. MARTIN, MR. MARTIN. Yes, yes, some stories, hurrah!

They applaud.

MR. SMITH. And what is even more interesting is the fact that firemen's stories are all true, and they're based on experience.

FIRE CHIEF. I speak from my own experience. Truth, nothing but the truth. No fiction.

MR. MARTIN. That's right. Truth is never found in books, only in life.

MRS. SMITH. Begin!

MR. MARTIN. Begin!

MRS. MARTIN. Be quiet, he is beginning.

FIRE CHIEF *(coughs slightly several times)*. Excuse me, don't look at me that way. You embarrass me. You know that I am shy.

MRS. SMITH. Isn't he charming! *(She kisses him)*.

FIRE CHIEF. I'm going to try to begin anyhow. But promise me that you won't listen.

MRS. MARTIN. But if we don't listen to you we won't hear you.

FIRE CHIEF. I didn't think of that!

MRS. SMITH. I told you, he's just a boy.

MR. MARTIN, MR. SMITH. Oh, the sweet child! *(They kiss him)*.[4]

MRS. MARTIN. Chin up!

FIRE CHIEF. Well, then! *(He coughs again in a voice shaken by emotion)*. "The Dog and the Cow," an experimental fable. Once upon a time another cow asked another dog: "Why have you not swallowed your trunk?" "Pardon me," replied the dog, "it is because I thought that I was an elephant."

MRS. MARTIN. What is the moral?

FIRE CHIEF. That's for you to find out.

MR. SMITH. He's right.

MRS. SMITH *(furious)*. Tell us another.

FIRE CHIEF. A young calf had eaten too much ground glass. As a result, it was obliged to give birth. It brought forth a cow into the world. However, since the calf was male, the cow could not call him Mamma. Nor could she call him Papa, because the calf was too little. The calf was then obliged to get married and the registry office carried out all the details completely à la mode.

MR. SMITH. À la mode de Caen.

MR. MARTIN. Like tripes.

FIRE CHIEF. You've heard that one?

MRS. SMITH. It was in all the papers.

MRS. MARTIN. It happened not far from our house.

FIRE CHIEF. I'll tell you another: "The Cock." Once upon a time, a cock wished to play the dog. But he had no luck because everyone recognized him right away.

MRS. SMITH. On the other hand, the dog that wished to play the cock was never recognized.

MR. SMITH. I'll tell you one: "The Snake and the Fox." Once upon a time, a snake came up to a fox and said: "It seems to me that I know you!" The fox replied to him: "Me too." "Then," said the snake, "give me some money." "A fox doesn't give money," replied the tricky animal, who, in order to escape, jumped down into a deep ravine full of strawberries and chicken honey. But the snake was there waiting for him with a Mephistophelean laugh. The fox pulled out his knife, shouting: "I'm going to teach you how to live!" Then he took to flight, turning his back. But he had no luck. The snake was quicker. With a well-chosen blow of his fist, he struck the fox in the middle of his forehead, which broke into a thousand pieces, while he cried: "No! No! Four times no! I'm not your daughter."[5]

MRS. MARTIN. It's interesting.

MRS. SMITH. It's not bad.

MR. MARTIN *(shaking MR. SMITH's hand)*. My congratulations.

FIRE CHIEF *(jealous)*. Not so good. And anyway, I've heard it before.

MRS. SMITH. It's terrible.

[4] In Nicolas Bataille's production, they did not kiss the Fire Chief.
[5] This story was deleted in Nicolas Bataille's production. Mr. Smith went through the gestures only, without making a sound.

MRS. SMITH. But it wasn't even true.

MRS. MARTIN. Yes, unfortunately.

MR. MARTIN (to MRS. SMITH). It's your turn, dear lady.

MRS. SMITH. I only know one. I'm going to tell it to you. It's called "The Bouquet."

MR. SMITH. My wife has always been romantic.

MR. MARTIN. She's a true Englishwoman.[6]

MRS. SMITH. Here it is: Once upon a time, a fiancé gave a bouquet of flowers to his fiancée, who said, "Thanks"; but before she had said, "Thanks," he, without saying a single word, took back the flowers he had given her in order to teach her a good lesson, and he said, "I take them back."
He said, "Goodbye," and took them back and went off in all directions.

MR. MARTIN. Oh, charming! (He either kisses or does not kiss MRS. SMITH).

MRS. MARTIN. You have a wife, Mr. Smith, of whom all the world is jealous.

MR. SMITH. It's true. My wife is intelligence personified. She's even more intelligent than I. In any case, she is much more feminine, everyone says so.

MRS. SMITH (to the FIRE CHIEF). Let's have another, Mr. Fire Chief.

FIRE CHIEF. Oh, no, it's too late.

MR. MARTIN. Tell us one, anyway.

FIRE CHIEF. I'm too tired.

MR. SMITH. Please do us a favor.

MR. MARTIN. I beg you.

FIRE CHIEF. No.

MRS. MARTIN. You have a heart of ice. We're sitting on hot coals.

MRS. SMITH (falls on her knees sobbing, or else she does not do this). I implore you!

FIRE CHIEF. Righto.

MR. SMITH (in MRS. MARTIN'S ear). He agrees! He's going to bore us again.

MRS. MARTIN. Shh.

MRS. SMITH. No luck. I was too polite.

FIRE CHIEF. "The Headcold." My brother-in law had, on the paternal side, a first cousin whose maternal uncle had a father-in-law whose paternal grandfather had married as his second wife a young native whose brother he had met on one of his travels, a girl of whom he was enamored and by whom he had a son who married an intrepid lady pharmacist who was none other than the niece of an unknown fourth-class petty officer of the Royal Navy and whose adopted father had an aunt who spoke Spanish fluently and who was, perhaps, one of the granddaughters of an engineer who died young, himself the grandson of the owner of a vineyard which produced mediocre wine, but who had a second cousin, a stay-at-home, a sergeant-major, whose son had married a very pretty young woman, a divorcée, whose first husband was the son of a loyal patriot who, in the hope of making his fortune, had managed to bring up one of his daughters so that she could marry a footman who had known Rothschild, and whose brother, after having changed his trade several times, married and had a daughter whose stunted great-grandfather wore spectacles which had been given him by a cousin of his, the brother-in-law of a man from Portugal, natural son of a miller, not too badly off, whose foster-brother had married the daughter of a former country doctor, who was himself a foster-brother of the son of a forrester, himself the natural son of another country doctor, married three times in a row, whose third wife . . .

MR. MARTIN. I knew that third wife, if I'm not mistaken. She ate chicken sitting on a hornet's nest.

FIRE CHIEF. It's not the same one.

MRS. SMITH. Shh!

FIRE CHIEF. As I was saying . . . whose third wife was the daughter of the best midwife in the region and who, early left a widow . . .

MR. SMITH. Like my wife.

FIRE CHIEF. . . . Had married a glazier who was full of life and who had had, by the daughter of a station master, a child who had burned his bridges . . .

MRS. SMITH. His britches?

MR. MARTIN. No his bridge game.

FIRE CHIEF. And had married an oyster woman, whose father had a brother, mayor of a small town, who had taken as his wife a blonde schoolteacher, whose cousin, a fly fisherman . . .

MR. MARTIN. A fly by night?

FIRE CHIEF. . . . Had married another blonde schoolteacher, named Marie, too, whose brother was married to another Marie, also a blonde schoolteacher . . .

MR. SMITH. Since she's blonde, she must be Marie.

FIRE CHIEF. . . . And whose father had been reared in Canada by an old woman who was the niece of a priest whose grandmother, occasionally in the winter, like everyone else, caught a cold.

MRS. SMITH. A curious story. Almost unbelievable.

MR. MARTIN. If you catch a cold, you should get yourself a colt.

MR. SMITH. It's a useless precaution, but absolutely necessary.

MRS. MARTIN. Excuse me, Mr. Fire Chief, but I did not follow your story very well. At the end, when we got to the grandmother of the priest, I got mixed up.

MR. SMITH. One always gets mixed up in the hands of a priest.

MRS. SMITH. Oh yes, Mr. Fire Chief, begin again. Everyone wants to hear.

FIRE CHIEF. Ah, I don't know whether I'll be able to. I'm on official business. It depends on what time it is.

MRS. SMITH. We don't have the time, here.

FIRE CHIEF. But the clock?

MR. SMITH. It runs badly. It is contradictory, and always indicates the opposite of what the hour really is.

Enter MARY.

MARY. Madam . . . sir . . .

MRS. SMITH. What do you want?

MR. SMITH. What have you come in here for?

MARY. I hope, madam and sir will excuse me . . . and these ladies and gentlemen too . . . I would like . . . I would like . . . to tell you a story, myself.

MRS. MARTIN. What is she saying?

MR. MARTIN. I believe that our friends' maid is going crazy . . . she wants to tell us a story, too.

FIRE CHIEF. Who does she think she is? *(He looks at her).* Oh!

MRS. SMITH. Why are you butting in?

MR. SMITH. This is really uncalled for, Mary . . .

FIRE CHIEF. Oh! But it is she! Incredible!

MR. SMITH. And you?

MARY. Incredible! Here!

MRS. SMITH. What does all this mean?

MR. SMITH. You know each other?

FIRE CHIEF. And how!

MARY throws herself on the neck of the FIRE CHIEF.

MARY. I'm so glad to see you again . . . at last!

MR. AND MRS. SMITH. Oh!

MR. SMITH. This is too much, here, in our home, in the suburbs of London.

MRS. SMITH. It's not proper! . . .

FIRE CHIEF. It was she who extinguished my first fires.

MARY. I'm your little firehose.

MR. MARTIN. If that is the case . . . dear friends . . . these emotions are understandable, human, honorable . . .

MRS. MARTIN. All that is human is honorable.

MRS. SMITH. Even so, I don't like to see it . . . here among us . . .

MR. SMITH. She's not been properly brought up . . .

FIRE CHIEF. Oh, you have too many prejudices.

MRS. MARTIN. What I think is that a maid, after all— even though it's none of my business—is never anything but a maid . . .

MR. MARTIN. Even if she can sometimes be a rather good detective.

FIRE CHIEF. Let me go.

MARY. Don't be upset! . . . They're not so bad really.

MR. SMITH. Hm . . . hm . . . you two are very touching, but at the same time, a little . . . a little . . .

MR. MARTIN. Yes, that's exactly the word.

MR. SMITH. . . . A little too exhibitionistic . . .

MR. MARTIN. There is a native British modesty—forgive me for attempting, yet again, to define my thought—not understood by foreigners, even by specialists, thanks to which, if I may thus express myself . . . of course, I don't mean to refer to you . . .

MARY. I was going to tell you . . .

MR. SMITH. Don't tell us anything . . .

MARY. Oh yes!

MRS. SMITH. Go, my little Mary, go quietly to the kitchen and read your poems before the mirror . . .

MR. MARTIN. You know, even though I'm not a maid, I also read poems before the mirror.

MRS. MARTIN. This morning when you looked at yourself in the mirror you didn't see yourself.

MR. MARTIN. That's because I wasn't there yet . . .

MARY. All the same, I could, perhaps, recite a little poem for you.

MRS. SMITH. My little Mary, you are frightfully obstinate.

MARY. I'm going to recite a poem, then, is that agreed? It is a poem entitled "The Fire" in honor of the Fire Chief:
The Fire
The polypoids were burning in the wood
A stone caught fire
The castle caught fire
The forest caught fire
The men caught fire
The women caught fire
The birds caught fire
The fish caught fire
The water caught fire
The sky caught fire
The ashes caught fire
The smoke caught fire
The fire caught fire
Everything caught fire
Caught fire, caught fire.

She recites the poem while the SMITHS are pushing her offstage.

MRS. MARTIN. That sent chills up my spine . . .

MR. MARTIN. And yet there's a certain warmth in those lines . . .

FIRE CHIEF. I thought it was marvelous.

MRS. SMITH. All the same . . .

MR. SMITH. You're exaggerating . . .

FIRE CHIEF. Just a minute . . . I admit . . . all this is very subjective . . . but this is my conception of the world. My world. My dream. My ideal . . . And now this reminds me that I must leave. Since you don't have the time here, I must tell you that in exactly three-quarters of an hour and sixteen minutes, I'm having a fire at the other end of the city. Consequently, I must hurry. Even though it will be quite unimportant.

MRS. SMITH. What will it be? A little chimney fire?

FIRE CHIEF. Oh, not even that. A straw fire and a little heartburn.

MR. SMITH. Well, we're sorry to see you go.

MRS. SMITH. You have been very entertaining.

MRS. MARTIN. Thanks to you, we have passed a truly Cartesian quarter of an hour.

FIRE CHIEF (*moving towards the door, then stopping*). Speaking of that—the bald soprano? (*General silence, embarrassment*).

MRS. SMITH. She always wears her hair in the same style.

FIRE CHIEF. Ah! Then goodbye, ladies and gentlemen.

MR. MARTIN. Good luck, and a good fire!

FIRE CHIEF. Let's hope so. For everybody.

FIRE CHIEF exits. All accompany him to the door and then return to their seats.

MRS. MARTIN. I can buy a pocketknife for my brother, but you can't buy Ireland for your grandfather.

MR. SMITH. One walks on his feet, but one heats with electricity or coal.

MR. MARTIN. He who sells an ox today, will have an egg tomorrow.

MRS. SMITH. In real life, one must look out of the window.

MRS. MARTIN. One can sit down on a chair, when the chair doesn't have any.

MR. SMITH. One must always think of everything.

MR. MARTIN. The ceiling is above, the floor is below.

MRS. SMITH. When I say yes, it's only a manner of speaking.

MRS. MARTIN. To each his own.

MR. SMITH. Take a circle, caress it, and it will turn vicious.

MRS. SMITH. A schoolmaster teaches his pupils to read, but the cat suckles her young when they are small.

MRS. MARTIN. Nevertheless, it was the cow that gave us tails.

MR. SMITH. When I'm in the country, I love the solitude and the quiet.

MR. MARTIN. You are not old enough yet for that.

MRS. SMITH. Benjamin Franklin was right; you are more nervous than he.

MRS. MARTIN. What are the seven days of the week?

MR. SMITH. Monday, Tuesday, Wednesday, Thursday, Friday, Saturday, Sunday.[7]

MR. MARTIN. Edward is a clerck; his sister Nancy is a typist, and his brother William a shop-assistant.[8]

MRS. SMITH. An odd family!

MRS. MARTIN. I prefer a bird in the bush to a sparrow in a barrow.

MR. SMITH. Rather a steak in a chalet than gristle in a castle.

MR. MARTIN. An Englishman's home is truly his castle.

MRS. SMITH. I don't know enough Spanish to make myself understood.

MRS. MARTIN. I'll give you my mother-in-law's slippers if you'll give me your husband's coffin.

MR. SMITH. I'm looking for a monophysite priest to marry to our maid.

MR. MARTIN. Bread is a staff, whereas bread is also a staff, and an oak springs from an oak every morning at dawn.

MRS. SMITH. My uncle lives in the country, but that's none of the midwife's business.

MR. MARTIN. Paper is for writing, the cat's for the rat. Cheese is for scratching.

MRS. SMITH. The car goes very fast, but the cook beats batter better.

MR. SMITH. Don't be turkeys; rather kiss the conspirator.

MR. MARTIN. Charity begins at home.[9]

MRS. SMITH. I'm waiting for the aqueduct to come and see me at my windmill.

MR. MARTIN. One can prove that social progress is definitely better with sugar.

MR. SMITH. To hell with polishing!

Following this last speech of MR. SMITH'S, *the others are silent for a moment, stupefied. We sense that there is a certain nervous irritation. The strokes of the clock are more nervous too. The speeches which follow must be said, at first, in a glacial, hostile tone. The hostility and the nervousness increase. At the end of this scene, the four characters must be standing very close to each other, screaming their speeches, raising their fists, ready to throw themselves upon each other.*

MR. MARTIN. One doesn't polish spectacles with black wax.

MRS. SMITH. Yes, but with money one can buy anything.

MR. MARTIN. I'd rather kill a rabbit than sing in the garden.

MR. SMITH. Cockatoos, cockatoos, cockatoos, cockatoos, cockatoos, cockatoos, cockatoos, cockatoos, cockatoos, cockatoos.

MRS. SMITH. Such caca, such caca, such caca, such caca, such caca, such caca, such caca, such caca, such caca.

[7] Translator's note: in the French text these speeches read as follows:
Mme Smith.—N'y touchez pas, elle est brisée.
M. Martin.—Sully!
M. Smith.—Prudhomme!
Mme Martin, M. Smith.—François.
Mme Smith, M. Martin.—Coppée.
Mme Martin, M. Smith.—Coppée Sully!
Mme Smith, M. Martin.—Prudhomme François.

[8] When produced some of the speeches in this last scene were cut or shuffled. Moreover, the final beginning again, if one can call it that, still involved the Smiths, since the author did not have the inspired idea of substituting the Martins for the Smiths until after the hundredth performance.

MR. MARTIN. Such cascades of cacas, such cascades of cacas, such cascades of cacas, such cascades of cacas, such cascades of cacas, such cascades of cacas, such cascades of cacas.

MR. SMITH. Dogs have fleas, dogs have fleas.

MRS. MARTIN. Cactus, coccyx! crocus! cockaded! cockroach!

MRS. SMITH. Incasker, you incask us.

MR. MARTIN. I'd rather lay an egg in a box than go and steal an ox.

MRS. MARTIN (opening her mouth very wide). Ah! oh! ah! oh! Let me gnash my teeth.

MR. SMITH. Crocodile!

MR. MARTIN. Let's go and slap Ulysses.

MR. SMITH. I'm going to live in my cabana among my cacao trees.

MRS. MARTIN. Cacao trees on cacao farms don't bear coconuts, they yield cocoa! Cacao trees on cacao farms don't bear coconuts, they yield cocoa! Cacao trees on cacao farms don't bear coconuts, they yield cocoa.

MRS. SMITH. Mice have lice, lice haven't mice.

MRS. MARTIN. Don't ruche my brooch!

MR. MARTIN. Don't smooch the brooch!

MR. SMITH. Groom the goose, don't goose the groom.

MRS. MARTIN. The goose grooms.

MRS. SMITH. Groom your tooth.

MR. MARTIN. Groom the bridegroom, groom the bridegroom.

MR. SMITH. Seducer seduced!

MRS. MARTIN. Scaramouche!

MRS. SMITH. Sainte-Nitouche!

MR. MARTIN. Go take a douche.

MR. SMITH. I've been goosed.

MRS. MARTIN. Sainte-Nitouche stoops to my cartouche.

MRS. SMITH. "Who'd stoop to blame? . . . and I never choose to stoop."

MR. MARTIN. Robert!

MR. SMITH. Browning!

MRS. MARTIN, MR. SMITH. Rudyard.

MRS. SMITH, MR. MARTIN. Kipling.

MRS. MARTIN, MR. SMITH. Robert Kipling!

MRS. SMITH, MR. MARTIN. Rudyard Browning.[10]

MRS. MARTIN. Silly gobblegobblers, silly gobblegobblers.

MR. MARTIN. Marietta, spot the pot!

MRS. SMITH. Krishnamurti, Krishnamurti, Krishnamurti!

MR. SMITH. The pope elopes! The pope's got no horoscope. The horoscope's bespoke.

MRS. MARTIN. Bazaar, Balzac, bazooka!

MR. MARTIN. Bizarre, beaux-arts, brassieres!

MR. SMITH. A, e, i, o, u, a, e, i, o, u, a, e, i, o, u, i!

MRS. MARTIN. B, c, d, f, g, l, m, n, p, r, s, t, v, w, x, z!

MR. MARTIN. From sage to stooge, from stage to serge!

MRS. SMITH (imitating a train). Choo, choo, choo, choo, choo, choo, choo, choo, choo, choo!

MR. SMITH. It's!

MRS. MARTIN. Not!

MR. MARTIN. That!

MRS. SMITH. Way!

MR. SMITH. It's!

MRS. MARTIN. O!

MR. MARTIN. Ver!

MRS. SMITH. Here!

All together, completely infuriated, screaming in each other's ears. The light is extinguished. In the darkness we hear, in an increasingly rapid rhythm:

ALL TOGETHER. It's not that way, it's over here, it's not that way, it's over here, it's not that way, it's over here, it's not that way, it's over here![11]

The words cease abruptly. Again, the lights come on. MR. and MRS. MARTIN are seated like the Smiths at the beginning of the play. The play begins again with the Martins, who say exactly the same lines as the Smiths in the first scene, while the curtain softly falls.

Dutchman

Introduction by Christa Lemoine
Amiri Baraka: Theatre and the Call for Cultural Identity

The Harlem Renaissance is probably one of the most well known assertions of African American influence in the world of art, poetry, music, and drama. During this time period, from 1919 to the mid-nineteen thirties, African American artists were exploring more than just simple artistic pursuits. Influences from many different aspects of this epoch bled into each other, creating unique and beautiful experiments in sound, rhythm, speech, visual arts, and drama, to name a few. Langston Hughes was heavily influenced by jazz and the blues and used that influence in the meter of his poetry. Zora Neale Hurston used her works as a sort of anthropological journal. They briefly collaborated on the unfinished play *Mule Bone*, which fused their styles and introduced a new influence, dialect. In this ill-fated play, Hughes and Hurston sought to honestly portray African American culture and folklore in the language and dialect of a distinct culture. However, the Harlem Renaissance was neither the first nor the last of these surges from a community that, according to the themes in Amiri Baraka's works, has been struggling to recognize and realize its cultural identity.

Writer, playwright, actor, director, teacher, and producer are only a few of the terms used to describe Baraka. He is also considered an activist and at times has been called anti-Semitic and racist. However, pigeonholing Baraka into any one category becomes increasingly difficult because his social and political views often rapidly change and evolve. There is one theme in his works that is always at the forefront, although in different forms: the theme of empowering African Americans to embrace their culture. Born Everett LeRoi Jones in Newark, New Jersey, in 1934, Baraka began life as an aspiring minister. Jones graduated from Barringer High School at the age of fifteen. After studying briefly at Rutgers University, he transferred to Howard University and earned his B.A. in English. After a brief stint in the air force that ended with his discharge in 1957, Jones traveled back to New Jersey before settling in New York's Greenwich Village. He married Hetti Roberta Cohen in 1958 and they founded the magazine *Yügen*. During this time, Jones wrote several critical essays on jazz and the blues. He became a well-known music critic. The influence of musicians such as John Coletrane and Thelonius Monk on Jones is one similarity between him and his predecessors of the Harlem Renaissance. After a trip to Cuba, Jones began to become more political in his writings. Jones's writings during this period explored several social themes that included sexuality and religion and racial identity. He and others developed the Black Arts Repertory Theatre/School, which focused on teaching acting, directing, technical skills, and other aspects of theatre, and it produced plays written by Jones and other students for black audiences. Jones was beginning to become more vocal about his political and social views. One play written during this period that exemplifies Jones's views of the assimilation of African Americans into white culture is *Dutchman*.

In 1965, several issues surrounding the African American community, including the assassination of Malcolm X and its aftermath, heavily influenced the direction that Jones was now heading. He divorced his wife and moved to Harlem. During this period, he

converted to the Nation of Islam and changed his name to Amiri Baraka. He married a woman named Sylvia Robinson in 1967 who eventually changed her name to Bibi Amina Baraka. As before, the writings of Baraka reflected his political, religious, and social views, which were often laden with anger. Around 1974, Baraka eventually moved in line with more communist ideals and began to distance himself from his more militant standpoint of the preceding years.

Today Baraka is still an active lecturer, writer, and teacher. He remains a controversial figure for his often polarizing writings and ideals. Despite the debate that easily revolves around Baraka, it is important to remember that many others came before him, including Langston Hughes, Zora Neale Hurston, and many other African Americans of the Harlem Renaissance that called for the black community to embrace their unique culture. August Wilson, writing during the same period as Baraka, also wrote plays that chronicled the journey of African American culture through the decades in what he called his Pittsburgh Cycle. Wilson counts Baraka, along with Hughes, as one of his influences. Although Wilson acknowledged that theatre has universal and cross-cultural importance and themes, he believed it was important that there were theatres dedicated to black drama. With all the similarities in the missions of these writers, it is easy to see that the cultural identity of African Americans is an important theme spanning decades and is used to create unique, beautiful, and powerful art forms that include, but certainly are not limited to, drama.

Dutchman

Amiri Baraka's *Dutchman*, which won an Obie Award in 1964, is a powerful one-act play that takes place in a subway. The two main characters are Clay, a young, middle-class black man, and Lula, a young, free-spirited white woman. The plot seems so simplistic at first. Clay notices Lula on the platform and she notices him looking at her. She joins him on the subway and despite its veritable emptiness, she sits next to him. They begin to talk and as they do Lula seems to be able to guess quite a lot about Clay. At first, Clay is thrown off by her wildly swinging moods and flirtations, but he quickly changes gears and becomes flirtatious, albeit cautious, too. Lula periodically taunts Clay with insulting remarks calling him "Uncle Tom," "liver-lipped white man," and "black son of a bitch." While Clay endures these taunts for a time, ignoring or deflecting their sting, he eventually explodes into a rage, allowing all the pent-up frustration out at Lula. In this play, Baraka has Clay break out of his assumed personality and finally accept his true identity. Although, Clay is angry, insulting, and violent, there seems to be a justification to his reaction to Lula, who has mercilessly goaded him.

Clay represents a dangerous element to Baraka, a black man repressing his culture while trying desperately to assimilate seamlessly into white culture. Baraka seems to indicate through Clay the dangers of this rejection and the violence that it leads to. Lula, on the other hand, recognizes Clay's desperation to fit into mainstream society and feeds on this. She chips away at the façade he presents and eventually faces the seething anger that repression has led to. Lula at the same time represents the freedom of the majority. Her actions, even at the end of the play, seem to be carried out without any fear of punishment. In fact, the play takes on a cyclical component at the end when another young black man on the train joins Lula.

This cyclical plot has drawn comparisons of Baraka's play with the myth of the Flying Dutchman, who is doomed to sail and is allowed to dock only once every seven to one hundred years (depending on the source). The Flying Dutchman searches for something to break his curse (once again that "something" depends on the source of the tale). In *Dutchman* Lula appears to have taken on the traits of the mythical figure as she searches for something on the flying subway. Baraka, however, does not want Lula and Clay to

simply become modern re-creations of this tale, nor does he intend for them to be simply characters that represent ideas. Instead, Baraka has asserted that Clay and Lula are individuals in their own right. They are unique people who play out the dangers of denying an entire culture.

Food for Thought

1. As you read the play, consider what significance, if any, the other riders on the subway have. Why do you feel this way?
2. For drama to be effective, it must maintain relevance. Do you feel that *Dutchman* has relevance in today's society? Why or why not? If so, do you feel that its relevance has changed since the play's initial production?
3. Do you consider Lula and Clay to be individual characters that can exist on their own, or do you feel that they can only exist as representations of a larger idea? Why?
4. Cultural and racial identities are definite themes in this play. However, there are other themes in the play. What other themes do you pick up on and how do they relate, if at all, to the main themes?
5. Do you feel that the fruit Lula periodically eats has any significance? Why or why not?
6. Do you feel that Baraka succeeds in conveying his point that African Americans need to embrace their culture? In what ways, if any, do you feel he especially succeeds or fails?

Fun Facts

1. Baraka was named the poet laureate of Newark, New Jersey, in December 2002.
2. Baraka was the state of New Jersey's poet laureate at the time of the September 11, 2001, attacks. The poem he wrote in response to the attacks was so controversial the New Jersey governor abolished the post of poet laureate in his state.

Dutchman

Amiri Baraka (LeRoi Jones) (1934–)

"One night I sat up all night and wrote a play I called *Dutchman*. I had gotten the title from *The Flying Dutchman* but abstracted it, because . . . It didn't quite serve my purpose. . . ."[1]

LeRoi Jones draws on Several historical and literary sources for his play. Jones's title brings to mind the Dutch slave ships that transported human cargo to the Americas. The title also suggests the Flying Dutchman maritime legend and Wagnerian opera about a ship that haunted the seas around the Cape of Good Hope, luring other ships to their destruction. One legend has it that a Dutch captain insisted on sailing around the Cape during a violent storm against the protests of his passengers and crew. When a vision of God Appeared on deck, the captain not only refused to acknowledge it but drew his pistol, fired, and cursed the image. His punishment was to wander the seas tormenting sailors until Judgment Day.

Richard Wagner's opera gives the captain an escape route—the curse can be lifted if he finds a woman who will love and be faithful to him unto death. For Wagner, the woman means redemption; for Jones, death. The characters in *Dutchman* are linked symbolically to the legend, Clay representing the God figure and Lula, the captain.

The Biblical story of Adam and Eve is also incorporated into Jones's play—Clay being Adam and Lula, Eve. Jones's Flying Dutchman is a subway train speeding through the innards of New York City. Within this underground serpent, Clay, a middle-class, naive, African American intellectual, encounters Lula, an apple-eating "nutty" and dangerous bohemian white woman. Lula sets out to seduce Clay, but to accomplish this she must first mold him into the image that she desires—the stereotypical Black figure whom whites create and demand. She taunts Clay about those things that single him out as middleclass, igniting his anger. Lula eventually discovers that gentle, "complaisant" Blacks can also be threatening and dangerous.

Jones uses the white myth of Black male sexuality to expose the systematic and deliberate annihilation of African Americans. Headlines in newspapers from around the country have described the horrors of lynching from the late nineteenth until well into the twentieth century: "Two Blacks Strung Up: Grave Doubt of Their Guilt," "Negro Lynched to Avenge Assault on White Woman," "An Innocent Man Lynched," "Lynch Mob May Have Erred," "Lynched Despite Protests of Rape Victim's Parents," "Doubt Bludgeoned Negro Was Accoster of Girls."[2] A large percentage of these lynchings were responses to allegations of rape, others to minor offenses. One of the most heinous lynchings occurred near Money, Mississippi, in 1955, When Emmett Till, a fourteen-year-old boy from Chicago, was abducted, beaten, and shot in the head, and his body thrown into the Tallahatchie River, for allegedly whistling at a white woman. James Baldwin used this tragedy as the basis for his play Blues for *Mister Charlie*. For Jones, Clay's murder becomes the symbolic lynching of all African Americans.

Jones was born in Newark, New Jersey. He attended Rutgers University in 1951 and transferred to Howard University, where he majored in English. He is a poet, playwright, author, and educator. He was founder-director of the Black Arts Repertory Theatre and School in Harlem in 1964, and later founder-director of Spirit House in Newark, where

[1] Amiri Baraka, *The Autobiography of LeRoi Jones/Amiri Baraka* (New York: Freundlich Books, 1984), p. 187.
[2] Ralph Ginzburg, *100 Years of Lynching* (New York: Lancer Books, 1962).

young African American playwrights' works were performed by the African Revolutionary Movers repertory theatre company. In addition to plays, he has published more than two dozen books, including poetry, fiction, and nonfiction. He has been the recipient of numerous grants, fellowships, and awards, and in 1972 was awarded a Doctor of Humane Letters degree by Malcolm X College in Chicago. Jones is hailed as the leader of the revolutionary Black Arts and Black Theatre movements of the 1960s. *Dutchman* won the Obie Award for best Off Broadway play in 1964.

Dutchman

Characters

Clay, a twenty-year-old Negro
Lula, thirty-year-old White Woman
Riders of Coach, White and Black
Young Negro
Conductor

In the flying underbelly of the city. Steaming hot, and summer on top, outside. Underground. The subway heaped in modern myth.

Opening scene is a man sitting in a subway seat, holding a magazine but looking vacantly just above its wilting pages. Occasionally he looks blankly toward the window on his right. Dim lights and darkness whistling by against the glass. (Or paste the lights, as admitted props, right on the subway windows. Have them move, even dim and flicker. But give the sense of speed. Also stations, whether the train is stopped or the glitter and activity of these stations merely flashes by the windows.)

The man is sitting alone. That is, only his seat is visible, though the rest of the car is outfitted as a complete subway car. But only his seat is shown.

There might be, for a time, as the play begins, a loud scream of the actual train. And it can recur throughout the play, or continue on a lower key once the dialogue starts.

The train slows after a time, pulling to a brief stop at one of the stations. The man looks idly up, until he sees a woman's face staring at him through the window; when it realizes that the man has noticed the face, it begins very premeditatedly to smile. The man smiles too, for a moment, without a trace of self-consciousness. Almost an instinctive though undesirable response. Then a kind of awkwardness or embarrassment sets in, and the man makes to look away, is further embarrassed, so he brings back his eyes to where the face was, but by now the train is moving again, and the face would seem to be left behind by the way the man turns his head to look back through the other windows at the slowly fading platform. He smiles then; more comfortably confident, hoping perhaps that his memory of this brief encounter will be pleasant. And then he is idle again.

Scene I- Train Roars. Lights Flash Outside the Windows

Lula enters from the rear of the car in bright, skimpy summer clothes and sandals. She carries a net bag full of paper books, fruit, and other anonymous articles. She is wearing sunglasses, which she pushes up on her forehead from time to tome. Lula is a tall, slender, beautiful woman with long red hair hanging straight down her back, wearing only loud lipstick in somebody's good taste. She is eating an apple, very daintily. Coming down the car toward Clay.

She stops beside Clay's seat and hangs languidly from the strap, still managing to eat the apple. It is apparent that she is going to sit in the seat next to Clay, and that she is only waiting for him to notice her before she sits.

Clay sits as before, looking just beyond his magazine, now and again pulling the magazine slowly back and forth in front of his face in a hopeless effort to fan himself. Then he sees the woman hanging there beside him and he looks up into her face, smiling quizzically.

LULA. Hello.

CLAY. Uh, hi're you?

LULA. I'm going to sit down. . . . O.K.?

CLAY. Sure.

LULA (*swings down onto the seat, pushing her legs straight out as if she is very weary*). Ooooof! Too much weight.

CLAY. Ha, doesn't look like much to me. (*leaning back against the window, a little surprised and maybe stiff*)

LULA. It's so anyway. (*And she moves her toes in the sandals, then pulls her right leg up on the left knee, better to inspect the bottoms of the sandals and back of her heel. She appears for a second not to notice that CLAY is sitting next to her or that she has spoken to him just a second before. CLAY looks at the magazine, then out the black window. As he does this, she turns very quickly toward him*) Weren't you staring at me through the window?

CLAY (*wheeling around and very much stiffened*). What?

LULA. Weren't you staring at me through the window? At the last stop?

CLAY. Staring at you? What do you mean?

LULA. Don't you know what staring means?

CLAY. I saw you through the window . . . if that's what it means. I don't know if I was staring. Seems to me you were staring through the window at me.

LULA. I was. But only after I'd turned around and saw you staring through that window down in the vicinity of my ass and legs.

CLAY. Really?

LULA. Really. I guess you were just taking those idle potshots. Nothing else to do. Run your mind over people's flesh.

CLAY. Oh boy. Wow, now I admit I was looking in your direction. But the rest of that weight is yours.

LULA. I suppose.

CLAY. Staring through train windows is weird business. Much weirder than staring very sedately at abstract asses.

LULA. That's why I came looking through the window . . . so you'd have more than that to go on. I even smiled at you.

CLAY. That's right.

LULA. I even got onto this train, going some other way than mine. Walked down the aisle . . . searching your out.

CLAY. Really? That's pretty funny.

LULA. That's pretty funny. . . . God, you're dull.

CLAY. Well, I'm sorry, lady, but I really wasn't prepared for party talk.

LULA. No, you're not. What are you prepared for? (*wrapping the apple core in a Kleenex and dropping it on the floor*)

CLAY (*takes her conversation as pure sex talk. He turns to confront her squarely with this idea*). I'm prepared for anything. How about you?

LULA (*laughing loudly and cutting it off abruptly*). What do you think you're doing?

CLAY. What?

LULA. You think I want to pick you up, get you to take me somewhere and screw me, huh?

CLAY. Is that the way I look?

LULA. You look like you been trying to grow a beard. That's exactly what you look like. You look like you live in New Jersey with your parents and are trying to grow a beard. That's what. You look like you've been reading Chinese poetry and drinking lukewarm sugarless tea. (*laughs, uncrossing and recrossing her legs*) You look like death eating a soda cracker.

CLAY (*Cocking his head from one side to the other, embarrassed and trying to make some comeback, but also intrigued by what the woman is saying . . . even the sharp city coarseness of her voice, which is still a kind of gentle sidewalk throb*). Really? I look like all that?

LULA. Not all of it. (*she feigns a seriousness to cover an actual somber tone*) I lie a lot. (*smiling*) It helps me control the world.

CLAY (*relieved and laughing louder than the humor*). Yeah, I bet.

LULA. But it's true, most of it, right? Jersey? Your bumpy neck?

CLAY. How'd you know all that? Huh? Really, I mean about Jersey . . . and even the beard. I met you before? You know Warren Enright?

LULA. You tried to make it with your sister when you were ten.

(CLAY *leans back hard against the back of the seat, his eyes opening now, still trying to look amused*)

But I succeeded a few weeks ago. (*she starts to laugh again*)

CLAY. What're you talking about? Warren tell you that? You're a friend of Georgia's?

LULA. I told you I lie. I don't know your sister. I don't know Warren Enright.

CLAY. You mean you're just picking these things out of the air?

LULA. Is Warren Enright a tall skinny black black boy with a phony English accent?

CLAY. I figured you knew him.

LULA. But I don't. I just figured you would know somebody like that. (*laughs*)

CLAY. Yeah, yeah.

LULA. You're probably on your way to his house now.

CLAY. That's right.

LULA (*putting her hand on* CLAY's *closest knee, drawing it from the knee up to the thigh's hinge, then removing it, watching his face very closely, and continuing to laugh, perhaps more gently than before*). Dull, dull, dull. I bet you think I'm, exciting.

CLAY. You're O.K.

LULA. Am I exciting you now?

CLAY. Right. That's not what's supposed to happen?

LULA. How do I know? (*she returns her hand, without moving it, then takes it away and plunges it in her bag to draw out an apple*) You want this?

CLAY. Sure.

LULA (*she gets one out of the bag for herself*). Eating apples together is always the first step. Or walking up uninhabited Seventh Avenue in the twenties on weekends. (*bites and giggles, glancing at* CLAY *and speaking in loose sing-song*) Can you get involved . . . boy? Get us involved. Um-huh. (*mock seriousness*) would you like to get involved with me, Mister Man?

CLAY (*trying to be as flippant as* LULA, *whacking happily at the apple*). Sure. Why not? A beautiful woman like you. Huh, I'd be a fool not to.

LULA. And I bet you're sure you know what you're talking about. (*taking him a little roughly be the wrists, so he cannot eat the apple, then shaking the wrist*) I bet you're sure of almost everything anybody ever asked you about . . . right? (*shakes his wrist harder*) Right?

CLAY. Yeah, right. . . . Wow, you're pretty strong, you know? Whatta you, a lady wrestler or something?

LULA. What's wrong with lady wrestlers? And don't answer because you never knew any. Huh. (*cynically*) That's for sure. They don't have any lady wrestlers in that part of Jersey. That's for sure.

CLAY. Hey, you still haven't told me how you know so much about me.

LULA. I told you I didn't know anything about *you* . . . you're a well-known type.

CLAY. Really?

LULA. Or at least I know the type very well. And your skinny English friend too.

CLAY. Anonymously?

LULA (*settles back in seat, single-mindedly finishing her apple and humming snatches of rhythm and blues song*). What?

CLAY. Without knowing us specifically?

LULA. Oh boy. (*looking quickly at* CLAY) What a face. You know, you could be a handsome man.

CLAY. I can't argue with you.

LULA (*vague, off-center response*). What?

CLAY (*raising his voice, thinking the train noise has drowned part of his sentence*). I can't argue with you.

LULA. My hair is turning gray. A gray hair for each year and type I've come through.

CLAY. Why do you want to sound so old?

LULA. But it's always gentle when it starts. (*attention drifting*) Hugged against tenements, day or night.

CLAY. What?

LULA (*refocusing*). Hey, why don't you take me to that party you're going to?

CLAY. You must be a friend of Warren's to know about the party.

LULA. Wouldn't you like to take me to the party? *(imitates clinging vine)* Oh, come on, ask me to your party.

CLAY. Of course I'll ask you to come with me to the party. And I'll bet you're a friend of Warren's.

LULA. Why not be a friend of Warren's? Why not? *(taking his arm)* Have you asked me yet?

CLAY. How can I ask you when I don't know your name?

LULA. Are you talking to my name?

CLAY. What is it, a secret?

LULA. I'm Lena the Hyena.

CLAY. The famous woman poet?

LULA. Poetess! The same!

CLAY. Well, you know so much about me . . . what's my name?

LULA. Morris the Hyena.

CLAY. The famous woman poet?

LULA. The same. *(laughing and going into her bag)* You want another apple?

CLAY. Can't make it, lady. I only have to keep one doctor away a day.

LULA. I bet your name is . . . something like . . . uh, Gerald or Walter. Huh?

CLAY. God, no.

LULA. Lloyd, Norman? One of those hopeless colored names creeping out of New Jersey. Leonard? Gag. . . .

CLAY. Like Warren?

LULA. Definitely. Just exactly like Warren. Or Everett.

CLAY. Gag. . . .

LULA. Well, for sure, it's not Willie.

CLAY. It's Clay.

LULA. Clay? Really? Clay what?

CLAY. Take your pick. Jackson, Johnson, or Williams.

LULA. Oh, really? Good for you. But it's got to be Williams. You're too pretentious to be a Jackson or Johnson.

CLAY. Thass right.

LULA. But Clay's O.K.

CLAY. So's Lena.

LULA. It's Lula.

CLAY. Oh?

LULA. Lula the Hyena.

CLAY. Very good.

LULA *(starts laughing again)*. Now you say to me, "Lula, Lula, why don't you go to this party with me tonight?" It's your turn, and let those be your lines.

CLAY. Lula, why don't you go to this party with me tonight, Huh?

LULA. Say my name twice before you ask, and no huh's.

CLAY. Lula, Lula, why don't you go to this party with me tonight?

LULA. I'd like to go, Clay, but how can you ask me to go when you barely know me?

CLAY. That is strange, isn't it?

LULA. What kind of reaction is that? You're supposed to say, "Aw, come on, we'll get to know each other better at the party."

CLAY. That's pretty corny.

LULA. What are you into anyway? *(looking at him half sullenly but still amused)* What thing are you playing at, Mister? Mister Clay Williams? *(grabs his thigh, up near the crotch)* What are *you* thinking about?

CLAY. Watch it now, you're gonna excite me for real.

LULA *(taking her hand away and throwing her apple core through the window)*. I bet. *(she slumps in the seat and is heavily silent)*

CLAY. I thought you knew everything about me? What happened?

(LULA looks at him, then looks slowly away, then over where the other aisle would be. Noise of the train. She reaches in her bag and pulls out one of the paper books. She puts it one her leg and thumbs the pages listlessly. CLAY cocks his head to see the title of the book. Noise of the train. LULA flips pages and her eyes drift. Both remain silent)

Are you going to the party with me, Lula?

LULA *(bored and not even looking)*. I don't even know you.

CLAY. You said you know my type.

LULA (*strangely irritated*). Don't get smart with me, Buster. I know you like the palm of my hand.

CLAY. The one you eat the apples with?

LULA. Yeh. And the one I open doors late Saturday evening with. That's my door. Up at the top of the stairs. Five flights. Above a lot of Italians and lying Americans. And scrape carrots with. Also . . . (*looks at him*) the same hand I unbutton my dress with, or let my skirt fall down. Same hand. Lover.

CLAY. Are you angry about anything? Did I say something wrong?

LULA. Everything you say is wrong. (*mock smile*) That's what makes you so attractive. Ha. In that funnybook jacket with all the buttons. (*more animate, taking hold of his jacket*) What've you got that jacket and tie on in all this heat for? And why're you wearing a jacket and tie like that? Did your people ever burn witches or start revolutions over the price of tea? Boy, those narrow-shoulder clothes come from a tradition you ought to feel oppressed by. A three-button suit. What right do you have to be wearing a three-button suit and striped tie? Your grandfather was a slave, he didn't go to Harvard.

CLAY. My grandfather was a night watchman.

LULA. And you went to a colored college where everybody thought they were Averell Harriman.

CLAY. All except me.

LULA. And who did you think you were? Who do you think you are now?

CLAY (*laughs as if to make light of the whole trend of the conversation*). Well, in college I thought I was Baudelaire. But I've slowed down since.

LULA. I bet you never once thought you were a Black nigger.

(*Mock serious, then she howls with laughter. CLAY is stunned but after initial reaction, he quickly tries to appreciate the humor. LULA almost shrieks*)

A Black Baudelaire.

CLAY. That's right.

LULA. Boy, are you corny. I take back what I said before. Everything you say is not wrong. It's perfect. You should be on television.

CLAY. You act like you're on television already.

LULA. That's because I'm an actress.

CLAY. I thought so.

LULA. Well, you're wrong. I'm no actress. I told you I always lie. I'm nothing, honey, and don't you ever forget it. (*lighter*) Although my mother was a Communist. The only person in my family ever to amount to anything.

CLAY. My mother was a Republican.

LULA. And your father voted for the man rather than the party.

CLAY. Right!

LULA. Yea for him. Yea, yea for him.

CLAY. Yea!

LULA. And yea for America where he is free to vote for the mediocrity of his choice! Yea!

CLAY. Yea!

LULA. And yea for America where he is free to vote for the mediocrity of his choice! Yea!

CLAY. Yea!

LULA. And yea for both your parents who even though they differ about so crucial a matter as the body politic still forged a union of love and sacrifice that was destined to flower at the birth of the noble Clay . . . what's your middle name?

CLAY. Clay.

LULA. A union of love and sacrifice that was destined to flower at the birth of the noble Clay Clay Williams. Yea! And most of all yea yea for you, Clay Clay. The Black Baudelaire! Yes. (*and with knifelike cynicism*) My Christ. My Christ.

CLAY. Thank you, ma'am.

LULA. May the people accept you as a ghost of the future. And love you, that you might not kill them when you can.

CLAY. What?

LULA. You're a murderer, Clay, and you know it. (*her voice darkening with significance*) You know goddamn well what I mean.

CLAY. I do?

LULA. So we'll pretend the air is light and full of perfume.

CLAY (sniffing at her blouse). It is.

LULA. And we'll pretend the people cannot see you. That is, the citizens. And that you are free of your own history. And I am free of my history. We'll pretend that we are both anonymous beauties smashing along through the city's entrails. (she yells as loud as she can) GROOVE!

Black
Scene II

Scene is the same as before, though now there are other seats visible in the car. And throughout the scene other people get on the subway. There are maybe one or two seated in the car as the scene opens, though neither CLAY nor LULA notices them. CLAY's tie is open. LULA is hugging his arm.

CLAY. The party!

LULA. I know it'll be something good. You can come in with me, looking casual and significant. I'll be strange, haughty, and silent, and walk with long low strides.

CLAY. Right.

LULA. When you get drunk, pat me once, very lovingly on the flanks, and I'll look at you cryptically, licking my lips.

CLAY. It sounds like something we can do.

LULA. You'll go around talking to young men about your mind, and to old men about your plans. If you meet a very close friend who is also with someone like me, we can stand together, sipping our drinks and exchanging codes of lust. The atmosphere will be slithering in love and half-love and very open moral decision.

CLAY. Great. Great.

LULA. And everyone will pretend they don't know your name, and then . . . (she pauses heavily) later, when they have to, they'll claim a friendship that denies your sterling character.

CLAY (kissing her neck and fingers). And then what?

LULA. Then? Well, then we'll go down the street, late night, eating apples and winding very deliberately toward my houses.

CLAY. Deliberately?

LULA. I mean, we'll look in all the shopwindows, and make fun of the queers. Maybe we'll meet a Jewish Buddhist and flatten his conceits over some very pretentious coffee.

CLAY. In honor of whose God?

LULA. Mine.

CLAY. Who is . . . ?

LULA. Me . . . and you?

CLAY. A corporate Godhead.

LULA. Exactly. Exactly. (notices one of the other people entering)

CLAY. Go on with the chronicle. Then what happens to us?

LULA (a mild depression, but she still makes her description triumphant and increasingly direct). To my house, of course.

CLAY. Of course.

LULA. And up the narrow steps of the tenement.

CLAY. You live in a tenement?

LULA. Wouldn't live anywhere else. Reminds me specifically of my novel form of insanity.

CLAY. Up the tenement stairs.

LULA. And with my apple-eating hand I push open the door and lead you, my tender big-eyed prey, into my . . . God, what can I call it . . . into my hovel.

CLAY. Then what happens?

LULA. After the dancing and games, after the long drinks and long walks, the real fun begins.

CLAY. Ah, the real fun. (embarrassed, in spite of himself) Which is . . . ?

LULA (laughs at him). Real fun in the dark house. Hah! Real fun in the dark house, high up above the street and the ignorant cowboys. I lead you in, holding your wet hand gently in my hand . . .

CLAY. Which is not wet?

LULA. Which is dry as ashes.

CLAY. And cold?

LULA. Don't think you'll get out of your responsibility that way. It's not cold at all. You Fascist! Into my dark living room. Where we'll sit and talk endlessly, endlessly.

CLAY. About what?

LULA. About what? About your manhood, what do you think? What do you think we've been talking about all this time?

CLAY. Well, I didn't know it was that. That's for sure. Every other thing in the world but that. (*notices another person entering, looks quickly, almost involuntarily up and down the car, seeing the other people in the car*) Hey, I didn't even notice when those people got on.

LULA. Yeah, I know.

CLAY. Man, this subway is slow.

LULA. Yeah, I know.

CLAY. Well, go on. We were talking about my manhood.

LULA. We still are. All the time.

CLAY. We were in your living room.

LULA. My dark living room. Talking endlessly.

CLAY. About my manhood.

LULA. I'll make you a map of it. Just as soon as we get to my house.

CLAY. Well, that's great.

LULA. One of the things we do while we talk. And screw.

CLAY. (*trying to make his smile broader and less shaky*) We finally got there.

LULA. And you'll call my rooms black as a grave. You'll say. "This place is like Juliet's tomb."

CLAY. (*laughs*) I might.

LULA. I know. You've probably said it before.

CLAY. And is that all? The whole grand tour?

CLAY. Not all. You'll say to me very close to my face, many, many times, you'll say, even whisper, that you love me.

CLAY. Maybe I will.

LULA. And you'll be lying.

CLAY. I wouldn't lie about something like that.

LULA. Hah. It's the only kind of thing you will lie about. Especially if you think it'll keep me alive.

CLAY. Keep you alive? I don't understand.

LULA. (*bursting out laughing, but too shrilly*) Don't understand? Well, don't look at me. It's the path I take, that's all. Where both feet take me when I set them down. One in front of the other.

CLAY. Morbid. Morbid. You sure you're not an actress? All that self-aggrandizement.

LULA. Well, I told you I wasn't an actress . . . but I also told you I lie all the time. Draw your own conclusions.

CLAY. Morbid. Morbid. You sure you're not an actress? All scribed? There's no more?

LULA. I've told you all I know. Or almost all.

CLAY. There's no funny parts?

LULA. I thought it was all funny.

CLAY. But you mean peculiar, not ha-ha.

LULA. You don't know what I mean.

CLAY. Well, tell me the almost part then. You said almost all. What else? I want the whole story.

LULA. (*searching aimlessly through her bag. She begins to talk breathlessly, with a light and silly tone*). All stories are whole stories. All of 'em. Our whole story . . . nothing but change. How could things go on like that forever? Huh? (*slaps him on the shoulder, begins finding things in her bag, taking them out and throwing them over her shoulder into the aisle*) Except I do go on as I do. Apples and long walks with deathless intelligent lovers. But you mix it up. Look out the window, all the time. Turning pages. Change change change. Till, shit, I don't know you. Wouldn't, for that matter. You're too serious. I bet you're even too serious to be psychoanalyzed. Like all those Jewish poets from Yonkers, who leave their mothers looking for other mothers, or others' mothers, on whose baggy tits they lay their fumbling heads. Their poems are always funny, and all about sex.

CLAY. They sound great. Like movies.

LULA. But you change. (*blankly*) And things work on you till you hate them.

(*More people come into the train. They come closer to the couple, some of them not sitting, but swinging drearily on the straps, staring at the two with uncertain interest*)

CLAY. Wow. All these people, so suddenly. They must all come from the same place.

LULA. Right. That they do.

CLAY. Oh? You know about them too?

LULA. Oh yeah. About them more than I know about you. Do they frighten you?

CLAY. Frighten me? Why should they frighten me?

LULA. 'Cause you're an escaped nigger.

CLAY. Yeah?

LULA. 'Cause you crawled through the wire and made tracks to my side.

CLAY. Wire?

LULA. Don't they have wire around plantations?

CLAY. You must be Jewish. All you can think about is wire. Plantations didn't have any wire. Plantations were big open white-washed places like heaven, and everybody on 'em was grooved to be there. Just strummin' and hummin' all day.

LULA. Yes, yes.

CLAY. And that's how the blues was born.

LULA. Yes, yes. And that's how the blues was born.

(Begins to make up a song that becomes quickly hysterical. As she sings she rises from her seat, still throwing things out of her bag into the aisle, beginning a rhythmical shudder and twistlike wiggle, which she continues up and down the aisle, bumping into many of the standing people and tripping over the feet of those sitting. Each time she runs into a person she lets out a very vicious piece of profanity, wiggling and stepping all the time)

And that's how the blues was born. Yes. Yes. Son of a bitch, get out of the way. Yes. Quack. Yes. Yes. And that's how the blues was born. Ten little niggers sitting on a limb, but none of them ever looked like him. (Points to CLAY, returns toward the seat, with her hands extended for him to rise and dance with her) And that's how blues was born. Yes. Come on, Clay. Let's do the nasty. Rub bellies. Rub bellies.

CLAY (waves his hand to refuse. He is embarrassed, but determined to get a kick out of the proceedings). Hey, what was in those apples? Mirror, mirror on the wall, who's the fairest one of all? Snow White, baby, and don't you forget it.

LULA (grabbing for his hands, which he draws away). Come on, Clay. Let's rub bellies on the train. The nasty. The nasty. Do the gritty grind, like your ol' rag-head mammy. Grind till you lose your mind. Shake it, shake it, shake it, shake it! OOOOweeee! Come on, Clay. Let's do the choo-choo train shuffle, the navel scratcher.

CLAY. Hey, you coming on like the lady who smoked up her grass skirt.

LULA (becoming annoyed that he will not dance, and becoming more animated as if to embarrass him still further). Come on, Clay . . . let's do the thing. Uhh! Uhh! Clay! Clay! You middleclass Black bastard. Forget your social-working mother for a few seconds and let's knock stomachs. Clay, you liver-lipped white man. You would-be Christian. You ain't no nigger, you're just a dirty white man. Get up, Clay. Dance with me, Clay.

CLAY. Lula! Sit down, now. Be cool.

LULA (mocking him, in wild dance). Be cool. Be cool. That's all you know . . . shaking that wildroot cream-oil on your knotty head, jackets buttoning up to your chin, so full of white man's words. Christ. God. Get up and scream at these people. Like scream meaningless shit in these hopeless faces. (she screams at people in train, still dancing) Red trains cough Jewish underwear for keeps! Expanding smells of silence. Gravy shot whistling like sea birds. Clay. Clay, you got to break out. Don't sit there dying the way they want you to die. Get up.

CLAY. Oh, sit the fuck down. (he moves to restrain her) Sit down, goddamn it.

LULA (twisting out of his reach). Screw yourself, Uncle Tom. Thomas Woolly-head. (begins to dance a kind of jig, mocking CLAY with loud forced humor) There is Uncle Tom . . . I mean Uncle Thomas Woolly-Head. With old white matted mane. He hobbles on his wooden cane. Old Tom. Old Tom. Let the white man hump his ol' mama, and he jes' shuffle off in the woods and hide his gentle gray head. Ol' Thomas Woolly-Head.

(Some of the other riders are laughing now. A drunk gets up and joins LULA in her dance, singing, as best he can, her "song." CLAY gets up out of his seat and visibly scans the faces of the other riders)

CLAY. Lula! Lula!

(She is dancing and turning, still shouting as loud as she can. The drunk too is shouting, and waving his hands wildly)

Lula . . . you dumb bitch. Why don't you stop it?

(He rushes half stumbling from his seat, and grabs one of her flailing arms)

Lula. Let me go! You Black son of a bitch. *(she struggles against him)* Let me go! Help!

(Clay is dragging her towards her seat, and the drunk seeks to interfere. He grabs Clay around the shoulders and begins wrestling with him. Clay clubs the drunk to the floor without releasing Lula, who is still screaming. Clay finally gets her to the seat and throws here into it)

Clay. Now you shut the hell up. *(grabbing her shoulders)* Just shut up. You don't know what you're talking about. You don't know anything. So just keep your stupid mouth closed.

Lula. You're afraid of white people. And your father was Uncle Tom Big Lip!

Clay.

(Slaps her as hard as he can, across the mouth. Lula's head bangs against the back of the seat. When she raises it again, Clay slaps her again)

Now shut up and let me talk.

(He turns toward the other riders, some of whom are sitting on the edge of their seats. The drunk is on one knee, rubbing his head, and singing softly the same song. He shuts up too when he sees Clay watching him. The others go back to newspapers or stare out the windows)

Shit, you don't have any sense, Lula, nor feelings either. I could murder you now. Such a tiny ugly throat. I could squeeze it flat, and watch you turn blue, on a humble. For dull kicks. All all these weak-faced ofays squatting around here, staring over their papers at me. Murder them too. Even if they expected it. That man there . . . *(points to well-dressed man)* I could rip that *Times* right out of his hand, as skinny and middle-classed as I am. I could rip that paper out of his hand and just as easily rip out his throat. It takes no great effort. For what? To kill you soft idiots? You don't understand anything but luxury.

Lula. You fool!

Clay *(pushing her against the seat)*. I'm not telling you again, Tallulah Bankhead! Luxury. In you face and your fingers. You telling me what I ought to do. *(sudden scream frightening the whole coach)* Well, don't! Don't you tell me anything! If I'm a middle-class fake white man . . . let me be. And let me be in the way I want.

(through his teeth) I'll rip your lousy breasts off! Let me be who I feel like being. Uncle Tom. Thomas. Whoever. It's none of your business. You don't know anything except what's there for you to see. An act. Lies. Device. Not the pure heart, the pumping Black heart. You don't ever know that. And I sit here, in this buttoned-up suit, to keep myself from cutting all your throats. I mean wantonly. You great liberated whore! You fuck some Black man, and right away you're an expert on Black people. What a lotta shit that is. The only thing you know is that you come if he bangs you hard enough. And that's all. The belly rub? You wanted to do the belly rub? Shit, you don't even know how. You don't know how. That ol' dipty-dip shit you do, rolling your ass like an elephant. That's not my kind of belly rub. Belly rub is not Queens. Belly rub is dark places, with big hats and overcoats held up with one arm. Belly rub hates you. Old bald-headed four-eyed ofays popping their fingers . . . and don't know yet what they're doing. They say, "I love Bessie Smith." And don't even understand that Bessie Smith is saying, "Kiss my ass, kiss my black unruly ass." Before love, suffering, desire, anything you can explain, she's saying and very plainly, "Kiss my black ass." And if you don't know that, it's you that's doing the kissing.

Charlie Parker? Charlie Parker. All the hip white boys scream for Bird. And Bird saying "Up your ass, feeble-minded ofay! Up your ass." And they sit there talking about the tortured genius of Charlie Parker. Bird would've played not a note of music if he just walked up to East Sixty-seventh Street and killed the first ten white people he saw. Not a note! And I'm, the great would-be poet. Yes. That's right! Poet. Some kind of bastard literature . . . all it needs is a simple knife thrust. Just let me bleed you, you loud whore, and one poem vanished. A whole people of neurotics, struggling to keep from being sane. And the only thing that would cure the neurosis would be your murder. Simple as that. I mean if I murdered you, then other white people would begin to understand me. You understand? No. I guess not. If Bessie smith had killed some white people she wouldn't have needed that music. She could have talked very straight and plain about the world. No metaphors. No grunts. No wiggles in the dark of her soul. Just straight two and two are four. Money. Power. Luxury. Like that. All of them. Crazy niggers turning their backs on sanity. When all it needs is that simple act. Murder. Just murder! Would make us all sane. *(suddenly weary)* Ahhh. Shit. But who needs it? I'd rather be a fool. Insane. Safe with my words, and no deaths, and clean, hard thoughts, urging me to new conquests.

My people's madness. Hah! That's a laugh. My people. They don't need me to claim them. They got legs and arms of their own. Personal insanities. Mirrors. They don't need all those words. They don't need any defense. But listen, though, one more thing. And you tell this to your father, who's probably the kind of man who needs to know at once. So he can plan ahead. Tell him not to preach so much rationalism and cold logic to these niggers. Let them alone. Let them sing curses at you in code and see your filth as simple lack of style. Don't make the mistake, through some irresponsible surge of Christian charity, of talking too much about the advantages of Western rationalism, or the great intellectual legacy of the white man, or maybe they'll begin to listen. And then, maybe one day, you'll find they actually do understand exactly what you are talking about, all these fantasy people. All these blues people. And on that day, as sure as shit, when you really believe you can "accept" them into your fold, as half-white trusties late of the subject peoples. With no more blues, except the very old ones, and not a watermelon in sight, the great missionary heart will have triumphed, and all of those ex-coons will be stand-up Western men, with eyes for clean hard useful lives, sober, pious and sane, and they'll murder you. They'll murder you, and have very rational explanations. Very much like your own. They'll cut your throats, and drag you out to the edge of your cities so the flesh can fall away from your bones, in sanitary isolation.

LULA (*her voice takes on a different, more businesslike quality*). I've heard enough.

CLAY (*reaching for his books*). I bet you have. I guess I better collect my stuff and get off this train. Looks like we won't be acting out that little pageant you outlined before.

LULA. No. We won't. You're right about that, at least. (*she turns to look quickly around the rest of the car*) All right!

(*The others respond*)

CLAY. (*bending across the girl to retrieve his belongings*) sorry, baby, I don't think we could make it.

(*As he is bending over her, the girl brings up a small knife and plunges it into* CLAY's *chest. Twice. He slumps across her knees, his mouth working stupidly*)

LULA. Sorry is right.

(*Turning to the others in the car who have already gotten up from their seats*)

Sorry is the rightest thing you've said. Get this man off me! Hurry, now!

(*The others come and drag* CLAY's *body down they aisle*)

Open the door and throw his body out.

(*They throw him off*)

And all of you get off at the next stop.

(*LULA busies herself straightening her things. Getting everything in order. She takes out a notebook and makes a quick scribbling note. Drops it in her bag. The train apparently stops and all the others get off, leaving her alone in the coach.*)

Very soon a young Negro of about twenty comes into the coach, with a couple of books under his arm. He sits a few seats in back of LULA. When he is seated she turns and gives him a long slow look. He looks up from his book and drops the book on his lap. Then an old Negro conductor comes into the car, doing a sort of restrained soft shoe, and half mumbling the words of some song. He looks at the young man, briefly, with a quick greeting)

CONDUCTOR. Hey, brother!

YOUNG MAN. Hey.

(*The conductor continues down the aisle with his little dance and the mumbled song. LULA turns to stare at him and follows him movements down the aisle. The conductor tips his hat when he reaches her seat, and continues out the car*)

(*Curtain*)

Fences

August Wilson: Voice of the African American Odyssey

One would be hard pressed to find an American playwright who has received as much critical acclaim as August Wilson. For most living theatre critics, Wilson ranks among the greatest American dramatists of all time. For many, he is considered the greatest of America's playwrights.

He was born Frederick August Kittel in 1945 and rose from a childhood of poverty in Pittsburgh to become a celebrated and successful voice of the African American experience. There were many bumps along the way. Wilson began his high school education as the only black student out of 1,500 pupils at Central Catholic High School. He was big enough to play football, but was kept off of the school team for unspecified reasons. The young Wilson ate alone in the cafeteria and was frequently threatened and jumped by his classmates. On at least one occasion, the school principal had to send him home in a cab to save him from packs of angry students waiting to ambush him after school. By the time he was fifteen, Wilson had had enough of formal education and dropped out of school. After a one-year stint in the U.S. Army, he spent the next several years working menial jobs as a gardener, dishwasher, cook, and porter. While working these jobs, he found time to write and submit poetry for publication.

In 1969, Wilson cofounded Pittsburgh's Black Horizons Theater and, by the late 1970s, he was working with a group of emerging black theatre artists in St. Paul, Minnesota. His big break came in 1982, when he submitted his play, *Ma Rainey's Black Bottom* to the Eugene O'Neill Center's National Playwrights Conference. The play caught the attention of director Lloyd Richards, who had directed Lorraine Hansberry's groundbreaking play, *A Raisin in the Sun*, in 1958.

In 1984, Lloyd Richards brought *Ma Rainey's Black Bottom* to Broadway. Wilson never looked back. He and Richards became one of the most famous directing and playwriting teams ever, churning out a string of publicly and critically successful plays, including: *Joe Turner's Come and Gone*, *Fences*, *The Piano Lesson*, *Two Trains Running*, and *Seven Guitars*.

Wilson's playwriting has earned him two Pulitzer Prizes, a Tony Award, multiple New York Drama Critics' Circle Awards, and Drama Desk Awards, to name but a few. The theatre world's most important critics and academics originally called him the most important playwright of the 1980s, but they have since gone on to rank him among the greatest American playwrights ever. The legendary theatre critic John Lahr even went so far as to place Wilson's significance to American theatre as greater than that of Eugene O'Neill's.

Perhaps Wilson's greatest skill as a writer was his ability to listen. He had a keen ear for the voices of those who surrounded him. He believed that oral tradition was a key component of African American history and culture, and he listened clearly to the tales of his people and the voices that passed these tales along. Voices alone weren't the only influence on Wilson's writing. He was heavily influenced by a myriad of sources, including: Dylan Thomas, jazz music, Amiri Baraka (LeRoi Jones), and Bessie Smith. Wilson once claimed that the first time he bought a Bessie Smith record, he played it twenty-two straight times.

Wilson passed away on October 2, 2005, but not before leaving behind an impressive legacy. His major works combine to form a ten-play cycle in which each play is set in a different decade of the twentieth century. Together, these plays are an impressive depiction of the African American experience over the course of a century.

Fences

The year was 1957 and for black America, skepticism, protest, and hope were all in the air. After nearly a century of being free, the black people were finally moving from the fringes of American culture and daily life into far more visible positions. The civil rights movement was shifting into high gear as African Americans began campaigning for better education, equal pay, legal recourse, and so one. Thelonious Monk, John Coltrane, and Charles Mingus were launching jazz music into an internationally recognized art form. Jackie Robinson, Roberto Clemente, and Hank Aaron were superstars in America's national pastime, baseball. This decade filled with uncertainty, strife, and the beginnings of African American success forms the backdrop for Wilson's masterpiece, *Fences*.

The play, often compared to Arthur Miller's *Death of a Salesman*, examines the life of Troy Maxson, a Pittsburgh garbage man and former Negro League baseball player. Much like Willy Loman in *Death of a Salesman*, Troy seems unable to accept that society is rapidly changing around him. Troy has given up his hopes and dreams in order to be a family man. While extremely proud of his family and the sacrifices he has made for them, he is also embittered by the racism and defeats that kept him down when he was a strong, young athlete full of promise. His family seems to be both his salvation and his bane. It saves him from the cruelties of the outside world, but it also keeps him isolated from life's possibilities.

Fences picks up the action at a time when Troy Maxson is facing some of his greatest challenges. His son is at odds with him over a career in sports, he is battling his superiors at work for the opportunity to drive the garbage truck rather than simply pick up the trash, and he is also becoming quite aware of his own mortality and the choices he has made. Troy makes a desperate bid for happiness, which alters his life forever.

Fences differs from *Death of a Salesman* in several key ways. While both Willy Loman and Troy Maxson pursue the American Dream, it is a much different dream when viewed from Troy's perspective. Also, where *Death of a Salesman* is expressionistic, *Fences* is quite realistic until it's symbolic, beautiful, and stirring conclusion.

Wilson took home four major awards for the 1987 Broadway production of *Fences*. The play, directed by Lloyd Richards, won the Pulitzer Prize for Drama, a Drama Desk Award, a New York Drama Critics Circle Award, and a Tony Award for Best Play. Widely regarded as his greatest play, *Fences* shows us a master playwright at the top of his game.

Food for Thought

As you read the play, consider the following questions:

1. Why do you suppose Wilson chose to call this play *Fences*? Why is Troy building his fence?
2. Late in the play, Troy succeeds in getting a promotion and being able to drive the garbage truck. Troy says to his friend, "It ain't the same, Bono. It ain't like working the back of the truck. Ain't got nobody to talk to . . . feel like you working by yourself." What do you think Wilson is trying to tell us with this statement?
3. Character is defined by a person's actions, not his or her words. What does Rose do in the play that defines what type of person she is? Do you like Rose? Why or why not?
4. When all is said and done, what do you think of Troy Maxson? Do you sympathize with him? Do you like him? Why?
5. Troy's brother, Gabriel, plays a key role in the closing moments of the play. What does he do? What sort of symbolism is Wilson employing here? How do these final moments leave you feeling at the play's conclusion?

Fun Facts

1. The actor James Earl Jones (that's right, the voice of Darth Vader) originated the role of Troy Maxson on Broadway and won his second Tony Award for his performance.
2. Wilson's other Pulitzer Prize–winning play, *The Piano Lesson*, was made into a television movie in 1995. The film was directed by Lloyd Richards and was nominated for several Emmy Awards.
3. Wilson's plays have helped launch the careers of several major Hollywood actors, including Laurence Fishburne, Cynthia Martells, and Charles S. Dutton.
4. Denzel Washigton starred as Troy Maxon in the March, 2010 Broadway revival of *Fences*.

Fences

August Wilson

Characters

Troy Maxson
Im Bono, Troy's friend
Rose, Troy's wife

Lyons, Troy's oldest son by previous marriage
Gabriel, Troy's brother
Cory, Troy and Rose's son
Raynell, Troy's daughter

> When the sins of our fathers visit us
> We do not have to play host.
> We can banish them with forgiveness
> As God, in His Largeness and Laws.
>
> —August Wilson

SETTING: *The setting is the yard which fronts the only entrance to the Maxson household, an ancient two-story brick house set back off a small alley in a big-city neighborhood. The entrance to the house is gained by two or three steps leading to a wooden porch badly in need of paint.*

A relatively recent addition to the house and running its full width, the porch lacks congruence. It is a sturdy porch with a flat roof. One or two chairs of dubious value sit at one end where the kitchen window opens onto the porch. An old-fashioned icebox stands silent guard at the opposite end.

The yard is a small dirt yard, partially fenced, except for the last scene, with a wooden sawhorse, a pile of lumber, and other fence-building equipment set off to the side. Opposite is a tree from which hangs a ball made of rags. A baseball bat leans against the tree. Two oil drums serve as garbage receptacles and sit near the house at right to complete the setting.

THE PLAY: *Near the turn of the century, the destitute of Europe sprang on the city with tenacious claws and an honest and solid dream. The city devoured them. They swelled its belly until it burst into a thousand furnaces and sewing machines, a thousand butcher shops and bakers' ovens, a thousand churches and hospitals and funeral parlors and moneylenders. The city grew. It nourished itself and offered each man a partnership limited only by his talent, his guile, and his willingness and capacity for hard work. For the immigrants of Europe, a dream dared and won true.*

The descendants of African slaves were offered no such welcome or participation. They came from places called the Carolinas and the Virginias, Georgia, Alabama, Mississippi, and Tennessee. They came strong, eager, searching. The city rejected them and they fled and settled along the riverbanks and under bridges in shallow, ram-shackle houses made of sticks and tar-paper. They collected rags and wood. They sold the use of their muscles and their bodies. They cleaned houses and washed clothes, they shined shoes, and in quiet desperation and vengeful pride, they stole, and lived in pursuit of their own dream. That they could breathe free, finally, and stand to meet life with the force of dignity and whatever eloquence the heart could call upon.

By 1957, the hard-won victories of the European immigrants had solidified the industrial might of America. War had been confronted and won with new energies that used loyalty and patriotism as its fuel. Life was rich, full, and flourishing. The Milwaukee Braves won the World Series, and the hot winds of change that would make the sixties a turbulent, racing, dangerous, and provocative decade had not yet begun to blow full.

Act I
Scene I

It is 1957. TROY and BONO enter the yard, engaged in conversation. TROY is fifty-three years old, a large man with thick, heavy hands; it is this largeness that he strives to fill out and make an accommodation with. Together with his blackness, his largeness informs his sensibilities and the choices he has made in his life.

Of the two men, BONO is obviously the follower. His commitment to their friendship of thirty-odd years is rooted in his admiration of TROY's honesty, capacity for hard work, and his strength, which BONO seeks to emulate.

It is Friday night, payday, and the one night of the week the two men engage in a ritual of talk and drink. TROY is usually the most talkative and at times he can be crude and almost vulgar, though he is capable of rising to profound heights of expression. The men carry lunch buckets and wear or carry burlap aprons and are dressed in clothes suitable to their jobs as garbage collectors.

BONO. Troy, you ought to stop that lying!

TROY. I ain't lying! The nigger had a watermelon this big.

He indicates with his hands.

Talking about . . ."What watermelon, Mr. Rand?" I liked to fell out! "What watermelon, Mr. Rand?" . . . And it sitting there big as life.

BONO. What did Mr. Rand say?

TROY. Ain't said nothing. Figure if the nigger too dumb to know he carrying a watermelon, he wasn't gonna get much sense out of him. Trying to hide that great big old watermelon under his coat. Afraid to let the white man see him carry it home.

BONO. I'm like you . . . I ain't got no time for them kind of people.

TROY. Now what he look like getting mad cause he see the man from the union talking to Mr. Rand?

BONO. He come to me talking about . . ."Maxson gonna get us fired." I told him to get away from me with that. He walked away from me calling you a troublemaker. What Mr. Rand say?

TROY. Ain't said nothing. He told me to go down the Commissioner's office next Friday. They called me down there to see them.

BONO. Well, as long as you got your complaint filed, they can't fire you. That's what one of them white fellows tell me.

TROY. I ain't worried about them firing me. They gonna fire me cause I asked a question? That's all I did. I went to Mr. Rand and asked him, "Why? Why you got the white mens driving and the colored lifting?" Told him, "what's the matter, don't I count? You think only white fellows got sense enough to drive a truck. That ain't no paper job! Hell, anybody can drive a truck. How come you got all whites driving and the colored lifting?" He told me "take it to the union." Well, hell, that's what I done! Now they wanna come up with this pack of lies.

BONO. I told Brownie if the man come and ask him any questions . . . just tell the truth! It ain't nothing but something they done trumped up on you cause you filed a complaint on them.

TROY. Brownie don't understand nothing. All I want them to do is change the job description. Give everybody a chance to drive the truck. Brownie can't see that. He ain't got that much sense.

BONO. How you figure he be making out with that gal be up at Taylors' all the time . . . that Alberta gal?

TROY. Same as you and me. Getting just as much as we is. Which is to say nothing.

BONO. It is, huh? I figure you doing a little better than me . . . and I ain't saying what I'm doing.

TROY. Aw, nigger, look here . . . I know you. If you had got anywhere near that gal, twenty minutes later you be looking to tell somebody. And the first one you gonna tell . . . that you gonna want to brag to . . . is gonna be me.

BONO. I ain't saying that. I see where you be eyeing her.

TROY. I eye all the women. I don't miss nothing. Don't never let nobody tell you Troy Maxson don't eye the women.

BONO. You been doing more than eyeing her. You done bought her a drink or two.

TROY. Hell yeah, I bought her a drink! What that mean? I bought you one, too. What that mean cause I buy her a drink? I'm just being polite.

BONO. It's alright to buy her one drink. That's what you call being polite. But when you wanna be buying two or three . . . that's what you call eyeing her.

TROY. Look here, as long as you known me . . . you ever known me to chase after women?

BONO. Hell yeah! Long as I done known you. You forgetting I knew you when.

TROY. Naw, I'm talking about since I been married to Rose?

BONO. Oh, not since you been married to Rose. Now, that's the truth, there. I can say that.

TROY. Alright then! Case closed.

BONO. I see you be walking up around Alberta's house. You supposed to be at Taylors' and you be walking up around there.

TROY. What you watching where I'm walking for? I ain't watching after you.

BONO. I seen you walking around there more than once.

TROY. Hell, you liable to see me walking anywhere! That don't mean nothing cause you see me walking around there.

BONO. Where she come from anyway? She just kinda showed up one day.

TROY. Tallahassee. You can look at her and tell she one of them Florida gals. They got some big healthy women down there. Grow them right up out the ground. Got a little bit of Indian in her. Most of them niggers down in Florida got some Indian in them.

BONO. I don't know about that Indian part. But she damn sure big and healthy. Woman wear some big stockings. Got them great big old legs and hips as wide as the Mississippi River.

TROY. Legs don't mean nothing. You don't do nothing but push them out of the way. But them hips cushion the ride!

BONO. Troy, you ain't got no sense.

TROY. It's the truth! Like you riding on Goodyears!

ROSE *enters from the house. She is ten years younger than* TROY, *her devotion to him stems from her recognition of the possibilities of her life without him: a succession of abusive men and their babies, a life of partying and running the streets, the Church, or aloneness with its attendant pain and frustration. She recognizes* TROY's *spirit as a fine and illuminating one and she either ignores or forgives his faults, only some of which she recognizes. Though she doesn't drink, her presence is an integral part of the Friday night rituals. She alternates between the porch and the kitchen, where supper preparations are under way.*

ROSE. What you all out here getting into?

TROY. What you worried about what we getting into for? This is men talk, woman.

ROSE. What I care what you all talking about? Bono, you gonna stay for supper?

BONO. No, I thank you, Rose. But Lucille say she cooking up a pot of pigfeet.

TROY. Pigfeet! Hell, I'm going home with you! Might even stay the night if you got some pigfeet. You got something in there to top them pigfeet, Rose?

ROSE. I'm cooking up some chicken. I got some chicken and collard greens.

TROY. Well, go on back in the house and let me and Bono finish what we was talking about. This is men talk. I got some talk for you later. You know what kind of talk I mean. You go on and powder it up.

ROSE. Troy Maxson, don't you start that now!

TROY (*puts his arm around her*). Aw, woman . . . come here. Look here, Bono . . . when I met this woman . . . I got out that place, say, "Hitch up my pony, saddle up my mare . . . there's a woman out there for me somewhere. I looked here. Looked there. Saw Rose and latched on to her." I latched on to her and told her—I'm gonna tell you the truth—I told her, "Baby, I don't wanna marry, I just wanna be your man." Rose told me . . . tell him what you told me, Rose.

ROSE. I told him if he wasn't the marrying kind, then move out the way so the marrying kind could find me.

TROY. That's what she told me. "Nigger, you in my way. You blocking the view! Move out the way so I can find me a husband." I thought it over two or three days. Come back—

ROSE. Ain't no two or three days nothing. You was back the same night.

TROY. Come back, told her . . . "Okay, baby . . . but I'm gonna buy me a banty rooster and put him out there

in the backyard . . . and when he sees a stranger come, he'll flap his wings and crow . . ." Look here, Bono, I could watch the front door by myself . . . it was that back door I was worried about.

ROSE. Troy, you ought not talk like that. Troy ain't doing nothing but telling a lie.

TROY. Only thing is . . . when we first got married . . . forget the rooster . . . we ain't had no yard!

BONO. I hear you tell it. Me and Lucille was staying down there on Logan Street. Had two rooms with the outhouse in the back. I ain't mind the outhouse none. But when that goddamn wind blow through there in the winter . . . that's what I'm talking about! To this day I wonder why in the hell I ever stayed down there for six long years. But see, I didn't know I could do no better. I thought only white folks had inside toilets and things.

ROSE. There's a lot of people don't know they can do no better than they doing now. That's just something you got to learn. A lot of folks still shop at Bella's.

TROY. Ain't nothing wrong with shopping at Bella's. She got fresh food.

ROSE. I ain't said nothing about if she got fresh food. I'm talking about what she charge. She charge ten cents more than the A&P.

TROY. The A&P ain't never done nothing for me. I spends my money where I'm treated right. I go down to Bella, say, "I need a loaf of bread, I'll pay you Friday." She give it to me. What sense that make when I got money to go and spend it somewhere else and ignore the person who done right by me? That ain't in the Bible.

ROSE. We ain't talking about what's in the Bible. What sense it make to shop there when she overcharge?

TROY. You shop where you want to. I'll do my shopping where the people been good to me.

ROSE. Well, I don't think it's right for her to overcharge. That's all I was saying.

BONO. Look here . . . I got to get on. Lucille going be raising all kind of hell.

TROY. Where you going, nigger? We ain't finished this pint. Come here, finish this pint.

BONO. Well, hell, I am . . . if you ever turn the bottle loose.

TROY (hands him the bottle). The only thing I say about the A&P is I'm glad Cory got that job down there.

Help him take care of his school clothes and things. Gabe done moved out and things getting tight around here. He got that job . . . He can start to look out for himself.

ROSE. Cory done went and got recruited by a college football team.

TROY. I told that boy about that football stuff. The white man ain't gonna let him get nowhere with that football. I told him when he first come to me with it. Now you come telling me he done went and got more tied up in it. He ought to go and get recruited in how to fix cars or something where he can make a living.

ROSE. He ain't talking about making no living playing football. It's just something the boys in school do. They gonna send a recruiter by to talk to you. He'll tell you he ain't talking about making no living playing football. It's a honor to be recruited.

TROY. It ain't gonna get him nowhere. Bono'll tell you that.

BONO. If he be like you in the sports . . . he's gonna be alright. Ain't but two men ever played baseball as good as you. That's Babe Ruth and Josh Gibson. Them's the only two men ever hit more home runs than you.

TROY. What it ever get me? Ain't got a pot to piss in or a window to throw it out of.

ROSE. Times have changed since you was playing baseball. Troy. That was before the war. Times have changed a lot since then.

TROY. How in hell they done changed?

ROSE. They got lots of colored boys playing ball now. Baseball and football.

BONO. You right about that, Rose. Times have changed, Troy. You just come along too early.

TROY. There ought not never have been no time called too early! Now you take that fellow . . . what's that fellow they had playing right field for the Yankees back then? You know who I'm talking about, Bono. Used to play right field for the Yankees.

ROSE. Selkirk?

TROY. Selkirk! That's it! Man batting .269, understand? .269. What kind of sense that make? I was hitting .432 with thirty-seven home runs! Man batting .269 and playing right field for the Yankees! I saw

Josh Gibson's daughter yesterday. She walking around with raggedy shoes on her feet. Now I bet you Selkirk's daughter ain't walking around with raggedy shoes on her feet! I bet you that!

ROSE. They got a lot of colored baseball players now. Jackie Robinson was the first. Folks had to wait for Jackie Robinson.

TROY. I done seen a hundred niggers play baseball better than Jackie Robinson. Hell, I know some teams Jackie Robinson couldn't even make! What you talking about Jackie Robinson. Jackie Robinson wasn't nobody. I'm talking about if you could play ball then they ought to have let you play. Don't care what color you were. Come telling me I come along too early. If you could play . . . then they ought to have let you play.

TROY *takes a long drink from the bottle.*

ROSE. You gonna drink yourself to death. You don't need to be drinking like that.

TROY. Death ain't nothing. I done seen him. Done wrassled with him. You can't tell me nothing about death. Death ain't nothing but a fastball on the outside corner. And you know what I'll do to that! Lookee here, Bono . . . am I lying? You get one of them fastballs, about waist high, over the outside corner of the plate where you can get the meat of the bat on it . . . and good god! You can kiss it goodbye. Now, am I lying?

BONO. Naw, you telling the truth there. I seen you do it.

TROY. If I'm lying . . . that 450 feet worth of lying!

Pause.

That's all death is to me. A fastball on the outside corner.

ROSE. I don't know why you want to get on talking about death.

TROY. Ain't nothing wrong with talking about death. That's part of life. Everybody gonna die. You gonna die, I'm gonna die. Bono's gonna die. Hell, we all gonna die.

ROSE. But you ain't got to talk about it. I don't like to talk about it.

TROY. You the one brought it up. Me and Bono was talking about baseball . . . you tell me I'm gonna drink myself to death. Ain't that right, Bono? You know I don't drink this but one night out of the week. That's Friday night. I'm gonna drink just enough to where I can handle it. Then I cuts it loose. I leave it alone. So don't you worry about me drinking myself to death. 'Cause I ain't worried about Death. I done seen him. I done wrestled with him.

Look here, Bono . . . I looked up one day and Death was marching straight at me. Like Soldiers on Parade! The Army of Death was marching straight at me. The middle of July, 1941. It got real cold just like it be winter. It seem like Death himself reached out and touched me on the shoulder. He touch me just like I touch you. I got cold as ice and Death standing there grinning at me.

ROSE. Troy, why don't you hush that talk.

TROY. I say . . . What you want, Mr. Death? You be wanting me? You done brought your army to be getting me? I looked him dead in the eye. I wasn't fearing nothing. I was ready to tangle. Just like I'm ready to tangle now. The Bible say be ever vigilant. That's why I don't get but so drunk. I got to keep watch.

ROSE. Troy was right down there in Mercy Hospital. You remember he had pneumonia? Laying there with a fever talking plumb out of his head.

TROY. Death standing there staring at me . . . carrying that sickle in his hand. Finally he say, "You want bound over for another year?" See, just like that . . ."You want bound over for another year?" I told him, "Bound over hell! Let's settle this now!"

It seem like he kinda fell back when I said that, and all the cold went out of me. I reached down and grabbed that sickle and threw it just as far as I could throw it . . . and me and him commenced to wrestling.

We wrestled for three days and three nights. I can't say where I found the strength from. Every time it seemed like he was gonna get the best of me, I'd reach way down deep inside myself and find the strength to do him one better.

ROSE. Every time Troy tell that story he find different ways to tell it. Different things to make up about it.

TROY. I ain't making up nothing. I'm telling you the facts of what happened. I wrestled with Death for three days and three nights and I'm standing here to tell you about it.

Pause.

Alright. At the end of the third night we done weakened each other to where we can't hardly move. Death stood up, throwed on his robe . . . had him a white robe with a hood on it. He threwed on that robe and went off to look for his sickle. Say, "I'll be back." Just like that. "I'll be back." I told him, say, "Yeah, but . . . you gonna have to find me!" I wasn't no fool. I wasn't going looking for him. Death ain't nothing to play with. And I know he's gonna get me. I know I got to join his army . . . his camp followers. But as long as I keep my strength and see him coming . . . as long as I keep up my vigilance . . . he's gonna have to fight to get me. I ain't going easy.

BONO. Well look here, since you got to keep up your vigilance . . . let me have the bottle.

TROY. Aw hell, I shouldn't have told you that part. I should have left out that part.

ROSE. Troy be talking that stuff and half the time don't even know what he be talking about.

TROY. Bono know me better than that.

BONO. That's right. I know you. I know you got some Uncle Remus in your blood. You got more stories than the devil got sinners.

TROY. Aw hell, I done seen him too! Done talked with the devil.

ROSE. Troy, don't nobody wanna be hearing all that stuff.

LYONS *enters the yard from the street. Thirty-four years old,* TROY's *son by a previous marriage, he sports a neatly trimmed goatee, sport coat, white shirt, tieless and buttoned at the collar. Though he fancies himself a musician, he is more caught up in the rituals and "idea" of being a musician than in the actual practice of the music. He has come to borrow money from* TROY, *and while he knows he will be successful, he is uncertain as to what extent his lifestyle will be held up to scrutiny and ridicule.*

LYONS. Hey, Pop.

TROY. What you come "Hey, Popping" me for?

LYONS. How you doing, Rose?

He kisses her.

Mr. Bono. How you doing?

BONO. Hey, Lyons . . . how you been?

TROY. He must have been doing alright. I ain't seen him around here last week.

ROSE. Troy, leave your boy alone. He come by to see you and you wanna start all that nonsense.

TROY. I ain't bothering Lyons.

Offers him the bottle.

Here . . . get you a drink. We got an understanding. I know why he come by to see me and he know I know.

LYONS. Come on, Pop . . . I just stopped by to say hi . . . see how you was doing.

TROY. You ain't stopped by yesterday.

ROSE. You gonna stay for supper, Lyons? I got some chicken cooking in the oven.

LYONS. No, Rose . . . thanks. I was just in then neighborhood and thought I'd stop by for a minute.

TROY. You was in the neighborhood alright, nigger. You telling the truth there. You was in the neighborhood cause it's my payday.

LYONS. Well, hell, since you mentioned it . . . let me have ten dollars.

TROY. I'll be damned! I'll die and go to hell and play black-jack with the devil before I give you ten dollars.

BONO. That's what I wanna know about . . . that devil you done seen.

LYONS. What . . . Pop done seen the devil? You too much, Pops.

TROY. Yeah, I done seen him. Talked to him too!

ROSE. You ain't seen no devil. I done told you that man ain't had nothing to do with the devil. Anything you can't understand, you want to call it the devil.

TROY. Look here, Bono . . . I went down to see Hertzberger about some furniture. Got three rooms for two-ninety-eight. That what it say on the radio. "Three rooms . . . two-ninety-eight." Even made up a little song about it. Go down there . . . man tell me I can't get no credit. I'm working every day and can't get no credit. What to do? I got an empty house with some raggedy furniture in it. Cory ain't got no bed. He's sleeping on a pile of rags on the floor. Working every day and can't get no credit. Come back here—Rose'll tell you—madder than hell. Sit down . . . try to figure what I'm gonna do. Come a knock on the door. Ain't been living here but three days. Who know I'm here? Open the door . . . devil standing there bigger than life. White fellow . . . got on good clothes and everything.

Standing there with a clipboard in his hand. I ain't had to say nothing. First words come out of his mouth was . . ."I understand you need some furniture and can't get no credit." I liked to fell over. He say "I'll give you all the credit you want, but you got to pay the interest on it." I told him, "Give me three rooms worth and charge whatever you want." Next day a truck pulled up here and two men unloaded them three rooms. Man what drove the truck give me a book. Say send ten dollars, first of every month to the address in the book and everything will be alright. Say if I miss a payment the devil was coming back and it'll be hell to pay. That was fifteen years ago. To this day . . . the first of the month I send my ten dollars, Rose'll tell you.

ROSE. Troy lying.

TROY. I ain't never seen that man since. Now you tell me who else that could have been but the devil? I ain't sold my soul or nothing like that, you understand. Naw, I wouldn't have truck with the devil about nothing like that. I got my furniture and pays my ten dollars the first of the month just like clockwork.

BONO. How long you say you been paying this ten dollars a month?

TROY. Fifteen years!

BONO. Hell, ain't you finished paying for it yet? How much the man done charged you.

TROY. Aw hell, I done paid for it. I done paid for it ten times over! The fact is I'm scared to stop paying it.

ROSE. Troy lying. We got that furniture from Mr. Glickman. He ain't paying no ten dollars a month to nobody.

TROY. Aw hell, woman. Bono know I ain't that big a fool.

LYONS. I was just getting ready to say . . . I know where there's a bridge for sale.

TROY. Look here, I'll tell you this . . . it don't matter to me if he was the devil. It don't matter if the devil give credit. Somebody has got to give it.

ROSE. It ought to matter. You going around talking about having truck with the devil . . . God's the one you gonna have to answer to. He's the one gonna be at the Judgment.

LYONS. Yeah, well, look here, Pop . . . let me have that ten dollars. I'll give it back to you. Bonnie got a job working at the hospital.

TROY. What I tell you, Bono? The only time I see this nigger is when he wants something. That's the only time I see him.

LYONS. Come on, Pop, Mr. Bono don't want to hear all that. Let me have the ten dollars. I told you Bonnie working.

TROY. What that mean to me? "Bonnie working." I don't care if she working. Go ask her for the ten dollars if she working. Talking about "Bonnie working." Why ain't you working?

LYONS. Aw, Pop, you know I can't find no decent job. Where am I gonna get a job at? You know I can't get no job.

TROY. I told you I know some people down there. I can get you on the rubbish if you want to work. I told you that the last time you came by here asking me for something.

LYONS. Naw, Pop . . . thanks. That ain't for me. I don't wanna be carrying nobody's rubbish. I don't wanna be punching nobody's time clock.

TROY. What's the matter, you too good to carry people's rubbish? Where you think that ten dollars you talking about come from? I'm just supposed to haul people's rubbish and give my money to you cause you too lazy to work. You too lazy to work and wanna know why you ain't got what I got.

ROSE. What hospital Bonnie working at? Mercy?

LYONS. She's down at Passavant working in the laundry.

TROY. I ain't got nothing as it is. I give you that ten dollars and I got to eat beans the rest of the week. Naw . . . you ain't getting no ten dollars here.

LYONS. You ain't got to be eating no beans. I don't know why you wanna say that.

TROY. I ain't got no extra money. Gabe done moved over to Miss Pearl's paying her the rent and things done got tight around here. I can't afford to be giving you every payday.

LYONS. I ain't asked you to give me nothing. I asked you to loan me ten dollars. I know you got ten dollars.

TROY. Yeah, I got it. You know why I got it? Cause I don't throw my money away out there in the streets. You living the fast life . . . wanna be a musician . . . running around in them clubs and things . . . then, you learn to take care of yourself. You

ain't gonna find me going and asking nobody for nothing. I done spent too many years without.

LYONS. You and me is two different people, Pop.

TROY. I done learned my mistake and learned to do what's right by it. You still trying to get something for nothing. Life don't owe you nothing. You owe it to yourself. Ask Bono. He'll tell you I'm right.

LYONS. You got your way of dealing with the world . . . I got mine. The only thing that matters to me is the music.

TROY. Yeah, I can see that! It don't matter how you gonna eat . . . where your next dollar is coming from. You telling the truth there.

LYONS. I know I got to eat. But I got to live too. I need something that gonna help me to get out of the bed in the morn-ing. Make me feel like I belong in the world. I don't bother nobody. I just stay with my music cause that's the only way I can find to live in the world. Otherwise there ain't no telling what I might do. Now I don't come criticizing you and how you live. I just come by to ask you for ten dollars. I don't wanna hear all that about how I live.

TROY. Boy, your mama did a hell of a job raising you.

LYONS. You can't change me, Pop. I'm thirty-four years old. If you wanted to change me, you should have been there when I was growing up. I come by to see you . . . ask for ten dollars and you want to talk about how I was raised. You don't know nothing about how I was raised.

ROSE. Let the boy have ten dollars, Troy.

TROY (*to* LYONS). What the hell you looking at me for? I ain't got no ten dollars. You know what I do with my money.

To ROSE.

Give him ten dollars if you want him to have it.

ROSE. I will. Just as soon as you turn it loose.

TROY (*handing* ROSE *the money*). There it is. Seventy-six dollars and forty-two cents. You see this, Bono? Now, I ain't gonna get but six of that back.

ROSE. You ought to stop telling that lie. Here, Lyons.

She hands him the money.

LYONS. Thanks, Rose. Look . . . I got to run . . . I'll see you later.

TROY. Wait a minute. You gonna say, "thanks, Rose" and ain't gonna look to see where she got that ten dollars from? See how they do me, Bono?

LYONS. I know she got it from you, Pop. Thank I'll give it back to you.

TROY. There he go telling another lie. Time I see that ten dollars . . . he'll be owing me thirty more.

LYONS. See you, Mr. Bono.

BONO. Take care, Lyons!

LYONS. Thanks, Pop. I'll see you again.

LYONS *exits the yard.*

TROY. I don't know why he don't go and get him a decent job and take care of that woman he got.

BONO. He'll be alright, Troy. The boy is still young.

TROY. The *boy* is thirty-four years old.

ROSE. Let's not get off into all that.

BONO. Look here . . . I got to be going. I got to be getting on. Lucille gonna be waiting.

TROY (*puts his arm around* ROSE). See this woman, Bono? I love this woman. I love this woman so much it hurts. I love her so much . . . I done run out of ways of loving her. So I got to go back to basics. Don't you come by my house Monday morning talking about time to go to work . . .' cause I'm still gonna be stroking!

ROSE. Troy! Stop it now!

BONO. I ain't paying him no mind, Rose. That ain't nothing but gin-talk. Go on, Troy. I'll see you Monday.

TROY. Don't you come by my house, nigger! I done told you what I'm gonna be doing.

The lights go down to black.

Scene II

The lights come up on ROSE *hanging up clothes. She hums and sings softly to herself. It is the following morning.*

ROSE (*sings*).
 Jesus, be a fence all around me every day.
 Jesus, I want you to protect me as I travel on my way.
 Jesus, be a fence all around me every day.

TROY *enters from the house.*

ROSE (*continues*).
Jesus, I want you to protect me
As I travel on my way.

To TROY.

'Morning. You ready for breakfast? I can fix it soon as I finish hanging up these clothes?

TROY. I got the coffee on. That'll be alright. I'll just drink some of that this morning.

ROSE. That 651 hit yesterday. That's the second time this month. Miss Pearl hit for a dollar . . . seem like those that need the least always get lucky. Poor folks can't get nothing.

TROY. Them numbers don't know nobody. I don't know why you fool with them. You and Lyons both.

ROSE. It's something to do.

TROY. You ain't doing nothing but throwing your money away.

ROSE. Troy, you know I don't play foolishly. I just play a nickel here and a nickel there.

TROY. That's two nickels you done thrown away.

ROSE. Now I hit sometimes . . . that makes up for it. It always comes in handy when I do hit. I don't hear you complaining then.

TROY. I ain't complaining now. I just say it's foolish. Trying to guess out of six hundred ways which way the number gonna come. If I had all the money niggers, these Negroes, throw away on numbers for one week—just one week—I'd be a rich man.

ROSE. Well, you wishing and calling it foolish ain't gonna stop folks from playing numbers. That's one thing for sure. Besides . . . some good things come from playing numbers. Look where Pope done bought him that restaurant off of numbers.

TROY. I can't stand niggers like that. Man ain't had two dimes to rub together. He walking around with his shoes all run over bumming money for cigarettes. Alright. Got lucky there and hit the numbers . . .

ROSE. TROY, I know all about it.

TROY. Had good sense, I'll say that for him. He ain't throwed his money away. I seen niggers hit the numbers and go through two thousand dollars in four days. Man bought him that restaurant down there . . . fixed it up real nice . . . and then didn't want nobody to come in it! A Negro go in there and can't get no kind of service. I seen a white fellow come in there and order a bowl of stew. Pope picked all the meat out the pot for him. Man ain't had nothing but a bowl of meat! Negro come behind him and ain't got nothing but the potatoes and carrots. Talking about what numbers do for people, you picked a wrong example. Ain't done nothing but make a worser fool out of him than he was before.

ROSE. TROY, you ought to stop worrying about what happened at work yesterday.

TROY. I ain't worried. Just told me to be down there at the Commissioner's office on Friday. Everybody think they gonna fire me. I ain't worried about them firing me. You ain't got to worry about that.

Pause.

Where's Cory? Cory in the house? (*Calls*). Cory?

ROSE. He gone out.

TROY. Out, huh? He gone out 'cause he know I want him to help me with this fence. I know how he is. That boy scared of work.

GABRIEL *enters. He comes halfway down the alley and, hearing* TROY'S *voice, stops.*

TROY (*continues*). He ain't done a lick of work in his life

ROSE. He had to go to football practice. Coach wanted them to get in a little extra practice before the season start.

TROY. I got his practice . . . running out of here before he get his chores done.

ROSE. TROY, what is wrong with you this morning? Don't nothing set right with you. Go on back in there and go to bed . . . get up on the other side.

TROY. Why something got to be wrong with me? I ain't said nothing wrong with me.

ROSE. You got something to say about everything. First it's the numbers . . . then it's the way the man runs his restaurant . . . then you done got on Cory. What's it gonna be next? Take a look up there and see if the weather suits you . . . or is it gonna be how you gonna put up the fence with the clothes hanging in the yard.

TROY. You hit the nail on the head then.

ROSE. I know you like I know the back of my hand. Go on in there and get you some coffee . . . see if that straighten you up. 'Cause you ain't right this morning.

TROY *starts into the house and sees* GABRIEL. GABRIEL *starts singing.* TROY*'s brother, he is seven years younger than* TROY. *Injured in World War II, he has a metal plate in his head. He carries an old trumpet tied around his waist and believes with every fiber of his being that he is the Archangel Gabriel. He carries a chipped basket with an assortment of discarded fruits and vegetables he has picked up in the strip district and which he attempts to sell.*

GABRIEL *(singing).*
 Yes, ma'am, I got plums
 You ask me how I sell them
 Oh ten cents apiece
 Three for a quarter
 Come and buy now
 'Cause I'm here today
 And tomorrow I'll be gone

GABRIEL *enters.*

Hey, Rose!

ROSE. How you doing, Gabe?

GABRIEL. There's TROY . . . Hey, TROY!

TROY. Hey, Gabe.

Exit into kitchen.

ROSE *(to* GABRIEL*).* What you got there?

GABRIEL. You know what I got, Rose. I got fruits and vegetables.

ROSE *(looking in basket).* Where's all these plums you talking about?

GABRIEL. I ain't got no plums today, Rose. I was just singing that. Have some tomorrow. Put me in a big order for plums. Have enough plums tomorrow for St. Peter and everybody.

TROY *re-enters from kitchen, crosses to steps.*

To ROSE.

 TROY's mad at me.

TROY. I ain't mad at you. What I got to be mad at you about? You ain't done nothing to me.

GABRIEL. I just moved over to Miss Pearl's to keep out from in your way. I ain't mean no harm by it.

TROY. Who said anything about that? I ain't said anything about that.

GABRIEL. You ain't mad at me, is you?

TROY. Naw . . . I ain't mad at you, Gabe. If I was mad at you I'd tell you about it.

GABRIEL. Got me two rooms. In the basement. Got my own door too. Wanna see my key?

He holds up a key.

 That's my own key! Ain't nobody else got a key like that. That's my key! My two rooms!

TROY. Well, that's good, Gabe. You got your own key . . . that's good.

ROSE. You hungry, Gabe? I was just fixing to cook Troy his breakfast.

GABRIEL. I'll take some biscuits. You got some biscuits? Did you know when I was in heaven . . . every morning me and St. Peter would sit down by the gate and eat some big fat biscuits? Oh, yeah! We had us a good time. We'd sit there and eat us them biscuits and then St. Peter would go off to sleep and tell me to wake him up when it's time to open the gates for the judgment.

ROSE. Well, come on . . . I'll make up a batch of biscuits.

ROSE *exits into the house.*

GABRIEL. TROY . . . St. Peter got your name in the book. I seen it. It say . . . Troy Maxson. I say . . . I know him! He got the same name like what I got. That's my brother!

TROY. How many times you gonna tell me that, Gabe?

GABRIEL. Ain't got my name in the book. Don't have to have my name. I done died and went to heaven. He got your name though. One morning St. Peter was looking at his book . . . marking it for the judgment . . . and he let me see your name. Got it in there under M. Got Rose's name . . . I ain't seen it like I seen yours . . . but I know it's in there. He got a great big book. Got everybody's name what was ever been born. That's what he told me. But I seen your name. Seen it with my own eyes.

TROY. Go on in the house there. Rose going to fix you something to eat.

GABRIEL. Oh, I ain't hungry. I done had breakfast with Aunt Jemimah. She come by and cooked me up a whole mess of flapjacks. Remember how we used to eat them flapjacks.

TROY. Go on in the house and get you something to eat now.

GABRIEL. I got to go sell my plums. I done sold some tomatoes. Got me two quarters. Wanna see?

He shows TROY *his quarters.*

I'm gonna save them and buy me a new horn so St. Peter can hear me when it's time to open the gates.

GABRIEL *stops suddenly. Listens.*

Hear that? That's the hellhounds. I got to chase them out of here. Go on get out of here! Get out!

GABRIEL *exits singing.*

Better get ready for the judgment
Better get ready for the judgment
My Lord is coming down

ROSE *enters from the house.*

TROY. He gone off somewhere.

GABRIEL *(offstage).*

Better get ready for the judgment
Better get ready for the judgment morning
Better get ready for the judgment
My God is coming down

ROSE. He ain't eating right. Miss Pearl say she can't get him to eat nothing.

TROY. What you want me to do about it, Rose? I done did everything I can for the man. I can't make him get well. Man got half his head blown away . . . what you expect?

ROSE. Seem like something ought to be done to help him.

TROY. Man don't bother nobody. He just mixed up from that metal plate he got in his head. Ain't no sense for him to go back into the hospital.

ROSE. Least he be eating right. They can help him take care of himself.

TROY. Don't nobody wanna be locked up, Rose. What you wanna lock him up for? Man go over there and fight the war . . . messin' around with them Japs, get half his head blown off . . . and they give him a lousy three thousand dollars. And I had to swoop down on that.

ROSE. Is you fixing to go into that again?

TROY. That's the only way I got a roof over my head . . . cause of that metal plate.

ROSE. Ain't no sense you blaming yourself for nothing. Gabe wasn't in no condition to manage that money.

You done what was right by him. Can't nobody say you ain't done what was right by him. Look how long you took care of him . . . till he wanted to have his own place and moved over there with Miss Pearl.

TROY. That ain't what I'm saying, woman! I'm just stating the facts. If my brother didn't have that metal plate in his head . . . I wouldn't have a pot to piss in or a window to throw it out of. And I'm fifty-three years old. Now see if you can understand that!

TROY *gets up from the porch and starts to exit the yard.*

ROSE. Where you going off to? You been running out of here every Saturday for weeks. I thought you was gonna work on this fence?

TROY. I'm gonna walk down to Taylors'. Listen to the ball game. I'll be back in a bit. I'll work on it when I get back.

He exits the yard. The lights go to black.

Scene III

The lights come up on the yard. It is four hours later. ROSE is taking down the clothes from the line. CORY enters carrying his football equipment.

ROSE. Your daddy like to had a fit with you running out of here this morning without doing your chores.

CORY. I told you I had to go to practice.

ROSE. He say you were supposed to help him with this fence.

CORY. He been saying that the last four or five Saturdays, and then he don't never do nothing, but go down to Taylors'. Did you tell him about the recruiter?

ROSE. Yeah, I told him.

CORY. What he say?

ROSE. He ain't said nothing too much. You get in there and get started on your chores before he gets back. Go on and scrub down them steps before he gets back here hollering and carrying on.

CORY. I'm hungry. What you got to eat, Mama?

ROSE. Go on and get started on your chores. I got some meat loaf in there. Go on and make you a sandwich . . . and don't leave no mess in there.

CORY *exits into the house.* ROSE *continues to take down the clothes.* TROY *enters the yard and sneaks up and grabs her from behind.*

TROY! Go on, now. You liked to scared me to death. What was the score of the game? Lucille had me on the phone and I couldn't keep up with it.

TROY. What I care about the game? Come here, woman.

He tries to kiss her.

ROSE. I thought you went down Taylors' to listen to the game. Go on, TROY! You supposed to be putting up this fence.

TROY *(attempting to kiss her again)*. I'll put it up when I finish with what is at hand.

ROSE. Go on, Troy. I ain't studying you.

TROY *(chasing after her)*. I'm studying you . . . fixing to do my homework!

ROSE. Troy, you better leave me alone.

TROY. Where's Cory? That boy brought his butt home yet?

ROSE. He's in the house doing his chores.

TROY *(calling)*. Cory! Get your butt out here, boy!

ROSE *exits into the house with the laundry.* TROY *goes over to the pile of wood, picks up a board, and starts sawing.* CORY *enters from the house.*

TROY. You just now coming in here from leaving this morning?

CORY. Yeah, I had to go to football practice.

TROY. Yeah, what?

CORY. Yessir.

TROY. I ain't but two seconds off you noway. The garbage sitting in there overflowing . . . you ain't done none of your chores . . . and you come in here talking about "Yeah."

CORY. I was just getting ready to do my chores now, Pop . . .

TROY. Your first chore is to help me with this fence on Saturday. Everything else come after that. Now get that saw and cut them boards.

CORY *takes the saw and begins cutting the boards.* TROY *continues working. There is a long pause.*

CORY. Hey, Pop . . . why don't you buy a TV?

TROY. What I want with a TV? What I want one of them.

CORY. Everybody got one. Earl. Ba Bra . . . Jesse!

TROY. I ain't asked you who had one. I say what I want with one?

CORY. So you can watch it. They got lots of things on TV. Baseball games and everything. We could watch the World Series.

TROY. Yeah . . . and how much this TV cost?

CORY. I don't know. They got them on sale for around two hundred dollars.

TROY. Two hundred dollars, huh?

CORY. That ain't that much, Pop.

TROY. Naw, it's just two hundred dollars. See that roof you got over your head at night? Let me tell you something about that roof. It's been over ten years since that roof was last tarred. See now . . . the snow come this winter and sit up there on that roof like it is . . . and it's gonna seep inside. It's just gonna be a little bit . . . ain't gonna hardly notice it. Then the next thing you know, it's gonna be leaking all over the house. Then the wood rot from all that water and you gonna need a whole new roof. Now, how much you think it cost to get that roof tarred?

CORY. I don't know.

TROY. Two hundred and sixty-four dollars . . . cash money. While you thinking about a TV, I got to be thinking about the roof . . . and whatever else go wrong around here. Now if you had two hundred dollars, what would you do . . . fix the roof or buy a TV?

CORY. I'd buy a TV. Then when the roof started to leak . . . when it needed fixing . . . I'd fix it.

TROY. Where you gonna get the money from? You done spent it for a TV. You gonna sit up and watch the water run all over your brand new TV.

CORY. Aw, Pop. You got money. I know you do.

TROY. Where I got it at, Huh?

CORY. You got it in the bank.

TROY. You wanna see my bankbook? You wanna see that seventy-three dollars and twenty-two cents I got setting up in there.

CORY. You ain't got to pay for it all at one time. You can put a down payment on it and carry it on home with you.

TROY. Not me. I ain't gonna owe nobody nothing if I can help it. Miss a payment and they come and

snatch it right out your house. Then what you got? Now, soon as I get two hundred dollars clear, then I'll buy a TV. Right now, as soon as I get two hundred and sixty-four dollars, I'm gonna have this roof tarred.

CORY. Aw . . . Pop!

TROY. You go on and get you two hundred dollars and buy one if ya want it. I got better things to do with my money.

CORY. I can't get no two hundred dollars. I ain't never seen two hundred dollars.

TROY. I'll tell you what . . . you get you a hundred dollars and I'll put the other hundred with it.

CORY. Alright, I'm gonna show you.

TROY. You gonna show me how you can cut them boards right now.

CORY *begins to cut the boards. There is a long pause.*

CORY. The Pirates won today. That makes five in a row.

TROY. I ain't thinking about the Pirates. Got an all-white team. Got that boy . . . that Puerto Rican boy . . . Clemente. Don't even half-play him. That boy could be something if they give him a chance. Play him one day and sit him on the bench the next.

CORY. He gets a lot of chances to play.

TROY. I'm talking about playing regular. Playing every day so you can get your timing. That's what I'm talking about.

CORY. They got some white guys on the team that don't play every day. You can't play everybody at the same time.

TROY. If they got a white fellow sitting on the bench . . . you can bet your last dollar he can't play! The colored guy got to be twice as good before he get on the team. That's why I don't want you to get all tied up in them sports. Man on the team and what it get him? They got colored on the team and don't use them. Same as not having them. All them teams the same.

CORY. The Braves got Hank Aaron and Wes Covington. Hank Aaron hit two home runs today. That makes forty-three.

TROY. Hank Aaron ain't nobody. That's what you supposed to do. That's how you supposed to play the game. Ain't nothing to it. It's just a matter of timing . . . getting the right follow-through. Hell, I can hit forty-three home runs right now!

CORY. Not off no major-league pitching, you couldn't.

TROY. We had better pitching in the Negro leagues. I hit seven home runs off of Satchel Paige. You can't get no better than that!

CORY. Sandy Koufax. He's leading the league in strikeouts.

TROY. I ain't thinking of no Sandy Koufax.

CORY. You got Warren Spahn and Lew Burdette. I bet you couldn't hit no home runs off of Warren Spahn.

TROY. I'm through with it now. You go on and cut them boards.

Pause.

Your mama tell me you done got recruited by a college football team? Is that right?

CORY. Yeah. Coach Zellman say the recruiter gonna be coming by to talk to you. Get you to sign the permission papers.

TROY. I thought you supposed to be working down there at the A&P. Ain't you suppose to be working down there after school?

CORY. Mr. Stawicki say he gonna hold my job for me until after the football season. Say starting next week I can work weekends.

TROY. I thought we had an understanding about this football stuff? You suppose to keep up with your chores and hold that job down at the A&P. Ain't been around here all day on a Saturday. Ain't none of your chores done . . . and now you telling me you done quit your job.

CORY. I'm gonna be working weekends.

TROY. You damn right you are! And ain't no need for nobody coming around here to talk to me about signing nothing.

CORY. Hey, Pop . . . you can't do that. He's coming all the way from North Carolina.

TROY. I don't care where he coming from. The white man ain't gonna let you get nowhere with that football noway. You go on and get your book-learning so you can work yourself up in that A&P or learn how to fix cars or build houses or something, get you a trade. That way you have something can't

nobody take away from you. You go on and learn how to put your hands to some good use. Besides hauling people's garbage.

CORY. I get good grades, Pop. That's why the recruiter wants to talk with you. You got to keep up your grades to get recruited. This way I'll be going to college. I'll get a chance . . .

TROY. First you gonna get your butt down there to the A&P and get your job back.

CORY. Mr. Stawicki done already hired somebody else 'cause I told him I was playing football.

TROY. You a bigger fool than I thought . . . to let somebody take away your job so you can play some football. Where you gonna get your money to take out your girlfriend and whatnot? What kind of foolishness is that to let somebody take away your job?

CORY. I'm still gonna be working weekends.

TROY. Naw . . . naw. You getting your butt out of here and finding you another job.

CORY. Come on, Pop! I got to practice. I can't work after school and play football too. The team needs me. That's what Coach Zellman say . . .

TROY. I don't care what nobody else say. I'm the boss . . . you understand? I'm the boss around here. I do the only saying what counts.

CORY. Come on, Pop!

TROY. I asked you . . . did you understand?

CORY. Yeah . . .

TROY. What?!

CORY. Yessir.

TROY. You go on down there to that A&P and see if you can get your job back. If you can't do both . . . then you quit the football team. You've got to take the crookeds with the straights.

CORY. Yessir.

Pause.

Can I ask you a question?

TROY. What the hell you wanna ask me? Mr. Stawicki the one you got the questions for.

CORY. How come you ain't never liked me?

TROY. Liked you? Who the hell say I got to like you? What law is there say I got to like you? Wanna stand up in my face and ask a damn fool-ass question like that. Talking about liking somebody. Come here boy, when I talk to you.

CORY *comes over to where* TROY *is working. He stands slouched over and* TROY *shoves him on his shoulder.*

Straighten up, goddammit! I asked you a question . . . what law is there say I got to like you?

CORY. None.

TROY. Well, alright then! Don't you eat every day?

Pause.

Answer me when I talk to you! Don't you eat every day?

CORY. Yeah.

TROY. Nigger, as long as you in my house, you put that sir on the end of it when you talk to me!

CORY. Yes . . . sir.

TROY. You eat every day.

CORY. Yessir!

TROY. Got a roof over your head.

CORY. Yessir!

TROY. Got clothes on your back.

CORY. Yessir.

TROY. Why you think that is?

CORY. Cause of you.

TROY. Aw, hell I know it's 'cause of me . . . but why do you think that is?

CORY. (*Hesitant*). Cause you like me.

TROY. Like you? I go out of here every morning . . . bust my butt . . . putting up with them crackers every day . . . cause I like you? You about the biggest fool I ever saw.

Pause.

It's my job. It's my responsibility! You understand that? A man got to take care of his family. You live in my house . . . sleep you behind on my bedclothes . . . fill you belly up with my food . . . cause you my son. You my flesh and blood. Not 'cause I like you! Cause it's my duty to take care of you. I owe a responsibility to you! Let's get this straight right here . . . before it go along any further . . . I ain't got to like you. Mr. Rand don't give me my money come

payday cause he likes me. He gives me cause he owe me. I done give you everything I had to give you. I gave you your life! Me and your mama worked that out between us. And liking your black ass wasn't part of the bargain. Don't you try and go through life worrying about if somebody like you or not. You best be making sure they doing right by you. You understand what I'm saying, boy?

CORY. Yessir.

TROY. Then get the hell out of my face, and get on down to that A&P.

ROSE *has been standing behind the screen door for much of the scene. She enters as* CORY *exits.*

ROSE. Why don't you let the boy go ahead and play football, Troy? Ain't no harm in that. He's just trying to be like you with the sports.

TROY. I don't want him to be like me! I want him to move as far away from my life as he can get. You the only decent thing that ever happened to me. I wish him that. But I don't wish him a thing else from my life. I decided seventeen years ago that boy wasn't getting involved in no sports. Not after what they did to me in the sports.

ROSE. Troy, why don't you admit you was too old to play in the major leagues? For once . . . why don't you admit that?

TROY. What do you mean too old? Don't come telling me I was too old. I just wasn't the right color. Hell, I'm fifty-three years old and can do better than Selkirk's .269 right now!

ROSE. How's was you gonna play ball when you were over forty? Sometimes I can't get no sense out of you.

TROY. I got good sense, woman. I got sense enough not to let my boy get hurt over playing no sports. You been mothering that boy too much. Worried about if people like him.

ROSE. Everything that boy do . . . he do for you. He wants you to say "Good job, son." That's all.

TROY. Rose, I ain't got time for that. He's alive. He's healthy. He's got to make his own way. I made mine. Ain't nobody gonna hold his hand when he get out there in that world.

ROSE. Times have changed from when you was young, Troy. People change. The world's changing around you and you can't even see it.

TROY (*slow, methodical*). Woman . . . I do the best I can do. I come in here every Friday. I carry a sack of potatoes and a bucket of lard. You all line up at the door with your hands out. I give you the lint from my pockets. I give you my sweat and my blood. I ain't got no tears. I done spent them. We go upstairs in that room at night . . . and I fall down on you and try to blast a hole into forever. I get up Monday morning . . . find my lunch on the table. I go out. Make my way. Find my strength to carry me through to the next Friday.

Pause.

That's all I got, Rose. That's all I got to give. I can't give nothing else.

TROY *exits into the house. The lights go down to black.*

Scene IV

It is Friday. Two weeks later. CORY *starts out of the house with his football equipment. The phone rings.*

CORY (*calling*). I got it!

He answers the phone and stands in the screen door talking.

Hello? Hey, Jesse, Naw . . . I was just getting ready to leave now.

ROSE (*calling*). Cory!

CORY. I told you, man, them spikes is all tore up. You can use them if you want, but they ain't no good. Earl got some spikes.

ROSE (*calling*). Cory!

CORY (*calling to* ROSE). Mam? I'm talking to Jesse.

Into phone.

When she say that. (*Pause*). Aw, you lying, man. I'm gonna tell her you said that.

ROSE (*calling*). Cory, don't you go nowhere!

CORY. I got to go to the game, Ma!

Into the phone.

Yeah, hey, look, I'll talk to you later. Yeah, I'll meet you over Earl's house. Later. Bye, Ma.

CORY *exits the house and starts out the yard.*

ROSE. Cory, where you going off to? You got that stuff all pulled out and thrown all over your room.

CORY (*in the yard*). I was looking for my spikes. Jesse wanted to borrow my spikes.

ROSE. Get up there and get that cleaned up before your daddy get back in here.

CORY. I got to go to the game! I'll clean it up *when I get back.*

CORY *exits.*

ROSE. That's all he need to do is see that room all messed up.

ROSE *exits into the house.* TROY *and* BONO *enter the yard.* TROY *is dressed in clothes other than his work clothes.*

BONO. He told him the same thing he told you. Take it to the union.

TROY. Brownie ain't got that much sense. Man wasn't thinking about nothing. He wait until I confront them on it . . . then he wanna come crying seniority.

Calls.

Hey, Rose!

BONO. I wish I could have seen Mr. Rand's face when he told you.

TROY. He couldn't get it out of his mouth! Liked to bit his tongue! When they called me down there to the Commissioner's office . . . he thought they was gonna fire me. Like everybody else.

BONO. I didn't think they was gonna fire you. I thought they was gonna put you on the warning paper.

TROY. Hey, Rose!

To BONO.

Yeah, Mr. Rand like to bit his tongue.

TROY *breaks the seal on the bottle, takes a drink, and hands it to* BONO.

BONO. I see you run right down to Taylors' and told that Alberta gal.

TROY *(calling).* Hey Rose! *(To* BONO*).* I told everybody. Hey, Rose! I went down there to cash my check.

ROSE *(entering from the house).* Hush all that hollering, man! I know you out here. What they say down there at the Commissioner's office?

TROY. You supposed to come when I call you, woman. Bono'll tell you that.

To BONO.

Don't Lucille come when you call her?

ROSE. Man, hush your mouth. I ain't no dog . . . talk about "come when you call me."

TROY *(puts his arm around* ROSE*).* You hear this, Bono? I had me an old dog used to get uppity like that. You say, "C'mere, Blue!" . . . and he just lay there and look at you. End up getting a stick and chasing him away trying to make him come.

ROSE. I ain't studying you and your dog. I remember you used to sing that old song.

TROY *(he sings).* Hear it ring! Hear it ring! I had a dog his name was Blue.

ROSE. Don't nobody wanna hear you sing that old song.

TROY *(sings).* You know Blue was mighty true.

ROSE. Used to have Cory running around here singing that song.

BONO. Hell, I remember that song myself.

TROY *(sings).*
 You know Blue was a good old dog.
 Blue treed a possum in a hollow log.
 That was my daddy's song. My daddy made up that song.

ROSE. I don't care who made it up. Don't nobody wanna hear you sing it.

TROY *(makes a song like calling a dog).* Come here, woman.

ROSE. You come in here carrying on, I reckon they ain't fired you. What they say down there at the Commissioner's office?

TROY. Look here, Rose . . . Mr. Rand called me into his office today when I got back from talking to them people down there . . . it come from up top . . . he called me in and told me they was making me a driver.

ROSE. Troy, you kidding!

TROY. No I ain't. Ask Bono.

ROSE. Well, that's great, Troy. Now you don't have to hassle them people no more.

LYONS *enters from the street.*

TROY. Aw hell, I wasn't looking to see you today. I thought you was in jail. Got it all over the front page of the *Courier* about them raiding Sefus' place . . . where you be hanging out with all them thugs?

LYONS. Hey, Pop . . . that ain't got nothing to do with me. I don't go down there gambling. I go down there to sit in with the band. I ain't got nothing to do with the gambling part. They got some good music down there.

TROY. They got some rogues . . . is what they got.

LYONS. How you been, Mr. Bono? Hi, Rose.

BONO. I see where you playing down at the Crawford Grill tonight.

ROSE. How come you ain't brought Bonnie like I told you. You should have brought Bonnie with you, she ain't been over in a month of Sundays.

LYONS. I was just in the neighborhood . . . thought I'd stop by.

TROY. Here he come . . .

BONO. Your daddy got a promotion on the rubbish. He's gonna be the first colored driver. Ain't got to do nothing but sit up there and read the paper like them white fellows.

LYONS. Hey, Pop . . . if you knew how to read you'd be alright.

BONO. Naw . . . naw . . . you mean if the nigger knew how to *drive* he'd be all right. Been fighting with them people about driving and ain't even got a license. Mr. Rand know you ain't got no driver's license?

TROY. Driving ain't nothing. All you do is point the truck where you want it to go. Driving ain't nothing.

BONO. Do Mr. Rand know you ain't got no driver's license? That's what I'm talking about. I ain't asked if driving was easy. I asked if Mr. Rand know you ain't got no driver's license.

TROY. He ain't got to know. The man ain't got to know my business. Time he find out, I have two or three driver's licenses.

LYONS (*going into his pocket*). Say, look here, Pop . . .

TROY. I knew it was coming. Didn't I tell you, Bono? I know what kind of "Look here, Pop" that was. The nigger fixing to ask me for some money. It's Friday night. It's my payday. All them rogues down there on the avenue . . . the ones that ain't in jail . . . and Lyons is hopping in his shoes to get down there with them.

LYONS. See, Pop . . . if you give somebody else a chance to talk sometime, you'd see that I was fixing to pay you back your ten dollars like I told you. Here . . . I told you I'd pay you when Bonnie got paid.

TROY. Naw . . . you go ahead and keep that ten dollars. Put it in the bank. The next time you feel like you wanna come by here and ask me for something . . . you go on down there and get that.

LYONS. Here's your ten dollars, Pop. I told you I don't want you to give me nothing. I just wanted to borrow ten dollars.

TROY. Naw . . . you go on and keep that for the next time you want to ask me.

LYONS. Come on, Pop . . . here go your ten dollars.

ROSE. Why don't you go on and let the boy pay you back, Troy?

LYONS. Here you go, Rose. If you don't take it I'm gonna have to hear about it for the next six months.

He hands her the money.

ROSE. You can hand yours over here too, Troy.

TROY. You see this, Bono. You see how they do me.

BONO. Yeah, Lucille do me the same way.

GABRIEL *is heard singing offstage. He enters.*

GABRIEL. Better get ready for the Judgment! Better get ready for . . . Hey! . . . Hey! . . . There's Troy's boy!

LYONS. How you doing, Uncle Gabe?

GABRIEL. Lyons . . . The King of the Jungle! Rose . . . hey, Rose. Got a flower for you.

He takes a rose from his pocket.

Picked it myself. That's the same rose like you is!

ROSE. That's right nice of you, Gabe.

LYONS. What you been doing, Uncle Gabe?

GABRIEL. Oh, I been chasing hellhounds and waiting on the time to tell St. Peter to open the gates.

LYONS. You been chasing hellhounds, huh? Well . . . you doing the right thing, Uncle Gabe. Somebody got to chase them.

GABRIEL. Oh, yeah . . . I know it. The devil's strong. The devil ain't no pushover. Hellhounds snipping at everybody's heels. But I got my trumpet waiting on the judgment time.

LYONS. Waiting on the Battle of Armageddon, huh?

GABRIEL. Ain't gonna be too much of a battle when God get to waving that Judgment sword. But the

people's gonna have a hell of a time trying to get into heaven if them gates ain't open.

LYONS (*putting his arm around* GABRIEL). You hear this, Pop. Uncle Gabe, you alright!

GABRIEL (*laughing with* LYONS). Lyons! King of the Jungle.

ROSE. You gonna stay for supper, Gabe. Want me to fix you a plate?

GABRIEL. I'll take a sandwich, Rose. Don't want no plate. Just wanna eat with my hands. I'll take a sandwich.

ROSE. How about you, Lyons? You staying? Got some short ribs cooking.

LYONS. Naw, I won't eat nothing till after we finished playing.

Pause.

You ought to come down and listen to me play, Pop.

TROY. I don't like that Chinese music. All that noise.

ROSE. Go on in the house and wash up, Gabe . . . I'll fix you a sandwich.

GABRIEL (*to* LYONS, *as he exists*). Troy's mad at me.

LYONS. What you mad at Uncle Gabe for, Pop.

ROSE. He thinks Troy's mad at him cause he moved over to Miss Pearl's.

TROY. I ain't mad at the man. He can live where he want to live at.

LYONS. What he move over there for? Miss Pearl don't like nobody.

ROSE. She don't mind him none. She treats him real nice. She just don't allow all that singing.

TROY. She don't mind that rent he be paying . . . that's what she don't mind.

ROSE. TROY, I ain't going through that with you no more. He's over there cause he want to have his own place. He can come and go as he please.

TROY. Hell, he could come and go as he please here. I wasn't stopping him. I ain't put no rules on him.

ROSE. It ain't the same thing, Troy. And you know it.

GABRIEL *comes to the door.*

Now, that's the last I wanna hear about that. I don't wanna hear nothing else about Gabe and Miss Pearl. And next week . . .

GABRIEL. I'm ready for my sandwich, Rose.

ROSE. And next week . . . when that recruiter come from that school . . . I want you to sign that paper and go on and let Cory play football. Then that'll be the last I have to hear about that.

TROY (*to* ROSE *as she exits into the house*). I ain't thinking about Cory nothing.

LYONS. What . . . Cory got recruited? What school he going to?

TROY. That boy walking around here smelling his piss . . . thinking he's grown. Thinking he's gonna do what he want, irrespective of what I say. Look here, Bono . . . I left the Commissioner's office and went down to the A&P . . . that boy ain't working down there. He lying to me. Telling me he got his job back . . . telling me he working weekends . . . telling me he working after school . . . Mr. Stawicki tell me he ain't working down there at all!

LYONS. Cory just growing up. He's just busting at the seams trying to fill out your shoes.

TROY. I don't care what he's doing. When he get to the point where he wanna disobey me . . . then it's time for him to move on. Bono'll tell you that. I bet he ain't never disobeyed his daddy without paying the consequences.

BONO. I ain't never had a chance. My daddy came on through . . . but I ain't never knew him to see him . . . or what he had on his mind or where he went. Just moving on through. Searching out the New Land. That's what the old folks used to call it. See a fellow moving around from place to place . . . woman to woman . . . called it searching out the New Land. I can't say if he ever found it. I come along, didn't want no kids. Didn't know if I was gonna be in one place long enough to fix on them right as their daddy. I figured I was going searching too. As it turned out I been hooked up with Lucille near about as long as your daddy been with Rose. Going on sixteen years.

TROY. Sometimes I wish I hadn't known my daddy. He ain't cared nothing about no kids. A kid to him wasn't nothing. All he wanted was for you to learn how to walk he could start you to working. When it come time for eating . . . he ate first. If there was anything left over, that's what you got. Man would sit down and eat two chickens and give you the wing.

LYONS. You ought to stop that, Pop. Everybody feed their kids. No matter how hard times is . . . everybody

care about their kids. Make sure they have something to eat.

TROY. The only thing my daddy cared about was getting them bales of cotton into Mr. Lubin. That's the only thing that mattered to him. Sometimes I used to wonder why he was living. Wonder why the devil hadn't come and got him. "Get them bales of cotton in to Mr. Lubin" and find out he owe him money . . .

LYONS. He should have just went on and left when he saw he couldn't get nowhere. That's what I would have done.

TROY. How he gonna leave with eleven kids? And where he gonna go? He ain't knew how to do nothing but farm. No, he was trapped and I think he knew it. But I'll say this for him . . . he felt a responsibility toward us. Maybe he ain't treated us the way I felt he should have . . . but without that responsibility he could have walked off and left us . . . made his own way.

BONO. A lot of them did. Back in those days what you talking about . . . they walk out their front door and just take on down one road or another and keep on walking.

LYONS. There you go! That's what I'm talking about.

BONO. Just keep on walking till you come to something else. Ain't you never heard of nobody having the walking blues? Well, that's what you call it when you just take off like that.

TROY. My daddy ain't had them walking blues! What you talking about? He stayed right there with his family. But he was just as evil as he could be. My mama couldn't stand him. Couldn't stand that evilness. She run off when I was about eight. She sneaked off one night after he had gone to sleep. Told me she was coming back for me. I ain't never seen her no more. All his women run off and left him. He wasn't good for nobody.

When my turn come to head out, I was fourteen and got to sniffing around Joe Canewell's daughter. Had us an old mule we called Greyboy. My daddy sent me out to do some plowing and I tied up Greyboy and went to fooling around with Joe Canewell's daughter. We done found us a nice little spot, got real cozy with each other. She about thirteen and we done figured we was grown anyway . . . so we down there enjoying ourselves . . . ain't thinking about nothing. We didn't know Greyboy had got loose and wandered back to the house and my daddy was looking for me. We down there by the creek enjoying ourselves when my daddy come up on us. Surprised us. He had them leather straps off the mule and commenced to whupping me like there was no tomorrow. I jumped up, mad and embarrassed. I was scared of my daddy. When he commenced to whupping on me . . . quite naturally I run to get out of the way.

Pause.

Now I thought he was mad cause I ain't done my work. But I see where he was chasing me off so he could have the gal for himself. When I see what the matter of it was, I lost all fear of my daddy. Right there is where I become a man . . . at fourteen years of age.

Pause.

Now it was my turn to run him off. I picked up them same reins that he had used on me. I picked up them reins and commenced to whupping on him. The gal jumped up and run off . . . and when my daddy turned to face me, I could see why the devil had never come to get him . . . cause he was the devil himself. I don't know what happened. When I woke up, I was laying right there by the creek, and Blue . . . this old dog we had . . . was licking my face. I thought I was blind. I couldn't see nothing. Both my eyes were swollen shut. I layed there and cried. I didn't know what I was gonna do. The only thing I knew was the time had come for me to leave my daddy's house. And right there the world suddenly got big. And it was a long time before I could cut it down to where I could handle it.

Part of that cutting down was when I got to the place where I could feel him kicking in my blood and knew that the only thing that separated us was the matter of a few years.

GABRIEL *enters from the house with a sandwich.*

LYONS. What you got there, Uncle Gabe?

GABRIEL. Got me a ham sandwich. Rose gave me a ham sandwich.

TROY. I don't know what happened to him. I done lost touch with everybody except Gabriel. But I hope he's dead. I hope he found some peace.

LYONS. That's heavy story, Pop. I didn't know you left home when you was fourteen.

TROY. And didn't know nothing. The only part of the world I knew was the forty-two acres of Mr. Lubin's land. That's all I knew about life.

LYONS. Fourteen's kinda young to be out on your own. (*Phone rings*). I don't even think I was ready to be out on my own at fourteen. I don't know what I would have done.

TROY. I got up from the creek and walked on down to Mobile. I was through with farming. Figured I could do better in the city. So I walked the two hundred miles to Mobile.

LYONS. Wait a minute . . . you ain't walked no two hundred miles, Pop. Ain't nobody gonna walk no two hundred miles. You talking about some walking there.

BONO. That's the only way you got anywhere back in them days.

LYONS. Shhh. Damn if I wouldn't have hitched a ride with somebody!

TROY. Who you gonna hitch it with? They ain't had no cars and things like they got now. We talking about 1918.

ROSE (*entering*). What you all out here getting into?

TROY (*to* ROSE). I'm telling Lyons how good he got it. He don't know nothing about this I'm talking.

ROSE. Lyons, that was Bonnie on the phone. She say you supposed to pick her up.

LYONS. Yeah, okay, Rose.

TROY. I walked on down to Mobile and hitched up with some of them fellows that was heading this way. Got up here and found out . . . not only couldn't you get a job . . . you couldn't find no place to live. I thought I was in freedom. Shhh. Colored folks living down there on the river-banks in whatever kind of shelter they could find for themselves. Right down there under the Brady Street Bridge. Living in shacks made of sticks and tarpaper. Messed around there and went from bad to worse. Started stealing. First it was food. Then I figured, hell, if I steal money I can buy me some food. Buy me some shoes too! One thing led to another. Met your mama. I was young and anxious to be a man. Met your mama and had you. What I do that for? Now I got to worry about feeding you and her. Got to steal three times as much. Went out one day looking for somebody to rob . . . that's what I was, a robber. I'll tell you the truth. I'm ashamed of it today. But it's the truth. Went to rob this fellow . . . pulled out my knife . . . and he pulled out a gun. Shot me in the chest. It felt just like somebody had taken a hot branding iron and laid it on me. When he shot me I jumped at him with my knife. They told me I killed him and they put me in the penitentiary and locked me up for fifteen years. That's where I met Bono. That's where I learned how to play baseball. Got out that place and your mama had taken you and went on to make life without me. Fifteen years was a long time for her to wait. But that fifteen years cured me of that robbing stuff. Rose'll tell you. She asked me when I met her if I had gotten all that foolishness out of my system. And I told her, "Baby, it's you and baseball all what count with me." You hear me, Bono? I meant it too. She say, "Which one comes first?" I told her, "Baby, ain't no doubt it's baseball . . . but you stick and get old with me and we'll both outlive this baseball." Am I right, Rose? And it's true.

ROSE. Man, hush your mouth. You ain't said no such thing. Talking about, "Baby, you know you'll always be number one with me." That's what you was talking.

TROY. You hear that, Bono. That's why I love her.

BONO. Rose'll keep you straight. You get off the track, she'll straighten you up.

ROSE. Lyons, you better get on up and get Bonnie. She waiting on you.

LYONS (*gets up to go*). Hey, Pop, why don't you come on down to the Grill and hear me play?

TROY. I ain't going down there. I'm too old to be sitting around in them clubs.

BONO. You got to be good to play down at the Grill.

LYONS. Come on, Pop . . .

TROY. I got to get up in the morning.

LYONS. You ain't got to stay long.

TROY. Naw, I'm gonna get my supper and go on to bed.

LYONS. Well, I got to go. I'll see you again.

TROY. Don't you come around my house on my payday.

ROSE. Pick up the phone and let somebody know you coming. And bring Bonnie with you. You know I'm always glad to see her.

LYONS. Yeah, I'll do that, Rose. You take care now. See you, Pop. See you, Mr. Bono. See you, Uncle Gabe.

GABRIEL. Lyons! King of the Jungle!

LYONS *exits*.

TROY. Is supper ready, woman? Me and you got some business to take care of. I'm gonna tear it up too.

ROSE. Troy, I done told you now!

TROY. (*Puts his arm around* Bono). Aw hell, woman . . . this is Bono. Bono like family. I done known this nigger since . . . how long I done know you?

BONO. It's been a long time.

TROY. I done known this nigger since Skippy was a pup. Me and him done been through some times.

BONO. You sure right about that.

TROY. Hell, I done know him longer than I known you. And we still standing shoulder to shoulder. Hey, look here, Bono . . . a man can't ask for no more than that.

Drinks to him.

I love you, nigger.

BONO. Hell, I love you too . . . but I got to get home see my woman. You got yours in hand. I got to go get mine.

BONO *starts to exit as* CORY *enters the yard, dressed in his football uniform. He gives* TROY *a hard, uncompromising look.*

CORY. What you do that for, Pop?

He throws his helmet down in the direction of TROY.

ROSE. What's the matter? Cory . . . what's the matter?

CORY. Papa done went up to the school and told Coach Zellman I can't play football no more. Wouldn't even let me play the game. Told him to tell the recruiter not to come.

ROSE. Troy . . .

TROY. What you Troying me for? Yeah, I did it. And the boy know why I did it.

CORY. Why you wanna do that to me? That was the one chance I had.

ROSE. Ain't nothing wrong with Cory playing football, Troy.

TROY. The boy lied to me. I told the nigger if he wanna play football . . . to keep his chores and hold down that job at the A&P. That was the conditions. Stopped down there to see Mr. Stawicki . . .

CORY. I can't work after school during the football season, Pop! I tried to tell you that Mr. Stawicki's

holding my job for me. You don't never want to listen to nobody. And then you wanna go and do this to me!

TROY. I ain't done nothing to you. You done it to yourself.

CORY. Just cause you didn't have a chance! You just scared I'm gonna be better than you, that's all.

TROY. Come here.

ROSE. Troy . . .

CORY *reluctantly crosses over to* TROY.

TROY. Alright! See. You done made a mistake.

CORY. I didn't even do nothing!

TROY. I'm gonna tell you what your mistake was. See . . . you swung at the ball and didn't hit it. That's strike one. See, you in the batter's box now. You swung and you missed. That's strike one. Don't you strike out!

Lights fade to black.

Act II
Scene I

The following morning. CORY is at the tree hitting the ball with the bat. He tries to mimic TROY, but his swing is awkward, less sure. ROSE enters from the house.

ROSE. Cory, I want you to help me with this cupboard.

CORY. I ain't quitting the team. I don't care what Poppa say.

ROSE. I'll talk to him when he gets back. He had to go see about your Uncle Gabe. The police done arrested him. Say he was disturbing the peace. He'll be back directly. Come on in here and help me clean out the top of this cupboard.

CORY *exits into the house.* ROSE *sees* TROY *and* BONO *coming down the alley.*

Troy . . . what they say down there?

TROY. Ain't said nothing. I give them fifty dollars and they let him go. I'll talk to you about it. Where's Cory?

ROSE. He's in there helping me clean out these cupboards.

TROY. Tell him to get his butt out here.

TROY and BONO go over to the pile of wood. BONO picks up the saw and begins sawing.

TROY (*to* BONO). All they want is the money. That makes six or seven times I done went down there and got him. See me coming they stick out their hands.

BONO. Yeah. I know what you mean. That's all they care about . . . that money. They don't care about what's right.

Pause.

Nigger, why you got to go and get some hard wood? You ain't doing nothing but building a little old fence. Get you some soft pine wood. That's all you need.

TROY. I know what I'm doing. This is outside wood. You put pine wood inside the house. Pine wood is inside wood. This here is outside wood. Now you tell me where the fence is gonna be?

BONO. You don't need this wood. You can put it up with pine wood and it's stand as long as you gonna be here looking at it.

TROY. How you know how long I'm gonna be here, nigger? Hell, I might just live forever. Live longer than old man Horsely.

BONO. That's what Magee used to say.

TROY. Magee's a damn fool. Now you tell me who you ever heard of gonna pull their own teeth with a pair of rusty pliers.

BONO. The old folks . . . my granddaddy used to pull his teeth with pliers. They ain't had no dentists for the colored folks back then.

TROY. Get clean pliers! You understand? Clean pliers! Sterilize them! Besides we ain't living back then. All Magee had to do was walk over to Doc Goldblums.

BONO. I see where you and that Tallahassee gal . . . that Alberta . . . I see where you all done got tight.

TROY. What you mean "got tight"?

BONO. I see where you be laughing and joking with her all the time.

TROY. I laughs and jokes with all of them, Bono. You know me.

BONO. That ain't the kind of laughing and joking I'm talking about.

CORY enters from the house.

CORY. How you doing, Mr. Bono?

TROY. Cory? Get that saw from Bono and cut some wood. He talking about the wood's too hard to cut. Stand back there, Jim, and let that young boy show you how it's done.

BONO. He's sure welcome to it.

CORY takes the saw and begins to cut the wood.

Whew-e-e! Look at that. Big old strong boy. Look like Joe Louis. Hell, must be getting old the way I'm watching that boy whip through that wood.

CORY. I don't see why Mama want a fence around the yard noways.

TROY. Damn if I know either. What the hell she keeping out with it? She ain't got nothing nobody want.

BONO. Some people build fences to keep people out . . . and other people build fences to keep people in. Rose wants to hold on to you all. She loves you.

TROY. Hell, nigger, I don't need nobody to tell me my wife loves me, Cory . . . go on in the house and see if you can find that other saw.

CORY. Where's it at?

TROY. I said find it! Look for it till you find it!

CORY exits into the house.

What's that supposed to mean? Wanna keep us in?

BONO. Troy . . . I done known you seem like damn near my whole life. You and Rose both. I done know both of you all for a long time. I remember when you met Rose. When you was hitting them baseball out the park. A lot of them old gals was after you then. You had the pick of the litter. When you picked Rose, I was happy for you. That was the first time I knew you had any sense. I said . . . My man Troy knows what he's doing . . . I'm gonna follow this nigger . . . he might take me somewhere. I been following you too. I done learned a whole heap of things about life watching you. I done learned how to tell where the shit lies. How to tell it from the alfalfa. You done learned me a lot of things. You showed me how to not make the same mistakes . . . to take life as it comes along and keep putting one foot in front of the other.

Pause.

Rose a good woman, Troy.

TROY. Hell, nigger, I know she a good woman. I been married to her for eighteen years. What you got on your mind, Bono?

BONO. I just say she a good woman. Just like I say anything. I ain't got to have nothing on my mind.

TROY. You just gonna say she a good woman and leave it hanging out there like that? Why you telling me she a good woman?

BONO. She loves you, Troy. Rose loves you.

TROY. You saying I don't measure up. That's what you trying to say. I don't measure up cause I'm seeing this other gal. I know what you trying to say.

BONO. I know what Rose means to you, Troy. I'm just trying to say I don't want to see you mess up.

TROY. Yeah, I appreciate that, Bono. If you was messing around on Lucille I'd be telling you the same thing.

BONO. Well, that's all I got to say. I just say that because I love you both.

TROY. Hell, you know me . . . I wasn't out there looking for nothing. You can't find a better woman, than Rose. I know that. But seems like this woman just stuck onto me where I can't shake her loose. I done wrestled with it, tried to throw her off me . . . but she just stuck on tighter, Now she's stuck on for good.

BONO. You's in control . . . that's what you tell me all the time. You responsible for what you do.

TROY. I ain't ducking the responsibility of it. As long as it sets right in my heart . . . then I'm okay. Cause that's all I listen to. It'll tell me right from wrong every time. And I ain't talking about doing Rose no bad turn. I love Rose. She done carried me a long ways and I love and respect her for that.

BONO. I know you do. That's why I don't want to see you hurt her. But what you gonna do when she find out? What you got then? If you try and juggle both of them . . . sooner or later you gonna drop one of them. That's common sense.

TROY. Yeah, I hear what you saying, Bono. I been trying to figure a way to work it out.

BONO. Work it out right, Troy. I don't want to be getting all up between you and Rose's business . . . but work it so it come out right.

TROY. Aw hell, I get all up between you and Lucille's business. When you gonna get that woman that refrigerator she been wanting? Don't tell me you ain't got no money now. I know who your banker is. Mellon don't need that money bad as Lucille want that refrigerator. I'll tell you that.

BONO. Tell you what I'll do . . . when you finish building this fence for Rose . . . I'll buy Lucille that refrigerator.

TROY. You done stuck your foot in your mouth now!

TROY *grabs up a board and begins to saw.* BONO *starts to walk out the yard.*

Hey, nigger . . . where you going?

BONO. I'm going home. I know you don't expect me to help you now. I'm protecting my money. I wanna see you put that fence up by yourself. That's what I want to see. You'll be here another six month without me.

TROY. Nigger, you ain't right.

BONO. When it comes to my money . . . I'm right as fireworks on the Fourth of July.

TROY. Alright, we gonna see now. You better get out your bankbook.

BONO *exits, and* TROY *continues to work.* ROSE *enters from the house.*

ROSE. What they say down there? What's happening with Gabe?

TROY. I went down there and got him out. Cost me fifty dollars. Say he was disturbing the peace. Judge set up a hearing for him in three weeks. Say to show cause why he shouldn't be re-committed.

ROSE. What was he doing that cause them to arrest him?

TROY. Some kids was teasing him and he run them off home. Say he was howling and carrying on. Some folks seen him and called the police. That's all it was.

ROSE. Well, what's you say? What'd you tell the judge?

TROY. Told him I'd look after him. It didn't make no sense to recommit the man. He stuck out his big greasy palm and told me to give him fifty dollars and take him on home.

ROSE. Where's he at now? Where'd he go off to?

TROY. He's gone on about his business. He don't need nobody to hold his hand.

ROSE. Well, I don't know. Seem like that would be the best place for him if they did put him into the hospital. I know what you're gonna say. But that's what I think would be best.

TROY. The man done had his life ruined fighting for what? And they wanna take and lock him up. Let him be free. He don't bother nobody.

ROSE. Well, everybody got their own way of looking at it I guess. Come on and get your lunch. I got a bowl of lima beans and some cornbread in the oven. Come on get some-thing to eat. Ain't no sense you fretting over Gabe.

ROSE *turns to go into the house.*

TROY. Rose . . . got something to tell you.

ROSE. Well, come on . . . wait till I get this food on the table.

TROY. Rose!

She stops and turns around.

I don't know how to say this.

Pause.

I can't explain it none. It just sort of grows on you till it gets out of hand. It starts out like a little bush . . . and the next thing you know it's a whole forest.

ROSE. Troy . . . what is you talking about?

TROY. I'm talking, woman, let me talk. I'm trying to find a way to tell you . . . I'm gonna be a daddy. I'm gonna be somebody's daddy.

ROSE. Troy . . . you're not telling me this? You're gonna be . . . what?

TROY. Rose . . . now . . . see . . .

ROSE. You telling me you gonna be somebody's daddy? You telling your *wife* this?

GABRIEL *enters from the street. He carries a rose in his hand.*

GABRIEL. Hey, Troy! Hey, Rose!

ROSE. I have to wait eighteen years to hear something like this.

GABRIEL. Hey, Rose . . . I got a flower for you.

He hands it to her.

That's a rose. Same rose like you is.

ROSE. Thanks, Gabe.

GABRIEL. Troy, you ain't mad at me is you? Them bad mens come and put me away. You ain't mad at me is you?

TROY. Naw, Gabe, I ain't mad at you.

ROSE. Eighteen years and you wanna come with this.

GABRIEL *(takes a quarter out of his pocket).* See what I got? Got a brand new quarter.

TROY. Rose . . . it's just . . .

ROSE. Ain't nothing you can say. Troy. Ain't no way of explaining that.

GABRIEL. Fellow that give me this quarter had a whole mess of them. I'm gonna keep this quarter till it stop shining.

ROSE. Gabe, go on in the house there. I got some watermelon in the frigidaire. Go on and get you a piece.

GABRIEL. Say, Rose . . . you know I was chasing hellhounds and them bad mens come and get me and take me away. Troy helped me. He come down there and told them they better let me go before he beat them up. Yeah, he did!

ROSE. You go on and get you a piece of watermelon, Gabe. Them bad mens is gone now.

GABRIEL. Okay, Rose . . . gonna get me some watermelon. The kind with the stripes on it.

GABRIEL *exits into the house.*

ROSE. Why, Troy? Why? After all these years to come dragging this in to me now. It don't make no sense at your age. I could have expected this ten or fifteen years ago, but not now.

TROY. Age ain't got nothing to do with it, Rose.

ROSE. I done tried to be everything a wife should be. Everything a wife could be. Been married eighteen years and I got to live to see the day you tell me you been seeing another woman and done fathered a child by her. And you know I ain't never wanted no half nothing in my family. My whole family is half. Everybody got different fathers and mothers . . . my two sisters and my brother. Can't hardly tell who's who. Can't never sit down and talk about Papa and Mama. It's your papa and your mama and my papa and my mama . . .

TROY. Rose . . . stop it now.

ROSE. I ain't never wanted that for none of my children. And now you wanna drag your behind in here and tell me something like this.

TROY. You ought to know. It's time for you to know.

ROSE. Well, I don't want to know, goddamn it!

TROY. I can't just make it go away. It's done now. I can't wish the circumstance of the thing away.

ROSE. And you don't want to either. Maybe you want to wish me and my boy away. Maybe that's what you want? Well, you can't wish us away. I've got eighteen years of my life invested in you. You ought to have stayed upstairs in my bed where you belong.

TROY. Rose . . . now listen to me . . . we can get a handle on this thing. We can talk this out . . . come to an understanding.

ROSE. All of a sudden it's "we." Where was "we" at when you was down there rolling around with some godforsaken woman? "We" should have come to an understanding before you started making a damn fool of yourself. You're a day late and a dollar short when it comes to an understanding with me.

TROY. It's just . . . She gives me a different idea . . . a different understanding about myself. I can step out of this house and get away from the pressures and problems . . . be a different man. I ain't got to wonder how I'm gonna pay the bills or get the roof fixed. I can just be a part of myself that I ain't never been.

ROSE. What I want to know . . . is do you plan to continue seeing her. That's all you can say to me.

TROY. I can sit up in her house and laugh. Do you understand what I'm saying. I can laugh out loud . . . and it feels good. It reaches all the way down to the bottom of my shoes.

Pause.

Rose, I can't give that up.

ROSE. Maybe you ought to go on and stay down there with her . . . if she a better woman than me.

TROY. It ain't about nobody being a better woman or nothing. Rose, you ain't the blame. A man couldn't ask for no woman to be a better wife than you've been. I'm responsible for it. I done locked myself into a pattern trying to take care of you all that I forgot about myself.

ROSE. What the hell was I there for? That was my job, not somebody else's.

TROY. Rose, I done tried all my life to live decent . . . to live a clean . . . hard . . . useful life. I tried to be a good husband to you. In every way I knew how. Maybe I come into the world backwards, I don't know. But . . . you born with two strikes on you before you come to the plate. You got to guard it closely . . . always looking for the curve-ball on the inside corner. You can't afford to let none get past you. You can't afford a call strike. If you going down . . . you going down swinging. Everything lined up against you. What you gonna do. I fooled them, Rose. I bunted. When I found you and Cory and a halfway decent job . . . I was safe. Couldn't nothing touch me. I wasn't gonna strike out no more. I wasn't going back to the penitentiary. I wasn't gonna lay in the streets with a bottle of wine. I was safe. I had me a family. A job. I wasn't gonna get that last strike. I was on first looking for one of them boys to knock me in. To get me home.

ROSE. You should have stayed in my bed, Troy.

TROY. Then when I saw that gal . . . she firmed up my backbone. And I got to thinking that if I tried . . . I just might be able to steal second. Do you understand after eighteen years I wanted to steal second.

ROSE. You should have held me tight. You should have grabbed me and held on.

TROY. I stood on first base for eighteen years and I thought . . . well, goddamn it . . . go on for it!

ROSE. We're not talking about baseball! We're talking about you going off to lay in bed with another woman . . . and then bring it home to me. That's what we're talking about. We ain't talking about no baseball.

TROY. Rose, you're not listening to me. I'm trying the best I can to explain it to you. It's not easy for me to admit that I been standing in the same place for eighteen years.

ROSE. I been standing with you! I been right here with you, Troy. I got a life too. I gave eighteen years of my life to stand in the same spot with you. Don't you think I ever wanted other things? Don't you think I had dreams and hopes? What about my life? What about me? Don't you think it ever crossed my mind to want to know other men? That I wanted to lay up somewhere and forget about my responsibilities? That I wanted someone to make me laugh so I could feel good? You not the only one who's got wants and needs. But I held

on to you. Troy. I took all my feelings, my wants and needs, my dreams . . . and I buried them inside you. I planted a seed and watched and prayed over it. I planted myself inside you and waited to bloom. And it didn't take me no eighteen years to find out the soil was hard and rocky and it wasn't never gonna bloom.

But I held on to you, Troy. I held you tighter. You was my husband. I owed you everything I had. Every part of me I could find to give you. And upstairs in that room . . . with the darkness falling in on me . . . I gave everything I had to try and erase the doubt that you wasn't the finest man in the world. And wherever you was going . . . I wanted to be there with you. Cause you was my husband. Cause that's the only way I was gonna survive as your wife. You always talking about what you give . . . and what you don't have to give. But you take too. You take . . . and don't even know nobody's giving!

ROSE *turns to exit into the house*; TROY *grabs her arm.*

TROY. You say I take and don't give!

ROSE. Troy! You're hurting me!

TROY. You say I take and don't give.

ROSE. Troy . . . you're hurting my arm! Let go!

TROY. I done give you everything I got. Don't you tell that lie on me.

ROSE. Troy!

TROY. Don't you tell that lie on me!

CORY *enters from the house.*

CORY. Mama!

ROSE. Troy. You're hurting me.

TROY. Don't you tell me about no taking and giving.

CORY *comes up behind* TROY *and grabs him.* TROY, *surprised, is thrown off balance just as* CORY *throws a glancing blow that catches him on the chest and knocks him down.* TROY *is stunned, as is* CORY.

ROSE. Troy. Troy. No!

TROY *gets to his feet and starts at* CORY.

Troy . . . no. Please! Troy!

ROSE *pulls on* TROY *to hold him back.* TROY *stops himself.*

TROY (*to Cory*). Alright. That's strike two. You stay away from around me, boy. Don't you strike out. You living with a full count. Don't you strike out.

TROY *exits out the yard as the lights go down.*

Scene II

It is six months later, early afternoon. TROY *enters from the house and starts to exit the yard.* ROSE *enters from the house.*

ROSE. Troy, I want to talk to you.

TROY. All of a sudden, after all this time, you want to talk to me, huh? You ain't wanted to talk to me for months. You ain't wanted to talk to me last night. You ain't wanted no part of me then. What you wanna talk to me about now?

ROSE. Tomorrow's Friday.

TROY. I know what day tomorrow is. You think I don't know tomorrow's Friday? My whole life I ain't done nothing but look to see Friday coming and you got to tell me it's Friday.

ROSE. I want to know if you're coming home.

TROY. I always come home, Rose. You know that. There ain't never been a night I ain't come home.

ROSE. That ain't what I mean . . . and you know it. I want to know if you're coming straight home after work.

TROY. I figure I'd cash my check . . . hang out at Taylors' with the boys . . . maybe play a game of checkers . . .

ROSE. Troy, I can't live like this. I won't live like this. You livin' on borrowed time with me. It's been going on six months now you ain't been coming home.

TROY. I be here every night. Every night of the year. That's 365 days.

ROSE. I want you to come home tomorrow after work.

TROY. Rose . . . I don't mess up my pay. You know that now. I take my pay and I give it to you. I don't have no money but what you give me back. I just want to have a little time to myself . . . a little time to enjoy life.

ROSE. What about me? When's my time to enjoy life?

TROY. I don't know what to tell you, Rose. I'm doing the best I can.

ROSE. You ain't been home from work but time enough to change your clothes and run out . . . and you wanna call that the best you can do?

TROY. I'm going over to the hospital to see Alberta. She went into the hospital this afternoon. Look like she might have the baby early. I won't be gone long.

ROSE. Well, you ought to know. They went over to Miss Pearl's and got Gabe today. She said you told them to go ahead and lock him up.

TROY. I ain't said no such thing. Whoever told you that is telling a lie. Pearl ain't doing nothing but telling a big fat lie.

ROSE. She ain't had to tell me. I read it on the papers.

TROY. I ain't told them nothing of the kind.

ROSE. I saw it right there on the papers.

TROY. What it say, huh?

ROSE. It said you told them to take him.

TROY. Then they screwed that up, just the way they screw up everything. I ain't worried about what they got on the paper.

ROSE. Say the government send part of his check to the hospital and the other part to you.

TROY. I ain't got nothing to do with that if that's the way it works. I ain't made up the rules about how it work.

ROSE. You did Gabe just like you did Cory. You wouldn't sign the paper for Cory . . . but you signed for Gabe. You signed that paper.

The telephone is heard ringing inside the house.

TROY. I told you I ain't signed nothing, woman! The only thing I signed was the release form. Hell, I can't read, I don't know what they had on that paper! I ain't signed nothing about sending Gabe away.

ROSE. I said send him to the hospital . . . you said let him be free . . . now you done went down there and signed him to the hospital for half his money. You went back on yourself, Troy. You gonna have to answer for that.

TROY. See now . . . you been over there talking to Miss Pearl. She done got mad cause she ain't getting Gabe's rent money. That's all it is. She's liable to say anything.

ROSE. Troy, I seen where you signed the paper.

TROY. You ain't seen nothing I signed. What she doing got papers on my brother anyway? Miss Pearl telling a big fat lie. And I'm gonna tell her about it too! You ain't seen nothing I signed. Say . . . you ain't seen nothing I signed.

ROSE *exits into the house to answer the telephone. Presently she returns.*

ROSE. Troy . . . that was the hospital. Alberta had the baby.

TROY. What she have? What is it?

ROSE. It's a girl.

TROY. I better get on down to the hospital to see her.

ROSE. Troy . . .

TROY. Rose . . . I got to go see her now. That's only right . . . what's the matter . . . the baby's alright, ain't it?

ROSE. Alberta died having the baby.

TROY. Died . . . you say she's dead? Alberta's dead?

ROSE. They said they done all they could. They couldn't do nothing for her.

TROY. The baby? How's the baby?

ROSE. They say it's healthy. I wonder who's gonna bury her.

TROY. She had family, Rose. She wasn't living in the world by herself.

ROSE. I know she wasn't living in the world by herself.

TROY. Next thing you gonna want to know if she had any insurance.

ROSE. Troy, you ain't got to talk like that.

TROY. That's the first thing that jumped out your mouth. "Who's gonna bury her?" Like I'm fixing to take on that task for myself.

ROSE. I am your wife. Don't push me away.

TROY. I ain't pushing nobody away. Just give me some space. That's all. Just give me some room to breathe.

ROSE *exits into the house.* TROY *walks about the yard.*

TROY (*with a quiet rage that threatens to consume him*). Alright . . . Mr. Death. See now . . . I'm gonna tell you what I'm gonna do. I'm gonna take and build me a fence around this yard. See? I'm gonna build me a fence around what belongs to me. And then I want you to stay on the other side. See? You stay over there until you're ready for me. Then you come on. Bring your army. Bring your sickle. Bring your wrestling clothes. I ain't gonna fall down on my vigilance this time. You ain't gonna sneak up on me no more. When you ready for me . . . when the top of your list say Troy Maxson . . . that's when you come around here. You come up

and knock on the front door. Ain't nobody else got nothing to do with this. This is between you and me. Man to man. You stay on the other side of that fence until you ready for me. Then you come up and knock on the front door. Anytime you want. I'll be ready for you.

The lights go down to black.

Scene III

The lights come up on the porch. It is late evening three days later. ROSE sits listening to the ball game waiting for TROY. The final out of the game is made and ROSE switches off the radio, TROY enters the yard carrying an infant wrapped in blankets. He stands back from the house and calls.

ROSE enters and stands on the porch. There is a long, awkward silence, the weight of which grows heavier with each passing second.

TROY. Rose . . . I'm standing here with my daughter in my arms. She ain't but a wee bittie little old thing. She don't know nothing about grownups' business. She innocent . . . and she ain't got no mama.

ROSE. What you telling me for, Troy?

She turns and exits into the house.

TROY. Well . . . I guess we'll just sit out here on the porch.

He sits down on the porch. There is an awkward indelicateness about the way he handles the baby. His largeness engulfs and seems to swallow it. He speaks loud enough for ROSE to hear.

A man's got to do what's right for him. I ain't sorry for nothing I done. It felt right in my heart.

To the baby.

What you smiling at? Your daddy's a big man. Got these great big old hands. But sometimes he's scared. And right now your daddy's scared cause we sitting out here and ain't got no home. Oh, I been homeless before. I ain't had no little baby with me. But I been homeless. You just be out on the road by your lonesome and you see one of them trains coming and you just kinda go like this . . .

He sings as a lullaby.

Please, Mr. Engineer let a man ride the line
Please, Mr. Engineer let a man ride the line
I ain't got no ticket please let me ride the blinds

ROSE *enters from the house.* TROY *hearing her steps behind him, stands and faces her.*

She's my daughter, Rose. My own flesh and blood. I can't deny her no more than I can deny them boys.

Pause.

You and them boys is my family. You and them and this child is all I got in the world. So I guess what I'm saying is . . . I'd appreciate it if you'd help take care of her.

ROSE. Okay, Troy . . . you're right. I'll take care of your baby for you . . . cause . . . like you say . . . she's innocent . . . and you can't visit the sins of the father upon the child. A motherless child has got a hard time.

She takes the baby from him.

From right now . . . this child got a mother. But you a womanless man.

ROSE *turns and exits into the house with the baby. Lights go down to black.*

Scene IV

It is two months later. LYONS enters from the street. He knocks on the door and calls.

LYONS. Hey, Rose! (*Pause*). Rose!

ROSE. (*From inside the house*). Stop that yelling. You gonna wake up Raynell. I just got her to sleep.

LYONS. I just stopped by to pay Papa this twenty dollars I owe him. Where's Papa at?

ROSE. He should be here in a minute. I'm getting ready to go down to the church. Sit down and wait on him.

LYONS. I got to go pick up Bonnie over her mother's house.

ROSE. Well, sit it down there on the table. He'll get it.

LYONS (*enters the house and sets the money on the table*). Tell Papa I said thanks. I'll see you again.

ROSE. Alright, Lyons. We'll see you.

LYONS *starts to exit as CORY enters.*

CORY. Hey, Lyons.

LYONS. What's happening, Cory. Say man, I'm sorry I missed your graduation. You know I had a gig and

couldn't get away. Otherwise, I would have been there, man. So what you doing?

CORY. I'm trying to find a job.

LYONS. Yeah I know how that go, man. It's rough out here. Jobs are scarce.

CORY. Yeah, I know.

LYONS. Look here, I got to run. Talk to Papa . . . he know some people. He'll be able to help get you a job. Talk to him . . . see what he say.

CORY. Yeah . . . alright, Lyons.

LYONS. You take care. I'll talk to you soon. We'll find some time to talk.

LYONS *exits the yard.* CORY *wanders over to the tree, picks up the bat and assumes a batting stance. He studies an imaginary pitcher and swings. Dissatisfied with the result, he tries again.* TROY *enters. They eye each other for a beat.* CORY *puts the bat down and exits the yard.* TROY *starts into the house as* ROSE *exits with* Raynell. *She is carrying a cake.*

TROY. I'm coming in and everybody's going out.

ROSE. I'm taking this cake down to the church for the bakesale. Lyons was by to see you. He stopped by to pay you your twenty dollars. It's laying in there on the table.

TROY *(going into his pocket).* Well . . . here go this money.

ROSE. Put it in there on the table, Troy. I'll get it.

TROY. What time you coming back?

ROSE. Ain't no use in you studying me. It don't matter what time I come back.

TROY. I just asked you a question, woman. What's the matter . . . can't I ask you a question?

ROSE. Troy, I don't want to go into it. Your dinner's in there on the stove. All you got to do is heat it up. And don't you be eating the rest of them cakes in there. I'm coming back for them. We having a bakesale at the church tomorrow.

ROSE *exits the yard.* TROY *sits down on the steps, takes a pint bottle from his pocket, opens it and drinks. He begins to sing.*

TROY. Hear it ring! Hear it ring!
Had an old dog his name was Blue
You know Blue was mighty true

You know Blue as a good old dog
Blue trees a possum in a hollow log
You know from that he was a good old dog.

BONO *enters the yard.*

BONO. Hey, Troy.

TROY. Hey, what's happening, Bono?

BONO. I just thought I'd stop by to see you.

TROY. What you stop by and see me for? You ain't stopped by in a month of Sundays. Hell, I must owe you money or something.

BONO. Since you got your promotion I can't keep up with you. Used to see you everyday. Now I don't even know what route you working.

TROY. They keep switching me around. Got me out in Green-tree now . . . hauling white folks' garbage.

BONO. Greentree, huh? You lucky, at least you ain't got to be lifting them barrels. Damn if they ain't getting heavier. I'm gonna put in my two years and call it quits.

TROY. I'm thinking about retiring myself.

BONO. You got it easy. You can *drive* for another five years.

TROY. It ain't the same, Bono. It ain't like working the back of the truck. Ain't got nobody to talk to . . . feel like you working by yourself. Naw, I'm thinking about retiring. How's Lucille?

BONO. She alright. Her arthritis get to acting up on her sometime. Saw Rose on my way in. She going down to the church, huh?

TROY. Yeah, she took up going down there. All them preachers looking for somebody to fatten their pockets.

Pause.

Got some gin here.

BONO. Naw, thanks. I just stopped by to say hello.

TROY. Hell, nigger . . . you can take a drink. I ain't never known you to say no to a drink. You ain't got to work tomorrow.

BONO. I just stopped by. I'm fixing to go over to Skinner's. We got us a domino game going over his house every Friday.

TROY. Nigger, you can't play no dominoes. I used to whup you four games out of five.

BONO. Well, that learned me. I'm getting better.

TROY. Yeah? Well, that's alright.

BONO. Look here . . . I got to be getting on. Stop by sometime, huh?

TROY. Yeah, I'll do that, Bono. Lucille told Rose you bought her a new refrigerator.

BONO. Yeah, Rose told Lucille you had finally built your fence . . . so I figured we'd call it even.

TROY. I knew you would.

BONO. Yeah . . . okay. I'll be talking to you.

TROY. Yeah, take care, Bono. Good to see you. I'm gonna stop over.

BONO. Yeah. Okay, Troy.

BONO *exits.* TROY *drinks from the bottle.*

TROY. Old Blue died and I dig his grave
 Let him down with a golden chain
 Every night when I hear old Blue bark
 I know Blue treed a possum in Noah's Ark.
 Hear it ring! Hear it ring!

CORY *enters the yard. They eye each other for a beat.* TROY *is sitting in the middle of the steps.* CORY *walks over.*

CORY. I got to get by.

TROY. Say what? What's you say?

CORY. You in my way. I got to get by.

TROY. You got to get by where? This is my house. Bought and paid for. In full. Took me fifteen years. And if you wanna go in my house and I'm sitting on the steps . . . you say excuse me. Like your mama taught you.

CORY. Come on, Pop . . . I got to get by.

CORY *starts to maneuver his way past* TROY. TROY *grabs his leg and shoves him back.*

TROY. You just gonna walk over top of me?

CORY. I live here too!

TROY (*advancing toward him*). You just gonna walk over top of me in my own house?

CORY. I ain't scared of you.

TROY. I ain't asked if you was scared of me. I asked you if you was fixing to walk over top of me in my own house? That's the question. You ain't gonna say excuse me? You just gonna walk over top of me?

CORY. If you wanna put it like that.

TROY. How else am I gonna put it?

CORY. I was walking by you to go into the house cause you sitting on the steps drunk, singing to yourself. You can put it like that.

TROY. Without saying excuse me???

CORY *doesn't respond.*

I asked you a question. Without saying excuse me???

CORY. I ain't got to say excuse me to you. You don't count around here no more.

TROY. Oh, I see . . . I don't count around here no more. You ain't got to say excuse me to your daddy. All of a sudden you done got so grown that your daddy don't count around here no more . . . Around here in his own house and yard that he done paid for with the sweat of his brow. You done got so grown to where you gonna take over. You gonna take over my house. Is that right? You gonna wear my pants. You gonna go in there and stretch out on my bed. You ain't got to say excuse me cause I don't count around here no more. Is that right?

CORY. That's right. You always talking this dumb stuff. Now, why don't you just get out my way.

TROY. I guess you got someplace to sleep and something to put in your belly. You got that, huh? You got that? That's what you need. You got that, huh?

CORY. You don't know what I got. You ain't got to worry about what I got.

TROY. You right! You one hundred percent right! I done spent the last seventeen years worrying about what you got. Now it's your turn, see? I'll tell you what to do. You grown . . . we done established that. You a man. Now, let's see you act like one. Turn your behind around and walk out this yard. And when you get out there in the alley . . . you can forget about this house. See? Cause this is my house. You go on and be a man and get your own house. You can forget about this. Cause this is mine. You go on and get yours cause I'm through with doing for you.

CORY. You talking about what you did for me . . . what'd you ever give me?

TROY. Them feet and bones! That pumping heart, nigger! I give you more than anybody else is ever gonna give you.

CORY. You ain't never gave me nothing! You ain't never done nothing but hold me back. Afraid I was gonna be better than you. All you ever did was try and make me scared of you. I used to tremble every time you called my name. Every time I heard your footsteps in the house. Wondering all the time . . . what's Papa gonna say if I do this? . . . What's he gonna say if I do that? . . . What's Papa gonna say if I turn on the radio? And Mama, too . . . she tries . . . but she's scared of you.

TROY. You leave your mama out of this. She ain't got nothing to do with this.

CORY. I don't know how she stand you . . . after what you did to her.

TROY. I told you to leave your mama out of this!

He advances toward CORY.

CORY. What you gonna do . . . give me a whupping? You can't whup me no more. You're too old. You just an old man.

TROY (*shoves him on his shoulder*). Nigger! That's what you are. You just another nigger on the street to me!

CORY. You crazy! You know that?

TROY. Go on now! You got the devil in you. Get on away from me!

CORY. You just a crazy old man . . . talking about I got the devil in me.

TROY. Yeah, I'm crazy! If you don't get on the other side of that yard . . . I'm gonna show you how crazy I am! Go on . . . get the hell out of my yard.

CORY. It ain't your yard. You took Uncle Gabe's money he got from the army to buy this house and then you put him out.

TROY (TROY *advances on* CORY). Get your black ass out of my yard!

TROY's *advance backs* CORY *up against the tree.* CORY *grabs up the bat.*

CORY. I ain't going nowhere! Come on . . . put me out! I ain't scared of you.

TROY. That's my bat!

CORY. Come on!

TROY. Put my bat down!

CORY. Come on, put me out.

CORY *swings at* TROY, *who backs across the yard.*

What's the matter? You so bad . . . put me out!

TROY *advances toward* CORY.

CORY (*backing up*). Come on! Come on!

TROY. You're gonna have to use it! You wanna draw that bat back on me . . . you're gonna have to use it.

CORY. Come on! . . . Come on!

CORY *swings the bat at* TROY *a second time. He misses.* TROY *continues to advance toward him.*

TROY. You're gonna have to kill me! You wanna draw that bat back on me. You're gonna have to kill me.

CORY, *backed up against the tree, can go no farther.* TROY *taunts him. He sticks out his head and offers him a target.*

Come on! Come on!

CORY *is unable to swing the bat.* TROY *grabs it.*

TROY. Then I'll show you.

CORY *and* TROY *struggle over the bat. The struggle is fierce and fully engaged.* TROY *ultimately is the stronger, and takes the bat from* CORY *and stands over him ready to swing. He stops himself.*

Go on and get away from around my house.

CORY, *stung by his defeat, picks himself up, walks slowly out of the yard and up the alley.*

CORY. Tell Mama I'll be back for my things.

TROY. They'll be on the other side of that fence.

CORY *exits.*

TROY. I can't taste nothing. Helluljah! I can't taste nothing no more. (TROY *assumes a batting posture and begins to taunt Death, the fastball in the outside corner*). Come on! It's between you and me now! Come on! Anytime you want! Come on! I be ready for you . . . but I ain't gonna be easy.

The lights go down on the scene.

Scene V

The time is 1965. The lights come up in the yard. It is the morning of TROY'S *funeral. A funeral plaque with a light hangs beside the door. There is a small garden plot off to the side. There is noise and activity in the house as* ROSE, LYONS *and* BONO *have gathered. The door opens and* RAYNELL, *seven years old, enters dressed in a flannel nightgown. She crosses to the garden and pokes around with a stick.* ROSE *calls from the house.*

ROSE. Raynell!

RAYNELL. Mam?

ROSE. What you doing out there?

RAYNELL. Nothing.

ROSE *comes to the door.*

ROSE. Girl, get in here and get dressed. What you doing?

RAYNELL. Seeing if my garden growed.

ROSE. I told you it ain't gonna grow overnight. You got to wait.

RAYNELL. It don't look like it never gonna grow. Dag!

ROSE. I told you a watched pot never boils. Get in here and get dressed.

RAYNELL. This ain't even no pot, Mama.

ROSE. You just have to give it a chance. It'll grow. Now you come on and do what I told you. We got to be getting ready. This ain't no morning to be playing around. You hear me?

RAYNELL. Yes, mam.

ROSE *exits into the house.* RAYNELL *continues to poke at her garden with a stick.* CORY *enters. He is dressed in a Marine corporal's uniform, and carries a duffel bag. His posture is that of a military man, and his speech has a clipped sternness.*

CORY *(to* RAYNELL*).* Hi.

Pause.

I bet your name is Raynell.

RAYNELL. Uh huh.

CORY. Is your mama home?

RAYNELL *runs up on the porch and calls through the screen door.*

RAYNELL. Mama . . . there's some man out here. Mama?

ROSE *comes to the door.*

ROSE. Cory? Lord have mercy! Look here, you all!

ROSE *and* CORY *embrace in a tearful reunion as* BONO *and* LYONS *enter from the house dressed in funeral clothes.*

BONO. Aw, looka here . . .

ROSE. Done got all grown up!

CORY. Don't cry, Mama. What you crying about?

ROSE. I'm just so glad you made it.

CORY. Hey Lyons. How you doing, Mr. Bono.

LYONS *goes to embrace* CORY.

LYONS. Look at you, man. Look at you. Don't he look good, Rose. Got them Corporal stripes.

ROSE. What took you so long.

CORY. You know how the Marines are, Mama. They got to get all their paperwork straight before they let you do anything.

ROSE. Well, I'm sure glad you made it. They let Lyons come. Your Uncle Gabe's still in the hospital. They don't know if they gonna let him out or not. I just talked to them a little while ago.

LYONS. A Corporal in the United States Marines.

BONO. Your daddy knew you had it in you. He used to tell me all the time.

LYONS. Don't he look good, Mr. Bono?

BONO. Yeah, he remind me of Troy when I first met him.

Pause.

Say, Rose, Lucille's down at the church with the choir. I'm gonna go down and get the pallbearers lined up. I'll be back to get you all.

ROSE. Thanks, Jim.

CORY. See you, Mr. Bono.

LYONS *(with his arm around* RAYNELL*).* Cory . . . look at Raynell. Ain't she precious? She gonna break a whole lot of hearts.

ROSE. Raynell, come and say hello to your brother. This is your brother, Cory. You remember Cory.

RAYNELL. No, Mam.

CORY. She don't remember me, Mama.

ROSE. Well, we talk about you. She heard us talk about you. She heard us talk about you. *(To* RAYNELL*).* This is your brother, Cory. Come on and say hello.

RAYNELL. Hi.

CORY. Hi. So you're Raynell. Mama told me a lot about you.

ROSE. You all come on into the house and let me fix you some breakfast. Keep up your strength.

CORY. I ain't hungry, Mama.

Lyons. You can fix me something, Rose. I'll be in there in a minute.

Rose. Cory, you sure you don't want nothing. I know they ain't feeding you right.

Cory. No, Mama . . . thanks. I don't feel like eating. I'll get something later.

Rose. Raynell . . . get on upstairs and get that dress on like I told you.

Rose *and* Raynell *exit into the house.*

Lyons. So . . . I hear you thinking about getting married.

Cory. Yeah, I done found the right one, Lyons. It's about time.

Lyons. Me and Bonnie been split up about four years now. About the time Papa retired. I guess she just got tired of all them changes I was putting her through.

Pause.

I always knew you was gonna make something out yourself. Your head was always in the right direction. So . . . you gonna stay in . . . make it a career . . . put in your twenty years?

Cory. I don't know. I got six already, I think that's enough.

Lyons. Stick with Uncle Sam and retire early. Ain't nothing out here. I guess Rose told you what happened with me. They got me down the workhouse. I thought I was being slick cashing other people's checks.

Cory. How much time you doing?

Lyons. They give me three years. I got that beat now. I ain't got but nine more months. It ain't so bad. You learn to deal with it like anything else. You got to take the crookeds with the straights. That's what Papa used to say. He used to say that when he struck out. I seen him strike out three times in a row . . . and the next time up he hit the ball over the grandstand. Right out there in Homestead Field. He wasn't satisfied hitting in the seats . . . he want to hit it over everything! After the game he had two hundred people standing around waiting to shake his hand. You got to take the crookeds with the straights. Yeah, papa was something else.

Cory. You still playing?

Lyons. Cory . . . you know I'm gonna do that. There's some fellows down there we got us a band . . . we gonna try and stay together when we get out . . . but yeah, I'm still playing. It still helps me to get out of bed in the morning. As long as it do that I'm gonna be right there playing and trying to make some sense out of it.

Rose (*calling*). Lyons, I got these eggs in the pan.

Lyons. Let me go on and get these eggs, man. Get ready to go bury Papa.

Pause.

How you doing? You doing alright?

Cory *nods.* Lyons *touches him on the shoulder and they share a moment of silent grief.* Lyons *exits into the house.* Cory *wanders about the yard.* Raynell *enters.*

Raynell. Hi.

Cory. Hi.

Raynell. Did you used to sleep in my room?

Cory. Yeah . . . that used to be my room.

Raynell. That's what Papa call it. "Cory's room." It got your football in the closet.

Rose *comes to the door.*

Rose. Raynell, get in there and get them good shoes on.

Raynell. Mama, can't I wear these. Them other ones hurt my feet.

Rose. Well, they just gonna have to hurt your feet for a while. You ain't said they hurt your feet when you went down to the store and got them.

Raynell. They didn't hurt then. My feet done got bigger.

Rose. Don't you give me no backtalk now. You get in there and get them shoes on.

Raynell *exits into the house.*

Ain't too much changed. He still got that piece of rag tied to that tree. He was out here swinging that bat. I was just ready to go back in the house. He swung that bat and then he just fell over. Seem like he swung it and stood there with this grin on his face . . . and then he just fell over. They carried him on down to the hospital, but I knew there wasn't no need . . . why don't you come on in the house?

Cory. Mama . . . I got something to tell you. I don't know how to tell you this . . . but I've got to tell you . . . I'm not going to Papa's funeral.

ROSE. Boy, hush your mouth. That's your daddy you talking about. I don't want hear that kind of talk this morning. I done raised you to come to this? You standing there all healthy and grown talking about you ain't going to your daddy's funeral.

CORY. Mama . . . listen . . .

ROSE. I don't want to hear it, Cory. You just get that thought out of your head.

CORY. I can't drag Papa with me everywhere I go. I've got to say no to him. One time in my life I've got to say no.

ROSE. Don't nobody have to listen to nothing like that. I know you and your daddy ain't seen eye to eye, but I ain't got to listen to that kind of talk this morning. Whatever was between you and your daddy . . . the time has come to put it aside. Just take it and set it over there on the shelf and forget about it. Disrespecting your daddy ain't gonna make you a man, Cory. You got to find a way to come to that on your own. Not going to your daddy's funeral ain't gonna make you a man.

CORY. The whole time I was growing up . . . living in his house . . . Papa was like a shadow that followed you everywhere. It weighed on you and sunk into your flesh. It would wrap around you and lay there until you couldn't tell which one was you anymore. That shadow digging in your flesh. Trying to crawl in. Trying to live through you. Everywhere I looked, Troy Maxson was staring back at me . . . hiding under the bed . . . in the closet. I'm just saying I've got to find a way to get rid of that shadow, Mama.

ROSE. You just like him. You got him in you good.

CORY. Don't tell me that. Mama.

ROSE. You Troy Maxson all over again.

CORY. I don't want to be Troy Maxson. I want to be me.

ROSE. You can't be nobody but who you are, Cory. That shadow wasn't nothing but you growing into yourself. You either got to grow into it or cut it down to fit you. But that's all you got to make life with. That's all you got to measure yourself against that world out there. Your daddy wanted you to be everything he wasn't . . . and at the same time he tried to make you into everything he was. I don't know if he was right or wrong . . . but I do know he meant to do more good than he meant to do harm. He wasn't always right. Sometimes when he touched he bruised. And sometimes when he took me in his arms he cut.

When I first met your daddy I thought . . . Here is a man I can lay down with and make a baby. That's the first thing I thought when I seen him. I was thirty years old and had done seen my share of men. But when he walked up to me and said, "I can dance a waltz that'll make you dizzy," I thought, Rose Lee, here is a man that you can open yourself up to and be filled to bursting. Here is a man that can fill all them empty spaces you been tipping around the edges of. One of them empty spaces was being somebody's mother.

I married your daddy and settled down to cooking his supper and keeping clean sheets on the bed. When your daddy walked through the house he was so big he filled it up. That was my first mistake. Not to make him leave some room for me. For my part in the matter. But at that time I wanted that. I wanted a house that I could sing in. And that's what your daddy gave me. I didn't know to keep up his strength I had to give up little pieces of mine. I did that. I took on his life as mine and mixed up the pieces so that you couldn't hardly tell which was which anymore. It was my choice. It was my life and I didn't have to live it like that. But that's what life offered me in the way of being a woman and I took it. I grabbed hold of it with both hands.

By the time Raynell came into the house, me and your daddy had done lost touch with one another. I didn't want to make my blessing off of nobody's misfortune . . . but I took on to Raynell like she was all them babies I had wanted and never had.

The phone rings.

Like I'd been blessed to relive a part of my life. And if the Lord see fit to keep up my strength . . . I'm gonna do her just like your daddy did you . . . I'm gonna give her the best of what's in me.

RAYNELL (*entering, still with her old shoes*). Mama . . . Reverend Tollivier on the phone.

ROSE *exits into the house.*

RAYNELL. Hi.

CORY. Hi.

RAYNELL. You in the Army or the Marines?

CORY. Marines.

RAYNELL. Papa said it was the Army. Did you know Blue?

CORY. Blue? Who's Blue?

RAYNELL. Papa's dog what he sing about all the time.

CORY (*singing*).
Hear it ring! Hear it ring!
I had a dog his name was Blue
You know Blue was mighty true
You know Blue was a good old dog
Blue treed a possum in a hollow log
You know from that he was a good old dog.
Hear it ring! Hear it ring!

RAYNELL *joins in singing.*

CORY AND RAYNELL. Blue treed a possum out on a limb
Blue looked at me and I looked at him
Grabbed that possum and put him in a sack
Blue stayed there till I came back
Old Blue's feets was big and round
Never allowed a possum to touch the ground.
Old Blue died and I dug his grave
I dug his grave with a silver spade
Let him down with a golden chain
And every night I call his name
Go on Blue, you good dog you
Go on Blue, you good dog you

RAYNELL. Blue laid down and died like a man

Blue laid down and died . . .

BOTH. Blue laid down and died like a man
Now he's treeing possums in the Promised Land
I'm gonna tell you this to let you know
Blue's gone where the good dogs go
When I hear old Blue bark
When I hear old Blue bark
Blue treed a possum in Noah's Ark
Blue treed a possum in Noah's Ark.

ROSE *comes to the screen door.*

ROSE. Cory, we gonna be ready to go in a minute.

CORY (*to* RAYNELL). You go on in the house and change them shoes like Mama told you so we can go to Papa's funeral.

RAYNELL. Okay, I'll be back.

RAYNELL *exits into the house.* CORY *gets up and crosses over to the tree.* ROSE *stands in the screen door watching him.* GABRIEL *enters from the alley.*

GABRIEL (*calling*). Hey, Rose!

ROSE. Gabe?

GABRIEL. I'm here, Rose. Hey Rose, I'm here!

ROSE *enters from the house.*

ROSE. Lord . . . Look here, Lyons!

LYONS. See, I told you, Rose . . . I told you they'd let him come.

CORY. How you doing, Uncle Gabe?

LYONS. How you doing, Uncle Gabe?

GABRIEL. Hey, Rose. It's time. It's time to tell St. Peter to open the gates. Troy, you ready? You ready, Troy. I'm gonna tell St. Peter to open the gates. You get ready now.

GABRIEL, *with great fanfare, braces himself to blow. The trumpet is without a mouthpiece. He puts the end of it into his mouth and blows with great force, like a man who has been waiting some twenty-odd years for this single moment. No sound comes out of the trumpet. He braces himself and blows again with the same result. A third time he blows. There is a weight of impossible description that falls away and leaves him bare and exposed to a frightful realization. It is a trauma that a sane and normal mind would be unable to withstand. He begins to dance. A slow, strange dance, eerie and lifegiving. A dance of atavistic signature and ritual.* LYONS *attempts to embrace him.* GABRIEL *pushes* LYONS *away. He begins to howl in what is an attempt at song, or perhaps a song turning back into itself in an attempt at speech. He finishes his dance and the gates of heaven stand open as wide as God's closet.*

That's the way that go!

Blackout.

How I Learned to Drive

Introduction by Chad Winters

Paula Vogel: Driven to Success

Can you remember the last time you saw a play written by a female playwright? In a predominantly male business, the woman's voice has been dormant for much of the theatre's rich history. It wasn't until the last few decades that audiences began to see prominent female voices in the theatre. The lack of women playwrights grew to become such an important issue that theatres around the country were founded with the desire to foster the development and production of plays written by women. Women Playwrights Initiative states that nationally only 17 percent of plays produced on America's main stages are written by women. Through the mission of these new theatres, the woman's voice has been growing stronger and stronger. One voice that has prospered in the last thirty years is Paula Vogel.

Paula Vogel was born on November 16, 1951, in Washington, D.C., and lived there for most of her early life. In 1969, she attended Bryn Mawr College on a scholarship before heading back to Washington to earn her bachelor of arts degree from Catholic University of America in 1974. After graduation, she moved to Ithaca, New York, where she attended Cornell University. There she earned enough credits for her Ph.D. but failed to submit her thesis, thus obtaining only an All but Dissertation (ABD), a status bestowed upon candidates for a doctoral degree after they have completed all coursework and comprehensive examinations and have only the dissertation left to write.

From 1979 to 1982, Vogel was a lecturer in women's studies and theatre arts at Cornell before being fired for political reasons. This was perhaps a blessing in disguise because she found herself with time to work on theatre projects and she hasn't looked back since. She has built a distinguished career as a playwright and teacher. Her extraordinary artistic achievements are matched only by her tireless commitment to the training and mentoring of young writers. In the classroom she is known for her provocative exercises that stretch the imagination of student playwrights.

In 2008, she was appointed the Eugene O'Neil Professor and Chair of the Playwriting Department at Yale School of Drama while continuing to be one of the most widely produced and honored playwrights writing in the English language. Her plays include *The Long Christmas Ride Home*, *The Mineola Twins*, *How I Learned to Drive*, *Hot 'n' Throbbing*, *The Baltimore Waltz*, *Desdemona*, *And Baby Makes Seven*, and *The Oldest Profession*. Her work has garnered numerous awards and prizes, including the 1998 Pulitzer Prize for Drama for *How I Learned to Drive*. She is currently working on a new play entitled *A Civil War Christmas* and her memoir *Beyond the Beltway*.

How I Learned to Drive

Vogel's inspiration for writing *How I Learned to Drive* was author Vladimir Nabokov's controversial novel *Lolita*. She wondered if a female playwright could take on *Lolita* from Lolita's point of view. Unconventional in its style of storytelling the play veers away from the straightforward plot toward an uneven mixture of flashbacks, narration, and monologues. The action of the play focuses on the affair between L'il Bit and her Uncle Peck and looks back over the course of many years, with the character of Li'l Bit maturing from age eleven to eighteen before she puts an end to it. In spite of the serious situation, Vogel achieves the seemingly impossible: a story about pedophilia that is both funny as it is serious. She doesn't condemn the characters but explores the basic humanity binding these two characters

together. The action fades from one time frame to another and one place to the next smoothly with the use of imaginative staging techniques. Three actors, in addition to those playing Li'l Bit and Peck, play all the other characters. She also employs the use of popular music from the early and late 1960s to help audiences understand the prevailing mood of the era that Vogel covers in this play. In the production notes of her script, Vogel urges the director to have fun with the music that is rife with pedophilic references such as The Beach Boys "Little Surfer Girl," Johnny Burnette's "You're Sixteen," and the Union's Gap's "This Girl Is a Woman Now." Through the music, Vogel helps us understand why a girl like Li'l Bit, filled with the insecurities of adolescence but coming of age in an era that emphasizes youth and fun, would turn to a flawed relationship where she can bask in the reverence of an older man.

Oddly enough, the role of Li'l Bit was originally written for the American Repertory Theatre actor Cherry Jones, placing the character in her forties looking back. After Cherry Jones became unavailable to play the part, the repertory company decided to go with the decade-younger Mary-Louise Parker. This simple choice of casting a younger actress illuminates Vogel's ability to paint women characters with such complexity that the mere age of the character can create a new dynamic that is unique to each production. Vogel requests that directors change the lines in the script to adjust to the age of the actor cast as Li'l Bit. In an interview from the *Boston Phoenix*, Vogel states that there are differences; with an older actress, the play becomes more contemplative, whereas with a younger actress, there's more immediate danger.

Written and developed at the Perseverance Theatre in Juneau, Alaska, *How I Learned to Drive* received its world premiere at the Vineyard Theatre in New York City and met with great success. With *How I Learned to Drive* Vogel continued to establish herself as an eminent voice in the theatre. The original off Broadway production was directed by Mark Brokow. Today the play has become one of Vogel's most produced plays regionally and internationally, delighting audiences with its wildly funny, surprising, and devastating tale of survival.

Food for Thought

As you read the play, consider the following questions:

1. How do the songs used in the play help to connect us to the story?
2. Why do you think Vogel chose to center the action on driving lessons? What about driving lessons would lead to such intimacy?
3. What purpose do the chorus characters serve? Do they function in the same way as the ancient Greek chorus?
4. Explain how today's view of abuse has changed from the two generations of women that guide Li'l Bit throughout the play.
5. Why do you think Li'l Bit chooses to stay involved in the affair for so many years?

Fun Facts

1. In Vogel's playwriting classes, she often asks her students to write plays that have a dog as the protagonist, a play that can't be staged, or a play about the end of the world in five pages.
2. The Signature Theatre Company, which produces full staged works of playwrights-in-residence, honored Paula Vogel by producing *The Oldest Profession, Baltimore Waltz,* and *Hot 'n' Throbbing* for its 2004–2005 season.
3. Vogel, a feminist writer, has often been criticized for creating deeply contradictory representations of women in our culture.

How I Learned to Drive

Characters

LI'L BIT. A woman who ages forty-something to eleven years old. (See Notes on the New York Production.)

PECK. Attractive man in his forties. Despite a few problems, he should be played by an actor one might cast in the role of Atticus in *To Kill a Mockingbird*.

THE GREEK CHORUS. If possible, these three members should be able to sing three-part harmony.

MALE GREEK CHORUS. Plays Grandfather, Waiter, High School Boys. Thirties–forties. (See Notes on the New York Production.)

FEMALE GREEK CHORUS. Plays Mother, Aunt Mary, High School Girls. Thirty-fifty. (See Notes on the New York Production.)

TEENAGE GREEK CHORUS. Plays Grandmother, high school girls and the voice of eleven-year-old Li'l Bit. Note on the casting of this actor: I would strongly recommend casting a young woman who is "of legal age," that is, twenty-one to twenty-five years old who can look as close to eleven as possible. The contrast with the other cast members will help. If the actor is too young, the audience may feel uncomfortable. (See Notes on the New York Production.)

As the house lights dim, a Voice announces:

Safety first—You and Driver Education.

Then the sound of a key turning the ignition of a car. Li'l Bit steps into a spotlight on the stage; "well-endowed," she is a softer-looking woman in the present time than she was at seventeen.

LI'L BIT. Sometimes to tell a secret, you first have to teach a lesson. We're going to start our lesson to-night on an early, warm summer evening.

In a parking lot overlooking the Beltsville Agricul-tural Farms in suburban Maryland.

Less than a mile away, the crumbling concrete of U.S. One wends its way past one-room revival churches, the porno drive-in, and boarded up motels with For Sale signs tumbling down.

Like I said, it's a warm summer evening.

Here on the land the Department of Agriculture owns, the smell of sleeping farm animal is thick on the air. The smells of clover and hay mix in with the smells of the leather dashboard. You can still imagine how Maryland used to be, before the malls took over. This countryside was once dotted with farmhouses—from their porches you could have witnessed the Civ-il War raging in the front fields.

Oh yes. There's a moon over Maryland tonight, that spills into the car where I sit beside a man old enough to be—did I mention how still the night is? Damp soil and tranquil air. It's the kind of night that makes a middle-aged man with a mortgage feel like a country boy again.

It's 1969. And I am very old, very cynical of the world, and I know it all. In short, I am seventeen years old, parking off a dark lane with a married man on an early summer night.

(Lights up on two chairs facing front—or a Buick Riviera, if you will. Waiting patiently, with a smile on his face, Peck sits sniffing the night air. Li'l Bit climbs in beside him, seventeen years old and tense. Throughout the following, the two sit facing directly front. They do not touch. Their bodies remain passive. Only their facial expressions emote.)

PECK. Ummm. I love the smell of your hair.

LI'L BIT. Uh-huh.

PECK. Oh, Lord. Ummmm. *(Beat)* A man could die happy like this.

LI'L BIT. Well, *don't.*

PECK. What shampoo is this?

LI'L BIT. Herbal Essence.

PECK. Herbal Essence. I'm gonna buy me some. Herb-al Essence. And when I'm all alone in the house, I'm going to get into the bathtub, and uncap the bottle and—

LI'L BIT. —Be good.

PECK. What?

LI'L BIT. Stop being . . . bad.

PECK. What did you think I was going to say? What do you think I'm going to do with the shampoo?

LI'L BIT. I don't want to know. I don't want to hear it.

PECK. I'm going to wash my hair. That's all.

LI'L BIT. Oh.

PECK. What did you think I was going to do?

LI'L BIT. Nothing. . . . I don't know. Something . . . nasty.

PECK. With shampoo? Lord, gal—your mind!

LI'L BIT. And whose fault is it?

PECK. Not mine. I've got the mind of a boy scout.

LI'L BIT. Right. A horny boy scout.

PECK. Boy scouts are always horny. What do you think the first Merit Badge is for?

LI'L BIT. There. You're going to be nasty again.

PECK. Oh, no. I'm good. Very good.

LI'L BIT. It's getting late.

PECK. Don't change the subject. I was talking about how good I am. *(Beat)* Are you ever gonna let me show you how good I am?

LI'L BIT. Don't go over the line now.

PECK. I won't. I'm not gonna do anything you don't want me to do.

LI'L BIT. That's right.

PECK. And I've been good all week.

LI'L BIT. You have?

PECK. Yes. All week. Not a single drink.

LI'L BIT. Good boy.

PECK. Do I get a reward? For not drinking?

LI'L BIT. A small one. It's getting late.

PECK. Just let me undo you. I'll do you back up.

LI'L BIT. All right. But be quick about it. *(Peck pantomimes undoing Li'l Bit's brassiere with one hand)* You know, that's amazing. The way you can undo the hooks through my blouse with one hand.

PECK. Years of practice.

LI'L BIT. You would make an incredible brain surgeon with that dexterity.

PECK. I'll bet Clyde—what's the name of the boy taking you to the prom?

LI'L BIT. Claude Souders.

PECK. Claude Souders. I'll bet it takes him two hands, lights on, and you helping him on to get to first base.

LI'L BIT. Maybe.

(Beat.)

PECK. Can I . . . kiss them? Please?

LI'L BIT. I don't know.

PECK. Don't make a grown man beg.

LI'L BIT. Just one kiss.

PECK. I'm going to lift your blouse.

LI'L BIT. It's a little cold.

(Peck laughs gently.)

PECK. That's not why you're shivering. *(They sit, perfectly still, for a long moment of silence. Peck makes gentle, concentric circles with his thumbs in the air in front of him)* How does that feel?

(Li'l Bit closes her eyes, carefully keeps her voice calm:)

LI'L BIT. It's . . . okay.

(Sacred music, organ music or a boy's choir swells beneath the following.)

PECK. I tell you, you can keep all the cathedrals of Europe. Just give me a second with these—these celestial orbs—

(Peck bows his head as if praying. But he is kissing her nipple. Li'l Bit, eyes still closed, rears back her head on the leather Buick car seat.)

LI'L BIT. Uncle Peck—we've got to go. I've got graduation rehearsal at school tomorrow morning. And you should get on home to Aunt Mary—

PECK. —All right, Li'l Bit.

LI'L BIT. —Don't call me that no more. *(Calmer)* Any more. I'm a big girl now, Uncle Peck. As you know.

(Li'l Bit pantomimes refastening her bra behind her back.)

PECK. That you are. Going on eighteen. Kittens will turn into cats.

(Sighs) I live all week long for these few minutes with you—you know that?

LI'L BIT. I'll drive.

(A Voice cuts in with:)

Idling in the Neutral Gear.

(Sound of car revving cuts off the sacred music; Li'l Bit, now an adult, rises out of the car and comes to us.)

LI'L BIT. In most families, relatives get names like "Junior," or "Brother," or "Bubba." In my family, if we call someone "Big Papa," it's not because he's tall. In my family, folks tend to get nicknamed for their genitalia. Uncle Peck, for example. My mama's adage was "the titles wonder," and my cousin Bobby got branded for life as "B.B."

(In unison with Greek Chorus:)

LI'L BIT. For blue balls.

GREEK CHORUS. For blue balls.

FEMALE GREEK CHORUS (As Mother). And of course, we were so excited to have a baby girl that when the nurse brought you in and said, "It's a girl! It's a baby girl!" I just had to see for myself. So we whipped your diapers down and parted your chubby little legs—and right between your legs there was—

(Peck has come over during the above and chimes along:)

PECK. Just a little bit.

GREEK CHORUS. Just a little bit.

FEMALE GREEK CHORUS (As Mother). And when you were born, you were so tiny that you fit in Uncle Peck's outstretched hand.

(Peck stretches his hand out.)

PECK. Now that's a fact. I held you, one day old, right in this hand.

(A traffic signal is projected of a bicycle in a circle with a diagonal red slash.)

LI'L BIT. Even with my family background, I was sixteen or so before I realized that pedophilia did not mean people who loved to bicycle. . . .

(A Voice intrudes:)

Driving in First Gear.

LI'L BIT. 1969. A typical family dinner.

FEMALE GREEK CHORUS (As Mother). Look, Grandma. Li'l Bit's getting to be as big in the bust as you are.

LI'L BIT. Mother! Could we please change the subject?

TEENAGE GREEK CHORUS (As Grandmother). Well, I hope you are buying her some decent bras. I never had a decent bra, growing up in the Depression, and now my shoulders are just crippled—crippled from the weight hanging on my shoulders—the dents from my bra straps are big enough to put your finger in.—Here, let me show you—

(As Grandmother starts to open her blouse:)

LI'L BIT. Grandma! Please don't undress at the dinner table.

PECK. I thought the entertainment came after the dinner.

LI'L BIT (To the audience). This is how it always starts. My grandfather, Big Papa, will chime in next with—

MALE GREEK CHORUS (As Grandfather). Yup. If Li'l Bit gets any bigger, we're gonna haveta buy her a wheelbarrow to carry in front of her—

LI'L BIT.—Damn it—

PECK.—How about those Redskins on Sunday, Big Papa?

LI'L BIT (To the audience). The only sport big Papa followed was chasing Grandma around the house—

MALE GREEK CHORUS (As Grandfather).—Or we could write to Kate Smith. Ask her for somma her used brassieres she don't want anymore—she could maybe give to Li'l Bit here—

LI'L BIT.—I can't stand it. I can't.

PECK. Now, honey, that's just their way—

FEMALE GREEK CHORUS (As Mother). I tell you, Grandma, Li'l Bit's at that age. She's so sensitive, you can't say boo—

LI'L BIT. I'd like some privacy, that's all. Okay? Some goddamn privacy—

PECK. —Well, at least she didn't use the savior's name—

LI'L BIT *(To the audience)*. And Big Papa wouldn't let a dead dog lie. No sirree.

MALE GREEK CHORUS *(As Grandfather)*. Well, she'd better stop being so sensitive. 'Cause five minutes before Li'l Bit turns the corner, her tits turn first—

LI'L BIT *(Starting to rise from the table)*.—That's it. That's it.

PECK. Li'l Bit, you can't let him get to you. Then he wins.

LI'L BIT. I hate him. *Hate* him.

PECK. That's fine. But hate him and eat a good dinner at the same time.

(Li'l Bit calms down and sits with perfect dignity.)

LI'L BIT. The gumbo is really good, Grandma.

MALE GREEK CHORUS *(As Grandfather)*. A'course, Li'l Bit's got a big surprise coming for her when she goes to that fancy college this fall—

PECK. Big Papa—let it go.

MALE GREEK CHORUS *(As Grandfather)*. What does she need a college degree for? She's got all the credentials she'll need on her chest—

LI'L BIT.—Maybe I want to learn things. Read. Rise above my cracker background—

PECK. —Whoa, now, Li'l Bit—

MALE GREEK CHORUS *(As Grandfather)*. What kind of things do you want to read?

LI'L BIT. There's a whole semester course, for example, on Shakespeare—

(Greek Chorus, as Grandfather, laughs until he weeps.)

MALE GREEK CHORUS *(As Grandfather)*. Shakespeare. That's a good one. Shakespeare is really going to help you in life.

PECK. I think it's wonderful. And on scholarship!

MALE GREEK CHORUS *(As Grandfather)*. How is Shakespeare going to help her lie on her back in the dark?

(Li'l Bit is on her feet.)

LI'L BIT. You're getting old, Big Papa. You are going to die—very very soon. Maybe even *tonight*. And when you get to heaven, God's going to be a beautiful black woman in a long white robe. She's gonna look

at your chart and say: Uh-oh. Fornication. Dog-ugly mean with blood relatives. Oh. Uh-oh. Voted for George Wallace. Well, one last chance: If you can name the play, all will be forgiven. And then she'll quote: "The quality of mercy is not strained." Your answer? Oh, too bad—*Merchant of Venice*: Act IV, Scene iii. And then she'll send your ass to fry in hell with all the other crackers. Excuse me, please.

(To the audience) And as I left the house, I would always hear Big Papa say:

MALE GREEK CHORUS *(As Grandfather)*. Lucy, your daughter's got a mouth on her. Well, no sense in wasting good gumbo. Pass me her plate, Mama.

LI'L BIT. And Aunt Mary would come up to Uncle Peck:

FEMALE GREEK CHORUS *(As Aunt Mary)*. Peck, go after her, will you? You're the only one she'll listen to when she gets like this.

PECK. She just needs to cool off.

FEMALE GREEK CHORUS *(As Aunt Mary)*. Please, Honey— Grandma's been on her feet cooking all day.

PECK. All right.

LI'L BIT. And as he left the room, Aunt Mary would say:

FEMALE GREEK CHORUS. *(As Aunt Mary)*. Peck's so good with them when they get to be this age.

(Li'l Bit has stormed to another part of the stage, her back turned, weeping with a teenage fury. Peck, cautiously, as if stalking a deer, comes to her. She turns away even more. He waits a bit.)

PECK. I don't suppose you're talking to family. *(No response)* Does it help that I'm in-law?

LI'L BIT. Don't you dare make fun of this.

PECK. I'm not. There's nothing funny about this. *(Beat)* Although I'll bet when Big Papa is about to meet his maker, he'll remember *The Merchant of Venice*.

LI'L BIT. I've got to get away from here.

PECK. You're going away. Soon. Here, take this.

(Peck hands her his folded handkerchief. Li'l Bit uses it, noisily. Hands it back. Without her seeing, he reverently puts it back.)

LI'L BIT. I hate this family.

PECK. Your grandfather's ignorant. And you're right—he's going to die soon. But he's family. Family is . . . family.

Li'l Bit. Grown-ups are always saying that. Family.

Peck. Well, when you get a little older, you'll see what we're saying.

Li'l Bit. Uh-huh. So family is another acquired taste, like French kissing?

Peck. Come again?

Li'l Bit. You know, at first it really grosses you out, but in time you grow to like it?

Peck. Girl, you are . . . a handful.

Li'l Bit. Uncle Peck—you have the keys to your car?

Peck. Where do you want to go?

Li'l Bit. Just up the road.

Peck. I'll come with you.

Li'l Bit. No—please? I just need to . . . to drive for a little bit. Alone.

(*Peck tosses her the keys.*)

Peck. When can I see you alone again?

Li'l Bit. Tonight.

(*Li'l Bit crosses to center stage while the lights dim around her. A Voice directs:*)

Shifting Forward from First to Second Gear.

Li'l Bit. There were a lot of rumors about why I got kicked out of that fancy school in 1970. Some say I got caught with a man in my room. Some say as a kid on scholarship I fooled around with a rich man's daughter.

(*Li'l Bit smiles innocently at the audience*) I'm not talking.

But the real truth was I had a constant companion in my dorm room—who was less than discrete. Canadian V.O. A fifth a day.

1970. A Nixon recession. I slept on the floors of friends who were out of work themselves. Took factory work when I could find it. A string of dead-end day jobs that didn't last very long.

What I did, most nights, was cruise the Beltway and the back roads of Maryland, where there was still country, past the battlefields and farm houses. Racing in a 1965 Mustang—and as long as I had gasoline for my car and whiskey for me, the nights would pass. Fully tanked, I would speed past the churches and the trees on the bend, thinking just one notch of the steering wheel would be all it would take, and yet some . . . reflex took

over. My hands on the wheel in the nine and three o'clock position—I never so much as got a ticker. He taught me well.

(*A voice announces:*)

You and the Reverse Gear.

Li'l Bit. Back up. 1968. On the Eastern Shore. A celebration dinner.

(*Li'l Bit joins Peck at a table in a restaurant.*)

Peck. Feeling better, missy?

Li'l Bit. The bathroom's really amazing here, Uncle Peck! They have these little soaps—instead of borax or something—and they're in the shape of shells.

Peck. I'll have to take a trip to the gentleman's room just to see.

Li'l Bit. How did you know about this place?

Peck. This inn is famous on the Eastern Shore—it's been open since the seventeenth century. And I know how you like history . . .

(*Li'l Bit is shy and pleased.*)

Li'l Bit. It's great.

Peck. And You've just done your first, legal, long-distance drive. You must be hungry.

Li'l Bit. I'm starved.

Peck. I would suggest a dozen oysters to start, and the crab imperial . . . (*Li'l Bit is genuinely agog*) You might be interested to know the town history. When the British sailed up this very river in the dead of night—see outside where I'm pointing?— they were going to bombard the heck out of this town. But the town fathers were ready for them. They crept up all the trees with lanterns so that the British would think they saw the town lights and they aimed their cannons too high. And that's why the inn is still here for business today.

Li'l Bit. That's a great story.

Peck (*Casually*). Would you like to start with a cocktail?

Li'l Bit. You're not . . . you're not going to start drinking, are you, Uncle Peck?

Peck. Not me. I told you, as long as you're with me, I'll never drink. I asked you if *you'd* like a cocktail before dinner. It's nice to have a little something with the oysters.

LI'L BIT. But . . . I'm not . . . legal. We could get arrested. Uncle Peck, they'll never believe I'm twenty-one!

PECK. So? Today we celebrate your driver's license—on the first try. This establishment reminds me a lot of places back home.

LI'L BIT. What does that mean?

PECK. In South Carolina, like here on the Eastern Shore, they're . . . (Searches for the right euphemism) . . . "European." Not so puritanical. And very understanding if gentlemen wish to escort very attractive young ladies who might want a before-dinner cocktail. If you want one, I'll order one.

LI'L BIT. Well—sure. Just . . . one.

(The Female Greek Chorus appears in a spot.)

FEMALE GREEK CHORUS (As Mother). A Mother's guide to Social Drinking:

A lady never gets sloppy—she may, however, get tipsy and a little gay.

Never drink on an empty stomach. Avail yourself of the bread basket and generous portions of butter. Slather the butter on your bread.

Sip your drink, slowly, let the beverage linger in your mouth—interspersed with interesting, fascinating conversation. Sip, never . . . slurp or gulp. Your glass should always be three-quarters full when his glass is empty.

Stay away from ladies' drinks: drinks like pink ladies, slow gin fizzes, daiquiris, gold cadillacs, Long Island iced teas, margaritas, piña coladas, mai tais, planters punch, white Russians, black Russians, red Russians, melon balls, blue balls, hummingbirds, hemorrhages and hurricanes. In short, avoid anything with sugar, or anything with an umbrella. Get your vitamin C from fruit. Don't order anything with Voodoo or Vixen in the title or sexual positions in the name like Dead Man Screw or the Missionary. (She sort of titters)

Believe me, they are lethal . . . I think you were conceived after one of those.

Drink, instead, like a man: straight up or on the rocks, with plenty of water in between.

Oh, yes. And never mix your drinks. Stay with one all night long, like the man you came in with: bourbon, gin, or tequila till dawn, damn the torpedoes, full speed ahead!

(As the Female Greek Chorus retreats, the Male Greek Chorus approaches the table as a Waiter.)

MALE GREEK CHORUS (As Waiter). I hope you all are having a pleasant evening. Is there something I can bring you, sir, before you order?

(Li'l Bit waits in anxious fear. Carefully, Uncle Peck says with command:)

PECK. I'll have a plain iced tea. The lady would like a drink, I believe.

(The Male Greek Chorus does a double take; there is a moment when Uncle Peck and he are in silent communication.)

MALE GREEK CHORUS. (As Waiter) Very good. What would the . . . lady like?

LI'L BIT. (A bit flushed) Is there . . . is there any sugar in a martini?

PECK. None that I know of.

LI'L BIT. That's what I'd like then—a dry martini. And cold we maybe have some bread?

PECK. A drink fit for a woman of the world.—Please bring the lady a dry martini, be generous with the olives, straight up.

(The Male Greek Chorus anticipates a large tip.)

MALE GREEK CHORUS. (As Waiter) Right away. Very good, sir.

(The Male Greek Chorus returns with an empty martini glass which he puts in front of Li'l Bit.)

PECK. Your glass is empty. Another martini, madam?

LI'L BIT. Yes, thank you.

(Peck signals the Male Greek Chorus, who nods) So why did you leave South Carolina, Uncle Peck?

PECK. I was stationed in D.C. after the war, and decided to stay. Go North, Young Man, someone might have said.

LI'L BIT. What did you do in the service anyway?

PECK (Suddenly taciturn). I . . . I did just this and that. Nothing heroic or spectacular.

LI'L BIT. But did you see fighting? Or go to Europe?

PECK. I served in the Pacific Theater. It's really nothing interesting to talk about.

Li'l Bit. Its is to me. *(The Waiter has brought another empty glass)* Oh, goody. I love the color of the swizzle sticks. What were we talking about?

Peck. Swizzle sticks.

Li'l Bit. Do you ever think of going back?

Peck. To the Marines?

Li'l Bit. No—to South Carolina.

Peck. Well, we do go back. To visit.

Li'l Bit. No, I mean to live.

Peck. Not very likely. I think it's better if my mother doesn't have a daily reminder of her disappointment.

Li'l Bit. Are these floorboards slanted?

Peck. Yes, the floor is very slanted. I think this is the original floor.

Li'l Bit. Oh, good.

(The Female Greek Chorus as Mother enters swaying a little, a little past tipsy.)

Female Greek Chorus *(As Mother).* Don't leave your drink unattended when you visit the ladies' room. There is such a thing as white slavery; the modus operandi is to spike an unsuspecting young girl's drink with a "mickey" when she's left the room to powder her nose.

But if you feel you have had more than your sufficiency in liquor, do go to the ladies' room—often. Pop your head out of doors for a refreshing breath of the night air. If your must, wet your face and head with tap water. Don't be afraid to dunk your head if necessary. A wet woman is still less conspicuous than a drunk woman.

(The Female Greek Chorus Stumbles a little; conspiratorially) When in the course of human events it becomes necessary, go to a corner stall and insert the index and middle finger down the throat almost to the epiglottis. Divulge your stomach contents by such persuasion, and then wait a few moments before rejoining your beau waiting for you at your table.

Oh, no. Don't be shy or embarrassed. In the very best of establishments, there's always one or two debutantes crouched in the corner stalls, their beaded purses tossed willy-nilly, sounding like cats in heat, heaving up the contents of their stomachs.

(The Female Greek Chorus begins to wander off) I wonder what it is they do in the men's rooms . . .

Li'l Bit. So why is your mother disappointed in you, Uncle Peck?

Peck. Every mother in Horry County has Great Expectations.

Li'l Bit. —Could I have another mar-ti-ni, please?

Peck. I think this is your last one.

(Peck signals the Waiter. The waiter looks at Li'l Bit and shakes his head no. Peck raises his eyebrow, raises his finger to indicate one more, and then rubs his fingers together. It looks like a secret code. The Waiter sighs, shakes his head sadly, and brings over another empty martini glass. He glares at Peck.)

Li'l Bit. The name of the county where you grew up is "Horry?" *(Li'l Bit, Plastered, begins to laugh. Then she stops)* I think your mother should be proud of you.

(Peck signals for the check.)

Peck. Well, missy, she wanted me to do—to *be* everything my father was not. She wanted me to amount to something.

Li'l Bit. But you have! You've amounted a lot. . . .

Peck. I'm just a very ordinary man.

(The Waiter has brought the check and waits. Peck draws out a large bill and hands it to the Waiter. Li'l Bit is in the soppy stage.)

Li'l Bit. I'll bet your mother loves you, Uncle Peck.

(Peck freezes a bit. To Male Greek Chorus as Waiter:)

Peck. Thank you. The service was exceptional. Please keep the change.

Male Greek Chorus. *(As Waiter, in a tone that could freeze).* Thank you, sir. Will you be needing any help?

Peck. I think we can manage, thank you.

(Just then, the Female Greek Chorus as Mother lurches on stage; the Male Greek Chorus as Waiter escorts her off as she delivers:)

Female Greek Chorus *(As Mother).* Thanks to judicious planning and several trips to the ladies' loo, your mother once out-drank an entire regiment of British officers on a good-will visit to Washington! Every last man of them! Milquetoasts! How'd they ever kick Hitler's cahones, huh? No match for an American lady—I could drink every man in here under the table.

(She delivers one last crucial hint before she is gently "bounced") As a last resort, when going out for an evening on the town, be sure to wear a skin-tight girdle—so tight that only a surgical knife or acetylene torch can get it off you—so that if you do pass out in the arms of your escort, he'll end up with rubber burns on his fingers before he can steal your virtue—

(A Voice punctures the interlude with:)

Vehicle Failure.

Even with careful maintenance and preventive operation of your automobile, it is all too common for us to experience an unexpected breakdown. If you are driving at any speed when a breakdown occurs, you must slow down and guide the automobile to the side of the road.

(Peck is slowly propping up Li'l Bit as they work their way to his car in the parking lot of the inn.)

PECK. How are you doing, missy?

LI'L BIT. It's so far to the car, Uncle Peck. Like the lanterns in the trees the British fired on . . .

(Li'l Bit stumbles. Peck swoops her up in his arms.)

PECK. Okay. I think we're going to take a more direct route.

(Li'l Bit closes her eyes) Dizzy? *(She nods her head)* Don't look at the ground. Almost there—do you feel sick to your stomach? *(Li'l Bit nods. They reach the "car." Peck gently deposits her on the front seat)* Just settle here a little while until things stop spinning. *(Li'l Bit opens her eyes)*

LI'L BIT. What are we doing?

PECK. We're just going to sit here until your tummy settles down.

LI'L BIT. It's such nice upholst'ry—

PECK. Think you can go for a ride, now?

LI'L BIT. Where are you taking me?

PECK. Home.

LI'L BIT. You're not taking me—upstairs? There's no room at the inn? *(Li'l Bit giggles)*

PECK. Do you want to go upstairs? *(Li'l Bit doesn't answer)* Or home?

LI'L BIT. —This isn't right, Uncle Peck.

PECK. What isn't right?

LI'L BIT. What we're doing. It's wrong. It's very wrong.

PECK. What are we doing? *(Li'l Bit does not answer)* We're just going out to dinner.

LI'L BIT. You know. It's not nice to aunt Mary.

PECK. You let me be the judge of what's nice and not nice to my wife.

(Beat.)

LI'L BIT. Now you're mad.

PECK. I'm not mad. It's just that I thought you . . . understood me, Li'l Bit. I think you're the only one who does.

LI'L BIT. Someone will get hurt.

PECK. Have I forced you to do anything?

(There is a long pause as Li'l Bit tries to get sober enough to think this through.)

LI'L BIT. . . . I guess not.

PECK. We are just enjoying each other's company. I've told you, nothing is going to happen between us until you want it to. Do you know that?

LI'L BIT. Yes.

PECK. Nothing is going to happen until you want it to. *(A second more, with Peck staring ahead at the river while seated at the wheel of his car. Then, softly:)* Do you want something to happen?

(Peck reaches over and strokes her face, very gently. Li'l Bit softens, reaches for him, and buries her head in his neck. Then she kisses him. Then she moves away, dizzy again.)

LI'L BIT. . . . I don't know.

(Peck smiles; this has been good news for him—it hasn't been a "no,")

PECK. Then I'll wait. I'm a very patient man. I've been waiting for a long time. I don't mind waiting.

LI'L BIT. Someone is going to get hurt.

PECK. No one is going to get hurt. *(Li'l Bit closes her eyes)* Are you feeling sick?

LI'L BIT. Sleepy.

(Carefully, Peck props Li'l Bit up on the seat.)

PECK. Stay here a second.

LI'L BIT. Where're you going?

PECK. I'm getting something from the back seat.

LI'L BIT. (*Scared; too loud*) What? What are you going to do?

(*Peck reappears in the front seat with a lap rug.*)

PECK. Shhhh. (*Peck covers Li'l Bit. She calms down*) There. Think you can sleep?

(*Li'l Bit nods. She slides over to rest on his shoulder. With a look of happiness, peck turns the ignition key. Beat. Peck leaves Li'l Bit sleeping in the car and strolls down to the audience. Wagner's* Flying Dutchman *comes up faintly. A Voice interjects:*)

Idling in the Neutral Gear.

TEENAGE GREEK CHORUS. Uncle Peck Teaches Cousin Bobby How to Fish.

PECK. I get back once or twice a year—supposedly to visit Mama and the family, but the real truth is to fish. I miss this the most of all. There's a smell in the Low Country—where the swamp and fresh inlet join the saltwater—a scent of sand and cypress, that I haven't found anywhere yet.

I don't say this very often up North because it will just play into the stereotype everyone has, but I will tell you: I didn't wear shoes in the summertime until I was sixteen. It's unnatural down here to pen up your feet in leather. Go ahead—take 'em off. Let yourself breathe—it really will make you feel better.

We're going to aim for some pompano today—and I have to tell you, they're a very shy, mercurial fish. Takes patience, and psychology. You have to believe it doesn't matter if you catch one or not.

Sky's pretty spectacular—there's some beer in the cooler next to the crab salad I packed, so help yourself if you get hungry. Are you hungry? Thirsty? Holler if you are.

Okay. You don't want to lean over the bridge like that—pompano feed in shallow water, and you don't want to get too close—they're frisky and shy little things—wait, check your line. Yep, something's been munching while we were talking.

Okay, look: We take the sand flea and you take the hook like this—right through his little sand flea rump. Sand fleas should always keep their backs to the wall. Okay. Cast it in, like I showed you. That's great! I can taste that pompano now, sautéed with some pecans and butter, a little bourbon—now—let it lie on the bottom—now, reel, jerk, reel, jerk—

Look—look at your line. There's something calling, all right. Okay, tip the rod up—not too sharp—hook it—all right, now easy, reel and then rest—let it play. And reel—play it out, that's right—really good! I can't believe it! It's a pompano.—Good work! Way to go! You are an official fisherman now. Pompano are hard to catch. We are going to have a delicious little—

What? Well, I don't know how much pain a fish feels—you can't think of that. Oh, no, don't cry, come on now, it's just a fish—the other guys are going to see you. —No, no, you're just real sensitive, and I think that's wonderful at your age—look, do you want me to cut it free? You do?

Okay, hand me those pliers—look—I'm cutting the hook—okay? And we're just going to drop it in—no I'm not mad. It's just for fun, okay? There—it's going to swim back to its lady friend and tell her what a terrible day it had and she's going to stroke him with her fins until he feels better, and then they'll do something alone together that will make them both feel good and sleepy. . . .

(*Peck bends down, very earnest*) I don't want you to feel ashamed about crying. I'm not going to tell anyone, okay? I can keep secrets. You know, men cry all the time. They just don't tell anybody, and they don't let anybody catch them. There's nothing you could do that would make me feel ashamed of you. Do you know that? Okay. (*Peck straightens up, smiles*)

Do you want to pack up and call it a day? I tell you what—I think I can still remember—there's a really neat tree house where I used to stay for days. I think it's still here—it was the last time I looked. But it's a secret place—you can't tell anybody we've gone there—least of all your mom or your sisters.—This is something special just between you and me. Sound good? We'll climb up there and have a beer and some crab salad—okay, B.B.? Bobby? Robert . . .

(*Li'l Bit sits at a kitchen table with the two Female Greek Chorus members.*)

LI'L BIT (*To the audience*). Three women, three generations, sit at the kitchen table.

On Men, Sex, and Women: Part I:

FEMALE GREEK CHORUS. (*As Mother*) Men only want one thing.

LI'L BIT (*Wide-eyed*). But what? What is it they want?

FEMALE GREEK CHORUS (As Mother). And once they have it, they lose all interest. So Don't Give It to Them.

TEENAGE GREEK CHORUS (As Grandmother). I never had the luxury of the rhythm method. Your grandfather is just a big bull. A big bull. Every morning, every evening.

FEMALE GREEK CHORUS (As Mother, whispers to Li'l Bit). And he used to come home for lunch every day.

LI'L BIT. My god, Grandma!

TEENAGE GREEK CHORUS (As Grandmother). Your grandfather only cares that I do two things: have the table set and the bed turned down.

FEMALE GREEK CHORUS (As Mother). And in all that time, Mother, you never have experienced—?

LI'L BIT (To the audience). —Now my grandmother believed in all the sacraments of the church, to the day she died. She believed in Santa Claus and the Easter Bunny until she was fifteen. But she didn't believe in—

TEENAGE GREEK CHORUS (As Grandmother). —Orgasm! That's just something you and Mary have made up! I don't believe you.

FEMALE GREEK CHORUS (As Mother). Mother, it happens to women all the time—

TEENAGE GREEK CHORUS (As Grandmother). —Oh, now you're going to tell me about the G force!

LI'L BIT. No, Grandma, I think that's astronauts—

FEMALE GREEK CHORUS (As Mother). Well, Mama, after all, you were a child bride when Big Papa came and got you—you were a married woman and you still believed in Santa Claus.

TEENAGE GREEK CHORUS (As Grandmother). It was legal, what Daddy and I did! I was fourteen and in those days, fourteen was a grown-up woman—

(Big Papa shuffles in the kitchen for a cookie.)

MALE GREEK CHORUS (As Grandfather). —Oh, now we're off on Grandma and the Rape of the Sa-bean Women!

TEENAGE GREEK CHORUS (As Grandmother). Well, you were the one in such a big hurry—

MALE GREEK CHORUS (As Grandfather to Li'l Bit). —I picked your grandmother out of that herd of sisters just like a lion chooses the gazelle—the plump,

slow, flaky gazelle dawdling at the edge of the herd—your sisters were too smart and too fast and too scrawny—

LI'L BIT (To the audience). —The family story is that when Big Papa came for Grandma, my Aunt Lily was waiting for him with a broom—and she beat him over the head all the way down the stairs as he was carrying out Grandma's hope chest—

MALE GREEK CHORUS (As Grandfather). —And they were mean. 'Specially Lily.

FEMALE GREEK CHORUS (As Mother). Well, you were robbing the baby of the family!

TEENAGE GREEK CHORUS (As Grandmother). I still keep a broom handy in the kitchen! And I know how to use it! So get your hand out of the cookie jar and don't you spoil your appetite for dinner—out of the kitchen!

(Male Greek Chorus as Grandfather leaves chuckling with a cookie.)

FEMALE GREEK CHORUS (As Mother). Just one thing a married woman needs to know how to use—the rolling pin or the broom. I prefer a heavy, cast-iron fry pan—they're great on a man's head, no matter how thick the skull is.

TEENAGE GREEK CHORUS (As Grandmother). Yes, sir, your father is ruled by only two bosses! Mr. Gut and Mr. Peter! And sometimes, first thing in the morning, Mr. Sphincter Muscle!

FEMALE GREEK CHORUS (As Mother). It's true. Men are like children. Just like little boys.

TEENAGE GREEK CHORUS (As Grandmother). Men are bulls! Big bulls!

(The Greek chorus is getting aroused.)

FEMALE GREEK CHORUS (As Mother). They'd still be crouched on their haunches over a fire in a cave if we hadn't cleaned them up!

TEENAGE GREEK CHORUS (As Grandmother, flushed). Coming in smelling of sweat—

FEMALE GREEK CHORUS (As Mother). —Looking at those naughty pictures like boys in a dime store with a dollar in their pockets!

TEENAGE GREEK CHORUS (As Grandmother; raucous). No matter to them what they smell like! They've got to have it, right then, on the spot, right there! Nasty!—

Female Greek Chorus (*As Mother*). —Vulgar!

Teenage Greek Chorus (*As Grandmother*). Primitive!—

Female Greek Chorus (*As Mother*). —Hot!—

Li'l Bit. And just about then, Big Papa would shuffle in with—

Male Greek Chorus (*As Grandfather*). —What are you all cackling about in here?

Teenage Greek Chorus (*As Grandmother*). Stay out of the kitchen! This is just for girls!

(*As Grandfather leaves:*)

Male Greek Chorus (*As Grandfather*). Lucy, you'd better not be filling Mama's head with sex! Every time you and Mary come over and start in about sex, when I ask a simple question like, "What time is dinner going to be ready?," Mama snaps my head off!

Teenage Greek Chorus (*As Grandmother*). Dinner will be ready when I'm good and ready! Stay out of this kitchen!

(*Li'l Bit steps out. A Voice directs:*)

When Making a Left Turn, You Must Downshift While Going Forward.

Li'l Bit. 1979. A long bus trip to Upstate New York. I settled in to read, when a young man sat beside me.

Male Greek Chorus (*As Young Man; voice cracking*). "What are you reading?"

Li'l Bit. He asked. His voice broke into that miserable equivalent of vocal acne, not quite falsetto and not tenor, either. I glanced a side view. He was appealing in an odd way, huge ears at a defiant angle springing forward at ninety degrees. He must have been shaving, because his face, with a peach sheen, was speckled with nicks and styptic. "I have a class tomorrow," I told him.

Male Greek Chorus (*As Young Man*). "You're taking a class?"

Li'l Bit. "I'm teaching a class." He concentrated on lowering his voice.

Male Greek Chorus (*As Young Man*). "I'm a senior. Walt Whitman High."

Li'l Bit. The light was fading outside, so perhaps he was—with a very high voice.

I felt his "interest" quicken. Five steps ahead of the hopes in his head, I slowed down, waited, pretended surprise, acted at listening, all the while knowing we would get off the bus, he would get off the bus, he would just then seem to think to ask me to dinner, he would chivalrously insist on walking me home, he would continue to converse in the street until I would casually invite him up to my room—and—I was only into the second moment of conversation and I could see the whole evening before me.

And dramaturgically speaking, after the faltering and slightly comical "first act," there was the very briefest of intermissions, and an extremely capable and forceful and *sustained* second act. And after the second act climax and a gentle denouement—before the postplay discussion—I lay on my back in the dark and I thought about you, Uncle Peck. Oh. Oh—this is the allure. Being older. Being the first. Being the translator, the teacher, the epicure, the already jaded. This is how the giver gets taken.

(*Li'l Bit changes her tone*) On Men, Sex, and Women: Part II:

(*Li'l Bit steps back into the scene as a fifteen year old, gawky and quiet, as the gazelle at the edge of the herd.*)

Teenage Greek Chorus (*As Grandmother; to Li'l Bit*). You're being mighty quiet, missy. Cat Got Your Tongue?

Li'l Bit. I'm just listening. Just thinking.

Teenage Greek Chorus. (*As Grandmother*) Oh, yes, Little Miss Radar Ears? Soaking it all in? Little Miss Sponge? Penny for your thoughts?

(*Li'l Bit hesitates to ask but she really wants to know.*)

Li'l Bit. Does it—when you do it—you know, theoretically when I do it and I haven't done it before—I mean—does it hurt?

Female Greek Chorus. (*As Mother*) Does what hurt, honey?

Li'l Bit. When a . . . when a girl does it for the first time—with a man—does it hurt?

Teenage Greek Chorus. (*As Grandmother; horrified*) *That's* what you're thinking about?

Female Greek Chorus. (*As Mother; calm*) Well, just a little bit. Like a pinch. And there's a little blood.

Teenage Greek Chorus. (*As Grandmother*) Don't tell her that! She's too young to be thinking those things!

FEMALE GREEK CHORUS (As Mother). Well, if she doesn't find out from me, where is she going to find out? In the street?

TEENAGE GREEK CHORUS (As Grandmother). Tell her it hurts! It's agony! You think you're going to die! Especially if you do it before marriage!

FEMALE GREEK CHORUS (As Mother). Mama! I'm going to tell her the truth! Unlike you, you left me and Mary completely in the dark with fairy tales and told us to go to the priest! What does an eighty-year-old priest know about love-making with girls!

LI'L BIT (Getting upset). It's not fair!

FEMALE GREEK CHORUS (As Mother). Now, see, she's getting upset—you're scaring her.

TEENAGE GREEK CHORUS (As Grandmother). Good! Let her be good and scared! It hurts! You bleed like a stuck pig! And you lay there and say, "Why, O Lord, have you forsaken me?!"

LI'L BIT. It's not fair! Why does everything have to hurt for girls? Why is there always blood?

FEMALE GREEK CHORUS (As Mother). It's not a lot of blood—and it feels wonderful after the pain subsides . . .

TEENAGE GREEK CHORUS (As Grandmother). You're encouraging her to just go out and find out with the first drugstore joe who buys her a milk shake!

FEMALE GREEK CHORUS (As Mother). Don't be scared. It won't hurt you—if the man you go to bed with really loves you. It's important that he loves you.

TEENAGE GREEK CHORUS (As Grandmother). —Why don't you just go out and rent a motel room for her, Lucy?

FEMALE GREEK CHORUS (As Mother). I believe in telling my daughter the truth! We have a very close relationship! I want her to be able to ask me anything—I'm not scaring her with stories about Eve's sin and snakes crawling on their bellies for eternity and women bearing children in mortal pain—

TEENAGE GREEK CHORUS (As Grandmother). —If she stops and thinks before she takes her knickers off, maybe someone in this family will finish high school!

(Li'l Bit knows what is about to happen and starts to retreat from the scene at this point.)

FEMALE GREEK CHORUS (As Mother). Mother! If you and Daddy had helped me—I wouldn't have had to marry that—that no-good-son-of-a—

TEENAGE GREEK CHORUS (As Grandmother). —He was good enough for you on a full moon! I hold you responsible!

FEMALE GREEK CHORUS (As Mother). —You could have helped me! You could have told me something about the facts of life!

TEENAGE GREEK CHORUS (As Grandmother). —I told you what my mother told me! A girl with her skirt up can outrun a man with his pants down!

(The Male Greek Chorus enters the fray; L'il Bit edges further downstage.)

FEMALE GREEK CHORUS. (As Mother) And when I turned to you for a little help, all I got afterwards was—

MALE GREEK CHORUS. (As Grandfather) You Made Your Bed; Now Lie On It!

(The Greek Chorus freezes, mouths open, argumentatively.)

LI'L BIT (To the audience). Oh, please! I still can't bear to listen to it, after all these years—

(The Male Greek Chorus "unfreezes," but out of his open mouth, as if to his surprise, comes a base refrain from a Motown song.)

MALE GREEK CHORUS. "Do-Bee-Do-Wah!"

(The Female Greek Chorus member is also surprised; but she, too, unfreezes.)

FEMALE GREEK CHORUS. "Shoo-doo-be-doo-be-doo; shoo-doo-be-doo-be-doo."

(The Male and Female Greek Chorus members continue with their harmony, until the Teenage member of the Chorus starts in with Motown lyrics such as "Dedicated to the One I Love," or "In the Still of the Night," or "Hold Me"—any Sam Cooke will do. The three modulate down into three part harmony, softly, until they are submerged by the actual recording playing over the radio in the car in which Uncle Peck sits in the driver's seat, waiting. Li'l Bit sits in the passenger's seat.)

LI'L BIT. Ahh. That's better.

(Uncle Peck reaches over and turns the volume down; to Li'l Bit:)

PECK. How can you hear yourself think?

(Li'l Bit does not answer.)

A Voice insinuates itself in the pause:)

Before You Drive.

Always check under your car for obstructions—broken bottles, fallen tree branches, and the bodies of small children. Each year hundreds of children are crushed beneath the wheels of unwary drivers in their own driveways. Children depend on you to watch them.

(Pause. The Voice continues:)

You and the Reverse Gear.

(In the following section, it would be nice to have slides of erotic photographs of women and cars: women posed over the hood; women draped along the sideboards; women with water hoses spraying the car; and the actress playing Li'l Bit with a Bel Air or any 1950s car one can find for the finale.)

LI'L BIT. 1967. In a parking lot of the Beltsville Agricultural Farms. The Initiation into a Boy's First Love.

PECK *(With a soft look on his face)*. Of course, my favorite car will always be the '56 Bel Air Sports Coupe. Chevy sold more '55s, but the '56!—a V-8 with Corvette option, 225 horsepower; went from zero to sixty miles per hour in 8.9 seconds.

LI'L BIT *(To the audience)*. Long after a mother's tits, but before a woman's breasts:

PECK. Super-Turbo-Fire! What a Power Pack—mechanical lifters, twin four-barrel carbs, lightweight valves, dual exhausts—

LI'L BIT *(To the audience)*. After the milk but before the beer:

PECK. A specific intake manifold, higher-lift camshaft, and the tightest squeeze Chevy had ever made—

LI'L BIT *(To the audience)*. Long after he's squeezed down the birth canal but before he's pushed his way back in: The boy falls in love with the thing that bears his weight with speed.

PECK. I want you to know your automobile inside and out.—Are you there? Li'l Bit?

(Slides end here.)

LI'L BIT.—What?

PECK. You're drifting. I need you to concentrate.

LI'L BIT. Sorry.

PECK. Okay. Get into the driver's seat. *(Li'l Bit does)* Okay. Now. Show me what you're going to do before you start the car.

(Li'l Bit sits, with her hands in her lap. She starts to giggle.)

LI'L BIT. I don't know, Uncle Peck.

PECK. Now, come on. What's the first thing you're going to adjust?

LI'L BIT. My bra strap?—

PECK.—Li'l Bit. What's the most important thing to have control of on the inside of the car?

LI'L BIT. That's easy. The radio. I tune the radio from Mama's old fart tunes to—

(Li'l Bit turns the radio up so we can hear a 1960s tune. With surprising firmness, Peck commands:)

PECK.—Radio off. Right now. *(Li'l Bit turns the radio off)* When you are driving your car, with your license, you can fiddle with the stations all you want. But when you are driving with a learner's permit in my car, I want all your attention to be on the road.

LI'L BIT. Yes, sir.

PECK. Okay. Now the seat—forward and up. *(Li'l Bit pushes it forward)* Do you want a cushion?

LI'L BIT. No—I'm good.

PECK. You should be able to reach all the switches and controls. Your feet should be able to push the accelerator, brake and clutch all the way down. Can you do that?

LI'L BIT. Yes.

PECK. Okay, the side mirrors. You want to be able to see just a bit of the right side of the car in the right mirror—can you?

LI'L BIT. Turn it out more.

PECK. Okay. How's that?

LI'L BIT. A little more. . . . Okay, that's good.

PECK. Now the left—again, you want to be able to see behind you—but the left lane—adjust it until you feel comfortable. *(Li'l Bit does so)* Next. I want you to check the rearview mirror. Angle it so you have a clear vision of the back. *(Li'l Bit does so)* Okay. Lock your door. Make sure all the doors are locked.

LI'L BIT *(Making a joke of it)*. But then I'm locked in with you.

PECK. Don't fool.

Li'l Bit. All right. We're locked in.

Peck. We'll deal with the air vents and defroster later. I'm teaching you on a manual—once you learn manual, you can drive anything. I want you to be able to drive any car, any machine. Manual gives you *control*. In ice, if your brakes fail, if you need more power—okay? It's a little harder at first, but then it becomes like breathing. Now. Put your hands on the wheel. I never want to see you driving with one hand. Always two hands. *(Li'l Bit hesitates)* What? What is it now?

Li'l Bit. If I put my hands on the wheel—how do I defend myself?

Peck *(Softly)*. Now listen. Listen up close. We're not going to fool around with this. This is serious business. I will never touch you when you are driving a car. Understand?

Li'l Bit. Okay.

Peck. Hands on the nine o'clock and three o'clock position gives you maximum control and turn.

(Peck goes silent for a while. Li'l Bit waits for more instruction)

Okay. Just relax and listen to me, Li'l Bit, okay? I want you to lift your hands for a second and look at them. *(Li'l Bit feels a bit silly, but does it)*

Those are your two hands. When you are driving, your life is in your own two hands. Understand? *(Li'l Bit nods)*

I don't have any sons. You're the nearest to a son I'll ever have—and I want to give you something. Something that really matters to me.

There's something about driving—when you're in control of the car, just you and the machine and the road—that nobody can take from you. A power. I feel more myself in my car than anywhere else. And that's what I want to give to you.

There's a lot of assholes out there. Crazy men, arrogant idiots, drunks, angry kids, geezers who are blind—and you have to be ready for them. I want to teach you to drive like a man.

Li'l Bit. What does that mean?

Peck. Men are taught to drive with confidence—with aggression. The road belongs to them. They drive defensively—always looking out for the other guy.

Women tend to be polite—to hesitate. And that can be fatal.

You're going to learn to think what the other guy is going to do before he does it. If there's an accident, and ten cars pile up, and people get killed, you're the one who's gonna steer through it, put your foot on the gas if you have to, and be the only one to walk away. I don't know how long you or I are going to live, but we're for damned sure not going to die in a car.

So if you're going to drive with me, I want you to take this very seriously.

Li'l Bit. I will, Uncle Peck. I want you to teach me to drive.

Peck. Good. You're going to pass your test on the first try. Perfect score. Before the next four weeks are over, you're going to know this baby inside and out. Treat her with respect.

Li'l Bit. Why is it a "she?"

Peck. Good question. It doesn't have to be a "she"—but when you close your eyes and think of someone who responds to your touch—someone who performs just for you and gives you what you ask for—I guess I always see a "she." You can call her what you like.

Li'l Bit *(To the audience)*. I closed my eyes—and decided not to change the gender.

(A Voice:)

Defensive driving involves defending yourself from hazardous and sudden changes in your automotive environment. By thinking ahead, the defensive driver can adjust to weather, road conditions and road kill. Good defensive driving involves mental and physical preparation. Are you prepared?

(Another Voice chimes in:)

You and the Reverse Gear.

Li'l Bit. 1966. The Anthropology of the Female Body in Ninth Grade—Or A Walk Down Mammary Lane.

(Throughout the following, there is occasional rhythmic beeping, like a transmitter signalling. Li'l Bit is aware of it, but can't figure out where it is coming from. No one else seems to hear it.)

Male Greek Chorus. In the hallway of Francis Scott Key Middle School.

(*A bell rings; the Greek Chorus is changing classes and meets in the hall, conspiratorially.*)

TEENAGE GREEK CHORUS. She's coming!

(*Li'l Bit enters the scene; the Male Greek Chorus member has a sudden, violent sneezing and lethal allergy attack.*)

FEMALE GREEK CHORUS. Jerome? Jerome? Are you all right?

MALE GREEK CHORUS. I—don't—know. I can't breathe—get Li'l Bit—

TEENAGE GREEK CHORUS. —He needs oxygen!—

FEMALE GREEK CHORUS. —Can you help us here?

LI'L BIT. What's wrong? Do you want me to get the school nurse—

(*The Male Greek Chorus member wheezes, grabs his throat and sniffs at Li'l Bit's chest, which is beeping away.*)

MALE GREEK CHORUS. No—it's okay—I only get this way when I'm around an allergy trigger—

LI'L BIT. Golly. What are you allergic to?

MALE GREEK CHORUS (*With a sudden grab of her breast*). Foam rubber.

(*The Greek Chorus members break up with hilarity; Jerome leaps away from Li'l Bit's kicking rage with agility; as he retreats:*)

LI'L BIT. Jerome! Creep! Cretin! Cro-Magnon!

TEENAGE GREEK CHORUS. Rage is not attractive in a girl.

FEMALE GREEK CHORUS. Really. Get a Sense of Humor.

(*A Voice echoes:*)

Good defensive driving involves mental and physical preparation. Were You Prepared?

FEMALE GREEK CHORUS. Gym Class: In the showers.

(*The sudden sound of water; the Female Greek Chorus members and Li'l Bit, while fully clothed, drape towels across their fronts, miming nudity. They stand, hesitate, at an imaginary shower's edge.*)

LI'L BIT. Water looks hot.

FEMALE GREEK CHORUS. Yesss. . . .

(*Female Greek Chorus members are not going to make the first move. One dips a tentative toe under the water, clutching the towel around her.*)

LI'L BIT. Well, I guess we'd better shower and get out of here.

FEMALE GREEK CHORUS. Yep. You go ahead. I'm still cooling off.

LI'L BIT. Okay.—Sally? Are you gonna shower?

TEENAGE GREEK CHORUS. After you—

(*Li'l Bit takes a deep breath for courage, drops the towel and plunges in: The two Female Greek Chorus members look at Li'l Bit in the all together, laugh, gasp and high-five each other.*)

TEENAGE GREEK CHORUS. Oh my god! Can you believe—

FEMALE GREEK CHORUS. Told you! It's not foam rubber! I win! Jerome owes me fifty cents!

(*A Voice editorializes:*)

Were You Prepared?

(*Li'l Bit tries to cover up; she is exposed, as suddenly 1960s Motown fills the room and we segue into:*)

FEMALE GREEK CHORUS. The Sock Hop.

(*Li'l Bit stands up against the wall with her female classmates. Teenage Greek Chorus is mesmerized by the music and just sways alone, lip-synching the lyrics.*)

LI'L BIT. I don't know. Maybe it's just me—but—do you ever feel like you're just a walking Mary Jane joke?

FEMALE GREEK CHORUS. I don't know what you mean.

LI'L BIT. You haven't heard the Mary Jane jokes? (*Female Greek Chorus member shakes her head no*) Okay. "Little Mary Jane is walking through the woods, when all of a sudden this man who was hiding behind a tree *jumps* out, *rips* open Mary Jane's blouse, and *plunges* his hands on her breasts. And Little Mary Jane just laughed and laughed because she knew her money was in her shoes."

(*Li'l Bit laughs; the Female Greek Chorus does not.*)

FEMALE GREEK CHORUS. You're weird.

(*In another space, in a strange light, Uncle Peck stands and stares at Li'l Bit's body. He is setting up a tripod, but he just stands, appreciative, watching her.*)

LI'L BIT. Well, don't you ever feel . . . self-conscious? Like you're being looked at all the time?

FEMALE GREEK CHORUS. That's not a problem for me. — Oh—look—Greg's coming over to ask you to dance.

(Teenage Greek Chorus becomes attentive, flustered. Male Greek Chorus member, as Greg, bends slightly as a very short young man, whose head is at Li'l Bit's chest level. Ardent, sincere and socially inept, Greg will become a successful gynecologist.)

TEENAGE GREEK CHORUS *(Softly)*. Hi, Greg.

(Greg does not hear. He is intent on only one thing.)

MALE GREEK CHORUS *(As Greg, to Li'l Bit)*. Good Evening. Would you care to dance?

LI'L BIT *(Gently)*. Thank you very much, Greg—but I'm going to sit this one out.

MALE GREEK CHORUS *(As Greg)*. Oh. Okay. I'll try my luck later.

(He disappears.)

TEENAGE GREEK CHORUS. Oohhh.

(Li'l Bit relaxes. Then she tenses, aware of Peck's gaze.)

FEMALE GREEK CHORUS. Take pity on him. Someone should.

LI'L BIT. But he's so short.

TEENAGE GREEK CHORUS. He can't help it.

LI'L BIT. But his head comes up to *(Li'l Bit gestures)* here. And I think he asks me on the fast dances so he can watch me—you know—jiggle.

FEMALE GREEK CHORUS. I wish I had your problems.

(The tune changes; Greg is across the room in a flash.)

MALE GREEK CHORUS. *(As Greg)* Evening again. May I ask you for the honor of a spin on the floor?

LI'L BIT. I'm . . . very complimented, Greg. But I . . . I just don't do fast dances.

MALE GREEK CHORUS. *(As Greg)* Oh. No problem. That's okay.

(He disappears. Teenage Greek Chorus watches him go.)

TEENAGE GREEK CHORUS. That is just so—*sad.*

(Li'l Bit becomes aware of Peck waiting.)

FEMALE GREEK CHORUS. You know, you should take it as a compliment that the guys want to watch you jiggle. They're guys. That's what they're supposed to do.

LI'L BIT. I guess you're right. But sometimes I feel like these alien life forces, these two mounds of flesh have grafted themselves onto my chest, and they're using me until they can "propagate" and take over the world and they'll just keep growing, with a mind of their own until I collapse under their weight and they suck all the nourishment out of my body and I finally just waste away while they get bigger and bigger and— *(Li'l Bit's classmates are just staring at her in disbelief)*

FEMALE GREEK CHORUS. —You are the strangest girl I have ever met.

(Li'l Bit's trying to joke but feels on the verge of tears.)

LI'L BIT. Or maybe someone's implanted radio transmitters in my chest at a frequency I can't hear, that girls can't detect, but they're sending out these signals to men who get mesmerized, like sirens, calling them to dash themselves on these "rocks"—

(Just then, the music segues into a slow dance, perhaps a Beach Boys tune like "Little Surfer," but over the music there's a rhythmic, hypnotic beeping transmitted, which both Greg and Peck hear. Li'l Bit hears it too, and in horror she stares at her chest. She, too, is almost hypnotized. In a trance, Greg responds to the signals and is called to her side—actually, her front. Like a zombie, he stands in front of her, his eyes planted on her two orbs.)

MALE GREEK CHORUS. *(As Greg)* This one's a slow dance. I hope your dance card isn't . . . filled?

(Li'l Bit is aware of Peck; but the signals are calling her to him. The signals are no longer transmitters, but an electromagnetic force, pulling Li'l Bit to his side, where he again waits for her to join him. She must get away from the dance floor.)

LI'L BIT. Greg—you really are a nice boy. But I don't like to dance.

MALE GREEK CHORUS. *(As Greg)* That's okay. We don't have to move or anything. I could just hold you and we could just *sway* a little—

LI'L BIT. —No! I'm sorry—but I think I have to leave; I hear someone calling me—

(Li'l Bit starts across the dance floor, leaving Greg behind. The beeping stops. The lights change, although the music does not. As Li'l Bit talks to the audience, she continues to change and prepare for the coming session. She should be wearing a tight tank top or a sheer blouse and very tight pants. To the audience:)

In every man's home some small room, some zone in his house, is set aside. It might be the attic, or the study, or a den. And there's an invisible sign as if from the old treehouse: Girls Keep Out.

Here, away from female eyes, lace doilies and crochet, he keeps his manly toys: the Vargas pinups, the tackle. A scent of tobacco and WD-40. (*She inhales deeply*) A dash of his Bay Rum. Ahhh . . . (*Li'l Bit savors it for just a moment more*)

Here he keeps his secrets: a violin or saxophone, drum set or darkroom, and the stacks of *Playboy*. (*In a whisper*) Here, in my aunt's home, it was the basement. Uncle Peck's turf.

(*A Voice commands:*)

You and the Reverse Gear.

LI'L BIT. 1965. The Photo Shoot.

(*Li'l Bit steps into the scene as a nervous but curious thirteen year old. Music, from the previous scene, continues to play, changing into something like Roy Orbison later—something seductive with a beat. Peck fiddles, all business, with his camera. As in the driving lesson, he is all competency and concentration. Li'l Bit stands awkwardly. He looks through the Leica camera on the tripod, adjusts the back lighting, etc.*)

PECK. Are you cold? The lights should heat up some in a few minutes—

LI'L BIT. —Aunt Mary is?

PECK. At the National Theatre matinee. With your mother. We have time.

LI'L BIT. But—what if—

PECK. —And so what if they return? I told them you and I were going to be working with my camera. They won't come down. (*Li'l Bit is quiet, apprehensive*)—Look, are you sure you want to do this?

LI'L BIT. I said I'd do it. But—

PECK. —I know. You've drawn the line.

LI'L BIT. (*Reassured*) That's right. No frontal nudity.

PECK. Good heavens, girl, where did you pick that up?

LI'L BIT. (*Defensive*) I read.

(*Peck tries not to laugh.*)

PECK. And I read *Playboy* for the interviews. Okay. Let's try some different music.

(*Peck goes to an expensive reel-to-reel and forwards. Something like "Sweet Dreams" begins to play.*)

LI'L BIT. I didn't know you listened to this.

PECK. I'm not dead, you know. I try to keep up. Do you like this song? (*Li'l Bit nods with pleasure*) Good. Now listen—at professional photo shoots, they always play music for the models. Okay? I want you to just enjoy the music. Listen to it with your body, and just—respond.

LI'L BIT. Respond to the music with my . . . body?

PECK. Right. Almost like dancing. Here—let's get you on the stool, first. (*Peck comes over and helps her up*)

LI'L BIT. But nothing showing—

(*Peck firmly, with his large capable hands, brushes back her hair, angles her face. Li'l Bit turns to him like a plant to the sun.*)

PECK. Nothing showing. Just a peek.

(*He holds her by the shoulder, looking at her critically. Then he unbuttons her blouse to the midpoint, and runs his hands over the flesh of her exposed sternum, arranging the fabric, just touching her. Deliberately, calmly. Asexually. Li'l Bit quiets, sits perfectly still, and closes her eyes*)

Okay?

LI'L BIT. Yes.

(*Peck goes back to his camera.*)

PECK. I'm going to keep talking to you. Listen without responding to what I'm saying; you want to *listen to the music*. Sway, move just your torso or your head—I've got to check the light meter.

LI'L BIT. But—you'll be watching.

PECK. No—I'm not here—just my voice. Pretend you're in your room all alone on a Friday night with your mirror—and the music feels good—just move for me, Li'l Bit—

(*Li'l Bit closes her eyes. At first self-conscious; then she gets more into the music and begins to sway. We hear the camera start to whir. Throughout the shoot, there can be a slide montage of actual shots of the actor playing Li'l Bit—interspersed with other models à la Playboy, Calvin Klein and Victoriana/Lewis Carroll's Alice Liddell*)

That's it. That looks great. Okay. Just keep doing that. Lift your head up a bit more, good, good, just keep moving, that a girl—you're a very beautiful young woman. Do you know that? (*Li'l Bit looks up, blushes. Peck shoots the camera. The audience should see this shot on the screen*)

Lı'ʟ Bɪᴛ. No. I don't know that.

Pᴇᴄᴋ. Listen to the music. (*Li'l Bit closes her eyes again*) Well you are. For a thirteen year old, you have a body a twenty-year-old woman would die for.

Lı'ʟ Bɪᴛ. The boys in school don't think so.

Pᴇᴄᴋ. The boys in school are little Neanderthals in short pants. You're ten years ahead of them in maturity; it's gonna take a while for them to catch up.

(*Peck clicks another shot; we see a faint smile on Li'l Bit on the screen*)

Girls turn into women long before boys turn into men.

Lı'ʟ Bɪᴛ. Why is that?

Pᴇᴄᴋ. I don't know, Li'l Bit. But it's a blessing for men.

(*Li'l Bit turns silent*) Keep moving. Try arching your back on the stool, hands behind you, and throw your head back. (*The slide shows a* Playboy *model in this pose*) Oohh, great. That one was great. Turn your head away, same position. (*Whir*) Beautiful.

(*Li'l Bit looks at him a bit defiantly.*)

Lı'ʟ Bɪᴛ. I think Aunt Mary is beautiful.

(*Peck stands still.*)

Pᴇᴄᴋ. My wife is a very beautiful woman. Her beauty doesn't cancel yours out. (*More casually; he returns to the camera*) All the women in your family are beautiful. In fact, I think all women are. You're not listening to the music. (*Peck shoots some more film in silence*) All right, turn your head to the left. Good. Now take the back of your right hand and put in on your right cheek—your elbow angled up—now slowly, slowly, stroke your cheek, draw back your hair with the back of your hand. (*Another classic* Playboy *or Vargas*) Good. One hand above and behind your head; stretch your body; smile. (*Another pose*)

Li'l Bit. I want you to think of something that makes you laugh—

Lı'ʟ Bɪᴛ. I can't think of anything.

Pᴇᴄᴋ. Okay. Think of Big Papa chasing Grandma around the living room. (*Li'l Bit lifts her head and laughs. Click. We should see this shot*) Good. Both hands behind your head. Great! Hold that. (*From behind his camera*) You're doing great work. If we keep this up, in five years we'll have a really professional portfolio.

(*Li'l Bit stops.*)

Lı'ʟ Bɪᴛ. What do you mean in five years?

Pᴇᴄᴋ. You can't submit work to *Playboy* until you're eighteen.—

(*Peck continues to shoot; he knows he's made a mistake.*)

Lı'ʟ Bɪᴛ. —Wait a minute. You're joking, aren't you, Uncle Peck?

Pᴇᴄᴋ. Heck, no. You can't get into *Playboy* unless you're the very best. And you are the very best.

Lı'ʟ Bɪᴛ. I would never do that!

(*Peck stops shooting. He turns off the music.*)

Pᴇᴄᴋ. Why? There's nothing wrong with *Playboy*—it's a very classy maga—

Lı'ʟ Bɪᴛ. (*More upset*) But I thought you said I should go to college!

Pᴇᴄᴋ. Wait—Li'l Bit—it's nothing like that. Very respectable women model for *Playboy*—actresses with major careers—women in college—there's an Ivy League issue every—

Lı'ʟ Bɪᴛ. —I'm never doing anything like that! You'd show other people these—other *men*—these—what I'm doing. —Why would you do that?! Any *boy* around here could just pick up, just go into The Stop & Go and *buy*— Why would you ever want to—to share—

Pᴇᴄᴋ. —Whoa, whoa. Just stop a second and listen to me. Li'l Bit. Listen. There's nothing wrong in what we're doing. I'm very proud of you. I think you have a wonderful body and an even more wonderful mind. And of course I want other people to *appreciate* it. It's not anything shameful.

Lı'ʟ Bɪᴛ. (*Hurt*) But this is something—that I'm only doing for you. This is something—that you said was just between us.

Pᴇᴄᴋ. It is. And if that's how you feel, five years from now, it will remain that way. Okay? I know you're not going to do anything you don't feel like doing.

(*He walks back to the camera*) Do you want to stop now? I've got just a few more shots on this roll—

Lı'ʟ Bɪᴛ. I don't want anyone seeing this.

PECK. I swear to you. No one will. I'll treasure this—that you're doing this only for me.

(Li'l Bit, still shaken, sits on the stool. She closes her eyes) Li'l Bit? Open your eyes and look at me. *(Li'l Bit shakes her head no)* Come on. Just open your eyes, honey.

LI'L BIT. If I look at you—if I look at the camera: You're gonna know what I'm thinking. You'll see right through me—

PECK. —No, I won't. I want you to look at me. All right, then. I just want you to listen. Li'l Bit. *(She waits)* I love you. *(Li'l Bit opens her eyes; she is startled. Peck captures the shot. On the screen we see right though her. Peck says softly)* Do you know that? *(Li'l Bit nods her head yes)* I have loved you every day since the day you were born.

LI'L BIT. Yes.

(Li'l Bit and Peck just look at each other. Beat. Beneath the shot of herself on the screen, Li'l Bit, still looking at her uncle, begins to unbutton her blouse.

A neutral Voice cuts off the above scene with:)

Implied Consent.

As an individual operating a motor vehicle in the state of Maryland, you must abide by "Implied Consent." If you do not consent to take the blood alcohol content test, there may be severe penalties: a suspension of license, a fine, community service and a possible jail sentence.

(The Voice shifts tone:)

Idling in the Neutral Gear.

MALE GREEK CHORUS. *(Announcing)* Aunt Mary on behalf of her husband.

(Female Greek Chorus checks her appearance, and with dignity comes to the front of the stage and sits down to talk to the audience.)

FEMALE GREEK CHORUS. *(As Aunt Mary)* My husband was such a good man—is. Is such a good man. Every night, he does the dishes. The second he comes home, he's taking out the garbage, or doing yard work, lifting the heavy things I can't. Everyone in the neighborhood borrows Peck—it's true—women with husbands of their own, men who just don't have Peck's abilities—there's always a knock on our door for a jump start on cold mornings, when anyone needs a ride, or help shoveling the sidewalk—I look out, and there Peck is, without a coat, pitching in.

I know I'm lucky. The man works from dawn to dusk. And the overtime he does every year—my poor sister. She sits every Christmas when I come to dinner with a new stole, or diamonds, or with the tickets to Bermuda.

I know he has troubles. And we don't talk about them. I wonder, sometimes, what happened to him during the war. The men who fought World War II didn't have "rap sessions" to talk about their feelings. Men in his generation were expected to be quiet about it and get on with their lives. And sometimes I can feel him just fighting the trouble—whatever has burrowed deeper than the scar tissue—and we don't talk about it. I know he's having a bad spell because he comes looking for me in the house, and just hangs around me until it passes. And I keep my banter light—I discuss a new recipe, or sales, or gossip—because I think domesticity can be a balm for men when they're lost. We sit in the house and listen to the peace of the clock ticking in his well-ordered living room, until it passes.

(Sharply) I'm not a fool. I know what's going on. I wish you could feel how hard Peck fights against it—he's swimming against the tide, and what he needs is to see me on the shore, believing in him, knowing he won't go under, he won't give up—

And I want to say this about my niece. She's a sly one, that one is. She knows exactly what she's doing; she's twisted Peck around her little finger and thinks it's all a big secret. Yet another one who's borrowing my husband until it doesn't suit her anymore.

Well. I'm counting the days until she goes away to school. And she manipulates someone else. And then he'll come back again, and sit in the kitchen while I bake, or beside me on the sofa when I sew in the evenings. I'm a very patient woman. But I'd like my husband back.

I am counting the days.

(A Voice repeats:)

You and the Reverse Gear.

MALE GREEK CHORUS. Li'l Bit's Thirteenth Christmas. Uncle Peck Does the Dishes. Christmas 1964.

(Peck stands in a dress shirt and tie, nice pants, with an apron. He is washing dishes. He's in a mood we haven't seen. Quiet, brooding. Li'l Bit watches him a moment before seeking him out.)

LI'L BIT. Uncle Peck? *(He does not answer. He continues to work on the pots)* I didn't know where you'd gone to. *(He nods. She takes this as a sign to come in)* Don't you want to sit with us for a while?

PECK. No. I'd rather do the dishes.

(Pause. Li'l Bit watches him.)

LI'L BIT. You're the only man I know who does dishes. *(Peck says nothing)* I think it's really nice.

PECK. My wife has been on her feet all day. So's your grandmother and your mother.

LI'L BIT. I know. *(Beat)* Do you want some help?

PECK. No. *(He softens a bit towards her)* You can help by just talking to me.

LI'L BIT. Big Papa never does the dishes. I think it's nice.

PECK. I think men should be nice to women. Women are always working for us. There's nothing particularly manly in wolfing down food and then sitting around in a stupor while the women clean up.

LI'L BIT. That looks like a really neat camera that Aunt Mary got you.

PECK. It is. It's a very nice one.

(Pause, as Peck works on the dishes and some demon that Li'l Bit intuits.)

LI'L BIT. Did Big Papa hurt your feelings?

PECK. *(Tired)* What? Oh, no—it doesn't hurt me. Family is family. I'd rather have him picking on me than—I don't pay him any mind, Li'l Bit.

LI'L BIT. Are you angry with us?

PECK. No, Li'l Bit. I'm not angry.

(Another pause.)

LI'L BIT. We missed you at Thanksgiving. . . . I did. I missed you.

PECK. Well, there were . . . "things" going on. I didn't want to spoil anyone's Thanksgiving.

LI'L BIT. Uncle Peck? *(Very carefully)* Please don't drink anymore tonight.

PECK. I'm not . . . overdoing it.

LI'L BIT. I know. *(Beat)* Why do you drink so much?

(Peck stops and thinks, carefully.)

PECK. Well, Li'l Bit—let me explain it this way. There are some people who have a . . . a "fire" in the belly.

I think they go to work on Wall Street or they run for office. And then there are people who have a "fire" in their heads—and they become writers or scientists or historians. *(He smiles a little at her)* You. You've got a "fire" in the head. And then there are people like me.

LI'L BIT. Where do you have . . . a fire?

PECK. I have a fire in my heart. And sometimes the drinking helps.

LI'L BIT. There's got to be other things that can help.

PECK. I suppose there are.

LI'L BIT. Does it help—to talk to me?

PECK. Yes. It does. *(Quiet)* I don't get to see you very much.

LI'L BIT. I know. *(Li'l Bit thinks)* You could talk to me more.

PECK. Oh?

LI'L BIT. I could make a deal with you, Uncle Peck.

PECK. I'm listening.

LI'L BIT. We could meet and talk—once a week. You could just store up whatever's bothering you during the week—and then we could talk.

PECK. Would you like that?

LI'L BIT. As long as you don't drink. I'd meet you somewhere for lunch or for a walk—on the weekends—as long as you stop drinking. And we could talk about whatever you want.

PECK. You would do that for me?

LI'L BIT. I don't think I'd want Mom to know. Or Aunt Mary. I wouldn't want them to think—

PECK. —No. It would just be us talking.

LI'L BIT. I'll tell Mom I'm going to a girlfriend's. To study. Mom doesn't get home until six, so you can call me after school and tell me where to meet you.

PECK. You get home at four?

LI'L BIT. We can meet once a week. But only in public. You've got to let me—draw the line. And once it's drawn, you mustn't cross it.

PECK. Understood.

LI'L BIT. Would that help?

(Peck is very moved.)

PECK. Yes. Very much.

Li'l Bit. I'm going to join the others in the living room now. (*Li'l Bit turns to go*)

Peck. Merry Christmas, Li'l Bit.

(*Li'l Bit bestows a very warm smile on him.*)

Li'l Bit. Merry Christmas, Uncle Peck.

(*A Voice dictates:*)

Shifting Forward from Second to Third Gear.

(*The Male and Female Greek Chorus members come forward.*)

Male Greek Chorus. 1969. Days and Gifts: A Countdown:

Female Greek Chorus. A note. "September 3, 1969. Li'l Bit: You've only been away two days and it feels like months. Hope your dorm room is cozy. I'm sending you this tape cassette—it's a new model— so you'll have some music in your room. Also that music you're reading about for class—*Carmina Burana*. Hope you enjoy. Only ninety days to go! —Peck."

Male Greek Chorus. September 22. A bouquet of roses. A note: "Miss you like crazy. Sixty-nine days . . ."

Teenage Greek Chorus. September 25. A box of chocolates. A card: "Don't worry about the weight gain. You still look great. Got a post office box—write to me there. Sixty-six days. —Love, your candy man."

Male Greek Chorus. October 16. A note: "Am trying to get through the Jane Austin you're reading— *Emma*—here's a book in return: *Liaisons Dangereuses*. Hope you're saving time for me." Scrawled in the margin the number: "47."

Female Greek Chorus. November 16. "Sixteen days to go!—Hope you like the perfume.—Having a hard time reaching you on the dorm phone. You must be in the library a lot. Won't you think about me getting you your own phone so we can talk?"

Teenage Greek Chorus. November 18. "Li'l Bit—got a package returned to the P.O. Box. Have you changed dorms? Call me at work or write to the P.O. Am still on the wagon. Waiting to see you. Only two weeks more!"

Male Greek Chorus. November 23. A letter. "Li'l Bit. So disappointed you couldn't come home for the turkey. Sending you some money for a nice dinner out—nine days and counting!"

Greek Chorus. (*In unison*) November 25th. A letter:

Li'l Bit. "Dear Uncle Peck: I am sending this to you at work. Don't come up next weekend for my birthday. I will not be here—"

(*A Voice directs:*)

Shifting Forward from Third to Fourth Gear.

Male Greek Chorus. December 10, 1969. A hotel room. Philadelphia. There is no moon tonight.

(*Peck sits on the side of the bed while Li'l Bit paces. He can't believe she's in his room, but there's a desperate edge to his happiness. Li'l Bit is furious, edgy. There is a bottle of champagne in an ice bucket in a very nice hotel room.*)

Peck. Why don't you sit?

Li'l Bit. I don't want to. —What's the champagne for?

Peck. I thought we might toast your birthday—

Li'l Bit. —I am so pissed off at you, Uncle Peck.

Peck. Why?

Li'l Bit. I mean, are you crazy?

Peck. What did I do?

Li'l Bit. You scared the holy crap out of me—sending me that stuff in the mail—

Peck. —They were gifts! I just wanted to give you some little perks your first semester—

Li'l Bit. —Well, what the hell were those numbers all about! Forty-four days to go—only two more weeks. —And then just numbers—69—68—67— like some serial killer!

Peck. Li'l Bit! Whoa! This is me you're talking to—I was just trying to pick up your spirits, trying to celebrate your birthday.

Li'l Bit. My *eighteenth* birthday. I'm not a child, Uncle Peck. You were counting down to my eighteenth birthday.

Peck. So?

Li'l Bit. So? So statutory rape is not in effect when a young woman turns eighteen. And you and I both know it.

(*Peck is walking on ice.*)

Peck. I think you misunderstand.

Li'l Bit. I think I understand all too well. I know what you want to do five steps ahead of you doing it. Defensive Driving 101.

Peck. Then why did you suggest we meet here instead of the restaurant?

Li'l Bit. I don't want to have this conversation in public.

Peck. Fine. Fine. We have a lot to talk about.

Li'l Bit. Yeah. We do.

(Li'l Bit doesn't want to do what she has to do) Could I . . . have some of that champagne?

Peck. Of course, madam! *(Peck makes a big show of it)* Let me do the honors. I wasn't sure which you might prefer—Taittingers or Veuve Clicquot—so I thought we'd start out with an old standard—Perrier Jouet. *(The bottle is popped)*

Quick—Li'l Bit—your glass! *(Uncle Peck fills Li'l Bit's glass. He puts the bottle back in the ice and goes for a can of ginger ale)* Let me get some of this ginger ale— my bubbly—and toast you.

(He turns and sees that Li'l Bit has not waited for him.)

Li'l Bit. Oh—sorry, Uncle Peck. Let me have another. *(Peck fills her glass and reaches for his ginger ale; she stops him)* Uncle Peck—maybe you should join me in the champagne.

Peck. You want me to—drink?

Li'l Bit. It's not polite to let a lady drink alone.

Peck. Well, missy, if you insist. . . . *(Peck hesitates)* —Just one. It's been a while. *(Peck fills another flute for himself)* There. I'd like to propose a toast to you and your birthday! *(Peck sips it tentatively)* I'm not used to this anymore.

Li'l Bit. You don't have anywhere to go tonight, do you?

(Peck hopes this is a good sign.)

Peck. I'm all yours. —God, it's good to see you! I've gotten so used to . . . to . . . talking to you in my head. I'm used to seeing you every week—there's so much—I don't quite know where to begin. How's school, Li'l Bit?

Li'l Bit. I—it's hard. Uncle Peck. Harder than I thought it would be. I'm in the middle of exams and papers and—I don't know.

Peck. You'll pull through. You always do.

Li'l Bit. Maybe. I . . . might be flunking out.

Peck. You always think the worse, Li'l Bit, but when the going gets tough— *(Li'l Bit shrugs and pours herself another glass)* —Hey, honey, go easy on that stuff, okay?

Li'l Bit. Is it very expensive?

Peck. Only the best for you. But the cost doesn't matter—champagne should be "sipped." *(Li'l Bit is quiet)* Look—if you're in trouble in school—you can always come back home for a while.

Li'l Bit. No— *(Li'l Bit tries not to be so harsh)* — Thanks, Uncle Peck, but I'll figure some way out of this.

Peck. You're supposed to get in scrapes, your first year away from home.

Li'l Bit. Right. How's Aunt Mary?

Peck. She's fine. *(Pause)* Well—how about the new car?

Li'l Bit. It's real nice. What is it, again?

Peck. It's a Cadillac El Dorado.

Li'l Bit. Oh. Well, I'm real happy for you, Uncle Peck.

Peck. I got it for you.

Li'l Bit. What?

Peck. I always wanted to get a Cadillac—but I thought, Peck, wait until Li'l Bit's old enough—and thought maybe you'd like to drive it, too.

Li'l Bit *(Confused)*. Why would I want to drive your car?

Peck. Just because it's the best—I want you to have the best.

(They are running out of "gas"; small talk.)

Li'l Bit Peck. Listen, Uncle Peck, I don't
I have been thinking of how know how to begin
this, to say this in my head, over but—and over—

Peck. Sorry.

Li'l Bit. You first.

Peck. Well, your going away—has just made me realize how much I miss you. Talking to you and being alone with you. I've really come to depend on you, Li'l Bit. And it's been so hard to get in touch with you lately—the distance and—and you're never in when I call—I guess you've been living in the library—

LI'L BIT. —No—the problem is, I haven't been in the library—

PECK. —Well, it doesn't matter—I hope you've been missing me as much.

LI'L BIT. Uncle Peck—I've been thinking a lot about this—and I came here tonight to tell you that—I'm not doing very well. I'm getting very confused—I can't concentrate on my work—and now that I'm away—I've been going over and over it in my mind—and I don't want us to "see" each other anymore. Other than with the rest of the family.

PECK (*Quiet*). Are you seeing other men?

LI'L BIT (*Getting agitated*). I—no, that's not the reason—I—well, yes, I am seeing other—listen, it's not really anybody's business!

PECK. Are you in love with anyone else?

LI'L BIT. That's not what this is about.

PECK. Li'l Bit—you're scared. Your mother and your grandparents have filled your head with all kinds of nonsense about men—I hear them working on you all the time—and you're scared. It won't hurt you—if the man you go to bed with really loves you. (*Li'l Bit is scared. She starts to tremble*) And I have loved you since the day I held you in my hand. And I think everyone's just gotten you frightened to death about something that is just like breathing—

LI'L BIT. Oh, my god—(*She takes a breath*) I can't see you anymore, Uncle Peck.

(*Peck downs the rest of his champagne.*)

PECK. Li'l Bit. Listen. Listen. Open your eyes and look at me. Come on. Just open your eyes, honey. (*Li'l Bit, eyes squeezed shut, refuses*) All right then. I just want you to listen. Li'l Bit—I'm going to ask you just this once. Of your own free will. Just lie down on the bed with me—our clothes on—just lie down with me, a man and a woman . . . and let's . . . hold one another. Nothing else. Before you say anything else. I want the chance to . . . hold you. Because sometimes the body knows things that the mind isn't listening to . . . and after I've held you, then I want you to tell me what you feel.

LI'L BIT. You'll just . . . hold me?

PECK. Yes. And then you can tell me what you're feeling.

(*Li'l Bit—half wanting to run, half wanting to get it over with, half wanting to be held by him:*)

LI'L BIT. Yes. All right. Just hold. Nothing else.

(*Peck lies down on the bed and holds his arms out to her. Li'l Bit lies beside him, putting her head on his chest. He looks as if he's trying to soak her into his pores by osmosis. He strokes her hair, and she lies very still. The Male Greek Chorus member and the Female Greek Chorus member as Aunt Mary come into the room.*)

MALE GREEK CHORUS. Recipe for a Southern Boy:

FEMALE GREEK CHORUS. (*As Aunt Mary*) A drawl of molasses in the way he speaks.

MALE GREEK CHORUS. A gumbo of red and brown mixed in the cream of his skin.

(*While Peck lies, his eyes closed, Li'l Bit rises in the bed and responds to her aunt.*)

LI'L BIT. Warm brown eyes—

FEMALE GREEK CHORUS. (*As Aunt Mary*) Bedroom eyes—

MALE GREEK CHORUS. A dash of Southern Baptist Fire and Brimstone—

LI'L BIT. A curl of Elvis on his forehead—

FEMALE GREEK CHORUS. (*As Aunt Mary*) A splash of Bay Rum—

MALE GREEK CHORUS. A closely shaven beard that he razors just for you—

FEMALE GREEK CHORUS. (*As Aunt Mary*) Large hands—rough hands—

LI'L BIT. Warm hands—

MALE GREEK CHORUS. The steel of the military in his walk—

LI'L BIT. The slouch of the fishing skiff in his walk—

MALE GREEK CHORUS. Neatly pressed khakis—

FEMALE GREEK CHORUS. (*As Aunt Mary*) And under the wide leather of the belt—

LI'L BIT. Sweat of cypress and sand—

MALE GREEK CHORUS. Neatly pressed khakis—

LI'L BIT. His heart beating Dixie—

FEMALE GREEK CHORUS. (*As Aunt Mary*) The whisper of the zipper—you could reach out with your hand and—

Li'l Bit. His mouth—

Female Greek Chorus (*As Aunt Mary*). You could just reach out and—

Li'l Bit. Hold him in your hand—

Female Greek Chorus (*As Aunt Mary*). And his mouth—

(*Li'l Bit rises above her uncle and looks at his mouth; she starts to lower herself to kiss him—and wrenches herself free. She gets up from the bed.*)

Li'l Bit. —I've got to get back.

Peck. Wait—Li'l Bit. Did you . . . feel nothing?

Li'l Bit. (*Lying*) No. Nothing.

Peck. Do you—do you think of me?

(*The Greek Chorus whispers:*)

Female Greek Chorus. Khakis—

Male Greek Chorus. Bay Rum—

Female Greek Chorus. The whisper of the—

Li'l Bit. —No.

(*Peck, in a rush, trembling, gets something out of his pocket.*)

Peck. I'm forty-five. That's not old for a man. And I haven't been able to do anything else but think of you. I can't concentrate on my work—Li'l Bit. You've got to—I want you to think about what I am about to ask you.

Li'l Bit. I'm listening.

(*Peck opens a small ring box.*)

Peck. I want you to be my wife.

Li'l Bit. This isn't happening.

Peck. I'll tell Mary I want a divorce. We're not blood-related. It would be legal—

Li'l Bit. —What have you been thinking! You are married to my aunt, Uncle Peck. She's my family. You have—you have gone way over the line. Family is family.

(*Quickly, Li'l Bit flies through the room, gets her coat*) I'm leaving. Now. I am not seeing you. Again.

(*Peck lies down on the bed for a moment, trying to absorb the terrible news. For a moment, he almost curls into a fetal position*)

I'm not coming home for Christmas. You should go home to Aunt Mary. Go home now, Uncle Peck.

(*Peck gets control, and sits, rigid*)

Uncle Peck?—I'm sorry but I have to go.

(*Pause*)

Are you all right.

(*With a discipline that comes from being told that boys don't cry, Peck stands upright.*)

Peck. I'm fine. I just think—I need a real drink.

(*The Male Greek Chorus has become a bartender. At a small counter, he is lining up shots for Peck. As Li'l Bit narrates, we see Peck sitting, carefully and calmly downing shot glasses.*)

Li'l Bit (*To the audience*). I never saw him again. I stayed away from Christmas and Thanksgiving for years after.

It took my uncle seven years to drink himself to death. First he lost his job. then his wife, and finally his driver's license. He retreated to his house, and had his bottles delivered.

(*Peck stands, and puts his hands in front of him—almost like Superman flying*)

One night he tried to go downstairs to the basement—and he flew down the steep basement stairs. My aunt came by weekly to put food on the porch, and she noticed the mail and the papers stacked up, uncollected.

They found him at the bottom of the stairs. Just steps away from his dark room.

Now that I'm old enough, there are some questions I would have liked to have asked him. Who did it to you, Uncle Peck? How old were you? Were you eleven?

(*Peck moves to the driver's seat of the car and waits*)

Sometimes I think of my uncle as a kind of Flying Dutchman. In the opera, the Dutchman is doomed to wander the sea; but every seven years he can come ashore, and if he finds a maiden who will love him of her own free will—he will be released.

And I see Uncle Peck in my mind, in his Chevy '56, a spirit driving up and down the back roads of Carolina—looking for a young girl who, of her own free will, will love him. Release him.

(*A Voice states:*)

You and the Reverse Gear.

Li'l Bit. The summer of 1962. On Men, Sex, and Women: Part III:

(Li'l Bit steps, as an eleven year old, into:)

FEMALE GREEK CHORUS *(As Mother)*. It is out of the question. End of Discussion.

LI'L BIT. But why?

FEMALE GREEK CHORUS *(As Mother)*. Li'l Bit—we are not discussing this. I said no.

LI'L BIT. But I could spend an extra week at the beach! You're not telling me why!

FEMALE GREEK CHORUS *(As Mother)*. Your uncle pays entirely too much attention to you.

LI'L BIT. He listens to me when I talk. And—and he talks to me. He teaches me about things. Mama— he knows an awful lot.

FEMALE GREEK CHORUS *(As Mother)*. He's a small town hick who's learned how to mix drinks from Hugh Hefner.

LI'L BIT. Who's Hugh Hefner?

(Beat.)

FEMALE GREEK CHORUS *(As Mother)*. I am not letting an eleven-year-old girl spend seven hours alone in the car with a man. . . . I don't like the way your uncle looks at you.

LI'L BIT. For god's sake, mother! Just because you've gone through a bad time with my father—you think every man is evil!

FEMALE GREEK CHORUS *(As Mother)*. Oh no, Li'l Bit— not all men. . . . We . . . we just haven't been very lucky with the men in our family.

LI'L BIT. Just because you lost your husband—I still deserve a chance at having a father! Someone! A man who will look out for me! Don't I get a chance?

FEMALE GREEK CHORUS *(As Mother)*. I will feel terrible if something happens.

LI'L BIT. Mother! It's in your head! Nothing will happen! I can take care of myself. And I can certainly handle Uncle Peck.

FEMALE GREEK CHORUS *(As Mother)*. All right. But I'm warning you—if anything happens, I hold you responsible.

(Li'l Bit moves out of this scene and toward the car.)

LI'L BIT. 1962. On the Back Roads of Carolina: The First Driving Lesson.

(The Teenage Greek Chorus member stands apart on stage. She will speak all of Li'l Bit's lines. Li'l Bit sits beside Peck in the front seat. She looks at him closely, remembering.)

PECK. Li'l Bit? Are you getting tired?

TEENAGE GREEK CHORUS. A little.

PECK. It's a long drive. But we're making really good time. We can take the back road from here and see . . . a little scenery. Say—I've got an idea—*(Peck checks his rearview mirror)*

TEENAGE GREEK CHORUS. Are we stopping, Uncle Peck?

PECK. There's no traffic here. Do you want to drive?

TEENAGE GREEK CHORUS. I can't drive.

PECK. It's easy. I'll show you how. I started driving when I was your age. Don't you want to?—

TEENAGE GREEK CHORUS. —But it's against the law at my age!

PECK. And that's why you can't tell anyone I'm letting you do this—

TEENAGE GREEK CHORUS. —But—I can't reach the pedals.

PECK. You can sit in my lap and steer. I'll push the pedals for you. Did your father ever let you drive his car?

TEENAGE GREEK CHORUS. No way.

PECK. Want to try?

TEENAGE GREEK CHORUS. Okay. *(Li'l Bit moves into Peck's lap. She leans against him, closing her eyes)*

PECK. You're just a little thing, aren't you? Okay—now think of the wheel as a big clock—I want you to put your right hand on the clock where three o'clock would be; and your left hand on the nine—

(Li'l Bit puts one hand to Peck's face, to stroke him. Then, she takes the wheel.)

TEENAGE GREEK CHORUS. Am I doing it right?

PECK. That's right. Now, whatever you do, don't let go of the wheel. You tell me whether to go faster or slower—

TEENAGE GREEK CHORUS. Not so fast, Uncle Peck!

PECK. Li'l Bit—I need you to watch the road—

(Peck puts his hands on Li'l Bit's breasts. She relaxes against him, silent, accepting his touch.)

TEENAGE GREEK CHORUS. Uncle Peck—what are you doing?

PECK. Keep driving. *(He slips his hands under her blouse)*

TEENAGE GREEK CHORUS. Uncle Peck—please don't do this—

PECK. —Just a moment longer . . . *(Peck tenses against Li'l Bit)*

TEENAGE GREEK CHORUS. *(Trying not to cry)* This isn't happening.

(Peck tenses more, sharply. He buries his face in Li'l Bit's neck, and moans softly. The Teenage Greek Chorus exits, and Li'l Bit steps out of the car. Peck, too, disappears.

A Voice reflects:)

Driving In Today's World.

LI'L BIT. That day was the last day I lived in my body. I retreated above the neck, and I've lived inside the "fire" in my head ever since.

And now that seems like a long, long time ago. When we were both very young.

And before you know it, I'll be thirty-five. That's getting up there for a woman. And I find myself believing in things that a younger self vowed never to believe in. Things like family and forgiveness.

I know I'm lucky. Although I still have never known what it feels like to jog or dance. Any thing that . . . "jiggles." I do like to watch people on the dance floor, or out on the running paths, just jiggling away. And I say—good for them. *(Li'l Bit moves to the car with pleasure)*

The nearest sensation I feel—of flight in the body—I guess I feel when I'm driving. On a day like today. It's five A.M. The radio says it's going to be clear and crisp.

I've got five hundred miles of highway ahead of me—and some back roads too. I filled the tank last night, and had the oil checked. Checked the tires, too. You've got to treat her . . . with respect.

First thing I do is: Check under the car. To see if any two year olds or household cats have crawled beneath, and strategically placed their skulls behind my back tires. *(Li'l Bit crouches)*

Nope. Then I get in the car. *(Li'l Bit does so)*

I lock the doors. And turn the key. Then I adjust the most important control on the dashboard—the radio— *(Li'l Bit turns the radio on: We hear all of the Greek Chorus overlapping, and static:)*

FEMALE GREEK CHORUS. *(Overlapping)* —"You were so tiny you fit in his hand—"

MALE GREEK CHORUS. *(Overlapping)* —"How is Shakespeare gonna help her lie on her back in the—"

TEENAGE GREEK CHORUS. *(Overlapping)* —"Am I doing it right?"

(Li'l Bit fine-tunes the radio station. A song like "Dedicated to the One I Love" or Orbison's "Sweet Dreams" comes on, and cuts off the Greek Chorus.)

LI'L BIT. Ahh . . . *(Beat)* I adjust my seat. Fasten my seat belt. Then I check the right side mirror—check the left side. *(She does)* Finally, I adjust the rearview mirror. *(As Li'l Bit adjusts the rearview mirror, a faint light strikes the spirit of Uncle Peck, who is sitting in the back seat of the car. She sees him in the mirror. She smiles at him, and he nods at her. They are happy to be going for a long drive together. Li'l Bit slips the car into first gear; to the audience:)* And then—I floor it. *(Sound of a car taking off. Blackout)*

End of Play

Topdog/Underdog

Suzan-Lori Parks: The Unflinching Street Poet

In the 1990s, a bold new voice began to be noticed by the American theatre scene. It was the voice of Suzan-Lori Parks. Parks was born into a military family in 1964 and attended high school in Germany, where her family was stationed. Some believe this formative time overseas enhanced both Parks's perspective and her grasp of language. She returned to the United States to attend college at Mount Holyoke in Massachusetts, where she studied writing with civil rights activist and novelist James Baldwin. Baldwin encouraged Parks to try writing plays. Her first endeavors were met with some harsh criticism, but Baldwin continued to support Parks, calling her "an utterly astounding and beautiful creature who may become one of the most valuable artists of our time."

After graduation, Parks spent a year studying the London theatre scene before moving to New York City. In New York, she did what most new playwrights do: she worked temporary jobs to pay the bills while trying to break into the New York theatre scene. In 1989, her first full-length play, *Imperceptible Mutabilities in the Third Kingdom,* was staged at the Brooklyn Arts and Culture Association. The play was highly praised by critics and went on to win the off Broadway Obie Award for Best New Play.

The rest, as they say, is history. Parks spent much of the 1990s writing both plays and screenplays and working with the Yale School of Drama, the Actors Theatre of Louisville, Spike Lee (she wrote the screenplay for *Girl 6*), and George C. Wolfe. Her plays from this period are filled with surreal imagery and exaggerated, uninhibited, and imaginative poetic language. She compares her theatrical writing style to what she calls the "rep and rev" of jazz music: the repetition and revision of a musical phrase. She uses her gift for language and the surreal to explore various perspectives on African American culture. Her 1999 play, *In the Blood,* was inspired by the themes of adultery and atonement in Nathaniel Hawthorne's *The Scarlet Letter,* but Parks's Hester is a modern-day homeless woman trying to raise children from five different fathers. *In the Blood* takes a darkly poetic look at poverty, the welfare system, motherhood, absentee and dead-beat fathers, and even religious hypocrisy. *Venus,* which won Parks her second Obie Award in 1996, is a fictional recounting of the Hottentot Venus. The real-life Hottentot Venus was Saartjie Baartman, an African woman who was placed naked in a cage and toured around Europe to be stared at as an exotic curiosity. Other major plays from this period include Parks's *The America Play* and *Fucking A.*

Topdog/Underdog (2001) took a step back from Parks's surrealistic works but still dealt heavily with black issues. Since her huge success with *Topdog/Underdog,* Parks has spent much of her creative energy writing for television and film. She wrote the screenplays for *Their Eyes Were Watching God* and *The Great Debaters*. From November 2002 through November 2003, Suzan-Lori Parks took on a unique and ambitious task. She wrote one short play per day for every single one of the three hundred and sixty five days of a calendar year. Every day she would force herself to begin and complete a short theatre piece. The result was Parks's *365 Days/365 Plays,* which has since been produced by more than 700 theatres around the world. Since then, Parks has written several new plays, including a musical about Ray Charles, and she is currently serving as the writer in residence at New York's Public Theatre.

Parks's ability to fearlessly and graphically examine the black experience through highly theatrical and poetic work makes her a treasure. She has her own style, and this

style has reenergized theatre audiences around the world. She is one of the world's most exciting contemporary dramatists.

Topdog/Underdog

Suzan-Lori Parks's 2001 masterpiece *Topdog/Underdog* is stylistically different from her more exaggerated and surrealistic early plays. The setting is quite realistic: a single room, inner-city apartment shared by two brothers. The older brother is Lincoln, an ex-three-card monte hustler who now makes a living as an Abraham Lincoln impersonator. The younger brother is Booth, a thief who is named for the man who assassinated President Lincoln.

While the play explores the gritty reality of these two brothers struggling in a merciless world, Parks layers powerful theatricality onto the piece. The character names alone are unusual and evocative. Her image of a black man made up in white face practicing his "death scene" as Abraham Lincoln is haunting. Parks uses her considerable skill with language by building in the rhythmic patter of a three-card monte dealer throughout the play. The three-card sequences are very in keeping with Parks's jazzy "rep and rev" as she calls it. Parks also has her own style when it comes to stage directions, which she often employs to enhance moments of silence between characters.

Topdog/Underdog first opened in 2001 at the Public Theatre in New York. The production was directed by the legendary George C. Wolfe, and it starred two powerhouse young actors: Don Cheadle and Jeffrey Wright. The show was a huge hit, eventually moving to Broadway and earning Suzan-Lori Parks a Pulitzer Prize for Drama.

The play stirs a powerful mixture of emotions in those who read and/or watch it. It is alternately chilling, hilarious, innocent, corrupt, intense, and deflating. A plot synopsis would only cheapen the impact of this incredible drama. It is not for the faint of heart. The language and content of this play can be brutally realistic. Approach it with an open mind and you'll get a good sense of the power of Suzan-Lori Parks's dramatic skill.

Food for Thought

As you read the play, consider the following questions:

1. Do you think these two brothers love one another? Why or why not?
2. Lincoln was obviously the more street-smart of the two brothers. What happened to him? Why is he a broken man when we first meet him?
3. What significance does the three-card monte game and patter hold for these characters?
4. Do Suzan-Lori Parks's unusual stage directions make this play stronger? Why or why not?
5. Why do you think Booth does the terrible things he does at the end of this play?

Fun Facts

1. When *Topdog/Underdog* moved to Broadway, rapper and actor Mos Def took over the role of Booth.
2. Suzan-Lori Parks was the first African American woman to receive the Pulitzer Prize for Drama.
3. Mount Holyoke has turned out two Pulitzer Prize–winning female playwrights. Wendy Wasserstein won the coveted award in 1989 for her play *The Heidi Chronicles*. Wasserstein graduated from Mount Holyoke in 1971.
4. *Time* magazine named Suzan-Lori Parks one of its "100 Innovators for the Next New Wave."

Topdog/Underdog

Suzan-Lori Parks

The Players
LINCOLN, *the topdog*
BOOTH (*aka 3-Card*), *the underdog*

A Spell
An elongated and heightened (Rest). Denoted by repetition of figures' names with no dialogue. Has sort of an architectural look:
LINCOLN
BOOTH
LINCOLN
BOOTH
This is a place where the figures experience their pure true simple state. While no action or stage business is necessary, directors should fill this moment as they best see fit. [Brackets in the text indicate optional cuts for production.] (Parentheses around dialogue indicate softly spoken passages (asides: sotto voce)).

Scene One

Thursday evening. A seedily furnished rooming house room. A bed, a reclining chair, a small wooden chair. Some other stuff but not much else. BOOTH, a black man in his early 30s, practices his 3-card monte scam on the classic setup: 3 playing cards and the cardboard playing board atop 2 mismatched milk crates. His moves and accompanying patter are, for the most part, studied and awkward.

BOOTH. Watch me close watch me close now: who-see-thuh-red-card-who-see-thuh-red-card? I-see-thuh-red-card. Thuh-red-card-is-thuh-winner. Pick-thuh-red-card-you-pick-uh-winner. Pick-uh-black-card-you-pick-uh-loser. Theres-thuh-loser, yeah, theres-thuh-black-card, theres-thuh-other-loser-and-theres-thuh-red-card, thuh-winner.

(Rest.)

Watch me close watch me close now: 3-Card-throws-thuh-cards-lightning-fast. 3-Card-that's-me-and-Ima-last. Watch-me-throw-cause-here-I-go. One-good-pickll-get-you-in, 2-good-picks-and-you-gone-win. See-thuh-red-ard-see-thuh-red-card-who-see-thuh-red-card?

(Rest.)

Dont touch my cards, man, just point to thuh one you want. You-pick-that-card-you-pick-a-loser, yeah, that-cards-a-loser. You-pick-that-card-that's-thuh-other-loser. You-pick-that-card-you-pick-a-winner. Follow that card. You gotta chase that card. You-pick-thuh-dark-deuce-thats-a-loser-other-dark-deuces-thuh-other-loser, reddeuce. thuh-deuce-of-heartsll-win-it-all. Follow thuh red card.

(Rest.)

Ima show you thuh cards: 2 black cards but only one heart. Now watch me now. Who-sees-thuh-red-card-who-knows-where-its-at? Go on, man, point to thuh card. Put yr money down cause you aint no clown. No? Ah you had thuh card, but you didnt have thuh heart.

(Rest.)

You wanna bet? 500 dollars? Shoot. You musta been watching 3-Card real close. Ok. Lay the cash in my hand cause 3-Cards thuh man. Thank you, mister. This card you say?

(Rest.)

Wrong! Sucker! Fool! Asshole! Bastard! I bet yr daddy heard how stupid you was and drank himself to death just cause he didn't wanna

have nothing to do witchu! I bet yr mama seen you when you comed out and she walked away from you with thuh afterbirth still hanging from out twixt her legs. sucker! Ha Ha Ha! And 3-Card, once again. wins all thuh money!!

(Rest.)

What? Cops looking my way? Fold up thuh game, and walk away. Sneak outa sight. Set up on another corner.

(Rest.)

Yeah.

(Rest.)

Having won the imaginary loot and dodged the imaginary cops. BOOTH *sets up his equipment and starts practicing his scam all over again.* LINCOLN *comes in quietly. He is a black man in his later 30s. He is dressed in an antique frock coat and wears a top hat and fake beard, that is, he is dressed to look like Abraham Lincoln. He surreptitiously walks into the room to stand right behind* BOOTH, *who engrossed in his cards, does not notice* LINCOLN *right away.*

BOOTH. Watch me close watch me close now; who-see-thuh-red-card-who-see-thuh-red-card? I-see-thuh-red-card. Thuh-red-card-is- thuh-winner. Pick- thuh-red-card-you-pick-uh-winner. Pick-uh-black-card-you-pick-uh-loser. Theres- thuh-loser-yeah-theres-thuh-black-card, theres-thuh-other-loser-and-theres-thuh-red-card, thuh-winner. Don't touch my cards, man, don't—

(Rest.)

Dont do that shit. Don't do that shit. Don't do that shit!

BOOTH, *sensing someone behind him, whirls around, pulling a gun from his pants. While the presence of* LINCOLN *doesn't surprise him, the Lincoln costume does.*

BOOTH. And woah. man dont *ever* be doing that shit! Who thuh fuck you think you is coming in my shit all spooked out and shit. You pull that one more time I'll shoot you!

LINCOLN. I only had a minute to make the bus.

BOOTH. Bullshit.

LINCOLN. Not completely. I mean, its either bull or shit, but not a complete lie so it aint bullshit, right?

(Rest.)

Put yr gun away.

BOOTH. Take off the damn hat at least.

LINCOLN *takes off the stovepipe hat.* BOOTH *puts his gun away.*

LINCOLN. Its cold out there. This thing kept my head warm.

LINCOLN. Better?

BOOTH. Take off the damn coat too. Damn, man. Bad enough you got to wear that shit all day you come up in here wearing it. What my women gonna say?

LINCOLN. What women?

BOOTH. I got a date with Grace tomorrow. Shes in love with me again but she dont now it yet. Aint no man can love her the way I can. She sees you in that getup its gonna reflect bad on me. She coulda seen you coming down the street. Shit. Could be standing outside right now taking her ring off and throwing it on the sidewalk.

BOOTH *takes a peek out the window.*

BOOTH. I got her this ring today. Diamond. Well, diamondesque, but it looks just as good as the real thing. Asked her what size she wore. She say 7 so I go boost a size 6 and a half, right? Show it to her and she loves it and I shove it on her finger and its a tight fit right, so she cant just take it off on a whim, like she did the last one I gave her. Smooth, right?

BOOTH *takes another peek out the window.*

LINCOLN. She out there?

BOOTH. Nope. Coast is clear.

LINCOLN. You boosted a ring?

BOOTH. Yeah. I thought about spending my inheritance on it but-take off that damn coat, man, you make me nervous standing there looking like a spook, and that damn face paint, take it off. You should take all of it off at work and leave it there.

LINCOLN I dont bring it home someone might steal it.

BOOTH. At least *take it off* there, then.

LINCOLN. Yeah.

(Rest.)

LINCOLN *takes off the frock coat and applies cold cream, removing the whiteface.*

LINCOLN. I was riding the bus. Really I only had a minute to make my bus and I was sitting in the arcade thinking, should I change into my street clothes or should I make the bus? Nobody was in there today anyway. Middle of week middle of winter. Not like on weekends. Weekends the place is packed. So Im riding the bus home. And this kid asked me for my autograph. I pretended I didnt hear him at first. I'd had a long day. But he kept asking. Theyd just done Lincoln in history class and he knew all about him, he'd been to the arcade but, I dunno, for some reason he was tripping cause there was Honest Abe right beside him on the bus. I wanted to tell him to go fuck hisself. But then I got a look at him. A little rich kid. Born on easy street, you know the type. So I waited until I could tell he really wanted it, the autograph and I told him he could have it for 10 bucks. I was gonna say 5, cause of the Lincoln connection but something in me made me ask for 10.

BOOTH. But he didnt have a 10. All he had was a penny. So you took the penny.

LINCOLN. All he had was a 20. So I took the 20 and told him to meet me on the bus tomorrow and Honest Abe would give him the change.

BOOTH. Shit.

LINCOLN. Shit is right.

(Rest.)

BOOTH. Whatd you do with thuh 20?

LINCOLN. Bought drinks at Luckys. A round for everybody. They got a kick out of the getup.

BOOTH. You shoulda called me down.

LINCOLN. Next time, bro.

(Rest.)

You making bookshelves? With the milk crates, you making bookshelves?

BOOTH. Yeah, a big bro, Im making bookshelves.

LINCOLN. Whats the cardboard part for.

BOOTH. Versatility.

LINCOLN. Oh.

BOOTH. I was thinking we dont got no bookshelves we dont got no dining room table so Im making a sorta modular unit you put the books in the bottom and the table top on top. We can eat and store our books. We could put the photo album in there.

BOOTH gets the raggedy family photo album and puts it in the milk crate.

BOOTH. Youd sit there. Id sit on the edge of the bed. Gathered around the dinner table. Like old times.

LINCOLN. We just gotta get some books but thats great, Booth, that's real great.

BOOTH. Dont be calling me Booth no more, K?

LINCOLN. You changing yr name?

BOOTH. May be.

LINCOLN

BOOTH

LINCOLN. What to?

BOOTH. Im not ready to reveal it yet.

LINCOLN. You already decided on something?

BOOTH. Maybe.

LINCOLN. You gonna call yrself something african? That be cool. Only pick something thats easy to spell and pronounce, man, cause you know, some of them african names. I mean, ok. Im down with the power to the people thing, but, no ones gonna hire you if they cant say yr name. And some of them fellas who got they african names, no one can say they names and they cant say they names neither. I mean, you dont want yr new handle to obstruct yr employment possibilities.

BOOTH

LINCOLN

BOOTH. You bring dinner?

LINCOLN. "Shango" would be a good name. The name of the thunder god. If you aint decided already Im just throwing it in the pot. I brought chinese.

BOOTH. Lets try the table out.

LINCOLN. Cool.

They both sit at the new table. The food is far away near the door.

LINCOLN

BOOTH

LINCOLN. I buy it you set it up. Thats the deal. Thats the deal, right?

BOOTH. You like this place?

LINCOLN. Ssallright.

BOOTH. But a little cramped sometimes, right?

LINCOLN. You dont hear me complain. Although that recliner sometimes Booth, man—no Booth, right—man, Im too old to be sleeping in that chair.

BOOTH. Its my place. You dont got a place. Cookie, she threw you out. And you cant seem to get another woman. Yr lucky I let you stay.

LINCOLN. Every Friday you say *mi casa cs su casa*.

BOOTH. Every Friday you come home with yr paycheck. Today is Thursday and I tell you brother, its a long way from Friday to Friday. All kinds of things can happen. All kinds of bad feelings can surface and erupt while yr little brother waits for you to bring in yr share.

(Rest.)

I got my Thursday head on. Link. Go get the food.

LINCOLN *doesnt budge.*

LINCOLN. You dont got no running water in here, man.

BOOTH. So?

LINCOLN. You dont got no toilet you dont got no sink.

BOOTH. Bathrooms down the hall.

LINCOLN. You living in thuh Third World, fool! Hey. I'll get thuh food.

LINCOLN *goes to get the food. He sees a stray card on the floor and examines it without touching it. He brings the food over, putting is nicely on the table.*

LINCOLN. You been playing cards?

BOOTH. Yeah.

LINCOLN. Solitaire?

BOOTH. Thats right. Im getting pretty good at it.

LINCOLN. Thats soup and thats sauce. I got you the meat and I got me the skrimps.

BOOTH. I wanted the skrimps.

LINCOLN. You said you wanted the meat. This morning when I left you said you wanted the meat.

(Rest.)

Here man, take the skrimps. No sweat.

They eat. Chinese food from syrofoam containers, cans of soda, fortune cookies. LINCOLN *eats slowly and carefully.* BOOTH *eats ravenously.*

LINCOLN. Yr getting good at solitaire?

BOOTH. Yeah. How about we play a hand after eating.

LINCOLN. Solitaire?

BOOTH. Poker or rummy or something.

LINCOLN. You know I dont touch thuh cards, man.

BOOTH. Just for fun.

LINCOLN. I dont touch thuh cards.

BOOTH. How about for money?

LINCOLN. You dont got to money. All the money you got I bring in here.

BOOTH. I got my inheritance.

LINCOLN. Thats like saying you dont got no money cause you aint never gonna do nothing with it so its like you dont got it.

BOOTH. At least I still got mines. You blew yrs.

LINCOLN

BOOTH

LINCOLN. You like the skrimps?

BOOTH. Ssallright.

LINCOLN. Whats yr fortune?

BOOTH. "Waste not want not." Whats yrs?

LINCOLN. "Your luck will change!"

BOOTH *finishes eating. He turns his back to* LINCOLN *and fiddles around with the cards, keeping them on the bed, just out of* LINCOLNs *sight. He mutters the 3-card patter under his breath. His moves are still clumsy. Every once in a while he darts a look over at* LINCOLN *who does his best to ignore* BOOTH.

BOOTH. ((((Watch me close watch me close now: who-see-thuh-red-card-who-see-thuh-red-card? I-see-thuh-red-card. Thuh-red-card-is-thuh-winner. Pick-thuh-red-card-you-pick-uh-winner. Pick-uh-black-card-and-you-pick-uh-loser. Theres-thuh-loser. yeah, theres-thuh-black-card, theres-thuh-other-loser-and-theres-thuh-red-card, thuh-winner! Cop C, Stick. Cop C! Go on—))))

LINCOLN. ((Shit.))

BOOTH. (((((((One-good-pickll-get-you-in, 2-good-picks-and-you-gone-win. Dont touch my cards, man, just point to thuh one you want. You-pick-that-card-you-pick-uh-loser, yeah, that-cards-uh-loser. You-pick-that-card-thats-thuh-other-loser. You-pick-that-card-you-pick-uh-winner. Follow-that-card. You-gotta-chase-that-card!)))))))

LINCOLN. You wanna hustle 3-card monte, you gotta do it right, you gotta break it down. Practice it in smaller bits, Yr trying to do the whole thing at once thats why you keep fucking it up.

BOOTH. Show me.

LINCOLN. No. Im just saying you wanna do it you gotta do it right and if you gonna do it right you gotta work on it in smaller bits, thatsall.

BOOTH. You and me could team up and do it together. We'd clean up, Link.

LINCOLN. I'll clean up—bro.

LINCOLN *cleans up. As he clears the food,* BOOTH *goes back to using the "table" for its original purpose.*

BOOTH. My new names 3-Card. 3-Card, got it? You wanted to know it so now you know it. 3-card monte by 3-Card. Call me 3-Card from here on out.

LINCOLN. 3-Card. Shit.

BOOTH. Im getting everybody to call me 3-Card. Grace likes 3-Card better that Booth. She says 3-Cards got something to it. Anybody not calling me 3-Card gets a bullet.

LINCOLN. Yr too much, man.

BOOTH. Im making a point.

LINCOLN. Point made, 3-Card. Point made.

LINCOLN *picks up his guitar. Plays at it.*

BOOTH. Oh, come on, man, we could make money you and me. Throwing down the cards. 3-Card and Link: look out! We could clean up you and me. You would throw the cards and I'd be yr Stickman. The one in the crowd who looks like just an innocent passerby, who looks like just another player, like just another customer, but who gots intimate connections with you, the Dealer, the one throwing the cards, the main man. I'd be the one who brings in the crowd, I'd be the one who makes them want to put they money down, you

do yr moves and I do mines. You turn yr head and I turn the card—

LINCOLN. It aint as easy as all that. Theres—

BOOTH. We could be a team, man. Rake in the money! Sure thered be some cats out there with fast eyes, some brothers and sisters who would watch real close and pick the right card, and so thered be some days when we could lose money, but most of the days we would come out on top! Pockets bulging, plenty of cash! And the ladies would be thrilling! You could afford to get laid! Grace would be all over me again.

LINCOLN. I thought you said she was all over you.

BOOTH. She is she is. Im seeing her tomorrow but today we gotta solidify the shit twixt you and me. Big Brother Link and little brother Booth—

LINCOLN. 3-Card.

BOOTH. Yeah. Scheming and dreaming. No one throws the cards like you, Link. And with yr moves and my magic, and we get Grace and a girl for you to round out the posse. We'd be golden, bro! Am I right?

LINCOLN

LINCOLN

BOOTH. Am I right?

BOOTH. I dont touch thuh cards. 3-Card. I dont touch thuh cards no more.

LINCOLN

BOOTH

LINCOLN

BOOTH

BOOTH. You know what Mom told me when she was packing to leave? You was at school motherfucker you was at school. You got up that morning and sat down in yr regular place and read the cereal box while Dad read the sports section and Mom brought you yr dick toast and then you got on the damn school bus cause you didnt have the sense to do nothing else you was so into yr own shit that you didnt have the sense to feel nothing else going on. I had the sense to go back cause I was feeling something going on man, I was feeling something changing. So I—

LINCOLN. Cut school that day like you did almost every day—

BOOTH. She was putting her stuff in bags. She had all them nice suitcases but she was putting her stuff in bags.

(Rest.)

Packing up her shit. She told me to look out for you. I told her I was the little brother and the big brother should look out after the little brother. She just said it again. That I should look out for you. Yeah. So who gonna look out for me. Not like you care. Here I am interested in an economic opportunity, willing to work hard, willing to take risks and all you can say you shiteating motherfucking pathetic limpdick uncle tom, all you can tell me is how you dont do no more what I be wanting to do. Here I am trying to earn a living and you standing in my way. YOU STANDING IN MY WAY, LINK!

LINCOLN. Im sorry.

BOOTH. Yeah, you sorry all right.

LINCOLN. I cant be hustling no more, bro.

BOOTH. What you do all day aint no hustle?

LINCOLN. Its honest work.

BOOTH. Dressing up like some crackerass white man, some dead president and letting people shoot at you sounds like a hustle to me.

LINCOLN. People know the real deal. When people know the real deal it aint a hustle.

BOOTH. We do the card game people will know the real deal. Sometimes we will win sometimes they will win. They fast they win, we faster we win.

LINCOLN. I aint going back to that, bro. I aint going back.

BOOTH. You play Honest Abe. You aint going back but you going all the way back. Back to way back then when folks was slaves and shit.

LINCOLN. Dont push me.

BOOTH

LINCOLN

BOOTH. You gonna have to leave.

LINCOLN. I'll be gone tomorrow.

BOOTH. Good. Cause this was only supposed to be a temporary arrangement.

LINCOLN. I will be gone tomorrow.

BOOTH. Good.

BOOTH sits on his bed LINCOLN, sitting in his easy chair with his guitar, plays and sings.

LINCOLN. My dear mother left me, my fathers gone away

My dear mother left me and my fathers gone away

I dont got no money, I dont got no place to stay.

My best girl, she threw me out into the street

My favorite horse, they ground him into meat

Im feeling cold from my head down to my feet.

My luck was bad but now it turned to worse

My luck was bad but now it turned to worse

Dont call me up a doctor, just call me up a hearse.

BOOTH. You just made that up?

LINCOLN. I had it in my head a few days.

BOOTH. Sounds good.

LINCOLN. Thanks.

(Rest.)

Daddy told me once why we got the names we do.

BOOTH. Yeah?

LINCOLN. Yeah?

(Rest.)

He was drunk when he told me, or maybe I was drunk when he told me. Any way he told me, may not be true, but he told me. Why he named us both. Lincoln and Booth.

BOOTH. How come. How come, man?

LINCOLN. It was his idea of a joke.

Both men relax back as the light fades.

Scene Two

Friday evening. The very next day. BOOTH comes in looking like he is bundled up against the cold. He makes sure his brother isnt home, then stands in the middle of the room. From his big coat sleeves he pulls out one new shoe then another, from another sleeve come two more shoes. He then slithers out a belt from each sleeve. He removes his coat. Underneath he wears a very nice new suit. He removes the jacket and pants revealing another new suit underneath. The suits still have the price tags on them. He takes two neckties from his pockets and two folded shirts from the back of his pants. He pulls a magazine from the front of his pants. Hes clearly had a busy day of shoplifting. He lays one suit out on LINCOLNs easy chair. The other he lays eat on his own bed. He goes out into the hall returning with a folding screen which he sets up between the bed and the recliner creating 2 separate spaces. He takes out a bottle of whiskey and two glasses, setting them on the two stacked milk crates. He hears footsteps and sits down in the small wooden chair reading the magazine. LINCOLN, dressed in street clothes, comes in.

LINCOLN. Taaaaadaaaaaaaa!

BOOTH. Lordamighty, Pa, I smells money!

LINCOLN. Sho nuff, Ma. Poppas brung home thuh bacon.

BOOTH. Bringitherebringitherebingithere

With a series of very elaborate moves LINCOLN brings the money over to BOOTH.

BOOTH. Put it in my hands. Pa!

LINCOLN. I want ya tuh smells it first. Ma.

BOOTH. Put in heath my nose then, Pa!

LINCOLN. Take yrself a good long whiff of them greenbacks.

BOOTH. Oh lordamighty Ima faint, Pa! Get me muh med-un!

LINCOLN quickly pours two large glasses of whiskey.

LINCOLN. Dont die on me. Ma!

BOOTH. Im fading fast, Pa!

LINCOLN. Thinka thuh children. Ma! Thinka thuh farm!

BOOTH. 1–2–3.

Both men gulp down their drinks simultaneously.

LINCOLN and BOOTH: AAAAAAAAAAAAAAAAAAAAH!

Lots of laughing and slapping on the backs.

LINCOLN. Budget it out man budget it out.

BOOTH. You in a hurry?

LINCOLN. Yeah. I wanna see how much we got for the week.

BOOTH. You rush in here and dont even look around. Could be a fucking A-bomb in the middle of the floor you wouldnt notice. Yr wife, Cookie—

LINCOLN. X-wife—

BOOTH.—could be in my bed you wouldnt notice—

LINCOLN. She was once—

BOOTH. Look the fuck around please.

LINCOLN looks around and sees the new suit on his chair.

LINCOLN. Wow.

BOOTH. Its yrs.

LINCOLN. Shit.

BOOTH. Got myself one too.

LINCOLN. Boosted?

BOOTH. Yeah, I boosted em. Theys stole from a big-ass department store. That store takes in more money in one day than we will in our whole life. I stole and I stole generously. I got one for me and I got one for you. Shoes belts shirts ties socks in the shoes and everything. Got that screen too.

LINCOLN. You all right, man.

BOOTH. Just cause I aint good as you at cards dont mean I cant do nothing.

LINCOLN. Lets try em on.

They stand in their separate sleeping spaces, BOOTH near his bed, LINCOLN near his recliner, and try on their new clothes.

BOOTH. Ima wear mine tonight. Gracell see me in this and *she* gonna ask me tuh marry *her*.

(*Rest.*)

I got you the blue and I got me the brown. I walked in there and walked out and they didnt as much as bat an eye. Thats how smooth lil bro be, Link.

LINCOLN. You did good. You did real good, 3-Card.

BOOTH. All in a days work.

LINCOLN. They say the clothes make the man. All day long I wear that getup. But that dont make me who I am. Old black coat not even real old just fake old. Its got worn spots on the elbows, little raggedy places thatll break through into holes before the winters out. Shiny strips around the cuffs and the collar. Dust from the cap guns on the left shoulder where they shoot him, where they shoot me I should say but I never feel like they shooting me. The fella who had the gig before I had it wore the same coat. When I got the job they had the getup hanging there waiting for me. Said thuh fella before me just took it off one day and never came back.

(Rest.)

Remember how Dads clothes used to hang in the closet?

BOOTH. Until you took em outside and burned em.

(Rest.)

He had some nice stuff. What he didnt spend on booze he spent on women. What he didnt spend on them two he spent on clothes. He had some nice stuff. I would look at his stuff and calculate thuh how long it would take till I was big enough to fit it. Then you went and burned it all up.

LINCOLN. I got tired of looking at em without him in em.

(Rest.)

They said thuh fella before me—he took off the getup one day, hung it up real nice, and never came back. And as they offered me thuh job, saying of course I would have to wear a little makeup and accept less than what they would offer a—another guy—

BOOTH. Go on, say it. "White." Theyd pay you less than theyd pay a white guy.

LINCOLN. I said to myself thats exactly what I would do: wear it out and then leave it hanging there and not come back. But until then, I would make a living at it. But it dont make me. Worn suit coat, not even worn by the fool that Im supposed to be playing, but making fools out of all those folks who come crowding in for they chance to play at something great. Fake beard. Top hat. Dont make me

into no Lincoln. I was Lincoln on my own before any of that.

The men finish dressing. They style and profile.

BOOTH. Sharp, huh?

LINCOLN. Very sharp.

BOOTH. You look sharp too, man. You look like the real you. Most of the time you walking around all bedraggled and shit. You look good. Like you used to look back in thuh day when you had Cookie in love with you and all the women in the world was eating out of yr hand.

LINCOLN. This is real nice, man. I dont Know where Im gonna wear it but its real nice.

BOOTH. Just wear it around. Itll make you feel good and when you feel good yll meet someone nice. Me I aint interested in meeting no one nice, I mean, I only got eyes for Grace. You think she'll go for me in this?

LINCOLN. I think thuh tie you gave me'll go better with what you got on.

BOOTH. Yeah?

LINCOLN. Grace likes bright colors dont she? My ties bright, yrs is too subdued.

BOOTH. Yeah. Gimmie yr tie.

LINCOLN. You gonna take back a gift?

BOOTH. I stole the damn thing didnt I? Gimmie yrs! I'll give you mines.

They switch neckties. BOOTH is pleased. LINCOLN is more pleased.

LINCOLN. Do thuh budget.

BOOTH. Right. Ok lets see: we got 314 dollars. We put 100 aside for the rent. 100 a week times 4 weeks makes the rent and—

LINCOLN and BOOTH: —we dont want thuh rent spent.

BOOTH. That leaves 214. We put aside 30 for the electric leaving 184. We put aside 50 for thuh phone leaving 134.

LINCOLN. We dont got a phone.

BOOTH. We pay our bill theyll turn it back on.

LINCOLN. We dont need no phone.

BOOTH. How you gonna get a woman if you dont got a phone? Women these days are more cautious, more waddacallit, more circumspect. You get a filly to give you her numerophono and gone is the days when she just gives you her number and dont ask for yrs.

LINCOLN. Like a woman is gonna call me.

BOOTH. She dont wanna call you she just doing a preliminary survey of the property. Shit, Link, you dont know nothin no more.

(Rest.)

She gives you her number and she asks for yrs. You give her yr number. The phone number of yr home. Thereby telling her 3 things: 1) you got a home, that is, you aint no smooth talking smooth dressing *homeless* joe; 2) that you is in possession of a telephone and a working telephone number which is to say that you got thuh cash and thuh wherewithal to acquire for yr self the worlds most revolutionary communication apparatus and you together enough to pay yr bills!

LINCOLN. Whats 3?

BOOTH. You give her yr number you telling her that its cool to call if she should so please, that is, that you aint got no wife or wife approximation on the premises.

(Rest.)

50 for the phone leaving 134. We put aside 40 for "medsin."

LINCOLN. The price went up. 2 bucks more a bottle.

BOOTH. We'll put aside 50, then. That covers the bills. We got 84 left. 40 for meals together during the week leaving 44, 30 for me 14 for you. I got a woman I gotta impress tonight.

LINCOLN. You didnt take out for the phone last week.

BOOTH. Last week I was depressed. This week things is looking up. For both of us.

LINCOLN. Theyre talking about cutbacks at the arcade. I only been there 8 months, so—

BOOTH. Dont sweat it man, we'll find something else.

LINCOLN. Not nothing like this. I like the job. This is sit down, you know, easy work. I just gotta sit there all day. Folks come in kill phony Honest Abe with the phony pistol. I can sit there and let my mind travel.

BOOTH. Think of women.

LINCOLN. Sometimes.

(Rest.)

All around the whole arcade is buzzing and popping. Thuh whirring of thuh duckshoot, baseballs smacking the back wall when someone misses the stack of cans, some woman getting happy cause her fella just won the ring toss. The Boss playing the barker talking up the fake freaks. The smell of the ocean and cotton candy and rat shit. And in thuh middle of all that, I can just sit and let my head go quiet. Make up songs, make plans. Forget.

(Rest.)

You should come down again.

BOOTH. Once was plenty, but thanks.

(Rest.)

Yr Best Customer, he come in today?

LINCOLN. Oh, yeah, he was there.

BOOTH. He shoot you?

LINCOLN. He shot Honest Abe, yeah.

BOOTH. He talk to you?

LINCOLN. In a whisper. Shoots on the left whispers on the right.

BOOTH. Whatd he say this time?

LINCOLN. "Does thuh show stop when no ones watching or does thuh show go on?"

BOOTH. Hes getting deep.

LINCOLN. Yeah.

BOOTH. Whatd he say, that one time? "Yr only yrself—"

LINCOLN. "—when no ones watching," yeah.

BOOTH. Thats deep shit.

(Rest.)

Hes a brother, right?

LINCOLN. I think so.

BOOTH. He know yr a brother?

LINCOLN. I dunno. Yesterday he had a good one. He shoots me, Im playing dead, and he leans in close then goes: "God aint nothing but a parasite."

BOOTH. Hes one *deep* black brother.

LINCOLN. Yeah. He makes the day interesting.

BOOTH

(Rest.)

Thats a fucked-up job you got.

LINCOLN. Its a living.

BOOTH. But you aint living.

LINCOLN. Im alive aint I?

(Rest.)

One day I was throwing the cards. Next day Lonny died. Somebody shot him. I knew I was next, so I quit. I saved my life.

(Rest.)

The arcade gig is the first lucky break Ive ever had. And Ive actually grown to like the work. And now theyre talking about cutting me.

BOOTH. You was lucky with thuh cards.

LINCOLN. Lucky? Aint nothing lucky about cards. Cards aint luck. Cards is work. Cards is skill. Aint never nothing lucky about cards.

(Rest.)

I dont wanna lose my job.

BOOTH. Then you gotta jazz up yr act. Elaborate yr moves, you know. You was always too stiff with it. You cant just sit there! Maybe, when they shoot you, you know leap up flail yr arms then fall down and wiggle around and shit so they gotta shoot you more than once. Blam! Blam! Blam! Blam!

LINCOLN. Help me practice. I'll sit here like I do it work and you be like one of the tourists.

BOOTH. No thanks.

LINCOLN. My paychecks on the line, man.

BOOTH. I got a date. Practice on yr own.

(Rest.)

I got a rendezvous with Grace. Shit she so sweat she makes my teeth hurt.

(Rest.)

Link, uh, howbout slipping me an extra 5 spot. Its the biggest night of my life.

LINCOLN

BOOTH

LINCOLN gives BOOTH a 5er.

BOOTH. Thanks.

LINCOLN. No sweat.

BOOTH. Howabout I run through it with you when I get back. Put on yr getup and practice till then.

LINCOLN. Sure.

BOOTH leaves. LINCOLN stands there alone. He takes off his shoes, giving them a shine. He takes off his socks and his fancy suit, hanging it neatly over the little wooden chair. He takes his getup out of his shopping bag. He puts it on, slowly, like an actor preparing for a great role: frock coat, pants, beard, top hat, necktie. He leaves his feet bare. The top hat has an elastic band which he positions securely underneath his chin. He picks up the white pancake makeup but decides against it. He sits. He pretends to get shot, flings himself on the floor and thrashes around. He gets up, considers giving the new moves another try, but instead pours himself a big glass of whiskey and sits there drinking.

Scene Three

Much later that same Friday evening. The recliner is reclined to its maximum horizontal position and LINCOLN lies there asleep. He wakes with a start. He is horrific, bleary eyed and hungover, in his full LINCOLN regalia. He takes a deep breath, realizes where he is and reclines again, going back to sleep. BOOTH comes in full of swaggar. He slams the door trying to wake his brother who is dead to the world. He opens the door and slams it again. This time LINCOLN wakes up, as hungover and horrid as before, BOOTH swaggers about, its moves are exaggerated, rooster-like. He walks round and round LINCOLN making sure his brother sees him.

LINCOLN. You hurt yrself?

BOOTH. I had me "an evening to remember."

LINCOLN. You look like you hurt yrself.

BOOTH. Grace Grace Grace. *Grace*. She wants me back. She wants me back so bad she wiped her hand over the past where we wasn't together just so she could say we aint never been apart. She wiped her hand over our breakup. She wiped her hand over her childhood, her teenage years, her first boyfriend, just so she could say that she been mine since the dawn of time.

LINCOLN. Thats great, man.

BOOTH. And all the shit I put her through; she wiped it clean. And the Women I saw while I was seeing her—

LINCOLN. Wiped clean too?

BOOTH. Mister Clean, Mister, Mister Clean!

LINCOLN. Whered you take her?

BOOTH. We was over at her place. I brought thuh food. Stopped at the best place I could find and stuffed my coat with only the best. We had candlelight, we had music we had—

LINCOLN. She let you do it?

BOOTH. Course she let me do it.

LINCOLN. She let you do it without a rubber?

BOOTH. —Yeah.

LINCOLN. Bullshit.

BOOTH. I put my foot down—and she *melted*. And she was—thuh—she was something else. I dont wanna get you jealous, though.

LINCOLN. Go head, I dont mind.

BOOTH

(Rest.)

Well, you know what she looks like.

LINCOLN. She walks on by and the emergency room fills up cause all the guys get whiplash from lookin at her.

BOOTH. Thats right thats right. Well—she comes to the door wearing nothing but her little nightie, eats up the food I'd brought like there was no tomorrow and then goes and eats on me.

(Rest.)

LINCOLN. Go on.

BOOTH. I dont wanna make you feel bad, man.

LINCOLN. Ssallright. Go on.

BOOTH

(Rest.)

Well, uh, you know what she likes. Wild. Good-looking. So sweet my teeth hurt.

LINCOLN. Sexmachine.

BOOTH. Yeah.

LINCOLN. Hotsy-Totsy.

BOOTH. Yeah.

LINCOLN. Amazing Grace.

BOOTH. Amazing Grace! Yeah. That's right. She let me do her how I wanted. And no rubber.

(Rest.)

LINCOLN. Go on.

BOOTH. You dont wanna hear the mushy shit.

LINCOLN. Sure I do.

BOOTH. You hate mushy shit. You always hated thuh mushy shit.

LINCOLN. Ive changed. Go head. You had "an evening to remember," remember? I was just here alone sitting here. Drinking. Go head. Tell Link thuh stink.

(Rest.)

Howd ya do her?

BOOTH. Dogstyle.

LINCOLN. Amazing Grace.

BOOTH. In front of a mirror.

LINCOLN. So you could see her. Her face her breasts her back her ass. Graces got a great ass.

BOOTH. Its all right.

LINCOLN. Amazing Grace!

BOOTH goes into his bed area and takes off his suit, tossing the clothes on the floor.

BOOTH. She said next time Ima have to use a rubber. She let me have my way this time but she said that next time I'd have to put my boots on.

LINCOLN. Im sure you can talk her out of it.

BOOTH. Yeah.

(Rest.)

What kind of rubbers you use, I mean, when you was with Cookie.

LINCOLN. We didnt use rubbers. We was married, man.

BOOTH. Right. But you had other women on the side. What kind you use when you was with them?

LINCOLN. Magnums.

BOOTH. Thats thuh kind I picked up. For next time. Grace was real strict about it.

While BOOTH sits on his bed fiddling with his box of condoms, LINCOLN sits in his chair and resumes drinking.

LINCOLN. Im sure you can talk her out of it. You put yr foot down and she'll melt.

BOOTH. She was real strict. Sides I wouldnt wanna be taking advantage of her or nothing. Putting my foot down and her melting all over thuh place.

LINCOLN. Magnums then.

(*Rest.*)

Theyre for "the larger man."

BOOTH. Right. Right.

LINCOLN keeps drinking as BOOTH, sitting in the privacy of his bedroom, fiddles with the condoms, perhaps trying to put one on.

LINCOLN. Thats right.

BOOTH. Graces real different from them fly-by-night gals I was making do with. Shes in school. Making something of herself. Studying cosmetology. You should see what she can do with a womans hair and nails.

LINCOLN. Too bad you aint a woman.

BOOTH. What?

LINCOLN. You could get yrs done for free. I mean.

BOOTH. Yeah. She got this way of sitting. Of talking. Everything she does is. Shes just so hot.

(*Rest.*)

We was together 2 years. Then we broke up. I had my little employment difficulty and she needed time to think.

LINCOLN. And shes through thinking now.

BOOTH. Thats right.

LINCOLN

BOOTH

LINCOLN. Whatcha doing back there?

BOOTH. Resting. That girl wore me out.

LINCOLN. You want some med-sin?

BOOTH. No thanks.

LINCOLN. Come practice my moves with me, then.

BOOTH. Lets hit it tomorrow, K?

LINCOLN. I been waiting. I got all dressed up and you said if I waited up—come on, man, they gonna replace me with a wax dummy.

BOOTH. No shit.

LINCOLN. Thats what theyre talking about. Probably just talk, but—come on, man. I even lent you 5 bucks.

BOOTH. Im tired.

LINCOLN. You didnt get shit tonight.

BOOTH. You jealous, man. You just jail-us.

LINCOLN. You laying over there yr balls blue as my boosted suit. Laying over there waiting for me to go back to sleep or black out so I wont hear you rustling thuh pages of yr fuck book.

BOOTH. Fuck you, man.

LINCOLN. I was over there looking for something the other week and theres like 100 fuck books under yr bed and theyre matted together like a bad fro, bro, cause you spunked in the pages and didnt wipe them off.

BOOTH. Im hot. I need constant sexual release. If I wasnt taking care of myself by myself I would be out there running around on thuh town which costs cash that I dont have so I would be doing worse: I'd be out there doing who knows what, shooting people and shit. Out of a need for unresolved sexual release. I'm a hot man. I aint apologizing for it. When I dont got a woman, I gotta make do. Not like you, Link. When you dont got a woman you just sit there. Letting yr shit fester. Yr dick, if it aint falled off yet, is hanging there between yr legs, little whiteface shriveled-up blank-shooting grub worm. As goes thuh man so goes thuh mans dick. Thats what I say. Least my shits intact.

(*Rest.*)

You a limp dick jealous whiteface motherfucker whose wife dumped him cause he couldnt get it up and she told me so. Came crawling to me cause she needed a man.

(*Rest.*)

I gave it to Grace good tonight. So goodnight.

LINCOLN

(*Rest.*)

　　Goodnight.

LINCOLN

BOOTH

LINCOLN

BOOTH

LINCOLN

BOOTH

LINCOLN sitting in his chair. BOOTH lying in bed. Time passes BOOTH peeks out to see if LINCOLN is asleep. LINCOLN is watching for him.

LINCOLN. You can hustle 3-card monte without me you know.

BOOTH. Im planning to.

LINCOLN. I could contact my old crew. You could work with them. Lonny aint around no more but theres the rest of them. Theyre good.

BOOTH. I can get my own crew. I dont need yr crew. Buncha hasbeens. I can get my own crew.

LINCOLN. My crews experienced. We usedta pull down a thousand a day. Thats 7 G a week. That was years ago. They probably do twice, 3 times that now.

BOOTH. I got my own connections, thank you.

LINCOLN. Theyd take you on in a heartbeat. With my say. My say still counts with them. They know you from before, when you tried to hang with us but—wernt ready yet. They know you from then, but I'd talk you up. I'd say yr my bro, which they know, and I'd say youd been working the west coast. Little towns. Mexican border. Taking tourists. I'd tell them you got moves like I dreamed of having. Meanwhile youd be working out yr shit right here, right in this room, getting good and getting better every day so when I did do the reintroductions youd have some marketable skills. Youd be passable.

BOOTH. I'd be more than passable, I'd be the be all end all.

LINCOLN. Youd be the be all end all. And youd have my say. If yr interested.

BOOTH. Could do.

LINCOLN. Youd have to get a piece. They all pack pistols, bro.

BOOTH. I *got* a piece.

LINCOLN. Youd have to be packing something more substantial than that pop gun, 3-Card. These hustlers is upper echelon hustlers they pack upper echelon heat, not no Saturday night shit, now.

BOOTH. Whata you know of heat? You aint hung with those guys for 6, 7 years. You swore off em. Threw yr heat in thuh river and you "Dont touch thuh cards." I know more about heat than you know about heat.

LINCOLN. Im around guns every day. At the arcade. Theyve all been reworked so they only fire caps but I see guns every day. Lots of guns.

BOOTH. What kinds?

LINCOLN. You been there, you seen them. Shiny deadly metal each with their own deadly personality.

BOOTH. Maybe I *could* visit you over there. I'd boost one of them guns and rework it to make it shoot for real again. What kind you think would best suit my personality?

LINCOLN. You aint stealing nothing from the arcade.

BOOTH. I go in there and steal it I want to go in there and, steal I go in there and steal.

LINCOLN. It aint worth it. They dont shoot nothing but blanks.

BOOTH. Yea, like you. Shooting blanks.

(*Rest.*)

(*Rest.*)

　　You ever wonder if someones gonna come in there with a real gun? A real gun with real slugs? Someone with uh axe tuh grind or something?

LINCOLN. No.

BOOTH. Someone who hates you come in there and guns you down and gets gone before anybody finds out.

LINCOLN. I dont got no enemies.

BOOTH. Yr X.

LINCOLN. Cookie dont hate me.

BOOTH. Yr Best Customer? Some miscellaneous stranger?

LINCOLN. I cant be worrying about the actions of miscellaneous strangers.

BOOTH. But there they come day in day out for a chance to shoot Honest Abe.

(Rest.)

Who are they mostly?

LINCOLN. I dont really look.

BOOTH. You must see something.

LINCOLN. Im supposed to be staring straight ahead. Watching a play, like Abe was.

BOOTH. All day goes by and you never ever take a sneak peek at who be pulling the trigger.

Pulled in by his own curiosity, BOOTH *has come out of his bed area to stand on the dividing line between the two spaces.*

LINCOLN. Its pretty dark. To keep thuh illusion of thuh whole thing.

(Rest.)

But on thuh wall opposite where I sit theres a little electrical box, like a fuse box. Silver metal. Its got uh dent in it like somebody hit it with they fist. Big old dent so everything reflected in it gets reflected upside down. Like yr looking in uh spoon. And thats where I can see em. The assassins.

(Rest.)

Not behind me yet but I can hear him coming. Coming in with his gun in hand, thuh gun he already picked out up front when he paid his fare. Coming on in. But not behind me yet. His dress shoes making too much noise on the carpet, the carpets too thin. Boss should get a new one but hes cheap. Not behind me yet. Not behind me yet. Cheap lightbulb just above my head.

(Rest.)

And there he is. Standing behind me. Standing in position. Standing upside down. Theres some feet shapes on the floor so he knows just where he oughta stand. So he wont miss. Thuh gun is always cold. Winter or summer thuh gun is always cold. And when the gun touches me he can feel that Im warm and he knows Im alive. And if Im alive then he can shoot me dead. And for a minute, with him hanging back there behind me, its real. Me looking at him upside down and him looking at me looking like Lincoln. Then he shoots.

(Rest.)

I slump down and close my eyes. And he goes out thuh other way. More come in. Uh whole day full. Bunches of kids, little good for nothings, in they school uniforms. Businessmen smelling like two for one martinis. Tourists in they theme park t-shirts trying to catch it on film. Housewives with they mouths closed tight, shooting more than once.

(Rest.)

They all get so into it. I do my best for them. And now they talking bout replacing me with uh wax dummy. Itll cut costs.

BOOTH. You just gotta show yr boss that you can do things a wax dummy cant do. You too dry with it. You gotta add spicy shit.

LINCOLN. Like what.

BOOTH. Like when they shoot you, I dunno, scream or something.

LINCOLN. Scream?

BOOTH *plays the killer without using his gun.*

BOOTH. Try it. I'll be the killer. Bang!

LINCOLN. Aaaah!

BOOTH. Thats good.

LINCOLN. A wax dummy can scream. They can put a voice-box in it and make it like its screaming.

BOOTH. You can curse. Try it. Bang!

LINCOLN. Motherfucking cocksucker!

BOOTH. That's good, man.

LINCOLN. They aint going for that, though.

BOOTH. You practice rolling and wiggling on the floor?

LINCOLN. A little.

BOOTH. Lemmie see. Bang!

LINCOLN *slumps down, falls on the floor and silently wiggles around.*

BOOTH. You look more like a worm on the sidewalk. Move yr arms. Good. Now scream or something.

LINCOLN. Aaaah! Aaaaah! Aaaah!

BOOTH. A little tougher than that, you sound like yr fucking.

LINCOLN. Aaaaaah!

BOOTH. Hold yr head or something, where I shotcha. Good. And look at me! I am the assassin! *I am Booth!!* Come on man this is life and death! Go all out!

LINCOLN *goes all out.*

BOOTH. Cool, man thats cool. Thats enough.

LINCOLN. Whatdoyathink?

BOOTH. I dunno, man. Something about it. I dunno. It was looking too real or something.

LINCOLN. They dont want it looking too real. I'd scare the customers. Then I'd be out for sure. Yr trying to get me fired.

BOOTH. Im trying to help. Cross my heart.

LINCOLN. People are funny about they Lincoln shit. Its historical. People like they historical shit in a certain way. They like it to unfold the way they folded it up. Neatly like a book. Not raggedy and bloody and screaming. You trying to get me fired.

(*Rest.*)

I am uh brother playing Lincoln. Its uh stretch for anyones imagination. And it aint easy for me neither. Every day I put on that shit. I leave my own shit at the door and I put on that shit and I go out there and I make it work. I make it look easy but its hard. That shit is hard. But it works. Cause I work it. And you trying to get me fired.

(*Rest.*)

I swore off them cards. Took nowhere jobs. Drank. Then Cookie threw me out. What thuh fuck was I gonna do? I seen that "Help Wanted" sign and I went up in there and I looked good in the getup and agreed to the whiteface and they really dug it that me and Honest Abe got the same name.

(*Rest.*)

Its a sit down job. With benefits. I dont wanna get fired. They wont give me a good reference if I get fired.

BOOTH. Iffen you was tuh get fired, then, well—then you and me could—hustle the cards together. We'd have to support ourselves somehow.

(*Rest.*)

Just show me how to do the hook part of the card hustle man. The part where the Dealer looks away but somehow he sees—

LINCOLN. I couldnt remember if I wanted to.

BOOTH. Sure you could.

LINCOLN. No.

(*Rest.*)

Night, man.

BOOTH. Yeah.

LINCOLN *stretches out in his recliner.* BOOTH *stands over him waiting for him to get up, to change his mind. But* LINCOLN *is fast asleep.* BOOTH *covers him with a blanket then goes to his bed, turning off the lights as he goes. He quietly rummages underneath his bed for a girlie magazine which, as the lights fade, he reads with great interest.*

Scene Four

Saturday. Just before dawn. LINCOLN gets up. Looks around. BOOTH is fast asleep, dead to the world.

LINCOLN. No fucking running water.

He stumbles around the room looking for something which he finally finds: a plastic cup, which he uses as a urinal. He finishes peeing and finds an out of the way place to stow the cup. He claws at his Lincoln getup, removing it and tearing it in the process. He strips down to his t-shirt and shorts.

LINCOLN. Hate falling asleep in this damn shit, Shit. Ripped the beard. I can just hear em tomorrow. Busiest day of the week. They looking me over to make sure Im presentable. They got a slew of guys working but Im the only one they look over every day. "Yr beards ripped, pal. Sure, we'll getcha new one but its gonna be coming outa yr say." Shit. I should quit right then and there. I'd yank off the beard, throw it on the ground and stomp it, then go straggle the fucking boss. Thatd be good. My hands around his neck and his bug eyes bugging out. You been ripping me off since I took this job and now Im gonna have to take it outa *yr* pay, motherfucker. Shit.

(*Rest.*)

Sit down job. With benefits.

(*Rest.*)

Hustling. Shit. I was good. I was great. Hell I was the be all end all. I was throwing cards like throwing

cards was made for me. Made for me and me alone. I was the best anyone ever seen. Coast to coast. Everybody said so. And I never lost. Not once. Not one time. Not never. Thats how much them cards was mines. I was the be all end all. I was that good.

(Rest.)

Then you woke up one day and you didnt have the taste for it no more. Like something in you knew. — Like something in you knew it was time to quit. Quit while you was still ahead. Something in you was telling you. — But hells no. Not Link thuh stink. So I went out there and threw one more time. What thuh fuck. And Lonny died.

(Rest.)

Got yrself a good job. And when the arcade lets you go yll get another good job. I dont gotta spend my whole life hustling. Theres more to Link than that. More to me than some cheap hustle. More to life than cheating some idiot out of his paycheck or his life savings.

(Rest.)

Like that joker and his wife from out of town. Always wanted to see the big city. I said you could see the bigger end of the big city with a little more cash. And if they was fast enough, faster than me, and here I slowed down my moves I slowed em way down and my Lonny, my right hand, my Stickman, spanish guy who looked white and could draw a customer in like nothing else, Lonny could draw a fly from fresh shit, he could draw Adam outa Eve just with that look he had. Lonny always got folks playing.

(Rest.)

Somebody shot him. They dont know who. Nobody knows nobody cares.

(Rest.)

We took that man and his wife for hundreds. No, thousands. We took them for everything they had and every thing they ever wanted to have. We took a father for the money he was gonna get his kids new bike with and he cried in the street while we vanished. We took a mothers welfare check, she pulled a knife on us and we ran. She threw it but her aim werent shit. People shopping. Greedy. Thinking they could take me and they got took instead.

(Rest.)

Swore off thuh cards. Something inside me telling me — .But I was good.

LINCOLN

LINCOLN

He sees a packet of cards. He studies them like an alcoholic would study a drink. Then he reaches for them, delicately picking them up and choosing 3 cards.

LINCOLN. Still got my moves. Still got my touch. Still got my chops. Thuh feel of it. And I aint hurting no one, God. Link is just here hustling hisself.

(Rest.)

Lets see whatcha got.

He stands over the monte setup. Then he bends over it placing the cards down and moving them around. Slowly at first, aimlessly, as if hes just making little ripples in water. But then the game draws him in. Unlike BOOTH, LINCOLN patter and moves are deft, dangerous, electric.

LINCOLN. (((Lean in close and watch me now: who see thuh black card who see thuh black card I see thuh black card black cards thuh winner pick thuh black card thats thuh winner pick thuh red card thats thuh loser pick thuh other red card thats thuh other loser pick thuh black card you pick thuh winner. Watch me as I throw thuh cards. Here we go.)))

(Rest.)

((((Who see thuh black card who see thuh black card? You pick thuh red card you pick a loser you pick that red card you pick a loser you pick thuh black card thuh deuce of spades you pick a winner who sees thuh deuce of spades thuh one who sees it never fades watch me now as I throw thuh cards. Red losers black winner follow thuh deuce of spaces chase thuh black deuce. Dark deuce will get you thuh win.)))

Even though LINCOLN speaks softly, BOOTH wakes and, unbeknownst to LINCOLN, listens intently.

(Rest.)

LINCOLN. ((10 will get you 20, 20 will get you 40.))

(Rest.)

((Ima show you thuh cards: 2 red cards but only one spade. Dark winner in thuh center and thuh red losers on thuh sides. Pick uh red card you got a

loser pick thuh other red card you got a loser pick thuh black card you got a winner. One good pickll get you in, 2 good picks and you gone win. Watch me come on watch me now.))

(Rest.)

((Who sees thuh winner who knows where its at? You do? You sure? Go on then, put yr money where yr mouth is. Put yr money down you aint no clown. No? Ah, you had thuh card but you didnt have thuh heart.))

(Rest.)

((Watch me now as I throw thuh cards watch me real close. Ok, man, you know which card is the deuce of spades? Was you watching Links lighting fast express? Was you watching Link cause he the best? So you sure, huh? Point it out first, then place yr bet and Linkll show you yr winner.))

(Rest.)

((500 dollars? You thuh man of thuh hour you thuh man with thuh power. You musta been watching Link real close. You must be thuh man who know thuh most. Ok. Lay the cash in my hand cause Link the man. Thank you, mister. This card you say?))

(Rest.)

((Wrong! Ha!))

(Rest.)

((Thats thuh show. We gotta go.))

LINCOLN *puts the cards down. He moves away from the monte setup. He sits on the edge of his easy chair, but he can't take his eyes off the cards.*

Intermission

Scene Five

Several days have passed. Its now Wednesday night. BOOTH *is sitting in his brand-new suit. The monte setup is nowhere in sight. In its place is a table with two nice chairs. The table is covered with a lovely tablecloth and there are nice plates, silverware, champagne glasses and candles. All the makings of a very romantic dinner for two. The whole apartment in fact takes its cue from the table. Its been cleaned up considerably. New curtains on the windows, a doily-like object on the recliner.* BOOTH *sits at the table darting his eyes around, making sure everything is looking good.*

BOOTH. Shit.

He notices some of his girlie magazines visible from underneath his bed. He goes over and nudges them out of sight. He sits back down. He notices that theyre still visible. He goes over and nudges them some more, kicking at them finally. Then he takes the spread from his bed and pulls it down, hiding them. He sits back down. He gets up. Checks the champagne on much melted ice. Checks the food.

BOOTH. Foods getting cold, Grace!! Dont worry man, she'll get here, she'll get here.

He sits back down. He goes over to the bed. Checks it for springiness. Smoothes down the bedspread. Double-checks 2 matching silk dressing gowns, very expensive, marked "His" and "Hers." Lays the dressing gowns across the bed again. He sits back down. He cant help but notice the visibility of the girlie magazines again. He goes to the bed, kicks them fiercely, then on his hands and knees shoves them. Then he begins to get under the bed to push them, but he remembers his nice clothing and takes off his jacket. After a beat he removes his pants and, in this half-dressed way, he crawls under the bed to give those telltale magazines a good and final shove. LINCOLN *comes in. At first* BOOTH, *still stripped down to his underwear, thinks its his date. When he realizes its his brother, he does his best to keep* LINCOLN *from entering the apartment.* LINCOLN *wears his frock coat and carries the rest of his getup in a plastic bag.*

LINCOLN. You in the middle of it?

BOOTH. What the hell you doing here?

LINCOLN. If yr in thuh middle of it I can go. Or I can just be real quiet and just—sing a song in my head or something.

BOOTH. The casas off limits to you tonight.

LINCOLN. You know when we lived in that 2-room place with the cement backyard and the frontyard with nothing but trash in it. Mom and Pops would do it in the middle of the night and I would always hear them but I would sing in my head, cause, I dunno, I couldnt bear to listen.

BOOTH. You gotta get out of here.

LINCOLN. I would make up all kinds of songs. Oh, sorry, yr all up in it. No sweat, bro. No sweat. Hey, Grace, howyadoing?!

BOOTH. She aint here yet, man. Shes running late. And its a good thing too cause I aint all dressed yet. Yr gonna spend thuh night with friends?

LINCOLN. Yeah.

BOOTH *waits for* LINCOLN *to leave.* LINCOLN *stands his ground.*

LINCOLN. I lost my job.

BOOTH. Hunh.

LINCOLN. I come in there right on time like I do every day and that motherfucker gives me some song and dance about cutbacks and too many folks complaining.

BOOTH. Hunh.

LINCOLN. Showd me thuh wax dummy—hes buying it right out of a catalog.

(*Rest.*)

I walked out still wearing my getup.

(*Rest.*)

I could go back in tomorrow. I could tell him I'll take another pay cut. Thatll get him to take me back.

BOOTH. Link. Yr free. Dont go crawling back. Yr free at lase! Now you can do anything you want. Yr not tied down by that job. You can—you can do something else. Something that pays better maybe.

LINCOLN. You mean Hustle.

BOOTH. Maybe. Hey, Graces on her way. You gotta go.

LINCOLN *flops into his chair,* BOOTH *is waiting for him to move* LINCOLN *doesnt budge.*

LINCOLN. I'll stay until she gets here. I'll act nice. I wont embarrass you.

BOOTH. You gotta go.

LINCOLN. What time she coming?

BOOTH. Shes late. She could be here any second.

LINCOLN. I'll meet her. I met her years ago. I'll meet her again.

(*Rest.*)

How late is she?

BOOTH. She was supposed to be here at 8.

LINCOLN. Its after 2 a.m. Shes—shes late.

(*Rest.*)

Maybe when she comes you could put the blanket over me and I'll just pretend like Im not here.

(*Rest.*)

I'll wait. And when she comes I'll go. I need to sit down.

I been walking around all day.

BOOTH

LINCOLN

BOOTH *goes to his bed and dresses hurriedly.*

BOOTH. Pretty nice, right? The china thuh silver thuh crystal.

LINCOLN. Its great.

(*Rest.*)

Boosted?

BOOTH. Yeah.

LINCOLN. Thought you went and spent yr inheritance for a minute, you had me going I was thinking shit, Booth—3-Card—that 3-Cards gone and spent his inheritance and the gal is—late.

BOOTH. Its boosted. Every bit of it.

(*Rest.*)

Fuck this waiting bullshit.

LINCOLN. She'll be here in a minute. Dont sweat it.

BOOTH. Right.

BOO H *comes to the table. Sits. Relaxes as best he can.*

BOOTH. How come I got a hand for boosting and I dont got a hand for throwing cards? Its sorta the same thing—you gotta be quick—and slick. Maybe yll show me yr moves sometime.

LINCOLN

BOOTH

LINCOLN

BOOTH

LINCOLN. Look out the window. When you see Grace coming, I'll go.

BOOTH. Cool. Cause youd jinx it, youd really jinx it. Maybe you being here has jinxed it already. Naw. Shes just a little late. You aint jinxed nothing.

BOOTH *sits by the window, glancing out, watching for his date.* LINCOLN *sits in his recliner. He finds the*

whiskey bottle, sips from it. He then rummages around, finding the raggedy photo album. He looks through it.

LINCOLN. There we are at the house. Remember when we moved in?

BOOTH. No.

LINCOLN. You were 2 or 3.

BOOTH. I was 5.

LINCOLN. I was 8. We all thought it was the best fucking house in the world.

BOOTH. Cement backyard and a frontyard full of trash, yeah, dont be going down memory lane man, yll jinx thuh vibe I got going in here. Gracell be walking in here and wrinkling up her nose cause you done jinxed up thuh joint with yr raggedy recollections.

LINCOLN. We had some great times in that house, bro. Selling lemonade on thuh corner, thuh treehouse out back, summers spent lying in thuh grass and looking at thuh stars.

BOOTH. We never did none of that shit.

LINCOLN. But we had us some good times. That row of nails I got you to line up behind Dads car so when he backed out the driveway to work—

BOOTH. He came back that night, only time I ever seen his face go red, 4 flat tires and yelling bout how thuh white man done sabotaged him again.

LINCOLN. And neither of us flinched. Neither of us let on that itd been us.

BOOTH. It was at dinner, right? What were we eating?

LINCOLN. Food.

BOOTH. We was eating pork chops, mashed potatoes and peas. I remember cause I had to look at them peas real hard to keep from letting on. And I would glance over at you, not really glancing not actually turning my head, but I was looking at you out thuh corner of my eye. I was sure he was gonna find us out and then he woulda whipped us good. But I kept glancing at you and you was cool, man. Like nothing was going on. You was cooooool.

(*Rest.*)

What time is it?

LINCOLN. After 3.

(*Rest.*)

You should call her. Something mighta happened.

BOOTH. No man, Im cool. She'll be here in a minute. Patience is a virtue. She'll be here.

LINCOLN. You look sad.

BOOTH. Nope. Im just, you know, Im just—

LINCOLN. Cool.

BOOTH. Yeah, Cool.

BOOTH comes over, takes the bottle of whiskey and pours himself a big glassful. He returns to the window looking out and drinking.

BOOTH. They give you a severance package, at thuh job?

LINCOLN. A weeks pay.

BOOTH. Great.

LINCOLN. I blew it. Spent it all.

BOOTH. On what?

LINCOLN. —Just spent it.

(*Rest.*)

It felt good, spending it. Felt really good. Like back in thuh day when I was really making money. Throwing thuh cards all day and strutting and rutting all night. Didnt have to take no shit from no fool, didnt have to worry about getting fired in favor of some damn wax dummy. I was thuh shit and they was my fools.

(*Rest.*)

Back in thuh day.

(*Rest.*)

(*Rest.*)

Why you think they left us, man?

BOOTH. Mom and Pops? I dont think about it too much.

LINCOLN. I dont think they liked us.

BOOTH. Naw. That aint it.

LINCOLN. I think there was something out there that they liked more than they liked us and for years they was struggling against moving towards that more liked something. Each of them had a special something that they was struggling against. Moms had hers. Pops had his. And they was struggling. We moved out of that nasty apartment into a house. A whole house. I wernt perfect but it was a house and theyd bought it and they brought us there and everything we owned, figuring we could

be a family in that house and them things, them two separate things each of them was struggling against, would just leave them be. Them things would see thuh house and be impressed and just leave them be. Would see thuh job Pops had and how he shined his shoes every night before he went to bed, shining them shoes whether they needed it or not, and thuh thing he was struggling against would see all that and just let him be, and thuh thing Moms was struggling against, it would see the food on the table every night and listen to her voice when she'd read to us sometimes, the clean clothes, the buttons sewed on all right and it would just let her be. Just let us all be, just regular people living in a house. That wernt too much to ask.

BOOTH. Least we was grown when they split.

LINCOLN. 16 and 13 aint grown.

BOOTH. 16s grown. Almost. And I was ok cause you were there.

(Rest.)

Shit man, it aint like they both one day both, together packed all they shit up and left us so they could have fun in thuh sun on some tropical island and you and me would have to grub in thuh dirt forever. They didnt leave together. That makes it different. She left, 2 years go by. Then he left. Like neither of them couldnt handle it no more. She split then he split. Like thuh whole family mortgage bills going to work thing was just too much. And I dont blame them. You dont see me holding down a steady job. Cause its bullshit and I know it. I seen how it cracked them up and I aint going there.

(Rest.)

It aint right me trying to make myself into a one woman man just because she wants me like that. One woman rubber-wearing motherfucker. Shit. Not me. She gonna walk in here looking all hot and shit trying to see how much she can get me to sweat, how much she can get me to give her before she gives me mines. Shit.

LINCOLN

BOOTH

LINCOLN. Moms told me I shouldnt never get married.

BOOTH. She told me thuh same thing.

LINCOLN. They gave us each 500 bucks then they cut out.

BOOTH. Thats what Im gonna do. Give my kids 500 bucks then cut out. Thats thuh way to do it.

LINCOLN. You dont got no kids.

BOOTH. Im gonna have kids then Im gonna cut out.

LINCOLN. Leaving each of yr offspring 500 bucks as yr splitting.

BOOTH. Yeah.

(Rest.)

Just goes to show Mom and Pops had some agreement between them.

LINCOLN. How so.

BOOTH. Theyd stopped talking to eachother. Theyd stopped *screwing* eachother. But they had an agreement. Somewhere in there when it looked like all they had was hate they sat down and did thuh "split" budget.

(Rest.)

When Moms splits she gives me 5 hundred-dollar bills rolled up and tied up tight in one of her nylon stockings. She tells me to put it in a safe place, to spend it only in case of an emergency, and not to tell nobody I got it, not even you. 2 years later Pops splits and before he goes—

LINCOLN. He slips me 10 fifties in a clean handkerchief: "Hide this somewheres good, dont go blowing it, dont tell no one you got it, especially that Booth."

BOOTH. Theyd been scheming together all along. They left separately but they was in agreement. Maybe they arrived at the same place at the same time, maybe they renewed they wedding vows, maybe they got another family.

LINCOLN. Maybe they got 2 new kids. 2 boys. Different than us, though. Better.

BOOTH. Maybe.

Their glasses are empty. The whiskey bottle is empty too. BOOTH takes the champagne bottle from the ice tub. He pops the cork and pours drinks for his brother and himself.

BOOTH. I didnt mind them leaving cause you was there. Thats why Im hooked on us working together. If we could work together it would be like old times. They split and we got that room downtown.

You was done with school and I stopped going. And we had to run around doing odd jobs just to keep the lights on and the hear going and thuh child protection bitch off our backs. It was you and me against thuh world. Link. It could be like that again.

LINCOLN

BOOTH

LINCOLN

BOOTH

LINCOLN. Throwing thuh cards aint as easy as it looks.

BOOTH. I aint stupid.

LINCOLN. When you hung with us back then, you was just on thuh sidelines. Thuh perspective from thuh sidelines is thuh perspective of a customer. There was all kinds of things you didnt know nothing about.

BOOTH. Lonny would entice folks into thuh game as they walked by. Thuh 2 folks on either side of ya looked like they was playing but they was only pretending tuh play. Just tuh generate excitement. You was moving thuh cards as fast as you could hoping that yr hands would be faster than yr customers eyes. Sometimes you won sometimes you lost what else is there to know?

LINCOLN. Thuh customer is actually called the "Mark." You know why?

BOOTH. Cause hes thuh one you got yr eye on. You mark him with yr eye.

LINCOLN

LINCOLN

BOOTH. Im right, right?

LINCOLN. Lemmie show you a few moves. If you pick up these yll have a chance.

BOOTH. Yr playing.

LINCOLN. Get thuh cards and set it up.

BOOTH. No shit.

LINCOLN. Set it up set it up.

In a flash, BOOTH clears away the romantic table setting by gathering it all up in the tablecloth and tossing it aside. As he does so he reveals the "table" underneath: the 2 stacked monte milk crates and the cardboard playing surface. LINCOLN lays out the cards. The brothers are ready. LINCOLN begins to teach BOOTH in earnest.

LINCOLN. Thuh deuce of spades is thuh card tub watch.

BOOTH. I work with thuh deuce of hearts. But spades is cool.

LINCOLN. Theres thuh Dealer, thuh Stickman, thuh Sides, thuh Lookout and thuh Mark. I'll be thuh Dealer.

BOOTH. I'll be thuh Lookout. Lemmie be thuh Lookout, right? I'll keep an eye for thuh cops. I got my piece on me.

LINCOLN. You got it on you right now?

BOOTH. I always carry it.

LINCOLN. Even on a date? In yr own home?

BOOTH. You never know, man.

(Rest.)

So Im thuh Lookout.

LINCOLN. Gimmie yr piece.

BOOTH gives LINCOLN his gun. LINCOLN moves the little wooden chair to face right in front of the setup. He then puts the gun on the chair.

LINCOLN. We dont need nobody standing on the corner watching for cops cause there aint none.

BOOTH. I'll be thuh Stickman, then.

LINCOLN. Stickman knows the game inside out. You aint there yet. But you will be. You wanna learn good, be my Sideman. Playing along with the Dealer, moving the Mark to lay his money down. You wanna learn, right?

BOOTH. I'll be thuh Side.

LINCOLN. Good.

(Rest.)

First thing you learn is what is. Next thing you learn is what aint. You dont know what is you dont know what aint, you dont know shit.

BOOTH. Right.

LINCOLN

BOOTH

BOOTH. Whatchu looking at?

LINCOLN. Im sizing you up.

BOOTH. Oh yeah?!

LINCOLN. Dealer always sizes up thuh crowd.

BOOTH. Im yr Side, Link, Im on yr team, you dont go sizing up yr own team. You save looks like that for yr Mark.

LINCOLN. Dealer always sizes up thuh crowd. Everybody out there is part of the crowd. His crew is part of the crowd, he himself is part of the crowd. Dealer always sizes up thuh crowd.

LINCOLN looks BOOTH over some more then looks around at an imaginary crowd.

BOOTH. Then what then what?

LINCOLN. Dealer dont wanna play.

BOOTH. Bullshit man! Come on you promised!

LINCOLN. Thats thuh Dealers attitude. He *acts* like he dont wanna play. He holds back and thuh crowd, with their eagerness to see his skill and their willingness to take a chance, and their greediness to win his cash, the larceny in their hearts, all goad him on and push him to throw his cards, although of course the Dealer has been wanting to throw his cards all along. Only he dont never show it.

BOOTH. Thats some sneaky shit, Link.

LINCOLN. It sets thuh mood. You wanna have them in yr hand before you deal a hand, K?

BOOTH. Cool.—K.

LINCOLN. Right.

LINCOLN

BOOTH

BOOTH. You sizing me up again?

LINCOLN. Theres 2 parts to throwing thuh cards. Both parts are fairly complicated. Thuh moves and thuh grooves, thuh talk and thuh walk, thuh patter and thuh pitter pat, thuh flap and thuh rap: what yr doing with yr mouth and what yr doing with yr hands.

BOOTH. I got thuh words down pretty good.

LINCOLN. You need to work on both.

BOOTH. K.

LINCOLN. A goodlooking walk and a dynamite talk captivates their entire attention. The Mark focuses with 2 organs primarily: his eyes and his ears. Leave one out you lose yr shirt. Captivate both, yr golden.

BOOTH. So them times I seen you lose, them times I seen thuh Mark best you, that was a time when yr hands werent fast enough or yr patter werent right.

LINCOLN. You could say that.

BOOTH. So, there was plenty of times—

LINCOLN moves the cards around.

LINCOLN. You see what Im doing? Dont look at my hands, man, look at my eyes. Know what is and know what aint.

BOOTH. What is?

LINCOLN. My eyes?

BOOTH. What aint?

LINCOLN. My hands. Look at my eyes not my hands. And you standing there thinking how thuh fuck I gonna learn how tuh throw thuh cards if I be looking in his eyes? Look into my eyes and get yr focus. Dont think about learning how tuh throw thuh cards. Dont think about nothing. Just look into my eyes. Focus.

BOOTH. Theyre red.

LINCOLN. Look into my eyes.

BOOTH. You been crying?

LINCOLN. Just look into my eyes, fool. Now. Look down at thuh cards. I been moving and moving and moving them around. Ready?

BOOTH. Yeah.

LINCOLN. Ok, Sideman, thuh Marks got his eye on you. Yr gonna show him its easy.

BOOTH. K.

LINCOLN. Pick out thuh deuce of spades. Dont pick it up just point to it.

BOOTH. This one, right?

LINCOLN. Dont ask thuh Dealer if yr right, man, point to yr card with confidence.

BOOTH points.

BOOTH. That one.

(Rest.)

Flip it over, man.

LINCOLN *flips over the card. It is in fact the deuce of spades. BOOTH struts around gloating like a rooster. LINCOLN is mildly crestfallen.*

BOOTH. Am I right or am I right?! Make room for 3-Card! Here comes thuh champ!

LINCOLN. Cool. Stay focused. Now we gonna add the second element. Listen.

LINCOLN *moves the cards and speaks in a low hypnotic voice.*

LINCOLN. Lean in close and watch me now: who see thuh black card who see thuh black card I see thuh black card black cards thuh winner pick thuh black card thats thuh winner pick thuh red card thats thuh loser pick thuh other red card thats thuh other loser pick thuh black card you pick thuh winner. Watch me as I throw thuh cards. Here we go.

(*Rest.*)

Who see thuh black card who see thuh black card? You pick thuh red card you pick a loser you pick that red card you pick a loser you pick thuh black card thuh deuce of spades you pick a win- ner who sees thuh deuce of spades thuh one who sees it never fades watch me now as I throw thuh cards. Red losers black winner follow thuh deuce of spades chase thuh black deuce. Dark deuce will get you thuh win. One good pickll get you in 2 good picks you gone win. 10 will get you 20, 20 will get you 40.

(*Rest.*)

Ima show you thuh cards: 2 red cards but only one spade. Dark winner in thuh center and thuh red losers on thuh sides. Pick uh red card you got a loser pick thuh other red card you got a loser pick thuh black card you got a winner. Watch me watch me watch me now.

(*Rest.*)

Ok, 3-Card, you know which cards thuh deuce of spade?

BOOTH. Yeah.

LINCOLN. You sure? Yeah? You sure you sure or you just think you sure? Oh you sure you sure huh? Was you watching Links lighting fast express? Was you watching Link cause he the best? So you sure, huh? Point it out. Now, place yr bet and Linkll turn over yr card.

BOOTH. What should I bet?

LINCOLN. Dont bet nothing man, we just playing. Slap me 5 and point out thuh deuce.

BOOTH *slaps LINCOLN 5, then points out a card which LINCOLN flips over. It is in fact, again the deuce of spades.*

BOOTH. Yeah, baby! 3-Card got thuh moves! You didnt know lil bro had thuh stuff, huh? Think again, Link, think again.

LINCOLN. You wanna learn or you wanna run yr mouth?

BOOTH. Thought you had fast hands. Wassup? What happened tuh "Links Lightning Fast Express"? Turned into uh local train looks like tuh me.

LINCOLN. Thats yr whole motherfucking problem. Yr so busy running yr mouth you aint never gonna learn nothing! You think you something but you aint shit.

BOOTH. I aint shit. I am *The* Shit. Shit. Wheres thuh dark deuce? Right there! Yes. baby!

LINCOLN. Ok. 3-Card. Cool. Lets switch. Take thuh cards and show me whatcha got. Go on. Dont touch thuh cards too heavy just—its a light touch. Like yr touching Graces skin. Or, whatever, man, just a light touch. Like uh whisper.

BOOTH. Like uh whisper.

BOOTH *moves the cards around, in an awkward imita- tion of his brother.*

LINCOLN. Good.

BOOTH. Yeah. All right. Look into my eyes.

BOOTHS *speech is loud and his movements are jerky. He is doing worse than when he threw the cards at the top of the play.*

BOOTH. Watch-me-close-watch-me-close-now: who- see-thuh-dark-card-who-see-thuh-dark-card? I-see- thuh-dark-card. Here-it-is. Thuh-dark-card-is- thuh-winner. Pick-thuh-dark-card-and-you-pick-uh- winner. Pick-uh-red-card-and-you-pick-uh-loser. Theres-thuh-loser-yeah-theres-thuh-red-card, theres-thuh-other-loser-and-theres-thuh-black- card, truth-winner. Watch-me-close-watch-me-close- now: 3-Card-throws-thuh-cards-lightning-fast. 3-Card-thats-me-and-lma-last. Watch-me-throw- cause-here-I-go. See truth black card? Yeah? Who see I see you see thuh black card?

LINCOLN. Hahahahhahahahahahahahah!

LINCOLN doubles over laughing. BOOTH puts on his coat and pockets the gun.

BOOTH. What?

LINCOLN. Nothing, man, nothing.

BOOTH. *What?!*

LINCOLN. Yr just, yr just a little wild with it. You talk like that on thuh street cards or no cards and theyll lock you up, man. Shit. Reminds me of that time when you hung with us and we let you try being thuh Stick cause you wanted to so bad. Thuh hustle was so simple. Remember? I told you that when I put my hand in my left pocket you was to get thuh Mark tuh pick thuh card on that side. You got to thinking something like Links left means my left some dyslexic shit and turned thuh wrong card. There was 800 bucks on the line and you fucked it up.

(*Rest.*)

But it was cool, little bro, cause, we made the money back. It worked out cool.

(*Rest.*)

So, yeah, I said a light touch, little bro. Throw thuh cards light. Like uh whisper.

BOOTH. Like Graces skin.

LINCOLN. Like Graces skin.

BOOTH. What time is it?

LINCOLN holds up his watch. BOOTH takes a look.

BOOTH. Bitch. *Bitch!* She said she was gonna show up around 8. 8-a-fucking-clock.

LINCOLN. Maybe she meant 8 *a.m.*

BOOTH. Yeah. She gonna come all up in my place talking bout how she *love* me. How she cant stop *thinking* bout me. Nother mans shit up in her nother mans thing in her nother mans dick on her breath.

LINCOLN. Maybe something happened to her.

BOOTH. Something happened to her all right. She trying to make a chump outa me. I aint her chump. I aint nobodys chump.

LINCOLN. Sit. I'll go to the payphone on the corner. I'll—

BOOTH. Thuh world puts its foot in yr face and you dont move. You tell thuh world tuh keep on stepping. But Im my own man, Link. I aint you.

BOOTH goes out, slamming the door behind him.

LINCOLN. You got that right.

After a moment LINCOLN picks up the cards. He moves them around fast, faster, faster.

Scene Six

Thursday night. The room looks empty, as if neither brother is home. LINCOLN comes in. Hes fairly drunk. He strides in, leaving the door slightly ajar.

LINCOLN. Taaadaaaa!

(*Rest.*)

(*Rest.*)

Taadaa, motherfucker. Taadaa!

(*Rest.*)

Booth—uh, 3-Card—you here? Nope. Good. Just as well.

Ha Ha *Ha Ha Ha!*

He pulls an enormous wad of money from his pocket. He counts it, slowly and luxuriously, arranging and smoothing the bills and sounding the amounts under his breath. He neatly rolls up the money, secures it with a rubber band and puts it back in his pocket. He relaxes in his chair. Then he takes the money out again, counting it all over again, but this time quickly, with the touch of an expert hustler.

LINCOLN. You didnt go back, Link, you got back, you got it back you got yr shit back in thuh saddle, man, you got back in business. Walking in Luckys and you seen how they was looking at you? Lucky starts pouring for you when you walk in. And the women. You see how they was looking at you? Bought drinks for everybody. Bought drinks for Lucky. Bought drinks for Luckys damn dog. Shit. And thuh women be hanging on me and purring. And I be feeling that old call of thuh wild calling. I got more phone numbers in my pockets between thuh time I walked out that door and thuh time I walked back in than I got in my whole life. Cause my shit is *back.* And back better than it was when it left too. Shoot. Who thuh man? Link. Thats right. Purrrrring all up on me and letting me touch them and promise them shit. 3 of them sweethearts in thuh restroom on my dick all at once and I was *there* my shit was there. And Cookie just went out

of my mind which is cool which is very cool. 3 of them. Fighting over it. Shit. Cause they knew I'd been throwing thuh cards. Theyd seen me on thuh corner with thuh old crew or if they aint seed me with they own eyes theyd heard word. Links thuh stink! Theyd heard word and they seed uh sad face on some poor sucker or a tear in thuh eye of some stupid fucking tourist and they figured it was me whod Just took thuh suckers last dime, it was me who had all thuh suckers loot. They knew. They knew.

BOOTH *appears in the room. He is standing behind the screen, unseen all this time. He goes to the door, sound-lessly, just stands there.*

LINCOLN. And they was all in Luckys. Shit. And they was waiting for me to come in from my last throw. Cant take too many fools in one day, its bad luck, Link, so they was all waiting in there for me to come in thuh door and let thuh liquor start flowing and thuh music start going and let thuh boys who dont have thuh balls to get nothing but a regular job and uh weekly paycheck, let them crowd around and get in somehow on thuh excite-ment, and make way for thuh ladies, so they can run they hands on my clothes and feel thuh magic and imagine thuh man, with plenty to go around, living and breathing underneath.

(*Rest.*)

They all thought I was down and out! They all thought I was some NoCount HasBeen LostCause motherfucker. But I got my shit back. Thats right. They stepped on me and kept right on stepping. Not no more. Who thuh man?! Goddamnit, who thuh —

BOOTH *closes the door.*

LINCOLN

BOOTH

(*Rest.*)

LINCOLN. Another evening to remember, huh?

BOOTH

(*Rest.*)

Uh — yeah, man, yeah. Thats right, thats right.

LINCOLN. Had me a memorable evening myself.

BOOTH. I got news.

(*Rest.*)

What you been up to?

LINCOLN. Yr news first.

BOOTH. Its good.

LINCOLN. Yeah?

BOOTH. Yeah.

LINCOLN. Go head then.

BOOTH

(*Rest.*)

Grace got down on her knees. Down on her knees, man.

Asked *me* tuh marry *her.*

LINCOLN. Shit.

BOOTH. Amazing Grace!

LINCOLN. Lucky you, man.

BOOTH. And guess where she was, I mean, while I was here waiting for her. She was over at her house watching tv. I'd told her come over Thursday and I got it all wrong and was thinking I said Wednesday and here I was sitting waiting my ass off and all she was doing was over at her house just watching tv.

LINCOLN. Howboutthat.

BOOTH. She wants to get married right away. Shes tired of waiting. Feels her clock ticking and shit. Wants to have a baby. But dont look so glum man, we gonna have a boy and we gonna name it after you.

LINCOLN. Thats great, man. That's really great.

BOOTH

LINCOLN

BOOTH. Whats yr news?

LINCOLN

(*Rest.*)

Nothing.

BOOTH. Mines good news, huh?

LINCOLN. Yeah. Real good news, bro.

BOOTH. Bad news is — well, shes real set on us living together.
And she always did like this place.

(Rest.)

Yr gonna have to leave. Sorry.

LINCOLN. No sweat.

BOOTH. This was only a temporary situation anyhow.

LINCOLN. No sweat man. You got a new life opening up for you, no sweat. Graces moving in today? I can leave right now.

BOOTH. I don't mean to put you out.

LINCOLN. No sweat. I'll just pack up.

LINCOLN *rummages around finding a suitcase and begins to pack his things.*

BOOTH. Just like that, huh? "No sweat"?! Yesterday you lost yr damn job. You dont got no cash. You dont got no friends, no nothing, but you clearing out just like that and its "no sweat"?!

LINCOLN. You've been real generous and you and Grace need me gone and its time I found my own place.

BOOTH. No sweat.

LINCOLN. No sweat.

(Rest.)

K. I'll spill it. I got another job, so getting my own place aint gonna be so bad.

BOOTH. You got a new job! Doing what?

LINCOLN. Security guard.

BOOTH.

(Rest.)

Security guard. Howaboutthat.

LINCOLN *continues packing a few things he has. He picks up a whiskey bottle.*

BOOTH. Go head, take thuh med-sin, bro. You gonna need it more than me. I got, you know. I got my love to keep me warm and shit.

LINCOLN. You gonna have to get some kind of work, or are you gonna let Grace support you?

BOOTH. I got plans.

LINCOLN. She might want you now but she wont want you for long if you dont get some kind of job. Shes a smart chick. And she cares about you. But she aint gonna let you treat her like some pack mule while shes out working her ass off and yr laying up in here scheming and dreaming to cover up thuh fact that you don't got no skills.

BOOTH. Grace is very cool with who I am and where I'm a thank you.

LINCOLN. It was just some advice. But, hey, yr doing great just like yr doing.

LINCOLN

BOOTH

LINCOLN

BOOTH

BOOTH. When Pops left he didnt take nothing with him. I always thought that was fucked-up.

LINCOLN. He was a drunk. Everything he did was always half regular and half fucked-up.

BOOTH. Whyd he leave his clothes though? Even drunks gotta wear clothes.

LINCOLN. Whyd he leave his clothes whyd he leave us? He was uh drunk, bro. He—whatever, right? I mean, you aint gonna figure it out by thinking about it. Just call it one of thuh great unsolved mysteries of existence.

BOOTH. Moms had a man on thuh side.

LINCOLN. yeah? Pops had side shit going on too. More than one. He would take me with him when he went to visit them. Yeah.

(Rest.)

Sometimes he'd let me meet the ladies. They was all very nice. Very polite. Most of them real pretty. Sometimes he'd let me watch. Most of thuh time I was just outside on thuh porch or in thuh lobby or in thuh car waiting for him but sometimes he'd let me watch.

BOOTH. What was it like?

LINCOLN. Nothing. It wasn't like nothing. He made it seem like it was this big deal this great thing he was letting me witness but it wasn't like nothing.

(Rest.)

One of his ladies liked me, so I would do her after he'd done her. Oh thuh sly though. He'd be laying there, spent and sleeping and snoring and her and me would be sneaking it.

BOOTH. Shit.

LINCOLN. It was alright.

BOOTH

LINCOLN

LINCOLN takes his crumpled Abe Lincoln getup from the closet. Isnt sure what to do with it.

BOOTH. Im gonna miss you coming home in that getup. I don't even got a picture of you in it for the album.

LINCOLN

(Rest.)

Hell, I'll put it on. Get thuh camera get thuh camera.

BOOTH. Yeah?

LINCOLN. What thuh fuck, right?

BOOTH. Yeah, what thuh fuck.

BOOTH scrambles around the apartment and finds the camera. LINCOLN quickly puts on the getup, including 2 thin smears of white pancake makeup, more like war paint than whiteface.

LINCOLN. They didnt fire me cause I wasnt no good. They fired me cause they was cutting back. Me getting dismissed didnt have no reflection on my performance. and I was damn good Honest Abe considering.

BOOTH. Yeah. You look great man, really great. Fix yr hat. Get in thuh light. Smile.

LINCOLN. Lincoln didnt never smile.

BOOTH. Sure he smiled.

LINCOLN. No he didnt, man, you seen thuh pictures of him. In all his pictures he was real serious.

BOOTH. You got a new job, yr having a good day, right?

LINCOLN. Yeah.

BOOTH. So smile.

LINCOLN. Snapshots gonna look pretty stupid with me—

BOOTH takes a picture.

BOOTH. Thisll look great in thuh album.

LINCOLN. Lets take one together, you and me.

BOOTH. No thanks. Save the film for the wedding.

LINCOLN. This wasnt a bad job. I just outgrew it. I could put in a word for you down there, maybe when business picks up again theyd hire you.

BOOTH. No thanks. That shit aint for me. I aint into pretending Im someone else all day.

LINCOLN. I was just sitting there in thuh getup. I wasnt pretending nothing.

BOOTH. What was going on in yr head?

LINCOLN. I would make up songs and shit.

BOOTH. And think about women.

LINCOLN. Sometimes.

BOOTH. Cookie.

LINCOLN. Sometimes.

BOOTH. And how she came over here one night looking for you.

LINCOLN. I was at Luckys.

BOOTH. She didn't know that.

LINCOLN. I was drinking.

BOOTH. All she knew was you couldnt get it up. You couldnt get it up with her so in her head you was tired of her and had gone out to screw somebody new and this time maybe werent never coming back.

(Rest.)

She had me pour her a drink or 2. I didnt want to. She wanted to get back at you by having some fun of her own and when I told her to go out and have it, she said she wanted to have her fun right here. With me.

(Rest.)

[And then, just like that, she changed her mind.

(Rest.)

But she'd hooked me. That bad part of me that I fight down everyday. You beat yrs down and its stays there dead but mine keeps coming up for another round. And she hooked the bad part of me. And the bad part of me opened my mouth and started promising her things. Promising her things I knew she wanted and you couldnt give her. And the bad part of me took her clothing off and carried her into thuh bed and had her, Link, yr Cookie. It wasnt just thuh bad part of me it was all of me, man,] I had her. Yr damn wife. Right in that bed.

LINCOLN. I used to think about her all thuh time but I don't think about her no more.

BOOTH. I told her if she dumped you I'd marry her but I changed my mind.

LINCOLN. I dont think about her no more.

BOOTH. You dont go back.

LINCOLN. Nope.

BOOTH. Cause you cant. No matter what you do you cant get back to being who you was. Best you can do is just pretend to be yr old self.

LINCOLN. Yr outa yr mind.

BOOTH. Least Im still me!

LINCOLN. Least I work. You never did like to work. You better come up with some kinda way to bring home the bacon or Gracell drop you like a hot rock.

BOOTH. I got plans!

LINCOLN. Yeah, you gonna throw thuh cards, right?

BOOTH. That's right!

LINCOLN. You a double left-handed motherfucker who dont stand a chance in all get out out there throwing no cards.

BOOTH. You scared.

LINCOLN. I'm gone.

LINCOLN goes to leave.

BOOTH. Fuck that!

LINCOLN. Yr standing in my way.

BOOTH. You scared I got yr shit.

LINCOLN. The only part of my shit you got is the part of my shit you think you got and that aint shit.

BOOTH. Did I pick right them last times? Yes. Oh, I got yr shit.

LINCOLN. Set up the cards.

BOOTH. Thought you was gone.

LINCOLN. Set it up.

BOOTH. I got yr shit and Ima go out there and be thuh man and you aint gonna be nothing.

LINCOLN. Set it up!

BOOTH hurriedly sets up the milk crates and cardboard top. LINCOLN throws the cards.

LINCOLN. Lean in close and watch me now: who see thuh black card who see thuh black card I see thuh black card black cards thuh winner pick thuh black card thats thuh winner pick thuh red card thats thuh loser pick thuh other red card thats thuh other loser pick thuh black card you pick thuh winner. Who see thuh black card who see thuh black card? You pick thuh red card you pick a loser you pick that red card you pick a loser you pick thuh black card thuh deuce of spades you pick a winner who sees thuh deuce of spades thuh one who sees it never fades watch me now as I throw thuh cards. Red losers black winner follow thuh deuce of spades chase thuh black deuce. Dark deuce will get you thuh win. 10 will get you 20, 20 will get you 40. One good pickll get you in 2 good picks and you gone win.

(Rest.)

Ok, man, wheres thuh black deuce?

BOOTH points to a card. LINCOLN flips it over. It is the deuce of spades.

BOOTH. Who thuh man?!

LINCOLN turns over the other 2 cards, looking at them confusedly.

LINCOLN. Hhhhh.

BOOTH. Who thuh man, Link?! Huh? Who thuh man, Link?!?!

LINCOLN. You thuh man, man.

BOOTH. I got yr shit down.

LINCOLN. Right.

BOOTH. "Right"? All you saying is "right"?

(Rest.)

You was out on the street throwing. Just today. Werent you? You wasnt gonna tell me.

LINCOLN. Tell you what?

BOOTH. That you was out throwing.

LINCOLN. I was gonna tell you, sure. Cant go and leave my little bro out thuh loop, can I? Didnt say nothing cause I thought you heard. Did all right today but Im still rusty, I guess. But hey—yr getting good.

BOOTH. But I'll get out there on thuh street and still fuck up, wont I?

LINCOLN. You seem pretty good, bro.

BOOTH. You gotta do it for real, man.

LINCOLN. I am doing it for real. And yr getting good.

BOOTH. I dunno. It didnt feel real. Kinda felt—well it didnt feel real.

LINCOLN. We're missing the essential elements. The crowd, the street, thuh traffic sounds, all that.

BOOTH. We missing something else too, thuh thing thatll really make it real.

LINCOLN. Whassat, bro?

BOOTH. Thuh cash. Its just bullshit without thuh money. Put some money down on thuh table then itd be real, then youd do it for real, then I'd win it for real.

(Rest.)

And dont be looking all glum like that. I know you got money. A whole pocketful. Put it down.

LINCOLN

BOOTH

BOOTH. You scared of losing it to thuh man, chump? Put it down, less you think thuh kid who got two left hands is gonna give you uh left hook. Put it down, bro, put it down.

LINCOLN *takes the roll of bills from his pocket and places it on the table.*

BOOTH. How much you got there?

LINCOLN. 500 bucks.

BOOTH. Cool.

(Rest.)

Ready?

LINCOLN. Does it feel real?

BOOTH. Yeah. Clean slate. Take it from the top. "One good pickll get you in 2 good picks and you gone win."

(Rest.)

Go head.

LINCOLN. Watch me now:

BOOTH. Woah, man, woah.

(Rest.)

You think Ima chump.

LINCOLN. No I dont.

BOOTH. You aint going full out.

LINCOLN. I was just getting started.

BOOTH. But when you got good and started you wasn't gonna go full out. You wasnt gonna go all out. Yon was gonna do thuh pussy shit, not thuh real shit.

LINCOLN. I put my money down. Money makes it real.

BOOTH. But not if I dont put no money down tuh match it.

LINCOLN. You dont got no money.

BOOTH. I got money!

LINCOLN. You aint worked in years. You dont got shit.

BOOTH: I got money.

LINCOLN. Whatcha been doing, skimming off my weekly paycheck and squirreling it away?

BOOTH. I got money.

(Rest.)

They stand there sizing eachother up. BOOTH breaks away, going over to his hiding place from which he gets an old nylon stocking with money in the toe, a knot holding the money secure.

LINCOLN

BOOTH

BOOTH. You know she was putting her stuff in plastic bags? She was just putting her stuff in plastic bags not putting but shoving. She was shoving her stuff in plastic bags and I was standing in thuh doorway watching her and she was so busy shoving thuh shit she didnt see me. "I aint made of money," thats what he always saying. The guy she had on the side. I would catch them together sometimes. Thuh first time I cut school I got tired of hanging out so I goes home—figured I could tell Mom I was sick and cover my ass. Come in thuh house real slow cause Im sick and moving slow and quiet. He had her bent over. They both had all they clothes on like they was about to do something like go out dancing cause they was dressed to thuh 9s but at thuh last minute his pants had fallen down and her dress had flown up and theyd ended up doing something else.

(Rest.)

They didnt see me come in, they didnt see me watching them, they didnt see me going out. That

was uh Thursday. Something told me tuh cut school thuh next Thursday and sure enough.— He was her Thursday man. Every Thursday. Yeah. And Thursday nights she was always all cleaned up and fresh and smelling nice. Serving up dinner. And Pops would grab her cause she was all bright and she would look at me, like she didnt know that I knew but she was asking me not to tell nohow. She was asking me to—oh who knows.

(Rest.)

She was talking with him one day, her sideman, her Thursday dude, her backdoor man, she needed some money for something, thered been some kind of problem some kind of mistake had been made some kind of mistake that needed cleaning up and she was asking Mr. Thursday for some money to take care of it. "I aint made of money," he says. He was putting his foot down. And then there she was 2 months later not showing yet, maybe she'd got rid of it maybe she hadnt maybe she'd stuffed it along with all her other things in them plastic bags while he waited outside in thuh car with thuh motor running. She must a known I was gonna walk in on her this time cause she had my payoff—my *inheritance*—she had it all ready for me. 500 dollars in a nylon stocking. Huh.

He places the stuffed nylon stocking on the table across from Lincolns *money roll.*

Booth. Now its real.

Lincoln. Dont put that down.

Booth. Throw thuh cards.

Lincoln. I dont want to play

Booth. Throw thuh fucking cards, man!!

Lincoln

(Rest.)

2 red cards but only one black. Pick thuh black you pick thuh winner. All thuh cards are face down you point out thuh cards and then you move them around. Now watch me now, now watch me real close. Put thuh winning deuce down in the center put thuh loser reds on either side then you just move thuh cards around. Move them slow or move them fast. Links thuh king he gonna last.

(Rest.)

Wheres thuh deuce of spades?

Booth *chooses a curd and chooses correctly.*

Booth. HA!

Lincoln. One good pickll get you in 2 good picks and you gone win.

Booth. I know man I know.

Lincoln. I'm just doing thuh talk.

Booth. Throw thuh fucking cards!

Lincoln *throws the cards.*

Lincoln. Lean in close and watch me now: who see thuh black card who see thuh black card I see thuh black card black cards thuh winner pick thuh black card thats thuh winner pick thuh red card thats thuh loser pick thuh other red card thats thuh other loser pick thuh black card you pick thuh winner. Watch me as I throw thuh cards. Here we go.

(Rest.)

Ima show you thuh cards: 2 red cards but only one spade. Dark winner in thuh center and thuh red losers on thuh sides. Pick up red card you got a loser pick thuh other red card you got a loser pick thuh black card you got a winner. Watch me watch me watch me now.

(Rest.)

Who see thuh black card who see thuh black card? You pick thuh red card you pick a loser you pick that red card you pick a loser you pick thuh black card thuh deuce of spades you pick a winner who sees thuh deuce of spades thuh one who sees it never fades watch me now as I throw thuh cards. Red losers black winner follow thuh deuce of spades chase thuh black deuce. Dark deuce will get you thuh win.

(Rest.)

Ok, 3–Card, you know which cards thuh deuce of spades? This is for real now, man. You pick wrong Im in yr wad and I keep mines.

Booth. I pick right I got yr shit.

Lincoln. Yeah.

BOOTH. Plus I beat you for real.

LINCOLN. Yeah.

(*Rest.*)

You think we're really brothers?

BOOTH. Huh?

LINCOLN. I know we *brothers*, but is we really brothers, you know, blood brothers or not, you and me, whatdubyathink?

BOOTH. I think we're brothers.

BOOTH

LINCOLN

BOOTH

LINCOLN

BOOTH

LINCOLN

LINCOLN. Go head man, wheres thuh deuce?

In a flash BOOTH *points out a card.*

LINCOLN. You sure?

BOOTH. Im sure!

LINCOLN. Yeah? Dont touch thuh cards, now.

BOOTH. Im sure.

The 2 brothers lock eyes. Lincoln *turns over the card that* BOOTH *selected and* BOOTH, *in a desperate break of concentration, glances down to see that he has chosen the wrong card.*

LINCOLN. Deuce of hearts, bro. Im sorry. Thuh deuce of spades was this one.

(*Rest.*)

I guess all this is mines.

He slides the money toward himself.

LINCOLN. You were almost right. Better luck next time.

(*Rest.*)

Aint yr fault if yr eyes aint fast. And you cant help it if you got 2 left hands, right? Throwing cards aint thuh whole world. You got other shit going for you. You got Grace.

BOOTH. Right.

LINCOLN. Whassamatter?

BOOTH. Mm.

LINCOLN. Whatsup?

BOOTH. Nothing.

LINCOLN

(*Rest.*)

It takes a certain kind of understanding to be able to play this game.

(*Rest.*)

I still got thuh moves, dont I?

BOOTH. Yeah you still got thuh moves.

LINCOLN *cant help himself. He chuckles.*

LINCOLN. I aint laughing at you, bro, Im just laughing. Shit there is so much to this game. This game is—there is just so much to it.

LINCOLN, *still chuckling, flops down in the easy chair. He takes up the nylon stocking and fiddles with the knot.*

LINCOLN. Woah, she sure did tie this up tight, didnt she?

BOOTH. Yeah. I aint opened it since she gived it to me.

LINCOLN. Yr kidding. 500 and you aint never opened it? Shit. Sure is tied tight. She said heres 500 bucks and you didnt undo thuh knot to get a look at the cash? You aint needed to take a peek in all these years? Shit. I woulda opened it right away. Just a little peek.

BOOTH. I been saving it.

(*Rest.*)

Oh. dont open it, man.

LINCOLN. How come?

BOOTH. You won it man. you dont gotta go opening it.

LINCOLN. "We gotta see whats in it.

BOOTH. We *know* whats in it. Dont open it.

LINCOLN. You are a chump, bro. There could be millions in here! There could be nothing! I'll open it.

BOOTH. Dont.

LINCOLN

BOOTH

(Rest.)

LINCOLN. Shit this knot aint coming out. I could cut it, but that would spoil the whole effect, wouldnt it? Shit. Sorry.

I aint laughing at you Im just laughing. Theres so much about those cards. You think you can learn them just by watching and just by playing but there is more to them cards than that. And—. Tell me something, Mr. 3–Card, she handed you this stocking and she said there was money in it and then she split and you say you didnt open it. Howd you know she was for real?

BOOTH. She was for real.

LINCOLN. How you know. She coulda been jiving you, bro. Jiving you that there really *was* money in this thing. Jiving you big time. Its like thuh cards. And ooooh you certainly was persistent. But you was in such a hurry to learn thuh last move that you didnt bother learning thuh first one. That was yr mistake. Cause its thuh first move that separates thuh Player from thuh Played. And thuh first move is to know that there aint no winning. It may look like you got a chance but the only time you pick right is when thuh man lets you. And when its thuh real deal, when its thuh real fucking deal, bro, and thuh moneys on thuh line, thats when thuh man wont want you picking right. He will want you picking wrong so he will make you pick wrong. Wrong wrong wrong. Ooooh, you thought you was finally happening. didnt you? You thought yr ship had come in or some shit, huh? Thought you was uh Player. But I played you, bro.

BOOTH. Fuck you. Fuck you FUCKYOU *FUCKYOU!!*

LINCOLN. Whatever, man. Damn this knot is tough. Ima cut it.

LINCOLN *reaches in his boot, pulling out a knife. He chuckles all the while.*

LINCOLN. Im not laughing at you, bro, Im just laughing.

BOOTH *chuckles with him.* LINCOLN *holds the knife high, ready to cut the stocking.*

LINCOLN. Turn yr head. You may not wanna look.

BOOTH *turns away slightly. They both continue laughing.* LINCOLN *brings the knife down to cut the stocking.*

BOOTH. I popped her.

LINCOLN. Huh?

BOOTH. Grace. I popped her. Grace.

(Rest.)

Who thuh fuck she think she is doing me like she done? Telling me I dont got nothing going on. I showed her what I got going on. Popped her good. Twice. 3 times. Whatever.

(Rest.)

She aint dead.

(Rest.)

She werent wearing my ring I gived her. Said it was too small. Fuck that. Said it hurt her. Fuck that. Said she was into bigger things. *Fuck* that. Shes alive not to worry, she aint going out that easy, shes alive shes shes—

LINCOLN. Dead. Shes—

BOOTH. Dead.

LINCOLN. Ima give you back yr stocking, man. Here, bro—

BOOTH. Only so long I can stand that little brother shit. Can only take it so long. I'm telling you—

LINCOLN. Take it back, man—

BOOTH. That little bro shit had to go—

LINCOLN. Cool—

BOOTH. Like Booth went—

LINCOLN. Here, 3–Card—

BOOTH. That Booth shit is over. 3–Cards thuh man now—

LINCOLN. I'm a give you yr stocking back, 3–Card—

BOOTH. Who thuh man now, huh? Who thuh man now?! Think you can fuck with me, motherfucker think again motherfucker think again! Think you can take me like I'm just some chump some two lefthanded pussy dickbreath chump who you can take and then go laugh at. Aint laughing at me you was just laughing bunch uh bullshit and you know it.

LINCOLN. Here. Take it.

BOOTH. I aint gonna be needing it. Go on. You won it you open it.

LINCOLN. No thanks.

BOOTH. Open it open it open it open it. *OPEN IT!!!*

(*Rest.*)

Open it up, bro.

LINCOLN

BOOTH

LINCOLN *brings the knife down to cut the stocking. In a flash,* BOOTH *grabs* LINCOLN *from behind. He pulls his gun and thrusts into the left side of* LINCOLN*s neck. They stop there poised.*

LINCOLN. Dont.

BOOTH *shoots* LINCOLN. LINCOLN *slumps forward, falling out of his chair and onto the floor. He lies there dead.* BOOTH *paces back and forth, like a panther in a cage, holding his gun.*

BOOTH. Think you can take my shit? My shit. That shit was mines. I kept it. Saved it. All this while. Through thick and through thin. Through fucking thick and through fucking thin, motherfucker. And you just gonna come up in here and mock my shit and call me two lefthanded talking about how she coulda been jiving me then go steal from me? My *inheritance.* You stole my *inheritance,* man. That aint right. That aint right and you know

it. You had yr own. And you blew it. You *blew it,* motherfucker! I saved mines and you blew yrs. Thinking you all that and blew yr shit. And I *saved* mines.

(*Rest.*)

You aint gonna be needing yr fucking money-roll no more, dead motherfucker, so I will pocket it thank you.

(*Rest.*)

Watch me close watch me close now: I'm a go out there and make a name for myself that don't have nothing to do with you. And 3–Cards gonna be in everybodys head and in everybodys mouth like Link was.

(*Rest.*)

I'm a take back my inheritance too. It was mines anyhow. Even when you stole it from me it was still mines cause she gave it to me. She didn't give it to you. And I been saving it all this while.

He bends to pick up the money-filled stocking. Then he just crumples. As he sits beside LINCOLN*s body, the money-stocking falls away.* BOOTH *holds* LINCOLN*s body, hugging him close. He sobs.*

BOOTH. *AAAAAAAAAAAAAAAAAAAAAH!*

END OF PLAY

Eurydice

Introduction by Benjamin Kerr and James Winter

Sarah Ruhl: A Fresh Perspective

Sarah Ruhl has been called one of the most acclaimed and accomplished young contemporary playwrights of today. Known for combining quirky comedy with intense emotion, Ruhl has won numerous awards, including the MacArthur Genius grant and was a finalist for the 2005 Pulitzer Prize. Her plays have been performed nationwide at Lincoln Center Theater, Alley Theatre, Second Stage, Playwrights Horizons, the Goodman Theatre, Yale Repertory Theatre, Woolly Mammoth, Berkeley Repertory Theater, The Wilma Theater, Cornerstone Theater Company, Madison Repertory Theatre, Clubbed Thumb, the Piven Theatre Workshop, and others.

After her father's death from bone cancer, Ruhl turned to theatre instead of traditional therapy as an outlet to express her grief. She wrote a short play as an assignment for a class taught at Brown University by American playwright and Pulitzer Prize–winner Paula Vogel. Written from a dog's perspective on the day of Ruhl's father's funeral, the play moved Vogel to tears and was the basis of a relationship in which Vogel has come to view Ruhl as a trusted colleague.

As the above story shows, Sarah Ruhl's plays are known for taking topics from daily life and examining them from a different angle. Ruhl claims she doesn't perceive reality as most normally see it and her plays certainly reflect that. Although she is a fairly young writer with quite a few plays to her credit, her process as a playwright is a slow one. She tends to research an idea for a play and then let her research "percolate" for a year before she actually starts writing. Ruhl believes this allows her sufficient time to view her characters as human beings before she begins putting them into action on the page.

Critics have accused Ruhl's plays of being irrational and lacking in psychological depth. In a 2009 interview for "The Record," she responded to her critics, stating, "Theater, from Shakespeare to the Greeks, has always been about irrationality, in some profound way. So I think to make it all linear and make it all causal is kind of weird. The rational unearthing of neuroses isn't enough." She manages to take criticism from a distance, understanding that everyone has an opinion but it is idealistic to long for unanimous approval.

The early twentieth century has not been an easy one for playwrights. Competition from other media and dwindling attendance has caused many theatres to shy away from unproven new works. Ruhl is one of the few exceptions. Her plays have become popular across the country. Despite her rapid success, Ruhl is remarkably candid about the potential brevity of her career as a dramatist. She claims to be quite satisfied with her success but is also well aware that it can end at any time and that there will always be new, young, emerging writers. With her sharp wit and dynamically varying plays, we can only hope that Sarah Ruhl and her plays will continue to entertain theatre audiences for a long time to come.

Eurydice

The tale of Eurydice and Orpheus has been told and retold since the days of the ancient Greeks. The story usually follows Orpheus on his doomed quest to save his beloved Eurydice from the depths of Hades. For millennia, listeners, readers, and audience members

have accompanied Orpheus through torturous trials and tribulations, only to have the sweetest taste of victory twist into the bitter ashes of defeat in one moment of weakness. Traditionally, this is how the story is known: Orpheus as the rock star leading man and Eurydice as the helpless love interest.

In Ruhl's retelling of this ancient story, events are witnessed through Eurydice's point of view. The play weaves tragedy, comedy, and drama together into an intricate exploration of loss. Eurydice loses all she is and all she was. Breaking the laws of the underworld, Eurydice almost recovers her identity, only to have her own moment of weakness rip it from her grasp.

A first reading of this play tends to have a twofold effect on most theatre artists. It is both tantalizing and frightening. Ruhl uses sparse, poetic language to capture the powerful emotions experienced by the characters in this story. Very few stage directions or character descriptions are given to us, and those that are leave much to our own interpretations. Throughout the play, we encounter a chorus of stones, an elevator in which it rains, a character who grows downward, and a house of string (which is actually built by a character before the audience's eyes). Such imagery is highly theatrical and, in many ways, a dream come true for directors, designers, and performers.

But there are traps when approaching a play like this. Ruhl gives us a beautiful blueprint for production, but the plans leave open a huge range of interpretation. One can't help but believe that no two productions of this play could ever be alike.

In 2003, *Eurydice* made its world premiere at Wisconsin's Madison Repertory Theatre. It has since become quite hot on the regional circuit. The play continues to appear as part of various professional and university theatre seasons around the country. While entirely different in style and scope, *Eurydice* has become nearly as well known as Ruhl's Pulitzer Prize finalist, *The Clean House*.

Food for Thought

As you read the play, consider the following questions:

1. *Eurydice* is filled with references to water. Why do you think this is so? Why is water so important to this play?
2. How do you picture the chorus of stones? What exactly are they? Why do you think Ruhl chose to include them in this play?
3. Why is Eurydice's father able to remember his past? What causes him to dip himself in the river and forget all he knows?
4. How does shifting the perspective of this ancient myth from Orpheus to Eurydice alter how we view this story?
5. Are the Nasty Interesting Man and the Lord of the Underworld the same person?

Fun Facts

1. Even though her plays have been criticized for "lacking psychological depth," Ruhl's sister and husband both work in the psychiatric field.
2. Just a few quirky events that happen in some of Sarah Ruhl's plays: A woman turns herself into an almond, a cooking recipe reveals the violent side of our universe, and a cell phone serves as a medium between the dead and the living.
3. Paula Vogel has compared some of Ruhl's writing to Kabuki theatre, an ancient Japanese performance style known for tackling daring topics while using extravagant décor and stylized changes in setting.

Eurydice

Sarah Ruhl

Characters

Eurydice
Her father
Orpheus
A nasty interesting man/the lord of the underworld

A chorus of stones:
 Big stone
 Little stone
 Loud stone

Set

The set contains a raining elevator,
a water pump,
some rusty exposed pipes,
an abstracted River of Forgetfulness,
an old-fashioned glow-in-the-dark globe.

First Movement
Scene 1

*A young man—Orpheus—and a young
woman—Eurydice.*
They wear swimming outfits from the 1950s.
*Orpheus makes a sweeping gesture with his arm,
indicating the sky.*

EURYDICE. All those birds? Thank you.
 *He nods. They make a quarter turn and he makes a
 sweeping gesture indicating an invisible sea.*
 And—the sea! For me? When?
 Orpheus opens his hands.
 Now? It's mine already?
 Orpheus nods.
 Wow.
 They kiss. He indicates the sky.
 Surely not—surely not the sky and the stars too?!
 Orpheus nods.
 That's very generous.
 Orpheus nods.
 Perhaps too generous?
 Orpheus shakes his head no.
 Thank you.
 Now—walk over there.

 *Orpheus walks in a straight line on an unseen
 boardwalk.*
 Don't look at me.
 He turns his face away from hers and walks.
 Now—stop.
 He stops.
 She runs and jumps into his arms.
 *He doesn't quite catch her and they fall down to-
 gether.*
 She crawls on top of him and kisses his eyes.
 What are you thinking about?

ORPHEUS. Music.

EURYDICE. How can you think about music? You ei-
 ther hear it or you don't.

ORPHEUS. I'm hearing it then.

EURYDICE. Oh.
 Pause.
 I read a book today.

ORPHEUS. Did you?

EURYDICE. Yes. It was very interesting.

ORPHEUS. That's good.

EURYDICE. Don't you want to know what it was about?

ORPHEUS. Of course.

EURYDICE. There were—stories—about people's lives—how some come out well—and others come out badly.

ORPHEUS. Do you love the book?

EURYDICE. Yes—I think so.

ORPHEUS. Why?

EURYDICE. It can be interesting to see if other people—like dead people who wrote books—agree or disagree with what you think.

ORPHEUS. Why?

EURYDICE. Because it makes you—a larger part of the human community. It had very interesting arguments.

ORPHEUS. Oh. And arguments that are interesting are good arguments?

EURYDICE. Well—yes.

ORPHEUS. I didn't know an argument should be interesting. I thought it should be right or wrong.

EURYDICE. Well, these particular arguments were very interesting.

ORPHEUS. Maybe you should make up your own thoughts. Instead of reading them in a book.

EURYDICE. I do. I do think up my own thoughts.

ORPHEUS. I know you do. I love how you love books. Don't be mad.
Pause.
I made up a song for you today.

EURYDICE. Did you?!

ORPHEUS. Yup. It's not *interesting or not interesting*. It just—is.

EURYDICE. Will you sing it for me?

ORPHEUS. It has too many parts.

EURYDICE. Let's go in the water.
They start walking, arm in arm,
on extensive unseen boardwalks, toward the water.

ORPHEUS. Wait—remember this melody.
He hums a bar of melody.

EURYDICE. I'm bad at remembering melodies. Why don't you remember it?

ORPHEUS. I have eleven other ones in my head, making for a total of twelve. You have it?

EURYDICE. Yes. I think so.

ORPHEUS. Let's hear it.
She sings the melody.
She misses a few notes.
She's not the best singer in the world.
Pretty good. The rhythm's a little off. Here—clap it out.
She claps.
He claps the rhythmic sequence for her.
She tries to imitate.
She is still off.

EURYDICE. Is that right?

ORPHEUS. We'll practice.

EURYDICE. I don't need to know about rhythm. I have my books.

ORPHEUS. Don't books have rhythm?

EURYDICE. Kind of. Let's go in the water.

ORPHEUS. Will you remember my melody under the water?

EURYDICE. Yes! I WILL ALWAYS REMEMBER YOUR MELODY! It will be imprinted on my heart like wax.

ORPHEUS. Thank you.

EURYDICE. You're welcome. When are you going to play me the whole song?

ORPHEUS. When I get twelve instruments.

EURYDICE. Where are you going to get twelve instruments?

ORPHEUS. I'm going to make each strand of your hair into an instrument. Your hair will stand on end as it plays my music and become a hair orchestra. It will fly up into the sky.

EURYDICE. I don't know if I want to be an instrument.

ORPHEUS. Why?

EURYDICE. Won't I fall down when the song ends?

ORPHEUS. That's true. But the clouds will be so moved by your music that they will fill up with water until they become heavy and you'll sit on one and fall gently down to earth. How about that?

EURYDICE. Okay.
They stop walking for a moment.
They gaze at each other.

ORPHEUS. It's settled then.

EURYDICE. What is?

ORPHEUS. Your hair will be my orchestra and—I love you.
Pause.

EURYDICE. I love you, too.

ORPHEUS. How will you remember?

EURYDICE. That I love you?

ORPHEUS. Yes.

EURYDICE. That's easy. I can't help it.

ORPHEUS. You never know. I'd better tie a string around your finger to remind you.

EURYDICE. Is there string at the ocean?

ORPHEUS. I always have string. In case I come upon a broken instrument.
He takes out a string from his pocket.
He takes her left hand.
This hand.
He wraps string deliberately around her fourth finger.
Is this too tight?

EURYDICE. No—it's fine.

ORPHEUS. There—now you'll remember.

EURYDICE. That's a very particular finger.

ORPHEUS. Yes.

EURYDICE. You're aware of that?

ORPHEUS. Yes.

EURYDICE. How aware?

ORPHEUS. Very aware.

EURYDICE. Orpheus—are we?

ORPHEUS. You tell me.

EURYDICE. Yes.
I think so.

ORPHEUS. You *think* so?

EURYDICE. I wasn't thinking.
I mean—yes. Just: Yes.

ORPHEUS. Yes?

EURYDICE. Yes.

ORPHEUS. Yes!

EURYDICE. Yes!

ORPHEUS. May our lives be full of music!
Music.
He picks her up and throws her into the sky.

EURYDICE. Maybe you could also get me another ring—a gold one—to put over the string one. You know?

ORPHEUS. Whatever makes you happy. Do you still have my melody?

EURYDICE. It's right here.
She points to her temple.
They look at each other. A silence.
What are you thinking about?

ORPHEUS. Music.
Her face falls.
Just kidding. I was thinking about you. And music.

EURYDICE. Let's go in the water. I'll race you!
She puts on her swimming goggles.

ORPHEUS. I'll race *you!*

EURYDICE. I'll race *you!*

ORPHEUS. I'll race *you!*

EURYDICE. I'll race *you!*
They race toward the water.

Scene 2

The Father, dressed in a gray suit, reads from a letter.

FATHER. Dear Eurydice,
A letter for you on your wedding day.

There is no choice of any importance in life but the choosing of a beloved. I haven't met Orpheus, but he seems like a serious young man. I understand he's a musician.

If I were to give a speech at your wedding I would start with one or two funny jokes, and then I might offer some words of advice. I would say:

Cultivate the arts of dancing and small talk.
Everything in moderation.
Court the companionship and respect of dogs.
Grilling a fish or toasting bread without burning requires singleness of purpose, vigilance and steadfast watching.
Keep quiet about politics, but vote for the right man.
Take care to change the light bulbs.

Continue to give yourself to others because that's the ultimate satisfaction in life—to love, accept, honor and help others.

As for me, this is what it's like being dead:

the atmosphere smells. And there are strange high-pitched noises—like a tea kettle always boiling over. But it doesn't seem to bother anyone. And, for the most part, there is a pleasant atmosphere and you can work and socialize, much like at home. I'm working in the business world and it seems that, here, you can better see the far-reaching consequences of your actions.

Also, I am one of the few dead people who still remembers how to read and write. That's a secret. If anyone finds out, they might dip me in the River again.

I write you letters. I don't know how to get them to you.

Love,
Your Father

He drops the letter as though into a mail slot.
It falls on the ground.
Wedding music.
In the underworld, the Father walks in a
straight line as though he is walking his daughter
down the aisle.
He is affectionate, then solemn, then glad, then sol-
emn, then amused then solemn.
He looks at his imaginary daughter; he looks straight
ahead; he acknowledges the guests at the wedding; he
gets choked-up; he looks at his daughter and smiles
an embarrassed smile for getting choked-up.
He looks straight ahead, calm.
He walks.
Suddenly, he checks his watch. He exits, in a hurry.

Scene 3

Eurydice, by a water pump.
The noise of a party, from far off.

EURYDICE. I hate parties.

And a wedding party is the biggest party of all.
All the guests arrived and Orpheus is taking a shower.
He's always taking a shower when the guests arrive so
 he doesn't have to greet them.
Then I have to greet them.

A wedding is for daughters and fathers. The mothers all dress up, trying to look like young women. But a wedding is for a father and a daughter. They stop being married to each other on that day.

I always thought there would be more interesting people at my wedding.

She drinks a cup of water from the water pump.
A Nasty Interesting Man, wearing a trench coat, appears.

MAN. Are you a homeless person?

EURYDICE. No.

MAN. Oh. I'm on my way to a party where there are really very interesting people. Would you like to join me?

EURYDICE. No. I just left my own party.

MAN. You were giving a party and you just—left?

EURYDICE. I was thirsty.

MAN. You must be a very interesting person, to leave your own party like that.

EURYDICE. Thank you.

MAN. You mustn't care at all what other people think of you. I always say that's a mark of a really interesting person, don't you?

EURYDICE. I guess.

MAN. So would you like to accompany me to this interesting affair?

EURYDICE. No, thank you. I just got married, you see.

MAN. Oh—lots of people do that.

EURYDICE. That's true—lots of people do.

MAN. What's your name?

EURYDICE. Eurydice.
 He looks at her, hungry.

MAN. Eurydice.

EURYDICE. Good-bye, then.

MAN. Good-bye.
 She exits. He sits by the water pump.
 He notices a letter on the ground.
 He picks it up and reads it.
 To himself:
 Dear Eurydice . . .
 Musty dripping sounds.

Scene 4

The Father tries to remember how to do the jitterbug in the underworld.
He does the jitterbug with an imaginary partner.
He has fun.
Orpheus and Eurydice dance together at their wedding.
They are happy.
They have had some champagne.
They sing together:

ORPHEUS AND EURYDICE. Don't sit under the apple tree
 With anyone else but me
 Anyone else but me
 Anyone else but me
 No no no.
 Don't sit under the apple tree
 With anyone else but me
 Till I come marching home . . .
 On the other side of the stage,
 the Father checks his watch.
 He stops doing the jitterbug.
 He exits, in a hurry.
 Don't go walking down lover's lane
 With anyone else but me
 Anyone else but me
 Anyone else but me
 No no no.
 Don't go walking down lover's lane
 With anyone else but me
 Till I come marching home . . .

EURYDICE. I'm warm. Are you warm?

ORPHEUS. Yes!

EURYDICE. I'm going to get a drink of water.

ORPHEUS. Don't go.

EURYDICE. I'll be right back.

ORPHEUS. Promise?

EURYDICE. Yes.

ORPHEUS. I can't stand to let you out of my sight today.

EURYDICE. Silly goose.
 They kiss.

Scene 5

Eurydice at the water pump,
getting a glass of water.
The Nasty Interesting Man appears.

EURYDICE. Oh—you're still here.

MAN. Yes. I forgot to tell you something. I have a letter. Addressed to Eurydice—that's you—from your father.

EURYDICE. That's not possible.

MAN. He wrote down some thoughts—for your wedding day.

EURYDICE. Let me see.

MAN. I left it at home. It got delivered to my elegant high-rise apartment by mistake.

EURYDICE. Why didn't you say so before?

MAN. You left in such a hurry.

EURYDICE. From my father?

MAN. Yes.

EURYDICE. You're sure?

MAN. Yes.

EURYDICE. I knew he'd send something!

MAN. It'll just take a moment. I live around the block. What an interesting dress you're wearing.

EURYDICE. Thank you.

Scene 6

Orpheus, from the water pump.

ORPHEUS. Eurydice?
 Eurydice!

Scene 7

The sound of a door closing.
The Interesting Apartment—a giant loft space with no furniture.
Eurydice and the Man enter, panting.

MAN. Voilà.

EURYDICE. You're very high up.

MAN. Yes. I am.

EURYDICE. I feel a little faint.

MAN. It'll pass.

EURYDICE. Have you ever thought about installing an elevator?

MAN. No. I prefer stairs.
I think architecture is so interesting, don't you?

EURYDICE. Oh, yes. So, where's the letter?

MAN. But isn't this an interesting building?

EURYDICE. It's so—high up.

MAN. Yes.

EURYDICE. There's no one here. I thought you were having a party.

MAN. I like to celebrate things quietly. With a few other interesting people. Don't you?
She tilts her head to the side and stares at him.
Would you like some champagne?

EURYDICE. Maybe some water.

MAN. Water it is! Make yourself comfortable.
He switches on Brazilian mood music. He exits.
Eurydice looks around.

EURYDICE. I can't stay long!
She looks out the window. She is very high up.
I can see my wedding from here!
The people are so small—they're dancing!
There's Orpheus!
He's not dancing.

MAN *(Shouting from offstage)*. So, who's this guy you're marrying?

EURYDICE *(Shouting)*. His name is Orpheus.
As he attempts to open champagne offstage:

MAN. Orpheus. Not a very interesting name. I've heard it before.

EURYDICE. Maybe you've heard of him. He's kind of famous. He plays the most beautiful music in the world, actually.

MAN. I can't hear you!

EURYDICE. So the letter was delivered—here—today?

MAN. That's right.

EURYDICE. Through the post?

MAN. It was—mysterious.
The sound of champagne popping.
He enters with one glass of champagne.
Voilà.
He drinks the champagne.

So. Eurydice. Tell me one thing. Name me one person you find interesting.

EURYDICE. Why?

MAN. Just making conversation.
He sways a little to the music.

EURYDICE. Right. Um—all the interesting people I know are dead or speak French.

MAN. Well, I don't speak French, Eurydice.
He takes one step toward her.
She takes one step back.

EURYDICE. I'm sorry. I have to go. There's no letter, is there?

MAN. Of course there's a letter. It's right here. (*He pats his breast pocket*) Eurydice. I'm not interesting, but I'm strong. You could teach me to be interesting. I would listen. Orpheus is too busy listening to his own thoughts. There's music in his head. Try to pluck the music out and it bites you. I'll bet you had an interesting thought today, for instance.
She tilts her head to the side, quizzical.
I bet you're always having them, the way you tilt your head to the side and stare . . .
She jerks her head back up.
Musty dripping sounds.

EURYDICE. I feel dizzy all of a sudden. I want my husband. I think I'd better go now.

MAN. You're free to go, whenever you like.

EURYDICE. I know.
I think I'll go now, in fact.
I'll just take my letter first, if you don't mind.
She holds out her hand for the letter.
He takes her hand.

MAN. Relax.
She takes her hand away.

EURYDICE. Good-bye.
She turns to exit.
He blocks the doorway.

MAN. Wait. Eurydice. Don't go. I love you.

EURYDICE. Oh no.

MAN. You need to get yourself a real man. A man with broad shoulders like me. Orpheus has long fingers that would tremble to pet a bull or pluck a bee from a hive—

EURYDICE. How do you know about my husband's fingers?

MAN. A man who can put his big arm around your little shoulders as he leads you through the crowd, a man who answers the door at parties . . . A man with big hands, with big stupid hands like potatoes, a man who can carry a cow in labor.
The Man backs Eurydice against the wall.
My lips were meant to kiss your eyelids, that's obvious!

EURYDICE. Close your eyes, then!
He closes his eyes, expecting a kiss.
She takes the letter from his breast pocket.
She slips by him and opens the door to the stairwell.
He opens his eyes.
She looks at the letter.
It's his handwriting!

MAN. Of course it is!
He reaches for her.

EURYDICE. Good-bye.
She runs for the stairs.
She wavers, off-balance, at the top of the stairwell.

MAN. Don't do that, you'll trip! There are six hundred stairs!

EURYDICE. Orpheus!
From the water pump:

ORPHEUS. Eurydice!
She runs, trips and pitches down the stairs, holding her letter.
She follows the letter down, down down . . .
Blackout.
A clatter. Strange sounds—xylophones, brass bands, sounds of falling, sounds of vertigo.
Sounds of breathing.

Second Movement

The underworld.
There is no set change.
Strange watery noises.
Drip, drip, drip.
The movement to the underworld is marked
by the entrance of stones.

Scene 1

THE STONES. We are a chorus of stones.

LITTLE STONE. I'm a little stone.

BIG STONE. I'm a big stone.

LOUD STONE. I'm a loud stone.

THE STONES. We are all three stones.

LITTLE STONE. We live with the dead people in the land of the dead.

BIG STONE. Eurydice was a great musician. Orpheus was his wife.

LOUD STONE. *(Correcting Big Stone)* Orpheus was a great musician. Eurydice was his wife. She died.

LITTLE STONE. Then he played the saddest music. Even we—

THE STONES. the stones—

LITTLE STONE. cried when we heard it.
The sound of three drops of water hitting a pond.
Oh, look,
she is coming into the land of the dead now.

BIG STONE. Oh!

LOUD STONE. Oh!

LITTLE STONE. Oh!
We might say: "Poor Eurydice"—

LOUD STONE. but stones don't feel bad for
dead people.
The sound of an elevator ding.
An elevator door opens.
Inside the elevator, it is raining.
Eurydice gets rained on inside the elevator.
She carries a suitcase and an umbrella.
She is dressed in the kind of 1930s suit
that women wore when they eloped.
She looks bewildered.
The sound of an elevator ding.
Eurydice steps out of the elevator.
The elevator door closes.
She walks toward the audience and opens her mouth,
trying to speak.
There is a great humming noise.
She closes her mouth.
The humming noise stops.
She opens her mouth for the second time,
attempting to tell her story to the audience.
There is a great humming noise.
She closes her mouth—the humming noise stops.
She has a tantrum of despair.
The Stones, to the audience:

THE STONES. Eurydice wants to speak to you.
But she can't speak your language anymore.
She talks in the language of dead people now.

LITTLE STONE. It's a very quiet language.

LOUD STONE. Like if the pores in your face
 opened up and talked.

BIG STONE. Like potatoes sleeping in the dirt.
 Little Stone and Loud Stone look at Big Stone as
 though that were a dumb thing to say.

LITTLE STONE. Pretend that you understand her
 or she'll be embarrassed.

BIG STONE. Yes—pretend for a moment
 that you understand
 the language of stones.

LOUD STONE. Listen to her the way you would listen
 to your own daughter
 if she died too young
 and tried to speak to you
 across long distances.
 Eurydice shakes out her umbrella.
 She approaches the audience.
 This time, she can speak.

EURYDICE. There was a roar, and a coldness—
 I think my husband was with me.
 What was my husband's name?
 Eurydice turns to the Stones.
 My husband's name? Do you know it?
 The Stones shrug their shoulders.
 How strange. I don't remember.
 It was horrible to see his face
 when I died. His eyes were
 two black birds
 and they flew to me.
 I said: no—star where you are—
 he needs you in order to see!
 When I got through the cold
 they made me swim in a river
 and I forgot his name.
 I forgot all the names.
 I know his name starts with my mouth
 shaped like a ball of twine—
 Oar—oar.
 I forget.
 They took me to a tiny boat.
 I only just fit inside.
 I looked at the oars
 and I wanted to cry.
 I tried to cry but I just drooled a little.
 I'll try now.
 She tries to cry but finds that she can't.
 What happiness it would he to cry.

She takes a breath.
 I was not lonely
 only alone with myself
 begging myself not to leave my own body
 but I *was* leaving.
 Good-bye, head—I said—
 it inclined itself a little, as though to nod to me
 in a solemn kind of way.
 She turns to the Stones.
 How do you say good-bye to yourself?
 They shake their heads.
 A train whistle.
 Eurydice steps onto a platform, surveying a large
 crowd.
 A train!

LITTLE STONE. The station is like a train but there is no
 train.

BIG STONE. The train has wheels that are not wheels.

LOUD STONE. There is the opposite of a wheel and the
 opposite of smoke and the opposite of a train.
 A train pulls away.

EURYDICE. Oh! I'm waiting for someone to meet me, I
 think.
 Eurydice's Father approaches and takes her baggage.

FATHER. Eurydice.

EURYDICE. *(To the Stones)* At last, a porter to meet me!
 (To the Father) Do you happen to know where the
 bank is? I need money. I've just arrived. I need to
 exchange my money at the Bureau de Change. I
 didn't bring traveler's checks because I left in such
 a hurry. They didn't even let me pack my suitcase.
 There's nothing in it! That's funny, right? Funny—
 ha ha! I suppose I can buy new clothes here. I would
 really love a bath.

FATHER. Eurydice!

EURYDICE. What is that language you're speaking? It
 gives me tingles. Say it again.

FATHER. Eurydice!

EURYDICE. Oooh—it's like a fruit! Again!

FATHER. Eurydice—I'm your father.

EURYDICE. *(Strangely imitating)* Eurydice—I'm your
 father! How funny! You remind me of something
 but I can't understand a word you're saying. Say it
 again!

FATHER. Your father.

THE STONES. *(To the Father)* Shut up, shut up!
She doesn't understand you.
She's dead now, too.
You have to speak in the language of stones.

FATHER. *(To Eurydice)* You're dead now. I'm dead, too.

EURYDICE. Yes, that's right. I need a reservation. For the fancy hotel.

FATHER. When you were alive, I was your father.

THE STONES. Father is not a word that dead people understand.

BIG STONE. He is what we call subversive.

FATHER. When you were alive, I was your tree.

EURYDICE. My tree! Yes, the tall one in the backyard! I used to sit all day in its shade!
She sits at the feet of her father.
Ah—there—shade!

LITTLE STONE. There is a problem here.

EURYDICE. Is there any entertainment at the hotel? Any dancing ladies? Like with the great big fans?

FATHER. I named you Eurydice. Your mother named all the other children. But Eurydice I chose for you.

BIG STONE. Be careful, sir.

FATHER. Eurydice. I wanted to remember your name. I asked the Stones. They said: forget the names— the names make you remember.

LOUD STONE. We told you how it works!

FATHER. One day it would not stop raining.
I heard your name inside the rain—somewhere between the drops—I saw falling letters. Each letter of your name—I began to translate.
E—I remembered elephants. U—I remembered ulcers and under. R—I remembered reindeers. I saw them putting their black noses into snow. Y—youth and yellow. D—dog, dig, daughter, day. Time poured into my head. The days of the week. Hours, months . . .

EURYDICE. The tree talks so beautifully.

THE STONES. Don't listen!

EURYDICE. I feel suddenly hungry! Where is the porter who met me at the station?

FATHER. Here I am.

EURYDICE. I would like a continental breakfast, please. Maybe some rolls and butter. Oh—and jam. Please take my suitcase to my room, if you would.

FATHER. I'm sorry, miss, but there are no rooms here.

EURYDICE. What? No rooms? Where do people sleep?

FATHER. People don't sleep here.

EURYDICE. I have to say I'm very disappointed. It's been such a tiring day. I've been traveling all day—first on a river, then on an elevator that rained, then on a train . . . I thought someone would meet me at the station . . .
Eurydice is on the verge of tears.

THE STONES. Don't cry! Don't cry!

EURYDICE. I don't know where I am and there are all these stones and I hate them! They're horrible! I want a bath! I thought someone would meet me at the station!

FATHER. Don't be sad. I'll take your luggage to your room.

THE STONES. THERE ARE NO ROOMS!
He picks up her luggage.
He gives the Stones a dirty look.
The sound of water in rusty pipes.

Scene 2

Orpheus writes a letter to Eurydice.

ORPHEUS. Dear Eurydice,
I miss you.
No—that's not enough.
He crumples up the letter.
He writes a new letter.
He thinks.
He writes:
Dear Eurydice,
Symphony for twelve instruments.
A pause.
He bears the music in his head.
He conducts.
Love,
Orpheus
He drops the letter as though into a mail slot.

Scene 3

The Father creates a room out of string for Eurydice.
He makes four walls and a door out of string.
Time passes.
It takes time to build a room out of string.
Eurydice observes the underworld.
There isn't much to observe.

She plays hop-scotch without chalk.
Every so often,
the Father looks at her,
happy to see her,
while he makes her room out of string.
She looks back at him, polite.

Scene 4

The Father has completed the string room.
He gestures for Eurydice to enter.
She enters with her suitcase.

EURYDICE. Thank you. That will do.
She nods to her Father.
He doesn't leave.
Oh.
I suppose you want a tip.
He shakes his head no.
Would you run a bath for me?

FATHER. Yes, miss.
He exits the string room.
Eurydice opens her suitcase.
She is surprised to find nothing inside.
She sits down inside her suitcase.

Scene 5

ORPHEUS. Dear Eurydice,
I love you. I'm going to find you. I play the saddest music now that you're gone. You know I hate writing letters. I'll give this letter to a worm. I hope he finds you.

Love,
Orpheus

He drops the letter as though into a mail slot.

Scene 6

The Father enters the string room with a letter on a silver tray.

FATHER. There is a letter for you, miss.

EURYDICE. A letter?
He nods.
A letter.
He hands her the letter.
It's addressed to you.

EURYDICE. There's dirt on it.
Eurydice wipes the dirt off the letter.
She opens it.
She scrutinizes it.
She does not know how to read it.
She puts it on the ground, takes off her shoes,
stands on the letter, and shuts her eyes.
She thinks, without language for the thought,
the melody: There's no place like home . . .

FATHER. Miss.

EURYDICE. What is it?

FATHER. Would you like me to *read you* the letter?

EURYDICE. Read me the letter?

FATHERS. You can't do it with your feet.
The Father guides her off the letter, picks it up and begins to read. It's addressed to Eurydice. That's you.

EURYDICE. That's you.

FATHER. You.
It says: I love you.

EURYDICE. I love you?

FATHER. It's like your tree.

EURYDICE. Tall?
The Father considers.
Green?

FATHER. It's like sitting in the shade.

EURYDICE. Oh.

FATHER. It's like sitting in the shade with no clothes on.

EURYDICE. Oh!—yes.

FATHER. (*Reading*) I'm going to find you. I play the saddest music—

EURYDICE. Music?
He whistles a note.

FATHER. It's like that.
She smiles.

EURYDICE. Go on.

FATHER. You know I hate writing letters. I'll give this letter to a worm. I hope he finds you.

Love,
Orpheus

EURYDICE. Orpheus?

FATHER. Orpheus.
 A *pause.*

EURYDICE. That word!
 It's like—I can't breathe.
 Orpheus! My husband.

Scene 7

ORPHEUS. Dear Eurydice,
 Last night I dreamed that we climbed Mount
 Olympus and we started to make love and all the
 strands of your hair were little faucets and water was
 streaming out of your bead and I said, why is water
 coming out of your hair? And you said, gravity is
 very compelling.

 And then we jumped off Mount Olympus and flew
 through the clouds and you held your knee to your
 chest because you skinned it on a sharp cloud and
 then we fell into a salty lake. Then I woke up and
 the window frightened me and I thought: Eurydice
 is dead. Then I thought—who is Eurydice? Then
 the whole room started to float and I thought: what
 are people? Then my bed clothes smiled at me with
 a crooked green mouth and I thought: who am I? It
 scares me, Eurydice.
 Please come back.

 Love,
 Orpheus

Scene 8

Eurydice and her father in the string room.

FATHER. Did you get my letters?

EURYDICE. No! You wrote me letters?

FATHER. Every day.

EURYDICE. What did they say?

FATHER. Oh—nothing much. The usual stuff.

EURYDICE. Tell me the names of my mother and broth-
 ers and sisters.

FATHER. I don't think that's a good idea. It will make
 you sad.

EURYDICE. I want to know.

FATHER. It's a long time to be sad.

EURYDICE. I'd rather be sad.

THE STONES. Being sad is not allowed! Act like a stone.

Scene 9

Time shifts.
Eurydice and her father in the string room.

EURYDICE. Teach me another.

FATHER. Ostracize.

EURYDICE. What does it mean?

FATHER. To exclude. The Greeks decided who to ban-
 ish. They wrote the name of the banished person
 on a white piece of pottery called ostrakon.

EURYDICE. Ostrakon.
 Another.

FATHER. Peripatetic. From the Greek. It means to walk
 slowly, speaking of weighty matters, in bare feet.

EURYDICE. Peripatetic: a learned fruit, wandering
 through the snow.
 Another.

FATHER. Defunct.

EURYDICE. Defunct.

FATHER. It means dead in a very abrupt way. Not the
 way I died, which was slowly. But all at once, in
 cowboy boots.

EURYDICE. Tell me a story of when you were little.

FATHER. Well, there was the time your uncle shot at
 me with a BB gun and I was mad at him so I swal-
 lowed a nail.
 Then there was the time I went to a dude ranch and
 I was riding a horse and I lassoed a car. The lady
 driving the car got out and spanked me. And your
 grandmother spanked me, too.

EURYDICE. Remember the Christmas when she gave
 me a doll and I said I see one more doll I'm going
 to throw up"?

FATHER. I think Grammy was a little surprised when
 you said that.

EURYDICE. Tell me a story about your mother.

FATHER. The most vivid recollection I have of Mother was
 seeing her at parties and in the house playing piano.

When she was younger she was extremely animated. She could really play the piano. She could play everything by ear. They called her Flaming Sally.

EURYDICE. I never saw Grammy play the piano.

FATHER. She was never the same after my father died. My father was a very gentle man.

EURYDICE. Tell me a story about your father.

FATHER. My father and I used to duck hunt. He would call up old Frank the night before and ask, "Where are the ducks moving tonight?" Frank was a guide and a farmer. Old Frank, he could really call the ducks. It was hard for me to kill the poor little ducks, but you get caught up in the fervor of it. You'd get as many as ten ducks.

If you went over the limit—there were only so many ducks per person—Father would throw the ducks to the side of the creek we were paddling on and make sure there was no game warden. If the warden was gone, he'd run back and get the extra ducks and throw them in the back of the car. My father was never a great conversationalist, but he loved to rhapsodize about hunting. He would always say, if I ever have to die, it's in a duck pond. And he did.

EURYDICE. There was something I always wanted to ask you. It was—how to do something—or—a story— or someone's name—I forget.

FATHER. Don't worry. You'll remember. There's plenty of time.

Scene 10

Orpheus writes a letter.

ORPHEUS. Dear Eurydice,
I wonder if you miss reading books in the underworld.
Orpheus holds the Collected Works of Shakespeare *with a long string attached.*
He drops it slowly to the ground.

Scene 11

Eurydice holds the Collected Works of Shakespeare.

EURYDICE. What is this?
She opens it. She doesn't understand it.
She throws the book on the ground.

What are you?
She is wary of it, as though it might bite her.
She tries to understand the book.
She tries to make the book do something.
To the book:
What do you do?
What do you DO?!
Are you a thing or a person?
Say something!
I hate you!
She stands on the book, trying to read it.
Damn you!
She throws the book at the Stones.
They duck.
THE STONES. That is not allowed!
Drops of water.
Time passes.
The Father picks up the book.
He brushes it off.
The Father reaches Eurydice how to read.
She looks over his shoulder as he reads out loud from King Lear.

FATHER. We two alone will sing like birds in the cage.
When thou dost ask my blessing, I'll kneel down
And ask of thee forgiveness; so we'll live,
And pray and sing . . .

Scene 12

Orpheus, with a telephone.

ORPHEUS. For Eurydice—E, U, R, Y—that's right. No, there's no last name. It's not like that. What? No, I don't know the country. I don't know the city either. I don't know the street. I don't know—it probably starts with a vowel. Could you just—would you mind checking please— I would really appreciate it. You can't enter a name without a city? Why not? Well, thank you for trying. Wait—miss—it's a special case. She's dead. Well, thank you for trying. You have a nice day, too.
He hangs up.
I'll find you. Don't move!
He fingers a glow-in-the-dark globe, looking for Eurydice.

Scene 13

Eurydice and her father in the string room.

EURYDICE. Tell me another story of when you were little.

FATHER. Let's see.
There was my first piano recital. I was playing "I Got Rhythm."
I played the first few chords and I couldn't remember the rest.
I ran out of the room and locked myself in the bathroom.

EURYDICE. Then what happened?

FATHER. Your grandmother pulled me out of the bathroom and made me apologize to everyone in the auditorium. I never played piano after that. But I still know the first four chords—let's see—
He plays the chords in the air with his hands.
Da Da *Dee* Da
Da Da *Dee* Da
Da Da *Dee* Da . . .

EURYDICE. What are the words?

FATHER. I can't remember.
Let's see . . .
Da Da *Dee* Da
Da Da *Dee* da . . .
They both start singing to the tune of "I Got Rhythm":

FATHER AND EURYDICE. Da da *Dee* Da
Da da *Dee* Da
Da da *Dee* Da
Da dee da da doo dee dee da.
Da da Da da
Da da Da da
Da Da da Da
Da da da . . .
Da da *Dee* Da
Da da *dee* da . . .

THE STONES. WHAT IS THAT NOISE?

LITTLE STONE. Stop singing!

LOUD STONE. STOP SINGING!

BIG STONE. Neither of you can carry a tune.

LITTLE STONE. It's awful

THE STONES. DEAD PEOPLE CAN'T SING!

EURYDICE. I'm not a very good singer.

FATHER. Neither am I.

THE STONES. *(To the Father)* Stop singing and go to work!

Scene 14

The Father leaves for work.
He takes his briefcase.
He waves to Eurydice.
She waves back.
She is alone in the string room.
She touches the string.
A child, the Lord of the Underworld, enters on his red tricycle.
Music from a heavy metal band accompanies his entrance.
His clothes and his hat are too small for him.
He stops pedaling at the entrance to the string room.

CHILD. Knock, knock.

EURYDICE. Who's there?

CHILD. I am Lord of the Underworld.

EURYDICE. Very funny.

CHILD. I am.

EURYDICE. Prove it.

CHILD. I can do chin-up inside your bones. Close your eyes.
She closes her eyes.

EURYDICE. Ow.

CHILD. See?

EURYDICE. What do you want?

CHILD. You're pretty.

EURYDICE. I'm dead.

CHILD. You're pretty.

EURYDICE. You're little.

CHILD. I grow downward. Like a turnip.

EURYDICE. What do you want?

CHILD. I wanted to see if you were comfortable.

EURYDICE. Comfortable?

CHILD. You're not itchy?

EURYDICE. No.

CHILD. That's good. Sometimes our residents get itchy. Then I scratch them.

EURYDICE. I'm not itchy.

CHILD. What's all this string?

EURYDICE. It's my room.

CHILD. Rooms are not allowed!
 (To the Stones) Tell her.

THE STONES. Rooms are not allowed!

CHILD. Who made your room?

EURYDICE. My father.

CHILD. Fathers are not allowed! Where is he?

EURYDICE. He's at work.

CHILD. We'll have to dip you in the river again and make sure you're good and dunked.

EURYDICE. Please, don't.

CHILD. Oooh—say that again. It's nice.

EURYDICE. Please don't.

CHILD. Say it in my ear.

EURYDICE. (Toward his ear) Please, don't.

CHILD. I like that.
 (A seduction) I'll huff and I'll puff and I'll blow your house down!
 He blows on her face.
 I mean that in the nicest possible way.

EURYDICE. I have a husband.

CHILD. Husbands are for children. You need a lover.
 I'll be back.
 To the Stones:
 See that she's . . . comfortable.

THE STONES. We will!

CHILD. Good-bye.

EURYDICE. Good-bye.

THE STONES. Good-bye.

CHILD. I'm growing. Can you tell? I'm growing!
 He laughs his hysterical laugh and speeds away on his red tricycle.

Scene 15

A big storm. The sound of rain on a roof.
Orpheus in a rain slicker.
Shouting above the storm:

ORPHEUS. If a drop of water enters the soil
 at a particular angle, with a particular pitch,

what's to say a man can't ride one note
into the earth like a fireman's pole?

He puts a bucket on the ground to catch rain falling.
He looks at the rain falling into the bucket.
He tunes his guitar, trying to make the pitch of each
 note
correspond with the pitch of each water drop.
Orpheus wonders if one particular pitch
might lead him to the underworld.
Orpheus wonders if the pitch
he is searching for might
correspond to the pitch of a drop
of rain, as it enters the soil.
A pitch.

Eurydice—did you hear that?
Another pitch.
Eurydice? That's the note. That one, right there.

Scene 16

Eurydice and her father in the string room.

EURYDICE. Orpheus never liked words. He had his music. He would get a funny look on his face and I would say what are you thinking about and he would always be thinking about music.

If we were in a restaurant, sometimes I would get embarrassed because Orpheus looked sullen and wouldn't talk to me and I thought people felt sorry for me. I should have realized that women envied me. Their husbands talked too much.

But I wanted to talk to him about my notions. I was working on a new philosophical system. It involved hats.

This is what it is to love an artist: The moon is always rising above your house. The houses of your neighbors look dull and lacking in moonlight. But he is always going away from you. Inside his head there is always something more beautiful.

Orpheus said the mind is a slide ruler. It can fit around anything. Words can mean anything. Show me your body, he said. It only means one thing.

She looks at her father, embarrassed for revealing too much.

Or maybe two or three things. But only one thing at a time.

Scene 17

ORPHEUS. Eurydice!

Before I go down there, I won't practice my music. Some say practice. But practice is a word invented by cowards. The animals don't have a word for practice. A gazelle does not run for practice. He runs because he is scared or he hungry. A bird doesn't sing for practice. She sings because she's happy or sad. So I say: store it up. The music sounds better in my head than it does in the world. When songs are pressing against my throat, then, only then, I will go down and sing for the devils and they will cry through their parched throats.

Eurydice, don't kiss a dead man. Their lips look red and tempting but put your tongue in their mouths and it tastes like oatmeal. I know how much you hate oatmeal.

I'm going the way of death.

Here is my plan: tonight, when I go to bed, I will turn off the light and put a straw in my mouth. When I fall asleep, I will crawl through the straw and my breath will push me like great wind into the darkness and I will sing your name and I will arrive. I have consulted the almanacs, the footstools, and the architects, and everyone agrees. Wait for me.

Love,
Orpheus
.

Scene 18

EURYDICE. I got a letter. From Orpheus.

FATHER. You sound serious. Nothing wrong I hope.

EURYDICE. No.

FATHER. What did he say?

EURYDICE. He says he's going to come find me.

FATHER. How?

EURYDICE. He's going to sing.

Scene 19

Darkness.
An unearthly light surrounds Orpheus.
He holds a straw up to his lips in slow motion.
He blows into the straw.
The sound of breath.
He disappears.

Scene 20

The sound of a knock.

LITTLE STONE. Someone is knocking!

BIG STONE. Who is it?

LOUD STONE. Who is it?
 The sound of three loud knocks, insistent.

THE STONES. NO ONE KNOCKS AT THE DOOR OF THE DEAD!

Third Movement
Scene 1

Orpheus stands at the gates of hell.
He opens his mouth.
He looks like he's singing, but he's silent.
Music surrounds him.
The melody Orpheus hummed in the first scene, repeated over and over again.
Raspberries, peaches and plums drop from the ceiling into the River.
Orpheus keeps singing.
The Stones weep.
They look at their tears, bewildered.
Orpheus keeps singing.
The child comes out of a yapdoor.

CHILD. Who are you?

ORPHEUS. I am Orpheus.

CHILD. I am Lord of the Underworld.

ORPHEUS. But you're so young!

CHILD. Don't be rude.

ORPHEUS. Sorry.
 Did you like my music?

CHILD. No. I prefer happy music with a nice beat.

ORPHEUS. Oh.

CHILD. You've come for Eurydice.

ORPHEUS. Yes!

CHILD. And you thought singing would get you through the gates of hell.

ORPHEUS. See here. I want my wife.

What do I have to do?

CHILD. You'll have to do more than sing.

ORPHEUS. I'm not sure what you mean, sir.

CHILD. Start walking home. Your wife just might be on the road behind you. We make it real nice here. So people want to stick around. As you walk, keep your eyes facing front. If you look back at her— poof! She's gone.

ORPHEUS. I can't look at her?

CHILD. No.

ORPHEUS. Why?

CHILD. Because.

ORPHEUS. Because?

CHILD. Because.

Do you understand me?

ORPHEUS. I look straight ahead. That's all?

CHILD. Yes.

ORPHEUS. That's easy.

CHILD. Good.
The child smiles. He exits.

Scene 2

Eurydice and her father.

EURYDICE. I hear him at the gates! That's his music! He's come to save me!

FATHER. Do you want to go with him?

EURYDICE. Yes, of course!
Oh—you'll be lonely, won't you?

FATHER. No, no. You should go to your husband. You should have grandchildren. You'll all come down and meet me one day.

EURYDICE. Are you sure?

FATHER. You should love your family until the grapes grow dust on their purple faces.
I'll take you to him.

EURYDICE. Now?

FATHER. It's for the best.

He takes her arm.
They process, arm in arm, as at a wedding.
Wedding music.
They are solemn and glad.
They walk.
They see Orpheus up ahead.
Is that him?

EURYDICE. Yes—I think so—

FATHER. His shoulders aren't very broad. Can he take care of you?

Eurydice nods.

Are you sure?

EURYDICE. Yes.

FATHER. There's one thing you need to know. If he turns around and sees you, you'll die a second death. Those are the rules. So step quietly. And don't cry out.

EURYDICE. I won't.

FATHER. Good-bye.
They embrace.

EURYDICE. I'll come back to you. I seem to keep dying.

FATHER. Don't let them dip you in the River too long, the second time. Hold your breath.

EURYDICE. I'll look for a tree.

FATHER. I'll write you letters.

EURYDICE. Where will I find them?

FATHER. I don't know yet. I'll think of something. Good-bye, Eurydice.

EURYDICE. Good-bye.
They move away.
The Father waves.
She waves back,
as though on an old steamer ship.
The Father exits.
Eurydice takes a deep breath.
She takes a big step forward toward the audience,
on an unseen gangplank.
She is brave.
She takes another step forward.
She hesitates.
She is all of a sudden not so brave.
She is afraid.
She looks back.
She turns in the direction of her father,

her back to the audience.
He's out of sight.
Wait, come back!

LITTLE STONE. You can't go back now, Eurydice.

LOUD STONE. Face forward!

BIG STONE. Keep walking.

EURYDICE. I'm afraid!

LOUD STONE. Your husband is waiting for you, Eurydice.

EURYDICE. I don't recognize him! That's a stranger!

LITTLE STONE. Go on. It's him.

EURYDICE. I want to go home! I want my father!

LOUD STONE. You're all grown-up now. You have a husband.

THE STONES. TURN AROUND!

EURYDICE. Why?

THE STONES. BECAUSE!

EURYDICE. That's a stupid reason.

LITTLE STONE. Orpheus braved the gates of hell to find you.

LOUD STONE. He played the saddest music.

BIG STONE. Even we—

THE STONES. The stones—

LITTLE STONE. cried when we heard it.

Eurydice turns slowly, facing front.

EURYDICE. That's Orpheus?

THE STONES. Yes, that's him!

EURYDICE. Where's his music?

THE STONES. It's in your head.
Orpheus walks slowly, in a straight line, with the
focus of a tightrope walker.
Eurydice moves to follow him. She follows him, several steps behind.
THEY WALK.
Eurydice follows him with precision, one step for every step he takes.
She makes a decision. She increases her pace.
She takes two steps for every step that Orpheus takes.
She catches up to him.

EURYDICE. Orpheus?
He turns toward her, startled.
Orpheus looks at Eurydice.
Eurydice looks at Orpheus.
The world falls away.
ORPHEUS. You startled me.
A small sound—ping.
They turn their faces away from each other, matter-of-fact, compelled.
The lights turn blue.

EURYDICE. I'm sorry.

ORPHEUS. Why?

EURYDICE. I don't know.

Syncopated:

ORPHEUS.
You always clapped your
 hands
on the third beat
you couldn't wait for the
 fourth.
Remember—
I tried to teach you—
in it—
you were always one step
 ahead
of the music
your sense of rhythm—
it was—off—

EURYDICE.
I could never spell the
 word
rhythm—
it is such a difficult
word to spell—
r—y—no—there's an H
somewhere—a breath—
rhy—rhy—
rhy—

ORPHEUS. I would say clap on the downbeat—
 no, the downbeat—
 It's dangerous not
 to have a sense of rhythm.
 You *lose* things when you can't
 keep a simple beat—
 why'd you have to say my name—
 Eurydice—

EURYDICE. I'm sorry.

ORPHEUS. I know we used to fight—
 it seems so silly now—if—

EURYDICE. If ifs and ands were pots and pans
 there'd be no need for tinkers—

ORPHEUS. Why?
They begin walking away from each other
on extensive unseen boardwalks,
their figures long shadows,
looking straight ahead.

EURYDICE. If ifs and ands were pots and pans
 there'd be no need for tinkers—

ORPHEUS. Eurydice—

EURYDICE. I think I see the gates.
 The stones—the boat—
 it looks familiar—
 the stones look happy to see me—

ORPHEUS. Don't look—

EURYDICE. Wow! That's the happiest I've ever seen
 them!

 Syncopated:

ORPHEUS.	EURYDICE.
Think of things we did	Everything is so gray—
	it looks familiar—
we went ice-skating—	like home—
	our house was—
I wore a red sweater—	gray—with a red door—
	we had two cats
	and two dogs
	and two fish
	that died—

ORPHEUS. Will you talk to me!

EURYDICE. The train looks like
 the opposite of a train—

ORPHEUS. Eurydice!
 WE'VE KNOWN EACH OTHER FOR CENTU-
 RIES!
 I want to reminisce!
 Remember when you wanted your name in a song
 so I put your name in a song—
 When I played my music
 at the gates of hell
 I was singing your name
 over and over and over again.
 Eurydice.
 He grows quiet.
 They walk away from each other on extended lines
 until they are out of sight.

Scene 3

THE STONES. Finally.
 Some peace.

LOUD STONE. And quiet.

THE STONES. Like the old days.
 No music.
 No conversation.

How about that.
 A pause.

FATHER. With Eurydice gone it will be a second death
 for me.

LITTLE STONE. Oh, please, sir—

BIG STONE. We're tired.

FATHER. Do you understand the love a father has for
 his daughter?

LITTLE STONE. Love is a big, funny word.

BIG STONE. Dead people should be seen and not heard.
 The Father looks at the Stones.
 He looks at the string room
 He dismantles the string room.
 matter-of-fact.
 There's nothing else to do.
 This can take rime.
 It takes time to dismantle a room made of string.
 Music.
 He sits down in what used to be the string room.

FATHER. How does a person remember to forget.
 It's difficult.

LOUD STONE. It's not difficult.

LITTLE STONE. We told you how it works.

LOUD STONE. Dip yourself in the river.

BIG STONE. Dip yourself in the river.

LITTLE STONE. Dip yourself in the river.

FATHER. I need directions.

LOUD STONE. That's ridiculous.

BIG STONE. There are no directions.
 A pause.
 The Father thinks.

FATHER. I remember.
 Take Tri-State South 294—
 to Route 88 West.
 Take Route 88 West to Route 80.
 You'll go over a bridge.
 Go three miles and you'll come
 to the exit for Middle Road.
 Proceed three to four miles.
 Duck Creek Park will be on the right.
 Take a left on Fernwood Avenue.
 Continue straight on Fernwood past
 two intersections.
 Go straight.

Fernwood will curve to the right leading
you to Forest Road.
Take a left on Forest Road.
Go two blocks.
Pass the first entrance to the alley on the right.
Take the second entrance.
You'll go about a hundred yards.
A red brick house will
be on the right.
Look for Illinois license plates.
Go inside the house.
In the living room,
look out the window.
You'll see the lights on the Mississippi River.
Take off your shoes.
Walk down the hill.
You'll pass a tree good for climbing on the right.
Cross the road.
Watch for traffic.
Cross the train tracks.
Catfish are sleeping in the mud, on your left.
Roll up your jeans.
Count to ten.
Put your feet in the river
and swim.
He dips himself in the river.
A small metallic sound of forgetfulness—ping.
The sound of water.
He lies down on the ground,
curled up, asleep.
Eurydice returns and sees that her string room is
gone.

EURYDICE. Where's my room?
The Stones are silent.
(To the Stones) WHERE IS MY ROOM?
Answer me!

LITTLE STONE. It's none of our business.

LOUD STONE. What are you doing here?

BIG STONE. You should be with your husband.

LOUD STONE. Up there.

EURYDICE. Where's my father?
The Stones point to the Father.
(To the Stones) Why is he sleeping?
The Stones shrug their shoulders.
(To her father) I've come back!

LOUD STONE. He can't hear you.

LITTLE STONE. It's too late.

EURYDICE. What are you talking about?

BIG STONE. He dipped himself in the River.

EURYDICE. My father did not dip himself in the River.

THE STONES. He did!
We saw him!
LOUD STONE. He wanted some peace and quiet.

EURYDICE. *(To the Stones)* HE DID NOT!
(To her father) Listen. I'll teach you the words. Then
we'll know each other again. Ready? We'll start with
my name. Eurydice. E, U, R, Y . . .

BIG STONE. He can't hear you.

LOUD STONE. He can't see you.

LITTLE STONE. He can't remember you.

EURYDICE. *(To the Stones)* I hate you! I've always hated
you!
Shut up! Shut up! Shut up!
(To her father) Listen. I'll tell you a story.

LITTLE STONE. He can't hear you.

BIG STONE. He can't see you.

LOUD STONE. He can't remember you.

LITTLE STONE. Try speaking in the language of stones.

LOUD STONE. It's a very quiet language.
Like if the pores in your
face opened up and wanted to talk.

EURYDICE. Stone.
Rock.
Tree. Rock. Stone.
It doesn't work.
She holds her father.

LOUD STONE. Didn't you already mourn for your father,
young lady?

LITTLE STONE. Some things should be left well enough
alone.

BIG STONE. To mourn twice is excessive.

LITTLE STONE. To mourn three times a sin.

LOUD STONE. Life is like a good meal.

BIG STONE. Only gluttons want more food when they
finish their helping.

LITTLE STONE. Learn to be more moderate.

BIG STONE. It's weird for a dead person to be morbid.

LITTLE STONE. We don't like to watch it!

LOUD STONE. We don't like to see it!

BIG STONE. It makes me uncomfortable.
Eurydice cries.

THE STONES. Don't cry!
Don't cry!

BIG STONE. Learn the art of keeping busy!

EURYDICE. IT'S HARD TO KEEP BUSY WHEN YOU'RE DEAD!

THE STONES. It is not hard!
We keep busy
And we like it
We're busy busy busy stones
Watch us work
Keeping still
Keeping quiet
It's hard work
To be a stone
No time for crying.
No no no!

EURYDICE. I HATE YOU! I'VE ALWAYS HATED YOU!
She runs toward the Stones and tries to hit them.

THE STONES. Go ahead.
Try to hit us.

LITTLE STONE. You'll hurt your fist.

BIG STONE. You'll break your hand.

THE STONES. Ha ha ha!
Enter the child.
He has grown.
Ha is now at least ten feet tall.
His voice sounds suspiciously
like the Nasty Interesting Man's.

CHILD. Is there a problem here?

THE STONES. No, sir.

CHILD. *(To Eurydice)* You chose to stay with us, huh?
Good.
He looks her over.
Perhaps to be my bride?

EURYDICE. I told you. You're too young.

CHILD. I'll be the judge of that.
I've grown.

EURYDICE. Yes—I see that.

CHILD. I'm ready to be a man now. I'm ready—to be—a man.

EURYDICE. Please. Leave me alone.

CHILD. I'll have them start preparing the satins and silks. You can't refuse me. I've made my choice. I'm ready to be a man now.

EURYDICE. Can I have a moment to prepare myself?

CHILD. Don't be long. The wedding songs are already being written. They're very quiet. Inaudible, you might say. A dirt-filled orchestra for my bride, Don't trouble the songs with your music, I say. A song is two dead bodies rubbing under the covers to keep warm.
He exits.

THE STONES. Well, well, well!

LITTLE STONE. You had better prepare yourself.

EURYDICE. There is nothing to prepare.

BIG STONE. You had better comb your hair.

LOUD STONE. You had better find a veil.

EURYDICE. I don't need a veil. I need a pen!

LITTLE STONE. Pens are forbidden here.

EURYDICE. I need a pencil then.

LOUD STONE. Pencils, too.

EURYDICE. Damn you! I'll dip you in the River!

BIG STONE. Too late, too late!

EURYDICE. There must be a pen. There are. There must be.
She remembers the pen and paper in the breast pocket of her father's coat.
She takes them out.
She holds the pen up to show the Stones.
She gloats.
A pen.
She writes a letter:
Dear Orpheus,
I'm sorry. I don't know what came over me. I was afraid. I'm not worthy of you. But I still love you, I think. Don't try to find me again. You would be lonely for music. I want you to be happy. I want you to marry again. I am going to write out instructions for your next wife.
To My Husband's Next Wife:
Be gentle.
Be sure to comb his hair when it's wet.

Do not fail to notice
that his face flushes pink
like a bride's
when you kiss him.
Give him lots to eat.
He forgets to eat and he gets cranky.
When he's sad,
kiss his forehead and I will thank you.
Because he is a young prince
and his robes are too heavy on him.
His crown falls down
around his ears.
I'll give this letter to a worm. I hope he finds you.
Love,

EURYDICE. *She puts the letter on the ground.*
She dips herself in the River.
A small metallic sound of forgetfulness—ping.
The sound of water.

She lies down next to her father, as though asleep.
The sound of an elevator—ding.
Orpheus appears in the elevator.
He sees Eurydice.
He is happy.
The elevator starts raining on Orpheus.
He forgets.
He steps out of the elevator.
He sees the letter on the ground.
He picks it up.
He scrutinizes it.
He can't read it.
He stands on it.
He closes his eyes.
The sound of water.
Then silence.

THE END

Dead Flowers

Introduction by Chad Winters

The Importance of New Work in the American Theatre

The development of new work is one of the most important tasks that an artist is called upon to do if he or she wishes to have a life in the theatre. Unlike the other plays in this anthology, *Dead Flowers* is a brand-new play. Throughout Stanislavski's career, he has stated repeatedly that there would be no theatre without great playwrights. The first duty of the theatre is toward the playwright; to project his or her ideas dynamically. Right now, you also play an important part in the future of the theatre. The audience and those who read this play must take an active part in its interpretation and, in doing so, help to project the ideas of the playwright to the people in your life. Theatre is for the people. Theatre is a worthy and important art form that can make changes in the world. In the Greek courts, the king surrounded himself with a soldier, a philosopher, an astronomer, a doctor, and a storyteller. The work of a playwright is a noble calling.

Along with a multitude of ideas the playwright is trying to project about the world he or she lives in, new work is a reflection of our time: spiritual, financial, political, and sexual. Theatre is an extension of our selves: where we've been, where we're going, and how we may get there. Track the history of theatre, and you track the history of the Western world. *Dead Flowers* is a reflection of the late 1990s and the choices of one generation upon the next. It is important for young playwrights to allow their new voices to be heard so they have an opportunity to exhibit ruthlessness in writing. *Ruthlessness* in this context means going where people don't want to go and don't want you to go. It is the duty of every playwright to take us to these places so we can learn, grow, and become better as individuals and a society.

The Collaborative Process

Creating a new play starts with a blank page and grows into a journey of ideas. The playwright is the truest of all theatre artists because his or her ideas start from nothing. The other artists who become involved later—the actor, director, and all the designers—are interpreters of that art. Once the play is committed to the page, all artists come on board and begin to collaborate together to bring the play to life.

The collaborative process is a very tricky animal, and there is no one way for a group of artists to share their ideas in a productive manner. The one shared here on these pages is just one example of how artists can work together to breathe life into a play. If you decide to pursue a life in the theatre, you will often be called on to collaborate with many artists when working on a play. The more you can learn and practice the ability to collaborate, the better an artist you will be. It is important to be open and fearless as you allow your instincts and artistry to work on the material.

An early draft of *Dead Flowers* was produced by the University of New Orleans as part of their 2002–2003 season. Subsequent readings and workshops were held at various locations in New York throughout 2005 and 2006. The final draft of *Dead Flowers* was finished in July 2006 with a two-week workshop in New York City at A.R.T., with the playwright, director, and a group of actors collaborating on the play. Each day the most up-to-date

scenes were read and analyzed, and then the actors would improvise the scenes, bringing their own instincts to the material. With each improvisation, the artists would discuss what happened, how they felt, and if their objectives fit into the super-objective of the play. Then they would improvise the scene again with an adjustment given by the director or playwright. The following day, the playwright would bring in rewrites inspired by the work done the night before. This process continued for the remainder of the two weeks. At the end of the workshop, the play had grown into a stronger and more powerful piece of drama. The passion that the artists had provided over the two-week period was very successful. Their work was one approach of many, but they took the risk in an attempt to do something great. Today, you, the reader, take part in this collaborative process by reading and taking an active part in this play. Your thoughts and ideas, whether shared in a class discussion, a paper, or sitting around talking to your friend, help *Dead Flowers* create change in the world we live in.

Jim Winter and Dead Flowers

Jim Winter, a founding member of the award-winning InSideOut Productions in New Orleans, has garnered many awards for his writing. He was a regional finalist for the Kennedy Center American College Theatre Festival's Ten-Minute Play Contest in 2002. Other works like "Angel," "Blue," and "Three" can be read in Lamia Ink!'s *One Page Play Series*. He has had many of his original works produced in New York City, New Orleans, Fort Worth, and Cleveland.

The play opens with Vincent bringing his semiconscious mother, Amanda, into his dirty, urban apartment. Amanda slowly gets her bearings, and it is revealed that Vincent has "rescued" her from an apparently bad situation. A rather mysterious turn of events leads to the arrival of Vincent's roommate, Brad, who makes it clear that he doesn't want Vincent's mother to stay at their place. As the tension mounts, the mysterious Tiger enters their safe haven and sinks his claws into Amanda. Throughout the remainder of the play, Vincent tries and fails to find ways to help his mother. A strange love affair appears to hold Amanda in the clutches of Tiger. In the second act, Vincent implores his younger brother to help save his mother, but it becomes evident that only Amanda can save herself and her son. Vincent is a tragic character because no matter what he knows or what actions he takes, he can't save his mother. The fate of Amanda lies only within herself and her desire to free herself from the ties that bind her.

This play seems to be Winter's attempt to understand the strange love affair that happens between the user and their drug. Why do so many people addicted to a drug have a hard time escaping from its deadly path? Even with the support and undying love of those in their lives, many cannot escape. Winter's play tries to understand these questions and drives toward a conclusion that is never completely answered. The answer can only be found within the person lost in the sea of addiction.

Pay careful attention to the use of language and how the characters express their ideas. Their actions often speak louder than their words, and their ideas are born of the impact their past has had on their lives. A particularly poignant moment takes place when they are stuck, smoking and listening to music. Winter explores their differences in the music that each generation listens to. The driving, thumping rhythms found in the late-1990s music appear to be an empty response to the members of that generation who tried to expand their world and to build something new and better while perhaps all the time building walls around those in their lives. Note carefully the use of music in the play. The music of *Dead Flowers* is a character in itself, and you will see how each generation expresses itself through music. The music is the heartbeat of the play. Pay special attention to the character of Tiger. He is the third person in a love triangle between Amanda and her son. The love triangle is a common tool used by playwrights to tell many stories, but in *Dead*

Flowers Winter has created something fresh, new, and different than what has been seen before. It is the duty of the playwright to bring his or her story to the world in a new, exciting way. Winter succeeds in doing this.

Food for Thought

As you read the play, consider the following questions:

1. How does the environment of the play help to further the story?
2. What makes Vincent a tragic character?
3. Why is some of the music of Vincent's generation much angrier than the music his parents listened to?
4. When Tiger appears, how does he control the mood of the play?
5. What do you think happens to Amanda after she leaves the house? How does the choice to leave affect Vincent's life?

Fun Facts

1. The last scene of the play was three pages longer, but the three pages were cut from the play after a discussion between the playwright and the director on their way home riding the Staten Island Ferry.
2. Jane was improvised by two different actors during the New York workshop.
3. In earlier drafts, Vincent left the house and thus left Brad and Amanda alone.

Dead Flowers (A Play in Two Acts)

Jim Winter

Characters

Vincent Perry, Early twenties. A young man not accustomed to making the right choices desperately trying to do the right thing.

Amanda Perry, Late forties, thin and sickly. Once very beautiful.

Brad, Early/mid twenties. The product of modern suburbia and an average '90s college education.

Billy Perry, Late teens. Handsome, wild child.

Jane, Late teens. Beautiful. A rock star's girlfriend if there ever was one. Pam Morrison, Patti Smith and Bianca Jagger all rolled into one.

Tiger, Ageless. Make of him what you will.

TIME:

THE LATE 1990'S.

PLACE:

A LOW RENT, URBAN APARTMENT.

AUTHOR'S NOTE:

THE TEXT IS FULL OF MUSICAL REFERENCES. THESE REFERENCES ARE ONLY SUGGESTIONS BY THE AUTHOR. HOWEVER, THOSE WHO HAVE PRODUCED AND OR WORKED ON THIS PLAY CAN ATTEST TO THE EFFECTIVENESS OF THESE PARTICULAR MUSICAL CHOICES. THE SONGS SUGGESTED NOT ONLY SET UP A VERY SPECIFIC MOOD, BUT THEY WERE ALSO CAREFULLY CHOSEN AS PIECES SYMBOLIC OF BOTH AMANDA'S GENERATION AND HER PLIGHT. REGARDLESS OF WHAT ONE CHOOSES TO DO WITH THIS PLAY, PLEASE REMEMBER THE IMPORTANCE OF MUSIC. IT DEFINES WHO WE ARE, KEY MOMENTS IN OUR LIVES, AND IT OFTEN HELPS GENERATIONS TO CONNECT WITH ONE ANOTHER, IF ONLY FOR A BRIEF WHILE.

Act One
Scene 1

Blackness. The sounds of nocturnal urban America, end of the 20th century. A car alarm, sirens, yelling. Lights up on the interior of an inner city apartment. The ceiling, walls, and floor should show signs of being crushed in, as if the entire apartment were being squeezed by some unseen force. They are still functional, but in terrible disrepair. A living room and kitchenette area fill most of the stage space. The living room contains a tattered couch and a coffee table. The kitchenette area contains a small, rusty refrigerator, an ancient stove, a tiny sink cluttered with dirty dishes, and a card table with a few folding chairs. There are two doors: the entrance to the apartment and a door which leads to the bathroom. There is a third doorway, with no door, which reveals a tiny, extremely dirty bedroom. Papers, ashtrays, takeout cartons and beer bottles are strewn throughout the apartment. The sound of keys jingling outside the door.

VINCENT. Hang in there mom. We're home. If I can just get this damn door . . .

The door swings open and VINCENT PERRY enters with his mother AMANDA in tow. AMANDA seems withdrawn, but she is filled with nervous energy. She is very thin; grossly underweight.

VINCENT. Here we are. You haven't even seen this place, have you? Here. Here. You okay? You okay? (Nothing). You just um make yourself comfortable; I'm . . . I'll take care of this. I'm gonna take care of this.

He locks the door and walks to the kitchenette. Gets a glass of water.

VINCENT. So, welcome to my humble abode! Seriously, I know the place looks like shit, but

I wasn't expecting company. Brad's a slob anyway. You want some water? (*Beat*). You should have some water, Mom. (*Nothing*). Can I get you . . . anything? (*Silence*). Guess not.

He starts to walk away.

AMANDA. You got any beer?

VINCENT. She speaks! Are you sure you—I mean, it won't, you know—

AMANDA. Just give me a beer.

VINCENT. Yeah.

He opens the fridge—it is full of beers. He grabs two.

VINCENT. Whadya know, the last two. Here you go.

AMANDA. Yeah, thank you.

AMANDA *sips the beer. After the first taste she begins to drink it rather compulsively.*

VINCENT. Ma, maybe you should take it easy with that.

AMANDA. I shouldn't have called you.

VINCENT. Don't—

AMANDA. No, I shouldn't have. You didn't have to come and get me.

VINCENT. Come on, Ma.

AMANDA. Thank you, Vinny. I love you. I love you so much . . . I . . .

VINCENT. Come on, stop cryin' now. You're outta there. I got you outta there.

AMANDA. Of course you did. You always were my favorite, you know that?

VINCENT. Stop.

AMANDA. My first and favorite. I can't do this to you. This time. This time I . . . You got a smoke?

VINCENT *pulls out a pack of smokes. Gives one to his mother and lights hers and his.*

AMANDA. Where's Brad?

VINCENT. He works nights.

AMANDA. Does he know . . . of course he doesn't. You wouldn't—Do you think—I'm sorry, Vinny. This is just for tonight. I had to get out of there. I couldn't take it. I'm sorry. I hope you guys don't mind. I promise I'll be out of here in the morning.

VINCENT. Mom, relax. You're not going back there.

AMANDA. I can't stay here. My stuff—

VINCENT. I'll go and get some of your stuff tomorrow.

AMANDA. He won't let you.

VINCENT. Fuck Mario.

AMANDA. Fuck Mario. Sure, that'll fix everything. I can't stay in this bachelor pad. I have a home—

VINCENT. That's no home; it's a rat's nest.

AMANDA. Oh and this is a real prize—

VINCENT. At least there aren't a bunch of . . .

AMANDA. What? Say it.

VINCENT. This is my home. I answered the phone. I went out there, climbed up the damn fire escape and got you. You called me. You begged me. Now you're here, and you're stayin'.

AMANDA. I can't stay here! In the morning I—

VINCENT. Don't worry about that now, okay? Just relax. You've never even seen my place. I've missed you. Stay at my place tonight. It'll be fun. We'll sit around and watch some old movies and smoke cigarettes. I'll even cook you breakfast in the morning.

AMANDA. When did you learn how to cook? You couldn't cook a box of macaroni at home.

VINCENT. Hey, that wasn't me. That was totally Billy's fault.

AMANDA. Don't try and put that one on your brother. I remember clearly—

VINCENT. I've learned, okay? I have turned myself into a fine chef.

AMANDA. Trial by fire?

VINCENT. Once or twice.

AMANDA. How is your brother?

VINCENT. Haven't you talked to him?

AMANDA. He still lives with asshole, don't forget. I haven't gotten through in months. And of course he never calls me.

VINCENT. He says he tries.

AMANDA. Don't try to cover for him. You're just as bad. You just don't have asshole screening your calls, so I occasionally get through. I hate that bastard, Vinny. I really do. He ruined me. Ruined me.

He ruined me and there wasn't a goddamn thing I could do to stop it. He knew if I finished school he'd be fucked . . . he knew exactly what he was doing. That son of a—

VINCENT. —Shhh.

AMANDA. I messed up one time. One time in how many years? One time and he has the balls to drag me into court. Make me look like a complete piece of shit—an unfit mother. I remember the shit he used to pull when you guys were younger. But did I haul him into court? File for divorce? No. I stuck by him. Tried to keep our family together. I fought to keep this family together. And I waited for him. He came home to a family. I messed up once. That vengeful, lying mother fucker!

VINCENT. Mom!

AMANDA. I'm sorry. I'm sorry. My head is just coming and going. I can't believe you really came and got me. I really thought it was the end of the line. This—I mean I've been low before but this is the bottom, Vinny. It can't get any lower. I gotta get better, baby. I'm dyin'.

VINCENT. You're not dying. Don't say that. You're sick and we're gonna do whatever we have to do to get you better. That's it. End of story.

AMANDA. Are you sure you want to do this?

VINCENT. Hell yes.

AMANDA. If we do this, we're doing it my way, Vincent.

VINCENT. Alright, but I think—

AMANDA. No. No. You listen to me. I've done this before. I've been through this shit before. And I've treated it and I'm telling you right now you are not checking me in anywhere! You got it?

VINCENT. Yeah, I know, I know, but what if things get really bad—

AMANDA. No! If you really want to do this, you've got to listen to me now, before it gets bad. I can't go in. I can't face those people. Those faces.

VINCENT. We can find a place where nobody—

AMANDA. Damnit Vincent! I hopped around every hospital and clinic in this city trying to stay employed until they knew . . . they all knew . . . and I just couldn't.

VINCENT. Hey now, you don't need to be going there now. Don't think about all that stuff.

AMANDA. Please don't check me in. I'm begging you. If you want to help me, get Billy over here and you can tell Brad or whatever, but just let's stay here, okay? Please?

VINCENT. Okay. (*He lays her down on the couch*). Just lay down, Ma. Rest.

AMANDA. It could be warmer in here.

He picks a blanket off of the floor and shakes it out.

VINCENT. I know. The heat sucks here. (*As he tucks her in*) Is this gonna be enough for you? I know you're probably going to get pretty cold—later—and I can get you something—

AMANDA. You can get me something?

VINCENT. Yeah. Something else to help keep you warm.

AMANDA. Oh. I'll be just fine, Vinny.

VINCENT. Maybe tomorrow we can . . .

AMANDA. You look tired, Vincent. Rest. Tomorrow will be here soon enough.

VINCENT. Yeah. Yeah.

AMANDA. I hope.

VINCENT. What?

AMANDA. I'm fine, Vinny, just let me rest for awhile, okay?

They share a look.

VINCENT. Hey mom . . . do you think he'll come looking for you?

AMANDA. He always does.

VINCENT. But Mario doesn't even know where I live.

AMANDA. No, Mario doesn't.

VINCENT. Then we're all good.

AMANDA. But *He* always knows where to find me.

VINCENT. What?

AMANDA. He'll come.

VINCENT. Who?

AMANDA. Later tonight.

VINCENT. How's he gonna come if he doesn't even know where I live?

AMANDA. *He* always finds me. I can't escape him.

VINCENT. What are you talking about?

AMANDA. He smells my blood. He's coming here now.

VINCENT. He'd better not come here.

AMANDA. You can't stop him.

VINCENT. I'll kill him if he comes here.

AMANDA. You can't.

VINCENT. He's a moron. I'll cut his balls off if he even knocks on my door.

AMANDA. Not Mario.

VINCENT. Who the hell are you talking about?

AMANDA *sits bolt upright. She listens; like an animal.*

AMANDA. Oh my God . . . he's coming. He's so much quicker than you think he is. He moves faster every time. I can't believe he's here.

VINCENT. He's here?

AMANDA. Like a shadow . . . sneaking up the stairs . . . drifting towards the door . . .

VINCENT. How do you—

The door strains against its hinges.

AMANDA. Knock, knock.

There is a knocking at the door.

VINCENT. Jesus Christ!

Knocking.

AMANDA. Maybe you'd better let him in.

VINCENT. Let him in?! I'll let him in alright!

VINCENT *runs into the bedroom and begins rummaging around like a wild man. More knocking.*

VINCENT. Let him in? I'll kill him! I swear to God! Where is it? Where the hell is it?!

TIGER (*offstage*). Can't you hear me knocking, sweet Amanda?

AMANDA. I hear you.

TIGER. Why don't you open this door and give me some shelter, baby?

VINCENT. Come on, where the hell is it?!

TIGER. You don't have to love in vain, baby. I know you heard me coming on the wind. I know you hear

me calling you. Sweet, sweet Amanda, won't you open your door to me?

AMANDA. Yes. Of course I will . . .

She rises and walks toward the door.

VINCENT. Aha!

TIGER. We're gonna have a real good time together. . . .

AMANDA *is almost to the door. Vincent races out of the bedroom with a baseball bat and rushes to the door.*

VINCENT. Get back Mom! You want some a this mother fucker?!

AMANDA. But it's not—

VINCENT *whips open the door—baseball bat ready to strike.* BRAD, *a young man in a waiter's uniform, leaps back in terror.*

VINCENT. Jesus!

BRAD. Jesus! Don't hit me! (*Beat*). What is wrong with you?

VINCENT. I . . . I thought you were somebody else.

BRAD. Yeah. Okay. Are you stoned? (*Beat*). Oh, hi Mrs. Perry.

AMANDA. Please Brad, Amanda.

BRAD. Alright. What a pleasant surprise. Sorry if I scared you two.

AMANDA. You didn't scare me.

BRAD. My key broke off in the door. That lock's a piece of junk. Let me just get some pliers and I'll pull it out. I didn't mean to surprise you. I got off early.

VINCENT. Got off early? That's a first.

BRAD. Well, they kinda sent me home. Hey, hey, I know that look. This has nothing to do with me and Erica in the cooler.

AMANDA. Who's Erica and what happened in the cooler?

BRAD. Mrs . . . Amanda, you don't want to go there.

VINCENT. This girl he fooled around with in the cooler at the diner.

BRAD. Yeah, let's just leave it at—

AMANDA. What's wrong with that?

VINCENT. Nothing.

BRAD. Exactly, nothing.

VINCENT. Except for that fact that she's like twelve.

AMANDA. Brad!

BRAD. Hey! She is not—

VINCENT. No, really she's like fifteen.

BRAD. She is not fifteen. She's gonna be eighteen in a couple of days.

The sounds of a door opening on a rap party drift in from down the hall.

BRAD. Savages . . . Sorry. I'll have this out in a minute.

AMANDA. Savages?

BRAD. Yeah, you know, that friggin' tribal monkey music they're always blastin'. I can't stand it.

AMANDA. Think they have any underage women down there?

Beat. BRAD *pulls the key from the door.*

BRAD. Got it.

He closes and locks the door. Grabs a beer from the fridge.

VINCENT. So, why did they send you home early?

BRAD. For doin' the right thing if you ask me.

VINCENT. That's a little vague.

BRAD. I don't know, jitters, man. Donnie sent me home. Said I was wrapped too tight.

VINCENT. So you got fired?

BRAD. No. Come on, I'm the best waiter they have. He just told me to go home and rest. Said I was—

VINCENT. Wrapped too tight.

BRAD. Speaking of . . . you don't have to answer the door with a baseball bat you know. I usually ask who it is before I bust out the Louisville slugger. I'm sorry, how rude. Welcome to our apartment Mrs. Amanda. What do you think?

AMANDA. I think . . . I'd like another beer.

BRAD. I'm on it.

VINCENT. Mom, don't you want to get some sleep?

AMANDA. This will help me sleep.

BRAD. So, to what do we owe this visit?

AMANDA. I missed my son.

BRAD. You want him back?

VINCENT. Nice.

BRAD. Did you have any trouble finding parking?

VINCENT. I picked her up. If it's cool with you, my Mom's going to be spending a few days with us.

AMANDA. Just tonight.

VINCENT. Mom.

AMANDA *begins to pace about the room, ever so subtly. She has become much more alert and aware.*

BRAD. Um . . . no problem. Make yourself at . . . home.

VINCENT. Seriously, ma, why don't you lay back down? You were practically asleep when we got here.

AMANDA. I'm not tired anymore. So, Brad, what happened at the diner?

VINCENT. Ma—

BRAD. You really wanna know?

VINCENT. Ma—

AMANDA. I really want to know.

BRAD. Fine, fine, I gotta talk about it anyway. I got into . . . well . . . okay here's the story. This group of P.R.s comes in—

AMANDA. P.R.s?

BRAD (*mock accent*). Puerto Ricans. Just my luck, they're on my station. No big deal—these guys actually have the flashy clothes. I figure if I'm civil I oughta get somethin' out of them. Well, this one spic, he's a—

AMANDA. —Spic?

BRAD. Yeah, yeah a spic. You know—

AMANDA. No, I don't know.

VINCENT. Mom—

BRAD. A Hispanic. A spic. Anyway, this one spic, he's a real prize, got this gorgeous chiquita with him—

AMANDA. —Uh huh.

BRAD. What?

VINCENT. Listen, maybe this—

BRAD. What?

AMANDA. No, please continue Brad. This is most . . . enlightening.

VINCENT. I really—

BRAD. Anyway, this guy's got a mouth on him. He just thinks he's God's greatest gift . . . bossin' me around like he's some kinda high roller. Of course his friends all get a real big kick out of this—watching him boss the white boy waiter around . . . Anyway, I'm takin' it in stride. "yes sir, is there anything else I can get for you? And how about for the lady?" you know . . . all that junk. Anyway . . . fast forward. I'm working on another table and I hear this commotion coming from over at the . . . (*mock accent*) Puerto Rican table. It seems Juan doesn't like—

AMANDA. Juan, was that his name?

BRAD. Sure. It seems Juan doesn't like something his woman had to say. Of course he's gotta curse her out right in the middle of the restaurant. The other customers are getting antsy. So I go over there. "Excuse me sir, can you keep it down a little" you know. "No problemo." I don't get five feet from this table, she starts to say something and he cracks her full on across the face. Well that was it. If there's one thing I won't stand for . . .

AMANDA. And who said chivalry was dead?

VINCENT. Ma—

BRAD. —So I go back over to this table, grab this scumbag by his shirt and call him out right there. God forbid they settle things like men—his three buddies are up before I can barely say a word, the whole wait staff comes runnin' over—they get thrown out—don't even pay for the food— customers freak—bad scene. Anyway, Donnie, my manager, he told me to go home and relax. Guy says I'm wrapped too tight.

Long pause. VINCENT *smokes.* AMANDA *stares at* BRAD, *smiling.* BRAD *stares back.*

AMANDA. Fascinating. (*She giggles*).

BRAD. What?

AMANDA *shakes her head.*

BRAD. What?

AMANDA. What did your parents do to you?

VINCENT. Mom.

BRAD. What do you mean?

VINCENT. Brad, let it—

AMANDA. —You're so young. So young, and yet . . .

BRAD. And yet?

AMANDA. Your moral values are completely fucked.

BRAD. What? My moral values are—

VINCENT. Brad, you don't want to do this.

AMANDA. Spics and P.R.s and savages and chiquitas and—

VINCENT. She's not—

BRAD. —completely fucked? Who are you to—

AMANDA. What is this, the fifties?

VINCENT. The two of you need to—

BRAD. —come in here and talk about my parents? In my apartment? You?

VINCENT. —shut up.

AMANDA. Me?

BRAD. Yeah, you, of all people—

VINCENT. Back off! Just put it down!

AMANDA *erupts in laughter.*

AMANDA. Oh, this is rich. This is—you've gotta help this guy, Vinny, you need to—oh! No!

AMANDA *doubles over and clutches her stomach. Her beer falls to the floor.*

VINCENT. Mom?

AMANDA *runs into the bathroom and slams the door.*

VINCENT. Mom? Are you alright? Mom?

AMANDA. Uh . . . I'll be fine. Owww! Just . . . leave me alone.

VINCENT. Okay. You just yell if you need anything.

He crosses quickly to BRAD *and pulls him aside.*

VINCENT. Just hear me out—

BRAD. Vince, I know it's your mom, but she's out of her—

VINCENT. —I know I know I know.

BRAD. Is she—

VINCENT. No. No. I'm pretty sure—

BRAD. —'cause we can't have that shi—

VINCENT. —She doesn't have any on her. I made sure when I picked her up.

BRAD. She's a mess, man. You've gotta take her somewhere.

VINCENT. I can't.

BRAD. Just take her to the hospital man.

VINCENT. I can't. Not yet. She won't go, she's a nurse—

BRAD. Used to be—

VINCENT. Dude, she'll flip if I try to take her in somewhere. She'll just check herself out. I can't make her go in.

BRAD. Why would she check herself out? If she's here, with you, she wants help, right?

VINCENT. No. Yes. Well, I don't know. She just called because she was depressed. But she said she wanted me to help her. So maybe. . . She sounded ready to kill herself, man. I had to go get her. She's embarrassed at the hospital. She's done this on her own before. You know, without professional help. On the way over here she told me she wants me to help her do it again.

BRAD. So what are you gonna do? I don't want—

VINCENT. Just listen to me. Really listen. I've got a plan. You saw her. I can't let her go back out there. So I'm just going to keep her here until she's ready to go to the clinic.

BRAD. Keep her? She's hitting it hard. Do you realize what you're dealing with here?

VINCENT. Yes. A few days. That's it. A few days until the worst of it passes. Then she'll be ready to go—

BRAD. A few days! She'll be climbing the fucking walls!

VINCENT. Keep your voice down!

BRAD. Come on! A few days? Listen, your mom used to be . . . I mean . . . look, your mom's great, but dude, we can't have her tearing full on into—

VINCENT. I can't let her go back out there—

BRAD. We can't stop her! What are we going to do—hold her prisoner?

VINCENT. Listen to me—

BRAD. And what if that guy—

VINCENT. Just listen to—

BRAD. What's his name? Mario?

VINCENT. Please, just listen to—

BRAD. What if Mario comes looking for her? Is that what the bat—

VINCENT. Shut up and listen to me! Please! My mother will die if she goes back out there. Just wait. Wait 'till she comes out of the bathroom and take a good look at her. There's not much left. I don't know what else to do. Help me. Let me try this. Please.

BRAD. Try what? What do you want to try?

VINCENT. I've got an idea. I'm not going to work tomorrow.

BRAD. Vince, I've been covering most of the bills around here, you can't just—

VINCENT. —I'll take care of that. C'mon, man, this is my Mom here. Did you get a good look at her?

BRAD. You ought to take a good look at yourself. When's the last time you slept? What's going on—

VINCENT. —This! This is what's going on. (*Beat*). Help me. Please.

BRAD. We can't do this alone. We have to try and get her to go somewhere as soon as possible.

VINCENT. Yeah. Maybe.

BRAD. No maybe. She's gonna go fucking apeshit, Vince. I've seen this on t.v.

VINCENT. Her head's all over the place right now, man. As soon as she gets to the point where she's willing to go get some real help—

BRAD. You just said she doesn't want real help.

VINCENT. She's gonna get sick.

BRAD. She's already sick.

VINCENT. As soon as her mood shifts and she's willing to go to a hospital we'll go.

BRAD. And until then? (*Beat*). Until then you just figured you'd use my apartment as a place to hold your mom hostage while she goes through severe—

VINCENT. I pay rent. This is my—

BRAD. I invited you here. Half the time you don't even have a job! I cover your ass all the time, Vince and this is how you balance the scales, huh?

Long pause.

VINCENT. There's nowhere else for us to go.

BRAD. There's nowhere else for me to go. You bring this shit in here, you bring it on me, Vince. Or didn't you think of that? I can't even go out and do something 'cause I got no tip money. I could be makin' tips but instead I'm here playing house with you and Courtney fuckin' Love! (*Beat*). You wanna know what really pisses me off about this whole thing? You never even asked me, man.

VINCENT. I'm asking you now. Help me. Please. (*Silence*). I'll call Billy, there'll be three of us here, we can—

BRAD. Billy? Your brother? Right. You think he's gonna come down here? Did you see the shape he was in the last time he came over here?

VINCENT. Brad—

BRAD. Fuckin' beggin' *me* for money—

VINCENT. If you're not gonna help me—

BRAD. I never said I wasn't gonna help you, Vince, but this is my place. What happens when she starts puking everywhere and tearing the place apart? Who's going to pay for that? You? You can't even pay your end of things as it is.

VINCENT. Three days!

BRAD. Three days?

VINCENT. Yeah, three days and she'll be past all this and I can get her in somewhere.

BRAD. Three days?

VINCENT. That's how long it takes. To detox. Well, the worst of it, anyway—

BRAD. You know this? You've studied this? I never knew you were a pre-med student—

VINCENT. I don't know, okay! I've never done this before, but I have to try.

BRAD. See, see, that's just it, you don't know what you're dealing with here and you bring this problem, this serious fucking problem into my house without even thinking to ask—

VINCENT. This is my mom, we're talking about damnit! I have to do this and I'm going to do this and you can either help me or get the hell out of my way!

BRAD. Okay, okay. You wanna do it this way?

VINCENT. Brad—

BRAD. You wanna do it this way? You've got three days. Just like you said. Three days and either she's out or you're out. Got it?

Silence. AMANDA *comes out of the bathroom.*

AMANDA. Maybe you should just take me home, Vinny.

BRAD. No no no. You just got here. Lay down, you'll feel better. Besides, when's the next time you're going to have the opportunity to enjoy such luxurious accommodations?

VINCENT. It's late, Mom. I need sleep and so do you. Lay down—you'll feel better.

AMANDA. It's that damn beer. Sorry I spilled—

VINCENT. I already forgot about it.

BRAD (*grabbing a towel and going to the spill*). You sure did.

VINCENT. I'm sorry, I—

BRAD. Don't worry about it.

VINCENT. Lay down mom. I'll get you something comfortable to change into. I don't know if we have any pants that will fit you, but I'm sure I've got a nice, warm sweatshirt laying around.

VINCENT *goes to rummage through a pile of clothes in the bedroom.*

AMANDA. Brad . . . I . . . I guess you know what's going on.

BRAD. Yep.

AMANDA. I don't want to put this on you. I can just go home.

BRAD. Stay.

AMANDA. Are you sure?

VINCENT. Here we are, Wright State. My alma mater.

VINCENT *hands her a stained college sweatshirt.*

AMANDA. Are you sure? Both of you?

VINCENT. Go ahead and get comfortable and change Mom.

AMANDA. It's going to get bad. Really bad.

BRAD. Oh, I know.

AMANDA. Do you?

BRAD. Let's give the lady some privacy while she changes.

BRAD pulls VINCENT into the bedroom and out of view. The two engage in a fairly heated conversation. AMANDA takes a quick look around and takes a step toward the door. She listens as if she hears something in the distance. She bites her lip and begins unbuttoning her blouse. She removes the blouse, revealing her skeletal, abused frame. Her skin is a pasty, bluish-white. There are a few bruises in various stages on her ribs. Most striking of all, however, are her arms. Both arms are riddled with track marks. On her left arm is a nasty looking abscess. She rubs her arms and a wave of anxiety washes over her. She looks to the door again, shudders and then puts on the sweatshirt and begins pacing. VINCENT reappears from the bedroom, followed quickly by BRAD.

BRAD. —my way.

VINCENT. Okay. Okay. Let's just be cool for right now. Everything's cool right now. Hey, Mom, here, why don't you try and sleep? Okay?

AMANDA. Okay.

VINCENT guides AMANDA to the couch and tucks her in. She stares out.

VINCENT. There you go. You tired?

AMANDA. Mmm.

VINCENT. I'll be right here. Now get some sleep.

AMANDA. I . . . will.

VINCENT crosses away from the couch but he continues to eye his mother nervously.

BRAD. Let her rest, man.

VINCENT. We've got to watch her.

BRAD. We will. Why don't we throw some cards for awhile until one of us gets tired? C'mon, it'll be a good diversion.

VINCENT joins BRAD at the kitchenette table. BRAD begins to deal some cards. The Rolling Stones' "Gimme Shelter" fades in as AMANDA stares blankly out at the audience with wide awake eyes and the lights fade.

Scene II

"Gimme Shelter" continues to play. The soft blue light of false dawn comes up on the apartment. Vincent is passed out at the table. BRAD has gone to bed. AMANDA is in the exact same position as she was at the end of scene one. After a few beats she sits bolt upright and listens. Slowly, softly, a voice fades in from offstage. It is TIGER. He sings a verse from "Gimme Shelter." AMANDA completes the verse and moves cautiously toward the door. Suddenly, out of the shadows behind her, a man materializes. It is TIGER. He is a tall, dark featured, handsome man. He is lean and charming. When he moves, he is as fluid and fleeting as smoke. He leans over and whispers in AMANDA's ear.

TIGER. It's just a shot away.

AMANDA. Tiger?

TIGER. Fine fine music. They're playing our song.

AMANDA. Tiger! Oh, I knew it was you. I heard you. I heard you on the wind.

TIGER. It hurt me real bad when you left.

AMANDA. I just needed to . . . get away for a little while—

TIGER. Beautiful, beautiful girl from the north . . .

AMANDA. But, I know now . . . just like I knew all the other times.

TIGER. You didn't know when you were sweet sixteen, with black leather boots . . .

AMANDA. I learned.

TIGER. You didn't know when I was just a dragon. Remember those days sweetheart? Do you remember chasing me?

AMANDA. Yes. So long ago.

TIGER. Chasing me with your head held high.

AMANDA. You were just . . . smoke. I couldn't touch you. I couldn't hold onto you.

TIGER. Until you opened your arms to the tiger.

AMANDA. Yes. You . . . kissed me. Pins and needles.

TIGER. Needles and pins.

Throughout the following, TIGER gently rolls up Amanda's sleeve and slowly and methodically kisses her fingers, wrist, and track marked forearm.

AMANDA. Needles and pins . . . so fast. You seized me and kissed me and I tingled all over and then bang! That explosion. . . . sooo hot. A lobster couldn't be that hot. Then comes that point. That point when everything is nothing and nothing matters in the world. High above it all, looking down. You kissed me and sent me to the moon. Everything so far away . . . climbing . . . climbing . . . climbing.

TIGER. There ain't a woman that comes close to you.

AMANDA. Tiger . . . will you . . . kiss me?

TIGER. Far away eyes. How could I refuse them?

AMANDA *(laughing)*. Kiss me, Tiger.

TIGER. Of course, of course.

AMANDA *leans in. It appears they are about to kiss. Then TIGER gently places a finger on AMANDA's lips.*

TIGER. Not here.

AMANDA *(loud)*. What? Why—

VINCENT *(stirring)*. Mom?

TIGER *(backing into the shadows)*. Shhhh.

AMANDA. Tiger, no! Please, come back to me!

VINCENT. Mom? Mom, what's going on?

TIGER has withdrawn into the shadows but he is still present . . . watching.

VINCENT. What's the matter? You okay?

AMANDA. No, Vincent, I'm not okay.

VINCENT. Can I get you something?

AMANDA *(scratching at herself, not knowing whether to sit or stand)*. You can get me the hell out of here. I need to get out of here. I need to go. I need to— oh! Goddamnit it hurts!

VINCENT. You need the bathroom?

AMANDA. No! No. It just hurts. Make it stop. Make it stop.

VINCENT. Shhh. Shhh. We're gonna make it stop.

AMANDA. You can't make it stop.

VINCENT sits beside her, stroking her hair as she sobs. After a few beats, she begins to relax.

VINCENT. There. There. We're gonna get through this.

AMANDA. I don't know. I don't know. I'm not strong enough, Vinny. It hurts.

VINCENT. Mom . . . you want to . . . right?

AMANDA. Huh?

VINCENT. You want to quit, right?

AMANDA. I have to. I have to . . . for you boys. You want me to. You and Billy want me to.

VINCENT. Of course we want you to, Ma. We wanna have you around for a while.

AMANDA. I know you do. It's so hard, baby.

VINCENT. You've got to.

AMANDA. I know. You're right. I've got to. For you boys. I'm going to do it . . . this time I'm really going to do it . . . for you. You've got to help me, though. I can't—

VINCENT. —I'm gonna help you.

AMANDA. —I gotta have something, I know it's weak, but I gotta have something. Will you take me to the clinic?

VINCENT. You mean it?

AMANDA. Yeah, yeah. Good old methadone. Hell, it worked for me seventeen years ago.

VINCENT. Sure. Lemme . . . lemme throw some water on my face and we'll go.

AMANDA. Hurry.

VINCENT. Two minutes, tops. Put your shoes on.

As VINCENT goes into the bathroom, Tiger drifts out from the shadows. AMANDA stares at him. He comes closer. They are within inches of one another. AMANDA breathes heavily.

TIGER. Why, you're trembling my dear. I bet that's nothing compared to those big old shakes that hurt your whole body.

AMANDA. Vin? Vinny, hurry up now.

TIGER suddenly seizes her around the waist and force-fully pulls her to him. The two begin to dance as if it were the last slow song at a prom. TIGER sings a verse from The Rolling Stones' "Let It Bleed" as they dance. When he finishes singing he dips AMANDA, holds the moment for a second, and then releases her, letting her fall gently to the floor. AMANDA quickly scrambles to her feet and grabs TIGER.

AMANDA. Please kiss me, Tiger. I'm sick when you're gone. Kiss me please! They're playing our song.

TIGER. And some people wait for things that never come . . . all through the night. You know the way home, baby.

AMANDA. Please! Just one little kiss!

TIGER. I can't help you here, baby. I can come knocking, but you've got to chase me, like when you were just a girl . . . you've got to come to me.

AMANDA. I can't.

TIGER. Can't? Or won't?

AMANDA. I don't have any money. And Vinny and—

TIGER hurts AMANDA; sends her to her knees.

TIGER. You go to that clinic and I'll seep through your veins and I'll eat you alive.

AMANDA. No. No. Please.

VINCENT enters. TIGER remains present, physically taunting AMANDA.

VINCENT. Okay, Mom. You got your shoes on? Mom, you okay? You ready to go?

AMANDA. Not now, Vinny.

VINCENT. What do you mean, not now? You just said you were ready for me to take you to—

AMANDA. I'm not going anywhere. Anywhere! Got it?

VINCENT. Mom, you just told me you wanted to go to the—

AMANDA. Shut up!

VINCENT backs away, unsure. TIGER smiles.

TIGER. You know where to find me. I'm just about a moonlight mile on down the road.

AMANDA remains huddled between her two men as The Rolling Stones' "Sister Morphine" fades in and the lights go to black.

Scene III

It is the fresh hope of daylight. VINCENT and AMANDA sit at the tiny card/kitchen table. AMANDA is wrapped in a blanket humming "Sister Morphine." The song fades out but she continues to hum it. Both of them smoke. Silence.

AMANDA. I thought you were gonna cook breakfast.

VINCENT. I thought you were gonna go to the clinic.

AMANDA. I thought you were gonna cook breakfast.

VINCENT. There's nothing to eat here! We've already been over this. I fucked up. I know I said I'd cook breakfast but there isn't anything to eat here so I can't cook breakfast I'm sorry. It's my fault. Okay?

Beat.

AMANDA. I just thought it was a nice idea. The old family breakfast. Everyone gathered around the table. I was even hoping maybe you'd call Billy and he could have—

VINCENT. I already called Billy, Ma, I told you—

AMANDA. Is he coming over? He could bring some bagels, then we could all have breakfast together. Is he coming?

VINCENT. Yeah. Later.

AMANDA. When?

VINCENT. I don't know. He's . . . he's got stuff to do. He said he'd come later.

AMANDA. Oh. I just thought breakfast was a nice idea.

VINCENT. It is a nice idea. A family meal. It's been a long time. (*Beat*). If you're hungry, we can stop by a deli on the way to the clinic.

AMANDA. I'm not hungry. I can't keep anything down.

VINCENT. Then why do you keep bringing up—

AMANDA. I just liked the idea. I thought it was a nice idea. (*Beat*). It's cold.

VINCENT nods. Beat.

AMANDA. You got any weed?

VINCENT. Wha—

AMANDA. I know you smoke.

VINCENT. Never mind you know I smoke. You're supposed to be cleaning out your system.

AMANDA. I'm sick. This is the longest I've gone without puking in hours. I just thought it might settle my stomach.

VINCENT. I'm not smoking up with you, Mom.

AMANDA. C'mon—

VINCENT. I quit. I don't do it anymore . . . much. I don't have any.

AMANDA. It'll settle my stomach and then we can ride to the clinic without me hanging out the window puking on people.

VINCENT. Ah, there's nothing like the old Perry family breakfast. An empty table, pack of smokes, talk of weed with the old parental units. I'm not having this conversation. (*Long pause*). So, you're saying if I smoke you up, we can go to the clinic.

AMANDA. In all these years we've never smoked together. I know you've smoked with your Dad.

VINCENT. You told me you don't like pot.

AMANDA. It'll settle my stomach.

VINCENT. This is . . . this is not breakfast. This is . . . God I need to sleep!

AMANDA. It'll put you to sleep.

VINCENT. No! (*Beat*). Look at me. If I do this . . . if we do this, will you let me take you to the clinic?

Beat.

AMANDA. It'll settle my stomach.

VINCENT. Fuck this! I'm not playing any more games with you, Mom. We're going to the goddamn clinic. I'm taking you now! I'll make you—

AMANDA. Please! Please Vinny, just a little something. I can't stop scratching. It hurts. I'm okay for a minute and then it hurts it hurts it hurts. Please, it's not that bad. It's pot. Just give me a little something to help me get a hold of myself and we'll go, okay?

VINCENT. Okay. Alright. I don't have any. I'm gonna see what Brad's got. If he's got a little, we'll smoke a bowl and then we'll go to the clinic.

AMANDA. We'll smoke a bowl and then we'll go to the clinic.

VINCENT goes into the bedroom. AMANDA sits shivering. She starts to hum a snatch of song. Stops. TIGER's voice fades in from offstage, singing a snatch from The Rolling Stones' "Dead Flowers." VINCENT comes out of the bedroom, fumbling with a small bag of weed. He stops and stares at his mother's back. He senses something. AMANDA sings along with TIGER. VINCENT shoves the bag into his pocket.

VINCENT. Mom . . .

AMANDA. Ready, honey?

VINCENT. There isn't any.

AMANDA. But—

VINCENT. There isn't any and we need to go.

AMANDA. You're a liar.

VINCENT. Mom—

AMANDA. You're a liar. You've got some and we both know it.

VINCENT. Mom—

AMANDA. Don't Mom me. You said—you promised me you'd get me high. You promised me you'd help me feel better. What's wrong with you? All I'm asking is for a little help from me son and you have to be this self-righteous—

VINCENT. I can't do this, Mom! I cannot sit here and get high with you when I'm trying to get you better!

AMANDA. You can't—

VINCENT. Can't you see how fucked up this is? We can't do this anymore! We can't keep playing this—

AMANDA. Who are you? Who are you to say—Who are you to keep me caged up like some fucking animal and then tell me where I'm going and what I'm doing?

VINCENT. Get your shoes on, we're going to the clinic. We're done! You're getting in the car and going to the clinic right now. No more bullshit. Shut up! You're sick! We're going. Now!

Brad has awakened.

AMANDA. I don't have to take this shit. I'm leaving.

VINCENT forcibly turns his mother to face him.

VINCENT. If you're going anywhere, you're going with me.

AMANDA smacks VINCENT in the head.

AMANDA. Get away from me. Don't you fuckin' touch me!

She goes for a second swing and Vincent grabs her arm.

VINCENT. Hit me again, Mom. Come on; you know how much I like—

BRAD. Okay, easy there—

AMANDA tears away from VINCENT and runs toward the bathroom.

AMANDA. Leave me alone!

She slams the bathroom door shut.

VINCENT. Good! Fuckin' stay in there!

Throughout the following, VINCENT begins barricading the bathroom door with anything he can find and move.

VINCENT. Stay in that miserable bathroom and puke and shake and climb the goddamn walls! That's exactly what I want you to do! Hide in there. Hide from the world.

BRAD. Vince—

VINCENT. Hide from your evil son who won't cook you breakfast and won't get you high even though you can't eat anything and you don't even like pot!

BRAD. Vince—

VINCENT. I'm gonna lock you in there. I'm gonna lock you in there until you're begging me to take you to the clinic. You wanna play games! Let's play! I learned from the best!

BRAD grabs VINCENT and stops him.

BRAD. Vince! Enough. C'mon, man. Enough.

VINCENT. I can't do this. I can't fucking do this. I can't I can't I can't—

BRAD. I hate to be that guy who says "I told you so," but I told you so.

VINCENT. I don't need to hear your shit right now, Brad.

BRAD. Hey, I'm not the one barricading my mother in the bathroom.

VINCENT. You saw her. What the hell else am I supposed to do? A couple of hours ago she tells me she's all set to go to the clinic and now . . . this.

BRAD. I think she's just pissed that you wouldn't smoke up with her.

VINCENT. C'mon.

BRAD. Seriously. That's a very insulting thing. How would you feel if I told you I was going to get you stoned and then I changed my mind? No, no, no—wait. You want to get high and you get all excited when your pal tells you he's going to set you right and then he turns around and tells you tough titty, no smoke for you. You'd be pissed, right?

VINCENT. She's not my pal, she's my mother and she's trying to get clean.

BRAD. From smack, not from a little pot.

VINCENT. It's still drugs!

BRAD. Dude, my grandmother smokes weed.

VINCENT. I am trying to get her to detox.

BRAD. Medicinal purposes, boss. Your mom's nauseous, she's sick, she's messed up, I mean she's probably got glaucoma, too.

VINCENT. Brad, I am not—

BRAD. This is what we're going to do. You need to take *my* bag of weed out of your pocket and roll us up a fatty.

VINCENT. I can't get baked, I've got—

BRAD. Listen to me, okay? Listen to me. You remember what we talked about last night? Yeah? Well your way doesn't seem to be yielding the best results at the moment, so why don't we try things my way?

VINCENT. What's your way?

BRAD. Yo, Amanda, we're fixin' to smoke a little schwag out here if you'd like to join us.

VINCENT. Brad—

BRAD. I must smoke a joint. I am going to smoke a joint. All of us are going to smoke a joint. We'll all relax, your mom'll feel better, maybe you'll sleep, I can watch The Jetsons and then jerk off to Erica before I go back to sleep—

VINCENT. —Brad, I don't think it's such a good idea to be doing this shit with her.

BRAD. You said she doesn't really smoke, right? So, we'll get her good and stoned and then she'll be like putty in our hands. C'mon, dude, thirty minutes from now she'll be ready for us to take her anywhere we say.

VINCENT. You're serious?

BRAD. As a heart attack.

Pause.

VINCENT. Alright, let's do it.

BRAD. Good, go roll me a joint. It'll give you something to do with your nervous energy. I'm gonna get us some tunes. Any musical preferences Amanda?

AMANDA (*off*). You're trying to trick me.

BRAD. Ain't no tricks here. Best come join us or you're gonna miss the weed train. Woo! Woo! Vinny's gonna smoke with us. 'Cause Brad's got a plan. Go on man, tell her we're smoking. Tell her.

VINCENT. That's right, Mom, we're going to smoke a joint.

AMANDA. Why?

VINCENT. Because Brad's got a plan.

BRAD. Damn straight.

BRAD *pulls out a beat up boom box and an assortment of cds.*

AMANDA (*off*). Where's Billy? I want to see Billy.

VINCENT. I called him, Mom, remember? I don't know where he is.

AMANDA (*off*). I'll come out once Billy's here. He won't let you hurt me.

VINCENT. I'm not gonna hurt you—

BRAD. Old Billy's gonna miss the train, too. What do you feel like hearing, man?

VINCENT. That thing still works?

BRAD. Yeah, I fixed it the last time we were partying. Remember—no, you probably don't remember, you fucking alcoholic. Oh yeah, I've got just the thing to start us off.

BRAD *begins to play something obnoxious from the nineties. Beastie Boys, Manson, something* AMANDA *would hate. He dances around, singing along.*

AMANDA (*off*). What is that shit?!

AMANDA. It's music, Mom. It's—

AMANDA (*off*). Do you hear me? I'm asking you a question!

BRAD. You about ready with that thing?

VINCENT. Um hum.

AMANDA *comes out from the bathroom, stalks over to the radio and silences it.*

AMANDA. I am not going to smoke with you if you're going to listen to that crap.

BRAD *laughs. All eye one another. Vincent looks uncertain.* BRAD *whips the joint out of* VINCE'S *hand and makes a spectacle of lighting it. He offers it to Amanda. She hits it and coughs a bit. The joint is* AMANDA *among the three of them throughout the following.*

AMANDA. Jesus.

BRAD. I don't know about you, but I can't smoke without a little music.

AMANDA. Music is nice . . . if you have good music.

BRAD. Come on, there's gotta be something you like in there.

AMANDA. Orgy? Alice in Chains? Kidney Thieves? Vincent, these can't be your cds.

BRAD. Nope, all mine. I think Vince sold all of his.

AMANDA. Sold? Why?

VINCENT. Times are tough.

AMANDA. Oh, baby, you used to have a ton. All the good stuff. The Stones, Cream, The Kinks, Lou Reed.

BRAD. I've got some oldies. What about the Beatles? You gotta like the Beatles.

VINCENT. She doesn't like—

AMANDA. Pretty boys. I never did like 'em. When I was in school all the girls loved the Beatles. They had pictures of Paul McCartney plastered all over their walls. Not me. I liked the bad boys. The Rolling Stones. Give me Mick and Keith any day. While the Beatles were singin' about Strawberry Fields and Penny Lane, the Stones were howlin' about sleazy sex and needles and spoons.

VINCENT. Mom . . . She's got a point, Brad; The Stones were way better than The Beatles.

AMANDA. I saw the Stones for five bucks at the Hollywood Bowl.

VINCENT. Mom, those tickets get cheaper every time you tell this story.

AMANDA. I'm serious. Shows were cheap then. For ten bucks you could be sitting fifth row center.

BRAD. Thirty-five'll get you nosebleeds today.

AMANDA. Crazy.

Brief pause as the marijuana begins to really work its magic on all three. BRAD *is happy,* AMANDA *is happy and already very stoned.* VINCENT *is already showing signs of falling asleep.*

AMANDA. I used to have this stereo . . . this guy I knew in a band built the speakers for me. They were this high.

BRAD. *This* high, huh? Were they really *this* high?

All share a laugh.

BRAD. You uh . . . you . . . forgot what I was gonna say.

More laughs. BRAD *puts his arm around* AMANDA.

BRAD. See, isn't this nice? Wasn't this a good idea? Who was right? Hey, what about The Doors? You like The Doors?

AMANDA. Finally, something decent.

BRAD puts in a cd.

BRAD (*grabbing a beer from the fridge*). You've gotta drink to the Doors. You guys want a beer?

AMANDA. I'd . . . I better not.

BRAD. Vince?

VINCENT. I'm good.

BRAD. Hey Amanda, maybe you should try eating something.

AMANDA. I don't think I could keep it down. I'll stick with my water.

BRAD. That's okay, 'cause we don't have anything to eat anyway. That's gonna suck when we get the munchies later. Hey, did you ever see these guys in concert?

AMANDA. I sure did. Jim was trashed out of his mind. He was one sexy bastard though. I saw the show in Miami where he got his cock sucked on stage!

VINCENT. Get outta here! You never told me that was the show you saw, Ma! That's, like, rock and roll history.

AMANDA. Uh huh. And I was close. I could see it.

BRAD. I bet he had a little dick. Little teeny weenie dick.

AMANDA smacks BRAD playfully.

AMANDA. Morrison was hung like a horse! I saw 'em all. Dylan, The Dead, David Bowie.

BRAD. Bowie's cool.

AMANDA. I saw David Bowie as Ziggy Stardust.

BRAD. Ziggy Stardust. What was that like?

AMANDA. He flew! He flew on stage! He had these big glittering wings! We were out of our minds! That was my scene. I loved that whole trashy, flashy New York scene. Bowie, Iggy, Lou Reed and the Velvets, David Johansen and the New York Dolls a little later. I had just moved out to New York from California. God, it was so intense. Andy Warhol. So dark. So morbidly intriguing. We didn't know. We were all so smart, but we didn't know. Prices and princesses doped up like zombies. Flirting

with death . . . we walked the line. You've got nothing like that now. What have you got? Limp Bizkit.

BRAD. Hey, I like Limp Bizkit. What's wrong with Limp Bizkit?

AMANDA. You kids just don't get it.

BRAD. Get what?

AMANDA. Music. Drugs.

BRAD. I do drugs while listening to music. What else is there to get?

AMANDA. It's so angry now. You're all so angry. These, these, these mosh pit things for instance.

BRAD. A good mosh pit can be very cathartic I'll have you know.

AMANDA. I'm getting old. It was all so new then. The experimenting and the exploring and the music. It was so new and so alive. Rock and roll, baby.

BRAD. It's still rock and roll, baby. It's just a little harder now.

AMANDA and BRAD are in their own little world. Vincent has fallen asleep.

AMANDA. When I was a girl, we used to get together just to listen to new music. Do you guys ever get away from your computers and just experience new music with each other?

BRAD. There's raves.

AMANDA. Raves?

BRAD. Yeah, that's where all the kids go and take ecstasy and dance until they collapse.

AMANDA. I've seen those on the news. You ever go?

BRAD. Sure.

AMANDA. You ever take ecstasy?

BRAD. Once or twice.

AMANDA. What's it like?

BRAD. Up. You're so alive. It's kinda like tripping, but a lot less visual and a lot happier. Everything's good. You're speeding, but it all feels great . . . heightened sensations—

AMANDA. I don't think I'd like it.

BRAD. I bet you would.

Brad *gently touches the bridge of* Amanda's *nose with his finger tip.*

Brad. Eyelash.

Amanda. I never liked that up stuff. I only used speed when I had to. I like it slow. You kids move too fast.

Awkward pause.

Brad. Seven-minute lull.

Amanda. Huh?

Brad. You never heard of the seven-minute lull? Supposedly, there's a lull in every conversation every seven minutes.

Amanda. That's bullshit. Vinny's asleep, that's why it got quiet.

Brad. I'll be damned. He fell out like that last night. Should I move him?

Amanda. Nah, leave him be.

Brad. Yeah, I'd hate to wake him. We can split the next joint two ways.

Amanda. Phew! Another?

Brad. How you feeling?

Amanda. I feel good, Brad. Yeah. I feel pretty good.

Brad. You look good.

Amanda. Thank you so much, Brad.

Brad. Hey, they don't call me The Pot Nazi for nothin'. Let me go shake hands with the Pope, then I'll get to work on bachelor number two. I'll only be a minute. If you need anything—

Amanda. —I'm feeling much better. You're good company.

Brad *enters the bathroom. As he enters the bathroom, Tiger exits it, unseen.*

Amanda. Good times. God, I haven't felt this good since—

Tiger *places his hands on* Amanda's *shoulders.*

Tiger. You know I can't let you . . . slide through my hands.

Amanda. Tiger! You haven't left me.

Tiger. Wild horses couldn't drag me away. I really expected you'd have left this dump by now. Whatcha doin' Mandy?

Amanda. Oh, just playing with Mary Jane and the boys.

Tiger. Mary Jane and the boys. It gets better. You know that, don't you? It can be so much better. Wouldn't you rather be playing with a real man?

Amanda. I know. I know. I'm just waiting for my—

Tiger. —man?

Amanda. Son.

Tiger. Vinny's two-thousand light years from home. Sound asleep.

Amanda. No. Billy. I'm waiting for Billy, he'll—

Tiger. Lonesome cowboy Bill? He's not coming here. You really think he wants to sit here and watch his mother cry her eyes out for the Tiger? Billy's finally realized that nothing can come between us, Mandy. He doesn't understand our love, and he resents you for it. He's his father's son. He's left you just like his father before him.

Amanda. That's not true. I left him.

Tiger. Only after he stopped coming home. I'd never treat you unkind.

He is caressing her arms. She smiles.

Amanda. I . . . can't. You have to help me. They won't let me go. I'm so sick and weak—I—need—

Tiger. Shhh. Will you walk with me, sweet Amanda?

Amanda. Yes. You know I will.

Tiger *picks up* Amanda *and carries her into the kitchenette, as a groom would carry his bride. He sets her down and perches atop the counter. He gestures to a drawer beneath him.*

Tiger. All that you need is right inside.

Amanda *reaches into it and removes a little orange prescription bottle.*

Amanda. Tylox. Pain killers! Thank God!

Amanda *rips the cap off of the bottle and prepares to take a few pills. Tiger grabs her wrist, stopping her.*

Tiger. Too bad you can't keep anything down. They're a poor substitute anyway. But I know somebody who'll love 'em. (*He picks up* Brad's *beer bottle and hands it to* Amanda). Mother's little helper.

Amanda *opens the pill bottle and pours out some pills. She opens one and pours its powdery contents into the*

beer bottle. She glances toward the bathroom and then adds the contents of a second pill. And a third.

AMANDA. Three. That should do it.

TIGER. Four.

AMANDA pours one more pill's contents into the bottle.

TIGER. I don't have much time, Lady Day. I have many belles waiting on their gentleman caller. You need to do this and get out of here. Perhaps you need some motivational music. I mean, the Doors? How juvenile. (*TIGER strolls over to the pile of cds and examines them*). You've got to be kidding me.

TIGER walks to AMANDA and performs a quick slight-of hand. A CD appears in his previously empty hand.

TIGER. I'm surprised you missed this one, Mandy. It's a real classic.

AMANDA grabs the cd and places it into the radio. She presses play. The Velvet Underground's "Heroin" begins to play. AMANDA and TIGER share a knowing smile. BRAD enters from the bathroom. TIGER withdraws to watch from the shadows.

BRAD. What happened to the Doors?

AMANDA. You'll like this.

She hands him his beer.

BRAD. Thanks. Who is this?

AMANDA. To my generation.

BRAD. Sure. Bottom's up. (*He chugs the rest of his beer*). I think that beer was skunked. I hope the rest of 'em aren't.

AMANDA. I doubt it.

BRAD gets another beer. AMANDA begins to pace.

BRAD. You okay?

AMANDA. Yep.

BRAD. You sure you're okay?

AMANDA. Yep.

BRAD. 'Cause you're making me kinda nervous here.

TIGER and AMANDA share a look.

AMANDA. I'm sorry. I just suddenly have all this energy. I must be feeling better.

BRAD. You don't look so great. You're sweating, you're. . . .

AMANDA. How you feeling?

BRAD. I'm great. Oh, man, I know what's wrong here.

AMANDA. What?

BRAD. I know exactly what's going on here.

Pause. AMANDA looks very nervous. TIGER glares from the shadows.

BRAD. You, my lady, need to smoke another joint.

AMANDA laughs, Vinny stirs momentarily.

BRAD. Shh. We don't want him cutting in on our fun.

AMANDA (*to TIGER*). If I smoke anymore I don't think I'll be able to go anywhere.

BRAD. So?

BRAD sits on the couch and begins to roll another joint. He is struggling a bit.

AMANDA (*to TIGER*). How much longer?

TIGER. Baby, baby, baby, I think he's out of time.

BRAD. Shit, maybe you don't need anymore. You enjoying your conversation over there . . . with your imaginary friend?

AMANDA. Um, yeah . . . Brad? Maybe we could just relax for a few minutes.

AMANDA crosses to Brad and begins rubbing his shoulders.

BRAD. What's this?

AMANDA. Well, everyone's always saying you're wrapped too tight. I thought maybe this would help.

BRAD. Yeah. That feels good. That feels . . . really . . . good right now. Man . . . that must be some creeper weed. I'm . . . I'm really . . . hey, aren't you feeling this shit?

AMANDA. I'm feeling just fine, baby.

BRAD. No . . . no. What's . . .

BRAD breaks away from AMANDA and stands up. He is staggering and disoriented. He lumbers awkwardly toward AMANDA.

BRAD. Something's . . . something's not right . . . here. This music. Did . . . did you . . . I'm so . . . fucked up.

He crashes to the ground, unconscious. VINCENT is awakened by the crash. TIGER has vanished. AMANDA glances around frantically, grabs her purse and lunges for the door. VINCENT intercepts her.

VINCENT. What the—

AMANDA. Get out of my way, Vincent. I'm going home.

VINCENT. What did you do to Brad?

AMANDA. Get out of my way, Vincent. I'm going home.

VINCENT. You'd better sit down right—

AMANDA. Get the fuck out of my way, Vincent!!! Get out! Get out!!!! Get the hell out of my way!!!

VINCENT *grapples with his mother, easily overpowering her. She fights with everything she's got.*

AMANDA: Get off me! Let me go! You mother-fucker! You little bastard! You can't keep me here! I'm not a fucking prisoner. You shit! Get offa me! Please! I'm dying! Please you—

VINCENT. Stop it! Stop it! Godamnit ma—Don't make me hurt you! Get a hold of yourself! Stop it! Stop it! Stop it!!! Shut up! Shut up! Shut the fuck up!!!

By this point VINCENT *is on his knees.* AMANDA *is wrapped up tightly in his arms. The two stare out at the audience, their parent child roles inverted.*

AMANDA: You . . . you can't keep me. You're . . . killing . . . me

The lights fade to black.

Act Two
Scene 1

Blackness. A harmonica moans out a bluesy tune. A single light shines down on Amanda. She is tied to one of the kitchenette chairs. She appears to have aged at least ten years since we last saw her. She is crying. TIGER kneels beside her, playing the harmonica. After a moment, TIGER finishes his tune.

TIGER. Did you ever wake up to find a day that broke up your mind? Mandy, girl, you got to talk to me. You done let me play dem blues solo.

AMANDA. It's over. I've messed everything up. Miserably. I've failed. Completely and utterly. My failure is complete.

TIGER. That's right, baby, sing dem blues. That's how we always get by, ain't it? We embrace all of the filth and the failure and the woes of the world and we sing real low and we dance real close and—

AMANDA. Why are you still here? I've got nothing for you. I am tied to a fuckin' chair and I've got nothing left. I'm done. Why won't you just go away?

TIGER. My love for you will not fade away.

TIGER *brushes the hair out of her face and stares into her eyes.*

TIGER. Just as beautiful as the day I met you. I watched you dancing in the light and you were so . . . vital. You were alive and daring and free and I knew I had to have you. You were the only one for me because I could see it in your eyes. You stared out at me through all the other bodies with eyes that said to me,

TIGER AND AMANDA. Pick me. Pick me. I'll never quit. I'll dance and dance and I'll never quit on you. Never.

TIGER *leans in and kisses* AMANDA. *It is a long, slow, perfect kiss. They continue to kiss as the sounds of a rainy night in the city filter in. With these sounds, the lights come up to reveal* VINCENT'S *apartment, more cluttered than ever.* BRAD *is sprawled out with a bloody t-shirt bandaged around his head.* VINCENT *is pushing the kitchenette table up against the apartment door.* TIGER *and* AMANDA *continue to kiss. She cannot embrace her man, and as the kiss progresses she becomes more and more agitated; straining against her bonds.*

VINCENT. Alright Ma, now that I've placed a few obstacles between you and the door, I guess I can untie you. (*The kiss continues*). So, you think you can keep yourself together if I untie you? (*More kissing, though no longer pleasurable for* AMANDA). The silent, sobbing treatment got old real fast. I am offering to let you out of that chair. Would you just say something? (*The kiss continues; it is unbearable*). Mom? Are you okay?

AMANDA. Fuck you!

VINCENT. Mouth still works.

TIGER *smiles and disappears into the shadows. He is gone.*

VINCENT. I'm gonna untie you now, Mom. Okay?

AMANDA. If you don't untie me right this fucking minute, I swear to God I'm gonna puke all over myself!

VINCENT. Okay! I just said I was gonna untie you!

AMANDA. Hurry. Hurry. Do it.

VINCENT carefully loosens the binds, as if he were freeing a wild animal. AMANDA wrenches herself free, stumbles and runs into the bathroom. VINCENT crosses to check on BRAD.

VINCENT. What the hell did she do to you?

BRAD (*still unconscious*). You gotta do something, man.

VINCENT. What? You're talking? Hey, hey Brad, do you—

BRAD. You gotta talk to that guy.

VINCENT. That guy? What guy? Are you—

BRAD *is completely out again.*

VINCENT. Brad? Dammit.

There is a knock at the door. VINCENT runs to the door, stops and considers the bat.

VINCENT. Who's there?

BILLY (*off*). Ozzy Osbourne. I'm looking for the Alamo, so I can piss on it.

VINCENT laughs.

VINCENT. Just a minute.

VINCENT struggles to clear his barricade. At last he opens the door. BILLY PERRY enters, holding hands with his girlfriend, JANE.

VINCENT. Thank God you made it. What the hell took you so long?

BILLY. We were . . . uh, busy.

VINCENT. Busy?

BILLY. Yeah, where's Brad?

BILLY crosses deeper into the apartment, leaving JANE and VINCENT at the door.

VINCENT. He's on the—

BILLY. Jesus, you weren't kidding! She took his ass out!

VINCENT looks at Jane, puzzled.

VINCENT. And . . . you are?

JANE. Hi Vincent, I'm Jane. I'm here to help.

VINCENT. Um . . . okay.

BILLY. Jane, come take a look at this guy. Pretty bad, huh? What did Mom do to him?

VINCENT. I don't know, she won't say. She's been talking all crazy—

JANE. He definitely needs to get to a hospital.

VINCENT. Yeah, but he's been out like this since I called you. Every once and a while he'll mutter something, but most of the time he's just out cold. That cut on his head's pretty nasty, too.

BILLY. Nice bandage.

JANE. Where's your Mom?

VINCENT. Bathroom. She's in there a lot. She's really sick, man.

JANE crosses to the bathroom door and knocks softly on it.

JANE. Mrs. Perry?

VINCENT. Jane, I wouldn't—

JANE. Mrs. Perry? Are you alright? Do you need anything?

BILLY. Look, Vince . . . I came down here for you. I'll help you get Brad up, or to the hospital, or whatever, but I don't know how much I can deal with her.

VINCENT. You've gotta help me. She's out of her mind. I don't know if I can do this alone.

BILLY. Hey, man—it was your crazy idea to kidnap her and ride out a cold turkey withdrawal. I can't handle that. And I'm not putting Jane through that.

JANE. I don't mind.

BILLY. Look, it's bad enough I have to explain to my girlfriend that my mother's a junkie—she doesn't need to sit here for a few days and watch mom roll around on the floor puking and screaming and—

VINCENT. Then why'd you bring her here?

BILLY.

JANE. I wanted to come. It sounded like you needed a little help over here.

VINCENT. Billy, I don't think this is the time for—

BILLY. Yeah, ya know, you're probably right, Vince. I'm sure Mom doesn't want to be meeting new people right now. Why don't you help Jane and I get Brad down to the car and—

VINCENT. You could at least say hello to her.

BILLY. I told you I'm here for you. I don't want to see her. I can't even talk to her anymore.

VINCENT. Try. She loves you. She's been asking for you all day. She's your mother.

BILLY. No. Mom's gone. That is not mom.

VINCENT. We can help her.

BILLY. You're stupid to even try.

VINCENT. That's a great fucking attitude to have—just write off your own mother!

BILLY. She wrote us off!

The sound of the toilet flushing. Activity in the room freezes. The bathroom door opens and AMANDA *staggers out; comes face to face with* JANE.

AMANDA. Who the fuck are you?

JANE. Hi, Mrs. Perry. I'm Jane.

VINCENT. Hey mom—

AMANDA. Shut up!

AMANDA *notices* BILLY.

BILLY. Hey, ma.

AMANDA. What, no hug for your mother?

BILLY *hugs her.*

AMANDA. Who's she?

BILLY. She's my girl, ma.

AMANDA. She's tall. And beautiful. Is this why I haven't heard from you since Christmas? You little shit! Christmas! You haven't called me one fucking time since Christmas! You know asshole won't let me talk to you when I try and call the house! You don't call or come see me, nothing! But I don't care about that now. You've come to take me home, haven't you? You've got to. He's crazy. He tied me to a chair, Billy!

BILLY. You tied her to a chair!

VINCENT. I had to!

BILLY. What the hell kind of show are you running here?

AMANDA. I'm dying in here, Billy. You've got to take me home—I'm so sick baby . . . Help me.

BILLY *and* JANE *ease* AMANDA *to the floor and wrap her tattered blanket around her.*

JANE. Shhh. It's alright. We'll help you.

AMANDA. You will?

JANE. Of course we will.

BILLY. Yeah . . . sure . . . But . . . ah, first things first. We need to help out old Brad, here.

JANE *sits on the floor cradling* AMANDA *and stroking her hair.*

JANE. What happened to Brad?

AMANDA. Don't worry about him. He's fine.

BILLY. He's not fine, his head's bleeding and—

AMANDA. —It's a small cut. Head wounds bleed a lot.

VINCENT. All I wanna know is what happened to him!

AMANDA. Kids these days . . . they just can't keep up with my generation.

BILLY. What?

AMANDA. Let him sleep it off.

VINCENT. Mom, what did you do to him?

AMANDA. Boy, a lot of fun these guys are.

BILLY. Just answer the question.

AMANDA. Why don't you guys put a little music on?

BILLY. We're asking you a question. Why don't you answer it?

JANE. Easy. What do you want to listen to?

BILLY. Jane, don't encourage her.

AMANDA. There ain't much here, kid. Vinny, how come you sold all of your cd's?

VINCENT. Mom, I already told—

AMANDA. —He used to have everything. What kind of music do you like Jane? Not that same shit that Billy likes I hope—

BILLY. Don't start with that now—

AMANDA. I don't know what the hell happened. I raised these boys on Zeppelin and Cream and—

BILLY. Jesus Christ! Will you shut up with that? That's all you ever talk about. Nobody gives a rat's ass about your stupid music!

AMANDA. Anger, that's all it's about now—

BILLY. I like my music! I hate that shit you listen to! Look at you—look at your—

VINCENT. Billy, don't—

BILLY. No! It's always the same shit. I like my angry music because I'm fucking angry—okay? I am an angry young man—not some sad strung out fifty year old woman clinging to the heroes of her youth.

JANE. Billy—

BILLY. Hey! Let's listen to some Stones guys! Then we can shoot our brains full of dope and flop around on the floor until we pass out and piss all over ourselves! Yeah! And then we'll have our kids put us to bed, because we can't even fucking crawl up the stairs!

VINCENT. Get a hold of yourself, man.

BILLY. Get a hold of myself? Look who's talking! You've really cooked up a great situation over here, Vince. When she's not tied to a chair, Mom's twitching and puking all over the place, Brad's unconscious with a t-shirt wrapped around his bleeding—

AMANDA. You see why you've gotta get me out of here? He's crazy! What kind of son ties his own mother to—ahhhhhhh!

AMANDA shudders violently and curls up into a ball on the floor. BILLY runs to her.

BILLY. What's happening to her?

JANE. She's really sick, Billy. She's burning up. We've got to get her some help.

BILLY. Sure. We'll just pile everyone into the car and take 'em to the hospital. And we'll make a special stop to drop Vince off at the nuthouse!

AMANDA. I . . . am . . . not going . . . to the . . . hospital.

JANE. I know, I know. I'll get you a cool cloth. Is there—

VINCENT. Bathroom.

BILLY. Be careful what you touch in there, baby.

AMANDA clutches BILLY'S shirt.

AMANDA. Don't be angry with me. You're my baby. Don't be mad; I'm just a little sick. I didn't mean to hurt you—I'd never hurt you.

BILLY frees himself and approaches Vince.

BILLY. Give me a cigarette.

By now JANE has returned and is cooling AMANDA'S forehead with a cloth.

VINCENT. Maybe you're right.

BILLY. Huh?

VINCENT. Maybe I am going crazy. It's all coming down. I had to tie her up, man. Just to control her and keep her until I could block the door. I hadn't really slept and . . . we smoked up . . . and, Bill . . . there's something . . . something's not right.

BILLY. You think?

VINCENT. I keep . . . last night, when Brad was at the door and in the middle of the night and just before you got here, Brad woke up and . . .

BILLY. What?

VINCENT. It's like . . . it's like I'm hearing something or someone. Something that's not really . . . here.

Beat.

BILLY. You, uh, see anything?

VINCENT. Huh?

BILLY. You see anything, anyone? You know, that's ah, not supposed to be here?

VINCENT. No. I'm not seeing things. I just keep hearing . . . never mind.

Awkward silence.

AMANDA. That feels good. It's nice to have a woman's touch. These boys aren't exactly running a Club Med over here.

JANE. I'm sorry Billy spoke to you the way he did. He's just—

AMANDA. Don't worry, I'm used to his temper. It runs in the family. Where do you think he got it from?

JANE. Just between me and you, I inherited a little of my parent's taste in music.

AMANDA. Oh yeah? Like what?

JANE. I like the Dead.

AMANDA. Come on sister, you can do better than that. What about the Stones?

JANE. Some.

AMANDA. Some?

JANE. Yeah, they had a stretch in there that was pure magic. Real heavy, bluesy, dirty rock and roll. Let it Bleed, Sticky Fingers—

AMANDA. Beggars Banquet.

JANE. Yeah.

AMANDA. You know your stuff. Maybe you can actually teach my son something. You did well this time Billy, I like this one.

BILLY. Uh huh.

AMANDA. It's against his religion to bring a girl home that his mother actually likes.

JANE. So, tell me something Amanda.

AMANDA. Anything.

JANE. What'd you slip Brad?

AMANDA. Smooth.

JANE. A woman's touch.

AMANDA. Tylox. Pain killers.

VINCENT. Where are they?

AMANDA *pulls out her purse, delves into it and throws the prescription bottle at* VINCENT.

AMANDA. Here! Take 'em. Take 'em all! It's not like I can swallow anything!

BILLY. You could blow it up your nose.

JANE. Bill!

AMANDA. Take it. You took everything else . . . damn kids. I gave up everything for them. But did they stick up for me when asshole—

BILLY. Stop it!

AMANDA. All those years . . . everything I did for these two—

JANE. Shhh. I know

AMANDA. Oh, you do? I guess Billy told you all about it. All about what a horrible mother I was.

VINCENT. Ma!

BILLY. Enough!

AMANDA. How I was so rotten that they stuck by their lazy, selfish step-father while he threw me out in the—owww! God Damnit! Ooooh.!

BILLY. Ma?

JANE *tends to* AMANDA *like a sick child.*

JANE. Shhh. It's alright.

AMANDA. I'm okay.

VINCENT. Seriously mom, how many of these did you give him?

AMANDA. Enough to make him sleep. Now leave me alone, I'm talking to Jane.

BILLY *pulls Vincent away.*

BILLY. I can't take much more of this—

VINCENT. You just got here.

BILLY. You don't understand—

VINCENT. I understand fine.

BILLY. No you don't. Tell me what you need me to do so I can do it and get the hell out of here.

VINCENT. Help me with Brad. We've got to get him to a doctor.

BILLY. I'm sure he'd appreciate it. What do you wanna do with him?

VINCENT. I don't—he hasn't moved. . . .

BILLY. I'll tell you what. You aren't in any shape to drive or, hell, to do much of anything. Help me get him downstairs and into my car and Jane and I will take him to the emergency room. We'll make sure he's alright. You can stay here and look after mom.

VINCENT. Okay.

BILLY. I'm sorry, Vince. It's hard . . . I . . . can't look at her, man. I can't look at her like his. You've always been tougher than me. It's like looking at a ghost. The end of the line.

VINCENT. Don't say that.

BILLY. Hear me, Please. I wanted so bad to come down here and help you but, as soon as I saw her I knew I couldn't do it. You weren't living at home at the end. You weren't there that night. That guy. I'll never forget. Now I know why dad stopped coming home. I wish I didn't come that night. I'm sorry, man . . . I can't put it down.

VINCENT *hugs his brother.*

VINCENT. Let's do this. We're not doing Brad any favors here.

BILLY. Thanks Vince.

VINCENT. Anytime.

BILLY. Jane, you and I are going to bring Brad to the hospital. Can you stay with my mom while me and Vince bring him down to the car?

JANE. Sure. I like Amanda.

AMANDA. Don't leave me here with Vincent. Take me with you. Jane, make Billy take me home.

BILLY. Mom, we've got to get Brad to—

AMANDA. Let Vinny take him!

BILLY. Vinny's gonna stay here with you.

AMANDA. No! Please, Billy, if you love me at all you won't leave me here with Vinny.

BILLY. Mom, we do not have time for—

JANE. What if I stay with you, Amanda? Would you like that?

BILLY. Jane—

AMANDA. Yes! I would like that very much.

BILLY. Jane—

JANE. It's fine, Bill. I think it's a good idea.

VINCENT. It's not a good idea, she might do something to you like she did to Brad.

JANE. Oh, I don't think Amanda would do that to me.

AMANDA. I wouldn't. I like Jane.

BILLY. You sure you wanna do this?

JANE. Yes.

BILLY. We'll be gone like, thirty minutes, tops.

JANE. That's fine. Just bring my guitar up before you go.

AMANDA. Guitar?

VINCENT. I don't know—

BILLY. Dude, she's a mess. I don't think she's gonna try anything. Besides, you gotta step back from this for a minute; you're losin' it.

VINCENT. No. I'm not leaving her with a complete stranger.

BILLY. You *need* a break.

VINCENT *looks to his mother, who is curled up and trembling in* JANE'S *arms.*

BILLY. Look at her.

VINCENT. Mom, are you sure you're okay with this?

AMANDA. Just leave.

VINCENT. Alright. How do you want to do this?

BILLY. I'm not gonna leave my car double parked while we lug his fat ass down three flights.

VINCENT. Alright, we'll get him down to the lobby and find a place to prop him while you get the car. The neighbors are gonna love this. You ready?

BILLY. I guess so.

The two men lift BRAD'S *dead weight off of the couch and support him around their shoulders. They slowly drag him to the door.*

JANE. Billy! Don't forget my guitar.

BILLY. Sure thing, dahlin'. If you hear a crashing sound, call 911 and pray I'm not at the bottom of the heap.

They disappear into the hall. Jane rises and watches them down the hall. She closes the door and takes a long look at AMANDA. *She crosses back and sits beside* AMANDA *on the floor.*

AMANDA. I'm surprised Vincent agreed to let you baby-sit me.

JANE. My friends say I have a persuasive effect on people¨.

AMANDA. So I've noticed. Vinny's as bull-headed as his mother.

JANE. So I've noticed.

AMANDA. Perceptive, too. Billy found the total package¨.

AMANDA *curls up in pain.* JANE *comforts her; placing* AMANDA *head on her lap and stroking her hair. There is a warmth in* JANE'S *comforting manner that the men cannot replicate.*

JANE. Do you want the garbage can?

AMANDA. No. No. Oh God, I'm really sick.

JANE. I know. What do you need? What can I do to make it feel better?

AMANDA *is in too much pain to respond.*

JANE. What makes it feel better? (*Long pause*). How long have you been doing it? When did it start feeling bad?

The pain begins to subside.

AMANDA. . . . Always . . . never . . .

JANE. You can't go back, can you?

AMANDA. . . . I don't think so, baby . . . Not any more.

JANE *begins to softly hum a tune.* AMANDA *slowly drifts off to sleep.* JANE *stares down at* AMANDA'S *sleeping form. The door opens and* BILLY *appears, holding an acoustic guitar.*

BILLY. Special delivery for—

JANE. Shhh. She's asleep.

BILLY. Wow, you're good.

JANE. I know.

They kiss. BILLY puts his hand on JANE'S thigh and begins to move his hand up Jane's skirt. She stops him, firmly.

JANE. You'd better get back down there.

BILLY. C'mon, just a quick—

JANE. No.

BILLY. Why?

JANE. Your family needs you and you act you like a jerk, Billy.

BILLY. I'm sorry. She . . . I can't explain it, baby . . . she makes me feel like a child.

JANE. Well stop acting like one and get downstairs.

BILLY. I know. I know. I'll be right back, I promise. Thirty, forty minutes, tops.

JANE. Go on.

BILLY. Lock the door behind me.

JANE. I will.

JANE turns her attention back to AMANDA. BILLY crosses to the door. He opens it and TIGER is standing there. BILLY bumps into him and notices him.

TIGER. Don't mind me. I'm just waiting on a friend.

BILLY closes the door. The Rolling Stones' "Love in Vain" begins to play. Blackout.

Scene 2

In the darkness, the canned "Love in Vain" becomes the sound of JANE playing the same song on her guitar. She is rough, but the tune is recognizable. Lights up. Time has passed. AMANDA sits eagerly listening to JANE play. JANE begins to sing. After a while, AMANDA joins in. The two find a natural stopping point and share a laugh.

AMANDA. I never was much of a singer.

JANE. You were great. It's hard for me to find people who know that one.

AMANDA. So, tell me something Jane.

JANE. Anything.

AMANDA. How'd you get into all this music? I always like to know where a woman gets her tastes.

JANE. Well, sure I grew up with the stuff but you get to that age when you don't want to have anything to do with your parents or the things they like.

AMANDA. Don't I know it; from both sides.

JANE. Then you get to that age where you really discover music—

AMANDA. Oh, yeah.

JANE. —and it just consumes you. All you want to do is listen to music in your room, doing chores, in the shower, just all the time you want music because all of a sudden it's talking, speaking to you. And you just can't get enough of it and you're a teenager . . . so you're broke—

AMANDA. Of course.

JANE. —and you can't just go and buy stuff all the time so . . . my dad had all these records. Crates and crates of old records and I started combing through them, pulling out stuff that looked like it might be good. I started out just pulling albums that had covers that looked cool or old song titles I recognized. God, and it was like all these bands from back before I was born . . . it was like they knew me. They knew who I was and how I felt and sometimes, on the really good ones, it was like I was hearing the voices in my head when I put those old albums on.

AMANDA. Yeah.

JANE. And I guess I just fell in love with them because . . . well, because they knew me.

AMANDA. Yeah. And then, one day, you hear those songs and you wonder if they knew you or if, over time, you became what you thought they wanted you to be.

JANE. That's intense.

AMANDA. It's all intense though, isn't it? I mean, c'mon when you're fifteen, sixteen years old I don't know if there's ever a moment when you're not intense.

JANE. I know, it's like your hormones are going nuts and everything's life or death. If some guy doesn't call you it's like the end of the world.

AMANDA. I know, right? And throw in the music and the drugs—

JANE. —It's like throwing gasoline on a fire.

AMANDA. Exactly!

JANE. How . . . how did you get started?

AMANDA. I was wondering when you'd get around to that. (JANE *laughs*). Oh, it was a long time ago. My girlfriend, I think. Girl, we couldn't get much higher, ya know? We wanted to get higher, push the envelope. See where these guys were coming from.

JANE. What's was it like the first time you tried it?

AMANDA. It's funny. It was kinda like sex the first time. It hurt. I was sick to my stomach all night. I think that happens to everyone the first time they do it. But, just like sex, there was something underneath the pain that said, try it again and it'll be a lot better.

JANE. Was it?

AMANDA. Oh, yeah.

JANE. Does it make you horny?

AMANDA. Don't they all?

JANE. Is sex better when you're on it?

AMANDA. I think so. Sometimes. Especially if the guy isn't too good.

JANE. When you first started, did you know what you were dealing with? I mean, it's really potent, right? It's like that Velvet Underground song, right—closing in on death.

AMANDA. I guess we knew. I mean nothing feels that good without a price.

JANE. Yeah. Why does the fun stuff always cost so damn much?

AMANDA. I don't know, but you only live once, right? Why on earth would you deprive yourself of the experience? The truth is, I don't think any of us ever expected to make it this far. Live fast, die young, you know?

JANE. When did it change? When did it get bad?

AMANDA. When it stopped being a choice and became a need.

JANE. Do you . . . do you regret it . . . ever?

AMANDA. I think it's kind of like being in love. Really in love, like the first time. Sometimes it hurts really, really bad and sometimes it just tears you to pieces but, you always come back because—when it's good—there's nothing in the world that feels better.

JANE. It makes you feel whole.

AMANDA. Complete.

JANE. Divine.

AMANDA. Oh, Jane, I don't want be here anymore. It hurts. I just want to go home.

They look into each other's eyes.

JANE. God . . .

JANE AND AMANDA. it's like I'm looking . . .

JANE. . . . forward.

AMANDA. . . . back.

JANE. Is this the end of the line?

AMANDA. Sometimes. Nothin' like a broken heart, is there kid?

JANE *gently kisses* AMANDA *on the lips.*

JANE. You don't need to go home tonight.

The Rolling Stones' "Monkey Man" begins to play as TIGER *appears in the bedroom door.* JANE *opens her little black purse and begins removing objects and setting them out on the floor in front of her. One by one, she removes an eyedropper, a spoon, a lighter, and a small plastic bag.* JANE *then hikes up her dress, revealing a bright red garter on her right thigh. The garter holds a small, metallic box. She carefully takes out the box, opens it, and removes a small, ornate hypodermic syringe.* TIGER *comes forward, takes a glass of water from the coffee table and hands it to* JANE.

TIGER. Don't forget this sweetie.

JANE. Thank you, Tiger.

AMANDA. I knew it. I could smell him on you, see him in your eyes.

JANE *glances back at the door and then begins to prepare a shot.*

TIGER. It's your lucky day, Amanda. You didn't even have to come to me. Sweet Jane here has brought me to you.

AMANDA. And will you kiss me?

TIGER. Yes, I'll kiss you. Soon enough. Don't be rude. You really ought to thank your . . . heroine.

AMANDA. Jane, honey, you're a life saver.

JANE. Am I?

AMANDA. I can't thank you enough. I'll do anything for you, if you need anything, ever, you just—

JANE (*putting her finger to* AMANDA's *lips*). Shhh. Give me your arm.

AMANDA. My arms aren't too good anymore. Still got a few good veins in here, though.

JANE *takes a strip of scarlet fabric out of her purse and ties off* AMANDA's *thigh.*

TIGER. You gotta move.

AMANDA. Kiss me Tiger. Kiss me.

JANE. He's comin'.

TIGER. Hurry it up, Pale Blue Eyes, the sister needs a fix.

JANE *had found a suitable vein. She takes the needle and prepares to inject* AMANDA, *but hesitates.*

AMANDA. Go ahead—

TIGER. Put the spike—

AMANDA. —I'm ready for it.

TIGER. —into her vein.

AMANDA. Give it to me.

JANE. Shhh. Close your eyes Amanda.

TIGER *leers over the two women, focused on the inches between the needle and the flesh, licking his lips.* JANE *takes a deep breath and prepares to inject* AMANDA. *As the needle is about to reach the skin, the door opens and* VINCENT *and* BILLY *enter.*

TIGER. Do it!

VINCENT. Okay ladies, here's the—what the hell?! No!!!!!

VINCENT *lunges at Jane and throws her away from* AMANDA. *The still-full syringe falls to the floor.* AMANDA *dives for the syringe. As her hand is about to grab it, Vincent's boot comes smashing down on it, shattering the syringe.* TIGER *curls behind* AMANDA *on the floor.*

AMANDA. No! No. No. No. No.

VINCENT. You sick bitch! You sick, fucking bitch!

BILLY. Vince!

VINCENT. NO! Get out! Get the hell out of my house! Get out now!!!

JANE. Vince—I didn't know what else to do, I—

VINCENT (*lunging at* JANE). Get out or I'll kill you!

BILLY *intercepts him and a shoving match ensues.*

BILLY. Get away from her!

VINCENT. You knew! You brought that fucking whore with her poison into my house!

BILLY *shoves* VINCENT *to the floor.*

BILLY. You brought this on yourself, Vince!

JANE. Billy, let's just get out of here!

VINCENT. You on it? Huh? Are you fucking on it? Answer me? Are you fucking on it?

BILLY *is silent.* AMANDA *looks up at him.*

AMANDA. Billy?

BILLY *looks at* AMANDA *and then at* VINCENT.

BILLY. Fuck you.

BILLY *turns and exits with* JANE. VINCENT *is silent for a moment. He rushes into the hall, calling after his brother, but* BILLY *is gone.*

VINCENT. Bill! Billy! I—

AMANDA. No. No. No. No. Please God, no.

VINCENT *enters and slams the door.*

VINCENT. Does it hurt?

AMANDA. I'm sorry—I'm so sorry. Why? Why? Why?

VINCENT. Does it hurt?

AMANDA. Yes.

VINCENT. What hurts worse, staring down at the broken needle . . . or knowing that someday your own son will be crawling around on the floor begging for a fix?

AMANDA. Don't say that!

VINCENT. Why not? You don't think that little piece of street trash pumps him full of that same shit you poisoned all of us with?

AMANDA. I never wished this for any of you. I warned him, Vinny . . . you've heard me warn you boys a thousand times.

VINCENT. Everybody always said he was just like you.

AMANDA. He's my baby. You can't let it happen, Vinny. Please. Oh God.

VINCENT. I can't let it happen? It's already happening! Have you hit the fucking bottom yet?

VINCENT kneels in front of the smashed syringe and touches his fingers to the liquid heroin on the floor. He rubs it between his fingers and tastes it with his tongue.

VINCENT. What is it about this stuff? It's so . . . fleeting. It's nothing. Why can't you put it down?

TIGER rises up from behind AMANDA and smiles down at VINCENT. VINCENT sees him.

TIGER. Pleased to meet you, hope you guessed my name.

VINCENT. I . . . I . . .

TIGER. I go by many names. Junk, Scat, Chiva, Scag—

VINCENT. I know you.

TIGER. Dragon, Harry, Horse, Smack—

VINCENT. I know what you are.

TIGER. Some folks even call me The Big H.

VINCENT. Your name is shit in this house.

TIGER. But, what does mamma like?

AMANDA is wracked with her worst withdrawal pains yet.

VINCENT. Leave her alone.

TIGER. You're so selfish, Vinny. You want her all for yourself. Why can't we share? There's plenty of Mommy to go around.

VINCENT. She doesn't want you anymore. She told me she doesn't want you anymore.

TIGER. Poor Vinny, haven't you learned? Never trust a junkie.

VINCENT. Shut up!

VINCENT. She's through with you.

TIGER. Is she? Are you through with me, Amanda?

AMANDA shudders violently.

TIGER. Why don't we let Mandy decide? She's a big girl.

VINCENT. Get away from her.

TIGER. I heard you're feeling down.

VINCENT. Don't listen to him, mom.

TIGER. You know I can ease your pain.

VINCENT. Don't listen to him, mom. He's a fucking liar!

TIGER. Mandy, Mandy, Mandy. I can't let you go . . .

VINCENT. He's poison, ma.

TIGER. They're playing our song, Mandy.

VINCENT. Think of Billy.

TIGER. We'll dance real close . . .

VINCENT. You gotta do this for Billy, ma!

AMANDA. Billy.

TIGER. And then I'll kiss you, just like that first time . . .

AMANDA. Ohhh

TIGER. I love you, Amanda.

VINCENT. Don't listen, ma! He's full of shit! That's not love. Love is—

TIGER. —Love is what, boy?

VINCENT. L . . . love—

TIGER. —Love is what? Illuminate us, Vincent.

VINCENT. Love . . . is . . .

TIGER. Love is what, Vincent? Tell us all about what twenty-three years of life have taught you about love. What is love?

VINCENT. Love is family! Flesh and blood and—

TIGER. *Wrong!* Love runs so much deeper than mortal flesh . . . love is need. Burning desire. I know you ache for me when I'm gone, Amanda. I know your desire for me runs so deep that it rattles your bones and breaks your heart when I'm not giving you my every ounce of attention. And I burn for you every second that I can't taste your flesh and course through your blood. I am nothing without you Amanda. I am an unseen vision. An undreamt dream. And you are no more than a hollow, empty shell. A sleeping beauty waiting for her dream. But when we come together . . . when you let me enter you . . . when I rush through your veins, I ignite every ounce of your being. I open your mind to the endless possibilities of the universe. We are creation itself. There is no pain, no failure, no loss. There is only the beauty of the world, the wondrous possibilities that dangle from each and every note of music in each and every beautiful, divine song. Locked in a timeless embrace, we dance on

that find line between life and death, flirting with immortality. Through you, with you, in you. I am all of God's light warming you from within . . . and you are the lady fair, my angel. Together we are magic. Together we are love.

VINCENT. No . . . it's not true.

TIGER. Open your arms to me, Amanda.

VINCENT. No. Don't listen to him . . .

TIGER. I'm ready to kiss you, Mandy.

VINCENT. Don't do it—

TIGER. Love is here, baby . . .

VINCENT. It's just hitting hard now, mom. In a couple of minutes, you'll be okay. Just fight it. Hold on. Fight it with everything you've got.

TIGER. Just one shot—

VINCENT. Hang on—

TIGER. Just one kiss—

VINCENT. Fight it—

TIGER. Just one fix—

VINCENT. Hold on—

TIGER. I know this hurts—

VINCENT. Listen to my voice—

TIGER. Let me in and it'll all be over—

VINCENT. Fight it, mom—

TIGER. They'll be no more—

VINCENT *lunges wildly at* TIGER, *drawing on all of his reserves, but all of his energy and passion cannot faze* TIGER.

VINCENT. Shut up! Shut up! Shut up! You have no place in my house! You're nothing. You're worse than nothing. You're a sick, little worm that's crawled inside of my mother. You're a spineless, poison, little piece of shit! I smashed you. I smashed you into the floor with my boots. Smashed you into a thousand little pieces, watched you soak into my floor and turn into nothing. Nothing. (*Crumbling*). There's nothing glamorous or smooth about you. You ain't no rock star. All you are is anorexic little bodies and collapsed veins and track marks and constipation and puke and HIV and Hepatitis and dirty little whores and skeevy old street urchins

and every filthy, rotten stinking gutter-punk excuse for flesh that shrivels up and blows away like so many faded dreams. You think we can't see you if we don't play your game. Well I saw you. I saw you a long time ago when I was just a kid. I saw you, and I smelled you, and I hated you. I've always hated you. And I still hate you with every ounce of my body. Get out! Get out of my house and get out of my family!

VINCENT *ends up face down on the floor, spent and mumbling.*

VINCENT. I smashed you . . . You're gone . . . All dried up.

VINCENT *begins to cry. His final push has left him with no reserves and all of his heartbreak, failure and frustration begin to spill out.* AMANDA *sits in silence. She is eerily calm.* TIGER *stares down at* VINCENT.

TIGER. All . . . your love's . . . in vain. (*He kneels down and begins to gently stroke* VINCENT's *hair*). Ah, Vinny, if you only knew. Love. Family. Look at yourself; you're so tired. Tired from swimming so hard against the current. You don't have to do this to yourself, Vincent. All you have to do is stop swimming and just . . . let the current take you. Go with the flow. Billy and your ma . . . they're family but they're flowing right past you; downstream. You can't beat 'em, Vinny. Join them.

VINCENT. I'm sorry.

TIGER. Come here. Come here. (*He embraces* VINCENT). I'm not gonna hurt you. What do you say, man, you wanna take a little walk on the wild side? It helps. You can put all this behind you and you won't be tired anymore. We can all be one big happy family.

VINCENT. Momma.

TIGER. I know. She's ill. We're gonna help her . . . together. (TIGER *takes* VINCENT's *hand*). Come on, Vinny . . . see what you're missing.

AMANDA *has risen. She crosses to them and taps* TIGER *on the shoulder.*

AMANDA. It's time for you to go.

TIGER. Amanda, darling, we're just getting started.

AMANDA. I said, it's time for you to go.

TIGER. I don't think Vinny wants me to go, do you Vinny?

AMANDA *physically brings* TIGER *to his feet. He is caught completely by surprise.*

AMANDA. Don't you fucking touch him.

TIGER. Don't be stupid, Amanda. He needs me just like you needed—

AMANDA *shoves* TIGER *away from* VINCENT. TIGER *scrambles to keep his footing.*

AMANDA. He doesn't need you. He's never needed you. Get the hell out of this house and don't you ever come back.

TIGER. But you need me—

AMANDA. I need you to leave! I am not fighting you anymore! Stay away from here! Stay away from my Vinny!

TIGER. Alright! I suppose one son's enough.

AMANDA *slaps him across the face.* TIGER *smiles.*

TIGER. I had that one coming. Haven't seen you this strong in a while. Didn't know you still had it in you. (AMANDA *opens the door*). You sure you wanna do this? (AMANDA *just glares at him. He steps out into the hall and turns back to her*). We had some good times, didn't we Mandy?

AMANDA. Yeah, we did.

TIGER. They'll come 'round again.

AMANDA. Maybe.

Long silence. They stare at one another. TIGER *leans in close.*

TIGER. How about a kiss goodbye?

AMANDA *holds a finger up to his lips and shakes her head. Their eyes meet again.*

TIGER. You know where to find me. Just about a moonlight mile on down the road.

AMANDA *closes the door.*

TIGER (*fading off*). I'll be in my basement room . . .

Silence. Mother and son eye one another.

VINCENT. Mom . . . Mom.

AMANDA. Yes?

VINCENT. You were so . . . strong.

AMANDA. I had to be.

VINCENT. You . . . were . . .

AMANDA. Don't look so surprised, baby. I am still a woman. I'm not a little girl. I make my own choices. And that's why I need to go now, Vinny.

VINCENT. Hold on, lemme just get—

AMANDA. —Alone, Vinny. I need to go. I need to walk out that door and back into my life while I've still got the strength to do it. Don't drag me kicking and screaming to some nuthouse; that's not how I want to go.

VINCENT. What're you saying?

AMANDA. I'm saying goodbye, Vincent. I'm leaving. This is the end of the line.

VINCENT. No, Mom—

AMANDA. —Look at me, Vinny. I can't go back, baby. I'm a nurse. I know full well when there's no going back.

VINCENT. You're not dying, Mom.

AMANDA. Not today, not tomorrow, but soon, honey. Hell, I've outlived a lot of my friends. Things catch up with you . . . after a while.

VINCENT. Nobody said anything about . . . I mean, you haven't even seen a doctor you just need to get clean and then—let's just go down to the clinic and—

AMANDA. Vincent Perry you listen to me! If you ever loved me you'll let me do this. Let me have my fucking dignity. I don't wanna be in a clinic or a ward or, if I'm septic, hooked up to some machine. God, no. I've seen all of that. Let me go the way I wanna go, baby.

VINCENT. I . . . (*Long pause*). Why?

AMANDA. Because I'm still pretty out there. When I'm dancing with him, I'm alive. I'm not a mother who can't take care of her kids. I'm not a failed nurse or a failed wife or a failed daughter. When he kisses me, I am none of those things. I'm a woman. Even in the arms of death, I'm alive.

VINCENT. Mama, I can't.

AMANDA. You don't need me, Vinny. I'm sorry. I'm so sorry I brought this on you and, if I could go back and change it, I would. But you're all grown up. A handsome young man with . . . such a good heart. You're young and strong. And so is Billy. Remember that, Vinny. Billy's young and strong and he can take care of himself. He just took a little misstep, that's all. You watch out for your brother, but you remember he's his own man. He's got his

own life to live. And . . . he's going to be alright. (*She kisses VINNY on the cheek*). I've got to go now, baby.

AMANDA picks up her purse and walks to the door. VINCENT stands in front of the door trying to speak.

VINCENT. M . . . Mom . . . don't . . . ple—

AMANDA. Shhh. Just say goodbye.

VINCENT is silent. He takes a defeated step away from the door. AMANDA opens the door and takes a step into the hallway.

VINCENT. I love you, mom.

AMANDA (*turning to face him, framed in the doorway*). I know. I love you, too. With all my heart.

AMANDA turns and exits down the hall. VINCENT stands in silence, staring off into nothingness. After several moments, he gently closes the door, without looking down the hall. He crosses slowly to the couch. He picks up the old blanket and smells it, inhaling his mother's scent. He sits on the couch, defeated, cradling the blanket in his arms. The lights fade to black.

END OF PLAY.

Parking Lot Babies

Snapshot of a Lost Generation

Zachary Boudreaux's *Parking Lot Babies* is about as new as new work gets. The original cast and crew of the play closed their run in March, 2010. Because Zachary continues to develop the piece, we are printing only an excerpt from it. You will have the opportunity to read the first few scenes of the play to get a taste of it. The full script with Zachary's final revisions should be available in published form in 2011.

Boudreaux finished writing the first draft of the play in October 2008. It was the first play he had ever written. Several workshop readings were done at Southeastern Louisiana University, and the students participating in and attending those readings immediately knew they were part of something special. Before long, the play was in full workshop mode, with dozens of students and theatre artists using improvisations and readings to help get the play to a point where it was ready for production.

By the time the play opened in November 2009, several independent rock bands had heard of it and donated their music to the production. The play took top honors at both the state and regional rounds of the Kennedy Center American College Theatre Festival, and Zachary received a national fellowship to study playwriting at the Kennedy Center in Washington, D.C.

So what was all the buzz about? In *Parking Lot Babies*, people ages fifteen to thirty (and even some outside that age range) heard the voice of their generation. The story is simple enough. It is essentially a few days in the lives of Mark Giles, a young writer, and his friends. Mark is attempting to chronicle his relationship with his girlfriend, Trisha, while the two are still involved. Mark is trying to go somewhere; Trisha knows she isn't going anywhere. Their assorted friends fall anywhere on the spectrum from not giving a damn about life to frantically trying to make the best of a miserable situation. Boudreaux uses various parking lots as the gathering places for these lost characters as they deal with day-to-day stresses and much deeper social issues. Alternately hysterically funny and truly sad, the play gives us insight into people we see every day but rarely pay much attention to. Sadly, these people are our children, siblings, students, coworkers and friends.

The language and the content are quite extreme at times, but the behaviors, attitudes, and the words these people use are about as realistic as it gets. Boudreaux is a communications major with an interest in journalism. He calls his writing style in *Parking Lot Babies* "gonzo playwriting" in honor of one of his major influences, the late Hunter S. Thompson.

Parking Lot Babies is a classic example of theatre holding a mirror up to society. It is also an excellent example of the power of the collaborative process. Boudreaux is the first to say that the final result of this play was the work of dozens of actors, designers, and other assorted theatre artists and audience members. He allowed the actors to help him flesh out the characters and various designers to help him solidify the world of the play. In his playwright's note for the original production, Zachary stated, "*Parking Lot Babies* is not mine. It's yours." It was his way of acknowledging the power and importance of theatre as a collaborative art form. But his is the voice that drives this piece, and his quirky, urban poetry is what holds the play together.

There are no Food for Thought study questions for this play because you get only a sample of it here. Our hope is that the full version will be part of our next edition. Regardless, Zachary Boudreaux has already made his voice heard among the new generation of dramatists.

Fun Facts

1. For the original production, the director added five extra actors to help add to the realism of the public locations in the play. These actors continuously changed costumes and hairstyles to portray dozens of people. Boudreaux dubbed these characters "the parking lot babies."
2. Zachary Boudreaux played the role of Mark Giles in the original production. He also played guitar and composed some of the original music used in the play.
3. The idea of Mark as both narrator and character was partially inspired by Tennessee Williams's *The Glass Menagerie*.
4. When their university was unable to pay for the play to travel to the regional round of the Kennedy Center American College Theatre Festival, the cast and crew raised several thousand dollars and toured the show themselves.

Parking Lot Babies

By Zachary L. Boudreaux

Characters

Trisha McManus: 20 years old, Mark's girlfriend
Mark Giles: 20 years old, fast-food employee
Guy R. Moore: 21 years old, Mark's best friend
Brianna Parker: 21 years old, shot-girl
Chris Savage: 23 years old, Brianna's fiancé
Basil: 29 years old, Guy's roommate
Marshall Cortley: 22 years old, Chris's best friend
Lacey: 19 years old, scene kid

Place

The suburban South

Time

Winter 2007

ACT 1: Jane Says

Scene 1

Setting: Outside a mall
At rise: GUY sits frozen in time. Other characters used as extras can be frozen around him to give the illusion of time paused. MARK stands from where he is seated next to GUY.

MARK. Parking Lot Babies by Mark Giles. For Trisha. It's odd growing up because you never know that it happened until it's over, kind of like a car wreck. You realize something is happening, but you're too freaked out to make any sense of it until you're standing outside talking to the cop and desperately trying to make up an excuse of why you didn't stop at that red light.

What can I say about Trisha? What can any man say about his youth, about the stupid wasted days and the fights with his parents and the shitty temp jobs or all the questionable hook-ups and shady parties and sketchy friends and situations he was in? What does some little asshole like that know about love? What can I say about Trisha? It seems like the older I get the more I tend to mark my life's phases with some particular event or thing or person, and that event, thing or person tends to define that part of my life. I guess you could say Trisha defined my genesis, the first steps onto the path I walk today. Who could've known that a little [color of Trisha's hair here] who I went to high school with and used to sneak in my window at night could have left such an impression. Then again, it's the impressions left from fossils in the mud that last for millions of years, long after the animal or plant's rotted away. Maybe that's why we hold old love so close—it's easier to hold fossils then something that's dead.

In the winter of 2008 all I had was days with my best friend Guy, nights with Trisha, and a brain full of dreams.

(*Mark sits next to Guy and the scene unfreezes*)

GUY. Are you bored? Do you need to borrow San Andreas again? Why are you writing a book?

MARK. I don't know. It's like a chronicle or an autobiography or something.

GUY. You gotta name for it yet?

MARK. Yeah. It's stupid though

GUY. Come on, dude.

MARK. It's . . . it's called Parking Lot Babies.

GUY. Why is it called Parking Lot Babies?

MARK. Well, where are we right now?

GUY. The mall.

MARK. No, I mean, where exactly are we?

GUY. We're in the parking lot of the mall.

MARK. There you go.

GUY. But parking lots are lame and we're not babies.

MARK. Well, parking lots are lame, but they're a big part of life, that's where the action happens, that's where the people are, the people like Trisha, who are kind of living on the fringes of society, you know? Like if the mall was adulthood or maturity or modern society or something like that, Trisha would be outside right here in the parking lot, smoking cigarettes and waiting to go inside.

GUY. That's a cool metaphor. Yeah, the book is sounding good so far, I mean, I'd read it, but why do you want to write a book about Trisha?

MARK. Well, she is my girlfriend.

GUY. Oh, so you're just trying to get laid.

MARK. No, not like that. I just know that she's that girl, that one that men never forget and I want to record this relationship. I think we have a pretty good story.

GUY. Well, I'm sure you do but why not wait until it's over to write it? Isn't that what writers do?

MARK. Yeah, that's the way it's supposed to be done but I feel like memory is so superficial, you know? So sentimental and unrealistic and lame. I'd rather write the story of us as a couple as we go rather than afterwards so whoever's reading it can get a sense of reality and truth in every chapter. I'm just writing it as I go.

GUY. So what's the plot?

MARK. There isn't really a plot, it's just life, and life doesn't have a plot, it's just a series of stories put together to show one larger picture.

GUY. You don't know what the hell you're talking about do you?

MARK. I do, I really do, man.

(Basil enters)

BASIL. What's up, bitches?

GUY. Chillin. I'm about to go inside and DDR in the arcade.

BASIL. Guy. Mark. Seriously. Why do you always hang out at the mall? You're both like 19, dude. Go out or something.

MARK. What, like, to a club?

BASIL. Yeah. You're not going to find any prospective penuche in the damn mall.

MARK. Well, I have Trisha and she's insane and stuff so I'm not really looking for prospects or anything.

GUY. I am, dude, and to tell you the truth, Basil, the freaky anime chicks I go for don't go to clubs or bars. I do enjoy the occasional one-night-stand with a sorority chick, but I'm into the white bitches with glasses. They're the true freaks and you find them in the arcade or somewhere writing bad poetry and reading Les Miserables or something, just waiting for a studly slice of chocolate pie to save them from their virginity.

MARK. Yeah, Basil, that's how I met Trisha. She fell in love with my *internal* blackness.

BASIL. Whatever. I like my women drunk, skanky and dancing to Lil John.

GUY. "From the window—"

BASIL. "To da wall . . ."

(*They look or motion to Mark.*)

MARK. Let sweat . . . drip . . . down . . . my balls?

GUY. That's what's up.

BASIL. Oh, check this out.

(*Basil takes CB radio off his belt and hands it to Guy.*)

GUY. Are you trying to catch that stupid Spanish emo radio station again?

BASIL. No, not this time, my friend. I work for the volunteer fire department and they never call me—

MARK. Wait, do you work there or do you volunteer?

GUY. Well, it's volunteer work so they kind of go hand-in-hand.

MARK. No, it doesn't. You either work somewhere or you volunteer somewhere but you can't do both.

GUY. He's working *as* a volunteer.

MARK. No, he's volunteering to work.

GUY. You are such a douche bag, Mark.

BASIL. Anyway. They never call me when there's a fire or whatever so I got this CB radio that's set on the emergency channel and when there's a fire I just show up and they can't say anything because they need help. It's pretty much genius.

MARK. Why don't they call you anymore, Basil?

GUY. Funny story really. One night he . . .

(*A girl walks by and they stop to watch her as she passes and then go directly back into conversation.*)

GUY. Donkey! Anyway one night he was all drunk and got butt naked under his fire suit and when this fireman chick—

BASIL. Her name is Holly and she's so hot, dude.

GUY. Okay, when Holly told pimp daddy cane here to bring the hose on up, he opened up his suit and let his hose hang out.

BASIL. Damn right I did.

(*Quick exchange of dap between Guy and Basil.*)

MARK. Impressive, Basil, very impressive. What are you doing at the mall anyway? Indecent exposure doesn't really fly with the rent-a-cops inside.

BASIL. Well, on Wednesdays they give out free chicken samples at Ball's Chicken in the food court so I'm gonna go score some mutha cluckin free chicken. Later, bitches.

(*Basil exits. Moment of silence.*)

MARK. Ooo, they got free chicken, Guy.

GUY. So?

MARK. Come on, man, you know that whole deal about black people.

GUY. And what, chicken?

MARK. Well—

GUY. So you think because I'm black I'm about to go into the food court and get chicken?

MARK. No, I was saying there's *free* chicken.

GUY. Oh so, since I'm black I jump over myself trying to get free food?

MARK. Right. Food that just happens to be chicken. Everyone knows black people love chicken, that's old news, but only some people know that black people really, really like free food. Is that so racist?

GUY. No, not really since I'm your best friend and all but don't go saying that to anyone else.

MARK. Like the guys on your basketball team? They are gangster as hell, dude.

(*Imitates them.*)

Yo, Guy what it do when we gonna roll out and holla at dem donkey trick ass hoes, son?

GUY. Don't ever say that in front of them either. Actually, Mark, don't ever do that again. You are way too honkey for all that.

MARK. Guy, you know I don't want to be a thug or anything. I just want to be a soulful old black man like Billy Dee Williams. Or like Curtis Mayfield— "Eddie you should bettah. Brother you know you wrong—"

GUY. You will never be black, Mark. Ever. You need to face it and get better heroes like old-school Sean Connery or Jim Morrison. Some white guys have soul, too. You can't just eat pickled pig lips and chitlins and listen to James Brown all the time and then expect people to think you're an old black dude. It doesn't work like that.

MARK. Oh well. I think sometimes I appreciate your culture more than you do. What time is it?

GUY. I'm going to say it's about . . . 4:17?

MARK (*Looks at cell phone.*) 4:16, my brotha.

GUY. I'm good.

MARK. I know you are. I have work at 6 and I told Trisha I'd give her a ride. It sucks working at the same place as your girlfriend, really—don't ever do it. She's has been in, like, Sinead O'Connor bitch mode lately. Just pissed off constantly. I want to get over there early so I can . . . *put her in a good mood* before we leave. I'll call you if we're doing something tonight.

GUY. Mark. Don't be a fool, wrap you tool.

MARK. Hey man, no glove—no love.

GUY. Don't get it on till you put it on.

MARK. Don't be a lover unless you gotta rubber.

GUY. If you just want a trick and not a baby mamma tonight, take just a second and wrap it up tight.

MARK. We should do a safe-sex commercial or something.

GUY. Hell yeah. "How to avoid parenthood and crotch rot by Mark and Guy." You should put that into your book.

MARK. I probably will. I'll see you later, dude.

GUY. Peace.

(*Mark exits. Blackout.*)

ACT 1
Scene 2

Setting: Back door of fast-food restaurant
At rise: Trisha and Mark in fast-food uniforms. Trisha is sitting down leaning against the wall and Mark is sitting next to her. Once the lights come up Mark gets up as Trisha remains motionless, with a cigarette in her mouth and her hand up holding a lighter, just about to light it. Mark stands up as he speaks.

MARK. Trisha's parents had gotten divorced before she was born and she was the product of whiskey, cocaine and the spacious bed of her father's 1979 El Camino. Her dad was a rolling stone and if she heard from him at all it was usually a couple days after Christmas or one time, when he needed bail money. Trisha had lived with her aunt for most of her life and had recently moved back in with her mother, a former swimsuit model and self-proclaimed sex addict who's parenting policy bordered on nihilism. As a result of this lifestyle Trisha had grown up to be tough but still somehow a perfect lady in every way. She used to cut herself and attempted suicide once before we met. She never talked about it though. She didn't wear girl's deodorant because she said it smelled like "flowers and bull-shit," she was a kick-boxer, she chain-smoked like she was always on adderall—I'd even seen her put back 22 beers before at a guy's 21st birthday just so she wouldn't be out done by him. At the same time though, she loved shopping, getting pedicures, Golden Girls marathons, snow globes, Tinker Bell, rainbow-colored toe socks and anything and I do mean anything even remotely involved with Dave Navarro. She was an anomaly to say the least.

(*Mark sits back down and a moment later Trisha unfreezes.*)

TRISHA. —And I was like, "Damn right I'm the mother fucking princess!"

MARK. I never doubted it for a minute, baby.

TRISHA. Shyeah, you know what's good for you. Stupid mom's. You know she does this shit *all the time* like she says she's gonna do something and gets all excited and makes plans and shit and she never does it. Like Mom, seriously, you're putting back two bottles of red wine a night and you're gonna get on me about a Bruce Lee gravity bong? It's fucking decorative; would you ever smoke out of a Bruce Lee gravity bong? Are you writing down everything I'm saying?

MARK. No.

TRISHA. What are you writing then?

MARK. Just working on my book, babe. I had an idea earlier, while I was in the can.

TRISHA. What's it called again? Like babies . . . in . . . some . . . where—

MARK. Parking Lot Babies.

TRISHA. Right, right. So why are you writing a book about *me*?

MARK. It's not about you, well yeah it is but it's not just you, it's me, too. I'm like, writing it while it's happening, to get like, um, you know like a more realistic perspective on our daily lives.

TRISHA. What do we do that's worthy for literature? Like let's see today I woke up . . . you came over . . . we ate pizza . . . we fucked . . . we ate some more pizza . . . and then . . . we came to work. Your book is gonna be about nothing.

MARK. So what? Lots of literature is about nothing like, uh, The Glass Menagerie or, um, Seinfeld.

TRISHA. Okay whoa, first of all Seinfeld is a TV show and it's funny. You don't have a zany gaggle of characters who get into wacky mishaps and sticky situations. Second, your life is nothing like The Glass Menagerie, it's more like um, Waiting for Godot. You know, it's just some people chilling and talking and the main character never comes.

MARK. Damn.

TRISHA. Ahhhhh hahahahaha no I'm kiddin, baby. No, seriously I come usually always.

MARK. Did you come today?

TRISHA. Yeah.

MARK. Was it good?

TRISHA. Hell no. I'm joooking, baby, I love yoooou. It was okay but you did that thing again.

MARK. What thing?

TRISHA. That thing I specifically told you never to do.

MARK. The thing with your foot and your ear at the same time?

TRISHA. Yes that thing. It's not sexy at all; it tickles and it feels gross.

MARK. But you seem to like it when I do it.

TRISHA. The only reason I squirm and stuff is because it tickles and I hate it and the reason I violently overtake you after is so that you'll stop. It makes me feel like I'm getting a dry wet willy from your tongue. I don't know, it's just creepy and, it's gross and, it's bad.

MARK. Well, I'm sorry. I mean you know, maybe it'd be better for you if you weren't just laying there staring at the ceiling. Read a Cosmo or something, shit.

TRISHA. Aww is the woochie woochie a little boochie boochie? Poor baby, oh poor baby. You want the boppie?

(*Motions with her breast closest to Mark.*)

Little boppie for baby? Baby hungry for the boppie, yes he is.

MARK. All right seriously, Trisha, that's so creepy and turns me on a little and you need to stop.

TRISHA. It's cool, baby.

(*Scoots closer to him.*)

Guess what? No seriously guess. Guess damnit!

MARK. What? For the love of God, what is it, woman?

TRISHA. I got a sack.

MARK. Me, too, and it's huge. They mistook it for a large teabag during the American Revolution and threw it into Boston Harbor to protest England's usage of very large cups.

TRISHA. What the hell? This sack.

(*Pulls a marijuana baggie from her back pocket.*)

Lets shhhhmoke.

MARK. Seriously Trisha? Seriously? We're on the damn clock.

TRISHA. No, we're on a smoke break.

MARK. Cigarettes, Trisha, cigarettes. Lucas is inside.

TRISHA. Man, fuck Lucas.

MARK. You probably would.

TRISHA. Shut up, ass! We're just gonna get a little stoned. It makes work fun.

MARK. No, this is stupid, he could come out any minute.

Trisha. He's not coming out here, he's probably sleeping in the breakroom or something.

MARK. All right, but just one bowl.

TRISHA. One bowl.

MARK. Okay, whatever, load it.

TRISHA. You will not regret it sir.

MARK. You are so crazy, seriously.

TRISHA. What did I do now?

(*Puff.*)

Watch this smoke circle, dude.

MARK. You are the only girl I know whose hobbies include mosh-pits, weed, and kick boxing.

(*Puff.*)

This was a call good call. Good call. This is a real smoke circle, watch.

TRISHA. You suck at them, too. You're right about one thing, I will kick some ass in kick boxing, son!

(*Puff.*)

My feets are like kangarooooooos.

MARK (*Puff.*) If you were a kangaroo—

(*Coughs.*)

I would totally hang out in your pouch all day.

TRISHA. Yeah, that'd be awesome if I had a pouch on my tummy. I could keep so much stuff in there. I'm going to start wearing a fanny pack with my pipe in it. Cops would like never search a chick with a fanny pack. A fanny pack would say I mean business but I keep it real. I want a walkie talkie too. If I had a walkie talkie, we could talk to each other while I'm in the bathroom. I guess kangaroos don't need walkie talkies.

MARK. When I was a kid, I wanted to be an Australian explorer.

TRISHA. What?

MARK. I don't know, that was like my big dream, to ride around in a jeep and explore Australia and then I found out they had already explored Australia in the 70s or something.

TRISHA. They call their biscuits cookies there. That's fucked up, dude, like, I like biscuits or whatever but I fuckin looooove cookies. I want a cookie. Australia sucks because they don't have cookies.

MARK. Yeah, Australia is pretty lame. I like Outback though.

TRISHA. Oh my God, I could kill a bloomin' onion right now. A bloomin' onion with Cane's sauce, I would drink baby blood for a bloomin' onion with Cane's sauce right now.

MARK. This shit is good.

TRISHA. Yeah dude wanted 25 bucks a gram too. I was like fuck that noise. Got it for 20. Did you want anymore?

MARK. No, I'm straight. Are you good to go back into work?

TRISHA. You know what I was thinking?

MARK (Stands up.) That an apple pie would kick fucking ass right now?

TRISHA. No, well, yeah, that would be tight like prom night but I saw that Hokey Pokey Town is playing at the American Legion Hall tonight.

MARK. I am actually glad I'm working tonight just so there is no way I would end up there.

TRISHA. Come on, baby, they're not that bad.

MARK. They did a hardcore version of Humpty Dumpty complete with an interpretive dance.

TRISHA. Well, I really, really want to see them. Guy wants to see them, too, but he doesn't have anyone to go with.

MARK. Sucks for you guys.

TRISHA. Okay let me try that again, we're going to go see Hokey Pokey Town tonight.

MARK. No way.

TRISHA. Mark, we just clock out, it's not a big deal, Lucas won't care, he's just letting us ride the clock tonight anyway.

MARK. Well, I don't know about you but I need the money, you know? I don't wanna live with my fucking parents forever.

TRISHA. Where the hell am I going? I don't have any bills to pay or anything. I'm just workin here for weed and food money, I don't give a shit. Fuck it, enjoy it while you can, baby.

MARK. Why don't you care about shit? You need to care more, you're just going to be a loser and smoke away everything and like, it's not cool, dude, you're so fucking smart and pretty and you're just being stupid and like I don't know just you need to like—

(Trisha, who has reloaded the pipe, grabs Mark by the back of his head and shotguns a hit.)

MARK. You owe me so big for this shit for real.

TRISHA (Takes another hit.) Don't get your muffet in a tuffet little curds and whey and like,

(Takes another hit.)

a spider and something about breaking her crown, like, fell . . . off a stool or something, like, she was, like, this bitch with . . . a muffin . . . or something . . . and curds and shit.

MARK. What?

(Trisha laughs in a very strange way, snorts several times in rapid succession, almost scares herself.)

MARK. Whoa.

TRISHA. That was insane. I hope I never laugh like that again. Whoa—that was intense. Let's like, take a minute and just, like, reflect on that shit, like, I don't even know. That was just, epic. Whoa.

(Moment of silence. They genuinely think about what just happened.)

MARK. Weren't we supposed to be doing something?

TRISHA (Laughs.) Yeah, but I can't remember what it was! Oh my God! I'm so stoned already!

MARK. Oh yeah! Oh we got a lot to do Trisha. Aw, man, we have to clock out and call Guy and go change and drive to the American Legion Hall. We're running out of time! We gotta get rollin if we're going to catch Hokey Pokey Town's set.

TRISHA. All right, I'll go clock us out, you call Guy. What if Lucas is in there and he's like waiting on me? What if like, he was listening and shit. That'd be crazy.

(Trisha begins to enter and then stops.)

You know what? I don't even care, I don't even give a fuck. If he's in there and he catches me tryin to clock out and shit, I don't even fuckin care. You know what I'm gonna do? I'm gonna go in the cooler get a whip

cream thing and I'm gonna do that fuckin whip-it right in front of him and be like "Yeah, it was me doin all the whip-its, fucking fire me you corporate puppet." Fuck all that. I hope, no I fucking *hope*, Mark, that he's up and like, if he is, like, yeah, um, I don't know. Haha. Yeah, clock us out okay.

(*Trisha exits into restaurant door.*)

MARK (*Fiddles with phone and dials number.*) Guy? Hey what's up my negro amigo? No, we're leaving, dude, and going to see Hokey Pokey Town at the American Legion. Yeah, I don't know, I'm really high and Trisha is like, very convincing. Hokey Pokey Town, son. I know you love Hokey Pokey Town, that's why I'm inviting you. I'll be over to pick you up once Trisha and I go get changed. Like 20 minutes. All right dude. Peace.

(*Trisha re-enters quickly.*)

TRISHA. Lucas is passed out in the breakroom. Let's do this shit. How are my eyes?

MARK. They're kind of really red.

TRISHA (*Checks her phone and begins texting.*) Shit. I don't know if my mom left for Ft. Walton yet. She gets all weird when I come home high. She made me piss in a cup. That shit is hard when you're stoned.

MARK. It'll be fine. How are mine?

TRISHA (*Doesn't look up. They begin walking.*) Pearls bitch. I got cotton mouth like a mother fucker. Oh my god! Do you want to go and get one of those little, um, creamy slushy things that are good that I like . . .

(*Trisha trails off into improv. Mark and Trisha exit. Blackout.*)

Have a Heart

Reality Programming—With a Twist

Our final play in this anthology has much in common with *Parking Lot Babies* and yet it is completely different. Both hold mirrors up to our society and reveal some difficult truths about human nature in the first decade of the new millennium. Both are brand new. In fact, Lisa Beth Allen's *Have a Heart* won't receive a full production until a few months after this book is published. In her latest play, the award-winning Allen examines some of the challenges another generation faces. It also examines the sometimes disturbing side of reality television.

Allen is no stranger to theatre or playwriting. She is a member of the Dramatists Guild of America, Actors' Equity Association, and the Screen Actors Guild. Allen served as conservatory director for the South Coast Repertory in Costa Mesa, California, as well as special project director and director of educational programming for the Sundance Institute. Currently, she serves as literary manager for Metta Theatre, in Taos, New Mexico. As a playwright, Allen has seen her work produced at Walnut Street Theatre in Philadelphia; The Organic Theatre in Chicago; South Coast Repertory in Costa Mesa, California; and at the Sundance Resort King Stage.

Have a Heart tells the story of Daniel R. Davis, a middle-aged Wall Street tycoon who is suffering from amyotrophic lateral sclerosis (ALS), a debilitating disease that will first incapacitate and eventually kill him. Enter Laurel Fein, Daniel's long-time friend and former lover. While Daniel has crushed everyone in his path in his ascent up the corporate ladder, Laurel has given her life in support of humanitarian efforts . . . until now. Weary of fighting the good fight for no reward, Laurel comes up with a brilliant but shocking plan. She wants to do a reality television show where Daniel has the opportunity to redeem himself by donating his heart to a worthy recipient. Desperate souls in need of a heart transplant will compete until Daniel and millions of viewers across the country select one lucky person who will get a second chance at life when Daniel passes away. But this elaborate and disturbing scheme is only the backdrop for a much deeper story. As Allen puts it, "This is not a play about ALS or reality television. It is about living and dying from the elusive realm of the heart."

Allen wrote *Have a Heart* over the course of several workshops through the University of New Orleans Low Residency Creative Writing program. The play was completed in partial fulfillment of her master of fine arts degree. In January 2010, director Jim Winter travelled to Taos, New Mexico, to spend an intense week workshopping *Have a Heart* at Metta Theatre. It was the first time the playwright and director had ever met. They assembled a group of incredibly talented actors and used readings and improvisation to help Allen get the script ready for production. The week of work culminated in a public, staged reading at Metta Theatre. A few weeks later, Lisa Beth Allen's *Have a Heart* won the Jean Kennedy Smith Playwriting Award from the John F. Kennedy Center. The play will receive a full production in the fall of 2010 at Metta Theatre in Taos.

The play's strength comes from Allen's incredible ability to reveal humanity through character. Daniel is the kind of person almost all of us want very badly to hate, and with good reason. Yet we fall in love with him over the course of the play. We quickly understand how a corporate dynamo and a humanitarian could actually fall deeply in love with one another. Those labels are just that—labels. We are only partially defined by how we chose to earn a living in this world. The reality is that we are all three-dimensional beings who feel and experience a full spectrum of emotions. Even the supporting characters have

rich inner lives and have powerful, well-developed relationships with the leading actors. *Have a Heart* is a truly moving character study set in an all-too-familiar world.

What follows is only an excerpt of this play. We hope to include the full play in our next edition. There are no study questions because you'll only get a taste of this piece. We are fairly certain that you won't have to wait long until Lisa Beth Allen's plays are reaching audiences around the country.

Fun Facts

1. Daniel R. Davis is actually based on a real-life Wall Street tycoon (who shall remain nameless).
2. Two different actors helped to develop Daniel's character in the Metta Theatre workshop sessions. Both had very different interpretations of the role and yet both helped to add tremendous depth to the character. This is probably a testament to just how well-written the character is.
3. Allen claims one of the biggest advantages of doing a workshop of the play was having male actors give voice to the masculine characters. It is a challenge to write realistic dialogue for the opposite sex, and Allen altered many of the male characters' lines after allowing the male actors to improvise some of the scenes.

Have a Heart

Lisa Beth Allen

Characters

Daniel R. Davis
Jennifer Santos
Laurel Fein
Kenneth Davis

Vic*
Addison*
Lukas Simms
Vanessa Roberts

Act 1
Scene 1

(An executive office that says "Success." Possibly decorated with artifacts from around the world and large photos of Daniel R. Davis with well-known politicians, businesspeople, and a celebrity or two. There is at least one door.

Early April. Sitting at desk is Daniel R. Davis, 48-year-old male. Once impressive in size and stature, now starting to look unwell. He is in the middle stages of ALS, beginning to exhibit symptoms in hands and legs. His speech is not yet affected.

Daniel wears an expensive suit. Suit jacket hangs on back of chair. He signs papers while on phone. Intermittently twirls pen between fingers. Eats from a box of Hostess Hohos.

Jen, 27, Daniel's exotically beautiful assistant, stands to the side of desk waiting.)

Daniel. (On Bluetooth) Ray. Ray. . . . Ray . . . if you'll just shut up for a minute I'll— Ray, it's business! Come on Ray . . . there'll be other. . . Nice? It's business.

(Daniel drops pen. He goes to get it and knocks papers off desk. JEN tries to help. He waves Her off. With some difficulty DANIEL retrieves pen and a paper or two.)

Look Raymond, you lost this one. Give it up. Ya played with the big boys and you lost. . . .

(Twirls pen.)

Come on, take it like a man. . . Hey, you were the guy who begged me to— You begged, Ray. . . yeah, you begged. It's business!

(JEN clears throat. DANIEL looks, mouths "What?" She holds up syringe. DANIEL offers Her Hoho. She declines)

Daniel. I gotta go, Ray. Ray, I have a meeting I've gotta get to across town. God damn it Ray . . .

(DANIEL spills water glass over papers on desk. He pulls papers out of puddle.)

you got in over your head. It was business. I'm a business man . . . Okay . . . Okay . . . yeah . . . Okay, Ray. . . I gotta go. Yeah, I'll see ya, bye.

(DANIEL appears smaller and weaker when off phone. During dialogue DANIEL leans over desk, lowers pants exposes upper butt. JEN preps shot.)

It's business, God damn it. I don't know what the hell they want from me. Should join the Boy Scouts if he wants nice. Maybe he can get a sweet little boy to—(She gives Him first shot.) Ow! Damn.

JEN. You're getting way worked up about this one.

Daniel. He's a friend of my sister-in-law. Never do business with family or friends of family.

JEN. Family or friends of family unless you never wanna' see them again.

(Gives Him second shot.)

Daniel. Oh shit! You're worse than the night nurse, and she really works to make it hurt.

(JEN picks up remainder of papers from floor. DANIEL pulls up pants.)

JEN. What makes you think I don't?

(JEN gives DANIEL five pills and more water. Wipes wet papers.)

*Vic can be doubled by actor playing Kenneth.
*Addison can be doubled by actor playing Jannifer.

Reprinted by permission of Lisa Beth Allen. The playwright is a member of the Dramatist Guild of America, Inc.

DANIEL. Because, you work to get that nice fat bonus you start to smell this time of year. Unless causing me pain a few times a day is enough for you?

JEN. Hmmmmm . . . I'll have to think about that one. (JEN *watches* DANIEL *struggle with pills. Takes wet paper.*) I'll print this one out again.

DANIEL. Thanks. I don't want to give Heslup anything to keep him from signing his life's work away tomorrow. He'd argue about an un-dotted "i" if he thought it might stall the merger.

(HE *has a* HOHO *chaser after pills.*)

JEN. (*As exits*) I swear, you'd come back from the dead if you thought you had a chance to make a— (*stops*) That was really messed up. Sorry.

DANIEL. (*Half true*) No, you are one hundred percent right.

JEN. No matter how bad you looked?

DANIEL. Or smelled.

Beat

Hey. (SHE *stops.*) Don't get all *careful* on me. Okay?

JEN. Yeah. Thanks.

(JEN *exits.* DANIEL'S *posture slumps.* HE *is fatigued.* DANIEL *Leans back in chair and closes eyes. Intercom sounds.*)

DANIEL. Yes.

JEN. (*Over intercom*) Laurel Fein is here to see you.

DANIEL. Was she on the schedule?

JEN. Uh, no. She was . . . in the neighborhood. Roger is here for his weekly lube and oil job.

DANIEL. Is he standing right there?

JEN. Of course not. He's in the can prepping his dip stick.

DANIEL. You're terrible. Remind me to give you a raise. Yeah, Okay.

(*Twirls pen.*)

You're gonna love this. Tell Rog we have to reschedule. Tell him the Berringer Group is pulling out of the TranStar Merger.

JEN. You're kidding.

DANIEL. Yes, I am. Tell him I've got to take an emergency meeting with Berringer's . . . uh . . .

granddaughter. Say, "Mr. Davis is trying to get in the back door" then look over at Laurel. Throw in . . . "it might be an all day thing," or something like that. Oughta' make him nice and twitchy.

(*Pen slips from* HIS *fingers.*)

JEN. (*Formal*) Yes sir . . . He's here and I will relay the message, in its entirety.

DANIEL. Thanks Jen. Give me a minute, then send Laurel in.

(DANIEL *puts suit coat on. Takes handkerchief from pocket, wipes head and face. Stretches muscles of hands and mouth.* HE *clears pill bottles off desk. Pulls out paper work, looks busy.* JEN *peeks in door.*)

JEN. Ready?

DANIEL. Yeah. (JEN *starts to leave.*) Hey wait, what did little Rog say? (JEN *grins.*)

JEN. I'll send Laurel in.

(SHE *closes door.* DANIEL *puffs himself up.* LAUREL FEIN *enters.* SHE *is an attractive 46-year-old woman, bright, warm, and intelligent. Simply dressed. Not stylish, but not out of style.*)

LAUREL. Who was that in your waiting area?

(DANIEL *responds without looking up.*)

DANIEL. Small, annoying and impeccably dressed?

LAUREL. Yeah.

DANIEL. Roger.

LAUREL. Yeah, Roger Stern, I got that . . . but . . . who is he? Another second out there and I think he was gonna start licking me.

DANIEL. He's an intern.

LAUREL. Where'd you find him?

DANIEL. Old man Stern's grandkid.

LAUREL. Oh . . . Does he always drool like that? Or, am I just special.

DANIEL. He thought you were someone important.

LAUREL. I'm not?

(DANIEL *looks up.* LAUREL *is visibly surprised by his physical decline.*)

Wow, Danny.

DANIEL. What?

LAUREL. Nothing . . . I mean . . . wow, you look—

DANIEL. (*Brushing it off*) Oh yeah . . . I've been working a lot of Overtime . . .

LAUREL. You mean overtime beyond your normal eighty-hour weeks?

DANIEL. Yeah . . . you know me. . . . (*Beat*) So what can I do for you today, miss bleeding heart? I'm swamped with paperwork . . . You don't mind if I don't get up?

(*LAUREL sits.*)

LAUREL. Oh, no . . . of course not.

(*LAUREL takes small paper bag out of purse, hands to DANIEL.*)

(*Beat*) So . . . knock anyone off the ladder recently?

(*HE opens bag.*)

DANIEL. No one who didn't deserve it.

(*Pulls out homemade Rice-Krispy treats made with extra pastel-colored mini-marshmallows.*)

DANIEL. You darling little manipulative witch. What is it this time?

LAUREL. What? I just felt like baking.

DANIEL. Another save-the-world project?

LAUREL. Can't a person do something nice without having an agenda?

(*HE tastes treats.*)

DANIEL. Not someone who knows your Achilles heel. A new artistic genius who needs a benefactor?

LAUREL. Am I that predictable?

DANIEL. Let's call it . . . consistent. (*Indicates treats.*) Thank you. You're the only one who would do this for me. (*LAUREL smiles. DANIEL twirls pen. Beat.*) So, what'll it be? Charity or art?

(*Beat*)

LAUREL. Actually today, I have a real business proposition.

DANIEL. Right.

(*DANIEL's hand stiffens. Pen is flung to floor. Starts to pick it up. Instead takes another from desk drawer. LAUREL watches HIM struggle. SHE bends down, gets pen.*)

Thanks. My back's a little stiff . . . rough racquet-ball match this morning . . . after . . . a . . . um . . . an all-night transatlantic flight. You look great, by the way.

(*Beat*)

DANIEL. So, why are you really here?

LAUREL. I told you.

DANIEL. You have a—

LAUREL. A business proposition . . . yes.

DANIEL. This oughta be good . . .

LAUREL. I'm serious. (*Pause*) How've you been feeling?

DANIEL. Great . . . perfect, except for this stiff back thing . . .

LAUREL. I stopped in about three weeks ago. They said you were Out . . . indefinitely . . .

DANIEL. Yeah . . . It looked like, I was maybe gonna have to . . . uh run the London office . . . for a . . . I don't know . . .a while.

LAUREL. (*Fishing*) Really. What happened?

DANIEL. With what?

(*Beat*)

Oh, London . . . yeah . . . one of the guys from the Paris office, single guy . . . you know . . . was able to uh . . . (*Beat*) Hey, I'm really busy, Lo . . . what d'you need?

LAUREL. I ran into your parents last week. At a brunch I set up for the Barker Foundation . . .

DANIEL. What a nice little surprise for you.

LAUREL. It was nice.

(*DANIEL picks off piece of treat. Eats. Twirls pen.*)

LAUREL. Your dad looks good, I'm glad he's getting out a little.

DANIEL. Yeah, he's on some new rheumatoid miracle cure diet thing.

LAUREL. I hope it works.

DANIEL. I'm pretty skeptical about anything with *miracle* attached to it. He might be better off seeing the village witch doctor.

LAUREL. I think it's great he's open to trying things.

DANIEL. I wish him well.

(*Silence*)

LAUREL. They . . . told me about . . . I know you're sick. I asked why you were out of the office, and they—

(*HE shuffles papers.*)

DANIEL. Well, yeah, I've got this thing. It's not serious though . . .

LAUREL. You have ALS. (*Silence.*) They told me everything.

(*Silence* DANIEL *gathers papers together.*)

DANIEL. I'm in the early stages.

LAUREL. You've been sick for almost three years.

(*Silence*)

DANIEL. Two years, seven months, and somewhere between thirty to ninety days. My mother has a very big mouth.

LAUREL. It was actually your father.

DANIEL. My father?

LAUREL. Your mom tried to stop him.

DANIEL. I'll be sure to give her a birthday bonus.

LAUREL. They both seemed like they needed to talk about it. (*Beat*) I'm really . . . sorry—

DANIEL. Have you ever known me to give in to being sick?

LAUREL. Nope. You are the most stubborn person I know.

DANIEL. I like to think of it as . . . tenacious.

LAUREL. It's Lou Gehrig's Disease . . . not just . . . a little sick . . .

(*HE struggles to put papers in an envelope.*)

DANIEL. The higher the stakes the harder I fall. Something you never understood.

LAUREL. Oh, I understood it, I just didn't want to be a part of it. Especially the part about spitting on the people you've knocked into the gutter while you pass them by.

DANIEL. I can't believe you still bring that up. I just said it to make you mad.

(*Tries clip on papers instead.*)

LAUREL. Maybe there was some wisdom in it.

DANIEL. Lo, I'm okay, you don't—

LAUREL. How are Liz and the kids handling it?

DANIEL. Knowing I'm dying? (*Silence*) I'm not, and they're fine.

LAUREL. Liz doesn't know?

DANIEL. Of course she does.

LAUREL. But the kids don't. . . . What do they think?

(*Frustrated, puts papers in desk drawer.*)

DANIEL. That I'm in Europe. I've been staying at my brother's Place . . . in Chelsea . . . since the symptoms have—

LAUREL. Wait. First of all, I can't believe you're staying with Ken . . . and secondly . . . why aren't you telling them?

DANIEL. It's just for now . . . while I'm working things out. Ken's in Holland with his new boyfriend . . .

(DANIEL *works a pill bottle open.*)

LAUREL. That's great. Is this the first since—

DANIEL. I wouldn't know . . . Liz seems to think it could be the First . . . serious one.

LAUREL. Have you guys reconciled?

DANIEL. No.

LAUREL. Is he—

DANIEL. A lousy ass drunk again? Liz keeps in contact . . . you'd have to ask her. (*Pops pill without water.*) Stop looking at me like that.

LAUREL. Like what?

DANIEL. Like "poor Danny, he's dying and can't bully or . . . or buy himself out of it, so he . . . he's taking it out on everyone else."

LAUREL. Wow. I was actually thinking about when the last time was that we were all together . . . You, me and Ken . . .

(*Pill is stuck.* DANIEL *drinks water.* LAUREL *studies* DANIEL.)

DANIEL. So, your big business deal . . .

LAUREL. I've been thinking about making a change . . . In careers . . .

DANIEL. You mean you're actually thinking about having one?

LAUREL. Very funny. I'm thinking about . . . climbing onto that ladder myself . . . I'm done with saving the world.

DANIEL. Lo, you do not mean that. I wish you did. But I know you don't.

LAUREL. Yeah, I do. I've been working my ass off for twenty-something years.

DANIEL. It's looking very nice by the way.

LAUREL. I'm serious. What do I have to show for all my effort? I don't own a home, I don't have a 401K

DANIEL. No one else does either now.

LAUREL. I didn't even have one to lose. I'm tired of taking care Of . . . of everyone but me.

(LAUREL *puts legs up on* DANIEL'S *desk, leans back in chair.*)

LAUREL. It's Laurel's turn to get a little.

(*The chair tips back,* SHE *loses balance.*)

Holy moly!

DANIEL. Oh shit!

(DANIEL *gets up to help. His leg stiffens and contracts. He stumbles, landing on the floor.*)

LAUREL. Oh my gosh. Are you Okay?

DANIEL. Yes. (*Beat*) No. Awwww, damn it.

LAUREL. Let me get some help.

DANIEL. No. I'm fine. It'll pass . . . It's just a cramp.

LAUREL. Are you sure? Maybe we should get someone—

DANIEL. I said I'll be fine. I will be fine.

LAUREL. You're not fine . . . you won't ever be fine again.

DANIEL. Fuck you.

LAUREL. I'd love to, but I'm thinking Liz won't approve.

DANIEL. If I'm dying, her approval might not matter.

(DANIEL *uses desk to pull* HIMSELF *up.* LAUREL *helps.* SHE *tears up.*)

LAUREL. I'm sorry. I promised myself I wouldn't cry.

DANIEL. I'd be disappointed if you didn't. It's a very . . . sweet.

LAUREL. Yeah, that's me, a real sweetheart.

DANIEL. You have a good heart.

LAUREL. Wasn't enough though, in the end.

DANIEL. I wanted to marry you. (*Beat*) Desperately.

(*Silence*)

LAUREL. I could never have been the kind of wife Liz is.

DANIEL. She never makes me Rice-Krispy treats.

LAUREL. With extra marshmallows.

DANIEL. Liz is more a personal manager and publicist with benefits, than a *wife*. (*Beat*) I'd be lost without her.

(DANIEL *with* LAUREL'S *help manages to get* HIMSELF *to a comfortable chair.*)

LAUREL. You're exhausted. What are you doing at the office?

DANIEL. Pushing people over and spitting on them.

LAUREL. Water?

DANIEL. Thanks.

(LAUREL *hands water glass to* DANIEL.)

DANIEL. Enough about me, what's this so-called business thing that you're throwing your goodness away for?

LAUREL. Well, okay, I have been accepted into a young producers program at Fox.

DANIEL. *Young* producers?

LAUREL. They think I'm younger than I am. (*Beat*) Yeah, okay, I lied.

DANIEL. Lo, you have come over to the dark side.

LAUREL. Anyway, I have to pitch an idea for a new reality show in a few weeks. They're actually going to pick one from the group and green light it.

(DANIEL *indicates treats.*)

DANIEL. How much do you need?

LAUREL. I don't need money.

(LAUREL *hands* HIM *one.*)

DANIEL. What then? A series about me? "Who wants to have an affair with a dying middle-aged tycoon?"

LAUREL. Actually, it is a series, about you. (*Silence*) Okay. Let me get the whole thing out before you say anything. (SHE *puts another treat on his lap. Silence.*) Okay. I know you're very sick.

DANIEL. I am not—

LAUREL. . . . and, I know you have about ten to fifteen months, now that your symptoms have started to show.

DANIEL. Jesus, Lo. Did'ya take a tact-suppressant before coming over here?

LAUREL. I'm sorry. I wish it weren't reality . . . but it is.

DANIEL. Some people live for ten years with this *thing*.

LAUREL. I also know that with ALS several of your organs will be completely unaffected. And it occurred to me—

DANIEL. The jury is still out on ALS and organ donation—

LAUREL. I know. (*HE twirls pen.*) It's not a commonly accepted practice for ALS but—

DANIEL. It's illegal to sell organs ya know.

LAUREL. It occurred to me that you might want to donate those organs.

DANIEL. I'm not—

LAUREL. Shush!

DANIEL. (*Laughing*) Shush?

LAUREL. One of the organs that should stay healthy is . . . your heart. (*Silence. SHE waits for an objection.*) Then, it occurred to me, that . . . Okay, that we could build a show around your search for someone to give your heart to. (*Silence*) I'm done.

(*HE laughs.*)

DANIEL. You are a very sick lady. Very sick, funny and still adorable. I appreciate your visit.

LAUREL. I wasn't being funny.

DANIEL. Liz'll love it.

LAUREL. This could be really big, Danny. We start by interviewing hundreds of people, all kinds, that need a heart. Then we do an episode on you. Your life, accomplishments, business, philanthropy, your family. Really play up the amazing person behind the heart.

DANIEL. Soaring the heights and crashing the depths—

LAUREL. Exactly. For the next five episodes we bring the seven finalists together, to live in one of your houses. The "benevolent wealthy donor, hosting those less fortunate"—that kind of thing.

DANIEL. Who's covering the liability insurance for "*that* kind of thing?"

LAUREL. Huh. I'm not sure. Network, probably. I'll have to find out.

(*LAUREL makes a note.*)

DANIEL. You're serious.

LAUREL. You spend time with each of them, our audience can e-mail or text in opinions. Maybe they each take us on a field trip to their lives, we meet their families, see where they work, go to church, whatever. I don't know.

DANIEL. Touching.

LAUREL. We watch them living together in the house, to see what they're really like—you know, are they putting us on when they spend time with you—

DANIEL. "Is the catheter bag hanging out of their pants a fake" kind of thing?

LAUREL. You eliminate one each week, until we're down to the last two. Then, we let America vote. It's called "Have a Heart."

DANIEL. What if I actually don't die, or at least, not on schedule?

LAUREL. We can do a two-hour special on the transplant whenever. (*Beat*) Well, not when*ever*, but as long as it's within a timetable that works for the person getting the—We can work those details out later. I don't think the timing's that important.

DANIEL. You're not kidding.

LAUREL. No.

DANIEL. Did this all occur to you at once, like a full blown . . . concept. Or have you actually spent time planning it out?

LAUREL. I guess the idea just came to me. (*Silence*) Then it took me about a week to come up with the treatment. (*Beat*) I thought you'd really love it. It's right up your alley. (*Beat*) There's a lot of money to be made in licensing too. *Have a Heart* T-shirts, ball caps, I don't know . . . maybe paper weights . . . All with your face. It'll make a fortune. (*Silence*) Well? What do you think?

DANIEL. What are you taking? Or maybe stopped taking?

LAUREL. What do you mean?

DANIEL. This is insane. It's cruel, immoral, parasitic, and inhumane.

LAUREL. But it's not illegal. I checked.

DANIEL. Am I being punk'd?

LAUREL. You made your entire fortune one cruel, immoral, parasitic, act at a time.

DANIEL. That's one perspective.

LAUREL. I thought you'd be all over this.

DANIEL. Where is this coming from?

LAUREL. You've wanted fame and fortune since you were old enough to know what it is. Okay, you made your fortune. You're running out of time. I can give you fame!

(Beat)

DANIEL. Who would want a heart from a man who died from ALS anyway?

LAUREL. Someone whose only other option is not getting one. (Beat) It's real-life drama. That's huge ratings.

DANIEL. Wow.

(Beat)

LAUREL. What do you object to Danny, the idea, or it being *your* heart?

DANIEL. The kindest, most loving and honorable person I know has just presented the most contemptible business venture I've ever heard. I object to that. And yes, I might love the idea, if I weren't the star and you weren't the creator.

LAUREL. I know it's a lot to take in. (Beat) This is something we could work on together . . . It could be—

DANIEL. Not from you Laurel. Not you.

LAUREL. Yeah, not *me* Danny, right? Because people like you need people like me so you can sleep at night knowing someone is being honorable and taking care of the sorry little people.

DANIEL. Lo—

LAUREL. So you can give away a fraction of your dirty money and have everyone tell you how *good* you are. It's people like me that have made people like you real heroes.

DANIEL. Come on, Lo . . .

LAUREL. But nothing ever really changes, does it?

DANIEL. Laurel—

LAUREL. The sorry little people get sorrier and needier, you get richer. And all I get is old.

DANIEL. You have made a big difference in peoples' lives.

LAUREL. How would you know? When was the last time you went slumming with the little people?

DANIEL. Saturday. Bellevue. Emergency room. Izzy took a soccer ball to the face. It was the closest hospital. (Beat) What? It's true? Great old candy machine.

LAUREL. You don't get rich taking care of the poor.

DANIEL. That was obvious from the employees' parking lot.

LAUREL. I'm being serious damn it!

(SHE's getting choked up again.)

DANIEL. You never seemed to care much about getting rich before. If you need money . . . I'd be happy to write you a check.

LAUREL. I don't want your charity.

DANIEL. What do you want, Lo? (Beat) What is it you really want?

(Silence)

LAUREL. I need to . . . do . . . something. I want to—

(A tentative knock on the door. JEN looks in.)

JEN. I'm sorry to interrupt, Mr. Davis, but you have a . . . an uh . . . *appointment*, in thirty minutes. Do you want me to call your car?

DANIEL. Thanks, Jen, Liz is coming. Would you call Dr. Frank's office and tell them I'm running late?

JEN. I'll let you know when Mrs. Davis gets here. Do you want me to get your coat?

DANIEL. Please. (JEN exits. Silence.) She's a good girl.

LAUREL. You wouldn't have it any other way.

(Silence)

DANIEL. I have to get going. I'm being interviewed for a new drug trial. (Beat) I can't just give up.

LAUREL. That's okay. I'm sure there's someone out there willing to sell their soul—or at least, their heart.

DANIEL. Is that what this is really about?

LAUREL. Yeah. What else? What do you mean?

DANIEL. I don't know. It's just . . . surprising . . .

(LAUREL *pauses.*)

LAUREL. Life is full of surprises.

DANIEL. You're telling me.

(JEN *enters with* DANIEL's *coat.*)

LAUREL. Bye, Danny.

(SHE *exits. Lights fade.*)

Act 2
Scene 2

(A park bench, Central Park. One week later. Early morning. DANIEL sits alone, dressed casually, the kind of casual that costs a lot. HE talks on Bluetooth, makes notes.)

DANIEL. So, if we take the foreign distribution including Asian markets . . . Yeah, we don't even need their domestic . . . Right. . . No, we'll just shut 'em down, auction off the stock, liquidate assets, and put it all back into opening up Africa. God, Mike, this is just too easy . . . I know . . . It's never as much fun when it's easy. Yeah, okay. Frankie's gonna run with this one . . . Yeah, Rog is working with him on it . . . Do we have a choice? No, do not, I repeat do not let Rog know about squashing their domestic. The last thing we need is him leaking it. I don't need the press banging down Stern's door until it's a done deal. Then he can honestly say he knew nothing about the cuts . . . Yeah, I know . . . It'll be around the holidays so, yeah, we'll come up with something nice, some kind of bonus to make them feel better about it.

(LAUREL *enters, carries paper bag and two cups.*)

Hey, they'll get to spend more time with their kids around the holidays. Who doesn't love that? Okay. Yeah . . . How's your kid? That's fantastic . . . They're great . . . Yeah. You bet. Great work . . . Only if there's a problem. I mean a big problem . . . Later.

(*Makes notes. Looks up, sees* LAUREL *staring.*)

Another rung.

LAUREL. What happens when you get to the top?

DANIEL. Hire a bunch of conniving, cut-throat wiz kids to keep me there.

LAUREL. (*Looks around*) New office?

DANIEL. Yeah, just a little something I picked up.

LAUREL. It's nice. Feels a little exposed though, for all that subterfuge you enjoy so much.

DANIEL. It's actually perfect. Trembling man, alone, enjoying a few hard-won breaths of fresh air. Great ploy. No one would suspect.

(SHE *sits.*)

LAUREL. You've got it all worked out. Always have.

(LAUREL *hands* DANIEL *cup. Opens bag, takes out muffin. Drinks other cup.*)

DANIEL. Apparently, not this time. (*Offers cup back*) I'm not supposed to drink coffee.

LAUREL. It's not coffee.

(HE *tastes.*)

DANIEL. That's really good. What is it?

LAUREL. I picked it up at Greening Max on 52nd.

DANIEL. It tasted better before I knew where it came from. Thanks. (*Silence*) I didn't like how we left things.

LAUREL. How'd the trial interview go?

DANIEL. It didn't.

LAUREL. What do you mean?

DANIEL. I was three years too old and no amount of money or intimidation was going to change the policy. I couldn't even pay off the medical student filling out the paperwork to lie about my age.

LAUREL. I'm sorry.

DANIEL. What's the world coming to when a guy can't buy his way into being a dumb guinea pig?

LAUREL. Did you offer to build them a new research lab?

DANIEL. Of course. Suddenly everyone wants to be all accountable and PC.

(HE *takes a piece of* HER *muffin.*)

LAUREL. Wanna go halfsies?

DANIEL. No, just a taste.

LAUREL. So? Now what?

(*Beat*)

DANIEL. I'm dying, Lo. I'm fucking dying. (*Eats*) Not bad, if you're into that whole health thing. (*Silence*)

LAUREL. Did you tell the kids?

(DANIEL *twirls pen.*)

DANIEL. Dad's returning from Europe tonight. (*He is unable to make his fingers move with any fluidity.*) With a whole lot of gifts and a little bad news. (*He tosses pen.*)

LAUREL. They'll be devastated.

DANIEL. Nick, and Izzy will . . . I'm afraid Janna takes after Liz . . . she'll wanna know that the will is all in order.

LAUREL. Liz is not really like . . . that. I'm sure she's very upset.

DANIEL. Not so far. It's not a bad thing really. It's what I fell in love with. The perfect rock to hold my ladder in place.

LAUREL. I'm sorry about our last visit. I really thought you'd love the idea. It was pretty insensitive of me.

DANIEL. Yeah, you really laid some pretty heavy shit on me.

LAUREL. I didn't mean to. Forgiven?

DANIEL. You were right. I do love it.

LAUREL. You do?

DANIEL. I just wasn't ready to be the perfect guy to cast in the role of the dying man. I still can't believe you thought of it.

LAUREL. I can't either actually.

(*Beat*)

DANIEL. I wanna do it.

LAUREL. What?

DANIEL. Your show . . . your remarkably insensitive and brilliant TV show.

LAUREL. Why? I don't even know if it'll get picked up . . . Oh my gosh. You really want to do this?

DANIEL. Yes, I do.

LAUREL. What changed your mind?

DANIEL. I made the mistake of telling Liz. Flipped over it. She has a remarkable way of putting deviant behavior in charitable perspective.

LAUREL. Wow. (*Beat*) This is great. I think. I mean, yeah . . . this is . . . great.

DANIEL. And . . . Although I haven't quite figured out why yet, it seemed important to you. (*Beat*) Something we can do together.

LAUREL. Wow. You really wanna do this . . . with me?

DANIEL. And . . . (*Beat*) I want to be remembered.

LAUREL. Of course you'll be remembered.

DANIEL. Not just some dead rich guy with his name on a bunch of buildings. I want people to remember *me*.

LAUREL. You're serious.

DANIEL. Yes, I am. Dead, serious.

LAUREL. Pun intended?

DANIEL. Absolutely.

(*He eats more of Her muffin.*)

LAUREL. You keep eating this healthy stuff and you won't have room for your Twinkies.

DANIEL. There's always room for Twinkies. (*Beat*) A few things.

LAUREL. Ah, here it comes.

DANIEL. All merchandising profits, I mean ALL go to Liz's new charity.

LAUREL. Which is?

DANIEL. The Daniel R. Davis Center for ALS Research.

(*Beat*)

LAUREL. I would give anything not to even be able to have this conversation with you.

DANIEL. Yeah, me, too . . . However . . .

LAUREL. That should actually help the network sell advertising.

DANIEL. You leave the kids alone.

LAUREL. No problem.

DANIEL. Liz sits in on all editing sessions. She wants to make sure the version of reality they're selling is *her* version. I can't blame her. She's the one who's gonna have to live with this.

LAUREL. That's not as easy as it sounds. But I will do everything humanly possible to make it happen.

DANIEL. Liz will be happy to help you *persuade* them.

LAUREL. Okay.

DANIEL. This last one is mine, Lo. You don't agree to this and the deal's off.

LAUREL. Why did my heart just relocate to my throat?

DANIEL. When the time comes that I can't stand living . . . in the torture chamber my body's gonna become, you have to help me . . . move on.

LAUREL. You mean like a *Do Not Resuscitate* sort of thing?

DANIEL. Nope, got one of those.

(Silence)

(Beat)

(LAUREL realizes HIS intent.)

LAUREL. No. Do not ask that of me. Do not do this.

DANIEL. You're the only one, Laurel. It has to be you.

LAUREL. But . . .

DANIEL. Look. With any luck the DNR will take care of . . . things, before I need your help. But—

LAUREL. I can't. I could never do that.

DANIEL. You think it's gonna be any less awful to sit there and watch me stuck inside a living tomb. 'Cause that's what my future holds.

LAUREL. It's like . . . like asking me to play God.

DANIEL. Oh, and deciding who gets to have a new heart and who doesn't isn't?

LAUREL. That's different.

DANIEL. It's not, Lo. You're building up the hopes of seven dying people then sending six of them off to their graves. *(Beat)* Have you really thought about what you're getting yourself into with this show?

LAUREL. Yes. No . . . mostly . . . Why not Liz? Why can't she . . .

DANIEL. I have no doubt Liz would do it. But I will not ask her to spend the rest of her life either hiding from or trying to explain to her children why she ended their father's life.

LAUREL. No. *(Beat)* There has to be someone . . . else . . . Please, Daniel, please don't ask me to do this . . .

DANIEL. It has to be you. *(Beat)* You're the only one I can trust. I know you would never take my life if you didn't *have* to. And, I know that if you make me a promise . . . you'll keep it.

LAUREL. I've spent my entire adult life saving lives. How could I . . .

DANIEL. It's a deal breaker, Lo.

(Long silence.)

LAUREL. Sometimes I hate loving you.

DANIEL. Hey, the higher you climb, the cloudier the view. *(Silence)* That surprises you? *(Silence)* So, how badly do you wanna play with my heart?

(Lights fade)

The Theatre at Aspendos, Turkey is considered to be the best preserved example of a Greco-Roman theatre. It can hold up to 20,000 spectators at a single time. Photo by Stephen Suber.

Jonathan Pryce and Jill Bennett in a 1980 production of *Hamlet* at The Royal Court Theatre. Image from Corel.

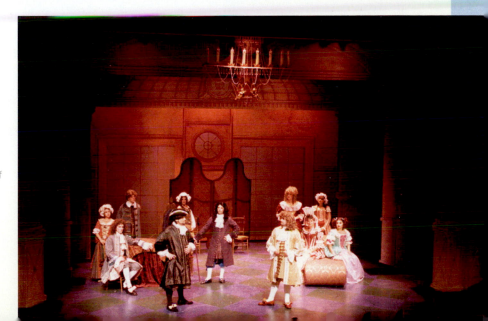

A production still from Southeastern Louisiana University's 1999 production of *Tartuffe*. Courtesy of SLU Theatre.

Production still from a 1997 production of Ibsen's *A Doll House*. © Heleimian Julien/CORBIS SYGMSA

Sean Scrutchins as Jack and Shelby Cade as Cecily in the University of Southern Mississippi's 2009 production of *The Importance of Being Earnest*. Directed by Sean Boyd. Photograph by Steve Rouse.

From left to right: Shawn Curry as Vincent, Whitney Allen as Amanda, and Jaren Mitchell as Tiger in Southeastern Louisiana University's 2007 production of *Dead Flowers*. Directed by Chad Winters. Photo by Steve Schepker.

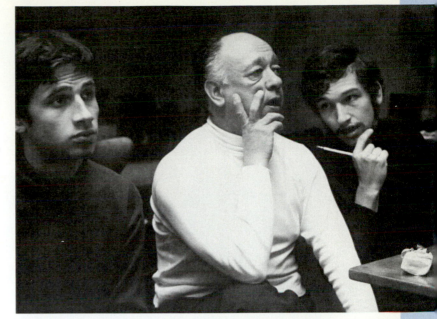

Eugene Ionesco (center) at a rehearsal for one of his plays. © Hueton-Deutsch Collection/CORBIS.

Award-winning actor James Earl Jones backstage for Fences. Jones won his second Tony Award for his portrayal of Troy Maxson in the original Broadway production of Fences. © Bettmann/CORBIS.

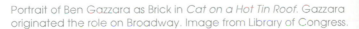

Portrait of Ben Gazzara as Brick in Cat on a Hot Tin Roof. Gazzara originated the role on Broadway. Image from Library of Congress.

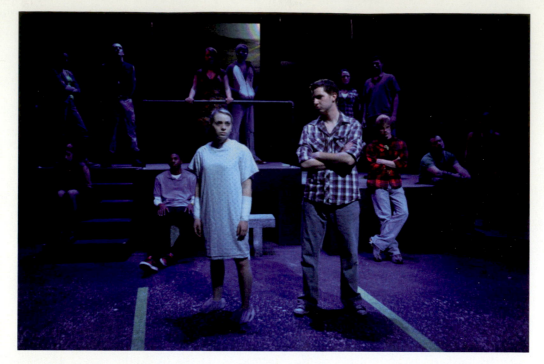

Production still from Southeastern Louisiana University's world premiere of *Parking Lot Babies*.
Directed by Jim Winter. Photo by Steve Schepker.

(From left to right:) Jim Winter directs Bruce McIntosh and Ramsey Scott during the Metta Theatre workshop of Lisa
Beth Allen's *Have a Heart*. Photograph by Anthony H. Cisneros.